ON
PRODUCING
SHAKESPEARE

ON PRODUCING
SHAKESPEARE

BY RONALD WATKINS

with drawings by
MAURICE PERCIVAL

BENJAMIN BLOM, INC.

New York

First published London 1950 by Michael Joseph, Ltd.
Second edition ⓒ Copyright 1964 by Benjamin Blom, Inc.
Library of Congress catalog number: 64-14718
Published by Benjamin Blom, Inc., New York 52.

Printed in U.S.A. by
NOBLE OFFSET PRINTERS, INC.
NEW YORK 3, N. Y.

To
MY WIFE

Introduction to Second Edition

Since 1950, when this book was first published, there have been, on both sides of the Atlantic, great changes in the Shakespearian productions of the professional theatre. The proscenium arch is quite out of fashion; swift continuity of action on a bare projecting platform, with adaptable features in a "permanent set", is now the rule rather than the exception. There have been experiments in steady lighting, and in the use of the unlocalised stage. More attention has been paid to the quality of speech, and a greater respect shown for the detail of the text. "Globe-type" stages have been built, both in England and America. Repertory companies have been formed to create a continuous tradition of acting. From evidence reaching these shores, it seems that the New World has been more active than the Old in furthering the cause. Stratford, Ontario, has, according to these reports, staged some of the outstanding Shakespearian productions of our time. Ten years after its inception in 1953, a critic in the London press was moved to explain "why Stratford, Ontario, is more important than Stratford, Warwickshire": and Tanya Moiseiwitsch's design has had its influence upon the architecture of our own Chichester. Meanwhile the sumptuous souvenir programmes of Angus L. Bowmer's Annual Festival from Ashland, Oregon, make me impatient for the day when I can cross the Atlantic to see for myself whether faith in Shakespeare's stagecraft is stronger there than in this country. For still, on our side, in the quarter-centenary year of Shakespeare's birth, it remains true that there is no professional playhouse devoted to presenting the plays in the conditions for which they were devised.

I remember in 1943 the excitement with which, holding Cranford Adams' new book in one hand and a tape-measure in the other, I discovered that we had in the Speech Room at Harrow School approximately the dimensions both of playhouse and platform as given in his Globe diagrams. His book was not only a revelation of historical fact but offered the first practical basis

i

for constructing a replica of Shakespeare's Globe. Its general thesis has since been reinforced with the familiar model on view in the Folger Library, and by the elaborately detailed account, with full-scale drawings, of Irwin Smith; though a number of its particular findings have been challenged by the conservative scholarship of C. Walter Hodges and the radical alternatives of Leslie Hotson, and more recently by the closely marshalled evidence of Bernard Beckerman, Director of the Shakespeare Festival at Dr. Adams' own Hofstra College. But *The Globe Playhouse* remains a pioneer work of the utmost importance for the understanding and appreciation of Shakespeare, just because it provides the local habitation for a fresh vision of the plays. In constructing my book, I propped a picture before me, drawn from his diagrams, and, with a reproduction of the first Folio text, re-read most of the plays in chronological order of composition (following Chambers' list), and saw them taking shape in the Elizabethan playhouse. Since then more than twenty of the plays have been produced in such conditions at Harrow: and, in spite of the technical inexperience of school-boy actors, it is no exaggeration to say that for many in the audiences Shakespeare's intentions have again and again been seen for the first time. There is nothing surprising in this: for the method of "production" has been constant and, one might say, fool-proof. After creating the essential conditions of his theatre, we have asked "What did the Chamberlain's Men do? Why did Shakespeare write it like this? What was his intention in this or that speech? In such-and-such a sequence?" And the rest followed: we found always that he had faced the problem before us, and solved it by means of his stagecraft, developed to meet the needs of his particular theatre.

My book reflects the earlier experiments of this annual series; and nothing learnt from subsequent productions has given me reason to change my previous convictions. I do not take my stand upon the detailed reconstruction of one or another contestant in the scholars' debate. Dr. Beckerman's important book *Shakespeare at the Globe,* published by Macmillan, New York, in 1962, gives an up-to-date summary of the findings of scholarship with regard to stage-craft, stage-design, acting tradition and staging. He finds in my book "the assumption that the stage structure and its machinery played the decisive role in the presentation of an Elizabethan drama." But I question whether this assumption is implicit in my argument: on the contrary, I find

myself in whole-hearted agreement with the concluding passage of his Chapter Three: "... the Globe was constructed and employed to tell a story as vigorously and as excitingly and as intensely as possible. Though spectators were usually informed where a scene took place, they were informed by the words they heard, not the sights they saw. Instead, place was given specific emphasis only when and to the degree the narrative required. Otherwise, the audience gazed upon a splendid symbol of the universe before which all sorts of human actions could be unfolded." I am chiefly concerned to apply the findings of scholarship, as productively as the evidence allows, to the practical process of reviving the dry bones of the printed word. To do this, I have been obliged to make use of conjecture: some guesswork is necessary, if the work of scholars in this field is not to remain sterile. But whereas the architectural details of the Elizabethan-Jacobean playhouse are still uncertain, there is enough agreement about the fundamental conditions of Shakespearian production to make it possible to reproduce them in actual performance or (by the reader) in the mind's eye.

The conditions which are most necessary are listed in my Epilogue (pp. 314-16). To this list I would add a further point, which experience has taught me to consider of prime importance. Instead of the composite "set" ingeniously designed *ad hoc,* the platform and the facade of the tiring-house—however conceived and designed—should be a permanent part of the structure of the playhouse; it should be taken for granted by the audience, when they come into the theatre, that they will see this familiar frame-work; and their interest will be kindled on each visit to wonder how the poet-dramatist will transform it this time. That post which was a tree last week will be a pillar now; the Tarras was once a Venetian balcony—is it a castle-parapet today? The Trap-door has led to a convivial cellar, or been haunted by ghosts—and this afternoon Ophelia will be buried in it. If there is to be visual illusion, it will be revealed in that shallow inset behind the curtains of the Study—bare, wind-swept bushes on Macbeth's blasted heath, the dais and curule chairs of Caesar's senate-house, the moss-bank and hawthorn-brake of Oberon's wood. The make-believe is itself an integral part of the dramatic thrill: the actors posture and gesture and create with their speech what we cannot see, except with the eye of faith, the mind's eye. But if they know their job, we shall be very ready to suspend our disbelief. It is a wonder to me that our actors do not *demand*

such conditions; for the opportunities for them are far greater than any the modern theatre has yet offered them.

"Perhaps the dream of a practical stage for the trying-out of theories and for demonstrations of established truths may not be realised, for theatres are costly things to build. Yet it would appear as though only something of this sort can aid us towards fuller and further accomplishment in the study of the Elizabethan theatre." So wrote Allardyce Nicoll in the first *Shakespeare Survey,* (Cambridge U.P.) of 1948: it is a little sad that 1964, the year of the quartercentenary, should not include among its countless services to Shakespeare the realisation of this dream. The need is for a playhouse with a permanent platform and tiring-house, and a permanent repertory company trained in the tradition of the Chamberlain's Men. In England William Poel blazed the trail in his renowned performances for the Elizabethan Stage Society; while Granville-Barker's *Prefaces,* as fresh and valid today as when they were written, provide a ready-made hand-book for producers. But while the English professional theatre experiments with every other way of producing Shakespeare, and there are of course many such other ways, the only way not so far in favour is Shakespeare's own. There's the rub. Perhaps the New World may yet redress the balance of the Old, and the Potomac of Missouri reflect in its waters a Globe Theatre denied to the Avon or the Thames.

R. W.

January, 1964

ILLUSTRATIONS

Stratford (Ontario) Shakespeare Festival

The Canadian Shakespeare Festival was launched on July 13, 1953, first under the artistic direction of Tyrone Guthrie and, more recently, of Michael Langham. It has presented 26 of Shakespeare's plays, and also plays by Sophocles, Rostand, Moliere, Wycherley, and Donald Jack, a contemporary Canadian playwright. Music and exhibits have been added to the Festival's activities.

The focal point of the theatre is the pillared, porticoed stage, designed in 1953 by Tanya Moiseiwitsch and Tyrone Guthrie, on which elaborate costumes and properties, in lieu of scenery, serve as the only dressing. The platform stage is a permanent structure—a modern adaptation of the Elizabethan stage with balcony, trap-doors, seven acting levels and nine major entrances. The steeply sloping amphitheatre surrounds the stage on three sides with its 220-degree sweep, establishing an unusually intimate actor-audience relationship. The addition of an 858-seat balcony brings the capacity of the theatre to 2,258 without sacrificing the intimacy of the auditorium in which no spectator is more than 65 feet from the stage.

STRATFORD, ONTARIO SHAKESPEARE FESTIVAL PHOTOS BY PETER SMITH

View of the 2,258 seat Auditorium

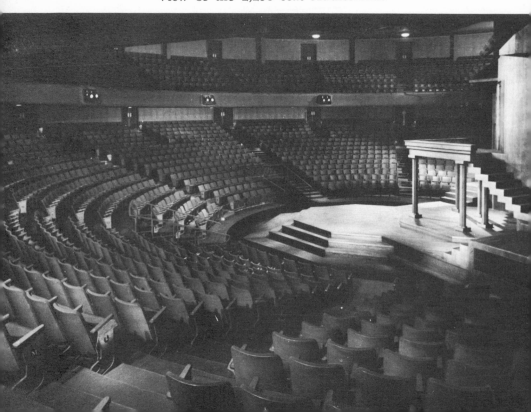

Macbeth, 1962

The Tempest, summer 1962

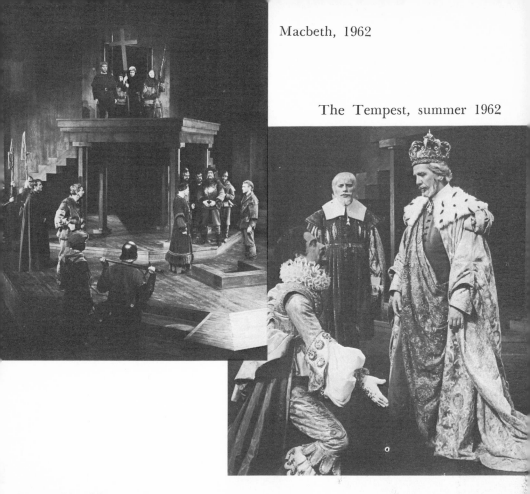

Henry V, 1956

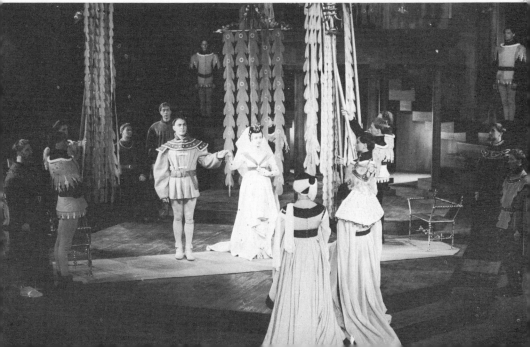

American Shakespeare Festival
STRATFORD, CONNECTICUT

The first professional Shakespearean Repertory Theatre in the United States opened its initial season in 1955. Using fragmentary suggestive scenery, the Connecticut artistic directors have achieved pageantry and spectacle through extensive use of elaborate properties and costumes. The productions have ranged from modern dress (As You Like It, 1961), Civil War (Troilus and Cressida, 1961), the American Southwest (Much Ado About Nothing, 1958), to Tudor, Italian Renaissance, and Elizabethan.

The theatre seats 1500, and its playing area is a huge proscenium stage with a large apron that thrusts into the audience. The stage provides an essentially open space where scenes and scenery can shift rapidly.

In a departure from its past policy of bringing in well known stars, the Theatre for the past two years has maintained a repertory company which has been working together under a grant from the Ford Foundation.

AMERICAN SHAKESPEARE FESTIVAL, (CONNECTICUT), PHOTOS BY FRIEDMAN-ABELES

A Midsummer Night's Dream, 1958

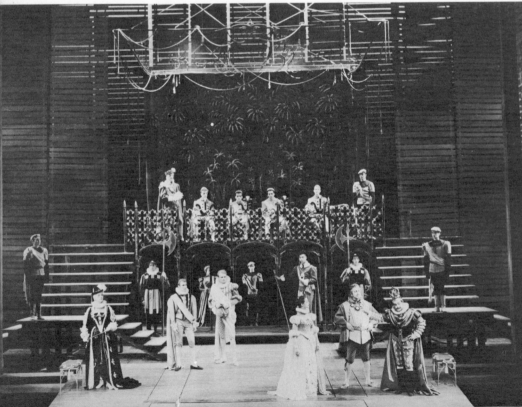

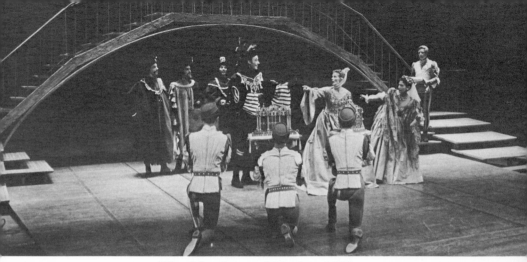

The Merchant of Venice, 1959

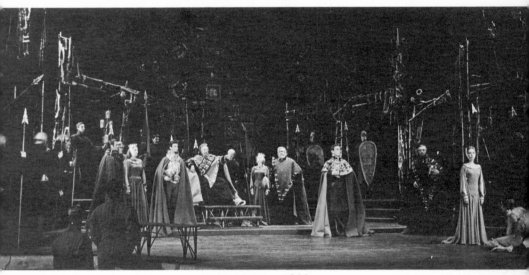

King Lear, 1963
A Winter's Tale, 1958

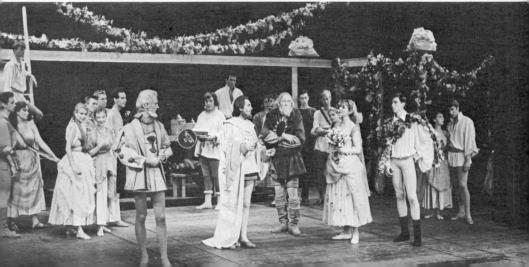

New York Shakespeare Festival

The New York Shakespeare Festival, Joseph Papp producer, was granted a non-profit, educational charter by the New York State Board of Regents in 1954. For two years performances were staged in the amphitheatre of a Sunday school, but in 1957 it moved to a temporary open-air theatre in Central Park, in the heart of Manhattan. It now operates there in its permanent home, the 2,260 seat open-air Delacorte Theater. The Festival presents an annual season of three plays, admission free, on a twentieth-century adaptation of Shakespeare's stage. The stage is essentially an open platform with the audience in a 120-degree arc around it. Scenery is minimal—abstract rather than representational. Usually the basic set embodies general elements of the locale, with changes suggested by banners or set pieces.

The Festival has performed more than 22 of Shakespeare's plays. Annually more than 150,000 people see the free performances of the three productions presented each summer. An additional 75,000 students see the company's winter production which tours the New York City public high schools and, starting in 1964, will be seen in the various parks, playgrounds, and housing developments in the five boroughs of New York City. Since 1961, the City of New York has appropriated $785,000 to the Festival's summer and school activities. The remainder of the annual budget is raised by contributions from civic groups, foundations and individuals.

NEW YORK SHAKESPEARE FESTIVAL PHOTOS BY GEORGE E. JOSEPH

Delacorte Theater in Central Park

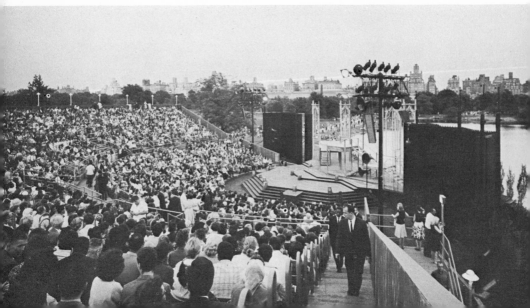

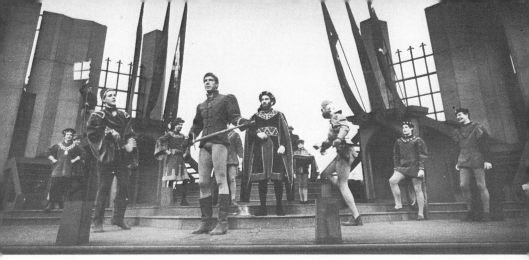

Henry V, summer 1960

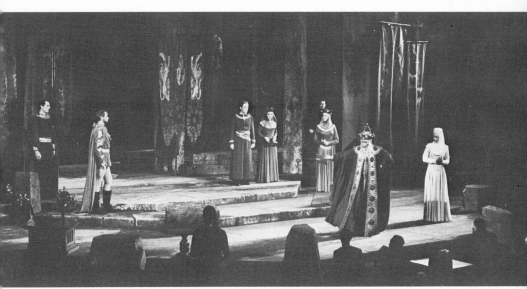

King Lear, summer 1962

The Tempest, summer 1962

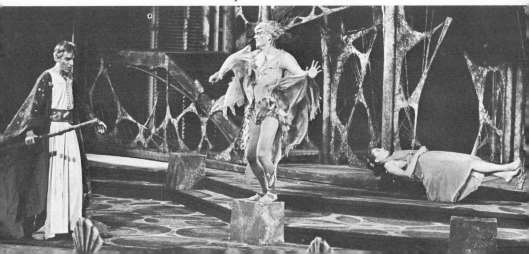

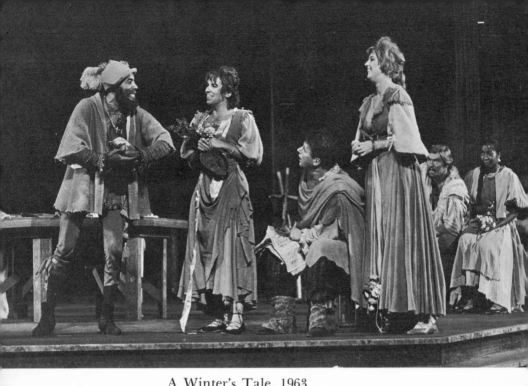

A Winter's Tale, 1963

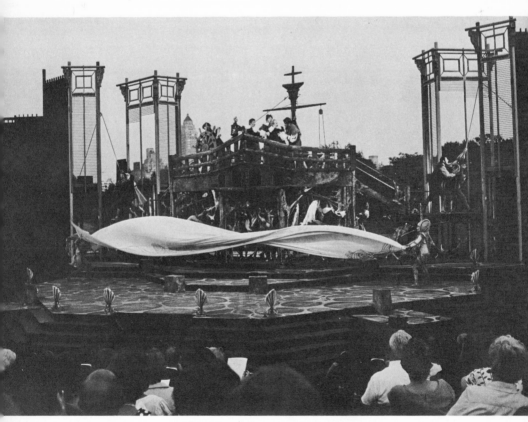

The Tempest, summer 1962

CONTENTS

Preface

NO ONE who writes about Shakespeare can hope to acknow-
ledge all that he owes to his predecessors. The names of
many to whom I am indebted are recorded in the text or the
footnotes of this book: but three I would like to mention here with
special gratitude. It was the *Prefaces* of Harley Granville-Barker that
first led me to study the Elizabethan presentation of Shakespeare's
plays. John Cranford Adams, by his *The Globe Playhouse: Its Design
and Equipment*, made clear to me what the material conditions of such
a presentation were, and I am glad of the opportunity to thank him
for his kindly personal interest in my researches and for his generous
permission to make use of his plans and models. Thirdly, I owe much
to T. W. Baldwin's *The Organization and Personnel of the Shakespearean
Company*, and for leave to reproduce some of the conjectural cast-lists
which appear in that book.

My thanks are also due to the Governors of Dulwich College for
permission to reproduce the portraits of Richard Burbadge and
William Sly from their Gallery; to the Keeper of the Ashmolean
Museum for the portrait of John Lowin; and to the Delegates of the
Clarendon Press for leave to print E. K. Chambers' chronological
list of the plays.

The theory of production put forward in my book would perhaps
carry less weight if it had not been possible to test it in practice by
continuous and progressive experiment. For this opportunity I am
first and foremost indebted to the Governors of Harrow School and
to two Head Masters; as also to the enthusiastic co-operation of all
who have taken part whether on or off the platform in Speech Room
since 1941; especially to Mr. Maurice Percival and the Reverend
H. L. Harris, who have collaborated in these productions; to Mr.
Henry Havergal and Mr. Hector McCurrach for their help with the
music, and to the latter in particular for his advice on the section of
my book which deals with the musical accompaniment of the play.
Not least is my debt to Mr. E. V. C. Plumptre, who both as official
chronicler and unofficial critic of the series has constantly encouraged

me to persevere in my attempts to convince others beside myself that there is a right way to produce Shakespeare.

Finally, I take this opportunity of thanking Mrs. Judith Thorp for drawing some of the plans and diagrams, Miss E. Stein and Mrs. M. Blundell for preparing the typescript for the press, and Mr. Douglas Wilson for his meticulous care in checking the quotations and references, and in constructing the indices.

<div align="right">R. W.</div>

INTRODUCTION

THE history of the production of Shakespeare's plays in this country is an interesting but melancholy study,[1] reflecting little credit on his own profession and excusing, if not justifying, the habitual apathy of those scholars and critics and other admirers of the poet who prefer to experience his plays in imagination rather than in the theatre. Amid a bewildering variety of experiments in new methods of presentation, one fact emerges with unmistakable clarity—that never since the closing of the theatres in 1642 has a play of his been performed in the conditions for which he devised it. The story of divergence begins with a positive and quite sincere attack, on critical principles: D'Avenant, learning in the school of Ben Jonson and in the French tradition, honestly believed that Shakespeare's artless genius needed refinement, and re-wrote *Macbeth* so that it should preserve harmony of style and balance of plot. Yet it was uncritical fashion and the demands of popular taste that, as soon as the theatres were again licensed, made two radical changes in the tradition of performance. The substance of a complaint by the old King's Men (the survivors of Shakespeare's own company) in a petition of October 13th, 1660, was that Killigrew had suppressed them till they agreed to act with women in a new theatre and with stage scenery. Already in the early 1660's Pepys was admiring the painted scenery in a performance of *Hamlet* and approving of the employment of actresses in Shakespearian adaptations; and Dryden's version of *The Tempest* (another "refinement", prompted no doubt by D'Avenant) provided two pairs of lovers, a sister for Caliban, and a lady spirit to dance with Ariel in the finale. The curtained inset that housed the painted scenery inevitably came to acquire more and more importance, but it was not till the eighteenth century that, to make the pit bigger, the fore-stage was reduced: thereafter the main acting arena lay behind the proscenium, and the space in front was no more than an annexe to it. This structural change, together with the previous importation of actresses and painted scenery, and the introduction of lighting effects—in which Garrick had a hand—created a quite new technique in production and (in the words of Harold Child) "henceforth there was a continuous series of attempts (culminating in the theatre of Beerbohm Tree) to fit Shakespeare not (as Dryden, D'Avenant and their like had) into new critical rules, but into a stage for which his plays were not written".[2]

[1] It is clearly and concisely set forth by Harold Child in the last chapter of *A Companion to Shakespeare Studies* (Cambridge), 325–46. [2] *op. cit.,* 335.

To-day we think we are in a position to smile at the misconceptions of D'Avenant and Dryden, to laugh outright at the outrages of Nahum Tate who provided *King Lear* with a happy ending, and to show but qualified approval of the influence of Garrick himself. For we have learnt some respect for the text of the poet. But we still have an inconsistent readiness to alter it when it crosses our purpose, and this it seems to do surprisingly often. Yet we should not be surprised, for the most frequent reason is plain enough—that we are trying the impossible, to fit the square peg into the round hole, to make the plays effective on a stage for which they were not designed. We are not without prophets who have denounced the absurdity of this procedure; William Poel's performances for the Elizabethan Stage Society are now almost legendary, and few in this generation will have been fortunate enough to see them; but Nugent Monck at Norwich still continues his long tradition which can boast the production of all Shakespeare's plays in an Elizabethan style; and Granville-Barker in his *Prefaces* and other essays never ceased to urge, with the sweet reasonableness characteristic of all his advocacy, that Shakespeare's stagecraft cannot be understood apart from the stage for which it was intended. Yet even these prophets of common sense have made concessions to convention and custom and the supposition that the twentieth century has little capacity for make-believe; lighting effects, for instance, are deemed necessary in spite of the Elizabethan daylight tradition, and a boy Cleopatra is still unthinkable. And though these concessions seem trivial, they are not so; for (to take but one example) a dramatist will not write a night scene the same way for a daylight performance as he will for an artificially darkened stage—not if he knows his job, still less if he is a poetic dramatist of genius. The strange thing is that though we acknowledge Shakespeare as the greatest of poets, his own profession, one and all, suppose that they can teach him a thing or two about stagecraft; and if we may judge by the current performances of the London theatre, none realise the truth that he is one of the select few—have there been as many as a dozen in the western hemisphere? —who have known how to create poetic drama.

It is not uncommon nowadays to hear lip-service paid to the memory of William Poel: it is said, for instance, that his soul goes marching on, that his spirit survives in the Shakespearian productions of to-day. Would it were so! The claim would seem to be based largely on such facts as that permanent sets are used in many productions to give speed to the continuity; that the scenic effects are often simple and stylised; that sometimes a kind of apron-annexe is employed to bring the actors nearer to their audience; that in

comparison with our predecessors we are much less squeamish in the
expurgation of the text. But if these are straws in the wind pointing
in Poel's direction, the wind itself has long since lost its force, and
with Granville-Barker's late lamented death is in danger of blowing
itself out altogether: soon we shall forget what even these straws
portend. More sinister even than the delusion that we are following
Poel's lead is the belief often expressed by our leading dramatic
critics and producers, and even sometimes by scholars, that there are
many different ways of presenting Shakespeare and every single one
of them right; that all the methods of the Shakespearian producers
are valuable, if sincerely, efficiently handled; that each man will
bring out his own points; that a production is bound to be successful
if it "has an idea behind it"; that (the most insidious form of the
doctrine) Shakespeare wrote for all time in writing for his own, and
so his universality makes it possible for his work to be produced in a
dozen different ways.

Such statements as these ignore the significant fact, one of the few
undisputed in Shakespeare's life, that during the busiest years of his
career as dramatist he was a working member of the most successful
theatrical company in London; and it is not rash to infer from con-
temporary evidence that he was one of the chief causes of their
success. He was indeed a practical man of the theatre and, whatever
his skill as an actor, he knew the ropes. He was writing for the
immediate needs of his theatre (a theatre fundamentally different
from the modern picture stage), and for a particular repertory com-
pany of players, whose tradition of acting was by necessity more
imaginative and versatile than that needed by our actors. It is with
a disloyalty unusual in the profession that their descendants of to-
day allow them to be represented as a sort of crude and incompetent
barn-stormers.

Why is it so hard to believe that Shakespeare was a dramatist of
genius as well as a poet of genius? Indeed he is perhaps the only
writer in our language who was both, and who discovered the
elusive art of poetic drama. And if a dramatist of genius, does that
not mean that he evolved from the conditions of his playhouse his
own method of presenting a story—which must be the *best*, if we can
discover it? We do not go to the other side of idolatry in our appre-
ciation if we suggest that it is a reasonable and becoming humility
for a producer, in approaching one or other of the plays, to assume
that Shakespeare knew more about stagecraft than he does himself.
His is the best method—if we can discover it. It is the purpose of this
book to show that we can, with the help of modern scholarship, go a
long way towards discovering it. If a perusal of this argument brings

actors and scholars closer together in a unity of purpose to interpret Shakespeare, it will have achieved something: but it is addressed not only to the experts of the theatre and the study, but also to the ordinary playgoer. Its ambition is a far-reaching one, nothing short, indeed, of realising the plays of Shakespeare as they have never been realised since the destruction of the second Globe. This ambition cannot, of course, be fulfilled by the mere writing and reading of a book. The text of a play does not come to life until it is performed, and the theory of a play's production has even less life than the play's text until that theory is put into practice. We cannot be sure what a performance at the Globe would be like till we have built the Globe and trained a repertory company in the special acting tradition of the Chamberlain's Men. Much, therefore, of what follows is tentative and conjectural, waiting upon such performance for the ultimate test: but the theory would not, and could not, have been put forward if it had not already received some practical testing in a series of experimental performances in a makeshift Globe; on such a series [3] the argument of the following pages is largely built.

It should be generally known that in the last decade American scholarship has provided the practical basis for constructing a replica of the Globe theatre. In 1942 John Cranford Adams published his comprehensive study of *The Globe Playhouse: Its Design and Equipment*, resolving the doubts and problems of previous investigations into a clear-cut factual account, both practically and æsthetically satisfying, of that famous structure. His work, while not unchallenged in points of detail, proceeds on firm critical principles to many positive conclusions, and is summarised in diagrams of the playhouse at all levels, from which it is possible to draw architect's plans, to construct a model, and to erect the playhouse itself.

An illustrated description of the Globe, based upon Dr. Adams' diagrams, is therefore the substance of the first chapter of this book, so that the reader may quickly feel at home in the familiar surroundings of Shakespeare's daily life. There follows a brief exhortation to approach the plays afresh by using nothing but the Quarto and Folio texts, some of which at least are very close to the poet's own manuscript or to the prompt-book from which the actors worked. Chapter III takes leave to suppose that a performance at the Globe would be plotted and rehearsed under the guidance of one leading

[3] In Harrow School Speech Room the following plays have been produced in Elizabethan conditions: *Twelfth Night* (1941), *Henry V* (1942), *Macbeth* (1943), *A Midsummer Night's Dream* (1945), *Julius Caesar* (1946), 1 *Henry IV* (1947); *Macbeth* was repeated in 1949, with the addition for the first time of an upper stage; and *Twelfth Night* was repeated in 1950.

member of the company, and for the immediate purpose that member is identified with the book-keeper. We look over his shoulder as he sets about preparing his prompt-book for performance: his province would include the distributing of the scene-rotation on the seven different acting areas of the multiple stage; the furnishing and properties; the use of the permanent stage features; the costumes; the music; the effects; the plotting of entries. Certain sequences we shall find recurring as especially well adapted to this playhouse—the street sequences, the battle sequences, and some others—and we shall take note of that characteristic quality of the Elizabethan stage (to the book-keeper and the players a commonplace) of seeming nowhere, of being for the moment unlocalised.

Chapter IV turns the attention of the reader from the book-keeper to his colleagues and discusses the peculiarities of their acting tradition—first, their mastery of the art of speech, involving accomplishments of whose existence all but a few of to-day's actors seem to be unaware; then their creative mimicry; the opportunities for variety of grouping afforded by the shape, dimensions and central position of the platform, and the consequent relation between actor and audience; the unusual quality of their characterisation. In a digression we make personal acquaintance with some of the players and discuss the important issue of the boy-actors playing the feminine rôles. The acting tradition is summarised in an example from *Julius Caesar*, which develops a typical train of reasoning to infer how the Chamberlain's Men would have played the scene of Caesar's murder.

The reader is now in a position to guess at the plotting of any of Shakespeare's plays upon the Globe stage, and to form some idea of how the players would render it. But the investigation would be of little value if it could not be shown that such an imaginative reconstruction of a Globe performance reveals the poet's stagecraft more clearly than ever before. Chapter V therefore sets the poet in his most natural surroundings, not at Court in the train of Essex and Southampton, but among his colleagues and collaborators in the playhouse. The attempt is made to show that the highest flights of his inspiration take wing from the firm ground of the multiple Globe stage, and the hardly changing personnel of a fixed repertory, and that they soar with no less lofty freedom for that reason; that with his genius for turning necessity into opportunity, he found the seeming limitations of his stage and its equipment the perfect vehicle for his poetic drama. The guess may be hazarded that if he had been born in a later age, more mechanically skilled than his own, he might have found the elaborate machinery a stricter curb upon the

freedom of his inspiration; and indeed that the growing popular interest in spectacle and masque may have had something to do with his willingness to break his rod at the early age of forty-six.

The argument is rounded off in Chapter VI with an extended example of his mature and sustained stagecraft. Some salient features of a performance of *Macbeth* at the Globe are described in the form of producer's notes. It will be observed that by the choice of this example (and by the drawing of most of the illustrations in the previous chapters from plays written before it) the field of investigation is deliberately limited to a time before the acquisition of the Blackfriars, before the influence of the private theatres and of the masque had begun to affect Shakespeare's style, before—can one say it?—the strain of decadence had crept in, which perhaps was one of the contributory causes of Shakespeare's giving up his association with the theatre. The last period—the period of the so-called romances—examined from this point of view, is worth a separate study. Meanwhile *Macbeth* is chosen to represent a summit of Shakespeare's stagecraft, mature and sustained and as yet unaffected by the decadence of fashion.

The book is by implication a plea for the rebuilding now, after three hundred years, of the Globe—in London, preferably, in Stratford too, if possible, and wherever an audience will meet to support a Shakespearian repertory. This is not the place to discuss the economics of such a venture, but it is worth whispering that, once the theatre was built, equipped and endowed, the expenses of production would be small compared with those current in our London theatres, and that the cost of building and endowment would perhaps be not much more than has been spent in making a film of one single play. It is likely that we shall be obliged to wait a number of years before we are allowed to pace the yard of the twentieth-century Globe. An interim policy is therefore urged in an Epilogue, which sets forth in recapitulation the bare essentials of the Elizabethan circumstances of performance. If a sufficient number of repertories, whether professional or amateur, believe in and practise the right method—Shakespeare's method—we can perhaps look forward to a time when we shall wonder how it was that anything else was ever thought tolerable. In conclusion, the suggestion is put forward that Shakespeare himself, in spite of an occasional disarming apology, was far from dissatisfied with the "Woodden O" in whose planning he is known to have taken a hand; and that poets of to-day might not be the last to welcome a new Globe in which to set free the wings of their inspiration now cramped behind the cage-door of the proscenium arch.

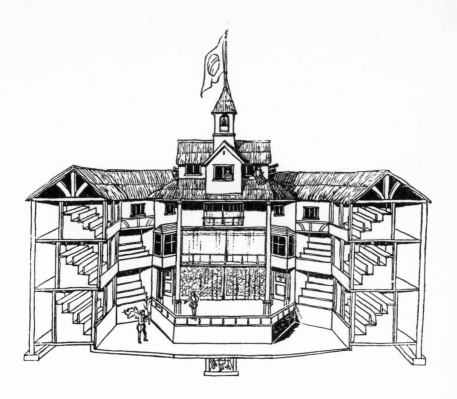

I

THE PLAYHOUSE [1]

SHAKESPEARE had good cause to be satisfied with the "Woodden O": he had a hand in planning it. The new playhouse, built on the Bankside with materials carried over the river from the old Theatre, was made to suit the wishes of a syndicate ·of seven men, among them Burbadge, Heminges, and Shakespeare.

[1] The account of the playhouse given in this chapter is based upon John Cranford Adams' *The Globe Playhouse: Its Design and Equipment* (Harvard University Press, 1942). The three sketch-plans are made from the diagrams in his book, and the diagonal view is based on a model made under his direction at Illinois University. The details of Adams' reconstruction (and even the octagonal shape) have not gone unchallenged since the publication of his book, but its completeness, the practical good sense of its reasoning, and the artistic "rightness" of the resultant plans, make it the most satisfactory blue-print available for the rebuilding of the Globe, whether in fact or in imagination, and thereby create the opportunity to recapture the atmosphere of the Elizabethan playhouse and the essential conditions of performance.

To this extent the design has the imprimatur of the poet himself. His familiarity with the idea of architectural projects finds expression in a play of 1597–8 [2]. We may suppose that the Globe was a development of the plan of its predecessor, but that it included improvements suggested by the daily experience of the actors.[3] It is not rash to assume that most of the plays Shakespeare wrote after 1599 [4] were devised for performance in this playhouse, and it seems likely that all his plays were at one time or another performed there.

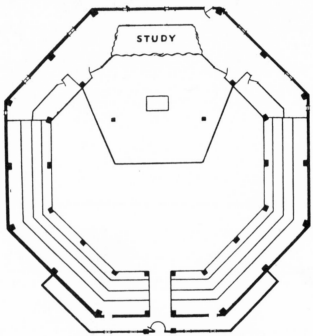

STUDY

The Playhouse—ground plan

A glance at the ground-plan is the best introduction to this building. The octagonal frame is about 84 feet in outside diameter—hardly more than the length of a lawn-tennis court. A concentric octagon within the frame bounds the Yard, which is open to the sky. Between the two octagons the space is roofed and the building rises to three storeys. Nearly five of the eight sides of the octagonal frame are occupied by galleries from which the eyes of the spectators converge upon the stage. The Yard will hold 600 standing close-packed

[2] 2 *Henry IV*, I. iii. 41 ff. The image is developed for some twenty lines.
[3] See Cranford Adams' diagram, *op. cit.*, 172.
[4] Though the possibility that after 1608 he was writing for the Blackfriars must be taken into account. See *Shakespeare Survey*, I, p. 47.

To this extent the design has the imprimatur of the poet himself. His familiarity with the idea of architectural projects finds expression in a play of 1597–8 [2]. We may suppose that the Globe was a development of the plan of its predecessor, but that it included improvements suggested by the daily experience of the actors.[3] It is not rash to assume that most of the plays Shakespeare wrote after 1599 [4] were devised for performance in this playhouse, and it seems likely that all his plays were at one time or another performed there.

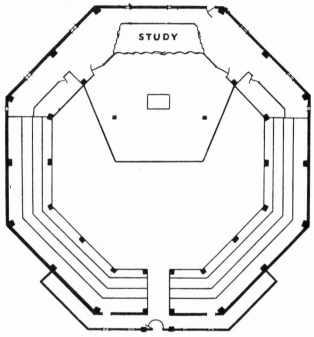

The Playhouse—ground plan

A glance at the ground-plan is the best introduction to this building. The octagonal frame is about 84 feet in outside diameter—hardly more than the length of a lawn-tennis court. A concentric octagon within the frame bounds the Yard, which is open to the sky. Between the two octagons the space is roofed and the building rises to three storeys. Nearly five of the eight sides of the octagonal frame are occupied by galleries from which the eyes of the spectators converge upon the stage. The Yard will hold 600 standing close-packed

[2] 2 *Henry IV*, I. iii. 41 ff. The image is developed for some twenty lines.
[3] See Cranford Adams' diagram, *op. cit.*, 172.
[4] Though the possibility that after 1608 he was writing for the Blackfriars must be taken into account. See *Shakespeare Survey*, I, p. 47.

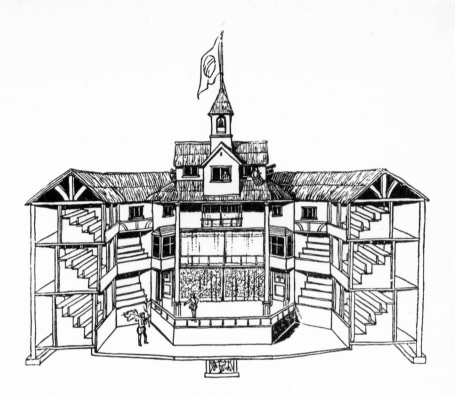

I

THE PLAYHOUSE [1]

SHAKESPEARE had good cause to be satisfied with the
"Woodden O": he had a hand in planning it. The new play-
house, built on the Bankside with materials carried over the
river from the old Theatre, was made to suit the wishes of a syndicate
·of seven men, among them Burbadge, Heminges, and Shakespeare.

[1] The account of the playhouse given in this chapter is based upon John Cran-
ford Adams' *The Globe Playhouse: Its Design and Equipment* (Harvard University
Press, 1942). The three sketch-plans are made from the diagrams in his book, and
the diagonal view is based on a model made under his direction at Illinois
University. The details of Adams' reconstruction (and even the octagonal shape)
have not gone unchallenged since the publication of his book, but its completeness,
the practical good sense of its reasoning, and the artistic "rightness" of the resultant
plans, make it the most satisfactory blue-print available for the rebuilding of the
Globe, whether in fact or in imagination, and thereby create the opportunity to
recapture the atmosphere of the Elizabethan playhouse and the essential conditions
of performance.

(the groundlings); the three galleries about 1,400. At the first
performance of a new play by Shakespeare, there would be as many
as 2,000 "within the Girdle of these walls". The first impression of
the playgoer in this theatre is that of being one of a great crowd, the
next of being in intimate touch with the players. This combination
of community and intimacy is a peculiar characteristic of the
Elizabethan playhouse, hardly known in the modern theatre except
perhaps when the comedian in a music-hall comes down to the foot-

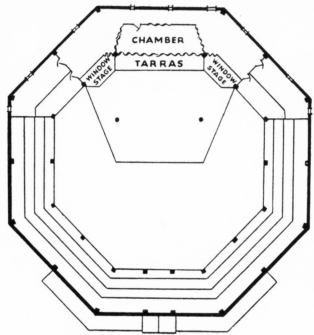

The Playhouse—Tarras level

lights to take his audience into his confidence. Intimacy is possible at
the Globe because of the position of the platform. The middle point
of the front edge is the exact centre of the octagon. The actor in
soliloquy can have his audience on three sides of him. There is real
distance in the depth of the stage, and an actor in the Study will
seem remote while another in front seems close at hand: this contrast
in their relation to the audience is often used for dramatic purpose.

The Platform is the main field of action for the players: it can
never be hidden from view and, except for the curtained recess on
all three levels, it will present the same architectural features
throughout the play. It tapers towards the front, stands probably
between 4 and 5 feet from the floor of the Yard, and is protected

from the groundlings by low rails: the front edge is 24 feet wide, at
its widest it is 41 feet; its depth from front to Study-curtain is 29 feet;
and the Study itself, when open, adds a further 7 or 8 feet. Con-
spicuous towards the front of the Platform stand the two Pillars
supporting the overhanging canopy of the Heavens: these are
probably made of masts from the shipping of the neighbouring
Thames, and are boxed in at the bottom to a height of about 3 feet.

The Tiring-House is the permanent background to the Platform:

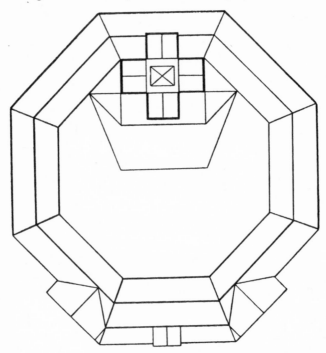

The Playhouse—roof level

its back is turned to the afternoon sun, so that no freaks of light and
shade distract from the illusion; at the same time the canopy of the
Heavens and the Huts above it protect the spectators from the glare
of the sun in their eyes. On the Platform level the curtained inset
usually called the Study is flanked by the two Doors, set forward at
an angle corresponding to the shape of the octagonal structure.
These are the two main entries for the players, and are always in
view undisguised: they have the appearance of the street-door of an
Elizabethan town-house, with substantial doorposts on either side
of them, supporting the bay-windows which overhang the lintel:
the streets of Tewkesbury or Gloucester provide examples of the

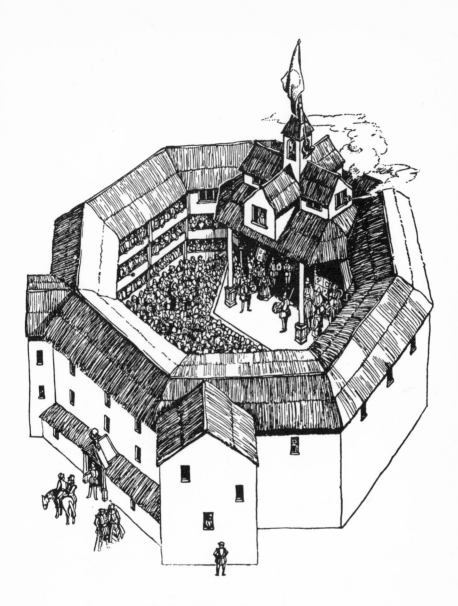

The Playhouse—diagonal view

architectural style. There is a knocker, and a wicket in the upper part for the use of the prompter or sometimes of a character in the play. On the second level the curtained inset, known as the Chamber, is flanked by the Window-Stages which overhang the Doors: these Windows are also used by the actors when the need arises. An important feature of the second level is the Tarras (or terrace), an overhanging balcony connecting the two Window-Stages; the Tarras can be used independently, when the drawn curtain is concealing the Chamber; but since its railing is made of slender balusters, it is no longer noticed when the Chamber is revealed. On either side then of the central face of the Tiring-House, there is a permanent architectural unit modelled on the façade of an Elizabethan town-house.

The appearance of this façade would perhaps be modified by the hangings of different colours chosen to suit the type of play.[5]

The central face is made up of curtained insets at all three levels. On the ground floor is the Study, 23 feet wide, 7 or 8 feet deep, 12 feet high. The appearance of this inner stage can be altered by hangings, furniture and properties, but it too has certain permanent features which can be used or concealed according to the needs of the moment. On the actors' left of the rear wall is a door which when opened reveals behind it the foot of a flight of stairs running up towards the right. On the actors' right is a window. Between door and window is a curtained recess for hiding or disclosing. On the second level the Chamber (23 feet wide, 11 feet deep with the Tarras, 11 feet high) has the same features as the Study, except that the door and window are on opposite sides of the recess: the logical reason for this difference is that the staircase which rises from the Study door on the left leads straight up to the Chamber door on the right. On the third level, a narrower gallery is mainly reserved for the musicians, but this too is sometimes used by the actors when the play demands an appearance at a lofty height.

Above the third level the canopy of the Heavens overhangs most of the Platform, painted blue and adorned with the signs of the zodiac, providing some cover for the actors and serving, it seems, as a sounding-board for their voices. Above the Heavens stand the Huts which contain the thunder (appropriately situated), the artillery and many other devices for creating effects of sound. There is also a winch and pulley operating through a trap-door in the

[5] The reader's attention is drawn to an article in *Theatre Notebook*, Vol. I, No. 8, for July, 1947, by C. Walter Hodges, who suggests an elaborate Italianate facade for the Tiring-House. A lively reconstruction of the Globe, which differs in many respects from that of Cranford Adams, appears in Hodges' *Shakespeare and the Players* (1948).

Heavens to allow sprites and other apparitions to descend by a cable on to the Platform. Other machinery and other trap-doors in all three floors of the Tiring-House can be brought into play both during performance and in the process of moving furniture and properties from the storerooms in preparation for the day's play.

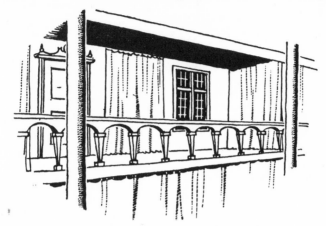

The Chamber

Above the Huts rises the Bell-Tower, and, surmounting all, a flag-pole from which streams the flag (of a colour fitting to the occasion) announcing to the citizens of London that the actors are presenting a play.

Under the Platform lies the capacious region of Hell, excavated to allow of a height of perhaps 8 feet, and approached by the big main Trap (8 feet by 4 feet) and other subsidiary traps on the Plat-form itself, and by the "grave-trap" in the Study. From this source arise apparitions, smoke and fog, and into its depths descend those who would go underground, whether into the cellar, the hold of a ship, or the tomb.

It will become more and more apparent as we study the plays in the setting of this playhouse how admirably equipped it is for all the needs of the dramatist, and especially how it suits the *poetic* dramatist and stirs him to

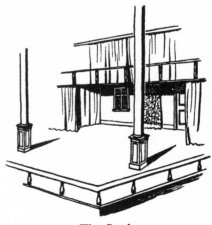

The Study

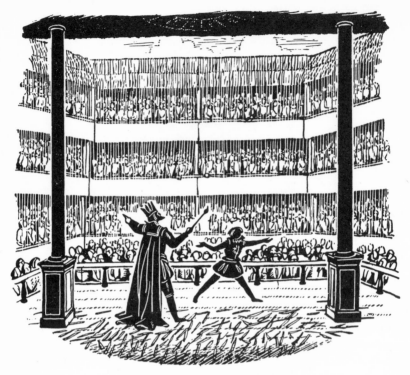

The audience from the Platform

his happiest invention. But it should be stressed at once that the conventional picture of the Elizabethan theatre as a simple and primitive structure, a handicap to those who had to work in it, is wide of the mark. As a medium of expression it compares favourably with the modern picture-stage enclosed in its proscenium arch. It has seven separate acting areas—the Platform, the Study, the Chamber, the Tarras, the two Window-Stages, and the Music Gallery—and it has dimensions both of height and depth beyond anything the modern stage can show. The sight-lines from the audience are such as to make the action three-dimensional instead of pictorial. The Platform itself is a vast area and dominates the playhouse. Standing between the Heavens above and Hell beneath, it is indeed a model of the whole world, the great Globe itself, and it is not surprising that Shakespeare was so fond of pointing the likeness in his familiar metaphor. If to him all the world's a stage, a stage where every man must play a part, the poet finds it no less easy to think of his stage and his theatre as all the world.

2

THE PROMPT BOOK

IF we are to study the methods of the Chamberlain's Men, we must first try to come by a copy of their prompt-book. Facsimiles of the early Quartos and the first Folio are now available, and there is no reason why the twentieth-century producer should not be put in touch thus far with the practice of the Globe company. The relation of the Quarto and Folio texts to Shakespeare's manuscript and the players' prompt-copy varies from play to play, and can be studied in Chapters IV, V and IX of the first volume of E. K. Chambers' *William Shakespeare*; for those plays which are already published in the New Cambridge Edition there is further and more elaborate speculation in Dover Wilson's "Notes on the Copy". Pollard, McKerrow and Greg all allow us to think that many of these printed texts may be derived from the theatrical prompt-books; and it is surprising how little the theatre of to-day has profited from this probability.

The value of studying the early printed texts is partly a negative one: by so doing we can ignore the misleading additions of later editors. We shall no longer try to give a geographical locality to scenes which Shakespeare was not at pains to define: we shall no longer be concerned with the division of act and scene, which disturbs the flow and rhythm of Shakespeare's continuity: we shall no longer regularise the metre and impose logic on the punctuation. But there are also positive advantages which, as this argument proceeds, will become clearer in detail. Some of these may well be suggested here in advance.

In the first place, we are helped at once by the feeling of being in and about the Tiring-House of the Globe at rehearsal time. Occasionally the names of the players pop out at us—quite famous actors like Kemp and Cowley, or obscurer "supers" like Sinklo and Humfrey who are bidden to enter *with Crosse-bowes in their hands;* or a singer, when in *Much Ado About Nothing, Enter prince, Leonato, Claudio, and Jacke Wilson;* or a mere musician, when the rustic comedians in *A Midsummer Night's Dream* are preceded by *Tawyer with a trumpet before them.* In an earlier scene of the same play *Enter Piramus with the ass*

head has a true whiff of the overworked property stores. As we read in *The Taming of the Shrew*, *Enter Biondello, Lucentio and Bianca, Gremio is out before*, we seem to hear the spoken explanations of the directing prompter.

Stage-directions—though few in number, and abrupt in tone, especially while the author is in active association with his players— are nevertheless sometimes revealing of the players' practice. A selected list from quartos and folios is given by W. W. Greg in *The Editorial Problem in Shakespeare*.[1] The most cursory glance at his list evokes a series of vivid pictures in the mind's eye. Particularly rich in description are those plays written before the poet had a major hand in their presentation, and, at the other end of the series, those of the period when Shakespeare was already severing his connection with the playhouse. But whether the directions reproduce the author's descriptive imagination or the book-keeper's practical play- house experience or a reporter's view of what he saw, they often give the hint of the practice of the players in interpreting Shake- speare's sure dramatic instinct. A Messenger enters with news of the Duke of York's death: *Enter one blowing*, reads the Folio. When the Prince of Morocco woos Portia, *Enter Morochus a tawnie Moore all in white, and three or foure followers accordingly*: no doubt the white robe throws his dark face—and Portia's involuntary revulsion—into relief; yet a recent Morocco at Stratford wore black and had a comely almond face. "Sweare," says the old mole in *Hamlet: Ghost cries under the Stage*, we are told; but mostly we must be content with a muffled outcry in the wings. The spellbound lovers in *A Midsummer Night's Dream* are roused by the hunt on May-morning: *Hornes and they wake. Shout within, they all start up*: this is a clear indication of the action on the stage. There is vivid drama in *Enter Cassandra with her haire about her eares*.

Sometimes the characterisation is made clear through the stage- directions of the text: it is thanks to the Folio that we know that Princess Katherine's attendant, Alice, is *an old Gentlewoman; Enter young Osricke* has the appropriate touch of patronage due to that "waterflie"; *Enter the King and his poore Soldiers* hits off to perfection the dangerous crisis of Henry V's invasion of France. Other evidence of this kind appears in the occasional cast-lists printed at beginning or end of the plays, where the persons of the play are sometimes further described by the characteristics of their part, as from *Othello*: *Iago, a Villaine; Rodorigo, a gull'd Gentleman*. We may feel very close to the prompt-book and indeed to Shakespeare's own composition

[1] pp. 158 ff.

when we come across the variation of speech-headings: *Capulet*, for instance, alternates with *Father*, *Lady Capulet* with *Mother; Armado* becomes *Braggart*, *Pedant* also stands for *Holofernes*. In discussing this phenomenon, McKerrow says: ". . . it seems to me highly probable that all plays in which we find this peculiar uncertainty as to speech-headings were printed either from the author's original manuscript or from a close transcript of this. I believe that, although Shakespeare generally fixed upon a name for each of his characters on his or her first introduction, in the heat of composition their qualities or the part which they played in the action were often more strongly present to his imagination than their personal names." [2] We shall have occasion to return to this theme in a later chapter: it is enough for the moment to suggest that if this was the attitude of the poet in composition, it might well affect the conception of the actor in the interpretation of his part.

More important than the stage-directions, cast-lists and speech-headings, is the text itself; and here the early editions can be of the greatest use to an actor who will take pains to study them. It is not a new discovery that the punctuation of the Folio can help the speaker to interpret Shakespeare's intention. McKerrow came to the conclusion that "throughout the [Elizabethan] period there seems to have been in progress a gradual change-over from a method of punctuation based simply upon the natural pauses in reading to one which took account mainly of the logical relationship of the parts of a sentence, with the natural result of much confusion between the two systems". He goes on: "In the majority of texts, at any rate in those that are printed from the First Folio, it will, I think, be found that though the punctuation may at first seem somewhat strange, and though it is undoubtedly less regular than we are accustomed to nowadays, it really presents no more difficulty to the reader than the old spelling does, while it often suggests the way in which a speech is intended to be uttered more clearly than does the more 'logical' punctuation of the modern texts." [3] But it was as recently as 1948 that Dr. Richard Flatter's book, *Shakespeare's Producing Hand*, in less than two hundred pages made plain the truth that the First Folio is a gold-mine of instruction for producers. It is not only the punctuation that over and over again indicates the intended pause: one need only dip into *Julius Caesar* to believe this, or to speak from the Folio page Hamlet's first soliloquy, and the subsequent dialogue with Horatio, Marcellus and Bernardo, or to hear Othello's dying speech.

[2] *Prolegomena to the Oxford Shakespeare*, 57.
[3] *op cit.*, pp. 41–2. The reader is also referred to Percy Simpson's monograph on *Shakesperian Punctuation*.

A trivial comic example occurs in *The Merry Wives of Windsor:* when Mrs. Quickly tells Falstaff that Ford "will be absence from his house, between ten and eleven", Falstaff reiterates the time "Ten, and eleven", and each mention has the comma to mark his deliberation and his anxiety to be sure. But Flatter makes it equally clear that the lineation is deliberately planned and that it contains, as plainly as a musical score, the instructions of the poet to his players. If a line is "defective", it is meant to be short: there is a pause to be filled by action, gesture, or the natural hesitation of profound feeling; or else an actor may be ignoring an interruption and continuing his own rhythm from a previous speech; or there may be simultaneous speaking of two or more speakers. Such is the trend of Flatter's skilful and convincing argument, and its corollary is that Nicholas Rowe and Pope and the other editors of Shakespeare have obscured these directions by "regularising" the verse and imposing a logical punctuation.

It should be added that while these early printed texts can be of the greatest value in interpretation, it is unwise to push the argument too far and to expect exactitude or consistency in the transmission of Shakespeare's purpose or the practice of his fellows. There is a carefree artlessness, a very human proneness to blunder in the compositors, an occasional twinge of impatience or a sly dig of exasperated humour. Leonato's brother is at first called *Bro.* in the speech-headings, but when Leonato persists in naming him, the printer yields under pressure of the repetition and marks him *Ant.* for Antonio. As Romeo and Juliet are parting for the last time, they are interrupted by the Nurse, who cries "Madam" to her newly-married charge: Juliet answers "Nurse". The compositor, his attention straying, puts in a direction—*Enter Madam and Nurse.* Hamlet asks Rosencrantz and Guildenstern to invite the King and Queen to come and see the play: "Will you two helpe to hasten them?" "We will my Lord": and the Second Quarto adds *Exeunt they two.* One wonders whether that compositor was altogether guiltless of a sense of humour who made Laertes say to Claudius "To his good Friends, thus wide Ile ope my Armes: And like the kinde Life-rend'ring Politician [*for* Pelican], Repast them with my blood". Exasperation and absence of mind and naïveté and impishness present the textual critic with untidy, unreliable material for his exact science: to the student of the theatre they add touches of reality and humanity to the imagined atmosphere.

One must not neglect, nor yet overstress, a further positive—if more intangible—advantage in using the contemporary editions. By their aid we see the whole drama through Elizabethan spectacles.

The sub-structure of Shakespeare's stage-vision is habitually Eliza-bethan: his Athenian yokels are grounded in Warwickshire, his Roman senators have a palpable kinship with the nobles at Queen Elizabeth's court. We shall have occasion to develop this theme in the opening of Chapter V. For the moment it is enough to say that the very look of the page and the individual freedom of the spelling helps to project our imagination into the atmosphere of the time, gives us the feeling that we are back in the Globe playhouse in the most astonishingly adventurous years of our theatrical history.

3

PLOTTING WITH THE BOOK-KEEPER

SOMEONE—or some two or three—in the Chamberlain's Company must have fulfilled the function of our producer. A play does not come to life in the theatre without some guiding hand in plotting and rehearsal; nor is it sensible to accept as fact the satirical picture of muddle made delightfully familiar by Sheridan in *The Critic* and with more specific reference by Maurice Baring in his *Diminutive Dramas*. We do not know exactly who gave the instructions—whether Burbadge or (as seems unlikely) Shakespeare himself or the book-keeper—but it is plain that the instructions were recorded by the "book-keeper" in the "book" to which the actors would refer their individual parts, and that the "book" was held by the prompter or "book-holder", who no doubt controlled the whole action during performance. Greg has a note on the subject: "The book-keeper was properly the person charged with the custody of the company's stock of 'books'. Presumably it was his business to see to the writing of the prompt-book, to prepare it in accordance with the needs of production, and to provide for its safe custody. I suppose he also attended to the writing of the plot and the actors' parts. The technical name for the prompter was the 'book-holder'. . . . It does not perhaps necessarily follow that the book-keeper and the book-holder were always the same person, but since it must be difficult to distinguish their functions it is simple to assume that they were." [1] Since we are embarked upon a voyage of conjecture, we may gratefully use the person of the book-keeper for our compass. Even if he is only acting as secretary for some other controlling spirit in the playhouse, we can look over his shoulder and see what he jots down in the prompt-book. To dally still more recklessly with surmise, we may follow Dover Wilson as he talks, in his "Note on the Folio Text" of *A Midsummer Night's Dream*, of Tawyer and his trumpet in the last act: "Tawyer is the name of an actor or rather a playhouse servant, who died in 1625 and was described in the sexton's register as 'Mr. Heminges man'. Now it is perfectly obvious that the bulk of the

[1] W. W. Greg, *The Editorial Problem in Shakespeare*, 158–9.

Q. stage-directions, before coming into the hands of the F. compositors, had been amplified, rectified and generally overhauled by some masterful person. The entry of Tawyer with his trumpet and of Bottom with 'the ass-head' tells us who this masterful person was: he was the stage-manager of Shakespeare's company, possibly Heminge himself or his friend Condell . . ." [2] T. W. Baldwin points out that Peter Quince exercises a triple function as book-keeper, prompter and stage-keeper,[3] and Peter Quince is, after all, in farcical guise, the model of the man we are looking for. The harassed Peter Quince or the masterful Heminges? We do not know his identity. Let us call him the Book-Keeper and take leave to look over his shoulder.

(i) Scene-Rotation

With the manuscript of the new play before him, one of his first problems will be to decide which scene is to be played on which part of the multiple stage. Shakespeare is presumably at his elbow to tell him his intention and, though we are not so lucky, there are usually clues enough for us to recapture the original scene-rotation.

In the first place, we must become used to the idea of the Platform being quite self-sufficient: it is not an apron in front of a proscenium; it is the main acting arena, to which the other stages are subsidiary. To test this, one need only begin reading on page 461 (125) of the Folio in 2 *Henry VI*. After the scene of the arrest of the Duchess of Gloster,[4] who appears *aloft*, there is no occasion for, or possibility of, using the upper stages for at least ten pages—nearly an hour in acting time. We get the impression that it was habitual to expect the main action on the Platform. This play was written before the Chamber had been developed as an acting stage. But even later, the traditional pre-eminence of the Platform persists. It appears that it was not an invariable rule that the Study should be open at the end or climax of a play. For instance, the last scene of *Much Ado About Nothing* cannot make use of the Study, which still contains the monument-furniture of the penultimate scene. Cranford Adams places the last four scenes of *King Lear* entirely on the Platform.[5]

The Platform can be anywhere or nowhere: it can assume its visible appearance, of a street with a row of houses; it can represent anything suggested by the words of the speakers, or by the furniture

[2] *A Midsummer Night's Dream (New Cambridge Shakespeare)*, 155. See below, p. 157.
[3] T. W. Baldwin, *Organization and Personnel of the Shakespearean Company*, 135.
[4] 2 *Henry VI*, I. iv.
[5] J. Cranford Adams, *The Original Staging of King Lear*, 332 ff.

of the Study, if open. Almost any scene which is supposed to take place in the open air—whether in the streets, in the wood, on the heath, or on the field of battle—will be acted on the Platform, with or without the addition of the Study. It is also used for an interior scene, often in conjunction with the Study which contains the solid furniture of such a scene.

The Study is sometimes used by itself for an interior setting, such as Friar Lawrence's cell. Scenes before and after show the characters entering or leaving the house in which the Study-scene takes place: an elaborate example of this is in *Troilus and Cressida*, during the first four scenes of Act IV [6]: the Folio makes clear the sequence which is obscured by the scene-headings of modern editions. Sometimes the Study represents an interior scene related to an exterior on the Platform, as when in the last scene of *Romeo and Juliet* the churchyard on the Platform leads to the monument in the Study. But more often it is combined and merged with the Platform and gives a colour to it by its furnishings, whether of indoors or outdoors. One thinks of the recurrent throne-room,[7] the orchard of *Julius Caesar*, the garden of *Twelfth Night*, the woods of *A Midsummer Night's Dream* and *As You Like It*, and the church of *Much Ado About Nothing*.

Of the upper stages, the Tarras is generally used in conjunction with the Platform, and represents battlements for parley at Bordeaux and Angiers,[8] or assault at Orleans, Rouen and Harfleur [9]: it serves Richard of Gloucester for his crowning hypocrisy *aloft, betweene two Bishops* on the leads of Baynards Castle [10]; Arthur falls to his death from these "walles" [11]; the Tarras is the gallery from which the Duchess of Gloucester watches the conjurers at their mumbo-jumbo [12]; it is probably the hill from which Pindarus, at Cassius' bidding, scans the battlefield of Philippi.[13] Occasionally it is used in isolation, without reference to the Platform: Hamlet's first sight of his father's ghost [14] must presumably be aloft, so that he may follow him to "a more removed ground" on the Platform itself; Hector must part from Andromache, one supposes, on the walls of Troy [15]; that legendary scene could hardly be set elsewhere than on the Tarras.

The Chamber, as distinct from the Tarras in front of it (which to all intents and purposes ceases to exist as soon as the Chamber

[6] See below, pp. 80 ff., where the sequence is studied in detail.
[7] *Henry VI*, IV. i; *Richard III*, IV. ii; *Richard II*, I. i; *King John*, IV. ii; *King Lear*, I. i.
[8] 1 *Henry VI*, IV. ii; *King John*, II. i. 201.
[9] 1 *Henry VI*, II. i; III. ii; *Henry V*, III. i.
[10] *Richard III*, III. vii. 94. [11] *King John*, IV. iii. [12] 2 *Henry VI*, I. iv. 16.
[13] *Julius Caesar*, V. iii. 20. [14] *Hamlet*, I. iv. [15] *Troilus and Cressida*, V. iii.

curtains are drawn apart), is hardly ever related to the Platform: it is usually a self-contained unit, and naturally becomes associated with domestic interiors. The ladies are at home there: in *The Comedy of Errors*, whose traffic is mostly in the streets of Ephesus, the cue for the first use of the Chamber is when we must go indoors to see Adriana and her sister; thereafter the whole play takes place on the Platform level except for the scenes when the ladies are at home. In *Romeo and Juliet* the Chamber is exclusively reserved for the heroine's apartment, and the sequence of her mock-death on the occasion of her projected marriage to Paris gains greatly in clarity if that distinction of locality is strictly preserved. Probably Prince Hal is at home in the Chamber for some of his informal scenes, as a contrast to the formality of throne-room and council-scenes which need the Platform and the Study in combination.[16] Portia talks gossip here with Nerissa,[17] so does Hero with her gentlewomen and Beatrice.[18] Hither by a natural and highly dramatic rotation Hamlet mounts the stairs to his mother's closet.[19] A neat scheme for *Twelfth Night* would set all Orsino's scenes (except the last, when he leaves home to visit Olivia) in the Chamber: they are mostly static and involve a minimum of movement.[20] In *King Lear* Cranford Adams reserves the Chamber exclusively for the sub-plot scenes, thereby revealing most vividly the design of Shakespeare's architecture: "For as long as the Edmund sub-plot runs parallel to the main plot, it is staged on the second level of the multiple stage. As the two plots merge into one the staging merges also, and the final episodes of the combined action are played on the main level." [21]

Familiar scenes of serenade and elopement suggest themselves as proper to the Window-Stages. False Proteus courts Silvia at her window in true Julia's hearing [22]; Juliet's window is the scene of more than one crisis in her story [23]; Jessica's window leans over Shylock's door, and out of it she throws her father's jewels to Lorenzo [24]; the second scene of *Troilus and Cressida* seems to begin on the Tarras, but when Pandarus urges his niece to come and watch the heroes passing by, saying: "Heere, heere, here's an excellent place, heere we may see most bravely," it looks as if he led her to

[16] e.g. 1 *Henry IV*, I. ii; 2 *Henry IV*, II. ii. [17] *The Merchant of Venice*, I. ii.
[18] *Much Ado About Nothing*, III. iv. [19] *Hamlet*, III. iv.
[20] See Appendix II, p. 319.
[21] J. Cranford Adams, *The Original Staging of King Lear*, 316.
[22] *The Two Gentlemen of Verona*, IV. ii.
[23] *Romeo and Juliet*, II. ii; III. v; Cranford Adams has a most interesting explanation of the latter scene, in which the proper use of Chamber and Window-Stage in combination heightens the tension of the drama. *The Globe Playhouse*, 273, 4.
[24] *The Merchant of Venice*, II. vi. 26.

one of the Window-Stages overlooking the Platform.[25] Brabantio is roused in the night to his window by Iago and Roderigo [26]; and the elaborate manœuvres of Cleopatra's monument and the hoisting of Antony seem to employ both Window-Stages and the Tarras in between them.[27]

On the third level, the Music Gallery is sometimes used by the actors when extra height is needed by some circumstance in the plot. The most obvious use would be for the ship-boy at the masthead in shipboard scenes; the dramatist may need to show the keep of a castle, or a lofty gallery overlooking both the Tarras and the Platform, or a high vantage point from which La Pucelle can signal with a torch.[28] Cranford Adams analyses the scene in *The Tempest* in which the enemies of Prospero are deluded by the magic banquet, and suggests that the only person who can control and synchronise the complicated movements and numerous personnel (both on and off stage) of that scene is—most appropriately—Prospero himself, standing aloft in front of the Musicians' Gallery.[29]

When we come to plot a play of Shakespeare on this multiple stage, it will usually be found that the story flows easily from one acting area to another, the action taking place largely on the Platform, but moving logically indoors to the Study, or upstairs to the Chamber, or making combined use of Tarras and Platform, or Window-Stage and Platform: often the opening of the Study and the showing of characteristic furniture will alter the appearance of the whole combined area of Study and Platform. Common sense will show that two succeeding scenes can seldom be played in the same area: the furniture of Study or Chamber suggests a definite locality, and to change the furniture and the locality takes time. But even the Platform will not readily give the impression in two successive scenes of a distinction between two widely different places or sets of circumstances, unless a transition is marked by the opening or closing of the curtain of the Study, or the use of Chamber or Tarras or Window-Stage. Sometimes the logic of the story's sequence will make the transition clear: something happens that we have been led to expect will happen, and we know where it will be. For instance, in 2 *Henry VI*, Act II, Scene ii takes place, as York quickly informs us, "in this close Walk". As soon as he and his fellow-peers leave the

[25] *Troilus and Cressida*, I. ii. 194. [26] *Othello*, I. i. 81.

[27] Cranford Adams has an elaborate explanation of the method of staging the scene of Antony's hoisting, in *The Globe Playhouse*, 346 ff. A different and equally ingenious interpretation is that of Bernard Jenkin, published in *R.E.S.*, vol. xxi, No. 81 (January, 1945).

[28] 1 *Henry VI*, III. ii. 26: *Enter Pucell on the top, thrusting out a Torch burning.*

[29] *The Tempest*, III. iii. See J. Cranford Adams, *The Globe Playhouse*, 319 ff.

one of the Window-Stages overlooking the Platform.[25] Brabantio is roused in the night to his window by Iago and Roderigo [26]; and the elaborate manœuvres of Cleopatra's monument and the hoisting of Antony seem to employ both Window-Stages and the Tarras in between them.[27]

On the third level, the Music Gallery is sometimes used by the actors when extra height is needed by some circumstance in the plot. The most obvious use would be for the ship-boy at the masthead in shipboard scenes; the dramatist may need to show the keep of a castle, or a lofty gallery overlooking both the Tarras and the Platform, or a high vantage point from which La Pucelle can signal with a torch.[28] Cranford Adams analyses the scene in *The Tempest* in which the enemies of Prospero are deluded by the magic banquet, and suggests that the only person who can control and synchronise the complicated movements and numerous personnel (both on and off stage) of that scene is—most appropriately—Prospero himself, standing aloft in front of the Musicians' Gallery.[29]

When we come to plot a play of Shakespeare on this multiple stage, it will usually be found that the story flows easily from one acting area to another, the action taking place largely on the Platform, but moving logically indoors to the Study, or upstairs to the Chamber, or making combined use of Tarras and Platform, or Window-Stage and Platform: often the opening of the Study and the showing of characteristic furniture will alter the appearance of the whole combined area of Study and Platform. Common sense will show that two succeeding scenes can seldom be played in the same area: the furniture of Study or Chamber suggests a definite locality, and to change the furniture and the locality takes time. But even the Platform will not readily give the impression in two successive scenes of a distinction between two widely different places or sets of circumstances, unless a transition is marked by the opening or closing of the curtain of the Study, or the use of Chamber or Tarras or Window-Stage. Sometimes the logic of the story's sequence will make the transition clear: something happens that we have been led to expect will happen, and we know where it will be. For instance, in 2 *Henry VI*, Act II, Scene ii takes place, as York quickly informs us, "in this close Walk". As soon as he and his fellow-peers leave the

[25] *Troilus and Cressida*, I. ii. 194. [26] *Othello*, I. i. 81.
[27] Cranford Adams has an elaborate explanation of the method of staging the scene of Antony's hoisting, in *The Globe Playhouse*, 346 ff. A different and equally ingenious interpretation is that of Bernard Jenkin, published in *R.E.S.*, vol. xxi, No. 81 (January, 1945).
[28] 1 *Henry VI*, III. ii. 26: *Enter Pucell on the top, thrusting out a Torch burning.*
[29] *The Tempest*, III. iii. See J. Cranford Adams, *The Globe Playhouse*, 319 ff.

curtains are drawn apart), is hardly ever related to the Platform: it is usually a self-contained unit, and naturally becomes associated with domestic interiors. The ladies are at home there: in *The Comedy of Errors*, whose traffic is mostly in the streets of Ephesus, the cue for the first use of the Chamber is when we must go indoors to see Adriana and her sister; thereafter the whole play takes place on the Platform level except for the scenes when the ladies are at home. In *Romeo and Juliet* the Chamber is exclusively reserved for the heroine's apartment, and the sequence of her mock-death on the occasion of her projected marriage to Paris gains greatly in clarity if that distinction of locality is strictly preserved. Probably Prince Hal is at home in the Chamber for some of his informal scenes, as a contrast to the formality of throne-room and council-scenes which need the Platform and the Study in combination.[16] Portia talks gossip here with Nerissa,[17] so does Hero with her gentlewomen and Beatrice.[18] Hither by a natural and highly dramatic rotation Hamlet mounts the stairs to his mother's closet.[19] A neat scheme for *Twelfth Night* would set all Orsino's scenes (except the last, when he leaves home to visit Olivia) in the Chamber: they are mostly static and involve a minimum of movement.[20] In *King Lear* Cranford Adams reserves the Chamber exclusively for the sub-plot scenes, thereby revealing most vividly the design of Shakespeare's architecture: "For as long as the Edmund sub-plot runs parallel to the main plot, it is staged on the second level of the multiple stage. As the two plots merge into one the staging merges also, and the final episodes of the combined action are played on the main level." [21]

Familiar scenes of serenade and elopement suggest themselves as proper to the Window-Stages. False Proteus courts Silvia at her window in true Julia's hearing [22]; Juliet's window is the scene of more than one crisis in her story [23]; Jessica's window leans over Shylock's door, and out of it she throws her father's jewels to Lorenzo [24]; the second scene of *Troilus and Cressida* seems to begin on the Tarras, but when Pandarus urges his niece to come and watch the heroes passing by, saying: "Heere, heere, here's an excellent place, heere we may see most bravely," it looks as if he led her to

[16] e.g. 1 *Henry IV*, I. ii; 2 *Henry IV*, II. ii. [17] *The Merchant of Venice*, I. ii.
[18] *Much Ado About Nothing*, III. iv. [19] *Hamlet*, III. iv.
[20] See Appendix II, p. 319.
[21] J. Cranford Adams, *The Original Staging of King Lear*, 316.
[22] *The Two Gentlemen of Verona*, IV. ii.
[23] *Romeo and Juliet*, II. ii; III. v; Cranford Adams has a most interesting explanation of the latter scene, in which the proper use of Chamber and Window-Stage in combination heightens the tension of the drama. *The Globe Playhouse*, 273, 4.
[24] *The Merchant of Venice*, II. vi. 26.

Platform, the Folio reads: *Sound Trumpets. Enter the King and State, with Guard, to banish the Duchesse.* We have been told in the last scene but one that this business was to take place in London. The King's opening words make the situation quite clear: "Stand forth Dame *Elianor Cobham, Gloster's* wife." Exactly whereabouts in London we are hardly matters: and indeed it is best not to ask, for in the same scene the Platform becomes the "Lysts" for the combat between Horner and Peter, who enter with their drunken supporters *at one Doore and at the other Doore.* The logic of the story makes the transition clear. Or it may be that a different group of characters appears whom we associate with a different place: in 1 *Henry VI*, the arrival of Talbot or Pucelle carries us at once from England to France: Rome and Egypt are thus easily differentiated in *Antony and Cleopatra.* But it will generally be found that when the story requires a drastic change of place or time, the transition marked in the dialogue is reinforced by some variation in the area of acting. It may be no more than the fact of making the action revolve round first one door and then, for a different locality, the other: thus Act IV, Scene ii of *Twelfth Night* revolves round one Door, Sir Thopas baiting Malvolio through the wicket, but the following scene opens with Sebastian stepping from the other Door, and when he says "This is the ayre, that is the glorious Sunne," we know he is out-of-doors but we do not associate his situation with the neighbourhood of Malvolio's prison. In reconstructing the scene-rotation the acid test is to try it out, and see what is plausible: if, with the aid of Shakespeare's dialogue, a transition is still not clear, then there should be some adjustment made in the plotting of the scene-rotation. But to apply the acid test, we need a rebuilt Globe. Cranford Adams puts the matter succinctly thus: "In Shakespeare's plays the dialogue, the logical sequence of events, and the corresponding movement from one stage to another enabled his audience to follow the action from beginning to end without difficulty, even when the scene shifts rapidly from place to place. In its ability to present a dramatic tale without interruption and without programme notes, yet with as many scenes and settings as the dramatist desires, the Elizabethan drama anticipated the motion picture of today."[30]

Let us study a sequence of ten pages in the Folio from *The Merchant of Venice.* On page 167 (Act II, Scene ii in modern editions) Launcelot Gobbo makes his first entry: the scene is in the street, as is plain from the arrival of old Gobbo and his wish to be directed to "Maister Jewes": a street-scene will of course be on the Platform.

[30] *The Original Staging of King Lear*, 318.

Shylock's house is identified by the first appearance of Jessica on page 169 (II. iii), at, let us say, the left-hand Door, Bassanio and Gratiano having departed by the right-hand Door. II. iv circulates round the right-hand Door. Shylock in II. v enters, of course, from his own (the left-hand) Door. The "penthouse" of II. vi is the over-hanging Tarras, "under which *Lorenzo* Desired us to make a stand". As Lorenzo approaches Shylock's house ("Here dwels my father Jew"), Jessica appears in the Window-Stage above the Door. Hither-to we have been all the time in the streets of Venice: there follows the first casket-scene, with Morocco, and the change of locality to Belmont is simply marked by the disclosing of the Study. The curtains drawn aside at the beginning of the scene and closed again at the end on Portia's instructions are either the alcove hangings between window and door in the rear wall of the Study, or "traverses" specially hung across the Study for the purpose.[31] Thereafter we continue with alternate street-scenes and casket-scenes down to page 176, the scene in which Shylock baits Antonio on his way to prison (III. iii).

Or, in a different vein, consider the opening sequence of *Henry V*. One must guess the position of the speaker of the Prologue, and it seems not unlikely that he would appear between the curtains of the Chamber on the Tarras. The Bishops (I. i) would converse on the Platform, for the Study would be set ready for the throne-room. I. ii would then use the Platform and Study in combination. At the end of the scene the Study would be closed again, and the Chorus would appear, this time on the Platform. II. i, a domestic scene of low life, strongly contrasted with the public splendour of the pre-vious scene, would rightly be in the Chamber; II. ii, the long scene of the exposure of the conspirators, on the Platform; II. iii, the account of Falstaff's death, once again in the Chamber, making a natural continuity with the previous Quickly scene; II. iv, involving the French King's "state", must have Study and Platform. Then the Chorus comes from the centre of the Study-curtains as soon as they are pulled: the action runs continuously into III. i, where the scaling-ladders carry the assault up to the "breach" on the Tarras; III. ii, as the comics are left behind by the attackers, takes place on the Platform. III. iii is the scene of the King's entry into Harfleur: it will need Study and Platform, with the wall and gates indicated in the Study, and the Tarras for the Governor to hold parley. Immedi-ately after the King's triumphant entry into the town, we have the delicious contrast of Princess Katherine being taught English by her

[31] J. Cranford Adams, *The Globe Playhouse*, 186 ff.

old Gentlewoman: this scene, of course, takes place in the Chamber, where the ladies are habitually at home.

Some plays, by the nature of their plots, are especially easy to set. One thinks of *A Midsummer Night's Dream* which, for most of its length, can be acted in front of the same woodland set. There is indeed no logical reason why there should be any change of scene from Titania's sleeping (II. ii. 26) till Bottom's waking (IV. i. 206): throughout the interval—more than seven pages in the Folio—the Study is open, and set with Titania's bank and Bottom's hawthorn-brake. *Romeo and Juliet* is so planned that the arrangements of Capulet's establishment fit the architecture of the Tiring-House and Platform. One need only follow the course of Juliet's projected marriage with Paris: it is first suggested in III. v, which begins with Romeo's descent from Juliet's window; it reaches its dismal conclusion at the end of Act IV. The interim, with its great variety of mood and atmosphere and incident, flows quite naturally from stage to stage: Juliet's apartment in the Chamber and Friar Lawrence's cell in the Study are the constants, and the rest of the movement is quite simply related to these. We shall see later in this chapter how street sequences fit easily into this setting, as the stage assumes its visible shape, with doors and doorposts and bay-windows and pent-house. We shall see also how battle-sequences, so familiar a feature in Shakespeare's plays, are skilfully organised in these conditions to seem clear in pattern and dramatically effective.

Of course, as one sets about the business of trying to reconstruct Shakespeare's scene-rotation, problems arise which are not always easy to solve on paper: but there are none, I think, which look likely to be insoluble in practice—to a company acting in a replica of the Globe. We cannot tell, till we have such conditions: and we cannot be sure that our paper theories are right until they are tested in the conditions of performance.

Reading the Folio or the Quartos, one has the impression of continuous action with no scene divisions. Those divisions of Act and Scene that appear in the Folio seem to be literary and unrelated to stage practice or the poet's conception.[32] Intervals there may have been for the convenience of the audience, or to rest the actors or give them time to change, even sometimes—though I think very rarely—to make it possible to alter a Study scene. But, whatever the practice of other dramatists, there is seldom if ever any logical reason in the architecture of a play of Shakespeare's own and only composition for a break: even the occasional Chorus figures (*Henry V, The Winter's*

[32] McKerrow's view is expressed in his *Prolegomena to the Oxford Shakespeare*, 49 ff.

Tale) are there to bridge a gap rather than to create one. The gain in continuity which can be achieved so easily by the scene-rotation of the Globe multiple stage, cannot be stressed too strongly. It is not merely a matter of saving time—even a mechanically rapid production in modern conditions can suffer from the loss of tension in transition from one scene to the next; for the fact of dropping a curtain over the whole stage, or switching off a light, breaks the continuous attention of the audience; they relax and have to be won all over again. It was the practice of the Elizabethan dramatist to write his story in many scenes, some very short, and with a great variety of place and personnel: the modern dramatist prefers long acts with unchanging scenes. The latter pays the price in lack of flexibility, but it should be recognised that the Elizabethans were acutely conscious of the problem of preserving continuity, and we shall see in a later chapter that the greatest of them solved the problem over and over again with a skill which is not generally realised by those who present his plays to-day.[33]

(ii) *Furnishing and Properties*

That the Chamberlain's Men were rich in furniture and properties, stored in the great lofts on the third level of the Tiring-House and perhaps in the capacious depths of Hell below the Platform, we can infer from Henslowe's inventories of the stock-in-trade of the Admiral's Men.[34] That they were sparing in their use of them, however, seems likely from the limited opportunity offered by the architecture of their stage. The areas available for setting solid, heavy furniture were just the Study and the Chamber.

The Chamber, as we have seen, usually represented a private apartment, whether Juliet's, Portia's, Princess Katherine's or Queen Gertrude's. Because of a characteristically modern objectivity in Shakespeare's turn of mind, to which we shall pay more attention in Chapter V, it is likely that this apartment would be furnished, without regard for the period of the play's plot, in the mixture of styles familiar to the eye of his Elizabethan audience. A modern producer will do well perhaps to use no furnishings of a period later than the Elizabethan, but need set himself no bounds before that date. It is

[33] In the Appendix at the end of this book will be found a suggested scene-rotation for *Twelfth Night*; J. Cranford Adams' rotation for *King Lear* is published in his paper, *The Original Staging of King Lear*. A complete rotation for *Macbeth* is included in Chapter 6 of this book.

[34] W. W. Greg, *Henslowe Papers*, 113–21. A selection from this list appears in J. Cranford Adams' *The Globe Playhouse*, 325–6.

the Elizabethan vision of Roman, Athenian or early Briton that we want to recapture: a Georgian or Victorian note can shatter the whole illusion.

The Study, besides being, like the Chamber, an interior on its own, can also give a great variety of effects in conjunction with the Platform. There were, one supposes, some stock and recurrent settings, turning up in play after play, and perhaps greeted by the audience with the sort of pleasure one feels in seeing old acquaintances crop up in a new guise and a new set of circumstances. There

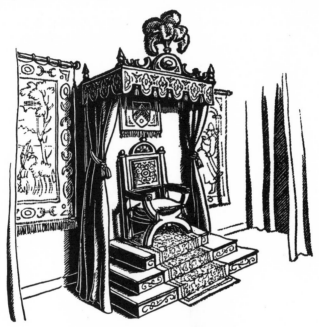

Throne-room Set in the Study

is the Throne-Room set, with its great throne or "state" on a dais with an overhanging canopy, rich carpets on the steps and floor, and tapestries hung all round on the three walls. Inevitably it turns up in the English history plays, and often to keen dramatic purpose, as when Richard of Gloucester appears *in pompe*, with his ambition satisfied at last but not his hunger for blood, and turning to Buckingham says: "Thus high, by thy advice, and thy assistance, Is King Richard seated: But shall we weare these Glories for a day?" One thinks of a similar and even more dramatic moment when Macbeth, at last enthroned, finds that "To be thus is nothing . . . Our feares in *Banquo* sticke deepe."

Another standard set is that of the Wall-and-Gates, used often as

the attacking force tries to force an entry into the castle. "Traverses (akin to modern 'flats') painted in imitation of castle walls are suspended at the rear of the Study (and at the sides as well?). In the middle of the rear traverse the usual curtained opening . . . is supplied with a practical door for use as the castle gate." [35] Cranford Adams points out that this would represent the outside of Gloucester's castle in *King Lear*, where Kent is put in the stocks for thrashing Oswald: this gate it is which Cornwall bids Gloucester shut against the old King after he has gone forth in high rage into the storm.

Wall-and-Gates Set in the Study

This set too will be a commonplace in the history plays, and will no doubt be used in the last act of *Macbeth*, when Malcolm is bidden by old Siward "This way my Lord, the Castles gently rendred."

For the garden-sets needed in *The Merchant of Venice*, *Twelfth Night* and *Julius Caesar*, there will be a different disposition of foliage and solid properties according to the various plots: Lorenzo's bank and Maria's box-tree dictate their own needs. The foliage—for single performances rather than for continuous runs—will probably be of natural leaves and branches, and even for three or four days evergreens will keep their freshness and their semblance of life: ilex especially will grace either wood or garden in the Study. The woodland set will again suit the needs of the particular play, whether it is

[35] J. Cranford Adams, *The Original Staging of King Lear*, 320.

Garden Set in the Study—*Lowlynesse is young Ambitions Ladder*

the hunting sequence in *Titus Andronicus*, the fairy-haunted wood of *A Midsummer Night's Dream* (in which play the necessary bank for Titania's lullaby and the hawthorn-brake for Bottom's tiring-house already fill the space available in the Study), or the forest of Arden.

It is not hard to identify, from the action or from the text itself, some of the solid properties used in the Study: "London Stone" supports the weight of Jack Cade as he begins his short-lived reign [36]; the "Mole-hill" upon which the Duke of Yorke is made to stand, while he receives the insults of Queen Margaret and his other enemies, seems (by a sort of poetic justice) to be the same property which serves as a seat for King Henry as he reflects in solitude when chid by his friends from the battle of Towton [37]; one thinks also of the "Monument" of *Romeo and Juliet* and *Much Ado About Nothing* [38]; the "Councell-Boord" of 1 *Henry IV*, I. iii [39]; "this Rocke" on which

[36] 2 *Henry VI*, IV, vi. 1.
[37] 3 *Henry VI*, I. iv. 67; II. v. 14.
[38] *Romeo and Juliet*, V. iii; *Much Ado about Nothing*, V. iii.
[39] Mentioned by Hotspur subsequently in describing how the King "Rated my Unckle from the Councell-Boord". 1 *Henry IV*, IV. iii. 99. See below, p. 175.

Brutus's "poore remaines of friends" are invited to rest [40]; the "Banke of Flowers" instanced in the "dumbe shew" in Hamlet.[41]

Sometimes in the course of a scene furniture or properties are brought on from within the Tiring-House, such as the stocks for Kent in *King Lear* [42]; they are moreover often enough carried forward on to the Platform itself, as when attendants set chairs for the spectators of a play in *A Midsummer Night's Dream* and in *Hamlet* [43];

Woodland Set in the Study

or when the sick King John is "brought in", presumably like Bedford in 1 *Henry VI* "brought in sicke in a chayre", or like King Lear "in a chaire carried by Servants" [44]; or when Caesar's coffin becomes the focus of the celebrated forum-scene.[45] It seems to be not an uncommon practice to carry a banquet forward on to the Platform: one may suppose that there is not much room in the Study for the nine to sit at table who are present at the end of *The Taming of*

[40] *Julius Caesar*, V. v. 1. [41] *Hamlet*, III. ii. 147. [42] *King Lear*, II. ii. 146.
[43] *A Midsummer Night's Dream*, V. i. 84; *Hamlet*, III. ii. 116.
[44] *King John*, V. vii. 28; 1 *Henry VI*, III. i. 41; *King Lear*, IV. vii. 21.
[45] *Julius Caesar*, III. ii.

the Shrew, and that the Study is too far back for scenes of such dramatic importance, with complex movement and shifting emphasis, as the gruesome repast of *Titus Andronicus* and the ghost-ridden supper of *Macbeth*.[46] I think it is likely that so elaborate a manœuvre as the carrying on of a banquet would be done with formality to music of the Hoboyes (specifically mentioned in *Titus Andronicus*) or with some by-play on the part of the comedians acting as serving-

Turne the Table up

men. No doubt the table would be of the trestle kind that can be turned up.[47] "Turne the Table up," is the instruction of Capulet when he wants room for his guests to dance.[48] But such large-scale scene-shifting in view of the audience would, I think, be the exception rather than the rule. Nothing would destroy more effectively the tension so skilfully nursed by the poet than an undramatic pause for redistribution of furniture on the Platform. For the most part, no solid furniture would be used which could not be set in the Study or

[46] *Taming of the Shrew*, V. ii; *Titus Andronicus*, V. iii; *Macbeth*, III. iv.
[47] A specimen of such a table is to be seen in the house of Mary Arden, Shakespeare's mother, at Wilmcote, three miles from Stratford.
[48] *Romeo and Juliet*, I. v. 31.

the Chamber, or be carried on and off easily in the course of the play. In practice, it will seldom be found necessary to break this "rule".

Other means there are also of introducing solid furniture and properties on to the Platform: objects can be let down through a trap in the Heavens from the Huts above, and others can be raised from Hell through the big central trap in the Platform itself. Three suns appear in the air to the three sons of brave Plantagenet,[49] and Jupiter descends from Heaven sitting upon an eagle [50]; up from Hell a *Spirit riseth* at the bidding of its conjurer,[51] and no doubt much infernal luggage can be delivered from the same quarter. But the number of situations in which the use during performance of the traps in the Heavens and in Hell would be plausible is very few. Nor does it seem likely that in many Elizabethan plays—with their habitual shifting of the locality and circumstances—solid furniture would be allowed to rest on the Platform throughout the performance of a play.

Yet here it must be insisted once again that the practical test is the only sure way of knowing what is and what is not effective in the theatre. A carpet of reeds on part of the Platform must often be present throughout a performance: sometimes it will signify the usual strewing of a nobleman's house or a hall at Court; in the following scene it will be transformed by the poet into "these greenes before your Towne" [52]; for long stretches of the play it will not be noticed at all. I am reminded of an effect in the production of *Julius Caesar* at Harrow, in 1946: against one of the Stage-Posts, with its back to the audience, stood a bust (Elizabethan style) on a plinth. This did duty in the opening scene for one of the "Images" that the tribune will not allow to be "hung with Caesars Trophies": Cassius made great play with it as he confronted Brutus with the comparison "*Brutus* and *Caesar*: What should be in that *Caesar*?" [53] But later, in the Senate-house, it became Pompey's statue, and Caesar fell dead at its base. For the battlefield in the second half of the play it would obviously have been out of place: so it was carried offstage in triumph (as Caesar again) by the rioters in the Forum as they ran amok. And no one in the audience noticed the discrepancy.

I think it probable that the Platform was usually left un-encumbered by furniture: and for the rest, there was clearly no room or opportunity for elaboration—it looks as if the Chamberlain's Men were content with what was *necessary for the action* or what

[49] *3 Henry VI*, II. i. 25. [50] *Cymbeline*, V. iv. 93. [51] *2 Henry VI*, I. iv. 25.
[52] *King John*, II. i. 242. [53] *Julius Caesar*, I. i. 72; I. ii. 141.

in their view was *significant in helping the words to create their desired effect*. The problem of the modern producer, therefore, is to see what this support in any given case might have been, and his success will depend upon the depth of his insight into their methods: in reconstructing their stage-sets we would do well to stick to the same limits—both in furniture and properties—as they.

As examples of what was *necessary* we have already seen that in *A Midsummer Night's Dream* we can infer from the text the furniture of the Study for the woodland sequence. When Olivia snubs Sir Andrew in favour of Viola ("Let the Garden doore be shut, and leave mee to my hearing"),[54] the probability is that III. i follows continuously upon II. v, and that the furniture of the Study includes the "Garden doore" as well as the box tree. As one reads the last scene of *Romeo and Juliet*, it is easy to make a substantial list of necessary "props": a torch for Paris, and a bunch of flowers; a torch for Romeo's boy, afterwards planted by Romeo in the vault, where its unexpected presence is twice mentioned with foreboding, a "Mattocke" and a "wrenching Iron", a Letter to be delivered early in the morning to Romeo's Lord and Father, a cup for the Appothecarie's drugs; "Lanthorne, Crow, and Spade" for Friar Lawrence; the "Masterlesse, and goarie Swords"; Juliet's "Happy Dagger". The Monument in the Study contains, of course, a tomb for Juliet's supposedly dead body to lie on, and perhaps also a suggestion of Tybalt lying in his "bloudy sheet". "Yond Young [*read* Yew] Trees," to which Paris points at the beginning of the scene, are created merely by poetical means out of one of the Stage-Posts, and likewise the bare Platform needs no tangible furniture to seem "loose, unfirme with digging up of Graves". An instructive example of how to select the necessary properties is in an earlier scene from the same play [55]: Capulet's "old accustom'd Feast" is quickly projected on the stage in a scurry of Servingmen who *come forth with their napkins*. It is plain that their immediate task is to "take away"— shifting and scraping trenchers, removing joint-stools and "the Court-cubbord", providing more light, turning up the tables and quenching the fire. The more of this detail that is reproduced with the appropriate properties in the action, the better: after all, the selection has been made by Shakespeare himself, whose eye for the significant detail is that of an artist of genius.

To illustrate the kind of furnishing which is *significant in helping the words*, without being actually necessary, let me quote examples from my own experience. In the episode of the highway robbery on Gads

[54] *Twelfth Night*, III. i. 105. [55] *Romeo and Juliet*, I. v.

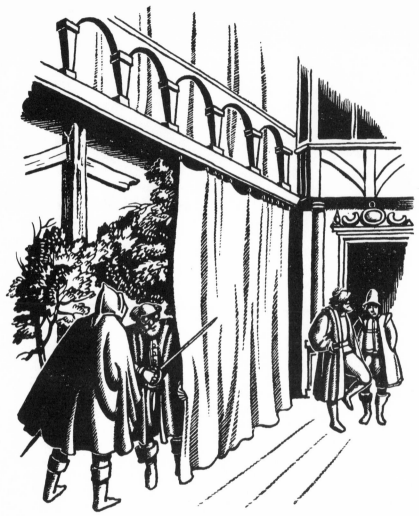

Now my Masters, happy man be his dole, say I

Hill, Shakespeare is at great pains to make clear the layout of his scene: we shall have cause to examine this scene in detail in Chapter V,[56] but for the moment it is enough to say that he creates through the dialogue the impression that the actors are on the slope of a hill: Falstaff has climbed up the hill, the prospective victims are stretching their legs down it; the highwaymen take cover in "the narrow Lane".[57] This lane would no doubt be indicated by a parting

[56] See below, pp. 203 ff. [57] 1 *Henry IV*, II. ii. 65.

of the Study-curtains and a suggestion of trees on either side: a battered fingerpost with one arm pointing downwards reinforces the notion of up- and down-hill, and adds greatly to the atmosphere of highway robbery. In the Boar's Head scenes of the same play, the wall of the Study may be hung with a threadbare tapestry portraying Dives in Hell and Lazarus in Abraham's bosom. We hear from Falstaff himself of Mistress Quickly's flybitten tapestries, his chamber at Windsor (which we do not see) is "painted about with the story of the Prodigall, fresh and new",[58] and the theme of Dives is an appropriate commentary on Falstaff's mode of life and a reminder of his recurrent fits of conscience-stricken melancholy. The visible presence of this painted parable adds much point to a scene in which Falstaff is trying to cure his melancholy by familiar gibes at Bardolph's face. "Why, Sir *John*," says the indignant Bardolph, "my Face does you no harme." "No, Ile be sworne," he retorts: "I make as good use of it, as many a man doth of a Deaths-Head, or a *Memento Mori*. I never see thy Face, but I thinke upon Hell fire, and *Dives* that lived in Purple; for there he is in his Robes burning, burning." [59] Of the same kind of conjectural reconstruction of the Globe furniture is the idea of setting a ladder against a fruit tree in the Study, so that as the reflective Brutus strolls in his orchard and his hand unconsciously falls upon a rung, the action suggests to him his metaphor of "young Ambitions ladder".[60]

It would be absurd to suggest that these guesses are comparable with the deduction of necessary items from the dialogue or the action. Nevertheless they are defensible, it seems to me, provided they are made sparingly, and have a clear value in interpreting the poet's dramatic intention. In general the choice of furniture and properties should be the minimum needed to enact and illustrate the dialogue and action of Shakespeare: they will have, as Granville-Barker says, "rather the utility of furniture than the value of scenery" [61]: but the minimum may be understood in a liberal sense: simplicity is what is wanted, not parsimony; simplicity by being always relevant and significant can have a richness far more effective than unweeded luxuriance.

(iii) Use of Stage Features

The permanent features of the Globe stage were remarkably positive in character: two uncompromising front doors with

[58] 2 *Henry IV*, II. i. 163; *M.W.W.*, IV. v. 8. [59] 1 *Henry IV*, III. iii. 32 ff.
[60] *Julius Caesar*, II. i. 22.
[61] Granville-Barker, *Prefaces to Shakespeare* (Second Series), 136.

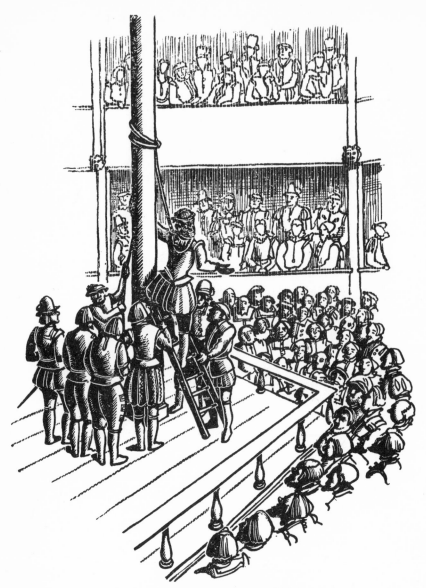

Tut, I have done a thousand dreadfull things

Come my Masters, let us share

knockers, side-posts and overhanging lintels; above which, bay-windows such as you can see jutting out over the shopfronts in Gloucester or Tewkesbury or Stratford to-day; a wicket in each door; rails round the edge of the Platform; the balustrade of the Tarras between the two Window-Stages; the most prominent feature, the two great mast-like Stage-Posts (perhaps masts indeed), with their three-foot square-shaped bases; and supported by these above the third level the stage-cover, the "Heavens", painted underneath with the signs of the zodiac. All this was visible throughout a performance, and the audience were used to seeing rushes strewn on part of the platform, and trap-doors opening in other parts.

Each item of these features was used when the story demanded its use—either in its visible shape or in some imaginary likeness conjured by the words of the dramatist or the miming of the actors. Thus the Stage-Posts, Cranford Adams tells us, were used "as trees; as a means of hiding from others on the platform; as posts to which notices of various sorts are affixed, or to which rogues or victims are bound; as a seeming may-pole, or road-side cross, or the gates of a bridge".[62] It seems likely that Aaron the Moor was to be hanged

[62] J. Cranford Adams, *The Globe Playhouse*, 112.

50

You have forgot the Will I told you of

from one of the Stage-Posts, and that he speaks his great tirades from the top of a ladder, with a halter round his neck.[63] When Launce makes his first appearance in *The Two Gentlemen of Verona*, "Crab my dog" is no doubt "tide" to one of these Posts.[64] Helena will pursue Demetrius round such a tree in the wood near Athens.[65] On Gads Hill, Prince Hal and Poins (*two Rogues in Buckrom Sutes*) will hide behind the two Posts, with backs to the audience, while Falstaff and his confederate are sharing the swag in the centre.[66] One can imagine Mark Antony jumping up on to the base of one of them, as he cries to the mob "You have forgot the Will I told you of." [67]

The two Doors will appear in their own likeness in street-sequences such as those in *The Comedy of Errors*, *The Taming of the Shrew*, *The Merchant of Venice* and *The Merry Wives of Windsor*. But whenever the Platform-and-Study represent a great hall for court or banquet—as for instance at Macbeth's "solemn Supper" [68]—then they will naturally be taken as the interior doors of a palace. When the Platform is being used for an outdoor scene in wood or on heath or battlefield, the Doors simply do not exist. As we read the Fisher Quarto of *A Midsummer Night's Dream*, we are forcibly reminded of their presence in the stage-direction: *Enter the King of Fairies, at one doore, with his traine; and the Queene, at another, with hers.* But the audience in the playhouse have forgotten them long before "Ill met by moonlight, proud Tytania".[69]

The Door-Posts come in handy for concealing assassins, as when Iago bids Roderigo lie in wait for Cassio "behinde this Barke [*read* Bulk]".[70] The wicket is used for prolonged recriminations in *The Comedy of Errors*,[71] and for the baiting of Malvolio in prison.[72] The

[63] *Titus Andronicus*, V. i. 53 ff. [64] *The Two Gentlemen of Verona*, II. iii.
[65] *A Midsummer Night's Dream*, II. i. 188 ff.
[66] 1 *Henry IV*, II. ii. 114. For the effect of this positioning, see below, pp. 136 f.
[67] *Julius Caesar*, III. ii. 243. [68] *Macbeth*, III. iv.
[69] *A Midsummer Night's Dream*, II. i. 60. [70] *Othello*, V. i. 1.
[71] *The Comedy of Errors*, III. i. [72] *Twelfth Night*, IV. ii.

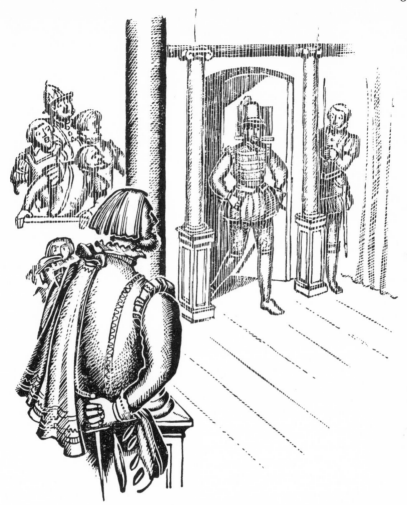

I know his gate, 'tis he

penthouse formed by the overhang of the Tarras is used as a *rendez-vous* by Gratiano and Salarino as they wait for Lorenzo,[73] and by the drunken Borachio and Conrade as shelter from the drizzling rain.[74] The Traps are used for sprites and witches and apparitions: the Study-trap was specially known as the "grave-trap" from its frequent use for burying the dead: Ophelia is formally (if with maimed rites) buried there,[75] and Oswald by Edgar with hasty

[73] *The Merchant of Venice*, II. vi. i.
[74] *Much Ado About Nothing*, III. iii. 109.
[75] *Hamlet*, V. i. 240 ff.

52

improvisation [76]; in *Titus Andronicus* it is used as a pit to trap the living.[77] Even the platform rails, we are told, are sometimes pressed into service by the actors.

Imagine the setting of the opening scene of *The Tempest*, which is nowadays often cut or, if not cut, is unintelligibly confused. A ship-board scene fits admirably into the structure of the Globe. There is the ship-boy at the masthead in the Music Gallery; the Ship-Master on his bridge on the Tarras; the Boteswaine and Mariners ranging freely on the Platform, some looking over the Platform-rails as if over the taffrail out to sea (the fact that there are two masts in parallel matters little in so dramatic a storm as the poet creates); and the distinguished company of villainous passengers come surging in their panic through the Study-Trap as if up the companion-way. Remember that the Huts above the

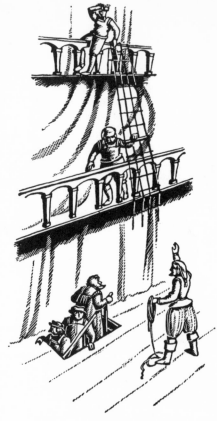

Keepe your Cabines; you do assist the storme

Heavens are meanwhile busy with the thunderbolts, and that all available members of the stage-gang are ready to make the *confused noyse within* ("Mercy on us. We split, we split")[78]—and you will have some idea of the versatile and comprehensive capacity of the Globe Playhouse. "This most excellent Canopy the Ayre, look you," says Hamlet, with a gesture at the Heavens; and "You here this fellow in the selleredge," as he stamps on the boards that separate him from Hell.[79] One has indeed the feeling that the Chamberlain's Men were well equipped for most experiences between Hell and Heaven.

"It was the habit of Elizabethan dramatists," says Cranford

[76] *King Lear*, IV. vi. 281 ff. See J. Cranford Adams, *The Original Staging of King Lear*, 331 ff.
[77] *Titus Andronicus*, II. iii. 186 ff.
[78] *The Tempest*, I. i. 65.
[79] *Hamlet*, II. ii. 318; I. v. 151.

Adams, "to accept the equipment of their stage rather literally and to refer to that equipment in dialogue. . . . Doors, door posts, wickets, stage posts, windows, 'penthouses' . . . all were actual parts of the visible scene, and all were made a part of the sphere of dramatic action and were referred to realistically." [80] These dramatists, the better among them, were practical men of the theatre. They made use of what they had at hand. It is especially true of the best of them, Shakespeare. He often made literal use; but still more often he translated the features for his purpose: we can but be astonished at his dexterity, and the quickness with which he concentrates focus on one feature and makes us forget the others. For long stretches we are allowed to forget altogether the conventional background: then we suddenly recognise (with the pleasure of the sudden-obvious) a happy stroke of the dramatist in exploiting or translating the familiar features of the playhouse.

The playhouse is indeed fully equipped: Shakespeare, however, is never distracted from his artistic purpose by the lure of the machinery—he uses it only when the theme warrants, and we should do well to re-plot likewise.

(iv) Costume

Peter Quince and Bottom are not unconcerned about problems of wardrobe. But when we try to overhear the Book-Keeper's conversation with Burbadge on this theme, the task is not easy. The building of a twentieth-century Globe would, one hopes, breed its own literature—among which there might be a practical manual on the costume and another on the music appropriate for different plays. Meanwhile, before we begin to rehearse the players in this theatre which we are trying to rebuild in imagination, let us make some kind of conjecture as to their appearance when dressed for the play.

Shakespeare himself had an eye for costume, as for almost everything else: frequent passages turn on it: he was able to make dramatic use of its beauty, its splendour, its incongruity, its absurdity, and the tyranny of its fashions. Moreover, we know from Henslowe's inventory that the acting companies spent large sums and had a large stock in their wardrobes. But the prices are high in Henslowe's list, and a moment's reflection will suggest that with their constantly changing repertory of plays, the players are unlikely to have had accurate period costumes for them all. One's admiration

[80] J. Cranford Adams, *The Globe Playhouse*, 233.

of their practical sense and good housekeeping increases with further acquaintance; and in this matter we must expect them to cut their coat to suit their cloth. Shakespeare certainly does not offend by capricious impracticability, and one imagines he would be quick to see that the dramatic needs of the story were more important than historical or national or period accuracy. This consideration, I think, is partly the cause of his obvious inclination for the common denominator of Elizabethan colour.

Shakespeare's stage-vision is essentially modern. It has long been a habit among commentators to point out his anachronisms, but it is perhaps only lately that he has been credited with a deliberate purpose in his modernity. E. M. W. Tillyard remarks it as being especially prominent in the two parts of *Henry IV*: "There is nothing archaistic," he says, "about the Eastcheap tavern and its hostess, about the two carriers in the inn yard at Rochester, about the bill found in Falstaff's pocket, about the satin ordered from Master Dombleton for Falstaff's short cloak and slops, or about the life Shallow liked to think he had led at the Inns of Court: they are all pure Elizabethan" [81]; and he suggests that Shakespeare, by this Elizabethan colour, is deliberately expressing his own feelings about his fatherland. But in fact there is what might be called an Elizabethan substructure in all the plays. Miss M. St. Clare Byrne, commenting on this feature of Shakespeare's imagination, says: "The point of it all is—verisimilitude, actuality," and she speaks of Oswald, Osric and Parolles as "accurate topical portraits, which must undoubtedly have made Shakespeare's own audience more at home in ancient Britain and at Elsinore." [82]

We shall return in Chapter V to the theme of Shakespeare's objective modern vision. Its relevance to the subject of costume is simply this: we cannot do better as a beginning than to use modern dress—by which I mean Shakespeare's modern dress, an Elizabethan wardrobe. And on this basis of an Elizabethan wardrobe, disregarding archaism, we must work at the dramatic emphasis of the story.

Out of this wardrobe the non-period plays would certainly be furnished. *The Taming of the Shrew* bears much evidence of contemporary costume as well as of other details of contemporary life. We have elaborate description of Petruchio and Grumio in their grotesque wedding-garments, we hear of how the serving-men came short of their proper apparel (their new fustian, and white stockings, and their blew coats brush'd), Kate's humiliating interview with the

[81] E. M. W. Tillyard, *Shakespeare's History Plays*, 299.
[82] *A Companion to Shakespeare Studies* (Cambridge), 193.

Tailor and the Haberdasher gives interesting information about current fashions, and Tranio's borrowed plumes are itemised by the indignant Vincentio.[83] In *Much Ado About Nothing*, Hero's wedding-dress loosens the tongue of her gossiping gentlewoman on the subject of "the Dutchesse of *Millaines* gowne that they praise so". "O that exceedes they say," cries Hero, and Margaret retorts: "By my troth's but a night-gowne in respect of yours, cloth a gold and cuts, and lac'd with silver, set with pearles, downe sleeves, side sleeves, and skirts, round underborn with a blewish tinsel, but for a fine queint gracefull and excellent fashion, yours is worth ten on't." [84]

In these examples there are no special contrasts of style needed: nor will there be any in *Twelfth Night*, save that it is important to get the social grades right: many a performance of this shapely comedy has been marred by a misunderstanding of the composition of an Elizabethan household: by a Sir Toby who pays court to Maria in the manner of an Edwardian policeman's back-door wooing, or by a Malvolio who could not possibly have aspired (even in his own ambitious mind) to the hand of his lady. In *The Merchant of Venice*, except when we are in the enchanted air of Belmont, the important thing is to present not a period Venice with accurate Italian costume but the contrast between Jew and Christian. Granville-Barker points out that Shakespeare's Venice is "the Venice of his dramatic needs; a city of royal merchants trading to the gorgeous East, of Jews in their gaberdines . . . and of splendid gentlemen rustling in silks", and he explains how important a part in creating this atmosphere is played by the words of Solanio and Salarino. Quoting

> There where your Argosies with portly saile
> Like Signiors and rich Burgers on the flood,
> Or as it were the Pageants of the sea,
> Do over-peere the pettie Traffiquers
> That curtsie to them, do them reverence
> As they flye by them with their woven wings—

he adds: "They are argosies themselves, these magnificent young men, of high-flowing speech; pageants to overpeer the callow English ruffians, to whom they are here displayed." [85] For the modern producer it is important that their costume and that of their fellow-Christians should have a splendour and dignity to match their language, and that they should by their manner and appearance constrain such traffickers as Shylock and Tubal instinctively to curtsy to them and do them reverence.

[83] *The Taming of the Shrew*, III. ii. 44 ff.; IV. i. 49, 93; IV. iii. 60 ff.; V. i. 67 ff.
[84] *Much Ado About Nothing*, III. iv. 16 ff.
[85] Granville-Barker, *Prefaces to Shakespeare* (Second Series), 80 ff.

In *A Midsummer Night's Dream* the Athenian colour hardly exists at all: we may assume that the *chiton* and *himation* are as far from Shakespeare's thoughts as the Acropolis and the Pnyx. The courtiers will be Elizabethan courtiers, the craftsmen good Londoners, and there is life in the idea that the fairies should imitate their mortal counterparts, the King and Queen like Theseus and Hippolyta, and the fairies dressed as courtiers, prelates, soldiers and the like; the materials will, of course, be gathered from the woods and fields in which they live. There is a negative virtue in this choice of wardrobe— that it cuts out the irrelevant overtones of ballet-fairyland. A bold principle begins to assert itself: a producer of to-day will be wise to use no costume of a period later than Shakespeare's own day: he may range freely before that date, but subsequent fashions are to be avoided as being foreign to Shakespeare's vision.

The great tragedies are also non-period in their timeless quality. Little stress in matters of detail and local colour is laid upon Hamlet's Denmark, on Venice and Cyprus in *Othello*, on Lear's ancient Britain or on the Scotland of *Macbeth*. For instance, the porter at Inverness has none of the national eccentricities of Captain Jamy, and between Macduff and Hotspur's friend, the Douglas, there is no doubt which is the better Scotsman. Such hints of costume as there are in these tragedies are contemporary Elizabethan. Again the principle applies, that it is more important to suit the dress to the emphasis of the story than to be accurate. Thus Hamlet's "Inky Cloake" at his first appearance must be in startling contrast to the ostentatious brilliance of Claudius and his courtiers, so that when he says "I am too much i' th' Sun", a glance to left and right will make his point clear at once. But later, when he puts his "Anticke disposition" on, he must

assume the guise so graphically described by the affrighted Ophelia:

> his doublet all unbrac'd,
> No hat upon his head, his stockings foul'd,
> Ungartred, and downe gived to his Anckle. [86]

A clear, dramatic contrast can be marked by differentiating in costume Horatio the student, Fortinbras the soldier, and Osric the "water-flie". Othello should be dressed to emphasise his difference from those of Desdemona's "owne Clime, Complexion, and Degree"—not so as to

preserve the romantic likeness of a popular actor. The description in the Folio of Portia's tawny suitor may serve as a guide: the costume there is designed to startle rather than soothe the spectator, and a similar suggestion is made by the appearance of Aaron, paramour of the Queen of the Goths, in a contemporary theatrical sketch. [87] Goneril and Regan should no doubt be "gorgeous", as Lear in the climax of his anger

[86] *Hamlet*, II. i. 78–80.
[87] The drawing of Henry Peacham (1595) is reproduced in E. K. Chambers' *William Shakespeare*, vol. i, 312, and also in *Shakespeare Survey*, I, where it is discussed at length by J. Dover Wilson (17 ff.).

58

Lord Hamlet with his doublet all unbrac'd

lets us know.[88] Pains should be taken over Edgar's "the thing it selfe". Lear cries at sight of him "unaccommodated man, is no more but such a poore, bare, forked Animall as thou art": but we have a more exact view of him given by himself in advance:

> my face Ile grime with filth,
> Blanket my loines, elfe all my
> haires in knots,
> And with presented nakednesse
> out-face
> The Windes——

and he means to adopt the practice

> Of Bedlam beggars, who with roaring voices,
> Strike in their num'd and mortified Armes,
> Pins, Wodden-prickes, Nayles, Sprigs of Rosemarie——[89]

If this disguise is hardly a problem for the wardrobe-master, it yet helps to bring home the point that the interpretation of Shakespeare's dramatic purpose is as important in the field of costume as in any other.

In the English histories, careful attention would, no doubt, be paid to the armorial bearings of noble families, most of which had contemporary representatives moving constantly before the eye of Shakespeare's audience. The broad issues of the long series ranging from *Richard II* to *Richard III* would be all the clearer if we came to recognise the recurrent emblems, some of which provide imagery for the poet's dialogue. But apart from this consideration, the same principle applies—that we should reinforce by the costumes the dramatic emphasis. Richard of Gloucester is "at Charges for a Looking-glasse", and we should see some striking result of his employing "a score or two of Taylors, To study fashions to adorne my body".[90] Richard II, who "every day, under his House-hold Roofe, Did keepe ten thousand men", should be a splendid figure against a sober-suited Bolingbroke.[91] We have already noticed Tillyard's

[88] *King Lear*, II. iv. 270 ff.
[90] *Richard III*, I. ii. 257.
[89] *King Lear*, III. iv. 109; II. iii. 9 ff.
[91] *Richard II*, IV. i. 282.

suggestion that in *Henry IV* Shakespeare is giving his picture of Elizabethan England. This gives the clue for a groundwork of contemporary costume: on this we will impose the traditional blazonry: and there is a special dramatic emphasis on the plumes of Prince Hal, which can be traced as a recurrent *motif* rising to a climax on the battlefield. Stung by his father's reproaches, the Prince declares that he will

> in the closing of some glorious day,
> Be bold to tell you, that I am your Sonne,
> When I will weare a Garment all of Blood,
> And staine my favours in a bloody Maske.

The promise is redeemed on Shrewsbury field, but with a touch of magnanimous courtesy the victor takes the plumes from his own crest and lays them on the dead Percy: "Let my favours," says he, "hide thy mangled face." Half-way between the promise and its fulfilment, we have the splendid description of the young Prince and his comrades spoken in the unwilling ears of Hotspur, by Sir Richard Vernon:

> All furnisht, all in Armes,
> All plum'd like Estridges, that with the Winde
> Bayted like Eagles, having lately bath'd,
> Glittering in Golden Coates, like Images . . .

When, within sixty lines of this description, the Prince appears on his way to the battlefield, the wardrobe-master would be failing of his duty if he did not provide him and his companions with the very best plumage and harness that the Globe store-rooms could provide.[92] On the other hand, a conspicuous absence of plumes makes a fine dramatic point when Prince Hal, now King Henry, sends defiance to the Constable of France:

> There's not a piece of feather in our Hoast:
> Good argument (I hope) we will not flye.[93]

The Roman plays present the problem in its acutest form. Here too, as the text-books remind us, the few hints of detail are contemporary—Caesar's Doublet and Night-gowne, the Night-cappes of the rabblement, the Hats and Cloakes of the conspiracie, the pocket of Brutus's gowne; Cleopatra's lace that must be cut. There is, of course, no doubt that the Elizabethans knew what Romans looked like: their pictures, their decorated books make clear what anyway is obvious. Yet it seems that it was not their stage practice to

[92] 1 *Henry IV*, III. ii. 133 ff.; V. iv. 96; IV. i. 97 ff.; IV. ii. 54. See below, pp. 252 ff.
[93] *Henry V*, IV. iii. 112 ff.

dress their actors accurately in period. Dover Wilson infers from the
Peacham drawing of *Titus Andronicus* [94] that while the lower classes
were played in "modern dress", every effort was made to attain
accuracy in the attire worn by patricians. I am not convinced that
the evidence of the picture is plain enough to support his con-
tention. More plausible, perhaps, is the compromise which
Granville-Barker advocates when, in his preface to *Julius Caesar*, he
writes: "Are not our noble Romans, flinging their togas gracefully
about them, slow-moving, consciously dignified, speaking with

An illustration from Holinshed

studied oratory and all past middle age, rather too like a schoolboy's
vision of a congress of headmasters? Compare them with the high-
mettled, quick-tongued crew of politicians and fighters that
Shakespeare imagines; and if it comes to accuracy, has he not more
the right of it than we, even though his Caesar be dressed in doublet
and hose? So let the designer at least provide an escape from this cold
classicism, which belongs neither to the true Rome nor to the play he
has to interpret. His way can be the way of all compromise. . . .
The methods of the Mask and the way of Renaissance painters with
classical subjects give us the hint we need. Whether from taste or
lack of information, when it came to picturing Greeks and Romans

[94] See above, p. 57; and *Shakespeare Survey*—**I, 21.**

they were for fancy dress; a mixture, as a rule, of helmet, cuirass, trunk hose, stockings and sandals, like nothing that ever was worn, but very wearable and delightful to look at." [95] Tintoretto and Paolo Veronese should therefore be among our models, and also the illustrations in Holinshed over which the poet pored so often and so long.

And halfe their Faces buried in their Cloakes

In practice, the Elizabethan touches help rather than hinder: a group of conspirators whose "Hats are pluckt about their Eares, And halfe their Faces buried in their Cloakes",[96] huddled under the foliage of a property tree in the Study, while Cassius advances to Brutus beside a Post-tree in his Orchard downstage on the Platform, suggests the feeling of the Babington plot in a contemporary woodcut,

[95] Granville-Barker, *Prefaces to Shakespeare* (First Series), 127, 128. Much sound sense is written on this theme by Miss M. St. Clare Byrne in her chapter on "The Social Background" in *A Companion to Shakespeare Studies* (Cambridge), 190–95. Her note (on page 194) on the illustrations in Holinshed is particularly interesting. The reader's attention is also drawn to an article on "John Speed's Theatre" in *Theatre Notebook*, Vol. III, No. 2, for January–March, 1949, in which C. Walter Hodges offers "some reflections on the style of the Elizabethan playhouse".

[96] *Julius Caesar*, II. i. 73 f.

and gains greatly thereby in verisimilitude, even to twentieth-century eyes. For Shakespeare's modernity is thus emphasised: this is the true "Shakespeare in modern dress".

And therefore, if we are to reconstruct the productions of the Chamberlain's Men, we cannot do better as a preliminary than to make a detailed study of Elizabethan costume—full as it is of beauty, individual character and variety, and in many of its fashions quite unlike the standard turn-out of the theatrical costumier. Some of the miniatures of Nicholas Hillyarde and Isaac Oliver provide fashion-plates that would enrich the characterisation of many of the plays of Shakespeare: one can identify in the "King Penguin" volume of *Elizabethan Miniatures* an Orlando, a Benedick and a Hotspur: there would no doubt be, somewhere for the finding, an appropriate and individual style for most of the Shakespearian characters. And having chosen our style, then we must learn to wear it with as much ease and comfort and grace as the portraits suggest—and with more, much more of the last quality than we are used to in the sartorial fashion of to-day.

(v) Music

When we turn to consider what musical plans the Book-Keeper would make, we have to use a special effort of the imagination in unthinking subsequent musical practice in the theatre. Nowadays we are used to an atmospheric overture, and an automatic musical link between scenes; indeed, the technique of the films goes further still in douching the dialogue and the action with a superficially appropriate musical comment. When this kind of treatment is applied to the production of Shakespeare, it is commonly assumed that he left no clear indications of his own preference. This is a strange assumption, when we remember his often expressed fondness for music: if he had an eye for costume, it is no less true that his works show him to have had a keen ear for music, and some knowledge of the technique of an art which in his day was more generally practised than in ours.

In fact, the musical directions in the Folio are usually quite explicit,[97] and though not exhaustive, yet they seem to miss few of the significant and emphatic cues. Some, of course, can be inferred from the dialogue itself. In the second scene of *Julius Caesar* there are three separate cues for the band in the first twenty-five lines: only

[97] McKerrow points out that the Folio Edition of *Titus Andronicus* seems to have been printed from a Playhouse prompt-copy "in which certain incidental music had been noted". *Prolegomena for the Oxford Shakespeare*, 70, note 2.

one (*sennet*) is marked in the stage-directions, but it can be inferred from Caesar's line "I heare a Tongue shriller then all the Musicke" that the musicians strike up on the words "Set on, and leave no Ceremony out"; and reading backwards, we can deduce another music cue for the entry of the procession, interrupted suddenly by Casca's cry of "Peace ho, *Caesar* speakes." [98] A modern producer will find no difficulty in making this kind of deduction. Moreover it is easy to understand that routine, such as could be taken for granted by the players, is often omitted from the prompt-book. Thus we do not need to be told of the normal method of calling the attention and silence of the audience at the beginning of the play: it is probably a repetition of the trumpet-call which had already been advertising from the Huts to the whole of London the fact that a play is to be given this afternoon. Once the audience is settled and attentive, the play itself can begin: more often than not it begins with dialogue or solo speech, sometimes with an uproarious crowd; exceptionally, as in *Twelfth Night*, with instrumental music; not seldom with a royal flourish of trumpets; but when music is used, it is an integral part of the performance, not a descriptive "overture" in our sense of the word.

It was neither customary nor necessary to link the scenes with music: the brisk continuity, as has been said above, was made by a natural transition created by the words and miming of the speakers, the logical sequence of the story, and the corresponding rotation from one part of the multiple stage to another. On the other hand, it was evidently usual—and indeed in practice seems almost necessary—to accompany a processional entry: it is hardly possible for a large number of actors to enter by a single stage-door with grace and dignity without some musical support; no doubt this practice was borrowed from real life.

It is important to have some knowledge of the different musical terms used in the stage-directions in the early printed texts. The subject is fully expounded by E. W. Naylor, and his help should be sought in interpreting the prompt-book. [99] Meanwhile the following observations arise from a perusal of the Folio. The *Flourish*, a blast of trumpets in the manner of a bugle-call, is the usual accompaniment of the entry of a royal or sovereign personage: but the *Sennet*, played probably by the cornets (which, though made of wood, are perhaps the counterpart of the modern brass band), is a formal musical

[98] *Julius Caesar*, I. ii. 1–25.
[99] E. W. Naylor, *Shakespeare and Music*, (J. M. Dent & Co., 1896). Even more concise, and of great practical help, is the same writer's essay on "Music and Shakespeare", in *The Musical Antiquary* for April, 1910.

piece generally used to grace a procession. The great moment when
Richard of Gloucester mounts the throne of his ambition is thus
marked in the Folio: *Sound a Sennet. Enter Richard in pompe.*[100] The
parallel crisis in Macbeth's fortune has: *Senit sounded. Enter Macbeth
as King.*[101] The last scene of *Henry V* is rounded with a *Senet*, since
there are so many royal and noble personages to make their way
into the Tiring-House.[102] As we have already seen, Caesar's proces-
sion at the Lupercal is so elaborate as to need a *Sennet*.[103] The
ceremonious splendour of King Lear's first entry is likewise accom-
panied.[104] Sometimes, when a prolonged movement is required by
the action, but with no visible ceremonial, the prompt-book marks a
Long Flourish. In the opening scene of *Titus Andronicus* it is necessary
for the Tribunes and Senators *aloft* to come down from the Tarras to
the Platform below: the direction is *A long Flourish till they come
downe*.[105] The musical accompaniment of the tourney in *Richard II* is
significant: *Flourish* for the King's entry; *Tucket* for Hereford's; *A
charge sounded* for the combatants' setting forward; *A long Flourish*
while Hereford and Mowbray "draw neere and list" to their
sentence.[106]

The *Tucket* usually heralds the arrival of persons of importance,
ambassadors or messengers. Thus Mountjoy's arrogant embassies
are preceded by a *tucket:* perhaps significantly, when after Agincourt
"His eyes are humbler than they us'd to be," no mention of a *tucket*
appears in the Folio.[107] In *All's Well that Ends Well, A Tucket afarre off*
heralds the approach of a victorious army.[108] *Tucket within* announces
the approach of Cornwall and Regan, and the same stage-direction
precedes Goneril's entry: from this last example it seems likely that
these tuckets were sometimes recognisable as the signal of an indi-
vidual owner: "What Trumpet's that?" says Cornwall. "I know't,
my Sisters," answers Regan, with savage relief and relish, as she
welcomes Goneril's support against her father.[109]

The *Hoboyes* (hautboys or oboes) are the equivalent of the modern
double-reed family of wood-wind instruments. Naylor says that a
band of oboes, cors anglais, bassoons and contra-fagotto would be
similar to the sixteenth-century Hautboy band, but more refined in
tone. "The indication of 'hautboys' in the plays," he says, "always
implies a special *importance* in the stage music, generally connected

[100] *Richard III*, IV. ii. 1. [101] *Macbeth*, III. i. 11. [102] *Henry V*, V. ii. 402.
[103] *Julius Caesar*, I. ii. 24. [104] *King Lear*, I. i. 36. [105] *Titus Andronicus*, I. i. 233.
[106] *Richard II*, I. iii. 1–124.
[107] *Henry V*, III. vi. 124; IV. iii. 78; IV. vii. 70.
[108] *All's Well That Ends Well*, III. v. 1.
[109] *King Lear*, II. i. 80; II. iv. 185 f. So, too, Iago's excited cry on the quayside
at Cyprus: "The Moore I know his Trumpet" (*Othello*, II. i. 181).

with a banquet, masque, or procession . . ." [110] *Hoboyes* accompany the bringing in of the Table for the feast at the end of *Titus Androni-cus*.[111] *Hoboyes play* during the *dumbe shew* in *Hamlet*.[112] *Hoboyes, and Torches* are specified as Duncan and his companions approach in cheerful mood the castle of his murderer. Again there are *Ho-boyes. Torches* to indicate the supper with which the King is welcomed.[113] In a different mood, they play as the Witches' cauldron sinks into Hell [114]: and they create a wonderful dramatic effect in *Antony and Cleopatra*, when the sentries are startled on their night-vigil; the poet's or the Book-Keeper's instruction is specifically marked: *Musicke of the Hoboyes is under the Stage*.[115]

The musical accompaniment of battle-sequences is simple and conventional, and the different types must have been easily recognisable to the audience. A drum for marching is so common that we read in 3 *Henry VI* the instruction: *the Drumme begins to march*.[116] The drum is also the basis of *Alarums*, a confused noise to which trumpets, the clash of arms and no doubt the human voice contribute. The *Alarum* seems to represent the fighting itself, continuing as long as the contest of the moment lasts: for instance, in *Troilus and Cressida*, when Hector and Ajax fight in the lists, the alarum begins on the cue "They are in action", but when Diomed cries: "You must no more," we are told that the *trumpets cease*.[117] An interesting hint of the method of preparing the battle is given by the Bastard in *King John*, when he says:

> Do but start
> An eccho with the clamor of thy drumme,
> And even at hand, a drumme is readie brac'd,
> That shall reverberate all, as lowd as thine.
> Sound but another, and another shall
> (As lowd as thine) rattle the Welkins eare,
> And mocke the deepe mouth'd Thunder.[118]

In the course of the Battle of Shrewsbury, the significant musical points are clearly marked in the Folio—the ceremonial *trumpets*, the *alarums*, (the *excursions*), the *retreat*, the trumpets of victory.[119] Add to these the *Parley*, quickly recognised as such by Jack Cade,[120] and answered by another trumpet within Flint Castle,[121] and we have most of the routine signals of playhouse battles. Especially notable

[110] Naylor, "Music and Shakespeare", in *The Musical Antiquary*, April, 1910, 133.
[111] *Titus Andronicus*, V. iii. 25.
[112] *Hamlet*, III. ii. 147.
[113] *Macbeth*, I. vi. 1; I. vii. i.
[114] *Macbeth*, IV. i. 106.
[115] *Antony and Cleopatra*, IV. iii. 12.
[116] 3 *Henry VI*, IV. vii. 51.
[117] *Troilus and Cressida*, IV. v. 113–6.
[118] *King John*, V. ii. 167 ff.
[119] 1 *Henry IV*, V. ii., iii., iv., and v.
[120] 2 *Henry VI*, IV. viii. 4 f.
[121] *Richard II*, III. iii. 61.

are the *Low Alarums* so carefully marked at the points of emphasis in the defeat of Philippi.[122] All these different effects make immediate impact, we must suppose, on the audience, and help thereby in telling them the story.

Of the more elaborate music, as opposed to formal fanfares and flourishes, the songs form a study by themselves and have been considered in detail by Richmond Noble.[123] He points out that with Shakespeare's increasing skill they become more and more an integral part of the drama. We may wonder at the diversity of effect that Shakespeare so produced, and it is enough to mention *Who is Sylvia?* the serenade made doubly dramatic by the presence of the rejected Julia; *Tell me where is Fancie bred*, with its riddling application to guide Bassanio in his choice; Lucius' song with its drowsy

This is a sleepy Tune

cadence, tactfully devised to leave Brutus alone with the atmosphere which breeds ghosts; the musical comments of *As You Like It* (the nearest thing among Shakespeare's plays to a musical comedy); *Come away death*, an example of the music that is the food of love; Ophelia's mad songs, reflecting the confusion of her grief-stricken mind; Desdemona's Song of Willough, most poignant of all Shakespeare's effects in music; *Full fadom five*, giving an air of magic unreality to the supposed bereavement of Ferdinand so that he may be ready for his meeting with admired Miranda.

Most of these songs, and particularly those of Lucius and Feste and Desdemona, are examples of atmospheric music in Shakespeare, and there are other occasions where he uses instrumental music for such effect. There is, for instance, the music which Richard II hears

[122] *Julius Caesar*, V. iii. 96; V. iv.
[123] Richmond Noble, *Shakespeare's Use of Song*.

expand the number of cues but still use the effect sparingly; the words must be heard. We can guess at the practice if we consider the storm in *Julius Caesar*. If we open the Folio at page 702 we find the cue *Thunder and Lightning* at the beginning of what we now call Act I, Scene iii. There is only one other cue (*Thunder still*) marked by the prompter. But one can perhaps legitimately add a roll or clap at Cicero's "This disturbed Skie is not to walke in". A lightning flash might well greet the arrival of Cassius, who boasts that he has:

> . . . bar'd my Bosome to the Thunder-stone
> And when the crosse blew Lightning seem'd to open
> The Brest of Heaven, I did present my selfe
> Even in the ayme, and very flash of it.

Other suitable moments are at Cassius' "Most like this dreadfull Night," and again when he says, just before the entry of Cinna:

> And the Complexion of the Element
> Is [*read* In] favors like the Worke we have in hand,
> Most bloodie, fierie, and most terrible.

The purpose, in all these additions, is to use the effects to point the dialogue. Then the thunderstorm drops for Brutus' orchard where it would obviously be inappropriate and disturbing both to Brutus' philosophic brooding and to the whispered colloquy of the conspirators, and indeed to the hushed intimacy of the Portia scene. But it picks up again with a sudden clap of *Thunder* just before the end of the Ligarius scene so as to remind us of the portentous night for the opening of the dialogue between Caesar and Calpurnia.[146] This is an instructive example of how the minimum of means can produce the necessary effect. The recurrent direction *Storme still* in *King Lear* reads also like a kind of reminder; as if these were the points where the noise becomes obtrusive above the dialogue. This can only be tested in practice, but we may take it for granted that a little will go a long way in creating the effect, and the kind of continuous bombardment that drowns the dialogue defeats the poet's end in an attempt at irrelevant realism.

Nevertheless there was no tendency to avoid verisimilitude on doctrinaire grounds. Quite the contrary: just as the visual effects in *Macbeth* would be real—the Apparitions, Banquo's ghost, Macbeth's severed head (but not, of course, the "Dagger of the Minde")—so with audible effects too: not only will clocks strike and bells jangle, but the owl, "the fatall Bell-man", will be heard to hoot through the

[146] *Julius Caesar*, I. iii; II. i. and ii. We shall notice a similar phenomenon when we come to study the night of Duncan's murder in *Macbeth*. See below, p. 291.

either genuine, if there is any suitable, or an imitation if the stanza of a lyric is metrically too complicated to find a tune that will fit. The overwhelming reason is that this was the golden age of English music, and that a strain of Byrd or Gibbons or Morley or Weelkes can evoke sooner even than Shakespeare's words the astonishing poetical freshness and vigour and strength of the age. Indeed, if we use the music of these composers, we may even find it easier to listen to Shakespeare himself with a less jaded ear, and hear his freshness anew. If we stick to the period for the purely musical pieces, then it is hardly less important to preserve a simplicity in the fanfares as well: anachronisms in musical texture are quicker than anything to destroy the sense of style; and they would soon undo the effect we are trying to build up of a performance such as the Chamberlain's Men would have given.

(vi) Effects

The back-stage crew at the Globe would have had plenty to do, and one can imagine that their work was done—like that of most stage-crews—with skill and enthusiasm. They worked in the Huts above the Heavens, and in Hell below the Platform, and at any other point of the Tiring-House or the whole playhouse where their services were required for the illusion. Details of their means and devices can be found in Cranford Adams and in W. J. Lawrence, and to the works of these authors the producer who wishes to re-construct the Globe performance should refer.[144] But for our present purpose, of seeing how far it is possible to re-plot with the Book-Keeper, it must be said that, as with the music, so the other sound-effects are mostly marked in the Quarto and Folio texts or easily inferred from them.

Let us consider, for instance, the oft-repeated cue of *Thunder*. Lawrence tells us of some of the dodges by which the effect was produced—"rolling an iron bullet down an inclined wooden trough provided here and there with slight obstructions over which it crashed"; "simulation of the thunder-clap by rolling a barrel half filled with stones"; or a thunder-roll on the base-drum; and "blowing rosin through a candle flame (the approved method of making stage lightning)."[145] As with the trumpet-calls, so here too the points of emphasis are marked in the early texts; we must no doubt

[144] J. Cranford Adams, *The Globe Playhouse*; W. J. Lawrence, *Pre-Restoration Stage Studies*.
[145] *Op. cit.*, 210, 263.

instrument, presumably the lute, and Pandarus likewise asks for an instrument before he sings for Helen of Troy [134]; we have already noticed Glendower's harp. Besides the solo voices, which are sometimes accompanied but often free (as, for instance, with Ophelia, Lear's fool, Autolycus), we have indications of choral singing when the fairies sing Titania to sleep [135]; when a "solemn hymne" is sung in the Monument of Leonato [136]; and twice in *As You Like It*—when the direction reads *Altogether heere* for "Who doth ambition shunne"; and again when in the dénouement Hymen announces a "Wedlocke Hymne".[137] There is a burden (*Ding, dong, bell*) in *The Merchant of Venice* [138] and another (*bowgh wawgh*) in *The Tempest*,[139] and a delightful, spontaneous duet in *As You Like It*, when one of two pages asks Touchstone: "Shall we clap into it roundly, without hauking, or spitting, or saying we are hoarse, which are the onely prologues to a bad voice?" [140]

As a further symptom of enterprising experiment, the musicians are made to travel all about the playhouse. In *The Two Gentlemen of Verona* they appear on the stage to serenade Sylvia.[141] In *2 Henry IV*, by the sickbed of the dying King, they are "in the other Roome" [142]; so the supposition is that they play off stage on the ground floor of the Tiring-House. In *Troilus and Cressida*, when Pandarus visits Paris and Helen, it is apparently a chamber scene, and the prompt-book says: *Musicke sounds within*.[143] One need only mention again Glendower's music which is said to "Hang in the Ayre a thousand Leagues from thence"—it looks as if they would play in the customary gallery—and the Hoboyes in *Antony and Cleopatra* under the Platform, and we may be said to have boxed the compass.

It seems then that in re-plotting the play, we should use the directions in the Folio and Quarto texts as a basis for the formal and ceremonial music of trumpets, etc.; follow the points of emphasis marked in the prompt-book; infer other cues from the dialogue (as in *Julius Caesar*, above); and expand on similar lines, but not unless the situation calls for it; covering a processional entry is a legitimate reason for expansion. The songs should be done as Shakespeare means them (and Noble is here a safe guide), without repetition or expansion. The instrumental music should also serve exactly the dramatic purpose of Shakespeare, and no more.

It is no mere archaistic affectation to stick to the period music—

[134] *Troilus and Cressida*, III. i. 106, 126.
[135] *A Midsummer Night's Dream*, II. ii. 7 ff.
[136] *Much Ado About Nothing*, V. iii. 11. [137] *As You Like It*, II. v. 38; V. iv. 144.
[138] *Merchant of Venice*, III. ii. 72. [139] *The Tempest*, I. ii. 375.
[140] *As You Like It*, V. iii. 12. [141] *Two Gentlemen of Verona*, IV. ii. 18.
[142] *2 Henry IV*, IV. v. 4. [143] *Troilus and Cressida*, II. iii. *fin*.

in prison and whose broken time provokes him to much irritable comment and yet at last makes him grateful to the player [124]; and the music on which Orsino feeds his passion in the opening phrases of *Twelfth Night*. Music is likewise used to heighten the pathos of a sickbed (though the explicit reason is to relieve the patient or to heal him); King Henry IV asks for music in his last illness,[125] and the Doctor prescribes louder music for the waking of Lear after his frenzy.[126]

An interesting example, where the dramatist seems to have an ironical purpose in employing music, occurs in *Much Ado About Nothing*.[127] Balthasar's song *Sigh No More Ladies* is, Benedick thinks, for Claudio's benefit; in fact, Claudio is not in a melting mood, but a mischievous one, and presumably the song is meant to hale Benedick's soul out of his body—in spite of himself. *Sneakes Noyse*, which is summoned to the Boar's Head to please Mistress Tearsheet, is surely a parody of the conventional love-music, appropriate to Falstaff's maudlin romance.[128] But in all these examples it will be noticed that the music is *part of the play;* it is *heard on the stage* and is never a comment shared only by the dramatist and the audience to the exclusion of persons of the play.

There is great versatility in the type of music and also in the instrumentation; there is nothing perfunctory or hidebound about Shakespeare's demands. He is audaciously experimental here as elsewhere. He attempts, for instance, to differentiate nationality in music, but usually for dramatic, never for archæological reasons. In 1 *Henry VI*, when La Pucelle persuades Burgundy to break away from his alliance with the English, the political issue is emphasised by a distinction between an *English March* for Talbot and a *French March* for Burgundy.[129] The flourish of cornets that announces the Prince of Morocco's presence at Belmont, suggests an appropriate characterisation.[130] Lady Mortimer's Welsh air, accompanied probably by the harp,[131] and the *Danish March* which introduces Claudius and his Court as they are "comming to the Play",[132] prove that Shakespeare is ready to take whatever is available or fashionable in London at the time. There is indeed a remarkable variety of instrumentation: besides the normal instruments—trumpets, drums, cornets, hautboys, viols and recorders—we get pipers at the end of *Much Ado About Nothing;* Lucius' song for Brutus [133] is sung to an

[124] *Richard II*, V. v. 41–66. [125] 2 *Henry IV*, IV. v. 3. [126] *King Lear*, IV. vii. 25.
[127] *Much Ado About Nothing*, II. iii. 60. [128] 2 *Henry IV*, II. iv. 12.
[129] 1 *Henry VI*, III. iii. 31, 34. [130] *The Merchant of Venice*, II. 1; II. vii.
[131] 1 *Henry IV*, III. i. 123, 248. See *Variorum* edition, *ad loc.*
[132] *Hamlet*, III. ii. 96. [133] *Julius Caesar*, IV. iii. 256 ff.

are the *Low Alarums* so carefully marked at the points of emphasis in the defeat of Philippi.[122] All these different effects make immediate impact, we must suppose, on the audience, and help thereby in telling them the story.

Of the more elaborate music, as opposed to formal fanfares and flourishes, the songs form a study by themselves and have been considered in detail by Richmond Noble.[123] He points out that with Shakespeare's increasing skill they become more and more an integral part of the drama. We may wonder at the diversity of effect that Shakespeare so produced, and it is enough to mention *Who is Sylvia?* the serenade made doubly dramatic by the presence of the rejected Julia; *Tell me where is Fancie bred*, with its riddling application to guide Bassanio in his choice; Lucius' song with its drowsy

This is a sleepy Tune

cadence, tactfully devised to leave Brutus alone with the atmosphere which breeds ghosts; the musical comments of *As You Like It* (the nearest thing among Shakespeare's plays to a musical comedy); *Come away death*, an example of the music that is the food of love; Ophelia's mad songs, reflecting the confusion of her grief-stricken mind; Desdemona's Song of Willough, most poignant of all Shakespeare's effects in music; *Full fadom five*, giving an air of magic unreality to the supposed bereavement of Ferdinand so that he may be ready for his meeting with admired Miranda.

Most of these songs, and particularly those of Lucius and Feste and Desdemona, are examples of atmospheric music in Shakespeare, and there are other occasions where he uses instrumental music for such effect. There is, for instance, the music which Richard II hears

[122] *Julius Caesar*, V. iii. 96; V. iv.
[123] Richmond Noble, *Shakespeare's Use of Song*.

with a banquet, masque, or procession . . ." [110] *Hoboyes* accompany
the bringing in of the Table for the feast at the end of *Titus Androni-
cus*.[111] *Hoboyes play* during the *dumbe shew* in *Hamlet*.[112] *Hoboyes, and
Torches* are specified as Duncan and his companions approach in
cheerful mood the castle of his murderer. Again there are *Ho-boyes.
Torches* to indicate the supper with which the King is welcomed.[113]
In a different mood, they play as the Witches' cauldron sinks into
Hell [114]: and they create a wonderful dramatic effect in *Antony and
Cleopatra*, when the sentries are startled on their night-vigil; the
poet's or the Book-Keeper's instruction is specifically marked:
Musicke of the Hoboyes is under the Stage.[115]

The musical accompaniment of battle-sequences is simple and
conventional, and the different types must have been easily recog-
nisable to the audience. A drum for marching is so common that we
read in 3 *Henry VI* the instruction: *the Drumme begins to march*.[116] The
drum is also the basis of *Alarums*, a confused noise to which trumpets,
the clash of arms and no doubt the human voice contribute. The
Alarum seems to represent the fighting itself, continuing as long as the
contest of the moment lasts: for instance, in *Troilus and Cressida*,
when Hector and Ajax fight in the lists, the alarum begins on the cue
"They are in action", but when Diomed cries: "You must no
more," we are told that the *trumpets cease*.[117] An interesting hint of
the method of preparing the battle is given by the Bastard in *King
John*, when he says:

> Do but start
> An eccho with the clamor of thy drumme,
> And even at hand, a drumme is readie brac'd,
> That shall reverberate all, as lowd as thine.
> Sound but another, and another shall
> (As lowd as thine) rattle the Welkins eare,
> And mocke the deepe mouth'd Thunder.[118]

In the course of the Battle of Shrewsbury, the significant musical
points are clearly marked in the Folio—the ceremonial *trumpets*, the
alarums, (the *excursions*), the *retreat*, the trumpets of victory.[119] Add to
these the *Parley*, quickly recognised as such by Jack Cade,[120] and
answered by another trumpet within Flint Castle,[121] and we have
most of the routine signals of playhouse battles. Especially notable

[110] Naylor, "Music and Shakespeare", in *The Musical Antiquary*, April, 1910, 133.
[111] *Titus Andronicus*, V. iii. 25. [112] *Hamlet*, III. ii. 147.
[113] *Macbeth*, I. vi. 1; I. vii. i. [114] *Macbeth*, IV. i. 106.
[115] *Antony and Cleopatra*, IV. iii. 12. [116] 3 *Henry VI*, IV. vii. 51.
[117] *Troilus and Cressida*, IV. v. 113-6. [118] *King John*, V. ii. 167 ff.
[119] 1 *Henry IV*, V. ii., iii., iv., and v. [120] 2 *Henry VI*, IV. viii. 4 f.
[121] *Richard II*, III. iii. 61.

medium of a good mimic.[147] The cocks will crow to drive away King Hamlet's ghost. Such skilful scene-painting as the Inn Yard scene in 1 *Henry IV* (II. i) can be clinched by the neighing of Neighbour Mugge's poor jade Cut, and the whinnying reply of Gadshill's gelding.[148] It needs a good deal of skill with the coconuts to make the horses not only approach but also "goe about" in the Banquo murder scene: Lawrence, after mentioning as stage-directions "a noise within, as of a horse falling" and "a noise within of driving beasts",

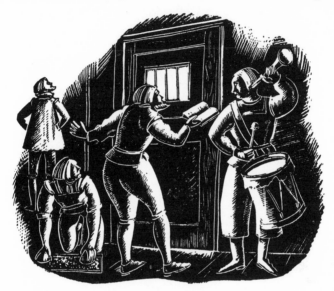

Prompter and Effects

remarks that "few dramatists hesitated about setting the players posers of this order".[149] It needs skill, too, to get the right kind of sound for the famous knocking in *Macbeth*, different, for instance, from the knocking in Brutus' orchard; or to hit the appropriate timbre for the little bell which tells Macbeth that his "drinke is ready"; to make the noise of banqueting offstage in *Macbeth;* to let

[147] "We may be sure that when Puck said warningly to Oberon: Fairie King attend and mark/I do hear the morning lark, it was the lark and no other sort of bird that was imitated."—W. J. Lawrence, *op. cit.*, 205.

[148] 1 *Henry IV*, II. i.

[149] W. J. Lawrence, *op. cit.*, 218; see also p. 199, where Lawrence says: ". . . if the prime conveyance of atmosphere was the poet's prerogative, none the less was it the producer's duty to prolong its vibrations. He had at his beck a rich comprehension of the science of the illusion of sounds, that subtler kind of realism which, when deftly brought into play, proves such a quickener of the imagination. As procured by him, it reinforced the pen-picture sketched in by the poet and gave it colour."

the storm-sounds penetrate into the farmhouse in *King Lear* every time the door opens.[150] One may wonder what they made of the sea-fight in *Antony and Cleopatra*.[151]

In this matter of "effects", it seems unlikely that the Book-Keeper would ignore the judgment of Shakespeare himself: his selective eye and ear for significant sight and sound (which we shall study further when we discuss his stagecraft in Chapter V) would be invaluable. It is perhaps not fanciful to imagine the poet constantly saying "don't overdo it". The gang would be inhuman if they did not err in this direction. The mechanicians of the theatre are easily intoxicated with the opportunities of their craft and want to use every trick in every play. Shakespeare, with the judgment of a great artist, could say that this is significant, that is irrelevant; this helps, that hinders. The Globe Playhouse, as Lawrence and Cranford Adams have shown, was fully equipped. Riches can be an embarrassment in this department. Probably Shakespeare lost the battle in the end: one cannot escape a suspicion that one reason why he was content to withdraw to Stratford was the fact that a new generation and a new fashion gave too much glory to the machinery: the masked displays of *Cymbeline* and *The Tempest* must have gone against the grain with the poet who knew that without such aids he had "bedymn'd The Noone-tide Sun". Perhaps the mishandling of the poetic drama began even thus early, the cleavage which Collier suggested when he wrote on a kindred theme: "The introduction of scenery . . . gives the date to the commencement of the decline of dramatic poetry." [152]

(vii) Plotting Entries

Now we are ready for the Book-Keeper to begin putting his actors on to this stage. If the problem of scene-rotation is satisfactorily solved, the plotting of the entries usually follows as an automatic corollary. It becomes simple because of the limited possibilities of entry on the Globe ground-plan. Disregard for the moment the upper stages and the "freak" entries of trap in floor and ceiling; the main action of any play takes place on the Platform with or without the addition of the Study. The possible entries therefore are: (without the Study) the two doors R and L, and through the centre of the Study curtain; (with the Study) the two doors, the sides of the Study R and L, and—if visible (neither, for instance, would be seen in the

[150] *King Lear*, III. vi. [151] *Antony and Cleopatra*, III. viii. 10.
[152] Collier, *English Dramatic Poetry*, Vol. III, 170 (Second Edition).

throne-room)—the door or the alcove (hardly both) in the rear wall of the Study.[153]

This limited number of available entries, at first sight a drawback, proves in practice a great help in clarifying the story and is quite adequate to handle even so complicated an operation as the three-day battle of Actium in *Antony and Cleopatra;* indeed, a more complicated architecture which attempts to differentiate several directions serves merely to confuse. What does the Book-Keeper in fact do in this matter? With his scene-rotation already mapped out, he chooses a door for his first entry and the rest follow almost inevitably from that initial choice. The result will read like very plain common sense, but it is worth emphasising the simplicity because it makes for remarkable clarity in presenting a swift-moving story.

With only two main entries to the Platform, the third through the curtain being accessory, he will often be confronted with a purely mathematical elimination. The fact that one character or group of characters has gone out of one door, means that the next-comer will enter by the other—to avoid the appearance of their having met outside. For instance in Cranford Adams' reconstruction of *King Lear*, banished Kent goes out through "Door A", and France and Burgundy enter at "B".[154] To indicate that they come from elsewhere, Hamlet and Horatio will use the opposite door to Ophelia's funeral procession.[155] If at the beginning of a scene both R and L doors are preoccupied with entrance, then the scene before (if it is not on an upper stage) must end with the departure into the Study, whether the curtain is drawn or not. Simultaneous entry of two persons or groups, meeting each other, will probably use the two doors; and this is sometimes so marked in the text. In *Richard III*, II. iii, where modern editions print "enter two Citizens, meeting", the Folio has: *Enter one Citizen at one Doore, and another at the other.* So in III. vii of the same play: *Enter Richard and Buckingham at severall* (i.e. different) *Doores.* We have already noted the Fisher Quarto's description of the first appearance of Oberon and Titania.[156] The simplicity of the convention is well seen in *King John*, when the rival armies outside Angiers leave the Platform for a battle, and after an indecisive engagement (occupying thirty-four lines of dialogue) return *at severall doores* to continue their dispute.[157]

But it must be remembered that, as with the music-cues, so the directions for entry in the contemporary texts will not be complete; the Book-Keeper will not need to be reminded of ordinary stage

[153] See ground plan on p. 18, above.
[154] J. Cranford Adams, *The Original Staging of King Lear*, 316.
[155] *Hamlet*, V. i. 60, 239. [156] See above, p. 50. [157] *King John*, II. i. 334.

practice. Thus, as Cranford Adams points out,[158] we need no *exit* or *enter* when an actor passes from the Platform through a stage door into the Study. Conversely, directions beginning *Enter* do not necessarily imply motion. *Enter Brutus in his Orchard* is the Folio's instruction when Brutus is presumably discovered in the Study (furnished with a garden set).[159] We have a similar case in *All's Well That Ends Well: Enter one of the Frenchmen, with five or six other souldiers in ambush.*[160]

So far, all is fairly obvious common sense. Sometimes for a number of scenes one door becomes associated with one group of characters and the other with another. Thus in the prelude to Shrewsbury Field one door will be Hotspur's tent (perhaps with his pennant hoisted on the corresponding stage-post) and the other the King's. A critical point is the transit of Worcester and Vernon back to Hotspur from their embassy: I fancy they must enter through the Study curtains, and make the tour outside the posts towards Hotspur's "tent".[161] Similarly throughout the fourth act of *Henry V* (the sequence of Agincourt), it is possible for the French to monopolise one door and the English the other, until in Scene vi the Platform (and the battlefield) belongs to King Harry. Mountjoy, in Scene vii, will still use the French door, but thereafter both doors are at the disposal of the English.

Sometimes over a long period a sense of direction prevails, as was the custom of the Roman Comedy—where the entries "from the town", "from the harbour", and so on, were fixed by convention. It is particularly true, as we shall see, of the street sequences, but one can find other examples: for instance, the audience are much helped if in *Twelfth Night* the geography of Olivia's garden is made clear to them; if, that is to say, one door may be thought to lead from the house, and the other from the street.[162] But of course the run of the story sometimes makes it impossible to persevere with this arrangement. The sense of locality suggested by the furniture of the Study or by the words of the actors will sometimes dictate the position of an entry. Cranford Adams makes clear, for instance, that when the wall-and-gates set is in the Study in *King Lear* (II. ii), neither of the stage-doors is used by any actor purporting to enter the Castle but only by those approaching it from outside. This kind of illusion is quite naturally taken for granted by an audience. By a similar

[158] J. Cranford Adams, *The Globe Playhouse*, 145. [159] *Julius Caesar*, II. i.
[160] *All's Well That Ends Well*, IV. i. 1. [161] 1 *Henry IV*, V. ii.
[162] On a small scale, the geography of the Study in the carriers' scene (1 *Henry IV*, II. i) should be quite clear—the inn towards L, the stable R—and in the sequel of the highway robbery we should be clear which direction is up hill and which down hill.

reasoning in the "Farmhouse" scene which is confined to the Study, all entries are made through the one door in the rear wall, so as to give the impression that there is only one way out of the hut to the stormy heath outside.[163]

Modern scholars speak of a "law of re-entry" which Cranford Adams defines by an illustration from *King Lear*: "Kent enters as this scene opens (III. i), yet is presumed to be at some little distance from Gloucester's Castle, the place where he last appeared. To make this remove seem possible in a scheme of dramatic time, he was withdrawn ten or more lines (there twenty-two lines) before the close of Scene ix (the preceding scene)." [164] The practice so formulated is an intelligible one. But the law is not inviolate: Brutus seems to break it twice in the last act of *Julius Caesar*. His impulsive entry on the battlefield—"Ride, ride Messala" (V. ii)—follows immediately after his departure from the Platform at the end of the previous scene. I take it that the transition in thought is made partly by the *Alarum*, a prolonged one for the start of the battle, and possibly also by the drawing of the Study curtain to reveal the battlefield set. Later, too, when after seeing Cassius' dead body, he leaves the Platform to "try Fortune in a second fight" (V. iii), he reappears at once in the thick of the battle. Here too a loud and prolonged *Alarum* marks the transition of both time and place.

But the fact is that poets and actors often recognise when it is justifiable to break the laws and principles formulated from their own practice by critics and scholars: the measure of success is the consideration of what is plausible, what creates the illusion. Much of it turns out to be common sense—common theatrical sense, such as any producer of to-day would think of as his a b c. The difference between what the Chamberlain's Men did and what is commonly done now is the difference between simplicity and complication. Three points of entry for the Platform, the main arena, are enough and to spare for Shakespeare.

We may now examine the effective simplicity of Shakespeare's stagecraft by plotting the entries in the first two acts of *Julius Caesar*. The play opens, I take it, with distant shouting to indicate the progress of Caesar's triumph: this will not swell to its full volume until the entry of Caesar's procession, but its general direction is at once made clear if the clamour is made on the left-hand side of the Tiring-House. The handful of citizens, the "idle Creatures", therefore stream on to the Platform from the R door, running towards the noise; and perhaps the liveliest of them, the "Mender of bad soules",

[163] J. Cranford Adams, *The Original Staging of King Lear*, 325; *King Lear*, III. vi.
[164] J. Cranford Adams, *The Original Staging of King Lear*, 323.

will jump up on to the base of the left-hand Stage-Post. Flavius and Marullus follow them in by the R door, and when they have cowed their enthusiasm, send them skulking back through the same entrance. When the two tribunes part on their mission to "Disrobe the Images", Marullus goes by the R door "towards the Capitoll" and Flavius through the centre of the Study curtain, thus leaving the L door free for Caesar's entry.

The citizens, who have had time to travel round the back of the Tiring-House, reappear through L door, forming an avenue for the procession, which makes a circular tour in front of the Stage-Posts. After the encounter with the Soothsayer, they all proceed through the R door, leaving Brutus and Cassius alone on the Platform. The repeated *Flourish and Shout*, which so disturb Brutus, are of course made on the right-hand side of the Tiring-House, and the re-appearance of Caesar followed by the "chidden Traine" is through the R door: his second departure will therefore be by the L door. Casca, after his blunt description of Antony's offer of the crown and Caesar's swoon, follows out L, but Brutus naturally takes the other door when he parts from Cassius. Cassius, at the end of the scene, goes through the centre of the Study curtain.

We can be sure of this, because Scene iii opens with the meeting of Cicero and Casca, who need both doors: Casca, who has recently gone out L, will conveniently return by the same entry: so Cicero uses the R door, and leaves (at line forty) by the L door. Cassius' simultaneous and sudden appearance is therefore by the R door. At first calculation Cinna's direction appears not to matter, but if we work backwards from the end of the scene, we can argue thus: the *rendez-vous* is Pompey's porch, and thither Cassius may be presumed to have been heading when he first appeared on the R; the L door therefore leads (for the moment) to Pompey's porch, and so Cassius and Casca will go out L at the end of the scene; but Cinna is sent on a job by Cassius which takes him first in a contrary direction; thus we may presume that he has entered by the L door, coming from Pompey's porch, but that he leaves by the R door to "bestow those Papers" at Cassius' bidding.

Actus Secundus begins: *Enter Brutus in his Orchard*. The Study is revealed for the first time in the play, and contains a garden-setting. The geography of the Study must be established and kept con-sistently: at line 60 Brutus says "Go to the Gate, some body knocks", and Lucius takes nine lines of Brutus' deliberate soliloquy to get there and back; it is therefore plain that the "Gate" is out of sight, not visible in the Study; we must choose a direction—let us say, Study R—for the gate, and the other—Study L—will thus lead

towards the house. This decision made, the scene plots itself. Lucius comes and goes by Study L until line 60, when he will take the other way. The conspirators enter by Study R and leave by the same course. It is worth suggesting in parenthesis that at line 110, when Casca tells us that "the high East Stands as the Capitoll, directly heere", he should point his sword towards the R of the Platform, a direction which already in the opening scene of the play has become associated with "the Capitoll". Portia's entry and departure are Study L, from the house and back again, and when the knocking at the gate disturbs her talk with Brutus, Lucius slips across the Study from L to R and brings back Ligarius from Study R. At Brutus' "Boy, stand aside," the inquisitive Lucius will reluctantly return into the house, and at the end of the scene Brutus will be leading Ligarius towards Study R, as the curtains are once more pulled across the orchard-set.

We now have the bare Platform again, with its entries by the two doors and the centre of the curtain. *Thunder & Lightning. Enter Julius Caesar in his Night-gowne.* He will take the centre entry: the Servant uses the L door, which we may associate with the domestic quarters of the house; Calpurnia naturally follows her lord through the curtain. Decius and all the rest of Caesar's visitors use the only other available entry, the R door; and at the end of the scene, when Caesar bids them "go in, and taste some wine", the whole party goes through the Study curtains.

No sooner are they gone than Artemidorus crosses the Platform from L door to R: it is plain from his words that he is in the street, and therefore when Portia and Lucius dart out of the centre of the Study curtains, they too may be understood to be in the street. Our attention is drawn throughout the breathless agitation of this little scene to the direction of the Capitoll. Lucius, bewildered by his mistress's incoherence, says: "Madam, what should I do? Run to the Capitoll, and nothing else?" Portia hears a "bussling Rumor like a Fray, And the winde brings it from the Capitoll". The Soothsayer, who wants to confront Caesar, goes to take his stand "To see him passe on to the Capitoll." The Book-Keeper will, I fancy, direct his players to follow the suggestion already established by Flavius and by Casca, that the Capitoll lies to the right-hand side of the Platform. The Soothsayer will go from L to R, and at the end of the scene, when Portia, saying "I must go in", retreats back into the Study curtains, Lucius will run off by the R door. Then we are all ready to expect the entry of Caesar's formal procession by the L door as he approaches the Capitoll.

We shall have cause later in the argument to return to the scene

of Caesar's murder. For the moment, it is, I hope, established that on the simple ground-plan of this playhouse the plotting of entries can be decided by a process of logical reasoning; and that the clarity of the narrative and the dramatic emphasis are sharpened in focus rather than blurred by this very simplicity.

(viii) Street Sequences

Street scenes are common in Shakespeare as in other Elizabethan dramatists and their audiences would be quick to recognise the everyday geography of Jack Cade's campaign through London— London-Stone, the Savoy and the Inns of Court, up Fish Street, down St. Magnus' Corner—and not slower to imagine the setting of the mob-scenes in *Julius Caesar* and *Coriolanus*. In such sequences where the emphasis is mostly on the mob itself, the architecture of the playhouse has no more importance than to differentiate by use of the Tarras the nobles from the rabble. Thus Lord Scales is seen . . . *upon the Tower walking;* and again King Henry appears *on the Tarras*, locality unspecified, to receive the submission of the *Multitudes with Halters about their Neckes*.[165]

But it is natural that several of the plays should make literal use of the visible shape of the Tiring-House, which has on either side of the curtained inner stages the recognisable façade of an Elizabethan town house—a street-door with knocker, and two doorposts supporting an overhanging bay-window.[166] Either of these doors can—with the readiness of the Elizabethan playwrights, noted above, to accept the features of their stage—become for the moment the focus of a scene. For instance, in *Richard III*, when Lord Stanley sends a midnight warning to Lord Hastings, we read: *Enter a Messenger to the Doore of Hastings:* and the envoy uses the knocker to rouse Hastings from his bed.[167] This direction is the opening of a new scene, but the doorway can rise up before our eyes in a flash while a scene is in progress. An interesting example of this process is the opening scene of *Othello* where, after a deliberately unlocalised start, we are suddenly told "Heere is her Fathers house",[168] and Brabantio appears *Above*, in the Window-Stage over the door. The effect is as if Iago and Roderigo have been walking along the street and opportunely find themselves outside the particular house. It is Roderigo who notices the house, but Iago is the opportunist, Iago has led him there

[165] 2 *Henry VI*, IV. v. 1; IV. ix.
[167] *Richard III*, III. ii. 1.

[166] See above, pp. 20 ff.
[168] *Othello*, I. i. 74.

as if by accident; or is it his creator, Shakespeare, who has found the door and window opportune for his dramatic purpose?

Sometimes the illusion of a street outside a specific house is kept up for some time. Intermittently it will "not exist", but it will not be anywhere else meanwhile. *The Comedy of Errors* is a notable case where, except when we see the ladies Adriana and Luciana at home (probably in the Chamber), the whole play takes place in the streets of Ephesus. For much of the play—but of course intermittently— one of the stage-doors is the front door of Antipholus of Ephesus (the action including a prolonged altercation through the wicket): later in the play the other door is identified as the Abbey. It is usual in such cases that when one door is identified, the other disappears, and it would be possible in the course of a long scene to seem to move from one house to another at a distance. At other times we are just in the street with no special local definition.[169]

In *The Taming of the Shrew* the two doors are likewise allotted to the house of Hortensio and the lodging of Lucentio; while some- times we penetrate to the interior of Baptista's and Petruchio's houses by opening the Study.

We have already seen how, in *The Merchant of Venice*, where for a long sequence (punctuated by the Belmont scenes which are differentiated by the drawing of the Study curtain) the action of the play takes place in the street, one door is identified with Shylock's house, and Jessica throws her casket from the window above this door: in the same scene opportunist's use is made of the Tarras which, as Cranford Adams tells us, "resembled a feature common to many London house-fronts, namely the 'penthouse', a sloping, tiled ledge extending over shopfronts to protect the counters from the rain".[170]

In *The Merry Wives of Windsor*, if the left-hand door becomes at first associated with Page's house (in I. i and ii, and again in II. i), then by the time the story reaches Ford's house for the buck-basket

[169] It should be mentioned here that W. W. Greg declares (*The Editorial Problem in Shakespeare*, 140) that the directions in the Folio text of *The Comedy of Errors*, "*from the Courtizans*", "*from the Bay*", "*to the Priorie*", "*to the Abbesse*" indicated an unusual disposition of the stage such as would not be practicable in the public theatre. I think that these directions are of a type which tells the story rather than indicates the geographical features of the stage: for instance, Antipholus E., on p. 91, tells us that he means to dine with "a wench of excellent discourse" (III. i. 109); his next appearance (IV. i. 14) is therefore quite naturally marked "*from the Courtizans*". Antipholus S. bids his Dromio "hie thee presently, post to the rode" (III. ii. 154)—i.e. the road-stead. Dromio's next entry (IV. i. 86) is "*from the Bay*". A similar narrative direction in the Folio is *Enter Angelo with the Chaine* (III. ii. 171). So, too, in 2 *Henry* VI, II. iii, *Enter the King . . . to banish the Duchesse*.

[170] J. Cranford Adams, *The Globe Playhouse*, 249.

scene (III. iii) we shall readily expect the R door to be Ford's front-door: by it Ford and his fellow searchers will approach the house, meeting the buck-basket in the very doorway. The search for Falstaff is conducted partly upstairs; Ford is heard speaking on the way down the staircase which connects the first and second levels of the Tiring-House. "I cannot finde him," he says, and Mrs. Page in the Study whispers to Mrs. Forde "Heard you that?" The search-party come out for a moment into the street again, when Evans says "If there be any pody in the house . . ." and then back into the house for the promised dinner at the end of the scene. We have here an example of the flexibility of the multiple stage by which we can see the actors pass from the street through the front-door into the house and even go upstairs. It is easy to conjure up a picture of this scene in progress at the Globe, with the Study set in the style of Anne Hathaway's Cottage or Mary Arden's house at Wilmcote.

To prove how this combination of street-exterior with domestic interior clarifies the dramatist's narrative (which is of course written for it), it will be worth following in close detail the sequence of Cressida's fetching from Troy. Act IV of *Troilus and Cressida* opens with a midnight encounter in the streets between Aeneas *at one doore with a Torch, at another Paris* conducting Diomedes, the Greek who has come to fetch Cressida, and Antenor, the Trojan who has been liberated in exchange for her. Aeneas goes off in advance of the rest (IV. i. 50) towards the house where Cressida is to be found: hitherto the Platform represents no more than the street; the doors are no more than entrances, and the sole need is that a sense of direction should be established. Aeneas has entered L (let us say), the others who have come for Cressida have entered R: L therefore is the direction towards Cressida's house, and both Aeneas and the rest of the party will go out L. As soon as the Platform is clear, Troilus and Cressida appear—probably in the Study; since they are certainly indoors, and Uncle Pandarus is to be called down ("He shall unbolt the Gates," IV. ii. 3). Pandarus appears (at line 20) through the permanent door in the Study, having just descended the Tiring-House stairs. Aeneas crosses the Platform from L to R in time to knock (line 35): thereby we take the right-hand stage-door to be Cressida's front-door. Cressida says to Troilus "I would not for halfe *Troy* have you seene here," and leads him back into her chamber—that is to say, they withdraw from the Study, perhaps through the Study door and up the staircase. Pandarus lets Aeneas in through the right-hand door, and they move directly into the Study, with no interruption in the dialogue. Troilus joins them there, and when he

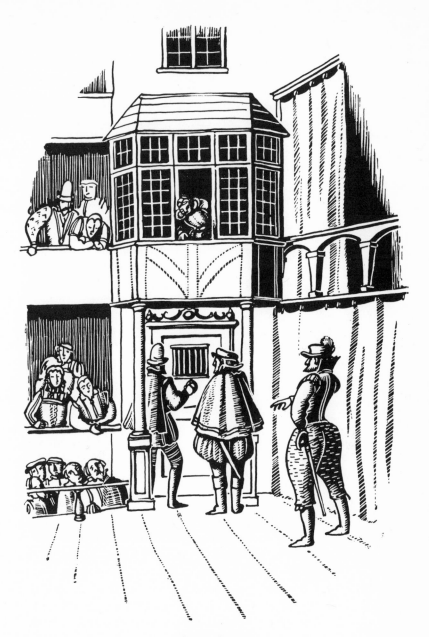

Street Scene

hears of the Greek mission, says hurriedly "I will goe meete them:
and my Lord *Aeneas*, We met by chance; you did not finde me here."
They go out into the street by the right-hand door, and make a tour
of the Platform, leaving it by the left-hand door. Meanwhile Cressida
rejoins Pandarus in the Study and hears from him the disastrous
news. Weeping and distracted, she rushes from the Study with the
words, "I will not goe from *Troy*." I think it likely that at this point
the curtains of the Study are closed: the visitors enter the Platform
by the left-hand door: "It is great morning," says Paris, "and the
houre prefixt Of her deliverie to this valiant Greeke Comes fast
upon." Troilus invites them all to "walke into her house", and seems
to precede the others through Cressida's door by no more than three
lines of dialogue. Nevertheless, when the Study curtains re-open and
disclose Pandarus counselling Cressida to "be moderate", it is nine
lines before Troilus joins them, and more than one hundred before
the rest of the party, after expostulations (*within*) from Aeneas and
Paris at the length of the lovers' parting, are allowed to appear in the
Study. When Troilus insists on accompanying Cressida and Dio-
medes "to the Port", they once again pass through the right-hand
door on to the Platform and across to the left-hand door. But
immediately after their departure, the battle-trumpet blows, the
narrative ceases to be domestic and intimate, and moves once more
on the public plane. This consideration, besides the technical need
for clearing the Platform for the crowded entry of Scene v, makes it
probable that the Study curtains close upon Aeneas' concluding
couplet (IV. iv. 148). The sequence of events—including night and
"great morning"—is quite clear to the audience, and it may be said
in parenthesis that the reconstruction in the mind's eye of such a
sequence suffers not at all from imagining a basis in costume and
furniture of contemporary style.

But it is not only in sustained sequences that the stage can be
thought of as a street: it is naturally the commonest of all trans-
formations, the quickest and most obvious assumption, that the stage
is what it seems; and as the examples in *Richard III* and *Othello* show,
the transformation can be made in a single line or speech or a
gesture of an actor: no miracles of stagecraft are needed for the poet
to evoke this familiar picture. But it is always ready to the poet's
hand when his story needs it. It is indeed an actually visible picture,
and the poet's task is often the opposite one, of making it disappear.
The fact that the house-façade is permanently before the eye makes
this task too a simpler one; through the very fact of familiarity it
becomes easy to look through the visible scene, to forget it and
ignore it.

hears of the Greek mission, says hurriedly "I will goe meete them:
and my Lord *Aeneas*, We met by chance; you did not finde me here."
They go out into the street by the right-hand door, and make a tour
of the Platform, leaving it by the left-hand door. Meanwhile Cressida
rejoins Pandarus in the Study and hears from him the disastrous
news. Weeping and distracted, she rushes from the Study with the
words, "I will not goe from *Troy*." I think it likely that at this point
the curtains of the Study are closed: the visitors enter the Platform
by the left-hand door: "It is great morning," says Paris, "and the
houre prefixt Of her deliverie to this valiant Greeke Comes fast
upon." Troilus invites them all to "walke into her house", and seems
to precede the others through Cressida's door by no more than three
lines of dialogue. Nevertheless, when the Study curtains re-open and
disclose Pandarus counselling Cressida to "be moderate", it is nine
lines before Troilus joins them, and more than one hundred before
the rest of the party, after expostulations (*within*) from Aeneas and
Paris at the length of the lovers' parting, are allowed to appear in the
Study. When Troilus insists on accompanying Cressida and Dio-
medes "to the Port", they once again pass through the right-hand
door on to the Platform and across to the left-hand door. But
immediately after their departure, the battle-trumpet blows, the
narrative ceases to be domestic and intimate, and moves once more
on the public plane. This consideration, besides the technical need
for clearing the Platform for the crowded entry of Scene v, makes it
probable that the Study curtains close upon Aeneas' concluding
couplet (IV. iv. 148). The sequence of events—including night and
"great morning"—is quite clear to the audience, and it may be said
in parenthesis that the reconstruction in the mind's eye of such a
sequence suffers not at all from imagining a basis in costume and
furniture of contemporary style.

But it is not only in sustained sequences that the stage can be
thought of as a street: it is naturally the commonest of all trans-
formations, the quickest and most obvious assumption, that the stage
is what it seems; and as the examples in *Richard III* and *Othello* show,
the transformation can be made in a single line or speech or a
gesture of an actor: no miracles of stagecraft are needed for the poet
to evoke this familiar picture. But it is always ready to the poet's
hand when his story needs it. It is indeed an actually visible picture,
and the poet's task is often the opposite one, of making it disappear.
The fact that the house-façade is permanently before the eye makes
this task too a simpler one; through the very fact of familiarity it
becomes easy to look through the visible scene, to forget it and
ignore it.

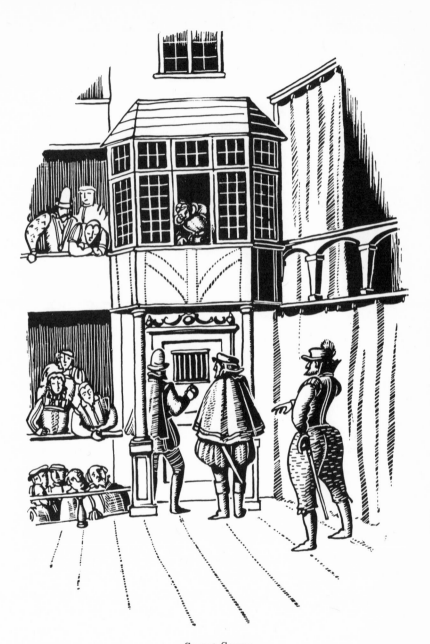

Street Scene

(ix) Battle Sequences

Shakespeare in approaching the theme of Agincourt chooses to be in a mood of anticipatory apology: but just as we learn to take his words about the new playhouse with a pinch of salt, so we must not think him too abject about his "foure or five most vile and ragged foyles". His imagined warfare finds substantial expression in the words of Othello:

> Farewell the plumed Troopes, and the bigge Warres,
> That makes Ambition, Vertue! Oh farewell;
> Farewell the neighing Steed, and the shrill Trumpe,
> The Spirit-stirring Drum, th' Eare-piercing Fife,
> The Royall Banner, and all Qualitie,
> Pride, Pompe, and Circumstance of glorious Warre:
> And O you mortall Engines, whose rude throates
> Th' immortall Joves dread Clamours, counterfet,
> Farewell: *Othello's* Occupation's gone.[171]

To this we may add the tang of saltpetre in Hotspur's sharp objective picture of the aftermath of Holmedon,[172] and Helena's terror lest her Bertram should be "the marke of smoakie Muskets" when she prays to the bullets:

> O you leaden messengers,
> That ride upon the violent speede of fire,
> Fly with false ayme, move the still-peering aire
> That sings with piercing, do not touch my Lord.[173]

Battle-scenes were popular in the Elizabethan theatre: that is obvious from the number of them, and from the fact that so many plays, including some of the deep-felt tragedies—*Julius Caesar* and *Macbeth*—end with a prolonged sequence on the battlefield. The Bastard Faulconbridge, that pattern of military glory, speaks of the shilly-shallying citizens of Angiers ". . . As in a Theater, whence they gape and point At your industrious Scenes and acts of death",[174] and we can imagine the excitement of the groundlings in the pageantry and rhetoric and athletic skill of those battles.

It may be said at once that the Globe Platform, spacious for manœuvring, centrally placed like a boxing-ring, and by the very reason of its position easy to make seem full, was ideal for presenting these battle-pieces. The indistinct muddle of the picture-stage, with everybody getting in everybody else's way and a general

[171] *Othello*, III. iii. 350 ff.
[173] *All's Well That Ends Well*, III. ii. 111 ff.
[172] 1 *Henry IV*. I. iii. 29 ff.
[174] *King John*, II. i. 375 f.

Stand ho, speake the word along

uncertainty among the audience as to who is who and which side is which, makes many a finale a sad anti-climax. Yet some of these Shakespearian battles are so well written that there is no reason for confusion; and in its proper setting the play often ends as it should, with a splendour of finality. Notable examples of such success are to be found in the last acts of 1 *Henry IV*, *Julius Caesar* and *Macbeth*, and to appreciate their quality it is worth spending a little time in examining elementary models of the same genre.

As we have seen, both in the preliminaries and the action itself, one stage-door will probably become associated with the forces of one side and the other with the other: but it will obviously not always be possible to keep this distinction hard and fast. Shakespeare apologises for his "foure or five" at Agincourt, and it will be readily understood that considerations of manpower and of wardrobe will confine the armies to a minimum strength: one would say the minimum to avoid the ludicrous, but the phrase is too negative; there would often be a positive splendour in the "plumed troop"— the best that the gang of hired men and the wardrobe-master could do. It is easy enough when Brutus and Cassius lead their armies on from open doors to parley in mid-stage, to use no more than three soldiers apiece—banner, drum and trumpet—and an officer or two:

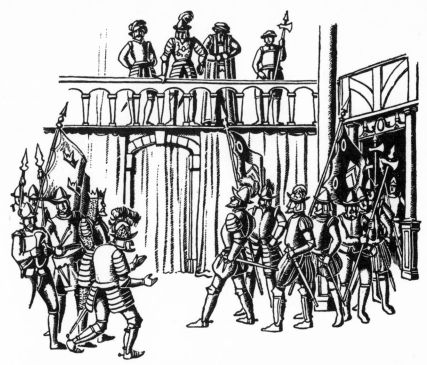

Loe, where George of Clarence sweepes along

the cries of "Stand, stand, stand" echoing at various distances off-stage will multiply a hundredfold. But when the forces have to leave their base at the Door and march across the Platform, more will be needed.

There is, in 3 *Henry VI*,[175] an elaborate scene in the course of which no fewer than five "armies" appear on the Platform. Warwick the King-Maker stands with the Mayor *upon the Walls* of Coventry (on the Tarras), awaiting reinforcements: he is especially anxious that the Duke of Clarence, lately become his son-in-law, should arrive in time. His drum is expected from the direction of Southam (let us say from the actors' left). Instead, a drum is heard from the right, and through the right-hand door march King Edward, Gloucester, *and Souldiers.* Edward and Gloucester are having the better of the ensuing parley, when from the left-hand door *Enter Oxford, with Drumme and Colours.* The newcomers are immediately admitted into the city: that is to say, they march through the gates, set in the Study alcove. Gloucester urges his brother to follow, with

[175] 3 *Henry VI,* V. i.

a characteristically impulsive cry of "The Gates are open, let us enter too." But Edward counsels caution: "Stand we in good array: for they no doubt Will issue out againe, and bid us battaile." Two more armies arrive from the left, led by Montague and Somerset, and likewise march through the gates. Then as the climax of the scene, "loe, where *George* of Clarence sweepes along, Of force enough to bid his Brother Battaile". The perjured Clarence takes the red rose from his hat and throws it at his father-in-law: then he joins forces with his brothers. The scene ends with mutual defiance between the Tarras and the Platform: "I will away," says Warwick, "towards Barnet presently, And bid thee Battaile, *Edward*, if thou dar'st." And the King retorts: "Yes, *Warwicke*, *Edward* dares, and leads the way," and he and his reinforced army march off by the left door to Barnet. If each of the armies is no more than eight men, such a scene will nevertheless tax the resources of the company to the full, and no doubt some discreet doubling, with quick change of helmets and weapons will be needed to keep the "conveyor belt" of soldiery supplied.

It will be noticed that there is nothing awkward on this Platform about the convention of the cross-stage wrangle. With Plantagenet's head fixed on the battlements of York, Lancastrians and Yorkists hurl invective at each other for nearly one hundred lines of dialogue.[176] Moreover, it is possible for superior defiance to leave the stage to their enemies in such circumstances. When the Triumvirs thus confront the conspirators at Philippi, at first there seems to be danger of an immediate clash. "Stirre not untill the Signall" commands Octavius: but after nearly forty lines of mutual recrimination he cries, "Defiance Traitors, hurle we in your teeth. If you dare fight to day, come to the Field." [177]

The procedure for assault of a town is simply exemplified in a passage of 1 *Henry VI*. At Orleans, Talbot, Bedford and Burgundy enter *with scaling Ladders*. "Ascend brave *Talbot*," says Bedford, "we will follow thee." "Not altogether," advises Talbot: "Better farre I guesse, That we do make our entrance severall wayes." "Agreed," says Bedford: "Ile to yond corner." "And I to this," says Burgundy. "Yond corner" and "this" are perhaps the two stage-doors, so that Talbot shall be given a clear run at the Tarras. The English scale the walls, and almost at once *The French leape ore the walles in their shirts*, no doubt amid the derisive cheers of the whole playhouse.[178] The classic instance is, of course, at the assault upon Harfleur which

[176] 3 *Henry VI*, II. ii. 81 ff.
[177] *Julius Caesar*, V. i. 21 ff.
[178] 1 *Henry VI*, II. i.

on the picture-stage can hardly reach perfection.[179] The movement is initiated by the Chorus and it seems likely that the Platform begins to fill with the attacking force while his words are creating the picture:

> Worke, worke your Thoughts, and therein see a Siege
> Behold the Ordenance on their Carriages,
> With fatall mouthes gaping on girded Harflew.

Although the "Ordenance" would no doubt be safer unseen, there might well be harquebusiers giving covering fire from beside the Stage-Posts.[180] The soldiers of the attacking force, engaged with

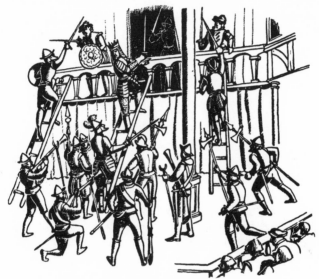

God for Harry, England and S. George

scaling ladders, throw themselves down on the Platform exhausted and discomfited, one perhaps binding a superficial wound with his torn shirt, another mending a broken pike. The figure of the Chorus, moving among them, tells us that

> . . . the nimble Gunner
> With Lynstock now the divellish Cannon touches.

With a deafening roar and a blinding flash and the stifling smell of gunpowder the *Chambers goe off* in the Huts.

> And downe goes all before them . . .

[179] *Henry V*, III. Chorus and Scenes i and ii.

[180] A contemporary picture of The Assault, reproduced in G. B. Harrison's *Elijabethan Journal* (for 1591-4) opposite p. 36, gives a sort of diagrammatic version of the orthodox process of attack.

that is to say, the curtains of the Chamber are parted to make a gap
—the breach in the wall—and some agitated Frenchmen appear
through it on the Tarras. At this juncture King Harry and his peers
enter the Platform and he rallies his despondent troops with the
famous cry:

> Once more unto the Breach,
> Deare friends, once more.

During his exhortation the soldiers on the Platform recover their
morale: they "Stiffen the sinewes, summon up the blood, Disguise
faire Nature with hard-favour'd Rage"; they "stand like Grey-
hounds in the slips, Straying [*read* Strayning] upon the Start"; and
when with the cry of "God for *Harry*, England and S. *George*" and a
further volley from the Chambers in the Huts, they swarm up the
ladders on to the Tarras after their leaders—then what groundling
in the Yard will be so mean and base as not to give them a rousing
cheer? Nothing—be it said in parenthesis—is more characteristically
Shakespearian than the sequel to this exhilarating scene. Bardolph
and his cronies are left at the heels of the assault, cheering with the
best of us, but all agreed that "the Knocks are too hot" to follow up
the ladders. "I would give all my fame," says their attendant Boy,
"for a Pot of Ale, and Safetie."

We may notice certain recurrent devices by which Shakespeare
gives dramatic interest to the pitched battle itself: the mere instruc-
tion to his hired men to indulge in *Excursions* is a trick that soon
wears thin and that has in itself little tragic or dramatic force.

Sometimes, to stir the interest of the audience the poet gives us a
high-sounding list of names of the principal combatants—a kind of
"match-card", sold to the spectators before the first ball of the Test
Match is bowled. The brief scene between the Archbishop of York
and Sir Michell [181] which leads on to the politics of 2 *Henry IV* has
little dramatic point in its position in the first part except as such a
"match-card" for the Battle of Shrewsbury:

> To morrow, good Sir *Michell*, is a day,
> Wherein the fortune of ten thousand men
> Must bide the touch—

and we are told of Northumberland's sickness and the absence of
Glendower and Mortimer: after which the principal figures on both
sides are announced. So, too, before Agincourt, the French King
gives us a very full list of his peers, calling upon them to "high
[*read* hie] to the field".

[181] 1 *Henry IV*, IV. iv.

> *Charles Delabreth,* High Constable of France,
> You Dukes of *Orleance, Burbon,* and of *Berry,*
> *Alanson, Brabant, Bar,* and *Burgonie,*
> *Jaques Chattillion, Rambures, Vaudemont,*
> *Beaumont, Grand Pree, Roussi,* and *Faulconbridge,*
> *Loys, Lestrale, Bouciquall,* and *Charaloyes,*
> High Dukes, great Princes, Barons, Lords, and Kings—[182]

The English team is, with its characteristic conciseness, no less moving:

> *Harry* the King, *Bedford* and *Exeter,*
> *Warwick* and *Talbot, Salisbury* and *Gloucester.*[183]

A corollary of the practice is to be seen in the casualty lists after the battle; the French no less imposing than before, the English by a miraculous contrast which the King duly ascribes to God,

> *Edward* the Duke of Yorke, the Earle of Suffolke,
> Sir *Richard Ketly, Davy Gam* Esquire.[184]

Often after parley and ultimatum the commanders will address their troops. Before Bosworth Field both Richmond and Richard deliver a speech, the former's described in the Folio as *His Oration to his Souldiers.*[185] The French King's speech in *Henry V,* quoted above, is such another. So too Hotspur, although he protests "I professe not talking", yet stirs his followers with the exhortation: "Let each man do his best." He ends his brief harangue by crying aloud:

> Sound all the lofty Instruments of Warre,
> And by that Musicke, let us all imbrace:
> For heaven to earth, some of us never shall
> A second time do such a curtesie.

And the moment of high chivalrous ceremony is specified in the Folio direction: *They embrace, the Trumpets sound.*[186] A similar musical stirring of the blood is created by Macduff's prelude:

> Make all our Trumpets speak, give them all breath
> Those clamorous Harbingers of Blood, & Death.[187]

Then the engagement will begin with *Alarums:* the opening *alarum* of battle might well sometimes take the form so vividly described by Faulconbridge.[188]

[182] *Henry V,* III. v. 40 ff.
[183] *Henry V,* IV. iii. 53 f. So in *Troilus and Cressida,* V. v. 6 ff., Agamemnon recites a somewhat perfunctory "match-card" of the battle already in progress.
[184] *Henry V,* IV. viii. 85 ff. [185] *Richard III,* V. iii. 238 ff., 315 ff.
[186] 1 *Henry IV,* V. ii. 91 ff. [187] *Macbeth,* V. vi. 9 f.
[188] See above, p. 65.

The normal procedure of battle itself is exemplified at St. Albans [189]; apology for the absence of horses; two single combats; one set of *Excursions; Alarum a farre off* while the non-combatants—the *King, Queene and others*—are on the Platform; one notices as characteristic the trumpet's *Retreat* to mark the end of the battle and the post-mortem description to complete it. At Wakefield [190] there is *A March afarre off*, followed eight lines later by an *Alarum :* then York goes to the battle: the child Rutland is murdered by Clifford. Then *Alarum. Enter Richard, Duke of Yorke*. York describes the course of the battle. *A*

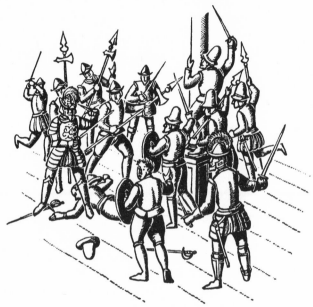

Alarums, Excursions

short Alarum within : and he cannot escape from his pursuers. Bosworth Field [191] is the simplest example of the normal. *Drum afarre off* interrupts Richard's address to the troops. *Alarum, excursions.* Catesby describes the King's prowess. *Alarums. Enter Richard.* "A Horse, a Horse, my Kingdome for a Horse" (the absence of horses turned to dramatic advantage). *Alarum* again. The fight between the two principals. *Retreat and Flourish* for the new King.

Two battles in *King John* make it clear that Shakespeare's method is to select his emphatic incidents and build his battles round them. The fine rhetorical scene in which the Papal Legate Pandulph comes

[189] *2 Henry VI*, V. ii. and iii.
[190] *3 Henry VI*, I. ii., iii., and iv. [191] *Richard III*, V. iii. and iv.

to the help of Constance in breaking up the newly made alliance between King John and King Philip ends with a great dramatic *crescendo* of inflamed tempers. "To Arms let's hie," cries King John. But the battle itself is over in ten lines, sandwiched between two sets of *Alarums, Excursions*, the second followed by the trumpet signal for *Retreat*.[192] The incidents are the decapitation of Austria and the capture of young Arthur—the first perfunctory, the second developed in the sequel. In the fifth act of the play the battle is more prolonged, but again one notices how the poet selects the salient incidents and builds round them: in this case there are three main points to be made—first, King John's sickness and retirement to Swinsted, secondly Melun's dying confession which stirs the English "Revolts" to return to their own side, and thirdly the Dolphin's reception of the news of their falling off and of the wreck of his supply on the Goodwin Sands.[193] Shakespeare sticks to these points and does not dally by the way; the insistent relevance of his dramatic narrative is a characteristic which we shall study further in Chapter V.

It is possible in some battles to trace a sort of Homeric pattern in the incidents. A hero is singled out for his ἀριστεία—his brief hour of triumph—and his defeat and death follow hard upon it: the weary struggle of the Wars of the Roses is thus given a perceptible rhythm in 2 and 3 *Henry VI*. Or a minor contest precedes the clash of mighty opposites: as at Shrewsbury, Blunt is killed by Douglas before Prince Hal and Hotspur meet. Sometimes the hero who is ultimately defeated is allowed to show his prowess in the earlier combat, just as Homer lets Hector kill Patroclus before he is himself killed by Achilles; so Macbeth (as we shall see in Chapter VI) must have young Siward for his victim before he is confronted by Macduff. It is perhaps true to say that the most obviously successful battle-pieces are built round personalities. Shrewsbury Field, the climax of 1 *Henry IV*, is a notable *tour-de-force*. The preliminaries, as we have seen, give some geographical clarity to the narrative: it may be that one Stage-Post bears the pennant of *Esperance*, and the other the Royal pennant. Prefaced by the "match-card", the oration to the troops, and an elaborate and moving ceremonial fanfare, the battle itself is brilliantly enriched—first by Blunt's masquerade and the insatiate Douglas' cry, "Ile murder all his Wardrobe peece by peece, Untill I meet the King"; then by the Prince's rescue of his father, and by the suspense so well sustained, as we wonder if the madcap Hal will rise to the great occasion; by Falstaff's ironical mumbling commentary; by the master-stroke of his "fight" with

[192] *King John*, III. i. and ii. [193] *King John*, V. iii., iv., and v.

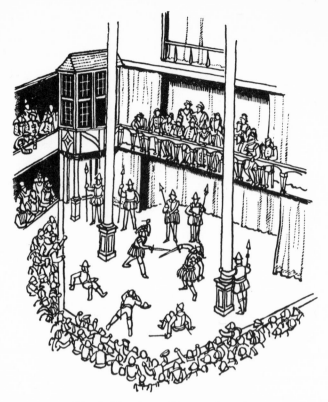

Single Combat—*They are in action*

Douglas, simultaneous with the clash of Hal and Hotspur, so that while we are still laughing at Falstaff's swift demise, the inevitable death of Hotspur shocks us with all the sudden dismay of the unexpected; and again by the vastly funny anti-climax of Falstaff's resurrection and his last triumphant trick of "killing" Percy.

Agincourt is of a wholly different kind. We have, it is true, some of the familiar features; the parley, the "match-card", and the oration to the troops. We have also an unique masterpiece in the prolonged night-prelude: first the arrogant and irritable Frenchmen impatiently wondering "Will it never be Morning?"; then the atmospheric painting by the Chorus of the night between the two camps; then the series of conversations in the English camp, culminating in Harry's soliloquy "Upon the King" and his prayer to the God of battles; then the stirring reveilles in both camps, the Crispin speech, the final interview with Mountjoy; and all for—what? All we are shown of the battle itself is the ludicrous encounter

between Pistol and Mounsieur le Fer. The heroic tone of the prelude is picked up again when the battle is over. Shakespeare seems for once to have been at a loss for a point of emphasis: his interest wanders rather than flags: he is intrigued by the inner man in King Henry, which emerges sometimes in Prince Hal, and which the poet is trying to reveal in the conversation with the three common soldiers and in the subsequent soliloquy. He is also, perhaps, interested in the army as a whole—all ranks—rather than in personalities. There is no chance of a Homeric pattern here: York's death, for instance, is presented to us (very movingly) in narrative, not in action.

By the time he wrote *Julius Caesar*, Shakespeare had begun to resolve his problem of projecting the inner man dramatically in his narrative. As we approach the climax at Philippi, the "match-card", though not actually proclaimed, is full of clear-cut characters round which the battle can be shaped. The incidents too are ready to hand in Plutarch. The geographical clue is given by Shakespeare at the very beginning of Act V:

> *Ant. Octavius*, leade your Battaile softly on
> Upon the left hand of the even Field.
> *Octa.* Upon the right hand I, keepe thou the left.
> *Ant.* Why do you crosse me in this exigent.
> *Octa.* I do not crosse you: but I will do so.

Octavius, of course, has his way. If the producer has chosen to have them enter from the right-hand side of the Tiring-House, the upshot of this little dispute will be that Octavius' wing of the army (the right wing) will attack the left-hand side of the Tiring-House, and Antony's the right-hand side. This is in fact the plan which is simply followed in the sequel. We learn later that the disposition of forces is: Octavius *v.* Brutus, Antony *v.* Cassius. In the former of these matches Brutus wins the opening round, in the latter Cassius is quickly defeated. Let us pick up the story at the moment when Octavius and Antony hurl defiance at the conspirators. "Why now blow winde," cries Cassius, "swell Billow, And swimme Barke: The Storme is up, and all is on the hazard" (V. i. 676), and, after expressing his mood of superstitious disquiet, takes his affecting leave of Brutus:

> For ever, and for ever, farewell *Brutus*:
> If we do meete againe, wee'l smile indeede;
> If not, 'tis true, this parting was well made.

No sooner have they left the Platform (by, let us say, the L door) than the *Alarum* for battle begins. I think that at the same moment

the Study is opened to reveal a battlefield-set—something simple, bleak and forlorn, with "this Rocke" visible for Brutus' "poore remaines of friends" in Scene v. The pulling of the curtain, as we have seen,[194] helps to save Brutus from violating the "law of re-entry": he returns immediately by the L door in a strongly contrasted mood of optimism, and sends instructions by Messala to Cassius' "Legions, on the other side". His words are interrupted by a *Lowd Alarum*, but if we do not hear them and take in their sense, Shakespeare's dramatisation of the whole battle will go for nothing: Brutus' misguided instructions are:

> Let them set on at once: for I perceive
> But cold demeanor in *Octavio's* wing:
> And sodaine push gives them the overthrow:
> Ride, ride *Messala*, let them all come downe.

Messala goes out by Study R towards Cassius, and Brutus returns as he came by the L door. The *Alarums* swell again, and Cassius comes in with Titinius by the R door, already in despair at Brutus' mistake: Titinius makes the point clear, and his every word must be heard throughout the theatre:

> O *Cassius, Brutus* gave the word too early,
> Who having some advantage on *Octavius*,
> Tooke it too eagerly: his Soldiers fell to spoyle,
> Whil'st we by *Antony* are all inclos'd.

Pindarus, Cassius' Parthian slave, comes to bring his master news of the burning of his tents: these may be taken to be in roughly the same direction from which Cassius made his entry. Let Pindarus therefore come in by Study R. Titinius is sent to investigate "yonder Troopes" who, in the tragic sequel, prove to be friend, not enemy: so he departs on his errand by the L door, towards Brutus. Pindarus is bidden "get higher on that hill", and Cassius' two and a half lines of melancholy brooding give him time to mount to the Tarras, whence he can "regard *Titinius*" by looking out towards the left. The *Showt* which Cassius misinterprets is also from the same quarter. *Enter Pindarus*, says the Folio, and again the Parthian is given time to come down from the Tarras. After he has killed Cassius, and left his body at the very front of the Platform, he takes to his heels, "Farre from this Country", and will therefore do well to choose the Study L, away from his previous entry. He cannot take the L door, for that is occupied by the reappearance of Titinius with Messala. The dialogue runs thus:

[194] See above, p. 75.

> *Messa.* It is but change, *Titinius*: for *Octavius*
> Is overthrowne by Noble *Brutus* power,
> As *Cassius* Legions are by *Antony*.
> *Titin.* These tydings will well comfort *Cassius*.
> *Messa.* Where did you leave him.
> *Titin.* All disconsolate,
> With *Pindarus* his Bondman, on this Hill.
> *Messa.* Is not that he that lyes upon the ground?
> *Titin.* He lies not like the Living. O my heart!
> *Messa.* Is not that hee?
> *Titin.* No, this was he *Messala*,
> But *Cassius* is no more.

The producer of *Julius Caesar* should read and re-read Granville-Barker's exposition of this wonderful fifth act. Of this passage he writes: "The stagecraft of this entrance, as of others like it, belongs, we must remember, to the Elizabethan theatre, with its doors at the back, and its distance for an actor to advance, attention full on him. Entrance from the wing of a conventional scenic stage will be quite another matter. . . . Stage direction is embodied in dialogue. We have the decelerated arrival telling of relief from strain, the glance around the seemingly empty place; then the sudden swift single-syllabled line and its repetition, Titinius' dart forward, Messala's graver question, the dire finality of the answer." [195]

We shall return, on a later page,[196] to the atmospheric creation of Titinius' ensuing words, as he kneels beside the fallen Cassius. Meanwhile we are concerned chiefly with the plotting of the battle. Messala goes to meet Brutus by Study L, and returns with him and his companions by the same entry, only to find that Titinius has followed Cassius in taking "a Romans part". The approach of Brutus to the pair of dead bodies in the front of the Platform is similar to the former discovery by Titinius and Messala. The *Low Alarums* of distant battle are heard on the right-hand side of the Tiring-House as Brutus kneels beside his friend: at the end of the scene (V. iii) he calls upon Lucilius and young Cato: "Let us to the Field," and they go off Study R toward the battle, while the dead bodies are borne off Study L. It will be noticed that all through the act so far the left-hand side of the Tiring-House has been associated with Brutus' base, and that he has been successful against Octavius. Cassius' base has been to the R, and has been the centre of defeat and despondency: the danger-point is now aptly towards the R. The battle surges on to the Platform for the first time, and all the

[195] H. Granville-Barker, *Prefaces to Shakespeare* (First Series), 116 f.
[196] See below, p. 216.

combatants therefore enter from the R door or from Study R. Brutus and young Cato are engaged in a fighting retreat: their backs are to Brutus' base, the left-hand side of the Tiring-House. Brutus drives some of the enemy off by Study R, but meanwhile young Cato (a kind of Patroclus in this battle) is killed on the Platform: Lucilius stoops over his body in a lull of the fighting, and is surprised by some of the enemy and made prisoner: his pretence of being Brutus repeats, with variation, the masquerade of Sir Walter Blunt at Shrewsbury. Antony will presumably make his entry from the R door or from Study R; his departure will certainly be towards the left—probably Study L—for he is making for Octavius' tent, and we may now assume that Brutus' base is captured. It will be seen that it has been quite easy throughout to preserve the general notion of Antony beating Cassius on the right-hand side, and Brutus having a momentary advantage over Octavius on the left. Now at this point the right-hand side of the Tiring-House is the focus of the victory of the triumvirs. Brutus and his "poore remaines of friends" struggle in from Study R, and "this Rocke" is part of the battlefield-set in the Study.

The beauty of this last scene has been eloquently expounded by Granville-Barker.[197] As for the moment we are concerned chiefly with the technicalities, it is enough to underline one or two of his— of Shakespeare's—points. The distance across the Platform gives verisimilitude to the whispered request which Brutus makes to each of his friends in turn; it enhances too the moment when, at Octavius' entry, Strato stands impassively beside the body of his dead lord: "What man is that?" says Octavius from the Study, and Strato and Brutus' body are right forward on the Platform. The dramatic *Low Alarums* and *Alarum still* rising to a *crescendo* of *Alarum. Retreat* after Brutus is safely dead—these sounds will probably come from the left-hand side of the Tiring-House, and Antony and Octavius will make their triumphant entry by Study L. On the other hand, the *Cry within, Flye, flye, flye* will come more appropriately from the right, and Clitus, Dardanius and Volumnius will make their escape (where Brutus, if he were not Brutus, might have followed them) by Study R. The final procession, with the carrying of Brutus' body, will travel (with a drum beating a march) round "this Rocke" and out through Study L towards Octavius' tent. No doubt the Study curtains will be pulled together as soon as may be, and before the last figures have disappeared from the Study.

This is indeed one of Shakespeare's most successful battle-pieces,

[197] *Op. cit.*, 118 ff.

and a close analysis of its mechanics is instructive for the producer who wishes to understand his methods. But of course, in this as in every other feature, Shakespeare will be bound by no rules: beside the orderly perfection of *Julius Caesar* and *Macbeth*, we must put also the deliberately skimped engagement in *King Lear*, when the *result* is all that matters; and on the other hand the magnificent expansiveness of the three-day battle of Actium in *Antony and Cleopatra*, where the military prowess of the doting general is a major theme in the drama.

(x) Some Other Settings

We have already noticed that some plays—such as *The Taming of the Shrew*, *Much Ado About Nothing* and *Twelfth Night*—have mainly domestic settings. In *The Merry Wives of Windsor*, the scenes which revolve round Ford's house (III. ii, the buck-basket scene, and IV. ii, where Falstaff makes his second escape disguised as Mother Prat) show how the architecture of the Tiring-House is naturally helpful to such plays, providing both interior and exterior, like a doll's house. Another such example is the sequence in *Troilus and Cressida* examined above.[198] In all these cases the flow of the narrative is much helped by the natural disposition of the playhouse. An interesting development of this running sequence is that of the prison episode in *Measure for Measure*. This begins at the opening of Act III and continues until the end of IV. iii (from page 70 to page 78 in the Folio), and is conducted in the prison or in the street outside it, except for the brief interlude of Mariana in the moated grange (IV. i). Apart from this scene, the whole eight pages can be played as a running sequence with the Study as the prison and the Platform as the street leading to it, one of the stage-doors being the means of communication between exterior and interior. Mariana's scene, which is domestic in character, is naturally placed in the Chamber.

The Chamber, it will be noticed, is often capable of absorbing the digressions from a continuous sequence: for instance, the poet is sometimes able to confine the sub-plot of his play to the second level of the playhouse, and thereby make the pattern of his double plot much clearer to his audience. We have already had occasion to quote J. Cranford Adams' interesting suggestion in reference to *King Lear*: "For as long as the Edmund sub-plot runs parallel to the main plot, it is staged on the second level of the multiple stage. As the two plots merge into one, the staging merges also, and the final

[198] See pp. 80 ff.

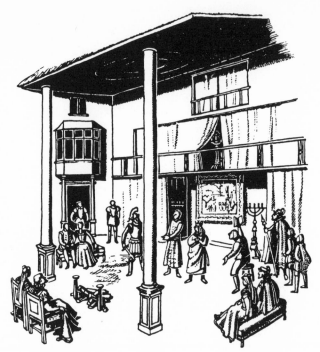

I see a voyce; now will I to the chinke

episodes of the combined action are played on the main level." [199]
How far this was a conscious æsthetic device of the poet's, and how
far a practical necessity, it is difficult to say: but it is quite likely that,
here as elsewhere, necessity was the mother of invention. It would be
interesting to apply the same idea to the plotting of *Hamlet*: but a
moment's reflection will show that the other calls upon the Tarras
and Chamber for ghost-scenes and for Gertrude's closet, preclude
the tidy pattern which Adams suggests for *King Lear*.

Apart from the sequences where the literal architecture of the
multiple stage is employed, certain conventional scenes will fall into
habitual shape. One thinks, for instance, of the throne-room scenes
which occur so frequently in the historical plays. The king's "state"
was a bulky piece of furniture, capable sometimes of seating others
beside the monarch: in *All's Well That Ends Well* the King, restored
to health by Helena, invites her with the words "Sit my preserver by
thy patient's side " [200]; when the desperate Queen Margaret visits
King Lewis of France, he bids her "Sit downe with us: it ill befits thy

[199] J. Cranford Adams, *The Original Staging of King Lear*, 316.
[200] *All's Well That Ends Well*, II. iii. 53.

State, And Birth, that thou should'st stand, while *Lewis* doth sit." [201]
Since there is little space for manoeuvring in the Study to right and
left of the throne, the approach to the royal presence would pre-
sumably be made through the stage-doors. A lane would be formed
by the lords and attendants for the approaching king or duke, though
sometimes an alternative method was adopted, the courtiers coming
on in the usual processional way, while the king was afterwards dis-
covered seated on his throne.[202] The King himself and his intimates
might use the entries to right and left in the Study.

More than once Shakespeare invites us to be spectators of a play
within a play. There is the tedious brief comedy of Pyramus and
Thisbe,[203] and its earlier cartoon in the show of the nine Worthies[204]:
there is the "Mouse-trap" in Hamlet[205]; and Prospero's "most
majesticke vision" for Ferdinand and Miranda.[206] In all these cases
a likely disposition would be to set the "play" in the Study or
against the background of the Tiring-House, while the chief
spectators would be seated at intervals round the front edge of the
Platform: they form thereby, as it were, the front row of the audience
standing in the Yard, and if one or two groundlings were put to in-
convenience by having to crane their necks round the seated nobility,
it would be a familiar touch of reality for those who were used to
struggling in a mob for a better view. The satirical comments of the
Athenian court and the intense drama of Hamlet's feverish com-
mentary would both gain greatly by the proximity to the playhouse
audience. This is a theme to which we shall return in the next
chapter. An opposite grouping in *The Taming of the Shrew* is the
exception rather than the rule. Christopher Sly, who is not himself
an actor in the play, presumably occupies the Chamber and watches
in listless fashion from aloft: and indeed before the play is half-way
through he seems to disappear from sight and likewise from mind.

Scenes of banqueting are interesting as an example of the carrying
forward of solid furniture on to the Platform.[207] That this was a
normal practice we may infer from the directions for the gruesome
feast which brings *Titus Andronicus* to its violent conclusion, *Hoboyes.
A Table brought in;* for the parallel comic climax of *The Taming of the
Shrew, The Servingmen with Tranio bringing in a Banquet;* and for Mac-
beth's "solemne Supper", *Banquet prepar'd.* We may suppose that the
complicated business of bringing forward the trestle-table and stools,

[201] 3 *Henry VI*, III. iii. 2 f.
[202] W. J. Lawrence, *Pre-Restoration Stage Studies*, 319.
[203] *A Midsummer Night's Dream*, V. i. 108 ff.
[204] *Love's Labour's Lost*, V. ii. 486 ff. [205] *Hamlet*, III. ii. 147 ff.
[206] *The Tempest*, IV. i. 60 ff. [207] See above, p. 42.

and the Dishes and Service, was executed by the comedy-gang and
hired men of the company, and that sometimes the musicians helped
with a tune on the hoboyes. The opposite process must presumably
have taken place at the end of the *Macbeth* Banquet scene (since it is
not at the conclusion of the play): Shakespeare gives us an instruc-
tive example with full dialogue in *Romeo and Juliet*.[208] Capulet's
"old accustom'd Feast", which is already over and has to be cleared
for the dancing, is probably set and disclosed in the Study—because
it is already over.

Scenes of conference, involving the use of a table, seem to be dis-
closed in the Study. King Henry IV rates Worcester from the
council-board [209]; and we must suppose therefore that the scene [210]
begins in the Study round the Table—a sort of Council Chamber
meeting, such as that at which Queen Elizabeth boxed the ears of
Essex. In the same play Glendower, Hotspur, Worcester and
Mortimer are disclosed at the conference-table, and return to it after
an altercation to study the map.[211] In the course of the long scene in
Brutus' tent, the generals and their officers sit "close about this
Taper heere" and make their plans of action.[212] These examples all
suggest that the business of the conference was not usually pro-
longed, but that one or more of the actors took an early opportunity
to advance on to the Platform. A contrary example is that of the
triumvirs' proscription,[213] which probably takes place in the
Chamber, so that there is no possibility of advancing. But it will be
noticed that this is a very brief scene.

The natural inference from a contemplation of these last two
typical settings—the banquets and the conferences—is that a prolonged
scene in the Study was not effective, that there is an undramatic gap
before the eyes of the spectators if the platform is not in use. Certainly
in practice the producer will find an insistent urge to bring his actors
forward from the Study. We may even occasionally detect such an
urge in Shakespeare's own dispositions: the remote position of the
"State" and the etiquette of facing the royal presence make a
problem by limiting the manœuvrability of the other characters. Is it
for this reason that in the tilting-scene of *Richard II* the King is at
pains after less than fifty lines to leave his throne and come forward
on to the Platform? [214] Antony, too, who begins his oration in the
Pulpit (which must be in the Study), is made to descend half-way
through the scene to show the mob sweet Caesar's wounds.[215] Very

[208] See above, p. 43. [209] See above, p. 41.
[210] 1 *Henry IV*, I. iii. [211] 1 *Henry IV*, III. i. 71.
[212] *Julius Caesar*, IV. iii. 163. [213] *Julius Caesar*, IV. i.
[214] *Richard II*, I. iii. 54. [215] *Julius Caesar*, III. ii. 165.

interesting, from this aspect, is the climax of the court-scene in *The Merchant of Venice*, which is conducted without any apparent reference to the presiding Duke. Is this the direct result of the scene's setting? For the Duke sits on his "state" in the Study, while the disputants and Antonio's friends are presumably all on the Platform, with Portia central between them—and so inevitably usurping the Duke's authority. With proper courtesy—after the climax—she reminds us all of the Duke's presence.[216] Cranford Adams in a rare mood of special pleading is at pains to show that the Study and the Chamber were used often and for long stretches by themselves. For instance, he seems to set the long Boar's Head scene of 1 *Henry IV* (the two-rogues-in-buckram scene) in the Study, and the parallel scene of 2 *Henry IV* (with the "drawers" and Doll Tearsheet) in the Chamber: and he tells us that "an analysis of plays written between 1599 and 1609 shows that nearly half as many scenes were acted on the rear stage as on the platform; and, furthermore, that the tendency to place scenes of dramatic importance on the rear stage, and scenes of climax on the combined stage (the platform and the rear stage), was growing every year".[217] In such a calculation the length of scenes is perhaps more important than their number, and it is well to remember that our tendency is to exaggerate the importance of the curtained inset over that of what we incurably think of as an annexe. It is timely to reiterate that the Platform was the main arena, quite self-sufficient for the main run of the action: that it is not even necessary to have the Study always open at the end of a play: that Cranford Adams himself in his scene-rotation of *King Lear* places the last four scenes on the bare Platform: and that the action of *Julius Caesar* takes place for most of its length out of doors—in the streets, in the orchard, in the forum, and on the field of battle— so that the Platform is constantly the main field of action. This is all the more remarkable if *Julius Caesar* is rightly dated as one of the first Globe plays. It shows that Shakespeare was by no means preoccupied with his inner and upper stages, and was not to be diverted from his dramatic inspiration by the mechanics of his playhouse.

Among the sequences that make prolonged use of the Platform level are the woodland scenes, usually indicated by the furnishing of the Study with suggestive properties—such as a "thick growne brake",[218] the "cheefest Thicket of the Parke",[219] and Herne's Oak

[216] *The Merchant of Venice*, IV. i. 176–364: throughout this passage the Duke never opens his mouth.

[217] J. Cranford Adams, *The Globe Playhouse*, 168. [218] 3 *Henry VI*, III. i. 1.

[219] 3 *Henry VI*, IV. v. 3.

with perhaps "a pit hard by" in the Study-trap.[220] The setting is sometimes perfunctory, as for the cardboard Outlaws of *The Two Gentlemen of Verona*.[221] The dialogue helps us with no more detailed description than "this wildernesse". Sometimes it is elaborate for the needs of the play, as for instance in the prolonged forest-sequence of *Titus Andronicus*. Tamora and Aaron meet in "a Counsaile-keeping Cave" in the Study: later Bassianus' body is cast into a pit, into which two other persons jump; and a bag of gold is found "Among the Nettles at the Elder tree: Which over-shades the mouth of that same pit"—that is to say, at the foot of one of the Stage-Posts, which may be said to over-shade the central Platform-trap.[222] We have already seen how the furniture of the woodland-set of *A Midsummer Night's Dream* can be deduced. This play shows an example of an exceptionally long sequence during which the locality has definition and consistency. Two long stretches seem to be definitely placed— first, while Titania is asleep before our eyes, and secondly, from Demetrius' first slumber till Bottom's waking.[223] Indeed, once Titania's bank is disclosed, there is no reason why the whole sequence until we leave the forest should not be played before the same woodland-set. With *As You Like It* the problem is different: we are constantly shifting our ground in the Forest of Arden and the transitions are made clear by the appearance of different sets of characters. The time shifts too: there is an instance where modern editions obscure the fact that we pass rapidly from moonlight to day-time. *Actus Tertius. Scena Secunda* opens with the entry of Orlando, who hangs one of his poems on a tree and then addresses the moon, the "thrice crowned Queene of night": after ten lines he runs off on his errand of carving Rosalind's name upon the trees: the sub-sequent scene between Corin and Touchstone is certainly a daylight meeting. It seems probable that Orlando's ten lines are spoken in the Study, and that the curtains pulled over his departure mark a transition in place and time. No doubt similar opening or closing of the Study marks other changes of venue in the forest, but the evidence of the dialogue suggests that the whole sequence would demand no change of furniture in the Study: rather there would be a generalised indication of woodland in the permanent setting. The occasional digressions involving Duke Frederick and Oliver would of course be relegated to the Chamber.

One must recognise, therefore, what may be called comprehensive

[220] *The Merry Wives of Windsor*, V. iii. 14.
[221] *The Two Gentlemen of Verona*, IV. i. 63.
[222] *Titus Andronicus*, II. iii. 24, 186, 272 f.
[223] *A Midsummer Night's Dream*, II. ii. 26—III. i. 136; III. ii. 87—IV. i. 226.

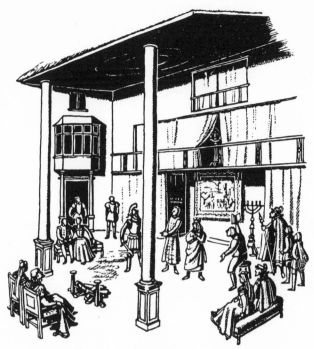

I see a voyce; now will I to the chinke

episodes of the combined action are played on the main level." [199]
How far this was a conscious æsthetic device of the poet's, and how
far a practical necessity, it is difficult to say: but it is quite likely that,
here as elsewhere, necessity was the mother of invention. It would be
interesting to apply the same idea to the plotting of *Hamlet*: but a
moment's reflection will show that the other calls upon the Tarras
and Chamber for ghost-scenes and for Gertrude's closet, preclude
the tidy pattern which Adams suggests for *King Lear*.

Apart from the sequences where the literal architecture of the
multiple stage is employed, certain conventional scenes will fall into
habitual shape. One thinks, for instance, of the throne-room scenes
which occur so frequently in the historical plays. The king's "state"
was a bulky piece of furniture, capable sometimes of seating others
beside the monarch: in *All's Well That Ends Well* the King, restored
to health by Helena, invites her with the words "Sit my preserver by
thy patient's side " [200]; when the desperate Queen Margaret visits
King Lewis of France, he bids her "Sit downe with us: it ill befits thy

[199] J. Cranford Adams, *The Original Staging of King Lear*, 316.
[200] *All's Well That Ends Well*, II. iii. 53.

and a close analysis of its mechanics is instructive for the producer who wishes to understand his methods. But of course, in this as in every other feature, Shakespeare will be bound by no rules: beside the orderly perfection of *Julius Caesar* and *Macbeth*, we must put also the deliberately skimped engagement in *King Lear*, when the *result* is all that matters; and on the other hand the magnificent expansiveness of the three-day battle of Actium in *Antony and Cleopatra*, where the military prowess of the doting general is a major theme in the drama.

(x) Some Other Settings

We have already noticed that some plays—such as *The Taming of the Shrew*, *Much Ado About Nothing* and *Twelfth Night*—have mainly domestic settings. In *The Merry Wives of Windsor*, the scenes which revolve round Ford's house (III. ii, the buck-basket scene, and IV. ii, where Falstaff makes his second escape disguised as Mother Prat) show how the architecture of the Tiring-House is naturally helpful to such plays, providing both interior and exterior, like a doll's house. Another such example is the sequence in *Troilus and Cressida* examined above.[198] In all these cases the flow of the narrative is much helped by the natural disposition of the playhouse. An interesting development of this running sequence is that of the prison episode in *Measure for Measure*. This begins at the opening of Act III and continues until the end of IV. iii (from page 70 to page 78 in the Folio), and is conducted in the prison or in the street outside it, except for the brief interlude of Mariana in the moated grange (IV. i). Apart from this scene, the whole eight pages can be played as a running sequence with the Study as the prison and the Platform as the street leading to it, one of the stage-doors being the means of communication between exterior and interior. Mariana's scene, which is domestic in character, is naturally placed in the Chamber.

The Chamber, it will be noticed, is often capable of absorbing the digressions from a continuous sequence: for instance, the poet is sometimes able to confine the sub-plot of his play to the second level of the playhouse, and thereby make the pattern of his double plot much clearer to his audience. We have already had occasion to quote J. Cranford Adams' interesting suggestion in reference to *King Lear*: "For as long as the Edmund sub-plot runs parallel to the main plot, it is staged on the second level of the multiple stage. As the two plots merge into one, the staging merges also, and the final

[198] See pp. 80 ff.

settings. As with the battlefield and the street sequences, so too with woodland and heath—the storm scenes in *King Lear* are an example of the latter—it is possible to have a succession of scenes on such a general background, supposed to take place in different parts, without changing the furniture of the Study, or indeed without opening it at all. The illusion of a change in locality is sometimes, but by no means always, indicated by the opening or closing of the Study or the Chamber. But the question of locality on the Globe stage is an important one, and deserves a section to itself.

(xi) *Locality and Unlocalisation*

In no respect is the reading of the Quarto and Folio texts a more salutary corrective than in the matter of locality. The editorial practice since Rowe has been to divide into scenes and to give each scene a locality in a heading, such as *A street in Rome, Another part of the plain, Another part of the Forest, A Room in the Castle.* Granville-Barker has made it clear that this practice leads to much confusion and a fundamental misunderstanding of Shakespeare's stagecraft.[224] A kindred belief which also dies hard suggests that it was the regular practice in the playhouse to indicate the whereabouts of each scene by exhibiting locality-boards on the wall of the Tiring-House. This was probably the exception rather than the rule,[225] and a careful perusal of the Folio, with an eye to the practical problems of the producer, leads to the plain conclusion that nowhere in Shakespeare (neither in the simplicities of the early histories nor in the complications of the mature tragedies) are such crude indicators necessary. That he would have thought them crude appears likely, if we read between the lines of the theatrical experiments of Peter Quince and company: for instance, the expedients discussed for presenting Moon-shine and Wall.[226] In Shakespeare's own plays, the rule holds that *you know where you are when you need to know.*

Often he makes a simple and direct statement of locality. Thus each of Talbot's three actions against the French is clearly notified with an introductory sentence: "At pleasure here we lye, neere Orleance"; "These are the Citie Gates, the Gates of Roan"; "Go to

[224] Granville-Barker, *Prefaces to Shakespeare* (Second Series), 130 ff. ("A digression, mainly upon the meaning of the word 'scene'.")

[225] J. Cranford Adams, *The Globe Playhouse*, 166.

[226] *A Midsummer Night's Dream*, III. i. 50 ff.

the gates of Burdeaux Trumpeter".[227] Of the same kind is the
question with which Richard II opens a scene: "Barkloughly Castle
call you this at hand?" [228] Such too the question and answer in
Twelfth Night: "What Country (Friends) is this?" "This is Illyria
Ladie." [229]

But just as often Shakespeare is not at all concerned to tell us
where we are. Talbot, outside Bordeaux, is in desperate need of
reinforcements. York and Somerset in their bitter rivalry both fail to
come to his assistance: we see each in turn dallying and abusing the
other: where either of them is, we neither know nor care; the point
is that they are *not at Bordeaux,* as the plot of the play, swift-moving at
this juncture, makes amply clear. As soon as Talbot returns to the
Platform, we know we are back at Bordeaux.[230] There is shrewd
relevance here, and to cumber us with exact geographical informa-
tion would obscure the main issue.

Shakespeare finds it easy to shift his locality from one place to
another, sometimes so swiftly and deftly that the change happens
without a stop or cadence in the middle of what we call a "scene".
A process like the travelling of the cinema-camera's lens can be seen
twice in *Julius Caesar.* We shall examine in detail on a later page the
scene of Caesar's murder. It is enough here to point out that it begins
in the streets, that is to say, on the bare Platform: Cassius prevents
the importunate Artemidorus from approaching Caesar, with the
words: "What, urge you your Petitions in the street? Come to the
Capitoll." Then, whilst the movement is covered by a tense inter-
change between the conspirators and Popilius Lena, the Study
curtains are drawn aside and Caesar mounts his "state": after
twenty lines the seated dictator opens the proceedings with the
words: "Are we all ready?" and the Platform-cum-Study has already
become the Senate-house.[231] Later in the play, by a precisely similar
process, Brutus and Cassius, who have confronted each other at the
heads of their armies, move into the Study, set for Brutus' tent, to
discuss their differences: *Manet Brutus and Cassius,* says the Folio: and
the great quarrel-scene, with its prolonged sequel ending in the
appearance of Caesar's ghost, ranges freely over the whole Platform,
which has changed from open ground to the interior of the tent.[232]
So too in *Romeo and Juliet* the masquers, after Mercutio's Queen
Mab speech *march about the Stage, and Servingmen come forth with their
napkins.* No doubt the remains of the banquet are discovered in

[227] 1 *Henry VI,* I. ii. 6; III. ii. 1; IV. ii. 1. [228] *Richard II,* III. ii. 1.
[229] *Twelfth Night,* I. ii. 1. [230] 1 *Henry VI,* IV. ii–v.
[231] *Julius Caesar,* III. i. 1–31. [232] *Julius Caesar,* IV. ii and iii.

the Study and duly removed by the servants, and the Platform-cum-Study changes in a trice from the street to the interior of Capulet's hospitable and festive house.[233] Another example can be seen in 2 *Henry IV*, when in the Folio text the King is made to say:

> I pray you take me up, and beare me hence
> Into some other Chamber: softly 'pray.
> Let there be no noyse made (my gentle friends)
> Unlesse some dull and favourable hand
> Will whisper Musicke to my wearie Spirit.

Here the modern editors mark the beginning of a new scene after the King's second line: in fact, as the Folio makes clear, the invalid is carried to his bed in the Study, the curtains being drawn aside at this moment to mark the change "into some other Chamber".[234] It is important to realise that in all these cases, on the opening of the Study curtains, even if there is a momentary confinement to that area, afterwards the whole Platform changes its locality under the influence of the Study furniture.

These examples have a logical basis in the movement of the characters, but there are others where there is no such logical explanation. In 2 *Henry VI* a scene begins with the ceremonial arraignment of "Dame *Elianor Cobham, Gloster's* wife": exactly *where* we are hardly matters, and indeed it is best not to ask, for without any indication of a change of locality the Platform becomes the "Lysts" for the combat (with staff and sandbag) between Horner and his man Peter, who enter with their drunken supporters *at one Doore . . . and at the other Doore*.[235] The painful and intimate "Closset Locke and Key" scene of *Othello* clearly suggests Desdemona's private apartments, but ends with a duologue between Iago and Roderigo, who quite obviously has no access thither: the end of the scene—probably on the Platform—is therefore without locality. Conversely, the following scene begins publicly, on the Platform, and continues in Desdemona's apartment where she is " un-pinned" by Aemilia.[236] What the Folio calls *Scaena Secunda* of the third act of *King John* [237] is an interesting example of a shifting locality. It begins in the battle itself outside Angiers, and its last line tells us that we are bound for Calais and home: meanwhile the locality is vague, first in the battle, then after it, but nowhere in particular. It is John's speech to Hubert which sets the scene, by playing tricks with

[233] *Romeo and Juliet*, I. iv. and v. [234] 2 *Henry IV*, IV. iv. 131 ff.
[235] 2 *Henry VI*, II. iii. [236] *Othello*, IV. ii. and iii.
[237] *King John*—in modern editions Act III, Scenes ii. and iii.

daylight, and complaining that it is not the right time and place for murder:

> . . . If the mid-night bell
> Did with his yron tongue, and brazen mouth
> Sound on into the drowzie race of night:
> If this same were a Church-yard where we stand,
> And thou possessed with a thousand wrongs:
> Or if that surly spirit melancholy
> Had bak'd thy bloud . . .

There are seeds here which grow to ripeness in Hamlet's "Tis now the verie witching time of night," and in Macbeth's "Now o're the one halfe World Nature seemes dead, and wicked Dreames abuse The Curtain'd sleepe." [238] We find indeed in this lifting of the imagination away from the visible scene an extreme example of what Granville-Barker calls the "unlocalised" stage.[239]

The question of the unlocalised stage needs further exploration. It is not simply that sometimes the idea of locality is, as it were, suspended in favour of the circumstantial situation of the characters, who by their dress, their properties, or their very presence tell us all we need to know about the *mise-en-scène*—as, for instance, at the first entry of Dogberry, Verges and their fellows, the familiar sight of the Watch, with a lantern, is of itself enough to tell us that it is night and the open streets, or as the appearance of Buckingham *with Halberds* suggests at once the way to execution with no further need of defining the locality—but often for several pages of the prompt-book, the continuity of the play lies in something other than the sequence of time and place. *Much Ado About Nothing*, for instance, is remarkable as being a play where the continuity is made chiefly by the intrigue and locality is incidental. If we read Act V in the Folio there is no indication of *where* we are supposed to be, except for the brief interlude in the Monument of Leonato: it is probable that Benedick's visit to Beatrice is located as a domestic scene in the Chamber: for the rest the story is strung quite logically on the thread of intrigue. As Granville-Barker puts it: "His drama is attached solely to its actors and their acting; that, perhaps, puts it in a phrase. They carry place and time with them as they move." [240]

In the great tragedies, too, sometimes our preoccupation with the story makes us forget altogether where we are supposed to be. From the beginning of Act III, Scene iii of *Othello* there is no question of

[238] *Hamlet*, III. ii. 413; *Macbeth*, II. i. 49.
[239] The reader is referred to *Prefaces to Shakespeare* (First Series), xix ff.—a passage in which Granville-Barker discusses "the Convention of Place".
[240] *Op. cit.*, xxiii.

locality until Act IV, Scene ii, (the "Closset Locke and Key" scene), which is presumably in the Chamber. For more than eight pages of the Folio, instead of scenery or visual suggestion of any kind, we are enthralled by the pervading themes, out of which the drama is built: the persons of the drama are all that matter and particularly their speech: there is, indeed, hardly any physical action during this period. And who is to tell us where, between Heaven and Hell, the last scene in *King Lear* is supposed to take place?

Buckingham, with Halberds, led to execution

The opportunities of this unlocalised platform were quite early on appreciated by Shakespeare, both in the speed with which its locality could be changed, and also in the fact that it could lose all sense of being anywhere. The technique, familiar from Greek drama, of creating a dramatic scene through the medium of a Messenger's Speech was often employed by him, and the effect of the unlocalised platform was to bring such scenes more vividly before the imagination of the audience. Hotspur's indignant description of the aftermath of Holmedon, and his painting of the encounter between Mortimer and Glendower are quite detached from the background of the council-chamber in which the scene opens.[241] Oberon's

[241] 1 *Henry IV*, I. iii. 29 ff; 93 ff.

familiar description of the origin of the "little westerne flower"
becomes far more vivid if the fairy king's voice is for the moment
disembodied, as it were, and not fettered to the irrelevant picture of
the Athenian wood.[242] When Queen Gertrude tells the tale of
Ophelia's drowning, the very speaker here is in a sense unlocalised:
the sentiment is quite unlike Gertrude. Ophelia's death is itself an
event in the play, and we almost see it before our eyes: it has its
immediate dramatic effect upon Laertes.[243] All these descriptive and
narrative speeches are the better for being detached from a sug-
gested locality. It is as if the Platform was a white screen upon which
a series of images was being projected in quick succession: Shake-
speare's poetical imagination is the projector and the speed is as
rapid as his thought.

The effect is still more telling when the substance of the speech is
not merely objective narrative, but a tissue of changing imagery.
This is a theme to which we shall return again, both in considering
the acting tradition of the Chamberlain's Men, and in discussing the
poet's stagecraft. But it is appropriate to mention it here, as we look
over the shoulder of the Book-Keeper, while he plots the play upon
the unlocalised Platform and the multiple stage of the Globe
Playhouse.

[242] *A Midsummer Night's Dream*, II. i. 155 ff.
[243] *Hamlet*, IV. vii. 167 ff.

4

THE ACTING TRADITION OF THE CHAMBERLAIN'S MEN

NOW that we have examined the main problems of the Book-Keeper in plotting a play upon the 'multiple stage of the Globe, we have reached a point in our investigation where it will be profitable to make closer acquaintance with his colleagues, the player members of the Chamberlain's or King's Company. In this chapter we will begin by considering in general some of the elements in the company's technical accomplishment, and later pay attention to their individual qualities in so far as they help to elucidate the characterisation and the casting of Shakespeare's plays.

But first it is proper to correct what seems still to be a fashionable belief—that they were a set of crude mountebanks or incompetent barnstormers, living a reckless hand-to-mouth life in bohemian circumstances. Popular fiction, touching this theme, likes to paint them in lurid colours, and the sponsors of a film version of *Henry V*, addressing a world-wide audience, were at pains to guy their predecessors in the art of the theatre with the facile assumption that they knew their job less well than themselves.

The evidence is mostly to the contrary. No one who has read the comprehensive account of them given in T. W. Baldwin's *The Organization and Personnel of the Shakespearean Company*—a book which should be more widely known than it is [1]—can doubt that they are more aptly described in the dialogue *Historia Histrionica* (1699) as "grave and sober men, living in reputation".[2] Baldwin presents us with a picture of a company financially prosperous, rigidly organised

[1] The strictures of E. K. Chambers (as expressed, for instance, in his *William Shakespeare*, vol. ii, 82, 83) have perhaps been largely responsible for the neglect in this country of Baldwin's work. Chapter III in Chambers vol. i may be read as a corrective in points of detail, but hardly diminishes the importance of the main contention.

[2] Granville-Barker in his essay *From Henry V to Hamlet* (p. 25) refers to this passage, and adds "it is likely to be the truth: for there is confirmation of it. Heminge and Condell were two of them. Does not the introduction to the First Folio reflect as much gravity and sobriety as you like". One could cite also the example of Edward Alleyn, principal actor of the neighbouring company, and founder of Dulwich College.

and carefully guarded in law—its shareholders or "housekeepers"
few and privileged, its other members striving to be thought worthy
of succeeding, when opportunity arose (through death or with-
drawal), to that privilege, its apprentices chosen young and often
passing from the tuition stage as boy actors to full membership in
adult parts.[3] In addition to the members and apprentices, the
Chamberlain's Men would regularly employ more than a score of
hired men as "Musitions and other necessary attendants". It is
clear that the experienced actors educated their pupils carefully and
that thus the repertory had its own school of acting, and a continuous
tradition. It is equally certain that they were the most successful
company of their time in London, no doubt largely because they had
the services of Shakespeare as one of their playwrights. Shakespeare
had a powerful effect upon their "box-office" receipts, but it is con-
versely probable that they had a notable effect upon Shakespeare's
plays: they were his acting material, and he wrote for them:
Baldwin hardly exaggerates when he declares that "Shakespeare's
plays represent not only his own individual invention but also the
collective invention of his company".[4] For this reason, if for no
other, it is worth while exploring their acting tradition, and seeing
how far we can reconstruct it.

It may be said straight away that the view expressed in the follow-
ing pages makes the optimistic assumption that the Chamberlain's
Men were worthy of the chance which Shakespeare gave them. The
plays themselves are a tribute to their resourcefulness, their versatility
and their all-round accomplishment. Contemporary records suggest
that they were in their time "the best in this kind". That is implied
too in the familiar passage of Hamlet's advice to the players. The
outspoken criticism of acting methods is surely not a hint from
Shakespeare to his colleagues in public—it is difficult to imagine the
company rehearsing without embarrassment for such an effect—but
a suggestion to the audience to notice how favourably they compared
with the other London companies. The suggestion lies in the words
of the Player: "I hope we have reform'd that indifferently with us,
Sir." [5] This is a politely modest way of saying, "That's what the
others do, but we don't, do we?"

But even if it were possible to prove that this assumption was too
optimistic, it would still be worth making. There can be no harm in
so doing; on the contrary, there would be positive good, if some of
our modern repertories could thereby be induced to study the

[3] The question of the apprenticeship of the Boy Actors is a point of fundamental
difference between Chambers and Baldwin: see *William Shakespeare*, vol. ii., 82 ff.
[4] *Op. cit.*, 303. [5] *Hamlet*, III. ii. 41.

technique Shakespeare and his fellows aimed at, and reproduce or excel (but in their own kind) their performance. Shakespeare probably wrote, as most playwrights do, for an ideal performance, but he shaped his plays for his fellow-actors, asking them for the best they could do—and sometimes (as genius will) for more. If we examine their acting tradition, we may find fresh clues to that shape: if we revive it in our own acting companies, we shall at least be aiming at that same best which Shakespeare asked for, and may even find inspiration now and then to achieve that more which genius evokes.

(i) Speech

In the forefront of any discussion of the acting tradition of the Chamberlain's Men must be put their command of speech—their most important accomplishment, as it should be still for the Shakespearian actor: for the spoken word is Shakespeare's sharpest weapon. An actor of to-day must not be content if he is assured by his critics that he satisfies a general demand, somewhat vaguely expressed, that the language should be clearly and beautifully spoken. The Chamberlain's Men did very much more than such a phrase seems to imply. They were helped, no doubt, by the easy and flexible acoustic of their playhouse, which could reflect the silver-sweet whispers of Romeo and Juliet, or of Lorenzo and Jessica, as clearly as the roaring of Macbeth or Lear, the asides of Falstaff or Iago as well as the rhetoric of Mark Antony. But the evidence of the plays themselves gives some idea of a range of accomplishment throughout the company which all but a few of our modern actors have ceased to aim at—as if they did not know that such tricks and devices and skills were part of the technique which Shakespeare took for granted.

Nor is it altogether the fault of the modern actor—though it is a fault he can go a long way to remedy. Circumstances are against him, and the history of the development of our language, now in a decline—or at least in a depressed period awaiting a new injection, perhaps from across the Atlantic, to rouse it to vitality. We must never forget, in dealing with Shakespeare's plays, that in his time the language was in a state of springtime freshness. The literary man and the courtier were positively adventurous in their experiments, but even the man in the street, even the groundling in the Yard, had a lively interest in language for its own sake. "A gathering of energy and confidence," says G. D. Willcock,[6] "is one of the striking features

[6] *A Companion to Shakespeare Studies* (Cambridge), 128 f.

of the years 1580–96. It shows itself in every department of life, art and thought, and is expressed in *language* with even less hesitation than else-where . . . there was a buccaneering spirit abroad in language as well as on the high seas." We, therefore, who are less sensitive to the stimulus of language, are in danger of missing the point by flattening out Shakespeare's words, reducing them by a depressingly automatic process to something nearer to the drabness of our own speech.

In an age when language was held in honour, Burbadge and his fellows had more complicated tasks than merely to bring out the meaning and point the right emphasis of their lines. Yet it is proper to pause and consider how often, even in this respect, we are dis-appointed to-day. The plain meaning of a sentence, at least from the earlier plays before the poet had developed the compressed com-plexity of his later style, should not, one would think, be difficult to bring out. Yet quite often nowadays, as one sits in the theatre, the meaning of what an actor says wholly escapes us. The reason is often that the actor (or his producer) takes too perfunctory and casual a view of the poetical content of Shakespeare's lines, as for instance when he understands as a cliché what is really an exact and pointed sentence. King Claudius inciting Laertes against Hamlet says, "Revenge should have no bounds," and the words may easily be spoken as a familiar catch-phrase: in fact they have an exact sense, as the context makes clear:

> *Kin.* what would you undertake,
> To show your selfe your Fathers sonne indeed,
> More then in words?
> *Laer.* To cut his throat i'th' Church.
> *Kin.* No place indeed should murder Sancturize;
> Revenge should have no bounds . . .[7]

So too Achilles, when he hears that Ajax is to have the honour of fighting Hector, says "I see my reputation is at stake": the sentence sounds prosaic until he continues, "My fame is shrowdly gored"[8]; then we realise that the metaphor comes from the neighbouring bear-pit.

There are of course differences of opinion as to what Shakespeare meant by this passage or that. Lines as familiar as

> The quality of mercy is not strain'd . . .

or—

> She should have dy'de heereafter;
> There would have beene a time for such a word . . .

admit of more than one interpretation. Here the Chamberlain's Men were at an advantage, for Shakespeare himself was there to tell

[7] *Hamlet*, IV. vii. 124 ff. [8] *Troilus and Cressida*, III. iii. 228 f.

them what he meant. We must rely upon the editors, and where they disagree, ultimately on our own judgment. But it is worth repeating here that help can be derived from the punctuation of the Quarto and Folio texts, especially when it represents a system not of grammatical but of declamatory pointing.[9] When we have decided on the meaning, we must bring it out: then the critics will agree or disagree with our interpretation, but they cannot complain that we have shirked the issue: what is inexcusable is that the lines should appear to have no meaning or force at all. This is too often the effect of the perfunctory gabble which is fashionable among Shakespearian actors of to-day. Nor is this style of speech merely a miscalculation of speed. The Chamberlain's Men, we may be sure, could speak "trippingly on the tongue". Hamlet, after his interview with the Ghost, or when the play has caught the conscience of the King, or as he tells Horatio about his adventure with the Pirates, speaks through the lips of Burbadge at a feverish and breakneck speed. Borachio (a minor actor) prompting the villainous Don John has a diabolical energy suggestive of Iago at his most active.[10] The unintelligent and unintelligible delivery of Shakespeare's lines almost always arises not from an excess of pace but from a probably unconscious under-rating of the dramatist's poetical skill.

Where we often fail to-day is in giving substance to the imagery, the metaphors and similes, the language that speaks of an image which is not present to the eye. The Chamberlain's Men must have been skilled in such realisation, for so much of their task consisted of precisely this. We shall see on a later page how gesture and mime can help here, but gesture and mime without great vocal skill would seldom bring the point home, and there are moments when they would help hardly at all and when the whole responsibility of bringing the image to the mind's eye lies with the voice. The sick King Henry, wakeful in the small hours of the night, appeals to the gentle Sleep who will not visit him:

> Wilt thou, upon the high and giddie Mast,
> Seale up the Ship-boyes Eyes, and rock his Braines,
> In Cradle of the rude imperious Surge,
> And in the visitation of the Windes,
> Who take the Ruffian Billowes by the top,
> Curling their monstrous heads, and hanging them
> With deaff'ning Clamors in the slipp'ry Clouds,
> That with the hurley, Death it selfe awakes?

[9] See above, pp. 27 f.

[10] *Much Ado About Nothing*, II. ii. 33 ff. Another example of such rapid delivery is the scene in the last act of *The Winter's Tale* (V. ii.) where three anonymous Gentlemen give us enough information to supply the dramatist with an extra act.

> Canst thou (O partiall Sleepe) give thy Repose
> To the wet Sea-Boy, in an houre so rude:
> And in the calmest, and most stillest Night,
> With all appliances, and meanes to boote,
> Deny it to a King? Then happy Lowe, lye downe,
> Uneasie lyes the Head, that weares a Crowne.[11]

How is this done? The eye can help here a little by seeing the ship-boy in the rigging, and by cowering before the mountainous billows: the hand and the whole body can react to the terror of the storm: an unexpected smile of contentment can register the beatific slumber of the ship-boy, and a frown the uneasy head of kingship. But the main task is with the voice, which must mime too—and rhythm will help to make the contrast between the storm at sea and "the calmest, and most stillest Night". I would hazard a guess that unless the actor himself, every time he speaks the speech, projects his mind into the imagined scenes of the storm and the King's apartment, he will not carry his audience there: if he does, he will. There are limits to such a process; the image is sometimes contained in a couple of words—as, for instance, when earlier in the same speech the restless couch of the King is compared to a "Watch-case" (a sentry-box) "or a common Larum-Bell" and there is not time to match Shakespeare's swift thought with action, hardly even with vocal change. But we must prepare to be as agile in passing from image to image, as the Chamberlain's Men probably were, or as Shakespeare certainly wanted them to be. It will be noticed that in striving to recreate the poet's imagery the actor will have to depart from realistic characterisation, to speak "out of character": for the tone that does justice to the deafening clamours of the storm will not be the feeble murmur of a man sick to death. Such agility of speech Shakespeare asked of Burbadge as he keyed up his audience to the idea of murdering Duncan:

> Now o're the one halfe World
> Nature seemes dead, and wicked Dreames abuse
> The Curtain'd sleepe: Witchcraft celebrates
> Pale *Heccats* Offrings: and wither'd Murther,
> Alarum'd by his Centinell, the Wolfe,
> Whose howle's his Watch, thus with his stealthy pace,
> With *Tarquins* ravishing strides, towards his designe
> Moves like a Ghost.[12]

We shall return in a later chapter to the means by which the player gave this soliloquy its utmost force.[13]

But when we have said that the Chamberlain's Men were able to

[11] 2 *Henry IV*, III. i. 18 ff. [12] *Macbeth*, II. i. 49 ff. [13] See below, p. 288.

> Canst thou (O partiall Sleepe) give thy Repose
> To the wet Sea-Boy, in an houre so rude:
> And in the calmest, and most stillest Night,
> With all appliances, and meanes to boote,
> Deny it to a King? Then happy Lowe, lye downe,
> Uneasie lyes the Head, that weares a Crowne.[11]

How is this done? The eye can help here a little by seeing the ship-boy in the rigging, and by cowering before the mountainous billows: the hand and the whole body can react to the terror of the storm: an unexpected smile of contentment can register the beatific slumber of the ship-boy, and a frown the uneasy head of kingship. But the main task is with the voice, which must mime too—and rhythm will help to make the contrast between the storm at sea and "the calmest, and most stillest Night". I would hazard a guess that unless the actor himself, every time he speaks the speech, projects his mind into the imagined scenes of the storm and the King's apartment, he will not carry his audience there: if he does, he will. There are limits to such a process; the image is sometimes contained in a couple of words—as, for instance, when earlier in the same speech the restless couch of the King is compared to a "Watch-case" (a sentry-box) "or a common Larum-Bell" and there is not time to match Shakespeare's swift thought with action, hardly even with vocal change. But we must prepare to be as agile in passing from image to image, as the Chamberlain's Men probably were, or as Shakespeare certainly wanted them to be. It will be noticed that in striving to recreate the poet's imagery the actor will have to depart from realistic characterisation, to speak "out of character": for the tone that does justice to the deafening clamours of the storm will not be the feeble murmur of a man sick to death. Such agility of speech Shakespeare asked of Burbadge as he keyed up his audience to the idea of murdering Duncan:

> Now o're the one halfe World
> Nature seemes dead, and wicked Dreames abuse
> The Curtain'd sleepe: Witchcraft celebrates
> Pale *Heccats* Offrings: and wither'd Murther,
> Alarum'd by his Centinell, the Wolfe,
> Whose howle's his Watch, thus with his stealthy pace,
> With *Tarquins* ravishing strides, towards his designe
> Moves like a Ghost.[12]

We shall return in a later chapter to the means by which the player gave this soliloquy its utmost force.[13]

But when we have said that the Chamberlain's Men were able to

[11] 2 *Henry IV*, III. i. 18 ff. [12] *Macbeth*, II. i. 49 ff. [13] See below, p. 288.

them what he meant. We must rely upon the editors, and where they disagree, ultimately on our own judgment. But it is worth repeating here that help can be derived from the punctuation of the Quarto and Folio texts, especially when it represents a system not of grammatical but of declamatory pointing.[9] When we have decided on the meaning, we must bring it out: then the critics will agree or disagree with our interpretation, but they cannot complain that we have shirked the issue: what is inexcusable is that the lines should appear to have no meaning or force at all. This is too often the effect of the perfunctory gabble which is fashionable among Shakespearian actors of to-day. Nor is this style of speech merely a miscalculation of speed. The Chamberlain's Men, we may be sure, could speak "trippingly on the tongue". Hamlet, after his interview with the Ghost, or when the play has caught the conscience of the King, or as he tells Horatio about his adventure with the Pirates, speaks through the lips of Burbadge at a feverish and breakneck speed. Borachio (a minor actor) prompting the villainous Don John has a diabolical energy suggestive of Iago at his most active.[10] The unintelligent and unintelligible delivery of Shakespeare's lines almost always arises not from an excess of pace but from a probably unconscious under-rating of the dramatist's poetical skill.

Where we often fail to-day is in giving substance to the imagery, the metaphors and similes, the language that speaks of an image which is not present to the eye. The Chamberlain's Men must have been skilled in such realisation, for so much of their task consisted of precisely this. We shall see on a later page how gesture and mime can help here, but gesture and mime without great vocal skill would seldom bring the point home, and there are moments when they would help hardly at all and when the whole responsibility of bringing the image to the mind's eye lies with the voice. The sick King Henry, wakeful in the small hours of the night, appeals to the gentle Sleep who will not visit him:

> Wilt thou, upon the high and giddie Mast,
> Seale up the Ship-boyes Eyes, and rock his Braines,
> In Cradle of the rude imperious Surge,
> And in the visitation of the Windes,
> Who take the Ruffian Billowes by the top,
> Curling their monstrous heads, and hanging them
> With deaff'ning Clamors in the slipp'ry Clouds,
> That with the hurley, Death it selfe awakes?

[9] See above, pp. 27 f.

[10] *Much Ado About Nothing*, II. ii. 33 ff. Another example of such rapid delivery is the scene in the last act of *The Winter's Tale* (V. ii.) where three anonymous Gentlemen give us enough information to supply the dramatist with an extra act.

bring out the plain meaning and the imagery, we are only at the beginning of their accomplishments: there is far more to it than this. Whether we complain with Matthew Arnold of Shakespeare's "irritability of fancy and over-curiousness of expression", or remark with Coleridge "the activity of thought in the play of words", we must accept the fact that the poet was addicted to the habit of word-play. It would be possible indeed to propound the view—though this is not the place to do so—that it was one of the fundamental elements of his style, developed from the crude and painful punning of Speed and Launce [14] to the subtle verbal irony of Hamlet, and including in its range not only the simple force of "*Puzel* or *Pussel*, Dolphin or Dog-fish . . ." or "For Suffolks Duke, may he be suffo-cate" [15] and the shrinking pathos of Desdemona's "I cannot say Whore, It do's abhorre me now I speake the word . . .",[16] but also such semi-conscious echoes of sound as "the half-atchieved Har-flew" [17] and "All length is torture: since the Torch is out . . ." [18] Even as early as *Richard III* the nimble tongue of Burbadge was asked to make no mistake about putting over "We are the Queenes *ab*jects, and must obey," and in the same play it was a boy-actor who, responding to the royal murderer's "Your Reasons are too shallow, and to quicke," must make the most of the Queen's punning retort "O no, my Reasons are too deepe and dead, Too deepe and dead (poore Infants) in their graves." [19] In Shakespeare's maturity the boy Edmans must give us the full horror of Lady Macbeth's "Ile guild the Faces of the Groomes withall, For it must seeme their Guilt." [20] If the actor fails to make these verbal points, he is like a musician who has no phrasing and who omits the *sforzandos* marked by the composer: the emphasis need not, of course, be heavy, any more than the *sf.* in a *pp* passage will be heavy; it will keep within the range of dynamics of the whole passage. The Eliza-bethan audience would be quick to take the point, or in the case of the semi-conscious echoes to feel the poetical effect; for, as has been said above, it was an age of linguistic expansion and enterprise. "Punning and verbal acrobatics," says Willcock, "show the same eager attention to words on the part of all classes . . ." and after mention of Feste, Olivia's "corrupter of words", he goes on ". . . People loved, then, to follow words; they were also trained to

[14] Though even these two are not allowed to be complacent about it: one says to the other, after an outrageous example, "Well, your old vice still: mistake the word" (*The Two Gentlemen of Verona*, III. i. 285).

[15] 1 *Henry VI*, I. iv. 107; 2 *Henry VI*, I. i. 125. [16] *Othello*, IV. ii. 161 f.

[17] *Henry V*, III. iii. 8. [18] *Antony and Cleopatra*, IV. xii. 46.

[19] *Richard III*, I. i. 106 (the italics are mine); IV. iv. 362 ff.

[20] *Macbeth*, II. ii. 57 f.

listen strenuously." [21] After all, we to-day are in the habit of listen-
ing, if not strenuously, at least continuously and—until television
supersedes the radio—without the aid of the eye. Maybe this habit,
imposed upon us by the capricious progress of scientific invention,
will effect a renewed interest in the spoken word: certainly one of the
symptoms is already apparent, for the popularity of Tommy
Handley's half-hour depended largely upon Ted Cavanagh's word-
play: the puns seemed funny enough as they were shot at us in rapid
fire. The difference between to-day and 1600 is that the language
itself was fresh and in the making then. This difference puts a strain
upon the actor of to-day, which his predecessor had not: both to
Burbadge and to his audience the words themselves were alive and
potentially provocative of wit and beauty; our actors, to revive the
tradition, must not only recapture that interest in and love of the
language, but must find the means to communicate it to their
audience.

The frequent wit-contests of the comedies are prolonged and
elaborate examples of such verbal acrobatics. The Princess in *Love's
Labour's Lost* commends two of her ladies for "a set of Wit well
played".[22] Both typical and tiresome is this dialogue of Romeo and
Mercutio:

> *Rom.* Good morrow to you both, what counterfeit did I give you?
> *Mer.* The slip sir, the slip, can you not conceive?
> *Rom.* Pardon *Mercutio*, my businesse was great, and in such a case as
> mine, a man may straine curtesie.
> *Mer.* That's as much as to say, such a case as yours constrains a man
> to bow in the hams.
> *Rom.* Meaning to cursie.
> *Mer.* Thou hast most kindly hit it.
> *Rom.* A most curteous exposition.
> *Mer.* Nay, I am the very pinck of curtesie.
> *Rom.* Pinke for flower.
> *Mer.* Right.
> *Rom.* Why then is my Pump well flowr'd.
> *Mer.* Sure wit, follow me this jeast, now till thou hast worne out thy
> Pump, that when the single sole of it is worne, the jeast may remaine
> after the wearing, sole-singular.
> *Rom.* O single sol'd jeast,
> Soly singular for the singlenesse.
> *Mer.* Come betweene us good *Benuolio*, my wits faints.
> *Rom.* Swits and spurs,
> Swits and spurs, or Ile crie a match.[23]

[21] *A Companion to Shakespeare Studies* (Cambridge), 130 f.
[22] *Love's Labour's Lost*, V. ii. 29. [23] *Romeo and Juliet*, II. iv. 52 ff.

This is but half the length of the battle, which must have been fought at so brisk a pace that, when Mercutio's "wits faints", those of the audience have long been in a swoon. Trained in this kind of exercise, the actors would be well equipped to give full flavour to the greater subtleties of Beatrice and Benedick, Rosalind and Orlando, Hal and Falstaff, and, in the tragic frame, of Hamlet's fencing with Rosencrantz and Guildenstern. Indeed, in the central phase of Shakespeare's composition, which included in four years the two parts of *Henry IV*, *Much Ado About Nothing*, *As You Like It*, *Twelfth Night* and *Hamlet*, it is hard to resist the belief that the poet's witty writing was for the time matched by the witty delivery of some half dozen at least of his player colleagues.[24]

As with most Elizabethan writers, a part of Shakespeare's stock-in-trade, from his earliest days, was rhetoric: and while language was a general contemporary interest, the art of rhetoric had long been a study of the educated man. The figures of classical rhetoric—especially balance (including antithesis) and repetition—influence the shape and design of English sentences: they are pervasive in Spenser and rife in the drama of the University Wits. They were thus a part of Shakespeare's heritage.[25] T. S. Eliot goes so far as to say that "we cannot grapple with even the simplest and most conversational lines in Tudor and early Stuart drama without having diagnosed the rhetoric in the sixteenth- and seventeenth-century mind. . . . An understanding of Elizabethan rhetoric is as essential to the appreciation of Elizabethan literature as an understanding of Victorian sentiment . . . to the appreciation of Victorian literature . . ."[26] Without insisting that it is necessary for the modern actor to make an exact study of an abstruse subject, it is however proper to reflect that the delivery of rhetorical passages, in such a way as to make them interesting or exciting in themselves, was as much a part of the Chamberlain's Men's stock craft, as it was Shakespeare's to compose them. Shakespeare not infrequently, even in his mature plays, when his purely dramatic inspiration flags, falls back—as other artists will do, not only at the start of their career—upon his technique. A case in point is Juliet's cadenza on the sound "I", a *tour de force* compounded of word-play and rhetorical conceit. The Nurse, clumsily breaking the news that Romeo has killed Tybalt, gives the poor girl the impression that it is her newly-wed

[24] T. W. Baldwin says (*op. cit.*, 309 f): ". . . it is natural that Shakespeare's heroines should appear in cycles, not necessarily because Shakespeare was interested in that type of woman at that particular time but because he had the apprentice whose natural expression was that type of woman."

[25] I paraphrase Willcock, *A Companion to Shakespeare Studies* (Cambridge), 126.

[26] T. S. Eliot, *The Sacred Wood*, 31.

husband who is dead. Juliet, aged fourteen, expresses her grief in
these terms:

> Hath *Romeo* slaine himselfe? say thou but I,
> And that bare vowell I shall poyson more
> Then the death-darting eye of Cockatrice,
> I am not I, if there be such an I.
> Or those eyes shot [*read* shut], that makes thee answere I:
> If he be slaine say I, or if not, no.
> Briefe, sounds, determine of my weale or wo.[27]

As an expression of genuine feeling the passage fails, but the rhetoric
carries the scene forward without flagging, and it is not hard to
imagine the apprentice Juliet being "taught his scales" in rehearsal
of this passage. In the same vein the rhetorical excesses of Bassanio,
particularly the discourse on "ornament" while he ponders his
choice among the caskets, and the subsequent description of "Faire
Portias counterfeit" demand great skill from Burbadge:

> Here are sever'd lips
> Parted with suger breath, so sweet a barre
> Should sunder such sweet friends: here in her haires
> The Painter plaies the Spider, and hath woven
> A golden mesh t'intrap the hearts of men
> Faster than gnats in cobwebs: but her eies,
> How could he see to doe them? having made one,
> Me thinkes it should have power to steale both his
> And leave it selfe unfurnisht . . .[28]

It is because this virtuoso rôle of Burbadge's is so often given to an
inexperienced actor that the play seems lopsided: the neglect of the
lyrical-conceited-rhetorical element, contained largely in the speeches
of Bassanio, helps to give Shylock his overweight—after all, his part
is little longer than Bassanio's and much shorter than Portia's—and to
make the rest of the play (by an attempt at realistic interpretation) dull.

 King John, the companion of *The Merchant of Venice* (1596-7) in
Chambers's list,[29] is an interesting play in this respect. We have, side
by side with the moving sincerity of the mourning Constance, King
Philip's strained conceit:

> Binde up those tresses: O what love I note
> In the faire multitude of those her haires;
> Where but by chance a silver drop hath falne,
> Even to that drop ten thousand wiery fiends [*read* friends]
> Doe glew themselves in sociable griefe,
> Like true, inseparable, faithfull loves,
> Sticking together in calamitie.

[27] *Romeo and Juliet*, III. ii. 45 ff.
[28] *The Merchant of Venice*, III. ii. 73 ff ; 118 ff. [29] See Appendix I, p. 318.

We have, in the scene of the attempt to blind Arthur, a strange compound of genuine emotion, stirred by the situation but also expressed in some of the speeches and artificial conceits. The simplicity of Arthur's pleading:

> Will you put out mine eyes?
> These eyes, that never did, nor never shall
> So much as frowne on you—

and Hubert's straightforward reply:

> I have sworne to do it:
> And with hot Irons must I burne them out—

are followed by this complex fancy from the lips of the frightened boy:

> Ah, none but in this Iron Age, would do it:
> The Iron of it selfe, though heate red hot,
> Approaching neere these eyes, would drinke my teares,
> And quench this fierie indignation,
> Even in the matter of mine innocence:
> Nay, after that, consume away in rust,
> But for containing fire to harme mine eye:
> Are you more stubborne hard, then hammer'd Iron?

It is necessary to insist here that, whatever we think of the poet's device, it was—and still should be—part of the actor's job to give the rhetoric its full force. That even rhetorical conceits can be profoundly moving on the tongue of a fully-realised character is plain from the Bastard's words to Hubert as he sees the body of Arthur newly fallen from the Tarras:

> If thou didst but consent
> To this most cruell Act: do but dispaire,
> And if thou want'st a Cord, the smallest thred
> That ever Spider twisted from her wombe
> Will serve to strangle thee: A rush will be a beame
> To hang thee on. Or wouldst thou drowne thy selfe,
> Put but a little water in a spoone,
> And it shall be as all the Ocean,
> Enough to stifle such a villaine up.[30]

Compare this speech with the patterned incantations of Pembroke, Salisbury and Bigot in the same scene, and it may appear that a part of the secret of the Bastard's vitality is the rhythmical strength of his lines. Compare the Arthur-blinding scene with the scene of the blinding of Gloucester in *King Lear*—with its bullying iteration of "Wherefore to Dover?" [31]—and there is no doubt that the rhythm is

[30] *King John*, III. iv. 61 ff.; IV. i. 56 ff.; IV. iii. 125 ff. [31] *King Lear*, III. vii.

half the battle. The wonders of Shakespeare's rhythmical effects
have been the object of much study, and it has become clear that the
punctuation and lineation of the Quarto and Folio texts often pre-
serve for us a record of the poet's intention in this particular.[32]
Certainly, if one reads *Julius Caesar* in the Folio, one has the impres-
sion that the punctuation is mostly very good for speaking. The same
thing is true of the Folio version of Hamlet's first soliloquy—it is the
rhythm of Hamlet's soliloquies which is half the secret of their
vitality—and the subsequent dialogue with Horatio, Marcellus and
Barnardo. Othello's last speech is printed thus in the Folio:

> Soft you; a word or two before you goe:
> I have done the State some service, and they know't:
> No more of that. I pray you in your Letters,
> When you shall these unluckie deeds relate,
> Speake of me, as I am. Nothing extenuate,
> Nor set downe ought in malice.
> Then must you speake,
> Of one that lov'd not wisely, but too well:
> Of one, not easily Jealious, but being wrought,
> Perplexed in the extreame: Of one, whose hand
> (Like the base Iudean) [*read* Indian] threw a Pearle away
> Richer than all his Tribe: Of one, whose subdu'd Eyes,
> Albeit un-used to the melting moode,
> Drops teares as fast as the Arabian Trees
> Their Medicinable gumme. Set you downe this:
> And say besides, that in *Aleppo* once,
> Where a malignant, and a Turbond-Turke
> Beate a Venetian, and traduc'd the State,
> I tooke by th' throat the circumcised Dogge,
> And smoate him, thus.[33]

One is tempted to say that the highly dramatic rhythm of this speech
is unmistakable in the punctuation and lineation of the printed text.

It was the task, then, of the actors in Shakespeare's theatre to
study the rhythm of their speeches, with something of the care that
musicians bestow upon this element of their art. The poet taxed their
utmost resources; he asked them to do justice to the rhythm peculiar
to individual characters—the cringing, calculating, race-proud,
venomous utterance of Shylock; Hotspur's stumbling impetuosity;
two distinct types of Welsh lilt, Glendower's and Fluellen's; the con-
trast between the febrile persuasion of Cassius and the measured
gravity of Brutus' hesitation, with the dry cadences of the blunt

[32] The reader is once again referred to Percy Simpson's *Shakesperian Punctuation*,
and to Richard Flatter's *Shakespeare's Producing Hand*.
[33] *Othello*, V. ii. 337 ff.

Casca as a third voice in the trio—the list is endless, and the individuality of speech is largely compounded of characteristic rhythm. He asked them also to render rhythmically the change of mood in the course of a scene. Two boy actors must study the exquisitely judged transition from witty prose to romantic verse, in Viola's first embassy to Olivia: Viola leads the way with her comment on Olivia's face:

> Tis beauty truly blent, whose red and white,
> Natures owne sweet, and cunning hand laid on—

and Olivia follows suit, after a last attempt with the inventory of her beauty (in prose) to resist her romantic mood.[34] Brabantio, broken-hearted by Desdemona's elopement, accepts the *fait accompli* in wry couplets which parody the canting consolation of the Duke:

> But words are words, I never yet did heare:
> That the bruized heart was pierc'd through the eares—

then breaks abruptly into prose as he dismisses the theme:

> I humbly beseech you, proceed to th'Affaires of State.[35]

Kent's couplets put the brake on Lear's frenzy:

> Fare thee well King, sith thus thou wilt appeare,
> Freedome lives hence, and banishment is here.

Goneril's iambics—

> Not only Sir this, your all-lycenc'd Foole—

bring us sharply back to formality after the Fool's ungoverned prose. There is an opposite effect when, at the end of the tempestuous opening scene at King Lear's court, the wicked sisters scurry cynically into prose for the deliberate calculation of their intrigues.[36] The players had to study also and reproduce the eloquence of short lines, of calculated gaps in the rhythm, like the pauses or the silent bars of a musical score. Horatio's harrowed urgency as he confronts the illusion, the Ghost that looks so "like the King that's dead", is obscured in the lineation of the Folio: but the Second Quarto gives the actor plainer instructions:

> If thou hast any sound or use of voyce,
> Speake to me, if there be any good thing to be done
> That may to thee doe ease, and grace to mee,
> Speake to me.
> If thou art privie to thy countries fate
> Which happily foreknowing may avoyd
> O Speake:[37]

[34] *Twelfth Night*, I. v. 259 ff. [35] *Othello*, I. iii. 218 ff.
[36] *King Lear*, I. i. 183 f.; I. iv. 223 ff.; I. i. 286 ff. [37] *Hamlet*, I. i. 128 ff.

Cordelia's refusal to respond to her father's demand seems doubly obstinate in that it shatters the compulsive rhythm of the old King's speech:

> *Lear.* What can you say, to draw
> A third, more opilent then your Sisters? speake.
> *Cor.* Nothing, my Lord.
> *Lear.* Nothing?
> *Cor.* Nothing.
> *Lear.* Nothing will come of nothing, speake againe.[38]

Burbadge would no doubt urge forward the rhythm of his infatuate question: then Cordelia's curt answer, his indignant echo and her still more abrupt repetition are without bar-lines: only after the King has had time to recover his balance does the interrupted rhythm proceed again.

These are but the characteristic details of a practice which Shakespeare at his best sustained over long passages of dialogue. The prose-duets of Rosalind and Orlando, of Hal and Falstaff, of Beatrice and Benedick are continuously rhythmical, with a variety of pace and tread which can be felt even in reading from the printed page. To refresh the memory, the reader is referred to the mock wooing in *As You Like It*, to the rogues-in-buckram scene at the Boar's Head Tavern, and to the compound of raillery, tenderness and ferocity with which Beatrice, half confessing her love for Benedick, prompts him to revenge her cousin's dishonour.[39] Greater than these masterpieces, because in the tragic key, are the verse-duets of Othello and Iago—the two long movements, with but brief intermission, in which Iago lures Othello from secure happiness to savage despair—and of Macbeth and his Lady after his descent from the King's chamber with the words "I have done the deed" until the frenzied self-pitying cry of "Wake *Duncan* with thy knocking: I would thou could'st." [40]

It was not only the principals who were able to sustain such dialogue: the whole team were trained in this art. The long rhythm of concerted scenes is one of the glories of Shakespeare's maturest poetic drama. From the moment when Lear comes forth from his unsuccessful attempt to see Regan and Cornwall:

> Deny to speake with me?
> They are sicke, they are weary,
> They have travail'd all the night? meere fetches,—

[38] *King Lear*, I. i. 87 ff.
[39] *As You Like It*, IV. i. 70–231; 1 *Henry IV*, II. iv. 128 ff.; *Much Ado About Nothing*, IV. i. 257 ff.
[40] *Othello*, III. iii. 92–480; *Macbeth*, II. ii. 16–75.

to his desperate sally out into the storm—

<div style="text-align:center">O Foole, I shall go mad—</div>

the rhythmical tension is not once relaxed (not even by the poignant jesting of the Fool).[41] The last scene of *Othello* [42]—with its *adagio* opening, the terrified swiftness of Desdemona's last pleading, the momentary timeless pause before Aemilia is admitted, Desdemona's smothered cry, the splendid courage of Aemilia's "itterance" ("My Husband?" "My Husband say she was false?" "My Friend, thy Husband; honest, honest *Iago*"), the revelation of the murder, Aemilia's rounding on the Moor and her husband, her pathetic singing at her death, the revival of Othello ("Behold, I have a weapon") and his agony as he looks upon his dead wife, the obdurate silence of the convicted Iago, the valediction of Othello with the startling climax of his death—the unflagging tension of this whole scene makes a great rhythmical movement, as carefully devised for variety of pace and pause, and also *crescendo* and *diminuendo*, as a symphonic first movement of Beethoven. A performance of *Othello* needs to be almost operatic in conception, and it was not Burbadge only, but half a dozen of his colleagues, who must feel and reproduce these great rhythmical movements. If the Chamberlain's Men did not always rise to the height of their author's hopes, it was not, I think—as one sometimes suspects nowadays—for want of study and practice of this particular part of their technique.

It may be said that some scenes depend almost wholly on the rhetoric to sustain them. From the distance of the Study, Phillips and Burbadge held their audience in the fine but long scene in which Prince Hal takes the crown from the King's pillow.[43] The situation— the dying father, the son seemingly filching the crown, the question of whether the madcap Hal will rise to the stature of the Ideal King —is intrinsically dramatic. But the treatment is not, and this poetical and rhetorical handling of political commonplaces was a popular feature of the historical plays. We shall see, when in a later chapter we come to deal in detail with *Macbeth*, that the long conversation between Malcolm and Macduff at the English court is another such exercise in rhetoric. Other scenes depend for their motive power upon witty conversation: such are the battle of wits between Beatrice and Benedick in the early exchanges of *Much Ado About Nothing*, and the first appearance of Prince Hal and Falstaff in the exposition of 1 *Henry IV*. To both rhetoric and wit, rhythm is usually an indispensable ally, and often if the rhythm of the dialogue is neglected, the play is marred. Listen how Leonato offers his daughter

[41] *King Lear*, II. iv. 89–289. [42] *Othello*, V. ii. [43] 2 *Henry IV*, IV. v. 90–223.

Hero to the Count Claudio in marriage: Beatrice, her cousin, is present, and also the gallant Prince Pedro:

> *Leona.* Count, take of me my daughter, and with her my fortunes: his grace hath made the match, & all grace say, Amen to it.
>
> *Beatr.* Speake Count, tis your Qu.
>
> *Claud.* Silence is the perfectest Herault of joy, I were but little happy if I could say, how much? Lady, as you are mine, I am yours, I give away my selfe for you, and doat upon the exchange.
>
> *Beat.* Speake cosin, or (if you cannot) stop his mouth with a kisse, and let not him speake neither.
>
> *Pedro.* Infaith Lady you have a merry heart.
>
> *Beatr.* Yea my Lord I thanke it, poore foole it keepes on the windy side of Care, my coosin tells him in his eare that he is in my [*read* her] heart.
>
> *Clau.* And so she doth coosin.
>
> *Beat.* Good Lord for alliance: thus goes every one to the world but I, and I am sun-burn'd, I may sit in a corner and cry, heigh ho for a husband.
>
> *Pedro.* Lady *Beatrice*, I will get you one.
>
> *Beat.* I would rather have one of your fathers getting: hath your Grace ne're a brother like you? your father got excellent husbands, if a maid could come by them.
>
> *Prince.* Will you have me? Lady.
>
> *Beat.* No, my Lord, unlesse I might have another for working-daies, your Grace is too costly to weare everie day: but I beseech your Grace pardon mee, I was borne to speake all mirth, and no matter.
>
> *Prince.* Your silence most offends me, and to be merry, best becomes you, for out of question, you were born in a merry howre.
>
> *Beatr.* No sure my Lord, my Mother cried, but then there was a starre daunst, and under that was I borne: cosins God give you joy.[44]

Between the lines of this dialogue, the rapturous hesitation of Claudio, the eloquent silence of Hero (who never speaks), the impetuous wit of Beatrice, with its undertone of affectionate envy of the lovers, its impulsive apology to the Prince, its sweet change of mood as she speaks of her birth—"No sure my Lord, my Mother cried, but then there was a starre daunst, and under that was I borne"—these are effects which can only come to spontaneous life by careful rehearsal.

Pure music of speech is the essence of such "set pieces" as the opening of the last scene in *The Merchant of Venice:*

> . . . in such a night
> *Troylus* me thinkes mounted the Trojan walls . . .

or the lyrical distraction of Silvius in *As You Like It:*

> If thou remembrest not the slightest folly,
> That ever love did make thee run into,
> Thou hast not lov'd——

[44] *Much Ado About Nothing,* II. i. 315 ff.

or the measured quartet from the same play:

> *Phe.* Good shepheard, tell this youth what 'tis to love
> *Sil.* It is to be all made of sighes and teares,
> And so am I for *Phebe*.
> *Phe.* And I for *Ganimed*.
> *Orl.* And I for *Rosalind*.
> *Ros.* And I for no woman.[45]

Here the dialogue is as musical as a song. There are whole plays, such as *Love's Labour's Lost* and *The Merchant of Venice*, which depend very largely on a relish for the music of words in the audience, and which demand therefore an unusual skill in performing the music of words; and this together with the other vocal skills of the Chamberlain's Men makes the most important element of their technique: their art, we must never cease to remind ourselves—at least when they were interpreting Shakespeare—was the art of the poetic drama.

(ii) Miming

The present revival on the stage of athletic activity, especially in the single combats, is a welcome change from the perfunctory "one, two, and the third in your bosom" of ten years ago. It is certainly in the tradition of the Chamberlain's Men, whose audiences relished a display of martial vigour and skill, and were accustomed to such sights as Burbadge's twenty-six-year-old Orlando wrestling and carrying Shakespeare on his back, and Falstaff also twice a performance shouldering Hotspur in full armour, and Puck breaking records for speed, and the angry Roman mob lynching Cinna, and witches vanishing by trap-doors, and (as the crowning marvel) Ariel flying from the Heavens on a wire. The mere size of the stage would invite an all-out chase as the lovers quarrel in the Athenian wood, and in a pitched battle or in the storming of the Tarras we may be sure that the armies did not hold their punches.

But it is plain that the miming of the Chamberlain's Men must have gone much further than athletic skill and a willingness to take an active part in a scene of riot, revelry or battle. To create some of the effects which Shakespeare asked of them, they needed the art of Ruth Draper or Jean-Louis Barrault—the pure art of make-believe, of making us believe that we see things which are not there. And this art must have been studied and practised not by the principals alone, but by every member of the company: it must have been part of the

[45] *The Merchant of Venice*, V. i. 3 f.; *As You Like It*, II. iv. 34; V. ii. 90 ff.

You are now within a foote of th'extreme Verge

tradition, and the result such teamwork of expressive mime as our generation have seen perhaps only in the performances of the *Compagnie des Quinze*. It was a common practice with the Chamberlain's Men to act a night scene on the day-lit stage. It might be the "black brow of night" in which Hubert seeks out the Bastard to give him "newes fitting to the night, Blacke, fearefull, comfortlesse, and horrible" [46]; or it might be the "soft stilnes" of the night in which Lorenzo and Jessica listen to the "musicke of the house" [47]; or the "perillous" night in which Cassius and Casca meet, "when the crosse blew Lightning seem'd to open The Brest of Heaven".[48] Each would require a different physical reaction from the players on the bare Platform. If Burbadge had the difficult task of creating in mid-air his "Dagger of the Minde", another actor, Lowin, must make us see the flight of the swallow as it swoops across the playhouse yard to its "pendant Bed, and procreant Cradle" in the imaginary buttresses of the Tiring-House façade.[49] So too Cassius (Phillips) must make us feel with the doomed army of the conspirators that

> Ravens, Crowes, and Kites
> Fly ore our heads, and downward looke on us
> As we were sickely prey; their shadowes seeme
> A Canopy most fatall, under which
> Our Army lies, ready to give up the Ghost.[50]

At least eight of the company could make the flat stage seem like the steep slope of Gads Hill—the slope which causes Falstaff so much trouble when his horse is removed by Poins, and down which the luckless travellers walk to ease their legs.[51] One thinks of the skilled

[46] *King John*, V. vi. 17 ff.
[48] *Julius Caesar*, I. iii. 47 ff.
[50] *Julius Caesar*, V. i. 85 ff.
[47] *The Merchant of Venice*, V. i. *init*.
[49] *Macbeth*, II. i. 33 ff.; I. vi. 3 ff.
[51] 1 *Henry IV*, II. ii. See below, pp. 203 f.

miming which preserves for so long the illusion of storm in *King Lear;* of the miracle at Dover Cliff when Edgar persuades his blind father to hurl himself down a precipice which is not there [52]; of Macbeth and Banquo on their first appearance thrusting their way head-down through foul weather, and dimly glimpsing the weird sisters through the fog and filthy air.[53] These effects with little scenic aid demand the expressive movement of dancers, and one fancies that Shakespeare's colleagues must have been very cunning in the art of mime.

A familiar feature of Shakespeare's drama is the re-enacting of an episode in pantomime by an actor. We may have seen this episode ourselves already, in which case the re-enaction is a commentary on what we have seen. Immediately after the rehearsal of the mechanicals in the wood, with Bottom's translation and Titania's awakening, Puck gives a circumstantial report to Oberon of how "My Mistris with a monster is in love". Each incident of the episode we have just witnessed is mimed for us with an extra twist of satire by the mischievous contriver.[54] Benvolio's account to Prince Escalus of the fray in which Mercutio and Tybalt were slain, sharpens our appreciation of the horrible dilemma which confronted Romeo. No doubt the player would recreate for our benefit Romeo's "calme looke, knees humbly bow'd", and "the unruly spleene Of *Tybalts* deafe to peace", and give us Mercutio

> Who all as hot, turnes deadly point to point,
> And with a Martiall scorne, with one hand beates
> Cold death aside, and with the other sends
> It back to *Tybalt*, whose dexterity
> Retorts it: . . .

We should see Romeo as he "beats downe their fatall points", and the "envious thrust" of Tybalt under Romeo's intervening arm: then the climax of the return of Romeo to revenge Mercutio's death.[55] A similar recital but given with a malign rather than friendly intent, is Iago's recapitulation of the brawl in which Cassio has lost his reputation. The villain interprets what we have just seen in such a way as to ensure Cassio's disgrace, but so subtly is the story presented that Othello says:

> I know *Iago*
> Thy honestie, and love doth mince this matter,
> Making it light to *Cassio.*

[52] *King Lear,* III. i., ii. and iv.; IV. vi. See below, pp. 204 f.
[53] *Macbeth,* I. iii. 38 ff. [54] *A Midsummer Night's Dream,* III. ii. 6 ff.
[55] *Romeo and Juliet,* III. i. 158 ff.

This trick of commenting on and interpreting the action of the play
in speech is a point to which we shall return on a later page.[56] For
the present purpose, it is enough to observe that Iago's account is
highly circumstantial and is recreated for Othello's benefit and ours
in lively mime.[57]

More often, however, the episode re-enacted in speech and mime
is one which we have *not* seen but which is important in the run of
the plot. Salarino's account of the parting of Anthonio and Bassanio
is such a narrative: the player would show us the action of the kind,
melancholy merchant, as he speaks the cadence:

> And even there his eye being big with teares,
> Turning his face, he put his hand behinde him,
> And with affection wondrous sencible
> He wrung *Bassanios* hand, and so they parted.

Earlier in the same scene, which consists entirely of narration, we
have Solanio's account of Shylock's tragi-comic distress at Jessica's
elopement:

> My daughter, O my ducats, O my daughter,
> Fled with a Christian, O my Christian ducats!

Shylock himself in this condition we are to see in a later scene, but
the clever miming parody of Solanio kindles our anticipation.[58]
Hotspur's caricature of Bolingbroke—

> Why what a caudie [*read* candie] deale of curtesie,
> This fawning Grey-hound then did proffer me.
> Looke when his infant Fortune came to age,
> And gentle *Harry Percy*, and kinde Cousin:
> O, the Divell take such Couzeners . . .

re-enacts a conversation in *Richard II*, but we may not have seen, or
may not remember, the earlier play.[59] The episode and the attitude
make themselves vivid enough in Hotspur's contemptuous burlesque.
A capital example of such miming is Harry Percy's brilliant pre-
sentation of the aftermath of Holmedon field, how he was "so
pestered with a Popingay" that he answered neglectingly the King's
demand for the surrender of his prisoners.[60] Other instances occur to
mind at random—an anonymous Lord's account of Jaques and the
"poore sequestred Stag" [61]; Cassius' two pictures of Caesar's "feeble

[56] See below, pp. 215 f., 228 f. [57] *Othello*, II. iii. 222 ff.
[58] *The Merchant of Venice*, II. viii. 35 ff.; 12 ff.
[59] 1 *Henry IV*, I. iii. 251 ff.; *Richard II*, II. iii. 45 ff.
[60] 1 *Henry IV*, I. iii. 29 ff. [61] *As You Like It*, II. i. 29 ff.

temper", swimming in the Tiber, and fever-stricken in Spain [62]; Casca's sarcastic tale of Caesar's "swound" in the market-place [63]; Malvolio's daydream of himself after three months of marriage with Olivia—"sitting in my state. . . . Calling my Officers about me, in my branch'd Velvet gowne . . ." ("looke how imagination blowes him," says Fabian, and we can see Phillips, who was also Cassius, revelling in the opportunity for mime) [64]; the boy Ophelia's description of Hamlet's distracted visit:

> He tooke me by the wrist, and held me hard;
> Then goes he to the length of all his arme;
> And with his other hand thus o're his brow,
> He fals to such perusall of my face,
> As he would draw it. Long staid he so,
> At last, a little shaking of mine Arme:
> And thrice his head thus waving up and downe;
> He rais'd a sigh, so pittious and profound,
> That it did seeme to shatter all his bulke,
> And end his being. That done, he lets me goe,
> And with his head over his shoulders turn'd,
> He seem'd to finde his way without his eyes,
> For out adores he went without their helpe;
> And to the last, bended their light on me. [65]

In all these cases—and there are many more—the player's ability to mime his story is an essential part of the poet's conception. It will be noticed that the demand is made upon the supporting actors as much as upon the principals.

We may add an occasional *tour de force* such as the charades in the Boar's Head Tavern, where Falstaff first stands for the King taking his son to task, and then, the parts exchanged, Hal plays his father, and Falstaff tickles us for a young Prince [66]; or the grim, tragic equivalent when Lear arraigns Goneril in the person of a joint-stool before a bench of justices consisting of the disguised Kent, the Fool and Tom o' Bedlam [67]; or Jaques' cadenza of the seven ages of man (imagine a Barrault giving us the whole gallery in succession) [68]; or Armin holding conversation between Feste and Sir Thopas outside Malvolio's prison [69]; or Ophelia's mad scenes [70]; or Lady Macbeth's sleepwalking, when (as we shall see on a later page) the boy-actor with his miming must re-evoke the horrors of the play in memory. [71]

[62] *Julius Caesar*, I. ii. 100 ff.
[64] *Twelfth Night*, II. v. 50 ff.
[66] 1 *Henry IV*, II. iv. 418 ff.
[68] *As You Like It*, II. vii. 139 ff.
[70] *Hamlet*, IV. v.

[63] *Julius Caesar*, I. ii. 234 ff.
[65] *Hamlet*, II. i. 87 ff. See above, p. 57.
[67] *King Lear*, III. vi. 38 ff.
[69] *Twelfth Night*, IV. ii. 21 ff.
[71] *Macbeth*, V. i. See below, pp. 305 f.

If it is true that the Chamberlain's Men practised their tongues to give life to the imagery, so also must they have called in gesture and movement for the same end. Few actors or producers on the modern stage seem to realise the need or the possibility of such mimetic interpretation of the imagery. Sometimes, indeed, no gesture suggests itself, and there is a danger of overdoing the method: nevertheless, it would be helpful if Friar Lawrence made a comment with his hands to bring his comparison to life, as he said:

> These violent delights have violent endes,
> And in their triumph: die like fire and powder;
> Which as they kisse consume. [72]

Puck can enrich his narrative of the panic when Bottom appeared among his fellows with the Ass-head, by acting his simile:

> when they him spie,
> As Wilde-geese, that the creeping Fowler eye,
> Or russed-pated choughes, many in fort
> (Rising and cawing at the guns report)
> Sever themselves, and madly sweepe the skye:
> So at his sight, away his fellowes flye . . . [73]

When Worcester suggests to his daredevil nephew a plot which shall be

> As full of perill and adventurous Spirit,
> As to o're walke a Current, roaring loud
> On the unstedfast footing of a Speare—

he must create for us the roaring torrent and the spear-bridge by voice and gesture; and Hotspur in making his impetuous response:

> If he fall in, good night, or sinke or swimme—

must show with his whole body the toppling balance and the desperate plunge. [74] One could multiply examples, each to be studied on its merits, many perhaps controversial and only to be approved in practice, if the actor can bring them off. But I hazard the suggestion that, just as the actor must sometimes use his voice "out of character", so too it is often more important for him to be using his powers of mime to interpret the imagery than to be making a realistic gesture or movement appropriate to his assumed character.

That Shakespeare knew the difference between good and bad miming appears from more than one passage in the plays; most vividly, perhaps, in Buckingham's boast:

[72] *Romeo and Juliet*, II. vi. 9 ff. The folio's colon seems to obscure the sense.
[73] *A Midsummer Night's Dream*, III. ii. 20 ff.
[74] 1 *Henry IV*, I. iii. 191 ff.

what we are used to on the picture stage. The effect of the shape, dimensions and central forward position of the Platform is easily felt in practice, but harder to convey on paper. Nevertheless, until the Globe is rebuilt and in continual use, we must strive to win converts with a paper exposition of its merits.

We can begin by stating the difference geometrically with a comparison of diagrams:

Fig. (a) *Fig. (b)*

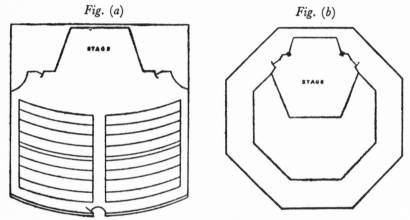

Diagrams contrasting the Globe Platform and the Picture-Stage

It is plain at once

(i) that the angle of vision reduces the impression of depth to a minimum in *Fig. (a)*, giving an image flat like a picture: but magnifies the impression of depth in *Fig. (b)*, so as to produce a feeling of three dimensions, like sculpture. The result is that the Globe stage not only *is* a little deeper than most modern stages, but also *seems* (which is more important) very much deeper;

(ii) that whereas the bane of the picture-stage is "masking", there is very little of that danger in *Fig. (b)*; indeed, a figure on the forward edge of the Globe Platform will in practice hardly ever obscure a figure up-stage;

(iii) the outer limits of vision allowed by the sight-lines because of the proscenium in *Fig. (a)* make a tapering effect of the opposite kind from that in *Fig. (b)*: the result is that the stage and even the play are, as it were, turned inside out, with an enfeebling effect upon much of the grouping, as will appear in what follows.

The most immediate and obvious effect of the ground-plan of the Globe is the real sense of distance, not only across the Platform, but

> Tut, I can counterfeit the deepe Tragedian,
> Speake, and looke backe, and prie on every side,
> Tremble and start at wagging of a Straw:
> Intending deepe suspition, gastly Lookes
> Are at my service, like enforced Smiles.[75]

The other side of the picture appears in the exhibition given by the First Player in his Pyrrhus-Hecuba speech, and more especially in Hamlet's comment—

> Is it not monstrous that this Player heere,
> But in a Fixion, in a dreame of Passion,
> Could force his soule so to his whole conceit,
> That from her working, all his visage warm'd [read wanned],
> Teares in his eyes, distraction in's Aspect,
> A broken voyce, and his whole Function suiting
> With Formes, to his Conceit? [76]

The man acts with his whole body: this is surely what the poet would have his players do.

If we return once more to consider the "Messenger's Speeches" mentioned above,[77] we find that many of these can be illuminated by the miming of the players, but that some are mostly vocal in their means of expression: as Shakespeare develops his art towards the maturity of the great tragic period, the speech becomes more important and more powerful, and carries more of the dramatic responsibility. As one thinks of the death of Ophelia, of the un-varnished tale of Othello's whole course of love, of the anonymous Gentleman's account of Cordelia's grief at hearing of her father's sufferings, of the bleeding Captaine's speech in *Macbeth*, of Eno-barbus' famous description of Cleopatra in her barge, of Ariel's account of the shipwreck he has caused [78]—one recognises a kind of speech-miming, a drama whose medium is almost wholly the voice, demanding the utmost skill on the part of the actors and—be it noted—finding a much more vivid reality of expression on the un-localised Platform of the Globe than on a picture-stage competing through the eye for the imaginative attention of the audience.

(iii) Positioning

Both the technique of the actors and the impression received by the audience were radically different in the Globe Playhouse from

[75] *Richard III*, III. v. 5 ff. [76] *Hamlet*, II. ii. 585 ff. [77] pp. 107 f.
[78] *Hamlet*, IV. vii. 167 ff.; *Othello*, I. iii. 128 ff.; *King Lear*, IV. iii. 13 ff.; *Macbeth*, I. ii. 7 ff.; *Antony and Cleopatra*, II. iii. 198 ff.; *The Tempest*, I. ii. 195 ff.

If it is true that the Chamberlain's Men practised their tongues to give life to the imagery, so also must they have called in gesture and movement for the same end. Few actors or producers on the modern stage seem to realise the need or the possibility of such mimetic interpretation of the imagery. Sometimes, indeed, no gesture suggests itself, and there is a danger of overdoing the method: nevertheless, it would be helpful if Friar Lawrence made a comment with his hands to bring his comparison to life, as he said:

> These violent delights have violent endes,
> And in their triumph: die like fire and powder;
> Which as they kisse consume.[72]

Puck can enrich his narrative of the panic when Bottom appeared among his fellows with the Ass-head, by acting his simile:

> when they him spie,
> As Wilde-geese, that the creeping Fowler eye,
> Or russed-pated choughes, many in fort
> (Rising and cawing at the guns report)
> Sever themselves, and madly sweepe the skye:
> So at his sight, away his fellowes flye . . .[73]

When Worcester suggests to his daredevil nephew a plot which shall be

> As full of perill and adventurous Spirit,
> As to o're walke a Current, roaring loud
> On the unstedfast footing of a Speare—

he must create for us the roaring torrent and the spear-bridge by voice and gesture; and Hotspur in making his impetuous response:

> If he fall in, good night, or sinke or swimme—

must show with his whole body the toppling balance and the desperate plunge.[74] One could multiply examples, each to be studied on its merits, many perhaps controversial and only to be approved in practice, if the actor can bring them off. But I hazard the suggestion that, just as the actor must sometimes use his voice "out of character", so too it is often more important for him to be using his powers of mime to interpret the imagery than to be making a realistic gesture or movement appropriate to his assumed character.

That Shakespeare knew the difference between good and bad miming appears from more than one passage in the plays; most vividly, perhaps, in Buckingham's boast:

[72] *Romeo and Juliet*, II. vi. 9 ff. The folio's colon seems to obscure the sense.
[73] *A Midsummer Night's Dream*, III. ii. 20 ff.
[74] 1 *Henry IV*, I. iii. 191 ff.

temper", swimming in the Tiber, and fever-stricken in Spain [62];
Casca's sarcastic tale of Caesar's "swound" in the market-place [63];
Malvolio's daydream of himself after three months of marriage with
Olivia—"sitting in my state. . . . Calling my Officers about me, in
my branch'd Velvet gowne . . ." ("looke how imagination blowes
him," says Fabian, and we can see Phillips, who was also Cassius,
revelling in the opportunity for mime) [64]; the boy Ophelia's descrip-
tion of Hamlet's distracted visit:

> He tooke me by the wrist, and held me hard;
> Then goes he to the length of all his arme;
> And with his other hand thus o're his brow,
> He fals to such perusall of my face,
> As he would draw it. Long staid he so,
> At last, a little shaking of mine Arme:
> And thrice his head thus waving up and downe;
> He rais'd a sigh, so pittious and profound,
> That it did seeme to shatter all his bulke,
> And end his being. That done, he lets me goe,
> And with his head over his shoulders turn'd,
> He seem'd to finde his way without his eyes,
> For out adores he went without their helpe;
> And to the last, bended their light on me. [65]

In all these cases—and there are many more—the player's ability to
mime his story is an essential part of the poet's conception. It will
be noticed that the demand is made upon the supporting actors as
much as upon the principals.

We may add an occasional *tour de force* such as the charades in the
Boar's Head Tavern, where Falstaff first stands for the King taking
his son to task, and then, the parts exchanged, Hal plays his father,
and Falstaff tickles us for a young Prince [66]; or the grim, tragic
equivalent when Lear arraigns Goneril in the person of a joint-stool
before a bench of justices consisting of the disguised Kent, the Fool
and Tom o' Bedlam [67]; or Jaques' cadenza of the seven ages of man
(imagine a Barrault giving us the whole gallery in succession)[68]; or
Armin holding conversation between Feste and Sir Thopas outside
Malvolio's prison [69]; or Ophelia's mad scenes [70]; or Lady Macbeth's
sleepwalking, when (as we shall see on a later page) the boy-actor
with his miming must re-evoke the horrors of the play in memory.[71]

[62] *Julius Caesar*, I. ii. 100 ff.
[64] *Twelfth Night*, II. v. 50 ff.
[66] 1 *Henry IV*, II. iv. 418 ff.
[68] *As You Like It*, II. vii. 139 ff.
[70] *Hamlet*, IV. v.

[63] *Julius Caesar*, I. ii. 234 ff.
[65] *Hamlet*, II. i. 87 ff. See above, p. 57.
[67] *King Lear*, III. vi. 38 ff.
[69] *Twelfth Night*, IV. ii. 21 ff.
[71] *Macbeth*, V. i. See below, pp. 305 f.

also between the forward (down-stage) and backward (up-stage) positions, making one group seem close to us in the audience, another remote. This, be it noticed, is the effect not only of the size but also of the central position of the platform. The impression of near and far, of perspective, makes lively sense of many scenes which are in danger of awkwardness on our picture-stage. Thus outside Flint Castle, Northumberland acts as ambassador going backwards and forwards between Bolingbroke, standing presumably outside one of the forward Stage-Posts, and Richard on the Tarras. When Richard descends with bitter humility to the "base Court", Bolingbroke bids his company "Stand all apart", and himself converses privately with the King: the two must be central and forward, the rest up-stage, close to the Tiring-House.[79] At the first interview between the Jew and the Merchant in *The Merchant of Venice*, Shylock makes a deliberate pretence of not seeing Antonio: the savage aside—"How like a fawning publican he lookes"—must be spoken right at the front of the Platform, while Bassanio goes up-stage to prompt his friend. Bassanio, returning, comes forward towards Shylock, who only after five or six lines "recognises" and greets Antonio: "Rest you faire good signior, Your worship was the last man in our mouthes."[80] So too Caesar's prolonged comment on "that spare *Cassius*" gains greatly in effectiveness by the opportunity of three-cornered grouping afforded by the Globe Platform: the dictator, irritable after his fit in the market-place, calls Antony to his side in front of one of the Stage-Posts; the "chidden Traine" of his companions linger close to the stage-door through which he has just entered; Cassius and Brutus, who have held their long conversation during Caesar's absence, are all the width and depth of the stage away from the rest, so that the words "Yond *Cassius* has a leane and hungry looke" put no strain upon the imagination of the audience.[81] Likewise the moment of panic outside the Capitol when Popilius Lena whispers to the conspirators "I wish your enterprize to day may thrive" is easy to plot on this Platform with the maximum of dramatic effect: we shall examine this scene in close detail at the end of this chapter.[82] We have already dealt with the moments in the battle of Philippi where the depth of the Platform adds pathos to the discovery of the dead bodies of Cassius and Titinius, and to the solitary figure of Strato standing like a sentinel beside the fallen Brutus.[83] In the graveyard scene Hamlet and Horatio enter *a farre*

[79] *Richard II*, III. iii. 72–end. [80] *The Merchant of Venice*, I. iii. 41 ff.
[81] *Julius Caesar*, I. ii. 189 ff.
[82] *Julius Caesar*, III. i. 13 ff. See below, pp. 175 ff.
[83] See above, pp. 95 f.

off. If the grave is in the centre of the Study (the grave-trap), then the Prince and his friend will hold their subsequent conversation in front of one of the Stage-Posts—that is to say, quite close to their audience, as is appropriate to their reflective comment. When they stand aside as the funeral approaches, they presumably hide by the doorposts on the opposite side to the procession's entry.[84] Cassio

Yond Cassius has a leane and hungry looke

asking Desdemona to intercede for him, takes a hurried leave on the approach of Othello: Iago pounces on his opportunity:

> *Iago.* Hah? I like not that.
> *Othel.* What dost thou say?
> *Iago.* Nothing my Lord; or if—I know not what.
> *Othel.* Was not that *Cassio* parted from my wife?
> *Iago.* *Cassio* my Lord? No sure, I cannot thinke it
> That he would steale away so guilty-like,
> Seeing your comming.
> *Othel.* I do beleeve 'twas he.
> *Des.* How now my Lord?
> I have bin talking with a Suitor heere,
> A man that languishes in your displeasure.
> *Othel.* Who is't you meane?
> *Des.* Why your Lieutenant *Cassio*: [85]

Othello and Iago have come swiftly through one door towards the nearest Stage-Post: Iago's embarrassed whispers are as close to the

audience's ear as to Othello's; Desdemona and Aemilia are meanwhile beside the other door through which Cassio has made his over-hasty departure.

Sometimes the sense of remoteness afforded by the Chamber or the Study helps the interpretation of a scene. Cranford Adams sets the blinding of Gloucester in the Chamber.[86] Certainly the horror would be more tolerable at that distance; for perhaps even the proverbial callousness of the Elizabethans might have been jolted if Cornwall had perpetrated his savagery in their midst; the objective detail of the spoken dialogue and the brutal rhythm of the verse make no bones about the barbaric business, but there is a saving grace of detachment for the audience if the physical action is set remotely up aloft. I imagine that the chair to which Gloucester's tormentors "Binde fast his corky armes" would have its back set against the middle of the Tarras rail, so that the old man's face would be invisible to us, but the onslaught facing the audience would be made through him upon us as well. A different, but no less justly calculated, effect is contrived in the scene of the murder of Clarence in *Richard III*.[87] Here there is a long and deliberately comic exchange between the two murderers—played presumably by two of the company's comic gang, who otherwise have little employment in this play—while their unwitting victim lies asleep. The incongruity of this vaudeville-turn, intervening between Clarence's eloquent and tragic nightmare and his unavailing pleading and murder, is an almost insoluble problem for the modern producer. The difficulty hardly exists if Clarence sleeps remotely in the Study, while the comedians play their ghoulish comedy at the front of the Platform. The sudden change of mood when Clarence wakes and advances on to the Platform seems then a natural transition and the tragedy is even heightened by the contrast.

The Stage-Posts have an important influence on the positioning of the actors: for they seem to give a kind of perspective to the Platform itself. Outside them there is a semicircular perimeter, leading by a roundabout tour from one doorway to the other; inside them an inner central area, seeming more distant than the perimeter though less remote than the Tiring-House, its various stages and its immediate vicinity. The convenience of this deep perspective is seen in many different circumstances. Romeo, on his way to the Capulets' ball, declares his intention of carrying a torch and not dancing. He sticks to this plan, for this is how he is employed when he first catches sight of Juliet.

[86] *King Lear*, III. vii. 28 ff. See J. Cranford Adams, *The Original Staging of King Lear*, 326. [87] *Richard III*, I. iv. 84 ff.

> *Rom.* What ladie is that which doth inrich the hand
> Of yonder Knight?
> *Ser.* I know not sir.
> *Rom.* O she doth teach the Torches to burne bright . . .

The dance, in which Juliet is taking her part, is in progress in the central area: Romeo, torch in hand, questions the servant on the perimeter. Tybalt's indignant argument with Capulet is also outside the Stage-Posts. But when Romeo addresses himself to Juliet, he probably joins her in the dance within, and the formal gallantry of their first conversation is spoken to the measure of the music.[88] A scene in *Much Ado About Nothing* presents an interesting variant on this theme: there the dance takes place off-stage, but we are shown the Maskers walking about with their partners *before* the music strikes up. In the game of mistaken identity, the ladies have the advantage. There are four pairs, and presumably the formal parade round the perimeter brings each pair in turn to the front central point of the Platform for their *tête-à-tête*. The pace of their walking must match the dialogue: Beatrice and Benedick, who come last and speak the most, linger in their progress: when the music begins, Claudio is left behind, at a distance from Don John and Borachio.[89] A similar manœuvre, but without the conversational interest, is indicated by the Folio direction when the Montagues approach the festive house of Capulet: *They march about the Stage.*[90] A circular tour of the perimeter is the technical basis of the scene in *Troilus and Cressida* where the Greek heroes "put on A forme of strangenesse" as they pass along in front of the tent of Achilles. Achilles and Patroclus stand in the entrance of the tent—that is to say, in a gap of the Study curtains. The Greeks, making the circuit of the perimeter, "passe by strangely", either ignoring them or with disdainful air, and so go out by one of the stage-doors. Ulysses, coming last in the queue, delays his progress by reading a book, while Achilles speaks his twenty lines.[91]

One remarkable result of the central position of the Platform in relation to the auditorium can best be illustrated from scenes of waylaying and ambush. At Gads Hill Prince Hal and Poins, disguised in their buckram suits, lie in wait to rob the robbers: Falstaff and his gang, after driving their victims out of sight, return to the Platform to share the booty. Now in Shakespeare's playhouse the Prince and Poins will hide outside the two Stage-Posts, that is to say,

[88] *Romeo and Juliet*, I. v. 45 ff.

[89] *Much Ado About Nothing*, II. i. 90 ff. An earlier example of the same pattern of four pairs can be seen in *Love's Labour's Lost*, V. ii. 212 ff.

[90] *Romeo and Juliet*, I. iv. 115. [91] *Troilus and Cressida*, III. iii. 38 ff.

in the front of the Platform close to the groundlings: the dramatic effect of their hiding is thus doubled, for we too in the audience seem to be lying in wait to pounce on Falstaff.[92] So, too, the murderers of Banquo will lurk in the shadow of the Stage-Posts, and we with them will twitch a dagger behind our backs as "neere approches The subject of our Watch".[93]

The deep and wide perspective of the playhouse helps the actors when there is a shifting of dramatic emphasis from one group to another. For instance, in *The Two Gentlemen of Verona*, Proteus for his own ends is helping the foolish Thurio to serenade Silvia in one of the window-stages: his faithful Julia, seeking him in the disguise of a page, has found him in the very moment of his infidelity: there follows a moving dialogue, charged with pathetic irony, between Julia and the innkeeper who has befriended her. The emphasis shifts from the pair of them to the serenade and back again; and it seems plain that the whispered conversation is held close to the audience at the front of the Platform while the musicians and Thurio and the faithless Proteus are under Silvia's window. After some time, Julia says hurriedly: "Peace, stand aside, the company parts," and while she and the Host retreat to the opposite door, Proteus and Thurio advance down-stage to capture the attention of the audience.[94] A characteristic grouping can be seen in the prelude to Philippi in *Julius Caesar* when, after the cross-stage wrangle between the opposing parties, "The Storme is up, and all is on the hazard." Brutus takes Lucilius aside and we do not hear their conversation; Cassius calls Messala to him and tells him of his superstitious foreboding. The emphatic conversation is right forward on the Platform, the incidental one behind: it would be impossible to look beyond a nearer group to a more distant one, and still seem to hear them in intimate discussion.[95] A very interesting example is the critical moment when Troilus, conducted by Ulysses, is a witness of Cressida's dalliance with Diomed. All four are on the Platform: Troilus and Ulysses stand "where the Torch may not discover us", and the indignant outbursts of the betrayed lover are suppressed to whispers by his Greek escort: Cressida and Diomed, unconscious of their audience, are not at pains to hush their speech. It is plain that their amorous duet is up-stage, while the hidden eavesdroppers are right forward and close to the groundlings: from this position it is easy for them to fulfil their author's purpose—for though talking in whispers, they speak as freely and as fully as the other two. On the

[92] 1 *Henry IV*, II. ii. 102 ff.
[93] *Macbeth*, III. iii.
[94] *Two Gentlemen of Verona*, IV. ii. 28 ff.
[95] *Julius Caesar*, V. i.

picture-stage the length of the "aside" dialogue is an embarrass-
ment: on Shakespeare's stage it is simply effective.[96]

That "asides" were not always spoken from the forward position
is clear from two scenes of eavesdropping in *Much Ado About Nothing*
—and it is to be expected of the brilliant opportunism of Shakespeare
(and, indeed, of his profession) that there will be no rigid rules of
stage-practice that cannot be broken to suit a particular set of
circumstances. The match-makers' plot induces both Benedick and
Beatrice to overhear a conversation deliberately staged for their
enlightenment. Benedick, spying the approach of the Prince with
Leonato and Claudio, betakes him to "the Arbor", which is pre-
sumably set in the Study. After a song calculated to put the sceptic
(in spite of his protestations to the contrary) in melting mood, the
conspirators approach their prey: "Stalke on, stalke on," whispers
Claudio, "the foule sits." There follows a long circumstantial tale of
Beatrice's concealed love for Benedick, punctuated by occasional
whispered comments on Benedick's reception of the news, and a rare
interjection from Benedick himself. I fancy that the conspirators hug
one doorway, while their quarry is at the opposite end of the Study
"in the Arbor". Then, when their work is done, Leonato says to the
Prince, "My Lord, will you walke? dinner is ready." The two
ensuing speeches, delivered so that Benedick cannot hear their
further plotting, must be spoken as the three conspirators tour the
perimeter of the Platform to depart by the opposite door. The ladies'
half of the conspiracy is conducted on exactly similar lines: Hero says

> looke where *Beatrice* like a Lapwing runs
> Close by the ground, to heare our conference—

and Ursula tells us that their prey

> even now,
> Is couched in the wood-bine coverture . . .

Once more, then, the victim is in the Study, and the plotting ladies
approach her sideways ("Then go we neare her that her eare loose
nothing"), hugging one of the doorways—perhaps for variety the
opposite one from that in the last scene. The departure of Hero and
Ursula is probably also done by a tour of the perimeter—though
faster this time, as behoves the boy-ladies, with but four skipping
lines of dialogue.[97] In the box-tree scene of *Twelfth Night*, the
situation is reversed: the victim speaks aloud, the conspirators aside.
The interruptions of Sir Toby and his crew come from the Study,

[96] *Troilus and Cressida*, V. ii.
[97] *Much Ado About Nothing*, II. iii. 39 ff.; III. i. 24 ff.

where the box-tree is set. But the writing of the scene seems designed for this disposition, for the emphasis is all upon Malvolio in front of the Platform. Moreover the considerable distance between him and the Study makes it possible for the surrounding audience to feel as if they were between the two groups, as if they too (like the conspirators) were poking fun at the infatuated steward's back.[98]

The sense of intimate contact between actors on this Platform and audience in the Yard must be felt to be fully realised. The steady daylight helps, for with the audience not only near but plainly visible, there is no artificial frontier at the footlights. From this close contact springs the popularity of the conventional "aside". Shakespeare used this device continually in his early plays and never grew tired of it. There is, for instance, in 1 *Henry VI*, a long scene in which Suffolk woos Margaret of Anjou by proxy for the King: the fact that he himself desires her touches the scene with irony, and there is a vein of deliberate comedy in the pattern of the "asides". First she speaks *to him* and he *aside;* then both *aside* together; then he *to her* and she *aside;* the culmination is her mocking "I cry you mercy, 'tis but *Quid* for *Quo*." [99] Of even longer duration is the four-part conversation when King Edward woos Lady Gray. The match is an unpopular one with the King's relations, and Gloucester and Clarence give a witty but bitterly outspoken commentary on the progress of their brother's suit.[100] The mourning scene at Towton with its ritual of lament needs triangular perspective to persuade an audience. The pious King sits on his Mole-Hill in the Study. The Son that has killed his Father and the Father that has killed his Son enter at opposite doors, and presumably come to rest in front of the corresponding Stage-Posts. All speak independently of each other, though their words form a pattern.[101] Falstaff, of course, is a past master in the use of speech "aside". He is continually ogling his audience and making us privy to his deceptions—the rogue's most powerful means of engaging our sympathy. Imagine him at a critical point of his narrative of the highway-robbery—the terrible odds of four against sixteen. "Pray Heaven," says Poins, "you have not murthered some of them," and something in his sniggering manner betrays the truth to Falstaff. Nimbly the old villain sees his way to turn the tables: "Nay, that's past praying for," he says; "I have pepper'd two of them: Two I am sure I have payed, two Rogues in Buckrom Sutes." Picture the scene: the Prince and Poins

[98] *Twelfth Night*, II. v. 18 ff.

[99] 1 *Henry VI*, V. iii. 72 ff. Shakespeare learnt later to do this more deftly: less naïve but in the same vein is Falstaff's successful attempt to score off the Lord Chief Justice "tap for tap, and so part faire" (2 *Henry IV*, II. i. 210.)

[100] 3 *Henry VI*, III. ii. [101] 3 *Henry VI*, II. v. 55 ff.

up-stage enjoying their joke together, Falstaff right forward on the
perimeter, enjoying *his* with the groundlings: the close contact with
the audience, the intimate wink, at first sharing his secret only with
his immediate neighbours in the Yard, conveys by infection to the
whole playhouse the truth that "I have pepper'd two of them"
means "I have seen through your stratagem." And the ensuing tale
with its monstrous arithmetical progression is seen by the audience
for what it is—Falstaff's riposte to the Prince's trick.[102] Granville-
Barker has explained how the conditions of the Elizabethan
playhouse give added point to Iago's cynical comment on the
civilities that pass between Desdemona and Cassio on the quayside

I have pepper'd two of them

at Cyprus: "He takes her by the palme: I, well said, whisper. With
as little a web as this, will I ensnare as great a Fly as *Cassio*. I smile
upon her, do . . ." Here we have the sculptured and the pictorial
together, the round and the flat: the pair Iago is describing make a
flat picture against the curtain of the Study; the villainous inter-
preter stands in the round, in our midst, and his devilish insinuations
make us accessory to his wickedness.[103]

A logical development of the "aside" is the soliloquy and this
device too is admirably suited to the conditions of the Elizabethan

[102] 1 *Henry IV*, II. iv. 213 ff. Dover Wilson has given the hint of how we should
read between the lines of this famous scene. See *The Fortunes of Falstaff*, 53.

[103] *Othello*, II. i. 168. See Granville-Barker, *Prefaces to Shakespeare* (Fourth Series),
19. He describes the visual effect of this moment as being "of a fully rounded
statue placed before a bas-relief".

playhouse.[104] Shakespeare's restlessly experimental mind invented constantly new variations of method and motive for solo speech, and it is impossible to lay down a hard-and-fast rule for the position and manner of its delivery. The informative tell-the-audience-the-story type—such as those of York in 2 *Henry VI*, of Richard of Gloucester

He takes her by the palme: I, well said, whisper

in 3 *Henry VI* and *Richard III*, of Proteus in *Two Gentlemen of Verona*, and (in the mature tragic period) of Iago [105]—addresses the audience almost as if lecturing, and is appropriately delivered from the centre

[104] Granville-Barker has a section on "The Soliloquy" in the Introduction to the First Series of his *Prefaces to Shakespeare*, xxx ff.

[105] 2 *Henry VI*, I. i. 215 ff.; III. i. 331 ff. 3 *Henry VI*, III. ii. 124 ff.; *Richard III*, I. i. 1 ff.; I. i. 144 ff.; I. ii. 229 ff.; I. iii. 324 ff. *Two Gentlemen of Verona*, II. iv. 193 ff.; II. vi. 1 ff.; IV. ii. 1 ff. *Othello*, I. iii. 389 ff.; II. i. 298 ff.; II. iii. 345 ff.

of the Platform. The same is true of the rhetorical *tours de force* of the
Bastard in *King John*: when he discourses on "observation" or
"commoditie", he takes the stage and harangues the meeting.[106] But
Richard II's "still breeding Thoughts" at Pomfret must have been
incarcerated in Study or Chamber.[107] Prince Hal's preliminary
statement of motive ("I know you all, and will a-while uphold The
unyoak'd humor of your idlenesse") was probably delivered from
the Chamber, while his more intimate address to his father's crown
("O pollish'd Perturbation! Golden Care!") is from the neighbour-
hood of the Study, where stands the bed of the dying King.[108] The
grave but detached philosophic reflection of Brutus would perhaps
pace the rushes of his Orchard strewn in the Study.[109] But after his
first interview with Isabella, Angelo's dynamic outburst, betraying
his uncontrolled passion, races off as the climax of the preceding
scene. " 'Save your Honour," says the virtuous maid in formal
valediction: "From thee," cries the Deputy, as soon as she has gone:
"even from thy vertue." The ensuing soliloquy must range over the
whole Platform. When we next see Angelo, he is revealed at prayer
in the Study, and speaks his dilemma from there.[110] King Claudius
must do likewise in similar vain attempt to pray: but Hamlet's sub-
sequent breathless hesitation in the same scene ("Now might I do it
pat . . .") would then move round the perimeter, away from Claudius
but close to us. How well this scene brings out the greater expressive-
ness of the Elizabethan multiple stage! Putting up his sword again,
the Prince continues his way round the front of the Platform and
goes out by the opposite door: he is bound for his Mother's Closet,
and after the King's despairing couplet—

> My words flye up, my thoughts remain below,
> Words without thoughts, never to Heaven go——

the play flows on in its uninterrupted course on the upper level.[111]
The solitary heart-searching of Hamlet's "Oh that this too too solid
Flesh, would melt" and "To be, or not to be, that is the Question"
and the hair-raising calculations of Macbeth ("This supernaturall
solliciting . . ." and "If it were done, when 'tis done . . .") strike pity
or terror into each one of us as Burbadge stands at the hub of the
octagon.[112]

The clowns are a law apart. The shape of the theatre and the fact
that the auditorium as well as the Platform was in steady daylight

[106] *King John*, I. i. 182 ff.; II. i. 561 ff. [107] *Richard II*, V. v. 1 ff.
[108] 1 *Henry IV*, I. ii. 217 ff.; 2 *Henry IV*, IV. v. 20 ff.
[109] *Julius Caesar*, II. i. 8 ff.
[110] *Measure for Measure*, II. ii. 161 ff.; II. iv. 1 ff. [111] *Hamlet*, III. iii. 36 ff.
[112] *Hamlet*, I. ii. 129 ff.; III. i. 56 ff. *Macbeth*, I. iii. 130 ff.; I. vii. 1 ff.

are partly responsible for their technique of frontal assault, their frequent direct appeals to the audience. Even a summary review of the practice of soliloquy shows that the serious characters often so address the playhouse, with varying degrees of explicitness: one thinks of Faulconbridge, Iago, Edmund, each (be it noted) with a touch of humour in his make-up. But it is of course a much commoner trick with the comic figures. No picture rises more vividly to the mind's eye than Launce (in the person of Kemp) with his dog Crab, surrounded by the laughter of the groundlings: "I thinke *Crab* my dog, be the sowrest natured dogge that lives: My Mother weeping: my Father wayling: my Sister crying: our Maid howling:

*Yet did not this cruell-hearted Curre
shedde one teare*

our Catte wringing her hands, and all our house in a great perplexitie, yet did not this cruell-hearted Curre shedde one teare." [113] Another such turn in the music-hall style is that of Launcelot Gobbo, drawn this way and that between his conscience and the fiend at his other elbow.[114] Kemp's successors of to-day would envy him his forward position in the centre of the playhouse, as they show by their tendency to walk into the footlights. It is the vaudeville comedians of to-day and yesterday who come nearest in their genre to the manner of the Elizabethan theatre: Saturday night at the old Palladium—twenty years ago—had the feeling, at least of the comic side of the business.

Falstaff, as we have seen, by taking the audience into his con-

[113] *Two Gentlemen of Verona*, II. iii. 5 ff. [114] *The Merchant of Venice*, II. ii. 1 ff.

fidence, makes us feel in collusion with his villainies. If the dramatist can do that, he has gone a long way to make his play live. We must expect him, and his actors with him, to do their utmost to lure us into the game too. But Falstaff has more than one trick up his sleeve: and if he cannot always carry the audience with him as confederates, he will sometimes associate them with those whom he wishes to make his dupes. When, standing in the central area within the Stage-Posts, he is in the full career of his ridiculous lies about the robbery on Gads Hill, Prince Hal and Poins (now on the perimeter) turn, as they think, the tables on the braggart: the Prince gives his version of the business, his plain tale to put Falstaff down, and cries "What trick? what device? what starting hole canst thou now find out, to hide thee from this open and apparent shame?" Falstaff, as always, has the last trick: blandly, amid the expectant silence, he says "I knew ye as well as he that made ye." Then if the player is doing his job, not only Hal and Poins but the audience too will burst into incredulous and uproarious laughter, and as he cries "Why heare ye my Masters . . ." Falstaff will have to silence the whole playhouse, shouting at the Prince and Poins, but through them at you and me in Yard and galleries. When he has reduced us all to silence, he need not raise his voice to say "was it for me to kill the Heire apparant?" For the nonce, the whole audience is within the hospitable four walls of mine Hostess' tavern.[115]

This taking up of the audience into the play lies at the root of the matter: as they stood or sat in the same steady light which shone on the actors, and were themselves easily visible by them, they were a constant and obvious and no doubt vocally explicit reminder to dramatist and players alike of the danger of failure. When there is a ring of critical spectators within a few feet of the stage, whose expressions are not concealed by the merciful darkening of the auditorium, then the actors and the playwright must take their courage in both hands, they must do or die; and in practice it is astonishing what people will succeed in doing rather than die. Certainly the Chamberlain's Men would be at great pains to make and keep a contact of sympathy with their audience, and to break down in imagination the barrier of the stage-rails between Platform and Yard. We can see them at it constantly, taking the groundlings into alliance. It may be that they are made the audience of a play within the play, when the nobility on the stage sitting at intervals round the Platform-rails seem but the front row of a larger company.[116] It may be that they

[115] 1 *Henry IV*, II. iv. 283 ff.
[116] See above, p. 99. The references there given are to *A Midsummer Night's Dream*, *Love's Labour's Lost*, *Hamlet* and *The Tempest*.

become the spectators of a duel, either on the battlefield or in single combat. The fencing-match which makes the climax of *Hamlet* has at the Globe all the tense excitement of a prizefight in the ring, and indeed at the duel between Hector and Ajax in *Troilus and Cressida* it looks as if some of the Greek chiefs watched from the Tarras, thereby completing the ring.[117] On other occasions the groundlings may seem to be the rest of the crowd, of whom typical members appear on the Platform itself. This seems to be Shakespeare's intention in his handling of the mob-scenes of *Julius Caesar*. The Folio text refers to the crowd as *certaine Commoners* on their first appearance, and their leader is introduced to us as a lively personality. Later they are called *the Plebeians*. In the Forum scene four individual speakers are instanced, and the folio seems to differentiate them with some care as 1, 2, 3 and 4. We may be tempted to change a number here and there, but there is certainly a robust independence and initiative discernible in the speeches assigned to Number 4. The stage-crowd would, I fancy, amount to no more than twelve all told, and can be thus few and individualised because by being thrust out among the

He poysons him i' th' Garden for's estate

[117] *Hamlet*, V. ii. 294 ff.; *Troilus and Cressida*, IV. v. 113 ff.

groundlings of the Yard they can seem to be but the fringe or front row of the groundlings themselves. A good Antony, helped by "infectious" crowd-actors (recruited from the comedy-gang of the Chamberlain's Men) would sway the whole Yard with his oratory. Yet another device for drawing the Yard into the action of the play is that of making them seem, as it were, the rest of a symbolical stage army. The occasion commonly arises when the generals address their troops before battle.[118] Especially stirring is the moment in *Henry V*

God send you sir, a speedie Infirmity, for the better
increasing your folly

of the assault on Harfleur, when on the cry of "God for *Harry*, England, and S. *George*," the whole Yard seem to hurl themselves into the breach. An interesting case is that of the French King's appeal in the same play when he mentions by name a far greater number of his peers than can be mustered among the Chamberlain's Men. The audience in the playhouse become for the time being the assembled chivalry of France.[119] The proclamation of Othello's Herald delivered presumably from the Tarras shows how, even

[118] A number of such occasions are listed on p. 89, above.
[119] *Henry V*, III. i. 34; III. v. 38 ff.

groundlings of the Yard they can seem to be but the fringe or front row of the groundlings themselves. A good Antony, helped by "infectious" crowd-actors (recruited from the comedy-gang of the Chamberlain's Men) would sway the whole Yard with his oratory. Yet another device for drawing the Yard into the action of the play is that of making them seem, as it were, the rest of a symbolical stage army. The occasion commonly arises when the generals address their troops before battle.[118] Especially stirring is the moment in *Henry V*

God send you sir, a speedie Infirmity, for the better
increasing your folly

of the assault on Harfleur, when on the cry of "God for *Harry*, England, and S. *George*," the whole Yard seem to hurl themselves into the breach. An interesting case is that of the French King's appeal in the same play when he mentions by name a far greater number of his peers than can be mustered among the Chamberlain's Men. The audience in the playhouse become for the time being the assembled chivalry of France.[119] The proclamation of Othello's Herald delivered presumably from the Tarras shows how, even

[118] A number of such occasions are listed on p. 89, above.
[119] *Henry V*, III. i. 34; III. v. 38 ff.

become the spectators of a duel, either on the battlefield or in single combat. The fencing-match which makes the climax of *Hamlet* has at the Globe all the tense excitement of a prizefight in the ring, and indeed at the duel between Hector and Ajax in *Troilus and Cressida* it looks as if some of the Greek chiefs watched from the Tarras, thereby completing the ring.[117] On other occasions the groundlings may seem to be the rest of the crowd, of whom typical members appear on the Platform itself. This seems to be Shakespeare's intention in his handling of the mob-scenes of *Julius Caesar*. The Folio text refers to the crowd as *certaine Commoners* on their first appearance, and their leader is introduced to us as a lively personality. Later they are called *the Plebeians*. In the Forum scene four individual speakers are instanced, and the folio seems to differentiate them with some care as 1, 2, 3 and 4. We may be tempted to change a number here and there, but there is certainly a robust independence and initiative discernible in the speeches assigned to Number 4. The stage-crowd would, I fancy, amount to no more than twelve all told, and can be thus few and individualised because by being thrust out among the

He poysons him i'th'Garden for's estate

[117] *Hamlet*, V. ii. 294 ff.; *Troilus and Cressida*, IV. v. 113 ff.

when the Platform is empty, the streets of Cyprus will—under the influence of an established convention—still seem full.[120]

In short, the architecture of the playhouse, and especially the shape, dimensions and central forward position of the Platform, are the basis of much of Shakespeare's stagecraft: they affect the positioning and grouping of his scenes, which were after all written for performance in this theatre. In these conditions we can bring his plays to vivid life again: for thus the action will be in the round, not flat; grouping will be easy and natural, not strained by the need to avoid "masking"; we in the audience shall be once again participants on the edge of a central group, not detached spectators of a distant, moving picture. In this playhouse we can co-operate almost physically in the play: we can see over an actor's shoulder, if he is down-stage, and so feel with him: we can make immediate response to his suggestion, and thereby help him to cast his spell. We can have a sense of being "in it". "It was like being out in the wood yourself," said a spectator of *A Midsummer Night's Dream* in such conditions. I have seen the Roman mob on such a Platform hobnobbing with their acquaintance in the audience. Not the least important result of such a revolution in stage-practice is this—that to make such a powerful and immediate impression on the audience, the technique of the actor must be more robust, more direct, more do-or-die than the methods we are used to now.

(iv) Characterisation

If we want to recapture the characterisation of the Chamberlain's Men, we shall have little help in contemporary references to performance, which are scanty and unhelpful.[121] Although we are not as fortunate as the poet's colleagues who could put their questions direct, yet even for us the most fertile field of evidence is Shakespeare himself; for the characterisation is very often fully prescribed somewhere in the words of one speaker or another. Shakespeare seldom leaves us in doubt about any of the major figures: yet he does not rely on the long descriptive character-notes of the modern dramatist, nor does he use bracketed adverbs to indicate the tone of a speech. If we can find out how he achieves this, we have gone some way to understanding the technique of poetic drama. We shall see, in the next chapter, how it is a feature of Shakespeare's poetic drama that the characters, like the scenery and the atmosphere (and sometimes the very action itself), are all contained in the spoken dialogue.

[120] *Othello*, II. ii.
[121] Even the familiar tribute of Leonard Digges does little more than tell us which figures were the most popular.

It is surprising, therefore, how often producer or actor seems to prefer his own interpretation. How seldom do we see a Polonius who succeeds in making his manifest absurdities compatible with the sound wisdom of his advice to Laertes, the shrewdness which underlies his absent-minded verbosity as he briefs Reynaldo, and the philosophical humility of his comment on his blundering judgment of Hamlet's "tenders" to Ophelia:

> It seemes it is as proper to our Age,
> To cast beyond our selves in our Opinions,
> As it is common for the yonger sort
> To lacke discretion . . .

so that we can feel that there is some substance in the Queen's posthumous tribute to the "good old man".[122] Horatio is not always of a stature to deserve Hamlet's moving panegyric:

> Since my deere Soule was Mistris of my choyse,
> And could of men distinguish, her election
> Hath seal'd thee for her selfe. For thou hast bene
> As one in suffering all, that suffers nothing.
> A man that Fortunes buffets, and Rewards
> Hath 'tane with equall Thankes. And blest are those,
> Whose Blood and Judgement are so well co-mingled,
> That they are not a Pipe for Fortunes finger,
> To sound what stop she please. Give me that man,
> That is not Passions Slave, and I will weare him
> In my hearts Core: I, in my Heart of heart,
> As I do thee.[123]

But how much the play suffers if Hamlet has not this comforting support to lean on in his time of need. We do not often see a Caesar who can reconcile the opposite colours in which Shakespeare deliberately paints him—on the one hand, the irritable epileptic who, fresh from his posturing hypocrisy in the market-place, mutters pettishly in Antony's ear "Let me have men about me, that are fat . . .", vacillating between the superstitious fears of his wife and his own self-esteem, and falling an easy victim to the subtle flattery of Decius; on the other, the man whose word might have stood against the world, who could pronounce himself before the Senate

> constant as the Northerne Starre,
> Of whose true fixt, and resting quality,
> There is no fellow in the Firmament.[124]

[122] *Hamlet,* I. iii. 58 ff.; II. i. 1–74; II. i. 114 ff.; IV. i. 12.
[123] *Hamlet,* III. ii. 68 ff.
[124] *Julius Caesar,* I. ii. 191 ff.; II. ii; III. i. 60 ff.

Heminges could do it, if it is true that he played both Polonius and the Earl of Kent. And when shall we see again the right Shakespearian Gloucester in *King Lear*, who can combine the impression of the opening sentences of the play with that of Edmund's dupe, who can be the casual and cheerful lecher, prone to superstition and suspicion, and gullible; and at the same time heroically loyal to the King, and eventually pitiable to us all? [125]

In the history plays there is even less reason than elsewhere for the misconception of Shakespeare's purpose in characterisation; for different plays of the cycle often offer hints of his conception, and if we read backwards and forwards we shall find that one play throws light upon the interpretation of another. True, it is a commonplace of criticism that King Henry V is not the same character as Prince Hal—an opinion which does not command unreserved acceptance. But even Prince Hal, as we see him in the theatre to-day, is seldom consistent with himself. The fault is usually one of casting: the star actor will not take this rôle, preferring Hotspur or Falstaff; so Hal is given to a young rising actor who unconsciously plays the part as if he were a foil to the star of Falstaff, not (as he should) as the heir-apparent, the central figure of the story. Here is a side of Shakespeare's conception which seldom appears in the performance of Hal's madcap escapades:

> hee is gracious, if hee be observ'd:
> Hee hath a Teare for Pitie, and a Hand
> Open (as Day) for melting Charitie:
> Yet notwithstanding, being incens'd, hee's Flint,
> As humorous as Winter, and as sudden,
> As Flawes congealed in the Spring of day.

Here too is a precise and explicit account of his way of life:

> The Prince but studies his Companions,
> Like a strange Tongue: wherein, to gaine the Language,
> 'Tis needfull, that the most immodest word
> Be look'd upon, and learn'd: which once attayn'd,
> Your Highnesse knowes, comes to no farther use,
> But to be knowne, and hated. So, like grosse termes,
> The Prince will, in the perfectnesse of time,
> Cast off his followers: and their memorie
> Shall as a Patterne, or a Measure, live,
> By which his Grace must mete the lives of others,
> Turning past-evills to advantages.[126]

[125] It is the more surprising that Gloucester is habitually misplayed when Granville-Barker has made an admirably Shakespearian study of the character in his *Prefaces to Shakespeare*, First Series, 202 ff.

[126] 2 *Henry IV*, IV. iv. 30 ff.; 68 ff.

If an actor were to begin the building of his interpretation upon these two passages, he could be sure that the foundation was Shakespeare's own, and finding opportunity to reveal these aspects of the character, would greatly enrich the high spirits of the earlier scenes by the contrast of serious mood and purpose. Hotspur projects his personality as soon as he opens his mouth, but there is plenty of other material to study for the full interpretation of the character. Lady Percy gives us his immediate mood when he is restless and uneasy in plotting rebellion: the description is reminiscent of Portia's account of Brutus in like circumstances, but the reaction of the two conspirators is characteristically different.[127] Harry Percy's general habit of speech and movement is drawn for us in his widow's posthumous panegyric:

> He was (indeed) the Glasse
> Wherein the Noble-Youth did dresse themselves.
> He had no Legges, that practic'd not his Gate:
> And speaking thicke (which Nature made his blemish)
> Became the Accents of the Valiant.
> For those that could speake low, and tardily,
> Would turne their owne Perfection, to Abuse,
> To seeme like him.[128]

Prince Hal's caricature throws another light on him: "he that killes me some sixe or seaven dozen of Scots at a Breakfast, washes his hands, and saies to his wife; Fie upon this quiet life, I want worke"; and the burlesque throws into strong relief the Prince's generous praise of his rival in the parleys before Shrewsbury Field. Worcester's bitter comment adds something to the picture:

> My Nephewes trespasse may be well forgot,
> It hath the excuse of youth, and heate of blood,
> And an adopted name of Privilege,
> A haire-brain'd *Hotspurre*, govern'd by a Spleene:

Hotspur's demeanour in his single combat with Hal is described vividly in the sequel, and might surprise some of the actors who represent him:

> But these mine eyes, saw him in bloody state,
> Rend'ring faint quittance (wearied, and out-breath'd)
> To *Henrie Monmouth*, whose swift wrath beate downe
> The never-daunted *Percie* to the earth,
> From whence (with life) he never more sprung up.

[127] 1 *Henry IV*, II. iii. 42 ff.; *Julius Caesar*, II. i. 237 ff.
[128] 2 *Henry IV*, II. iii. 21 ff.

The growth of the character in Shakespeare's mind can be studied in his brief but not insignificant appearance in *Richard II*.[129] Nor is it perhaps irrelevant to remember that his familiar speech on honour is burlesqued in *The Knight of the Burning Pestle* when Ralph, being asked to speak a "huffing part", delivers Hotspur's lines.[130] From this rich variety of material it is possible to make a synthesis which approximates to Shakespeare's own intention: there is no need for producer or actor to work up a personal interpretation of the part.

The hunt for Shakespeare's intention is not always so easy as in the case of Hotspur. Sometimes we must clear away the errors of subsequent theatrical tradition. A not infrequent source of misunderstanding is a neglect of Shakespeare's habit of modern objective vision. The point is readily illustrated by the usual manhandling of the sub-plot in *Twelfth Night*. The social position of Malvolio as a dignified gentleman who is Steward of a great household, makes his aspiration to the hand of his mistress a quite credible ambition: "There is example for't," says he, and Miss M. St. Clair Byrne, in an admirable passage on this theme, quotes more than one precedent from contemporary history. Such a figure as this (a victim worth the gulling) together with a Maria who is a well-educated gentlewoman, a Sir Toby for all his cakes and ale still unequivocally my lady's kinsman, a Sir Andrew in spite of his absurdity a man of substance and position, worth the humouring (for he is "a great quarreller") so long as Sir Toby can hope for any profit from him—here is material for pure comedy very different from the farcical riot that is now the traditional rendering. The clues to Shakespeare's meaning are, as usual, embedded in the dialogue, but the producer must here seek some expert elucidation of the Elizabethan social background.[131] Falstaff himself suffers if producer and actor have not a firm conception of his social status, if the actor is hail-fellow-well-met with all men and does not insist on his gang of parasites keeping their place and distance: as his creator draws him, he never forgets his position; indeed his aloofness is an offence below-stairs at the Boar's Head, where he is known as "proud Jack" among the Drawers.[132] Even in

[129] 1 *Henry IV*, II. iv. 117 ff.; V. i. 85 ff.; V. ii. 16 ff.; 2 *Henry IV*, I. i. 107 ff.; *Richard II*, II. iii. 21 ff.; III. iii. 20 ff.

[130] Beaumont and Fletcher, *The Knight of the Burning Pestle*, Induction. E. M. W. Tillyard, commenting on this fact, says that "Hotspur, however captivating his vitality, verges on the ridiculous from the very beginning, through his childish inability to control his passions" (*Shakespeare's History Plays*, 283).

[131] The reader is referred to Miss M. St. Clare Byrne's chapter in *A Companion to Shakespeare Studies* (Cambridge), 187 ff. (and especially 209 ff.); and also to Charles Lamb's observations on *Twelfth Night* in his essay "On Some of the Old Actors" (*Essays of Elia*).

[132] 1 *Henry IV*, II. iv. 12.

the ecstasies of courtship he makes it clear to Mistress Ford that he
knows himself to be a cut above her.[133]

Sometimes a light is thrown upon the characterisation by a com-
parison of similar parts in different plays. The likeness may be in
habitual circumstances. The Countess' Steward in *All's Well That
Ends Well* is a highly privileged and trusted servant: he first discloses
Helena's passion to his mistress, and later is asked to write a con-
fidential letter for the Countess to her son.[134] A virtuous Oswald we
might call him (Oswald also writes his Lady's letters),[135] a discreet
Malvolio; his name is Rinaldo, to remind us of Polonius' confidential
envoy [136]; the comparisons are not without value in helping an actor
of any of these four parts to conceive his performance. It may be the
immediate situation that is similar: thus Roderigo, Iago's financial
backer and his dupe, gulled into thinking himself a likely suitor for
the hand of Desdemona, is the tragic equivalent of Sir Andrew, who
stands in a like relation to Sir Toby and Olivia. Or the resemblance
may be in temperament: there is common ground between Iago and
Edmund, though their station differs, and bastardy is not the only
affinity between Edmund and Faulconbridge, though their characters
are fundamentally unlike. But this line of approach needs discretion:
it is easy to overstress the similarity in observing a superficial
resemblance.

We are trying all the time to get closer to Shakespeare's intention,
and one obvious way of achieving that is to examine his sources and
see how paragraphs, and even single phrases, give a hint of what was
in the poet's mind. Sometimes the poet adopts the version of his
predecessor, sometimes he alters it: either process is interesting to
the student who wants to follow the working of Shakespeare's mind.
Plutarch is the most fertile field here, because Plutarch himself had
so keen a dramatic sense, as Shakespeare acknowledges in the extent
of his borrowing. There is a wonderful feeling at times of looking
over the poet's shoulder as he "Opens his Plutarch, puts him in the
place Of Roman, Grecian". While he was writing *Macbeth*, we may
suppose that his evening reading was the life of Marcus Antonius:
one night he was occupied with the passage where a soothsayer
visits Antony and warns him to depart from Rome and the
neighbourhood of Octavius: "For thy Demon, said he, (that is to
say, the good angell and spirit that keepeth thee) is affraied of his:
and being coragious and high when he is alone, becommeth fearefull

[133] *The Merry Wives of Windsor*, III. iii. 52 ff.
[134] *All's Well That Ends Well*, I. iii. 112 ff.; III. iv. 29 ff.
[135] *King Lear*, I. iv. 359. [136] *Hamlet*, II. 1.

and timerous when he commeth neere unto the other." [137] Next day
he made Macbeth say of Banquo that

> under him,
> My *Genius* is rebuk'd, as it is said
> *Mark Anthonies* was by *Caesar*.[138]

And in his next play, the episode in Plutarch is elaborated into a
scene which changes the course of the drama.[139] The producer of
Julius Caesar, if he would give us Shakespeare's intention, must study
Plutarch's lives of Brutus and Caesar in North's version.[140] There he
will find much of the characterisation and many of the episodes
already in being, and can observe the added touches of the poet's
genius. Holinshed and Hall, and the other known sources, though to
a lesser degree, are nevertheless indispensable aids to the under-
standing of Shakespeare's intended characterisation.

At second remove from Shakespeare's shoulder, but nearer to the
practice of his colleagues, is the evidence of the Quarto and Folio
texts, which give us an idea of the intention not only of the poet but
also of the Book-Keeper, or sometimes indeed a reporter's recollec-
tion of the performance.[141] We may have a hint of the calculated
emphasis in the plot from the Quarto title-page. For instance, the
1602 text of *The Merry Wives of Windsor* begins with an elaborate
programme note: "A Most pleasaunt and excellent conceited
Comedie, of Syr *John Falstaffe*, and the merrie Wives of *Windsor*.
Entermixed with sundrie variable and pleasing humors, of Syr *Hugh*
the Welch Knight, Justice *Shallow*, and his wise Cousin M. *Slender*.
With the swaggering vaine of Auncient *Pistoll*, and Corporall *Nym*."
The 1608 (Pied Bull) *King Lear* speaks of "M. William Shak-speare:
His True Chronicle Historie of the life and death of King LEAR
and his three Daughters. *With the unfortunate life of* Edgar, *sonne* and
heire to the Earle of Gloster, and his sullen and assumed humor of
Tom of Bedlam." More useful, perhaps, are the occasional cast-lists
in the Folio. At the end of *Measure for Measure* "The names of all the
Actors" include *Lucio, a fantastique; Elbow, a simple Constable; Froth, a
foolish Gentleman; Clowne* (which means Pompey); and *Barnardine, a
dissolute prisoner*. A similar list at the end of *Othello* describes Cassio as
an Honourable Lieutenant, Iago as *a Villaine*, and Rodorigo as *a gull'd*

[137] Plutarch's *Life of Antonius* (North's Translation, 1579).

[138] *Macbeth*, III. i. 55 ff.

[139] *Antony and Cleopatra*, II. iii. 10 ff.

[140] A full, if not exhaustive, selection of the relevant passages can be conveniently
studied in Verity's edition of the play in the Pitt Press series.

[141] See Chapter II, "The Prompt Book", pp. 25 ff., above.

Gentleman (further link with Sir Andrew, who is called "a gull" by Sir Toby in parting).[142] It will be noticed that there is a marked tendency in these lists to label the characters by their type, or rather according to the part which they play in the plot: it is not insignificant that Brabantio is described not in his quality as a reverend senator, but as *Father to Desdemona*.

Scattered here and there among the stage-directions are epithets or phrases that help us to interpret the poet's characterisation. We learn from the Folio that Princess Katherine's attendant Alice is *an old Gentlewoman*, our only direct indication of her age. *Enter young Osricke* has just the right tone of patronage in speaking of "this water-flie", and reflects perhaps also the condescension of the member to the apprentice-player.[143] An occasional direction, indicating action or appearance, helps to suggest to the player his demeanour at a certain moment: *Enter one blowing*, as a messenger brings the news of the Duke of York's death; *Enter the Queene with her haire about her ears, Rivers & Dorset after her; Enter Richard, and Buckingham, in rotten Armour, marvellous ill-favoured; Enter the King and his poore Souldiers; Enter Ofelia playing on a lute, and her hair down, singing* (this last example from the First Quarto).[144]

Perhaps the most interesting of all the suggestions to be derived from the texts is the habit (noted above, in discussion of the prompt-book)[145] of varying the speech-headings—of writing type-names instead of personal names, or rather names showing the quality or the function of the character in the play. Thus in *Love's Labour's Lost* we have *Braggart* alternating with *Armado*, *Pedant* with *Holofernes*, *Curate* with *Nathaniel*. In *Romeo and Juliet*, *Capulet* is described as *Father*, *Lady Capulet* as *Mother*. In the vastly entertaining quarrel-scene of *Henry V* in which the four corners of the Kingdom are participants, Fluellen's speech-heading is changed to *Welch* as soon as the international issue is raised, and Macmorice and Captaine Jamy are described as *Irish* and *Scot* throughout.[146] It is most instructive to follow the nomenclature of the Countess in *All's Well That Ends Well*, who first appears as *Mother* with the line "In delivering my sonne from me, I burie a second husband"; next with her Steward and the Clowne she is properly designated *Countesse*; and then in the middle of the same scene, when Helen appears, the speech-heading alters to *Old Cou.* with the words "Even so it was

[142] *Twelfth Night*, V. i. 216. [143] *Henry V*, III. iv. 1; *Hamlet*, V. ii. 81.

[144] 3 *Henry VI*, II. i. 43. *Richard III*, II. ii. 34; III. v. 1. *Henry V*, III. vi. 94. *Hamlet*, IV. v. 21. The reader is strongly recommended to glance at the appendix of stage directions in W. W. Greg's *The Editorial Problem in Shakespeare*, 158 ff.

[145] See pp. 26 f. [146] *Henry V*, III. ii. 76 ff.

with me when I was young". In each case her relation to the immediate situation—to the other characters—dictates the appropriate style.[147] We seem to be very close to the original manuscript of Shakespeare here and, as we have seen above, McKerrow infers that this is the way the poet's mind worked: in the heat of composition the qualities of the characters or the part which they played in the action were often more strongly present to his imagination than their personal names.[148] If this is true, then the same general attitude to the characterisation should be present in the mind of a producer, and through him communicate itself to the actors.

A highly interesting field for speculation—if not research—is to be found among the individual personalities of the Chamberlain's Men. We must remember that Shakespeare was writing his plays not only for a particular playhouse but also for a particular company of players, and that, as Baldwin says, "the play was regularly fitted to the company, not the company to the play".[149] It follows that, if the cast-lists themselves had survived, as they have occasionally for the plays of Ben Jonson and others, their importance as evidence of characterisation could hardly be exaggerated; and that we may learn much even from conjecture, when it is based on so close a study as Baldwin's. From the point of view of the present enquiry, it is obviously interesting to find that Augustine Phillips, who played Cassius, turned his lean and hungry look in the same year to good effect as Malvolio; that the same actor (Pope) played Shylock, Falstaff and Fluellen; that Burbadge played Bassanio and Prince Hal—both parts distorted by under-casting nowadays. A glance at Lowin's portrait suggests that his Gloucester in *King Lear* would have shown a more full-blooded semblance of the "Goatish disposition" indicated in the opening dialogue of the play, than we are used to in the dry, doddering impersonations of to-day; and he, it seems, also played the "blowt king" Claudius. The succession of Robert Armin to the place of Will Kemp, who left the company in 1599, made a fundamental change—as has often been pointed out—in Shakespeare's conception of the principal comedian's rôle.

[147] *All's Well That Ends Well*, I. i. 1; I. iii. 1; 136.

[148] See above, p. 27.

[149] T. W. Baldwin, *Organization and Personnel of the Shakespearean Company*, 197. In another passage (305, 307), Baldwin uses the analogy of a tailor, calling Shakespeare a good tailor-playwright, as opposed to Ben Jonson, who was not adaptable. The distinction chimes with what we know of their contrasted temperaments.

(v) The Repertory

This, then, is an appropriate place to turn aside for a moment and become more closely acquainted with some individual members of the company.[150]

Richard Burbadge, who with his brother, Cuthbert, held a half of the total number of shares in the playhouse, joined the company about 1590, when it came to his father's theatre. Once he had proved himself as Talbot and *Richard III*,[151] he remained the leading man as long as he was with the company. Baldwin assigns to him Berowne, Romeo, Demetrius (*A Midsummer Night's Dream*), Bassanio, Prince Hal, Claudio (*Much Ado About Nothing*), Henry V, Brutus, Orlando, Orsino, *Hamlet*, Ford, Bertram, Angelo, *Othello*, *Lear*, Macbeth, Antony (*Antony and Cleopatra*), Timon, Pericles. We have already noticed that he played Bassanio and Prince Hal, and no doubt the weight of his personality preserved the balance where nowadays these plays usually suffer distortion; the same may be said, perhaps, of his playing Claudio in *Much Ado About Nothing*, and Orsino. Berowne and Romeo are akin to this style, which shows him a master of subtle speech-music, wit and decorative conceit. The parts grow in stature with him: Brutus "with himself at warre" marks a turning point, compensating for the comparative failure in the mature Hal of *Henry V*, and indeed developing some of the depth of introspection attempted in the prelude to Agincourt. Thereafter, in the sequence of great tragedies Shakespeare sets him a task, in study and performance, second only to his own in composition. There is no reason to think that he failed him. The mere mention of Hamlet, Othello, Lear, Macbeth and Antony speaks volumes for Burbadge's versatility—which seems to have stopped short only of pure comedy, of which quality, says Baldwin, "he had almost none, his comic effects being procured by a half satiric contrast of high ideals turned

[150] For fuller information about the players, the reader is referred to T. W. Baldwin's *The Organization and Personnel of the Shakespearean Company*. A number of Baldwin's conjectural cast-lists are reproduced below in the Appendix III, pp. 320 ff. Baldwin uses an unorthodox chronology, and in listing the parts assigned to the various players, I have adjusted the order to the chronology of E. K. Chambers, which is reproduced below in the Appendix I, p. 318. Baldwin goes too far in drawing inferences about the appearance and personality of the actors from references to the characters they played, and even reaches the extremity of supposing that Shakespeare habitually fitted the age of his character to the age of his actor. For a more orthodox and less adventurous account of the players, the reader is referred to E. K. Chambers' *William Shakespeare*, vol. i, Chapter III, and vol. ii, Appendix A, Section VIII, "Shakespeare and his Fellows"; and also to the same author's *Elizabethan Stage*, vol. ii, 192, 295.

[151] Characters printed in italics indicate certain ascriptions, for which there is recognised evidence.

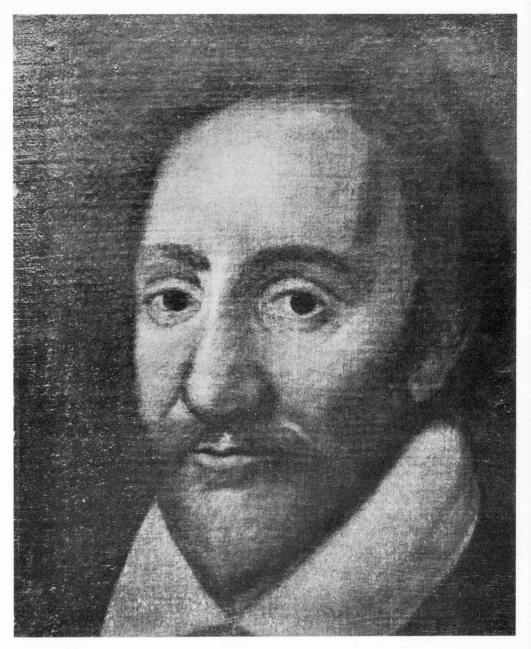

Richard Burbadge
(*from the picture in the Gallery of Dulwich College*)

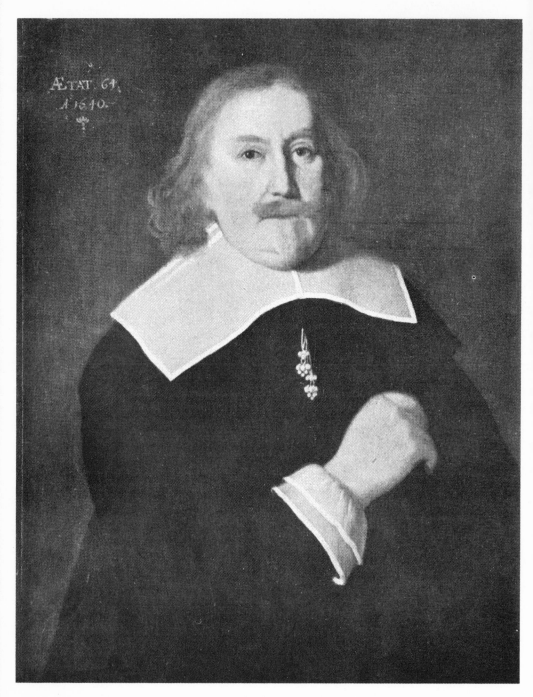

ÆTAT 64.
A 1640.

John Lowin
(*from the picture in the Ashmolean*)

loose to be laughed at in a practical world, somewhat after the manner of Cervantes".[152] If in looking at his portrait, our first instinct is to exclaim "Was this the face . . .?" it is worth recording the opinion that the best actors are those who can assume a great variety of characters, not those who are content to exploit or have exploited for them their own graceful or attractive personality: if the art of acting consists of the deliberate assumption of other characters, it is quite probable that the face in repose when not making that effort will bear no trace of the distinction of its many impersonations.

If this guess hits the mark, that Burbadge was able to assume so many different rôles, because his own personality was neutral, then he was probably an exception in the company. Though all his colleagues show some measure of versatility, there is a remarkable gallery of distinctive and forceful personalities among them. John Heminges, a house-keeper from the building of the Globe till 1631, the business manager of the company (to everybody's satisfaction) for more than a quarter of a century, who survived all the original members of 1595 to join with Cundall in honouring Shakespeare's memory in the Folio of 1623, lives even through the phrases of the preface to that volume: Dover Wilson has an interesting suggestion that he might have been the masterful person who overhauled the Quarto stage-directions of *A Midsummer Night's Dream*, and so perhaps the stage-manager of the company, since it was certainly "Mr. Heminges man", Tawyer, who was detailed in the Folio text of the play to blow his trumpet before the entry of Quince's dumb-show.[153] A glance at the parts ascribed to him reinforces the impression of a man to be respected among his fellows, seeming elderly, able easily to assume gravity or hot temper or prosiness or sardonic wit. He is down for (among other parts) Boyet, Capulet, Egeus, Glendower, the Lord Chief Justice, Leonato, Exeter (*Henry V*), Caesar, Duke Senior, Fabian (unexpectedly), Polonius, the Host (*The Merry Wives of Windsor*), Lafeu, Brabantio, Kent (*King Lear*), Ross. It is easy to see a resemblance in treatment between Capulet, Egeus, Glendower (the same phrase occurs on the lips of Capulet and Glendower, "a peevish selfe-will'd Harlotry"),[154] Leonato, Polonius and Brabantio —all concerned with refractory daughters. Baldwin points out, not inappositely, that Heminges had himself more than a dozen children.[155] Exeter and Ross are alike in their gravity, especially in reciting bad news; and Kent has something in common with these

[152] Baldwin, *op. cit.*, 203.
[153] *A Midsummer Night's Dream* (New Cambridge Edition), 155. See above, pp. 30 f.
[154] *Romeo and Juliet*, IV. ii. 14; 1 *Henry IV*, III. i. 197.
[155] Baldwin, *op. cit.*, 249.

two. Already one catches a glimpse of Baldwin's theory, upon which he bases his conjectural cast-lists, that it is possible to establish the "lines" or types of part appropriate to each of the principal actors and boys. And already it is apparent that a study of the similar parts of the same "line" can help in forming our idea of Shakespeare's intended characterisation. To Heminges is ascribed "the line of the old dignitary, upon occasion merry or peppery, Shakespeare's 'humorous man' ".[156]

Very interesting is the "line" represented by Thomas Pope and passing, when he left the company, to John Lowin. Pope was evidently himself something of a character in private life, with an oddly-assorted household which, as Baldwin says,[157] was perhaps the target of Ben Jonson's slanderous insinuations, but which might also suggest affinity with the establishment of the generous-hearted Dr. Sam. His parts include Petruchio, Speed, Armado, Quince, the Bastard Faulconbridge, Shylock, Falstaff,[158] Benedick, Fluellen, Casca, Jaques and Sir Toby.

The mixture is at first bewildering, but a closer inspection shows him a master of a kind of robust, bluff comedy part. Petruchio and Benedick have much in common; so have Sir John and Sir Toby. He was able to be heroic as the Bastard, and even for a brief moment tragic as Mercutio; and there is more than one echo of Mercutio's speech in the Bastard's. To this mixture Armado and Jaques add a touch of the fantastic. Baldwin detects a "scolding streak" in the Bastard, Casca and Jaques "who has been considered everything from a plain clown to the deepest philosopher. Since he was Pope, he was exactly that". Shylock is described as "hero-villain-clown. The Elizabethan Shylock is a characteristic part for Pope . . . but it must be admitted that Pope would not be much at home with the heroic figure Shylock has become". Baldwin adds his verdict that "possibly the best composite representative of this line is the clownish Welsh soldier Fluellen".[159] If it is true that the actors did much to inspire Shakespeare's characterisation, then we owe a debt of gratitude to Thomas Pope, as his rich and varied list shows.

Succeeding Pope, John Lowin takes up this same "line", but gives it a slight twist, no doubt due to some difference of temperament or personality: there is certainly an individuality of character in his

[156] Baldwin, *op. cit.*, 235. [157] Baldwin, *op. cit.*, 234.
 [158] The part of Falstaff is often assigned to Kemp. The two renderings would be fundamentally different. The producer, before he finds his Falstaff, must in fact decide whether he is looking for a Pope or a Kemp. I have little doubt that the part was written for the actor of Pope's "line" rather than for the "creator" of Bottom, Launcelot Gobbo and Dogberry.
 [159] Baldwin, *op. cit.*, 246.

portrait. Baldwin gives him Claudius in *Hamlet*, Falstaff in *The Merry Wives of Windsor*, Parolles, Lucio (*Measure for Measure*), Iago, Gloucester (*King Lear*), Banquo, Enobarbus. The robust bluffness takes a more sombre turn, with the change of mood of Shakespeare's composition; even the Falstaff of *The Merry Wives of Windsor* is indicative of a different personality. Perhaps the substitution of Lowin for Pope (as also of Armin for Kemp) was a contributory factor in Shakespeare's change of tone. But it is essentially the same "line" as Pope's, and it is interesting to find Iago and Enobarbus in the succession. Baldwin hits it off when he says that "the fundamental characteristic of Lowin is a certain bluff gruffness, which may be of the 'honest' soldier type, or that of the rather domineering villain".[160]

William Sly, whose portrait also shows a pronounced personality, is suited with Tybalt, Lewis (*King John*), Lorenzo, Hotspur, The Dauphin (*Henry V*), Octavius (*Julius Caesar*), Silvius (*As You Like It*), Sebastian (*Twelfth Night*), Laertes, Fenton, Claudio (*Measure for Measure*), Roderigo, Edmund, Macduff—a "line" that in most details speaks for itself, stressing youth, romantic or soldierly, calculating or impulsive, in early days the stage Frenchman, and growing in stature to the scope of Edmund and Macduff. Baldwin has an interesting suggestion that the mercurial, nervous temperament of Shakespeare's Hotspur, which is not to be found in the source, was perhaps suggested by Sly's own personal bearing.[161] In some cases, he is the rival to Burbadge's hero, and on several occasions literally crosses swords with him. Roderigo comes rather oddly in the list, and suggests that, though he is in a sense the tragic equivalent of Sir Andrew, the part and the play itself loses some force if the actor makes him wholly ridiculous.

Henry Cundall, who deserves like honour with Heminges as his collaborator in editing the 1623 Folio, though not himself one of the first seven house-keepers who built the Globe, was with Sly a member of the older generation of actors.[162] His parts show a bewildering variety and include Friar Lawrence, Antonio (*The Merchant of Venice*), Mark Antony (*Julius Caesar*), Horatio, Cassio, the Duke in *Measure for Measure* (his longest), Edgar, Malcolm, and Octavius Caesar. Mark Antony was perhaps his first big chance, and it is noteworthy that the obvious difference between this Antony and the later hero of *Antony and Cleopatra* corresponds with a difference in calibre between Cundall and Burbadge.

[160] Baldwin, *op. cit.*, 186, note. [161] Baldwin, *op. cit.*, 253.
[162] Baldwin, *op. cit.*, 83, and note.

Particularly instructive is the succession of Armin to Kemp. William Kemp is credited by Baldwin with Costard, *Peter* (*Romeo and Juliet*), Bottom, Launcelot Gobbo, Shallow (with Cowley as Silence), *Dogberry* (with Cowley as Verges). Kemp was a famous figure of the time, whose triumphal progresses of morris-dancing to Norwich and again over the Alps to Rome suggests the fan-mail and star-gazers of modern times. His style of clowning was obviously set and formal, and his parts would no doubt have been played with much stock "business" and gagging, to the discomfiture, no doubt, of his authors. Baldwin quotes a scene from *The Pilgrimage to Parnassus* which caricatures Kemp's method when left on the stage to his own devices. Dromo draws in a clown with a rope and tells him "Clownes have bene thrust into playes by head and shoulders ever since Kempe could make a scurvey face; and therefore reason thou shouldst be drawne in with a cart-rope." "But what must I doe nowe?" says the Clown. "Why, if thou canst but draw thy mouth awrye, laye thy legg over thy staffe, sawe a peece of cheese assunder with thy dagger, lape up drinke on the earth, I warrant thee theile laught mightilie. Well, I'le turne thee loose to them; ether saie somwhat for thy selfe, or hang and be *non plus*." Left alone, the Clown faces his audience: "This is fine, y-faith! nowe, when they have noebodie to leave on the stage, they bring mee up, and, which is worse, tell mee not what I shoulde saye! Gentles, I dare saie youe looke for a fitt of mirthe . . ." and so he proceeds to do his stock turn.[163]

Robert Armin, who succeeded him in 1600, was a very different person; himself a playwright, and author of pamphlets on the subject of Fooling. We may think of him as something of a doctrinaire therefore, and it is reasonable to suppose that Shakespeare had discussions with him on the subject, and that his joining the company had an even more direct effect upon Shakespeare's composition than the collaboration of the rest of his colleagues. Armin's parts are listed thus: Touchstone, Feste, First Grave-digger, Evans, Pompey (*Measure for Measure*), Fool (*King Lear*), Porter (*Macbeth*), Clown (*Antony and Cleopatra*). The Touchstone-William scene (*As You Like It*, V. i) is interesting as being the first Armin-Cowley association: comparison with Shallow-Silence and Dogberry-Verges illuminates the difference between Kemp and Armin. Kemp and Cowley are a pair; with Armin and Cowley there is an intellectual distinction between the wit and the simpleton. The next Armin-Cowley association is Feste and Aguecheek. Duke Senior's comment on Touchstone

[163] Baldwin, *op. cit.*, 242.

Particularly instructive is the succession of Armin to Kemp. William Kemp is credited by Baldwin with Costard, *Peter* (*Romeo and Juliet*), Bottom, Launcelot Gobbo, Shallow (with Cowley as Silence), *Dogberry* (with Cowley as Verges). Kemp was a famous figure of the time, whose triumphal progresses of morris-dancing to Norwich and again over the Alps to Rome suggests the fan-mail and star-gazers of modern times. His style of clowning was obviously set and formal, and his parts would no doubt have been played with much stock "business" and gagging, to the discomfiture, no doubt, of his authors. Baldwin quotes a scene from *The Pilgrimage to Parnassus* which caricatures Kemp's method when left on the stage to his own devices. Dromo draws in a clown with a rope and tells him "Clownes have bene thrust into playes by head and shoulders ever since Kempe could make a scurvey face; and therefore reason thou shouldst be drawne in with a cart-rope." "But what must I doe nowe?" says the Clown. "Why, if thou canst but draw thy mouth awrye, laye thy legg over thy staffe, sawe a peece of cheese assunder with thy dagger, lape up drinke on the earth, I warrant thee theile laught mightilie. Well, I'le turne thee loose to them; ether saie somwhat for thy selfe, or hang and be *non plus.*" Left alone, the Clown faces his audience: "This is fine, y-faith! nowe, when they have noebodie to leave on the stage, they bring mee up, and, which is worse, tell mee not what I shoulde saye! Gentles, I dare saie youe looke for a fitt of mirthe . . ." and so he proceeds to do his stock turn.[163]

Robert Armin, who succeeded him in 1600, was a very different person; himself a playwright, and author of pamphlets on the subject of Fooling. We may think of him as something of a doctrinaire therefore, and it is reasonable to suppose that Shakespeare had discussions with him on the subject, and that his joining the company had an even more direct effect upon Shakespeare's composition than the collaboration of the rest of his colleagues. Armin's parts are listed thus: Touchstone, Feste, First Grave-digger, Evans, Pompey (*Measure for Measure*), Fool (*King Lear*), Porter (*Macbeth*), Clown (*Antony and Cleopatra*). The Touchstone-William scene (*As You Like It*, V. i) is interesting as being the first Armin-Cowley association: comparison with Shallow-Silence and Dogberry-Verges illuminates the difference between Kemp and Armin. Kemp and Cowley are a pair; with Armin and Cowley there is an intellectual distinction between the wit and the simpleton. The next Armin-Cowley association is Feste and Aguecheek. Duke Senior's comment on Touchstone

[163] Baldwin, *op. cit.*, 242.

portrait. Baldwin gives him Claudius in *Hamlet*, Falstaff in *The Merry Wives of Windsor*, Parolles, Lucio (*Measure for Measure*), Iago, Gloucester (*King Lear*), Banquo, Enobarbus. The robust bluffness takes a more sombre turn, with the change of mood of Shakespeare's composition; even the Falstaff of *The Merry Wives of Windsor* is indicative of a different personality. Perhaps the substitution of Lowin for Pope (as also of Armin for Kemp) was a contributory factor in Shakespeare's change of tone. But it is essentially the same "line" as Pope's, and it is interesting to find Iago and Enobarbus in the succession. Baldwin hits it off when he says that "the fundamental characteristic of Lowin is a certain bluff gruffness, which may be of the 'honest' soldier type, or that of the rather domineering villain".[160]

William Sly, whose portrait also shows a pronounced personality, is suited with Tybalt, Lewis (*King John*), Lorenzo, Hotspur, The Dauphin (*Henry V*), Octavius (*Julius Caesar*), Silvius (*As You Like It*), Sebastian (*Twelfth Night*), Laertes, Fenton, Claudio (*Measure for Measure*), Roderigo, Edmund, Macduff—a "line" that in most details speaks for itself, stressing youth, romantic or soldierly, calculating or impulsive, in early days the stage Frenchman, and growing in stature to the scope of Edmund and Macduff. Baldwin has an interesting suggestion that the mercurial, nervous temperament of Shakespeare's Hotspur, which is not to be found in the source, was perhaps suggested by Sly's own personal bearing.[161] In some cases, he is the rival to Burbadge's hero, and on several occasions literally crosses swords with him. Roderigo comes rather oddly in the list, and suggests that, though he is in a sense the tragic equivalent of Sir Andrew, the part and the play itself loses some force if the actor makes him wholly ridiculous.

Henry Cundall, who deserves like honour with Heminges as his collaborator in editing the 1623 Folio, though not himself one of the first seven house-keepers who built the Globe, was with Sly a member of the older generation of actors.[162] His parts show a bewildering variety and include Friar Lawrence, Antonio (*The Merchant of Venice*), Mark Antony (*Julius Caesar*), Horatio, Cassio, the Duke in *Measure for Measure* (his longest), Edgar, Malcolm, and Octavius Caesar. Mark Antony was perhaps his first big chance, and it is noteworthy that the obvious difference between this Antony and the later hero of *Antony and Cleopatra* corresponds with a difference in calibre between Cundall and Burbadge.

[160] Baldwin, *op. cit.*, 186, note. [161] Baldwin, *op. cit.*, 253.
[162] Baldwin, *op. cit.*, 83, and note.

hits off Armin's style as opposed to Kemp's: "He uses his folly like a stalking-horse, and under the presentation of that he shoots his wit." [164] The idea of wiseman-fool is the novelty. Viola's comment on Feste—

> This fellow is wise enough to play the foole,
> And to do that well, craves a kinde of wit:
> He must observe their mood on whom he jests,
> The quality of persons, and the time:
> And like the Haggard, checke at every Feather
> That comes before his eye. This is a practice,
> As full of labour as a Wise-mans Art:
> For folly that he wisely shews, is fit;
> But wisemens folly falne, quite taint their wit . . .

reads like an extract from Armin's treatise.[165] Both Touchstone and Feste suggest that Shakespeare was much taken up at this time with conversations with Armin; and Jaques' long dissertation after his first meeting with Touchstone probably reflects these conversations; as also perhaps the passage about clowns in Hamlet's advice to the players.[166] The combined triumph of poet and player came five years later in Lear's Fool, of whose shrewd commentary on the follies of his misguided master we have a foretaste in Feste's "proofe" that Olivia is a fool to mourn for her brother's death. Like Viola, Kent says of him too, "This is not altogether foole my Lord." [167]

One of Baldwin's most convincing character-sketches is that of Richard Cowley, who played second fiddle to both Pope and Kemp, and afterwards to Armin. He is known to have been *Verges* to Kemp's Dogberry, and other parts assigned to him are Robert Faulconbridge, Old Gobbo, Silence, William in *As You Like It*, Aguecheek and Slender. Baldwin tells us: "Cowley seems to have been decidedly thin, and to have capitalized this characteristic for comic effect. Thus half-faced Robert has legs that are

> two such riding-rods,
> My arms, such eel-skins stuffed, my face so thin,
> That in mine ear I durst not stick a rose
> Lest men should say, "look where three farthings goes".

Aguecheek is 'a thin-faced knave', named accordingly. Slender is also labelled with this characteristic, having but 'a little whey face'.

[164] *As You Like It*, V. iv. 112 ff. [165] *Twelfth Night*, III. i. 68 ff.
[166] *As You Like It*, II. vii. 13 ff.; *Hamlet*, III. ii. 43 ff.
[167] *Twelfth Night*, I. v. 62 ff.; *King Lear*, I. iv. 166.

Also Aguecheek's hair 'hangs like flax on a distaff', and Slender has 'a little yellow beard—a cane-coloured beard'. As Slender walks, 'does he not held up his head, as it were, and strut in his gait?' In these youthful caricatures, Cowley was represented as approximately his own age, William in *As You Like It*, for instance, being twenty-five. But this slenderness was also used for aged comic caricatures. Here are Silence, Gobbo, and Verges, this last character being one that we know from contemporary evidence was Cowley's. As this comic old man, Cowley was usually paired with Kemp; but as the comic young man he was usually connected with Pope." [168]

These are some of the leading personalities among the members of the Chamberlain's-King's company of players, whose number never rose to more than a round dozen at a single time. Among so few the choice for distribution of parts is not as difficult to make as might be expected, and Baldwin's "lines" become plausible. With a score or so of hired men, and at most, five or six boy apprentices, the full strength of the company engaged in a normal performance would be between thirty-five and forty. Of the hired men not much need here be said, except to point out that they were a very necessary part of the company, and that their functions were much varied; we have a list of twenty-one names—hardly more than names—dating from 1624, and the list is described as "Musitions and other necessary attendantes". We must think of them as playing and singing when needed, as being handymen behind the Tiring-House wall to move furniture and properties, as being at the beck and call of the Book-Keeper, often as appearing on the Platform in minor parts (parts over which Shakespeare often takes pains to give them dramatic life), or as attendants on a royal or noble personage, as armies in the field, as mobs in the streets, and used of course to frequent doubling of parts. *Julius Caesar* is a particularly interesting play from the point of view of casting—where there is a kind of cleavage half-way, the mob turning into the soldiers of the rival armies, and the rear-rank conspirators into their officers. The fairies for *A Midsummer Night's Dream* and *The Merry Wives of Windsor* would need to be specially recruited for the occasion—perhaps from one of the Choir Schools, perhaps as Chambers suggests from the musical establishment of the second Lord Hunsdon.[169] And no doubt sometimes a musician of special accomplishment would be enlisted for a particular occasion. But in general there would be a collection of about twenty hired men available, working on a wage basis, with little chance of belonging

[168] Baldwin, *op. cit.*, 254. *King John*, I. i. 140 ff. *Twelfth Night*, V. i. 215; I. iii. 110. *The Merry Wives of Windsor*, I. iv. 22 ff.
[169] E. K. Chambers, *William Shakespeare*, vol. ii, 86.

to the class of masters, but content to renew their contracts every two or three years with so successful a company as the Chamberlain's Men. "At least in theory," says Baldwin, "they accepted Menenius' orthodox parable of the belly, and were not ill content." [170] Their descendants in the modern theatre are more specialised in their functions: many of the Globe hired men were no doubt Johannes Factotum, and if there is any truth in the tradition mentioned by Malone that Shakespeare's "first office in the theatre was that of *Call-boy*, or prompter's attendant", then that is perhaps why—as his stagecraft shows—he had such a firm grip on the practical technique of his art.

(vi) *The Boy Actors*

But the apprentices, the boy-actors, need separate treatment; for they raise a fundamental issue in examining the art of Shakespeare's theatre. The conditions of their employment are obscure. It is tantalising to read in Baldwin that the master of an apprentice "took the boy at ten and broke him in on minor parts supplied by the dramatist. As the boy grew older, his parts become more difficult till a few years before his graduation at the age of twenty-one he was playing the leading part in his line . . ." and that "this system of training necessitated the closest co-operation on the part of the dramatist also. It was his business in co-operation with the master (of the apprentices) to supply proper parts for each youngster to begin with and develop in. He had also to be careful not to create any female part for which there was not a properly trained actor." [171] It is tantalising because Chambers will not allow us to believe in this picture. Baldwin's speculations are, he says, "vitiated by a misconception as to the nature of theatrical apprenticeship" and he will only allow us to "take the engagements to have been for terms of two or three years, rather than of seven years or longer, and not under formal indentures of apprenticeship, but, as in the case of men, ordinary contracts of service with individual sharers, backed by bonds".[172] Whatever the facts, we can readily assume that the boy-actors were carefully trained by the full members of the company, one being groomed as successor to another whose voice was "crack'd within the ring", and that if they proved apt pupils, their contracts were likely to last long enough for them to be admitted in time to full membership of the company. Many of them had long enough to wait, and some were never admitted. It is, moreover,

[170] Baldwin, *op. cit.*, 147. [171] Baldwin, *op. cit.*, 227.
[172] E. K. Chambers, *William Shakespeare*, vol. i, 82; vol. ii, 85.

likely that some of the boys were still capable of playing female parts at the age of twenty: and we may presume that some of the maturer rôles were designed for players who had grown beyond the stage of boyhood.

To dally once more with surmise—for it is easier to see in concrete examples if a theory is plausible or not—Baldwin's conjecture gives us Eccleston as Moth, Nerissa, Juliet's Nurse, Mrs. Quickly (*Henry IV*), Beatrice, and after a long gap "Lord E." in *All's Well That Ends Well;* and Goffe as Juliet, Portia, Princess (*Love's Labour's Lost*) and Lady Mortimer, and "Lord G." in *All's Well That Ends Well;* Rosalind and Viola are the climax of Ned Shakespeare's list of boy parts, which also include Francis the Drawer and Doll Tearsheet. Edmans is the "creator" of Regan, Lady Macbeth and Cleopatra. Crosse, who plays Mrs. Quickly in *Henry V* and *Merry Wives of Windsor*, Audrey in *As You Like It*, Maria in *Twelfth Night*, Mistress Overdone, Queen Gertrude, and Emilia, is perhaps not inappropriately described in *Measure for Measure* as "A Bawd of eleven yeares continuance".[173] With the shifting personnel of adolescence, one would not expect here the same assurance of conjecture as with the adult members, nor the same clear demarcation of "lines". Nevertheless, one can play with the idea of a contrast between Eccleston's vein of impudent merriment and Goffe's of tender dignity; Ned Shakespeare's flair for a type of candid wit; Edmans' for tragic intensity.

In general it must be said that Shakespeare's expectation of the boys, as indicated by the parts he wrote for them, suggests a very high range of accomplishment. The tragic queens of the early histories are compounded largely of rhetoric. Juliet is a landmark, for while her tragic development draws upon the rhetorical intensity of the tragic characters in the histories, the background of her daily circumstances is akin to that of the comedies. For the comic vein, Rosalind gives us some of the tricks of the trade when she makes up for Orlando's benefit her story of how she cured a lover of his malady:

> Hee was to imagine me his Love, his Mistris: and I set him everie day to woe me. At which time would I, being but a moonish youth, greeve, be effeminate, changeable, longing, and liking, proud, fantastical, apish, shallow, inconstant, ful of teares, full of smiles; for everie passion something, and for no passion truly any thing, as boyes and women are for the most part, cattle of this colour: would now like him, now loath him: then entertaine him, then forswear him: now weepe for him, then spit at him; that I drave my Sutor from his mad humor of love, to a living humor of

[173] *Measure for Measure*, III. ii. 212.

madness, w^c was to forsweare the ful stream of y^e world, and to live in a nooke meerly Monastick: and thus I cur'd him, and this way wil I take upon mee to wash your Liver as cleane as a sound sheepes heart, that there shal not be one spot of Love in't.[174]

And there are most explicit instructions given to the boy who is to play the part of wife to Christopher Sly in the induction to *The Taming of the Shrew*.[175] One can see the comedy parts growing; from the simple sincerity of Julia in *Two Gentlemen of Verona* and the "tongues of mocking wenches" in *Love's Labour's Lost*, through the robustly boyish skirmishing of Hermia and Helena, to Portia of Belmont (the first time a boy's part was the longest in the play). When she and Nerissa speak their quick-fire rhythmical prose, they show promise already of Rosalind and Beatrice. Portia's opening scene, with its satirical mimicry, is very well suited for a boy to play, and the unaffected candour of a boy's voice can still redeem even the hackneyed "mercy" speech from the sententiousness that has overgrown it in the intervening years since it was written. For the great comedy parts, Beatrice, Rosalind, Viola, the boy must have been quick-witted and remarkably sensitive in expressing changes of mood with his voice and in his miming. It is unthinkable that the brilliant wit of Beatrice can have been done less than justice by Shakespeare's original actor, or that the known popularity of the duets between her and Benedick [176]—

> let but *Beatrice*
> And *Benedicke* be seene, loe in a trice
> The Cockpit Galleries, Boxes, all are full—

can have arisen from the gauche antics of a boy-girl such as we saw pilloried in a recent Shakespearian film. It is perhaps less astonishing to us in this generation who have been shown over and over again on the films, from France, from Germany, from Italy, from our own studios, the powers of children in acting rôles of great intensity to wring our hearts, and their versatility in making us laugh and weep with the sincerity of their playing. Anyone who has seen *Poil de Carotte*, *Mädchen in Uniform*, *Shoe Shine* or *The Fallen Idol*, will be ready to believe that the acting of the Globe boys was not the least moving part of the performance, and will understand why it was that the boys' companies were sometimes a menace to their adult rivals.

It has often been pointed out that the trick of male disguise is a

[174] *As You Like It*, III. ii. 433 ff.
[175] *The Taming of the Shrew*, Induction. I. 105 ff.
[176] Leonard Digges, Commendatory Verses to Shakespeare's *Poems* (1640), reproduced in E. K. Chambers' *William Shakespeare*, vol. ii, 232 ff.

device to suit the convention, but we should notice too the ingenuity with which Shakespeare exploits the device for his comic purposes. Portia tells Nerissa

> Ile prove the prettier fellow of the two,
> And weare my dagger with the braver grace,
> And speake betweene the change of man and boy,
> With a reede voyce, and turne two minsing steps
> Into a manly stride.[177]

Viola, becoming suddenly aware of Olivia's passion, cries "Fortune forbid my out-side have not charm'd her," and there is a special piquancy in the boy-player's embarrassed realisation "I am the man".[178] In the dénouement of *The Merry Wives of Windsor*, while Anne Page is away with her Fenton, Slender is fobbed off with "a great lubberly boy" and Dr. Caius finds that he has married a "Garsoon".[179] Shakespeare is never afraid of reminding us that there is a positive pleasure in the very fact of make-believe. One of his boldest strokes of opportunism is Cleopatra's indignant outcry, as she contemplates the prospect of being taken by Octavius in triumph to Rome—

> The quicke Comedians
> Extemporally will stage us, and present
> Our Alexandrian Revels: *Anthony*
> Shall be brought drunken forth, and I shall see
> Some squeaking *Cleopatra* Boy my greatnesse
> I'th' posture of a Whore.[180]

That he can remind us of the convention with so much confidence is an indication of his own trust in the plausibility of the boys' acting: there would be no point in the irony (rather a danger of its being turned on the players themselves) if we were not for the moment under the spell.

The last of these examples is from a tragedy, and from a tragic passage in a tragedy that has many comic episodes. We may think, when we come to consider *Macbeth* in detail, that the deliberate "unsexing" of the fiendish queen is a kind of tragic equivalent of the male disguise of comedy. She and Goneril and Regan are easily within the range of a boy's expression—primitive cruelty, is it true to say? coming more easily than the more civilised emotions. The remarkable thing—but remarkable only until we remember that Shakespeare was a practical man of the theatre and knew his

[177] *The Merchant of Venice*, III. iv. 64 ff. [178] *Twelfth Night*, II. ii. 26.
[179] *The Merry Wives of Windsor*, V. v. 202, 228.
[180] *Antony and Cleopatra*, V. ii. 215 ff.

material—is that the love scenes too are so written that they can be easily played by boys. Granville-Barker has an admirable passage on this theme [181]: ". . . it is Shakespeare's constant care," he says, "to demand nothing of a boy-actress that might turn to unseemliness or ridicule," and he goes on to show how discreetly the part of Juliet is written with such intent, and contrasts Shakespeare's handling of Cleopatra "with a Cleopatra planned to the advantage of the actress of to-day". I would add as an example the wonderfully cunning way in which Shakespeare portrays the love of Hotspur and Lady Percy —his absent-minded brusqueness, her teasing, eager anxiety, "Indeede Ile breake thy little finger *Harry*, if thou wilt not tel me true"; his bluster, "Away, away, you trifler: Love, I love thee not, I care not for thee *Kate:* this is no world To play with Mammets, and to tilt with lips"; and then, when she insists, "Do ye not love me? . . . Nay tell me if thou speak'st in jest, or no," his tender parry, "Come, wilt thou see me ride? And when I am a-horsebacke, I will sweare I love thee infinitely." Subtler still is the comedy of the contrasted pairs in Glendower's hall—Hotspur and his Lady bickering as before, and the sentimental parting of the others stripped of embarrassment because to speak one word to his wife Mortimer must depend on his father-in-law as interpreter. How easy is this scene for the boy-singer-player to act! [182] The midnight encounter between Brutus and Portia is more straightforward and just as easy.[183] But it will be noticed that in no case does the poet leave us in doubt of the real warmth of affection between husband and wife. Granville-Barker continues: "Shakespeare, artist that he was, turned this limitation to account, made loss into a gain. Feminine charm—of which the modern stage makes such capital—was a medium denied him. So his men and women encounter upon a plane where their relation is made rarer and intenser by poetry, or enfranchised in a humour which surpasses more primitive love-making. And thus, perhaps, he was helped to discover that the true stuff of tragedy and of the liveliest comedy lies beyond sensual bounds. His studies of women seem often to be begun from some spiritual paces beyond the point at which a modern dramatist leaves off. Curious that not a little of the praise lavished upon the beauty and truth of them—mainly by women—may be due to their having been written to be played by boys!" This paragraph, eloquent and true as it is of nine-tenths of Shakespeare's creation in this kind, ignores the few occasions when his story necessitates his stressing the ugliness of sensual passion. But

[181] Granville-Barker, *Prefaces to Shakespeare*, First Series, Introduction, xxviii f.
[182] 1 *Henry IV*, II. iii. 41 ff.; III. i. 191 ff.
[183] *Julius Caesar*, II. i. 234 ff.

even there he makes no embarrassment for his boy-actors. The lechery of Claudius puts no strain upon the player of Gertrude: we witness no amorous *tête-à-tête;* if we may borrow from Iago, "it were a tedious difficulty, I thinke, To bring them to that Prospect"; once only do we see them alone, and then in a state of panic immediately after the death of Polonius. On the other hand, Shakespeare is ruthless and unsparing in his verbal picture, whether in metaphor—

> Nay, but to live
> In the ranke sweat of an enseamed bed,
> Stew'd in Corruption; honying and making love
> Over the nasty Stye . . .

or in objective statement—

> Let the blunt [*read* bloat] King tempt you againe to bed,
> Pinch Wanton on your cheeke, call you his Mouse,
> And let him for a paire of reechie kisses,
> Or padling in your necke with his damn'd Fingers
> Make you to rovell all this matter out.[184]

When Cressida bandies pleasantries with the Greek chiefs on her return from Troy, Nestor describes her as "A woman of quick sence", but Ulysses is uncompromising in his judgment:

> Fie, fie, upon her:
> Ther's a language in her eye, her cheeke, her lip;
> Nay, her foote speakes, her wanton spirites looke out
> At every joynt, and motive of her body:
> Oh these encounterers so glib of tongue,
> That give a coasting welcome ere it comes;
> And wide unclaspe the tables of their thoughts,
> To every tickling reader: set them downe,
> For sluttish spoyles of opportunitie;
> And daughters of the game.[185]

These last two examples give us a hint of the secret of Shakespeare's method: he creates his feminine characters, as indeed the whole of his drama, by means of the words: here especially they are the creation of the poetic drama. We can use again the analogy of the white screen, suggested above in discussing unlocalisation.[186] The neutral personalities of the boy players are a white screen upon which the poet projects the images of Rosalind, Viola, Beatrice,

[184] *Hamlet*, III. iv. 91 ff., 182 ff.
[185] *Troilus and Cressida*, IV. iv. 54 ff. Dover Wilson expresses the opinion that even Doll Tearsheet was well within the scope of the boy-actor (*The Fortunes of Falstaff*, 108).
[186] See above, p. 108,

Lady Macbeth and Cleopatra. The actress will, perhaps, unconsciously and instinctively, paint something of her own upon the screen which cannot do other than blur the clear image of the poet. Desmond McCarthy says something of the kind when in criticising a performance with boy-actors he remarks that it is "interesting to see what Shakespeare took for granted: boys impersonating women. The effect of that convention was by diminishing personal interest to direct the attention of the spectator towards the character impersonated rather than upon the impersonator. This also was in harmony with that technique which required the actor never to allow the spectator to forget completely that he was 'acting', but on the contrary, to draw additional pleasure from his skill. And it may be of some significance that the decline of poetical drama to which that technique was so admirably suited, begins when women begin to take women's parts".[187] I have seen a Desdemona, unnaturally propped on a couch under a powerful spotlight, affronting the gallery with her coiffure that had "woven A golden mesh t'intrap the hearts of men Faster then gnats in cobwebs". This is the unquestioned privilege of the leading lady. The boy Wilson at the first performance would be given no such consideration: hardly visible in the depths of the Study, he would yet exist for us in the clearest and most poignant of pictures as no spotlight and make-up artist, as no camera even, could possibly show us:

> that whiter skin of hers, then Snow,
> And smooth as Monumentall Alablaster . . .

It is the voice of Burbadge that paints Desdemona for us—

> Thou cunning'st Patterne of excelling Nature, . . .
> When I have pluck'd thy Rose,
> I cannot give it vitall growth againe,
> It needs must wither. Ile smell it on the Tree.
> Oh Balmy breath, that dost almost perswade
> Justice to breake her Sword.[188]

The poetry gives us not only the impression of Desdemona's innocent sleep, but also "the pity of it". The actress, too often, offers us into the bargain a hair-do, a frock, a figure, and her personal charm. And it is in the nature of man to be distracted by such irrelevance

[187] The quotation is from an article in *The New Statesman* for July 12th, 1947. The decline began as early as the Restoration, and is already fully developed in Dryden's 1667 version of *The Tempest*. See Harold Child's description in *A Companion to Shakespeare Studies* (Cambridge), 331, 332. It is interesting to compare McCarthy's last sentence with the remark of Collier quoted on p. 72 above.

[188] *Othello*, V. ii. 4 f.; 11 ff.

from the point—which is not that she is beautiful or charming, but that she is like a rose (as innocent and as easily destructible) and that Othello who knows how easily the rose will wither, takes her innocence for seeming which is really truth; and there's the pity of it.

Ultimately, of course, this condemnation of the poor leading lady is applicable to our male actors too—though in a lesser degree, for the instinct to obtrude themselves is less strong with them. But the fact remains that they too, most of them, will not let Shakespeare have his way; they too will not recognise that the essence of the poetic drama is in the words and that their job is to speak and mime the drama which is complete in the words—their meaning, their emphasis, their style, their phrasing, their rhythm, their mood, their characterisation—and to interpose nothing of their own irrelevant invention.

(vii) Characterisation (recapitulated)

We may now return from this digression among the individual personalities of the Chamberlain's Men, to consider and summarise their practice in characterisation. We have taken note of the old-men parts of Heminges, the Pope-Lowin "line" of robust bluffness hardly changing in the succession, the *jeune premier* of Sly, the Kemp "line" transformed in Armin, a hint of repetitive parts among the boy-actors. The common denominator in each case is the "line" of the actor—made up of his voice, his person, his habitual mannerisms, his chosen style of mimicry; the variations are Shakespeare's. Let it not be thought that each actor could play but one type of part: the lists assert the contrary; and it is not only Burbadge who shows considerable versatility; the "lines" are more elastic than this. But we are surely right to follow Baldwin in studying the individuals of the company, and if we were rebuilding a Shakespearian repertory, we should provide a representative capable of performing each of the main "lines". The capabilities and limitations of his principal actors were as much part of Shakespeare's data as the conditions of his playhouse.

We can go further than this. Professor E. E. Stoll opens his *Art and Artifice in Shakespeare* with a forthright declaration: "The core of tragedy (and of comedy too, for that matter) is situation; and a situation is a character in contrast, and perhaps also in conflict, with other characters or with circumstances. We have ordinarily been taught that with the author character comes first and foremost, not only in importance but in point of time, and (cause of no little confusion) that the action is only its issue. But there is no drama until

the character is conceived in a complication; and in the dramatist's mind it is so conceived at the outset." [189] For the moment, we are more concerned with the actors than with the poet, and, concurring with Stoll, we may notice that his view chimes with our interpretation of the typical speech-headings and the descriptive cast-lists of the Folio.[190] If the prompt-copy speaks of Capulet and Lady Capulet as *Father* and *Mother*, it stands to reason that not only the author but also the players were accustomed to think of these (and other) characters "in a complication"; that if Heminges were asked what part he played in *Romeo and Juliet*, he would answer instinctively "I'm the girl's father". Indeed, it would hardly be necessary to ask him: he was so used to playing the part of "the girl's father". Nothing is more revealing in this connection than the case of the Countess in *All's Well That Ends Well*, already cited.[191] The boy-actor of this rôle is all the time playing his part in the story. We must in fact think of the Chamberlain's Men as playing not with such psychological subtlety as to provoke us to speculate on the life of their characters before and after the action of the play and when they are off the stage, but simply as figures, active or passive, agent or sufferer, in a drama, made up of certain defined episodes or situations, beyond which the characters do not exist.

We shall have cause to see in the next chapter that Shakespeare's stagecraft works on such lines as these, and that he regularly thinks of his main characters with an insistent relevance only in their relation to his story. The truth is that the immediate moment is always Shakespeare's first concern, and he is careless of implications and overtones. Indeed, sometimes, if he wants his actors to create an effect of mood or atmosphere by poetical means, he will ask them to speak altogether "out of character". The night-alarm at the opening of *Othello* is created by the player of Iago's part: "Heere is her Fathers house," says Roderigo, "Ile call aloud." "Doe," cries Iago, "with like timerous accent, and dire yell, As when (by Night and Negligence) the Fire is spied in populous Citties." The same player paints Othello for us in the pangs of jealousy:

> Not Poppy, nor Mandragora,
> Nor all the drowsie Syrrups of the world
> Shall ever medicine thee to that sweete sleepe
> Which thou owd'st yesterday.

The murderer of Banquo waxes lyrical to create the atmosphere of dangerous dusk:

[189] E. E. Stoll, *Art and Artifice in Shakespeare*, 1. [190] See above, pp. 26 f.
[191] See above, pp. 154 f.

> The West yet glimmers with some streakes of Day.
> Now spurres the lated Traveller apace,
> To gayne the timely Inne . . .

Gertrude's vivid recital of Ophelia's drowning, the bleeding sergeant more concerned to show us the prowess of Macbeth carving out his passage through the battle than to display his own fainting condition,[192] these are all cases where characterisation is subordinated to another effect in Shakespeare's dramatic purpose.

We shall also see in the next chapter that Shakespeare's method of characterisation changed, with his changing motive, during the progress from *Henry V* to *Hamlet*, and in the following years which may be described in Professor Toynbee's phrase as the poet's years of "Withdrawal-and-Return". Always restlessly experimental, he tired of the objectively-drawn figure, made vivid by an unerring choice of significant detail, and taught himself to portray the heart of man. The desire to do so was already present perhaps in the creation of the merchant Antonio's unplumbed melancholy. We can see the contrast clearly in a comparison of Lady Percy's account of her dead Hotspur with King Henry's description of his son [193]: Harry Percy is one of the most vivid examples of Shakespeare's objective portraiture; Harry Plantagenet, although after his coronation his development causes general disappointment among the critics, nevertheless contains, in certain passages of all three plays in which he figures, the seeds of Brutus, Hamlet and Macbeth.[194] Yet even these inwardly-conceived characters are contained wholly in the spoken words of the poet's text, and we gain nothing—we lose rather—by turning aside from them to speculation on a life for the character independent of those words.

Whether he was dealing with the earlier objective or the later "inward" character, Burbadge, I think, did not digress into psychological speculations such as are supposed to have given distinction to many a new interpretation of Hamlet (for instance) since his day. His manner of acting realised that the character was already there, complete in the words the poet gives him; that he, like the poet, must stick to the matter in hand and give the fullest force to the immediate moment. Consider the closet-scene: it is no part of the player's business to bother his head about the previous relationship of Hamlet to his mother, whether he was fonder of his father in his life-

[192] *Othello*, I. i. 74 ff.; III. iii. 331 ff. *Macbeth*, III. iii. 5 ff.; I. ii. 7 ff. *Hamlet*, IV. vii. 167 ff.

[193] See above, pp. 149 f.

[194] E. M. W. Tillyard expresses such an opinion in his *Shakespeare's History Plays*, 313 f.

time, whether he was neglected by his mother in childhood, whether he had an "Œdipus-complex" or some other inhibition. If he wants to know with what feelings and with what aspect he must burst into his mother's presence, he has his clear instructions in a previous soliloquy:

> 'Tis now the verie witching time of night,
> When Churchyards yawne, and Hell it selfe breaths out
> Contagion to this world. Now could I drink hot blood,
> And do such bitter businesse as the day
> Would quake to looke on. Soft now, to my Mother:
> Oh Heart, loose not thy Nature; let not ever
> The Soule of *Nero*, enter this firme bosome:
> Let me be cruell, not unnaturall,
> I will speake Daggers to her, but use none . . .[195]

This is the mood Shakespeare asks for, and, if we are not properly frightened at the beginning of the closet-scene, it may be partly the Queen's fault, but it will also be Hamlet's for not making the most of the preparatory atmosphere of these lines. Burbadge, we may be sure, confronted the boy Crosse with incisive wit, with violent action, with a flood of rhetoric, launching the passionate rhythm, and then at the climax of his passion bringing in brilliant miming to reinforce the impression of the supernatural presence: the Ghost scene is explicitly created in the words of all three speakers; Burbadge, Crosse, and Shakespeare himself (as the Ghost) have but to follow the instructions contained in the dialogue, to harrow us with fear and wonder. The Ghost describes the Queen:

> But looke, Amazement on thy Mother sits;
> O step betweene her, and her fighting Soule,
> Conceit in weakest bodies, strongest workes.

The Queen describes Hamlet:

> Alas, how is't with you?
> That you bend your eye on vacancie,
> And with their corporall ayre do hold discourse.
> Forth at your eyes, your spirits wildely peepe,
> And as the sleeping Soldiours in th' Alarme,
> Your bedded haire, like life in excrements,
> Start up, and stand an end.

And Hamlet describes the Ghost in moving terms:

> look you how pale he glares,

[195] *Hamlet*, III. ii. 413 ff.

and

> Do not looke upon me,
> Least with this pitteous action you convert
> My sterne effects:

and again

> looke how it steals away:
> My Father in his habite, as he lived,
> Looke where he goes even now out at the Portall.[196]

It is almost as if Shakespeare was bent on leaving nothing to chance. All this detailed description is needed where, with modern stage-lighting and make-up, or with the "close-up" of the cinema, it would not be. The poetry takes the place of the lighting and the close focus. The limitation of mechanical means in the Elizabethan theatre is not wholly a disadvantage: for this very limitation breeds the poetic drama: the necessity of description gives the poet the opportunity to comment as well as to describe, to illuminate with metaphor and imagery, to suggest our mood. For instance, the words "Forth at your eyes, your spirits wildely peepe" produce an impression that no amount of grimacing could convey with certainty. The fullness of Shakespeare's description and comment is what makes many of his admirers content to read him in the armchair. It also makes the producer's and actor's task quite unmistakably clear, if only they will aim at Shakespeare's interpretation, and not seek to impose their own.

We shall return in the next chapter to this habit of "close-up" description, which is seemingly implicit in the technique of the poetic drama. Meanwhile let it be observed that it arises directly from the conditions of the playhouse. Daylight, coming mostly from overhead, though making quite clear what was happening and which character was which (in contrast to the not infrequent confusion among our elaborate lighting effects), would not illuminate the details of facial expression, as our use of strong make-up and powerful lights does. No doubt make-up was not unknown in the Elizabethan playhouse: one thinks of Othello's complexion, Bardolph's nose, Piramus' beard. But its purpose would be broad disguise rather than the revelation of facial expression or subtle visual illusion. So these, like much of the atmospheric effect, had to be supplied by the poet's words.

In summary, it is possible to draw a parallel between the essential simplicity of the stage, its furniture and properties, on the one hand, with the subtleties of Shakespeare's atmospheric transformations of

[196] *Hamlet*, III. iv. 111 ff.

it, and on the other, the broad lines of the actor's impersonation, with the subtleties of Shakespeare's elaboration of it. The actor had his "line", allowing of considerable variation within itself (and Shakespeare was quick to take advantage of this latitude); he also knew, every time he went on the stage, the business he was to transact, the part he was to play in carrying forward the plot of the story: to this he stuck with a clear-cut relevance, which was characteristic also of his author. I believe this is true even of so highly complex a characterisation as Hamlet, and that if your actor remembers the business, the agenda, of each scene (quite literally *what it is about*)—then, provided he has the skill and grace of voice and gesture that Burbadge had, he will give a capital performance of Shakespeare's sweet prince.

(viii) The Method in Practice

To recapitulate this chapter on the acting tradition of the Chamberlain's Men, we may now attempt a detailed illustration of the method in practice. What did the Chamberlain's Men do? This is the question we must ask ourselves every time we set about plotting a play in the manner of a performance at the Globe.

Each play, each scene, will present its own problems, and we must use every trick of the detective's art to solve them. Hints are often there for the observant. Corin in *As You Like It* lets us know in a later scene that his charming conversation with Silvius on the theme of love was conducted while sitting "on the Turph": there are clues here for deciding on the scene rotation—for the turf is likely to be in the Study—and the positioning of the earlier scene.[197] When Sir Walter Blunt visits Hotspur as envoy from the King before Shrewsbury field, one of the complaints that Harry Percy utters is that the King

> Rated my Unckle from the Councell-Boord.

He is clearly referring to the occasion when earlier in the play Worcester is snubbed by the King:

> You have good leave to leave us. When we need
> Your use and Counsell, we shall send for you.

Thus we know that the earlier scene opens with a council of state, with the King and his nobles sitting round the table set in the Study.[198] It is possible to multiply such clues, which the producer with the single-minded purpose of discovering Shakespeare's intention

[197] *As You Like It*, III. iv. 50; II. iv. 22 ff.
[198] 1 *Henry IV*, IV. iii. 99; I. iii. 20 f. See above, p. 41 (and note 39).

will not find hard to detect; though we shall not always be so lucky as when we catch Jaques with his food half-way to his mouth. "Forbeare, and eate no more," cries Orlando, to startle the company; "Why I have eate none yet," retorts Jaques, with the sang-froid of the cynic; and no doubt Pope proceeded to stuff his mouth in spite of the stranger's desperate prohibition.[199] We must look out especially for subsequent descriptions of a past scene, such as Benvolio's account of the death of Mercutio and Tybalt, Puck's version of the clowns' rehearsal and the "translation" of Bottom, or Iago's picture of the brawl in which Cassio lost his reputation.[200] The Constable of France, refuting the Dauphin's opinion of England's new King as a "vaine giddie shallow humorous Youth", says:

> Question your Grace the late Embassadors,
> With what great State he heard their Embassie,
> How well supply'd with Noble Councellors . . .

A due consideration of this comment on the earlier scene might have spared us the farcical tomfoolery which was presented on the screen as the Chamberlain's Men's version of King Henry among his peers.[201] Sometimes the clue precedes the scene in which it may be applied; as when Hamlet warns us that he means "To put an Anticke disposition on," or in his preparations for the play that he will rivet his eyes to his uncle's face; or as, when Lady Macbeth looks forward to the discovery of Duncan's murder, saying, "we shall make our Griefes and Clamor rore, Upon his Death", she gives us a hint of Macbeth's manner when he protests too loudly his horror at the deed.[202]

So much in general terms about the method of detection. Now let us take a specific example, and set about reconstructing what the Chamberlain's Men did with the scene of Caesar's murder. In this case we are not short of documentary evidence. We have two separate accounts by Antony after the event: he speaks in the Forum of the blow of Brutus' dagger:

> This was the most unkindest cut of all.
> For when the Noble *Caesar* saw him stab,
> Ingratitude, more strong then Traitors armes,
> Quite vanquish'd him: then burst his Mighty heart,
> And in his Mantle, muffling up his face,
> Even at the Base of *Pompeyes* Statue
> (Which all the while ran blood) great *Caesar* fell . . .

[199] *As You Like It*, II. vii. 88.
[200] These three examples are mentioned above, p. 127.
[201] *King Henry V*, II. iv. 28 ff.; I. ii.
[202] *Hamlet*, I. v. 172; III. ii. 90. *Macbeth*, I. vii. 78 f.; II. iii. 98 ff.

and he taunts the conspirators before Philippi because they uttered no warning threat before they attacked their victim:

> Villains: you did not so, when your vile daggers
> Hackt one another in the sides of *Caesar*:
> You shew'd your teethes like Apes,
> And fawn'd like Hounds,
> And bow'd like Bondmen, kissing *Caesars* feete;
> Whil'st damned *Caska*, like a Curre, behinde
> Strooke *Caesar* on the necke.[203]

We have moreover some most graphic descriptions in Plutarch, which suggest much of the stage-business which Shakespeare would presumably have passed on to the Book-Keeper and to his fellow actors. We can read, as Shakespeare read, of how "Popilius Laena, after he had saluted Brutus and Cassius more friendlie then he was wont to doe: he rounded softlie in their eares, and told them, I pray the goddes you may goe through with that you have taken in hande, but withall, dispatche I reade you, for your enterprise is bewrayed. When he had sayd, he presentlie departed from them, and left them both affrayed that their conspiracie woulde out".[204] We hear of "the great prease and multitude of people that followed him" and how Caesar "received all the supplications that were offered him, and that he gave them straight to his men that were about him".[205] Plutarch continues: "When Caesar came out of his litter: Popilius Laena, that had talked before with Brutus and Cassius, and had prayed the goddes they might bring this enterprise to passe: went unto Caesar, and kept him a long time with a talke. Caesar gave good eare unto him. Wherefore the conspirators (if so they shoulde be called) not hearing what he sayd to Caesar, but conjecturing by that he had tolde them a little before, that his talke was none other but the verie discoverie of their conspiracie: they were affrayed everie man of them, and one looking in an others face, it was easie to see that they all were of a minde, that it was no tarying for them till they were apprehended, but rather that they should kill them selves with their owne hands. And when Cassius and certeine other clapped their handes on their swordes under their gownes to draw them: Brutus marking the countenaunce and gesture of Laena, and considering that he did use him selfe rather like an humble and earnest suter, then like an accuser: he sayd nothing to his companion (bicause there were many amongest them that were not of the

[203] *Julius Caesar*, III. ii. 188 ff.; V. i. 39 ff.
[204] Plutarch's *Life of Brutus* (North's Translation, 1579).
[205] Plutarch's *Life of Caesar*.

conspiracie) but with a pleasaunt countenaunce encouraged Cassius. And immediatlie after, Laena went from Caesar, and kissed his hande: which shewed plainlie that it was for some matter concerning him selfe, that he had held him so long in talke. Nowe all the Senators being entred first into this place or chapter house where the counsell should be kept: all the other conspirators straight stoode about Caesars chaire, as if they had some thing to have sayd unto him. And some say, that Cassius casting his eyes upon Pompeys image, made his prayer unto it, as if it had bene alive. Trebonius on thother side, drewe Antonius atoside, as he came into the house where the Senate sate, and helde him with a long talke without. When Caesar was come into the house, all the Senate rose to honor him at his comming in. So when he was set, the conspirators flocked about him, and amongst them they presented one Tullius Cimber, who made humble sute for the calling home againe of his brother that was banished. They all made as though they were intercessors for him, and tooke him by the handes, and kissed his head and brest. Caesar at the first, simplie refused their kindnesse and intreaties: but afterwardes, perceiving they still pressed on him, he violently thrust them from him. Then Cimber with both his hands plucked Caesars gowne over his shoulders, and Caska that stoode behinde him, drew his dagger first, and strake Caesar upon the shoulder, but gave him no great wound. Caesar feeling him selfe hurt, tooke him straight by the hande he held his dagger in, and cried out in Latin: O traitor, Casca, what doest thou? Casca on thother side cried in Graeke, and called his brother to helpe him. So divers running on a heape together to flie uppon Caesar, he looking about him to have fledde, sawe Brutus with a sworde drawen in his hande readie to strike at him: then he let Cascaes hande goe, and casting his gowne over his face, suffered everie man to strike at him that woulde. Then the conspirators thronging one upon an other bicause everie man was desirous to have a cut at him, so many swords and daggers lighting upon one bodie, one of them hurte an other, and among them Brutus caught a blowe on his hande, bicause he would make one in murdering of him, and all the rest also were every man of them bloudied." [206] A second account, in the *Life of Caesar*, is no less graphic in detail: "So Caesar comming into the house, all the Senate stoode up on their feete to doe him honor. Then parte of Brutus companie and confederates stoode rounde about Caesars chayer, and parte of them also came towardes him, as though they made sute with Metellus Cimber, to call home his brother againe from banish-

[206] Plutarch's *Life of Brutus*.

ment: and thus prosecuting still their sute, they followed Caesar, till he was set in his chayer. Who, denying their petitions, and being offended with them one after an other, bicause the more they were denied, the more they pressed upon him, and were the earnester with him: Metellus at length, taking his gowne with both his handes, pulled it over his necke, which was the signe geven the confederates to sette apon him. Then Casca behinde him strake him in the necke with his sword, howbeit the wounde was not great nor mortall, bicause it seemed, the feare of such a develishe attempt did amaze him, and take his strength from him, that he killed him not at the first blowe. But Caesar turning straight unto him, caught hold of his sword, and held it hard: and they both cried out, Caesar in Latin: O vile traitor Casca, what doest thou? and Casca in Greeke to his brother, Brother, helpe me. At the beginning of this sturre, they that were present, not knowing of the conspiracie were so amazed with the horrible sight they sawe: that they had no power to flie, neither to helpe him, not so much, as once to make any outcrie. They on thother side that had conspired his death, compassed him in on everie side with their swordes drawen in their handes, that Caesar turned him no where, but he was striken at by some, and still had naked swords in his face, and was hacked and mangeled amonge them, as a wilde beaste taken of hunters. For it was agreed among them, that every man should geve him a wound, bicause all their partes should be in this murther: and then Brutus him selfe gave him one wounde about his privities. Men reporte also, that Caesar did still defende him selfe against the rest, running everie waye with his bodie: but when he sawe Brutus with his sworde drawen in his hande, then he pulled his gowne over his heade, and made no more resistaunce, and was driven either casually, or purposedly, by the counsell of the conspirators, against the base whereupon Pompeys image stoode, which ranne all of a goare bloude, till he was slaine. Thus it seemed, that the image tooke just revenge of Pompeys enemie, being throwen downe on the ground at his feete, and yelding up his ghost there, for the number of wounds he had upon him. For it is reported, that he had three and twenty wounds apon his body: and divers of the conspirators did hurt them selves, striking one body with so many blowes.'' [207]

It is plain that the scene starts on the Platform and that the Study curtains are parted as Caesar approaches the Capitol [208]: they reveal a "state"—probably in this case a dais with chairs for Caesar himself and a senator on either side. Casca's first blow must fall on Caesar

[207] Plutarch's *Life of Caesar*. [208] See above, p. 104.

from behind, as he sits on the dais. Yet Caesar's dead body must be down-stage during what follows, first because it is the focus of attention at Antony's entry and when he makes his passionate address to it after the conspirators have gone; further, because the mechanical need for the entry of Octavius' servant at the end of the scene is that the body must be carried off ("Lend me your hand") and this would not be necessary if the body still lay in the Study. The logical place for the body to lie is beside one of the fore-stage Pillars—that is, at the base of Pompey's statue. How did it get there? The answer is provided by Plutarch, whose stage-business is just what is wanted.

If we cast the play according to Baldwin's list, there is new life and interest in the characterisation. Here is Burbadge exploring new ground as the reflective Brutus; here is Phillips playing Cassius with the cutting edge which he will turn to comic purpose in the same year as Malvolio; Heminges bringing to Caesar his natural gravity so near the borderline of the absurd; Pope giving life to the blunt fellow Casca, who was "quick Mettle, when he went to Schoole"; Cundall grasping his first big chance as Antony. Within the limits of this scene, there is ample scope for creative speech, and the stature of Caesar and consequently the greatness of his fall will depend largely upon the verbal skill of Heminges: there is opportunity for miming in the movements of the conspirators, their furtive manœuvring from the perimeter towards the Study, with Phillips perhaps "casting his eyes upon Pompeys image" and making his prayer to it, "as if it had bene alive", and their assumed servility, taking Caesar by the hands, and kissing his head and breast; vigorous miming too in the violent and prolonged struggle of the murder itself with its three distinct phases. Moreover, the three-dimensional positioning of the Globe stage is fully illustrated in the approach to the senate-house from the street, and the expressively dramatic episode of Popilius Lena's false alarm.

Let us then annotate the prompt-book, plotting the scene as the Book-Keeper might have done.

The Prompt Book
Annotated

Immediately after *Portia's* distracted retreat between the closed curtains of the Study, the crowd (A-H) surge in from R door, bringing with them the *Soothsayer* and *Artemidorus*: their excited murmurs and a long flourish of trumpets accompany a brisk processional entry from L door. *Caesar* is confronted with the *Soothsayer* between the two pillars. *Decius*, who came to fetch him to the senate-house, is still at his elbow, ready to intervene by drawing attention to the suit of *Trebonius*, just behind him.

10 *What, is the fellow mad?* The curtains of the Study drawn quickly to disclose the furniture of the senate-house—a dais with three chairs, the central one for *Caesar*; broad steps in front, and other steps at both ends of the dais.

11–12 *Cassius's* question and the description in Plutarch suggest what happened here. *Caesar's* progress to the Capitol is checked in mid-stage by a throng of petitioners kneeling in his way: this in dumb-show forms a background to the whispered dialogue of the panic-stricken conspirators at the front of the platform. The passage from the street to the Capitol is (as Granville-Barker makes clear, *Prefaces to Shakespeare*, First Series, 122) an excellent example of the simple effectiveness of Shakespeare's stagecraft. When *Caesar* reaches his "state", the crowd disperse to right and left, leaving a clear approach for the conspirators to their object.

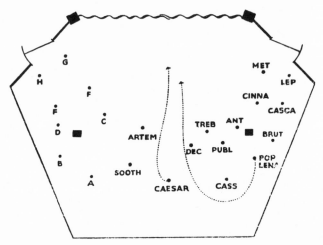

Positioning: *The Ides of March are come*

13–30 The details of both background and foreground are made clear in the dialogue—the movements of *Popilius*, the moment when *Caesar* and he are in conversation (conspicuous by being raised on the dais), the departure of *Antony* and *Trebonius*; the approach of the suitors to *Caesar*, first *Metellus*, then *Decius*; *Casca*, at *Cinna's* prompting, creeps stealthily behind the dais. *Cinna* the last to approach *Caesar* (line 74), can lend a touch of terror to the foreground by holding his dagger ready behind his back.

Flourish

Enter *Caesar, Brutus, Cassius, Caska, Decius, Metellus, Trebonius, Cynna, Antony,*
 Lepidus, Artimedorus, Publius, and the *Soothsayer.*

Caes. The Ides of March are come.
Sooth. I *Caesar,* but not gone.
Art. Haile *Caesar:* Read this Scedule.
Deci. Trebonius doth desire you to ore-read
 (At your best leysure) this his humble suite. 5
Art. O *Caesar,* reade mine first: for mine's a suite
 That touches *Caesar* neerer. Read it great *Caesar.*
Caes. What touches us our selfe, shall be last serv'd.
Art. Delay not *Caesar,* read it instantly.

I wish your enterprize to day may thrive

Caes. What, is the fellow mad? 10
Pub. Sirra, give place.
Cassi. What, urge you your Petitions in the street?
 Come to the Capitoll.
Popil. I wish your enterprize to day may thrive.
Cassi. What enterprize *Popillius?*
Popil. Fare you well.
Bru. What said *Popillius Lena?* 15
Cassi. He wisht to day our enterprize might thrive:
 I feare our purpose is discovered.
Bru. Looke how he makes to *Caesar:* marke him.
Cassi. Caska be sodaine, for we feare prevention.
 Brutus what shall be done? If this be knowne, 20
 Cassius or *Caesar* never shall turne backe,
 For I will slay my selfe.

31 *Are we all ready?* The crowd, chidden by *Publius* in front of *Caesar* and
 Popilius behind him, have parted to left and right, and remain
 quiescent until the moment of the murder: a discreet actor in the
 part of *Artemidorus* can help to increase the tension by his ill-
 concealed anxiety: but the crowd are an inconspicuous frame to the
 picture of *Caesar's* greatness, raised by Shakespeare to its fullest
 stature in preparation for the catastrophic fall.

Caesar's last two speeches have the rhythm and diction of greatness: there
is no mistaking Shakespeare's intention to build up the stature of the
dictator, so that we may afterwards recognise the dramatic force of Antony's

> *Are all thy Conquests, Glories, Triumphes, Spoiles,*
> *Shrunke to this little Measure?*

and in the Forum speech, his

> *O what a fall was there, my countrymen?*

But I am constant as the Northern Starre

47–48 Producers here must choose between the reading of the Folio and
 that other version which Ben Jonson scorned, but which may well
 seem to other critics not only characteristic of Shakespeare, but
 also preferable.

> *Know, Caesar doth not wrong, but with good cause,*
> *Nor without cause will he be satisfied—*

has the authentic ring of rhetoric, pushed to the verge of absurdity.
It is indeed very like Shakespeare to recognise that grandeur and
absurdity are not incompatible, and Shakespeare's Caesar certainly
has elements of both.

49 ff. The conspirators, supporting the petition of *Metellus*, close in on
 Caesar, so that *Casca* and *Metellus* can begin the assault from behind.
 Cassius, Decius and *Cinna* meet him as he struggles down the steps,
 and *Brutus* confronts him in mid-stage.

Bru. Cassius be constant:
 Popillius Lena speaks not of our purposes,
 For looke he smiles, and *Caesar* doth not change.
Cassi. Trebonius knowes his time: for look you *Brutus*25
 He drawes *Mark Antony* out of the way.
Deci. Where is *Metellus Cimber*, let him go,
 And presently preferre his suite to *Caesar*
Bru. He is addrest: presse neere, and second him.
Cin. Caska, you are the first that reares your hand.30
Caes. Are we all ready? What is now amisse,
 That *Caesar* and his Senate must redresse?
Metel. Most high, most mighty, and most puisant *Caesar*
 Metellus Cymber throwes before thy Seate
 An humble heart.
Caes. I must prevent thee *Cymber:*35
 These couchings and these lowly courtesies
 Might fire the blood of ordinary men,
 And turne pre-Ordinance, and first Decree
 Into the lane [*read* law] of Children. Be not fond,
 To thinke that *Caesar* beares such Rebell blood40
 That will be thaw'd from the true quality
 With that which melteth Fooles, I meane sweet words,
 Low-crooked-curtsies, and base Spaniell fawning:
 Thy Brother by decree is banished:
 If thou doest bend, and pray, and fawne for him,45
 I spurne thee like a Curre out of my way:
 Know *Caesar* doth not wrong, nor without cause
 Will he be satisfied.
Metel. Is there no voyce more worthy then my owne,
 To sound more sweetly in great *Caesars* eare,50
 For the repealing of my banish'd Brother?
Bru. I kisse thy hand, but not in flattery *Caesar:*
 Desiring thee, that *Publius Cymber* may
 Have an immediate freedome of repeale.
Caes. What *Brutus?*55
Cassi. Pardon *Caesar: Caesar* pardon:
 As lowe as to they foote doth *Cassius* fall,
 To begge infranchisement for *Publius Cymber.*
Caes. I could be well mov'd, if I were as you,
 If I could pray to moove, Prayers would moove me:
 But I am constant as the Northerne Starre,60
 Of whose true fixt, and resting quality,
 There is no fellow in the Firmament.
 The Skies are painted with unnumbred sparkes,
 They are all Fire, and every one doth shine:
 But, there's but one in all doth hold his place.65
 So, in the World; 'Tis furnish'd well with Men,
 And Men are Flesh and Blood, and apprehensive;
 Yet in the number, I do know but One
 That unassayleable holds on his Ranke,

76 *Speak, hands, for me.* It seems likely that the Chamberlain's Men
 would build their action upon the vivid accounts of Plutarch as
 distilled through the imagination of the poet. Salient features are
 the initial stab of *Casca* from behind on the neck, while *Metellus*
 throws *Caesar's* cloak over his head; then a prolonged and violent
 struggle in which *Caesar* defends himself with vigour and the con-
 spirators wound each other in panic; then a dramatic moment
 when *Caesar* comes face to face with *Brutus*; then *Brutus'* deliberate
 blow; *Caesar's* cry, and the muffling of his head; then with no
 further resistance, the conspirators hustle their victim to the base of
 Pompey's statue and dispatch him.

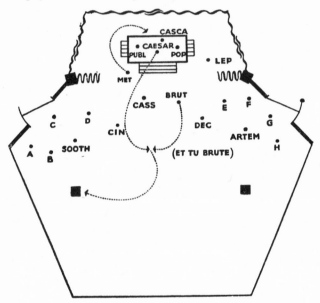

Positioning: *Speake hands for me*

On Shakespeare's stage, the action could be rendered thus: *Casca* and
Metellus both spring their surprise attack from behind the chair of the seated
Caesar; the prolonged struggle takes place on the dais and on the broad steps
in front of it; *Brutus* confronts *Caesar* in the very middle of the Platform; after
his blow, and *Caesar's* cry, the conspirators close in again and drive *Caesar* to
the base of the R pillar, where the bust (hitherto *Caesar's* image) is now
easily taken for Pompey's statue (see above, p. 44).

78 A moment of dead silence before *Cinna's* cry, a half hysterical out-
 burst which loosens the pent emotions of the theatre, and launches
 a panic among the mob: one half of them (E, F, G, H, with
 Artemidorus) surge forward round the perimeter, communicating
 their terror to the groundlings.

83 In spite of *Brutus'* reassuring words, the mob (both sections) run out
 by R door. Their clamour is heard off-stage R until the exit of
 Publius (line 95).

95 *Trebonius* returns inset R, where he went with *Antony* earlier in the
 scene.

Unshak'd of Motion: and that I am he, 70
 Let me a little shew it, even in this:
 That I was constant *Cymber* should be banish'd,
 And constant do remaine to keepe him so.
Cinna. O *Caesar.*
Caes. Hence: Wilt thou lift up Olympus?
Decius. Great *Caesar.*
Caes. Doth not *Brutus* bootlesse kneele? 75
Cask. Speake hands for me.
<div align="center">

They stab Caesar.
</div>

Caes. Et Tu Brutè?—— Then fall *Caesar Dyes*
Cin. Liberty, Freedome; Tyranny is dead,
 Run hence, proclaime, cry it about the Streets.
Cassi. Some to the common Pulpits, and cry out 80
 Liberty, Freedome, and Enfranchisement.
Bru. People and Senators, be not affrighted:
 Fly not, stand still: Ambitions debt is paid.
Cask. Go to the Pulpit *Brutus.*
Dec. And *Cassius* too.
Bru. Where's *Publius?*
Cin. Heere, quite confounded with this mutiny.
Met. Stand fast together, least some Friend of *Caesars*
 Should chance——
Bru. Talke not of standing. *Publius* good cheere,
 There is no harme intended to your person, 90
 Nor to no Roman else: so tell them *Publius.*
Cassi. And leave us *Publius*, least that the people
 Rushing on us, should do your Age some mischiefe.
Bru. Do so, and let no man abide this deede,
 But we the Doers. 95

<div align="center">

Enter Trebonius.
</div>

Cassi. Where is *Antony?*
Treb. Fled to his House amaz'd:
 Men, Wives, and Children, stare, cry out, and run,
 As it were Doomesday.
Bru. Fates, we will know your pleasures:
 That we shall dye we know, 'tis but the time
 And drawing dayes out, that men stand upon. 100

5

THE POET'S STAGECRAFT

HITHERTO we have considered the playhouse, the prompt-book, the Book-Keeper's problems, and the accomplishments of the players: it is now time to turn to the poet himself, and re-study his stagecraft against a background of the conditions for which it was devised. If it can be proved that by such a process Shakespeare's intention is clarified, and new light shed upon his conception of the art of poetic drama, then this inquiry will be not merely of academic or archæological interest but a necessary pre-liminary to the interpretation and production of his plays in the future. The inquiry cannot, within the compass of this volume, be exhaustive: little more can be attempted than to indicate that there is a wide field open for new research. It is indeed doubtful whether the study can be carried much further without more practical experience of the conditions—which means, if not the rebuilding of the playhouse, at least a drastic alteration of existing conditions, and the training of a repertory in the tradition of the Chamberlain's Men. For there is no art in which theory needs practical testing more than the art of the theatre.

Nor is it intended here to attempt a detailed analysis of Shake-speare's poetry—that has been done often elsewhere and with much penetration [1]—but rather to consider how poetry is made dramatic by Shakespeare, how it is the keystone of his stagecraft, and how it is devised for the conditions of the Elizabethan playhouse. As we have already seen, a comparison of the prompt-book with the sources helps us often to guess at Shakespeare's intention [2]: we can get much nearer still—such is the contention of the present chapter—if we make a habit of imagining each play, and each scene in each play, in the setting of the Globe and through the eyes of the Chamberlain's Men.

The Globe, we must remember, and its predecessor across the

[1] The reader is referred to George Rylands' chapter, "Shakespeare the Poet", in *A Companion to Shakespeare Studies* (Cambridge), 89 ff., and to the select bibliography on pp. 353 ff. of the same book. Certainly an actor who has studied the mechanics of the poetry can give a better account of Shakespeare than one who has not.

[2] See above, p. 152.

river, were the scene of Shakespeare's daily life for most of his work-
ing years, and the Chamberlain's Men were his daily companions
and collaborators. Baldwin has given us a mass of evidence about
this company of players: even if his handling of the evidence is
sometimes open to criticism, yet its very bulk is impressive and its
substance most interesting, and the reconstruction of Shakespeare's
daily life in association with his colleagues, contained in his last
chapter called "Facing the Facts with Shakespeare", deserves closer
study and a wider public.[3] It certainly provides a far more plausible
background—to think of him striking fire from Burbadge, discussing
back-stage problems with Heminges, theorising on fooling with
Armin—than the romantic picture of hobnobbing with Southampton
and Essex on the fringes of the Queen's pleasure, which is not con-
fined to the pages of popular fiction, but finds favour sometimes even
with the scholars and critics.

(i) Objectivity of Vision

"I could be bounded in a nutshell," says Hamlet, "and count my
selfe a King of infinite space——" [4] There is an exuberance in the
words which suggests Shakespeare's own imaginative freedom. His
nutshell is the Globe Playhouse, and we would do well to recognise
that neither Shakespeare nor the most part of his contemporary
playwrights were reluctant to accept the fact of the nutshell. We
have seen in Chapter III how readily the plays are set back in this
theatre, how easy it is to reconstruct the original scene-rotation and
the plotting of entries. We have been told by Cranford Adams that it
was the habit of the Elizabethan dramatists to make no bones about
the permanent features of the visible scene: he points out, moreover,
that the playwright Middleton, in his *Black Book*, makes Lucifer
remark:

[3] After explaining that an author's work was subject to direction and suggestion
from the players' company, Baldwin continues: "But where the dramatist and
company worked in harmony together, as did Shakespeare and his company,
dictation would be replaced by suggestion and consultation. Thus Shakespeare's
plays represent not only his own individual invention but also the collective
invention of his company. . . . Doubtless even Shakespeare's plays were the better
for the suggestions of these the most expert actors of their age, whose lives had been
spent in their profession, although the suggestions may at times have occasioned the
dramatist a wry face. In view of the social standing of these men and the training
through which they entered their profession, it is now high time that we ceased to
brand them as only a source of contamination and pollution to the dramatist,
labelling their contributions as only 'the ill-conditioned interpolations and
alterations of actors and theatrical managers'. Since their position rendered them
and not the dramatist the dictators of the drama, that drama is their sufficient
vindication" (T. W. Baldwin, *op. cit.*, 303 f.).

[4] *Hamlet*, II. ii. 264 f.

> And now that I have vaulted up so high
> Above the stage rails of this earthen globe
> I must turn actor—

and that Chapman, in his *Caesar and Pompey,* has the lines:

> We are now like
> The two poles propping heaven, on which heaven moves,
> And they are fixed and quiet.[5]

In both these examples the terms of the metaphor—the rails, the globe, the poles, the heaven—are the concrete and visible features of the playhouse.[6] Shakespeare himself is full of the same kind of imagery. Some examples are familiar, such as Duke Senior's

> Thou seest, we are not all alone unhappie:
> This wide and universall Theater
> Presents more wofull Pageants than the Sceane
> Wherein we play in . . .

and Jaques' reply:

> All the world's a stage,
> And all the men and women, meerely Players . . .[7]

or Antonio's

> I hold the world but as the world *Gratiano,*
> A stage, where every man must play a part,
> And mine a sad one . . .[8]

or Macbeth's

> Life's but a walking Shadow, a poore Player,
> That struts and frets his houre upon the Stage,
> And then is heard no more . . .[9]

or King Lear's

> When we are borne, we cry that we are come
> To this great stage of Fooles.[10]

But the image sometimes appears unexpectedly and may be overlooked if the actor does not point it with the appropriate glance or gesture. Ross, commenting on the unnatural darkness that follows on the night of Duncan's murder, says:

[5] See above, pp. 52 f.; and J. Cranford Adams, *The Globe Playhouse,* 100, 108.

[6] Perhaps we have here instances of what E. M. W. Tillyard calls, in a different context, the "Elizabethan hovering between equivalence and metaphor" (*The Elizabethan World Picture,* 92).

[7] *As You Like It,* II. vii. 137 ff. [8] *The Merchant of Venice,* I. i. 77 ff.

[9] *Macbeth,* V. v. 24 ff. [10] *King Lear,* IV. vi. 187 f.

> Thou seest the Heavens, as troubled with mans Act,
> Threatens his bloody Stage.[11]

A familiar speech in *Hamlet* mentions "this goodly frame the Earth
... this most excellent Canopy the Ayre ... this Majesticall Roofe,
fretted with golden fire ..." [12] and it seems likely that Burbadge
would have made plain the reference to the frame of the playhouse,
the canopy of "the Heavens", and the thatched roof lit up by the
afternoon sun.[13] When we see how often Shakespeare uses this par-
ticular range of metaphor—and frequently indeed at moments of
extreme dramatic tension or of spiritual exaltation or profundity—
we may discount such apologies as those of the Chorus in *Henry V* as
being the mock-modesty of the skilful orator, and suppose rather that
he was very well pleased with the means at his disposal: it was in the
first year of the new Globe that the poet was pretending to apologise
for "this unworthy Scaffold", "this Cock-Pit", "this Woodden O".[14]
We may also infer that the visible features of the playhouse were
constantly in his mind as he wrote. A very interesting example where
we can catch him thinking *unconsciously* in the theatre rather than in
the imagined scene occurs in the sequel to Hamlet's encounter with
the Ghost: the unearthly voice *cries under the Stage,* and Hamlet says
to his astonished companions "you here this fellowe in the Sellerige":
the phrase is hardly appropriate to the supposed scene high on the
battlements of Elsinore, but the Ghost (in the person of Shakespeare
himself) is wandering hither and thither in the capacious cellarage
of Hell beneath the Platform of the Globe.[15] It is indeed Shake-
speare's constant habit to see his theme in the setting of his playhouse:
he does not write *in vacuo* (as might perhaps be said of Marlowe, for
instance, in *Tamburlaine*)—he is always the practical man of the
theatre. There is reason to believe that, though he may sometimes
deliberately ignore and sometimes transcend the visible scene, what
he writes can always be acted on that multiple stage; that in fact the
conventional elements of the scene underlie even the most ambitious
flights of the poet's fancy.

His practical sense of the stage and his objective turn of mind are
further shown by the fact that he does not forget his actors. Indeed,
as we have seen, it is Baldwin's view that "the play was regularly
fitted to the company, not the company to the play"; and we may
quote once again his analogy of the tailor—when he calls Shake-

[11] *Macbeth*, II. iv. 5 f. [12] *Hamlet*, II. ii. 317 ff.
[13] Among many further examples of playhouse imagery may be mentioned
Romeo and Juliet, I. iv. 7 f.; *King John*, II. i. 375 f.; *Troilus and Cressida*, I. iii. 153 ff.;
Othello, I. ii. 83 f.
[14] *Henry V*, Prologue, 10 ff. [15] *Hamlet*, I. v. 151.

speare a better tailor-playwright than Ben Jonson.[16] We need not
accept his belief that Shakespeare wrote the parts to suit the exact
age of his players, but it is hard to ignore the probability of his theory
of "lines", by which it is to be understood that he had his principal
players in mind in planning the chief characters of his plays.

There are, by the way, some amusing topicalities which emerge
from a study of Baldwin's lists. Pope's Fluellen speaks of how Harry
Monmouth ". . . turn'd away the fat Knight with the great belly
doublet: he was full of jests, and gypes, and knaveries, and mockes,
I have forgot his name",[17] and the tone of superior contempt has an
added touch of piquancy if it is true that Pope was also the creator of
Falstaff. Polonius tells Hamlet, "I did enact *Julius Caesar*, I was
kill'd i'th' Capitol: *Brutus* kill'd me." Hamlet, in teasing voice,
replies, "It was a bruite part of him, to kill so Capitall a Calfe
there." The indifferent jest gains something from the fact that
Heminges did in fact play Caesar the year before, and Burbadge was
Brutus.[18] Goffe, as Mistress Overdone, is described as "A Bawd of
eleven yeares continuance", and the audience who had seen the boy
play many such parts would take the point of the joke at his expense.[19]
This kind of topicality is much more probable than the conjectured
caricaturing of court-figures or discussion of high political intrigues,
which were likely to be dangerous in the poet's lifetime. Actors in
revue and on the music-hall stage are still prone to make jokes about
each other, and the audience still likes such allusions as well as any.
One may suspect, without possibility of certainty, that some of the
minor rôles in the plays are individual portraits of the less prominent
players. There is the living skeleton who played Pinch in *The Comedy
of Errors* and the Apothecary in *Romeo and Juliet*, and who was
probably also the Beadle whom Mistress Quickly calls "Thou
Anatomy, thou", as he hales her and Doll off to "base Durance".
His name may have been Sinklo.[20] There is Sir Nathaniel the Curate,
who represents Alexander in the Show of the Nine Worthies, and of
whom Costard says "a foolish milde man, an honest man, looke you,
& soon dasht. He is a marvellous good neighbour insooth, and a verie
good Bowler; but for *Alisander*, alas you see, how 'tis a little ore-
parted".[21] There is Barnardine who is introduced into *Measure for
Measure* solely for the purpose of providing a substitute head for
Claudio's to be presented to Angelo; who has been drinking all the

[16] See above, p. 155, and note 149. [17] *Henry V*, IV. vii. 51 ff.
[18] *Hamlet*, III. ii. 109 ff.
[19] *Measure for Measure*, III. ii. 212; and see above, p. 164.
[20] See W. W. Greg, *The Editorial Problem in Shakespeare*, 116, and note 3.
[21] *Love's Labour's Lost*, V. ii. 582 ff.

night and so will not consent to die; and who survives to be pardoned by the Duke in the last scene.[22] There is Edmund's gruff officer who, when given his sealed orders to kill Lear and Cordelia in prison, says:

> I cannot draw a cart, nor eate dride oats,
> If it bee mans worke ile do't.[23]

It is of course mere guesswork which suggests that some mannerism or cast of personality in his fellow players prompted Shakespeare to give such individual life and vitality to many minor rôles.

One notices a practical common sense in the handling of limited manpower, when in *Julius Caesar* the minor conspirators and senators and plebeians of the first half vanish to provide officers and soldiers for the plains of Philippi. The treatment of the mob which develops there from the merry truants of the opening scene to the frenzied hooligans who murder Cinna, is a *tour de force* of dramatic art; but it is worth remembering that here are the familiar comedy gang of the company leading half a dozen hired men; their parts are written accordingly with the traditional gambits, even in so sinister a scene as the lynching of the innocent poet.[24] At every turn the producer of to-day, if he follows in the steps of Shakespeare and the Chamberlain's Men, will find a shrewd realisation of the practical needs. The revolt of Laertes against Claudius, quelled as soon as mentioned, is simply achieved by the sound of a riotous mob outside the King's apartment. "Where is this King?" cries Laertes, bursting into the presence; then he turns back in the doorway and shouts "sirs stand you all without". "No lets come in," they cry. "I pray you give me leave," says Laertes, and they answer "We will, we will": their acquiescence saves the wardrobe-master a deal of trouble and expense.[25]

But Shakespeare's objective vision goes deeper than this: he conceives not only in terms of his theatre, but also in terms of the age he lived in. We must not be misled by the familiar eulogy, "not of his age, but for all time". It is his habit to see his story through modern —that is to say, Elizabethan—spectacles.[26] W. J. Lawrence suggests that this was an habitual feature of the public theatre [27]: certainly it is most clearly marked in Shakespeare. It is not merely a matter of topical jokes, such as the grave-digger's quip, when he speaks of Hamlet's being sent into England because he was mad—" 'Twill not be seene in him there, there the men are as mad as hee" [28]; or Iago's

[22] *Measure for Measure*, IV. ii. 132 ff.; IV. iii. 42 ff.; V. i. 479 ff.
[23] *King Lear*, V. iii. 39 f. [24] *Julius Caesar*, III. iii.
[25] *Hamlet*, IV. v. 112 ff. [26] See above, p. 54.
[27] W. J. Lawrence, *Pre-Restoration Stage Studies*, 29. [28] *Hamlet*, V. i. 168 f.

comment on drinking in England, "where indeed they are most
potent in Potting" [29]; nor of topical caricatures such as Osric,
Parolles and Oswald [30]; nor of topical themes such as that in *Hamlet*
of the boys' companies—the "little Yases"—who have "so be-ratled
the common Stages" that the Tragedians of the City must go on
tour.[31] These instances are introduced into, or superimposed on, the
main texture of the play. But often the theme itself is worked out in
modern terms. For all its Roman feeling derived from Plutarch,
there is no archæology in Shakespeare's conception of *Julius Caesar*.
The background colour is largely modern, as may be shown in a list
of items—the pocket, the gown, the doublet, the aprons, the taper,
the closet, the striking clock. The boy Lucius' description of the
conspirators,

> their Hats are pluckt about their Eares,
> And halfe their Faces buried in their Cloakes . . .

suggests resemblance to a woodcut of the Babington plot in Carle-
ton's *Thankfull Remembrance*.[32] The opening scene of the play is a good
example of Shakespeare's mixture of the elements: Plutarch's Rome
appears in many details of the speeches of Flavius and Marullus
(Tributaries, Chariot Wheeles, *Pompey*, Tyber, the Capitoll, the dis-
robing of the Images); but side by side with these is contemporary
London (Battlements, Towres, and Windowes, Chimney tops, and
the familiar hawking image applied to Caesar's growing Feathers);
and the scene owes its initial momentum to the stock contribution of
the playhouse comics.[33] It is this habit of mind that mixes *Alcides*
with "Ale-house painted signes" in the same speech of Aaron in
Titus Andronicus [34]; that follows the opening recriminations of Oberon
and Titania—in which such names as Corin, Phillida, Peregenia,
Ariadne and Atiopa are called in question—with a homely descrip-
tion of the Warwickshire countryside—

> The Oxe hath therefore stretch'd his yoake in vaine,
> The Ploughman lost his sweat, and the greene Corne
> Hath rotted, ere his youth attain'd a beard:
> The fold stands empty in the drowned field,
> And Crowes are fatted with the murrion flocke,
> The nine mens Morris is fild up with mud,
> And the queint Mazes in the wanton greene,
> For lacke of tread are undistinguishable . . .[35]

[29] *Othello*, II. iii. 78 ff. [30] See above, p. 54.
[31] *Hamlet*, II. ii. 362 ff.
[32] *Julius Caesar*, II. i. 73 f. The woodcut is reproduced in *Shakespeare's England*,
vol. i, p. 9. [33] *Julius Caesar*, I. i.
[34] *Titus Andronicus*, IV. ii. 96–9. [35] *A Midsummer Night's Dream*, II. i. 60 ff.

that dubs Hector and Ajax "Knights", and thinks no profanity to call Helen of Troy "Nell" [36]; that makes the inmates of Vienna jail sound like a sort of travesty of Bunyan—with Mr. *Caper*, Master *Three-Pile*, yong *Dizie*, yong Mr. *Deepe-vow*, Mr. *Copperspurre*, Mr. *Starve-Lackey*, yong *Drop-heire* that kild lustie *Pudding*, Mr. *Forthlight*, Mr. *Shootie*, and wilde *Halfe-Canne*.[37]

Shakespeare's objectivity of language, especially of simile and metaphor, hardly needs an example except for identification. Berowne compares the wife that he seeks to

> a Germane Cloake [*read* clock],
> Still a repairing: ever out of frame,
> And never going a right, being a Watch:
> But being watcht, that it may still goe right.[38]

Silvius, imploring Phebe to let him down lightly if she must refuse his suit, says:

> the common executioner
> Whose heart th'accustom'd sight of death makes hard
> Falls not the axe upon the humbled neck,
> But first begs pardon: will you sterner be
> Then he that dies and lives by bloody drops?

Jaques says of Touchstone that his brain is "as drie as the remainder bisket After a voyage".[39] It is in the same play that Quiller-Couch detected on the lips of Adam (the poet's own part) "an exquisite instance of Shakespeare's habitual stroke!—with which the general idea, 'unregarded age', is no sooner presented than (as it were) he stabs the concrete into it, drawing blood: 'unregarded age *in corners thrown*' ".[40] Perhaps if we could analyse and understand this habit of Shakespeare's mind, the objective modernity of his vision, we could come nearer to-day to solving the problem of how to bring poetry— even dramatic poetry—into touch with contemporary life. When, for instance, will a twentieth-century poet follow this example to bring vivid life to a Roman theme, or an Elizabethan theme, or an eighteenth- or nineteenth-century theme?

It is well to repeat here that the prompt-book (Quarto or Folio) will help greatly to recapture this modern flavour of Shakespeare's mind, and that the use of Elizabethan costume, or at least a sub-structure of Elizabethan costume, and contemporary furnishing and

[36] *Troilus and Cressida*, IV. v. 67; III. i. 152.
[37] *Measure for Measure*, IV. iii. 1–21.
[38] *Love's Labour's Lost*, III. i. 200 ff.
[39] *As You Like It*, III. v. 3 ff.; II. vii. 39.
[40] Sir Arthur Quiller-Couch, *Shakespeare's Workmanship*, 98; *As You Like It*, II. iii. 42.

properties, will help likewise. So, for the same reason, will the use of
the Elizabethan Platform with the conventional background of the
Tiring-House façade.

(ii) Opportunity snatched from Necessity

It should, moreover, be clear that so far from regretting his nut-
shell, Shakespeare seems actually to revel in it; that the inclination
of his mind, his natural bent, leans towards the acknowledgment and
exploitation of his limited resources; that he finds a positive joy in
make-believe, in turning necessity or handicap into opportunity.
Faced with a difficulty, he makes it into a chance: with him the most
effective defence is always counter-attack. Travellers are to be shown
being waylaid by highwaymen: their horses cannot appear on the
Platform—Shakespeare finds the solution, by making them stretch
their legs in a walk down the hill.[41] An explanation must be found of
why the players in *Hamlet* are on tour: he pounces on the chance to
have a fling at the children's companies, and the topical theme gives
verisimilitude to the whole episode of the players' visit. After the
first Player has shown his paces, Hamlet in soliloquy cries:

> Is it not monstrous that this Player heere,
> But in a Fixion, in a dreame of Passion,
> Could force his soule so to his whole conceit,

and the point of the speech depends on the illusion that Hamlet is
not Burbadge! [42] It is Shakespeare's (and Burbadge's) delight to
"get away" with such impudent conjuring. After the night-brawl in
which Cassio loses his reputation, Iago and his creator want to go
straight on with their plot without interruption: "Dull not Device,
by coldnesse, and delay." So night must be turned into day: a line
and a half are enough for the purpose, but how brilliantly the need
is turned to dramatic profit! Iago's words are

> bi' the masse tis morning;
> Pleasure, and Action, make the houres seeme short.[43]

Here again, Shakespeare goes straight for the heart of the problem—
that the clock has been moving almost too fast to be plausible.
That's what I thought, too, says Iago in effect, but then I've been
enjoying myself: haven't *you*? The great storm in *King Lear* has to be
established in the dialogue: it starts in a scene between Kent and an
unnamed Gentleman. "Who's there besides foule weather?" says
Kent, and the answer comes: "One minded like the weather, most

[41] 1 *Henry IV*, II. ii. 86 ff. [42] *Hamlet*, II. ii. 585 ff.
[43] *Othello*, II. iii. 387 ff.

unquietly." [44] The need to create the storm confronts the poet, but the poet counter-attacks by making emotional capital out of the storm. So too at Macbeth's first entry upon the Platform, the exultation of the victorious general is brilliantly combined with the sinister jingle of the Witches' former incantation:

So foule and faire a day I have not seene . . .[45]

and this is Shakespeare's response to the technical necessity of conveying the impression of wild and ominous weather. When the conspirators visit Brutus' orchard at night, the narrative demands that Cassius should have a brief private word with Brutus: therefore the ball must be kept rolling by the others. The dispute about the daybreak and the points of the compass not only serves to produce the appropriate effect, but also turns our anxious minds once more towards the Capitoll, combining the idea with the dawn of the Ides of March and putting it into the mouth of Casca who is to be the first to rear his hand against Caesar. "Heere, as I point my Sword, the Sunne arises," he says, ". . . and the high East Stands as the Capitoll, directly heere." [46]

This particular habit of Shakespeare's invention is well exampled in a short scene in *Twelfth Night* between Sebastian and Antonio.[47] The need is to show us Antonio *giving his purse* to Sebastian, and to remind us again of Antonio's *danger* in Illyria. Shakespeare takes the opportunity to make a lively objective scene, of which the elements are Sebastian's thanks instead of payment ("ever oft good turnes, Are shuffel'd off with such uncurrant pay"); his desire to go sight-seeing, which Antonio dare not; the *rendez-vous* ("In the South Suburbes at the Elephant"); "I will bespeake our dyet"; "Why I your purse?" "Haply your eye shall light upon some toy . . ." The scene is only fifty lines long, but instead of giving us a perfunctorily informative dialogue, the poet fills the conversation with objective detail so as to create the realistic atmosphere of the town round the idyllic atmosphere of Orsino's court: when the time comes, Sebastian is thus all the more bewildered at his experiences with Olivia and her entourage.

The Chorus in *Henry V* is typical of such resourcefulness. Created to supply the need of epic grandeur, full of apology for the lack of material resources, he is in his own person the great glory of the play, skilfully evoking the illusion of crossing the Channel, fronting Harfleur, camping at midnight before Agincourt. The very magnitude of the handicap gives the poet his great opportunity: his Muse

[44] *King Lear*, III. i. 1 f. [45] *Macbeth*, I. iii. 38.
[46] *Julius Caesar*, II. i. 101 ff. [47] *Twelfth Night*, III. iii.

does indeed ascend the brightest Heaven of Invention. It is perhaps significant that in his later and greater works, when his imaginative range is still more ambitious than in *Henry V*, he no longer apologises for his resources. Think, for instance, of *Antony and Cleopatra* in this respect: the problem is not unlike—"in little roome confining mightie men". But in the later play there is no apology, and no need for it; the technique is assured. He can there handle the three-day battle of Actium with perfect clarity upon the Globe stage.[48] It is arguable that in the plays of the last period—the so-called romances—Shakespeare, more and more out of touch with the Globe, was no longer at pains to fit his inspiration to the practical needs of the playhouse. But assuredly in the great tragic period, in *Othello*, *King Lear*, *Macbeth*, and *Antony and Cleopatra*, while in the very act of showing himself a king of infinite space, he is still at pains to remember that he is bounded in a nutshell: more than that, he still takes a positive pleasure in triumphing over his limitations, in finding that "our meere defects Prove our Commodities", in turning handicap into opportunity, in showing just how much can be done with the wooden O, in proving that his material means are ideal for his purpose, that the Globe playhouse is a perfect medium for presenting the poetic drama.

(iii) Creation in Words—of Atmosphere

Certainly he is a king of infinite space; and we, if we take him aright, can be made sharers of his kingdom. There is probably a touch of autobiography in the deliberate ambiguity of Prospero's farewell to his art:

> I have bedymn'd
> The Noone-tide Sun, call'd forth the mutenous windes,
> And twixt the greene Sea, and the azur'd vault
> Set roaring warre: To the dread ratling Thunder
> Have I given fire, and rifted *Joves* stowt Oke
> With his owne Bolt: The strong bass'd promontorie
> Have I made shake, and by the spurs pluckt up
> The Pyne, and Cedar. Graves at my command
> Have wak'd their sleepers, op'd, and let 'em forth
> By my so potent Art.[49]

What is this so potent Art? It is a question which producer and actors must know how to answer if we are to have the full experience of being spellbound by this great magician. It would not be amiss

[48] Granville-Barker's Preface to the play makes this point quite plain, and it is a pity that we have not yet seen his advice put into practice (*Prefaces to Shakespeare*, Second Series, 143 ff.). [49] *The Tempest*, V. i. 41 ff.

that the audience too should have some idea of how the spell is worked: the hypnotist invites the co-operation of his patient, and Shakespeare (as the Chorus in *Henry V* shows) played constantly for the active imaginative collaboration of his hearers.

The answer can be quite simply given: the potent art lies in the spoken word. The fact is so simple and so obvious as to seem a truism; yet it is so often ignored or only half understood that it needs repeating and expounding. The poetry was of course supported— and I think very skilfully supported—by effects of sight, sound and even smell: by the clever miming of the actors, the well-chosen and significant furniture and properties, by lightning, smoke, fog and mist from the traps, by the waving of a branch to register the wind on the heath; by the sound of knocking on gate or door carefully rehearsed for its special occasion, by bells and clocks, by a horse's whinney or hoofbeats, by the voice of the owl, by thunder or the rushing of the wind; by the whiff of saltpetre for battle, by foliage and rushes which breathe of the open air, by straw reeking of the inn-yard. But for all that, it is the words that create the atmosphere, the character and the action of the poet's play. After all, almost all that we have left of Shakespeare is the spoken word: the stage-directions are of the shortest, and seldom descriptive of elaborate action or atmospheric subtlety; the scene-headings are hardly ever geographical or descriptive; there are no descriptions of character, no bracketed adverbs to indicate the tone of a speech or the mood of a speaker. Yet in spite of this, even in reading, we have the most vivid impressions of atmosphere, of character, and of action, so that often people talk about the plays as if they were discussing real persons, real occasions, real actions.

Let us consider first how Shakespeare sets about creating the atmosphere which he desires. In its simplest form, this process consists of investing properties or furniture or the stage-features and the stage itself with colour. Thus the graveyard for the climax of *Romeo and Juliet* is fully furnished with the necessary and significant properties by the poet's own cunningly selective eye; as we have seen above, they are mentioned and sometimes vividly characterised in the dialogue.[50] Thus Oberon describes for us, just before we see it disclosed in the Study, the

> banke where the wilde time blowes
> Where Oxslips and the nodding Violet growes,
> Quite over-cannoped with luscious woodbine,
> With sweet muske roses, and with Eglantine;

[50] See above, p. 45.

> There sleepes *Tytania*, sometime of the night,
> Lul'd in these flowers, with dances and delight:
> And there the snake throwes her enammel'd skinne,
> Weed wide enough to rap a Fairy in.[51]

The stock property moss-bank is translated by his words into a couch fit for the Fairy Queen. Old Adam, who has heard of Oliver's treachery, standing outside one of the stage-doors, warns Orlando "Come not within these doores": at the end of the same scene he makes of this door a moving symbol of the house in which he has served so long and from which he must now for ever part:

> From seaventie [*read* seventeen] yeeres, till now
> almost fourescore
> Here lived I, but now live here no more
> At seaventeene yeeres, many their fortunes seeke
> But at fourescore, it is too late a weeke . . .[52]

It would have been interesting to hear the poet himself working his own magic in the part of Adam. Bolingbroke, standing on the perimeter, points at the Tarras, saying:

> Goe to the rude Ribs of that ancient Castle,
> Through Brazen Trumpet send the breath of Parle
> Into his ruin'd Eares . . .[53]

King John likewise, arriving before Angiers simultaneously with the French, warns a Citizen on the Tarras that

> but for our approch, those sleeping stones,
> That as a waste doth girdle you about
> By the compulsion of their Ordinance,
> By this time from their fixed beds of lime
> Had bin dishabited.[54]

The greater subtlety of the painting when Duncan approaches the castle of Inverness is a sign of the poet's development in this art.[55] King Philip of France adds to the scene-painting at Angiers by translating the rushes on the Platform into "these greenes before your Towne".[56] During the battle which hastens the dénouement of *King Lear*, blind Gloucester is bidden by Edgar to "take the shadow of this Tree"[57]: so simply are the Stage-Posts converted for a momentary purpose. The orchard of the Capulets, where Romeo speaks his love to Juliet at her window, is created by poetical means. Constantly, yet without strain, the impressions of night and darkness

[51] *A Midsummer Night's Dream*, II. i. 249 ff. [52] *As You Like It*, II. iii. 71 ff.
[53] *Richard II*, III. iii. 32 ff. [54] *King John*, II. i. 216 ff.
[55] *Macbeth*, I. vi. 1 ff. [56] *King John*, II. i. 242.
[57] *King Lear*, V. ii. 1.

and the moon, and danger and the walled orchard, are present in the dialogue: the actors, using this poetical effect and trained miming, will easily create the illusion. One notices here Shakespeare's growing skill in working the "atmospherics" into the dialogue so that they have dramatic force. Such a stroke is Romeo's impulsive oath:

> Lady, by yonder blessed Moone I vow,
> That tips with silver all These Fruite tree tops.[58]

Remarkable in this respect is the moment of Richard II's return from Ireland. For swift continuity Shakespeare wants to make clear at once the geography and the circumstances: so the King asks, "Barkloughly Castle call you this at hand?" and Aumerle replies "Yea, my Lord: how brooks your Grace the ayre, After your late tossing on the breaking Seas?" So much for necessity: but then follows the stroke of the master, as he plucks opportunity from the need. Richard replies:

> Needs must I like it well: I weepe for joy
> To stand upon my Kingdome once againe.
> Deere Earth, I doe salute thee with my hand,
> Though Rebels wound thee with their Horses hoofes:
> As a long parted Mother with her Child,
> Playes fondly with her teares, and smiles in meeting;
> So weeping, smiling, greet I thee my Earth,
> And doe thee favor with my Royall hands.

We note how he goes on to create the earth from the bare scaffoldage of the Platform—with the Spiders, the heavie-gaited Toades, the stinging Nettles, the Flower, the Adder, these Stones—so that in the end we are persuaded that "This Earth shall have a feeling".[59] We shall have cause to return to this passage later, to study an early example of the poet's preoccupation with a theme: for the theme of the "earth" runs through this phase of the play. For the moment we can but admire the skill with which the atmospheric painting is turned to dramatic effect.

It is not only the visible stage itself and its features that the poet can invest with life. Its neighbourhood too is subject to his magic. Across the Yard we see with sudden startling clarity the legendary walls of Troy, as Ulysses prophesies to Hector that

> yonder wals that pertly front your Towne,
> Yond Towers, whose wanton tops do busse the clouds,
> Must kisse their owne feet . . .

[58] *Romeo and Juliet*, II. ii. 107 f. [59] *Richard II*, III. ii. 1–24.

and Hector, with moving restraint, replies

> I must not beleeve you:
> There they stand yet: and modestly I thinke,
> The fall of every Phrygian stone will cost
> A drop of Grecian blood: the end crownes all,
> And that old common Arbitrator, Time,
> Will one day end it.[60]

The illusion can in fact be extended to cover the circumstances of a scene, as, when Brutus and Cassius encounter on the Platform, the presence of great armies is swiftly indicated in the text:

> *Bru.* Hearke, he is arriv'd:
> March gently on to meete him.
> *Cassi.* Stand ho.
> *Bru.* Stand ho, speake the word along.
> Stand.
> Stand.
> Stand.[61]

The echoing order to "Stand" grows gradually more distant as it passes down the line, the furthest being perhaps spoken by someone outside the playhouse. So too when the storm is raging off the coast of Cyprus, and there is a cry *Within:* "A Saile, a Saile, a Saile." The comment of a Gentleman on the Platform

> The Towne is empty: on the brow o'th'Sea
> Stand rankes of People, and they cry, a Saile . . .[62]

has an expansive effect, making the Platform seem but one headland on a long sea-coast. A single line sometimes does the trick, as when Antony asks for the news from Sicyon, and a superior flunkey shouts through the door: "The man from *Scicion*, Is there such an one?" [63] The contemptuous casual tone of the flunkey creates for us a vista of crowded ante-chambers and long-suffering queues outside the stage-door. We have, in fact, a glimpse of "The insolence of Office, and the Spurnes That patient merit of the unworthy takes". The opening scene of *The Tempest* shows how the whole multiple stage of Platform and Tiring-House can be made to seem like a ship tossing on a stormy sea—with the Master on his bridge on the Tarras, and perhaps the Ship-Boy on the high and giddy mast in the Musicians' gallery, the Boatswain bidding the gentry keep below as they struggle up through the trap-door from the ship's hold in Hell, the Stage-Posts serving for masts, the Stage-Rails as the taffrail, and

[60] *Troilus and Cressida*, IV. v. 218 ff. [61] *Julius Caesar*, IV. ii. 30 ff.
[62] *Othello*, II. i. 53 f. [63] *Antony and Cleopatra*, I. ii. 123.

A tempestuous noise of Thunder and Lightning heard from the Huts above the Heavens.[64]

The episode of the highway robbery in 1 *Henry IV* [65] shows Shakespeare's method *in extenso*. The prelude of the two carriers in the inn-yard, sometimes omitted in the productions of to-day, is an essential part of Shakespeare's stagecraft. Throughout the first act of the play we have been at court. The change of circumstances is indicated partly perhaps by the opening of the Study, in which are set some indications of the inn-yard—a bale of straw, a pannier, a rake, bridle and harness, a bucket, a trough—but mostly by the dialogue of the two carriers. Crammed with local colour, it is a masterpiece of compression: one of them carries a lantern: it is still dark but the star over the new chimney tells him that it is "foure by the day": his "poore Jade" is galled by the saddle: the "Pease and Beanes are as danke here as a Dog": the whole place is topsy-turvy since Robin the Ostler died: we hear complaints of the fleas and the sanitary arrangements: the load is of bacon and ginger, "to be delivered as farre as Charing-Crosse": the ostler has not given the turkeys in the pannier anything to eat overnight. All this and more is given us in a matter of thirty-five lines, and then to the setting of the circumstances is added the sinister note as the two carriers show their suspicion of the inquisitive spy and "setter" Gadshill. "What time do you mean to come to London?" he asks, and one of the carriers answers: "Time enough to goe to bed with a Candle, I warrant thee. Come neighbour *Mugges*, wee'll call up the Gentlemen, they will along with company, for they have great charge." When they have gone, the Chamberlain of the inn, Gadshill's accomplice, confirms the information that he gave him yester-night: there is a Franklin with three hundred marks in gold, and a "kinde of Auditor, one that hath abundance of charge too"; they are already up and calling for breakfast. The two rogues shake hands on their villainy and take their several ways, the Chamberlain back into the inn, Gadshill towards the stable. The Study curtains close, and we proceed with no interruptions to the projected scene of operations. Now the flat Platform becomes the slope of Gads Hill: the ten players, who take part in the scene, are carefully instructed in their miming to preserve the illusion of up and down hill. Falstaff's horse has been "removed" by Poins and the "fat-kidney'd Rascall", to whom "eight yards of uneven ground, is threescore and ten miles afoot", comes puffing up the hill from the left door. The Prince tells him that Poins has walked up to the top of the hill, and himself

[64] *The Tempest*, I. i. [65] 1 *Henry IV*, II. i and ii.

follows him out towards the right. The entry of Gadshill is a moment of melodramatic comedy. I fancy that as Falstaff grumbles at the Prince "Go hang thy selfe in thine owne heire-apparant-Garters", he has his back to the Study curtains, which slowly part to a gap of a few feet, and reveal the figure of a masked highwayman, pistol in hand, perhaps under a weatherbeaten signpost, one arm of which points left-handed down the hill. "Stand," roars the masked figure: "So I do against my will," cries Falstaff, and then amid laughter we recognise Gadshill. We hear that "ther's money of the Kings comming downe the hill", so that we expect the Travellers from the right door. "You foure shall front them in the narrow Lane," says the Prince, indicating the gap in the Study curtains; "*Ned* and I, will walke lower," and the pair of them retreat downhill through the left door. Falstaff and his gang bestow themselves in the Study, while the Franklin, the Auditor and the two carriers appear through the right door. "Come Neighbor," says the Franklin, "the boy shall leade our Horses downe the hill: Wee'l walke a-foot a while, and ease our Legges." We need not pursue the scene to its uproarious climax to realise that the dialogue is most skilfully contrived to create on the Platform of the Globe the circumstances and atmosphere of the London-Rochester highway. In a more leisurely vein, it is just such atmospheric painting of objective detail that gives verisimilitude to the country establishment of Mr. Justice Shallow in Gloucestershire.[66]

The classic example of the creation of circumstances not visible to the eye of the beholder is the episode of Dover cliff in *King Lear*.[67] Cranford Adams would set Gloucester's leap in the Study and provide him with a property bank to jump from—"a 'verge' evident to the audience as well as to Gloucester's limited senses." [68] I am not convinced that this concession is necessary or desirable, but would suspend judgment until it is possible to try it in practice—the only safe test in matters of dramatic illusion. Here, for once, we have the conjurer with his coat off, showing us how he does his tricks: for Edgar is casting upon his blind father such a spell as the poet is constantly attempting to cast upon his audience. Gloucester, like us, protests scepticism; and, like us, is ultimately persuaded against his judgment.

> *Glou.* When shall I come to th' top of that same hill?
> *Edg.* You do climbe up it now. Look how we labour.
> *Glou.* Me thinkes the ground is eeven.
> *Edg.* Horrible steepe.
> Hearke, do you heare the Sea?

[66] 2 *Henry IV*, III. ii; V. i; V. iii. [67] *King Lear*, IV. vi. 1–81.
[68] J. Cranford Adams, *The Original Staging of King Lear*, pp. 300 f.

> *Glou.* No truly.
> *Edg.* Why then your other Senses grow imperfect
> By your eyes anguish.

The bedlam beggar leads the blind man to the supposed edge of the cliff: even the rhythm of his words suggests vertigo and the holding of the breath:

> Come on Sir,
> Heere's the place: stand still: how fearefull
> And dizie 'tis, to cast ones eyes so low—

The crows flying half-way down seem hardly as big as beetles: there is a man there gathering samphire, a dangerous business: he looks no larger than his head: the fishermen on the beach are like mice: "and yond tall Anchoring Barke, Diminish'd to her Cocke." To the visual illusion is added the aural; for though you can see the surf on the pebbles, you cannot hear it so high up. Edgar pretends that he dare not look any longer, for fear of giddiness. With a blessing for his lost son Edgar on his lips, the blind man hurls himself over the imaginary cliff. But the poet's tricks are not finished yet. Changing his voice and his manner, Edgar pretends to find the old man huddled at the bottom of the precipice. The opposite illusion, of looking up from below, is again created by poetical means:

> *Edg.* Had'st thou beene ought
> But Gozemore, Feathers, Ayre,
> (So many fathome downe precipitating)
> Thou'dst shiver'd like an Egge: but thou do'st breath:
> Hast heavy substance, bleed'st not, speak'st, art sound,
> Ten Masts at each, make not the altitude
> Which thou hast perpendicularly fell,
> Thy Life's a Myracle. Speake yet againe.
> *Glou.* But have I falne, or no?
> *Edg.* From the dread Sommet of this Chalkie Bourne.
> Looke up a height, the shrill-gorg'd Larke so farre,
> Cannot be seene, or heard:—

Our physical eyes are of course as wide open as Edgar's: but if the mind's eye cannot see and feel with Gloucester, cannot surrender to the poet's magic, then the despairing plunge over the precipice will seem but a ridiculous tumble on a flat Platform, and Edgar's redemption of his father a childish absurdity.

A special need in the steady daylight of the afternoon performances at the Globe, with the hardly changing appearance of the Platform and the Tiring-House, was the creation of atmosphere in a more literal sense of the word—the suggestion of different times of

day and night, and of varying weather. There are many night
scenes in Shakespeare's plays. An episode in the course of the siege of
Orleans opens with a Sentinel grumbling

> Thus are poore Servitors
> (When others sleepe upon their quiet beds)
> Constrain'd to watch in darknesse, raine, and cold. [69]

The interest of this early example lies in the fact that already we see
the poet finding a dramatic justification for his atmospheric painting.
The eve of Bosworth Field is admirably sketched: Richmond begins
it with the words:

> The weary Sunne, hath made a Golden set,
> And by the bright Tract of his fiery Carre,
> Gives token of a goodly day to morrow.

He invites his companions to a conference, bidding them come

> Into my Tent, the Dew is rawe and cold.

The ensuing scene at Richard's headquarters is full of graphic
detail: we learn that it is supper time, nine o'clock: but the King will
not sup to-night: Norfolk is bidden to choose trusty sentinels, and to
"Stir with the Larke to morrow": a message is sent to Stanley to

> bid him bring his power
> Before Sun-rising, least his Sonne *George* fall
> Into the blinde Cave of eternall night.

The "melancholly Lord Northumberland" with the Earl of Surrey

> Much about Cockshut time, from Troope to Troope
> Went through the Army, chearing up the Souldiers.

Richard's final orders to his aide-de-camp are:

> Bid my Guard watch. Leave me.
> *Ratcliffe*, about the mid of night come to my Tent
> And helpe to arme me.

Almost at once, from the other side of the Platform, we hear the
voice of Derby saying to Richmond:

> The silent houres steale on,
> And flakie darknesse breakes within the East. [70]

The poet has bestowed such careful attention upon the painting of
this night in the two camps because he is building up to the elaborate

[69] 1 *Henry VI*, II. i. 5 ff. [70] *Richard III*, V. iii. 19 ff.

ghost-scene, when Richard's victims curse him and bless his antagonist. It is interesting to compare this early night-piece with a later and more mature essay in the same vein, the portrayal of the night before Agincourt. Here the main burden falls upon the Chorus, who creates the atmosphere in narrative form. I think it likely, though, that his narrative was accompanied by the gathering of the characters who were to play the following scene in the English camp. The Frenchmen have filled the Platform with their nervous, boastful bickering, protesting "Will it never be Morning?" and "What a long Night is this", and "Will it never be day? I will trot to morrow a mile, and my way shall be paved with English Faces". Now they retreat into the far corner by the right-hand door to polish their armour and play at dice, waiting for the dawn. The Chorus appears on the Tarras and bids us

> entertaine conjecture of a time,
> When creeping Murmure and the poring Darke
> Fills the wide Vessell of the Universe.

Then he proceeds with swift strokes to paint the scene:

> From Camp to Camp, through the foule Womb of Night
> The Humme of eyther Army stilly sounds;
> That the fixt Centinels almost receive
> The secret Whispers of each others Watch.

The English sentinels come from the left door, and prowl along the closed curtain of the Study: a moment later three common soldiers appear—the same three who will afterwards discuss the ethics of war with their disguised King—and erect their tripod and cauldron on the perimeter outside the left Stage-Post:

> Fire answers fire, and through their paly flames
> Each Battaile sees the others umber'd face.

There is a small trap-door in their corner of the Platform, from which, perhaps, the flames can be supplied to light up their bent, pensive faces. The neighing of horses, the strange sound of the armourers' hammers, the crowing of cocks, the clocks' tolling, all add their touch of realism. Other soldiers, no more than three or four, lie here and there upon the Platform taking their restless ease outside their tents in this fateful night. Old Sir Thomas Erpingham alone seems unmoved as, like an old campaigner, he makes a pillow of his cloak and prepares for his habitual sleep in the central space within the Stage-Posts. With a glance at the Frenchmen the Chorus points the contrast in the other camp:

> The poore condemned English,
> Like Sacrifices, by their watchfull Fires
> Sit patiently, and inly ruminate
> The Mornings danger: and their gesture sad,
> Investing lanke-leane Cheekes, and Warre-worne Coats,
> Presenteth them unto the gazing Moone
> So many horride Ghosts.

Into this picture steps the familiar figure of the King:

> O now, who will behold
> The Royall Captaine of this ruin'd Band
> Walking from Watch to Watch, from Tent to Tent;
> Let him cry, Prayse and Glory on his head . . .

He goes from group to group, bidding good morrow, and would put courage even into the shivering Pistol, who stands to warm himself by the fire his fellow-soldiers have made:

> That every Wretch, pining and pale before,
> Beholding him, plucks comfort from his Lookes.
> . . . that meane and gentle all.
> Behold, as may unworthinesse define,
> A little touch of *Harry* in the Night . . .

It seems now quite dark: every eye in the playhouse is peering through the shadows in fear of the Frenchmen, overwhelming in their numbers: the poet's apology for the resources of his stage seems needless: his audience are in camp, at midnight before the day of battle, and feel genuine comfort when they hear the hushed voice of their commander:

> *Gloster*, 'tis true that we are in great danger,
> The greater therefore should our Courage be.[71]

There in the steady light, on the unlocalised Platform of the Globe, the simple miracle is performed. Shakespeare's positive delight in make-believe infects his hearers with a like pleasure: his medium is the spoken word, poetry: all through the play he has thrown down his explicit challenge to them to use their imagination: undistracted by pictorial realism, their imagination responds to his bidding—and lo! it is midnight between the rival camps.

The robbery on Gads Hill is a good example of an incidental but important effect of the Globe's daylight convention. There is a great advantage in such a scene in being able to see who's who: in a recent performance of the play, with the stage plunged in gloom, it was as

[71] *Henry V*, III. vii. IV. Chorus and i.

much as the audience could do to discern the bulky silhouette of Falstaff, and most of the fun was therefore missed. I have sometimes seen a "thriller" on the cinema-screen marred by such a miscalculation of the degree of darkness, the audience left helplessly and irritably bewildered by a succession of shots of muffled figures, with glinting pistols and flickering torches pouncing on unrecognisable victims. Compare with them the horrifying clarity of the attempted murder of Cassio,[72] where we see every actor in the drama and yet feel we are in the dark: the dialogue illuminates every significant detail. Roderigo lurks "behind this Barke [*read* Bulke]", and bids Iago "Be neere at hand, I may miscarry in't". Cassio is recognised by his gait, but Roderigo's thrust is made ineffectual by the stoutness of his victim's coat. Roderigo is mortally wounded, but Cassio only "maym'd for ever". Othello, aloft on the Tarras, cannot see, but hears enough to spur him on to follow the example of "brave *Iago*, honest, and just". Cassio calls for a surgeon. Lodovico and Gratiano, groping in the dark, are reluctant to approach the groaning pair:

> These may be counterfeits: Let's think't unsafe
> To come into the cry, without more helpe.

Iago returns to the scene, as if newly roused from sleep, "in his shirt, with Light, and Weapons". He goes to Cassio's help, but hearing Roderigo's cry from the other side of the Platform, takes the chance to stop his mouth for ever, crying in hypocritical indignation:

> Kill men i'th'darke?
> Where be these bloddy Theeves?
> How silent is this Towne? Hoa, murther, murther.

then turns to Lodovico and Gratiano and asks them

> What may you be? Are you of good, or evill?

Cassio declares that his leg is "cut in two", and Iago cries

> Light Gentlemen, Ile binde it with my shirt.

Still bending over his task, he asks the wounded man (in a voice tense with anxiety for his own safety):

> *Cassio,* may you suspect
> Who they should be, that have thus mangled you?

Reassured by Cassio's "No", he finishes his first-aid:

> Lend me a Garter. So:—— Oh for a Chaire
> To beare him easily hence.

[72] *Othello,* V. 1.

The devilish, brilliant opportunism of Iago is only matched by Shakespeare's own unflagging invention, but how little of this masterly stagecraft survives in the confused twilight of the picture-stage!

The moonlit wood is created by lyrical repetition in the early passages of *A Midsummer Night's Dream*, such as these lines of Lysander as he reveals to Helena his tryst with Hermia:

> To morrow night, when *Phoebe* doth beholde
> Her silver visage, in the watry glasse,
> Decking with liquid pearle, the bladed grasse . . .[73]

and the moonlit garden at Belmont is even more explicitly lyrical:

> The moone shines bright. In such a night as this,
> When the sweet winde did gently kisse the trees,
> And they did make no noyse . . .

and again—

> How sweet the moone-light sleepes upon this banke,
> Here will we sit, and let the sounds of musicke
> Creepe in our eares [*read* eares:] soft stilnes, and the night
> Become the tutches of sweet harmonie . . .

and the impression of still moonlit night is reinforced by other phrases, including Portia's playful description of the rapt pair of lovers—

> the Moone sleepes with Endimion,
> And would not be awak'd.[74]

It is typical of the concise compression of Shakespeare's later style that Othello, in a tense moment of night encounter, reinforces the torchlight with a single line:

> Keepe up your bright Swords, for the dew will rust them.[75]

There is once again a dramatic motivation in Enobarbus' dying appeal to the moon as

> Soveraigne Mistris of true Melancholly.[76]

The converse process of producing daylight after darkness is of course no less necessary on the daylit stage. The eve of Bosworth and of Agincourt are both followed by vivid portrayal of the morning of

[73] *A Midsummer Night's Dream*, I. i. 209 ff.
[74] *The Merchant of Venice*, V. i. 1 ff.; 54 ff.; 109 f.
[75] *Othello*, I. ii. 59. [76] *Antony and Cleopatra*, IV. ix. 12.

battle. King Richard counts the clock, consults the calendar, and observes that the sun "disdaines to shine":

> The sky doth frowne, and lowre upon our Army.
> I would these dewy teares were from the ground.[77]

At Agincourt one of the French peers, in high spirits, cries:

> The Sunne doth gild our Armour up, my Lords.[78]

The effect can be studied in detail in *A Midsummer Night's Dream,* where the plot demands, after the long sequence in the moonlit, fairy-haunted wood, that the lovers should be discovered by the Duke in the early morning. Shakespeare, as usual, meets the difficulty by turning it into an opportunity: Hippolyta the Amazon suggests to his imagination the notion of a hunting-party—she and Theseus talk the jargon of the hunt, and how beautifully it is calculated to dispel the atmosphere of moonlight and fairies. Gone is the moonlit bower of Titania: instead we have "the vaward of the day", the "Westerne valley" where the forester is to uncouple, the neighbouring mountain-top, the drooping ears of the Duke's hounds that "sweepe away the morning dew"; and when Theseus sees the lovers asleep, he says

> No doubt, they rose up early, to observe
> The right of May . . .[79]

Hot noon is vividly realised in the scene of Mercutio's untimely death. Benvolio strikes the note at once in his opening lines:

> I pray thee good *Mercutio* lets retire,
> The day is hot, the *Capulets* abroad:
> And if we meet, we shal not scape a brawle,
> For now these hot dayes, is the mad blood stirring.

The impression is casually reinforced by Mercutio's "thou hast quarrel'd with a man for coffing in the street, because he hath wakened thy Dog that hath laine asleepe in the Sun", and there is a touch of the sun-baked street too in Benvolio's anxious intervention, as the mad blood begins to stir—

> We talke here in the publike haunt of men:
> Either withdraw unto some private place,
> Or reason coldly of your greevances:
> Or else depart, here all eies gaze on us.[80]

[77] *Richard III*, V. iii. 277 ff. [78] *Henry V*, IV. ii. 1.
[79] *A Midsummer Night's Dream*, IV. i. 109 ff. See my *Moonlight at the Globe*, 90 f. An earlier attempt at the same effect, for a similar purpose (to establish the idea of early morning), can be seen in the Induction to *The Taming of the Shrew*, lines 16 ff.
[80] *Romeo and Juliet*, III. i. 1 ff.; 26 ff.; 55 ff.

It is noticeable here that Shakespeare not only projects the required atmosphere upon the stage, but also makes us feel the effect of it on the tempers of his characters.

We have a vivid storm in *Julius Caesar* created by Pope and Phillips: Casca is mainly descriptive, but Cassius makes dramatic capital out of the elements:

> Now could I (*Caska*) name to thee a man,
> Most like this dreadfull Night,
> That Thunders, Lightens, opens Graves, and roares,
> As doth the Lyon in the Capitoll:

and again:

> the Complexion of the Element
> Is [*read* In] Favors, like the Worke we have in hand,
> Most bloodie, fierie, and most terrible.

It is interesting to see how Shakespeare moulds the storm to his own purposes, creating an artificial lull in Brutus' orchard as a background to the musing of the philosopher "with himselfe at warre", and reviving the cue of *Thunder* just before the end of the orchard scene as a preparation for the outcry of the sleepless Caesar: "Nor Heaven, nor Earth, Have beene at peace to night." [81] But this "disturbed Skie" is insignificant beside the "Cataracts, and Hyrricano's" of *King Lear*, where the storm is as integral a part of the texture of the drama as the darkness is in *Macbeth*. The means by which this tempest is contrived deserve a close inspection. We have a presentiment of it long before it begins in the brief interlude of Edgar's escape from the hue and cry: he tells us in soliloquy his intention to disguise himself as a Bedlam beggar,

> And with presented nakednesse out-face
> The Windes, and persecutions of the skie . . .

and to visit

> low Farmes,
> Poore pelting Villages, Sheeps-Coates, and Milles . . . [82]

The very phrases are echoed in the storm-scenes. The first evidence of the storm itself is a stage-direction, *Storme and Tempest*, just before the King's frenzied departure from Gloucester's house. The Platform represents the courtyard outside the house, and the great gates are set in the Study. "Let us withdraw," says Cornwall, " 'twill be a Storme." Gloucester, who has "Followed the old man forth", returns in helpless agitation:

[81] *Julius Caesar*, I. iii. 72 ff.; 128 ff.; II. ii. 1.
[82] *King Lear*, II. iii. 11 f.; 17 f.

> Alacke the night comes on, and the high windes
> Do sorely ruffle, for many Miles about
> There's scarce a Bush.

But Regan is heartless in her determination, and Cornwall no less ruthless as he advises Gloucester—

> Shut up your doores my Lord, 'tis a wil'd night,
> My *Regan* counsels well: come out o'th'storme.[83]

The company withdraw into the house: the great gates clash to behind them, the Study curtains are pulled, and without interruption, as the Huts get busy with the mechanics of thunder and wind, Kent and a Gentleman appear, heads down against the weather, at opposite stage-doors.

> *Kent.* Who's there besides foule weather?
> *Gen.* One minded like the weather, most unquietly.

The Quarto of 1608 gives us full measure of the atmospheric painting which is an essential part of the poet's scheme [84]: it is this anonymous gentleman, a minor player, who is entrusted with the preliminary description (which gives much added pathos to the subsequent entry of the King) of how he

> Contending with the fretfull element,
> Bids the wind blow the earth into the sea,
> Or swell the curled waters bove the maine
> That things might change or cease, teares his white haire,
> Which the impetuous blasts with eyles rage
> Catch in their furie, and make nothing of,
> Strives in his little world of man to outscorne,
> The too and fro conflicting wind and raine.[85]

It would carry us too far afield to examine the details of Lear's own creation of the storm in words—that masterly fusion of imagery and rhythm which produces such explosions as

> Strike flat the thicke Rotundity o'th'world . . .

and

> Rumble thy belly full: spit Fire, spowt Raine:
> Nor Raine, Winde, Thunder, Fire are my Daughters.

[83] *King Lear*, II. iv. 290, 303 ff., 311 f.
[84] Already by 1623 his colleagues had initiated the process by which since their day such atmospheric poetry has been sliced wholesale from the active text.
[85] *King Lear*, III. i. 1 f., 4 ff.

But two things should be noticed in this context: first, that it was Burbadge's task not only to seem

> A poore, infirme, weake, and dispis'd old man . . .

but also to create with all the force that his voice and his gesture could command the "high-engender'd Battailes" of the elements.[86] This is a clear example of how Shakespeare will sometimes expect his player to go beyond the mere representation of the character he plays to the creation of the atmospheric effect of the scene in which he plays it. The second point has been often observed before; that this storm is itself an integral part of the tragedy, close-woven into the poet's pattern, as is clear in the King's outcry—

> Thou think'st 'tis much that this contentious storme
> Invades us to the skin: so 'tis to thee,
> But where the greater malady is fixt,
> The lesser is scarce felt . . .
> the tempest in my mind,
> Doth from my sences take all feeling else,
> Save what beates there, Fillial ingratitude . . .[87]

We must also notice that the poet is at pains to prompt our reactions to the storm: it is not only the comments of the Gentleman and Kent, nor the pathetic chattering of the Fool—"heere's a night pitties neither Wisemen nor Fooles" and " 'tis a naughtie night to swimme in"—but Gloucester's words as the five wanderers reach shelter, "Heere is better then the open ayre, take it thankfully," make us too in the audience grateful for the relief, and correspondingly distressed (as Gloucester returns to say that they must go out again) at Kent's "This rest might yet have balmed thy broken sinewes." [88] The storm has its moments of aftermath, when Gloucester, at the mercy of his tormentors, protests

> The Sea, with such a storme as his bare head,
> In Hell-blacke-night indur'd, would have buoy'd up
> And quench'd the Stelled fires:
> Yet poore old heart, he holpe the Heavens to raine.
> If Wolves had at thy Gate howl'd that sterne time,
> Thou should'st have said, good Porter turne the Key:[89]

and when Cordelia, gazing on her father's face as he sleeps in his chair, cries

[86] *King Lear*, III. ii. 7, 14 f., 20, 23.
[87] *King Lear*, III. iv. 6 ff.
[88] *King Lear*, III. ii. 13; III. iv. 113; III. vi. 1 ff., 107.
[89] *King Lear*, III. vii. 59 ff.

> Was this a face
> To be oppos'd against the jarring windes?
> Mine Enemies dogge, though he had bit me,
> Should have stood that night against my fire . . .[90]

In both these last examples, it will be seen that Shakespeare is adding to his creation of the storm a strong prompting of our feelings about it and about the cruelty of those who drove the old King out into it.

From the formal ritual scene of the visitation of ghosts at the end of *Richard III*, Shakespeare advanced to the masterpieces of *Julius Caesar* and *Hamlet*. "The deepe of night is crept upon our talke," says Brutus, and calls for his gown before he bids good night to Cassius. Lucius, bringing the gown, speaks drowsily. The guards are invited to sleep on cushions in the tent. The absent-minded Brutus finds the book he had looked for in the pocket of his gown. The boy is asked to hold up his heavy eyes awhile, and play a tune: he sings, and falls asleep in the middle of his song. Brutus opens his book, finds his place, and begins to read: "How ill this Taper burnes." As always, the poet selects the details that will most easily and most vividly make his dramatic effect.[91] But the ghost in *Hamlet* is the more astonishing *tour de force*: for there is so little time to prepare the ground: within forty lines of the play's beginning the ghost is before our eyes. The strokes are swiftly made: the opening challenge unexpectedly coming from the relieving sentry not yet at his post; the punctual arrival—no, it is already "strook twelve"; the "releefe" (the word is deliberately ambiguous) of Francisco, who is "sicke at heart"; "Not a Mouse stirring"; "bid them make hast"; the arrival of the neighbour watch; "What, ha's this thing appear'd againe to night"; "this dreaded sight, twice seene of us"; "this Apparition"; the *crescendo* dwindles again before Horatio's scepticism; they sit down awhile to hear Barnardo's tale:

> Last night of all,
> When yond same Starre that's Westward from the Pole
> Had made his course t'illume that part of Heaven
> Where now it burnes, *Marcellus* and my selfe,
> The Bell then beating one . . .

and lo! the player Shakespeare has already taken his cue and "In the same figure, like the King that's dead", stalks martially across the Tarras.[92]

It grows clearer, as we contemplate more examples, that it became Shakespeare's practice not only to give us the atmosphere

[90] *King Lear,* IV. vii. 31 ff. [91] *Julius Caesar*, IV. iii. 225 ff.
[92] *Hamlet*, I. i. 1 ff.

and to motivate it, but also quite often to guide and influence—
subtly sometimes and almost imperceptibly—our reactions to it; and
that the chance of so guiding us is one of the great strengths of the
method of the poetic drama. We have seen examples from *King Lear*,
and the Ghost in *Hamlet*, when he opens his mouth, not only hints at
the secrets of his prison-house but guides our feelings too:

> I could a Tale unfold, whose lightest word
> Would harrow up thy soule, freeze thy young blood,
> Make thy two eyes like Starres, start from their Spheres,
> Thy knotty and combined locks to part,
> And each particular haire to stand an end,
> Like Quilles upon the fretfull Porpentine:
> But this eternall blason must not be
> To eares of flesh and bloud . . .[93]

A most striking instance of this practice can be studied in *Julius
Caesar*. Titinius kneels beside the dead body of his friend Cassius on
the battlefield of Philippi; or rather a minor actor kneels beside
Augustine Phillips on the bare Platform of the Globe and, lifting his
eyes, gazes intently at horizon-level across the Yard. Then he cries
aloud:

> O setting Sunne:
> As in thy red Rayes thou dost sinke to night;
> So in his red blood *Cassius* day is set.
> The Sunne of Rome is set. Our day is gone,
> Clowds, Dewes, and Dangers come . . .[94]

Now your lighting expert with his cyclorama can manage a sunset,
and your make-up artist some red blood for Cassius. But what more
can they do than has been done for them already by the poet? And
the poet leaves them behind when he goes on to weave the two
strands together—the red rays and the red blood—in a texture that
colours the whole of that wonderful last act. Through our ears, our
imagination is pierced with the intense suffering in the minds of the
idealists, the dismal realisation that their labour has all been in vain,
and their belief that Rome has gone down with them: it is (to them)
the end of Rome. The sun of Rome is set. Our day is gone. Clouds,
dews and dangers come. The play ends in the twilight shed by those
lines—an atmosphere that no lighting-effect could produce, that any
attempt at lighting-effect would merely hinder—and we feel that we
are watching the twilight of a great cause.

We shall see when, in the next chapter, we come to consider

[93] *Hamlet*, I. v. 15 ff. [94] *Julius Caesar*, V. iii. 60 ff.

Macbeth in detail, how in creating the twilight for Banquo's murder, the poet plays most powerfully upon our feelings and makes us long to be under cover, to gain the timely inn.[95]

(iv) Creation in Words—of Character

Familiar, even from the earliest plays, is the poet's habit of drawing his characters in the direct description of their fellows. The good Duke Humphrey of Gloucester thus indicts the enemies who confront him in the royal presence:

> *Beaufords* red sparkling eyes blab his hearts mallice,
> And *Suffolks* cloudie Brow his stormie hate;
> Sharpe *Buckingham* unburthens with his tongue,
> The envious Load that lyes upon his heart:
> And dogged *Yorke*, that reaches at the Moone,
> Whose over-weening Arme I have pluckt back,
> By false accuse doth levell at my Life.[96]

When York falls into the hands of the Lancastrians, Queen Margaret's mocking is bitterest of all:

> Where are your Messe of Sonnes, to back you now?
> The wanton *Edward*, and the lustie *George*?
> And where's that valiant Crook-back Prodigie,
> *Dickie*, your Boy, that with his grumbling voyce
> Was wont to cheare his Dad in Mutinies?
> Or with the rest, where is your Darling, *Rutland*? [97]

Richard Crookback's mother adds much to our understanding of him when she describes (as it were) his "four ages of man":

> Tetchy and wayward was thy Infancie.
> Thy School-daies frightfull, desp'rate, wilde, and furious,
> Thy prime of Manhood, daring, bold, and venturous:
> Thy Age confirm'd, proud, subtle, slye, and bloody,
> More milde, but yet more harmfull; Kinde in hatred . . .[98]

The actor who would play the part of Boyet in *Love's Labour's Lost* has ample material in Berowne's twenty lines of satire:

> This fellow pickes up wit as Pigeons pease,
> And utters it againe, when *Jove* doth please.
> He is Wits Pedler, and retailes his Wares,
> At Wakes, and Wassels, Meetings, Markets, Faires,
> And we that sell by grosse, the Lord doth know,
> Have not the grace to grace it with such show . . .[99]

[95] See below, p. 298.
[97] 3 *Henry VI*, I. iv. 73 ff.
[99] *Love's Labour's Lost*, V. ii. 316 ff.

[96] 2 *Henry VI*, III. i. 154 ff.
[98] *Richard III*, IV. iv. 169 ff.

(Who would not—absent-mindedly and without book—think he was listening to Dryden or Pope?)

The narrative portrait sketches of Jaques and Touchstone in *As You Like It* are familiar; so likewise Maria's caricatures of Sir Andrew and Malvolio in *Twelfth Night*.[100] A play especially rich in the method is *Julius Caesar*: there is, for instance, Caesar's elaborate picture of

> that spare *Cassius*. He reades much,
> He is a great Observer, and he lookes
> Quite through the Deeds of men. He loves no Playes,
> As thou dost *Antony*: he heares no Musicke;
> Seldome he smiles, and smiles in such a sort
> As if he mock'd himselfe, and scorn'd his spirit
> That could be mov'd to smile at any thing.
> Such men as he, be never at hearts ease,
> Whiles they behold a greater then themselves,
> And therefore are they very dangerous.

There is Cicero whose silver-haired gravity does not outweigh Brutus' adverse judgment:

> let us not breake with him,
> For he will never follow any thing
> That other men begin.

There is Casca, of whom Brutus says

> What a blunt fellow is this growne to be?
> He was quick Mettle, when he went to Schoole.

and of whom Cassius answers

> So is he now, in execution
> Of any bold, or Noble Enterprize,
> How-ever he puts on this tardie forme:
> This Rudenesse is a Sawce to his good Wit,
> Which gives men stomacke to disgest his words
> With better Appetite.

There is Antony who loves plays, who is given "To sports, to wildenesse, and much company", who "Revels long a-nights", who seems to Brutus "but a Limbe of *Caesar*", who is indeed a dark horse until the death of Caesar, in spite of the hint of Cassius:

> we shall finde of him
> A shrew'd Contriver. And you know, his meanes
> If he improve them, may well stretch so farre
> As to annoy us all . . .

[100] *As You Like It*, II. i. 25 ff.; II. vii. 12 ff. *Twelfth Night*, I. iii. 16 ff.; II. iii. 161 ff.

There is Brutus, "with himselfe at warre", whom Cassius thinks he can sum up:

> Well *Brutus*, thou art Noble, yet I see,
> Thy Honorable Mettle may be wrought
> From that it is dispos'd: therefore it is meet,
> That Noble mindes keepe ever with their likes . . .

who gains so much in vivid reality by the intimate domestic glimpse of him which Portia gives us:

> yesternight at Supper
> You sodainly arose, and walk'd about,
> Musing, and sighing, with your armes a-crosse:
> And when I ask'd you what the matter was,
> You star'd upon me, with ungentle lookes.
> I urg'd you further, then you scratch'd your head,
> And too impatiently stampt with your foote:
> Yet I insisted, . . .[101]

the whole episode, as she describes it, is eloquent of the man's inward struggle. She succeeds in conveying, in this masterly scene, with hardly a word from Brutus except the one eloquent profession of love, a complete picture of their relationship, their daily life, his recent behaviour and her own character. It is of great value in creating Brutus' portrait, and pays a big dividend later in the play at a climax of the long scene in Brutus' tent. All these characters in this play are reinforced in the description of their fellows—sometimes, be it noticed, in a contradictory sense. It is indeed a feature of the play which cannot be accidental that Shakespeare presents his characters in two diametrically opposite manifestations: the blunt Casca reappears in a state of feverish excitement in the thunderstorm; the grave dignity of Cato's daughter returns to the stage as the hysterical Portia who sends Lucius to the Senate-house on a fool's errand; Cassius, who "lookes Quite through the Deeds of men", is panic-stricken by the ambiguous greeting of Popilius Laena, and on other occasions too reveals "that rash humour which my Mother gave me"; Caesar, the vain, suspicious epileptic, shows himself at the last "as constant as the Northerne Starre"; the "gamesom" Antony becomes the prophetic voice of "*Caesars* Spirit ranging for Revenge". It is as though Shakespeare's intention was, by taking his pictures from two different angles, to give a stereoscopic roundness to his figures.

From some of these examples it will be noted that, as with the

[101] *Julius Caesar*, I. ii. 200 ff.; II. i. 150 ff.; I. ii. 300 f.; II. i. 157 ff.; I. ii. 313 ff.; II. i. 238 ff.

creation of atmosphere, so also in character-drawing the method of
the poetic drama not only gives us the character but also sometimes
hints at how we should react to it. Ulysses' portrait of Diomed—

> 'Tis he, I ken the manner of his gate,
> He rises on the toe: that spirit of his
> In aspiration lifts him from the earth . . .

goes beyond objective description to interpret what we see; and still
more clearly does he prompt us to understand Cressida for what
she is—

> Ther's a language in her eye, her cheeke, her lip;
> Nay, her foote speakes, her wanton spirites looke out
> At every joynt, and motive of her body . . .[102]

One may go further and observe that Shakespeare is at pains to
prevent us being misled by the public demeanour of a character
whose dramatic interest is not on the surface. That is the purpose of
Prince Hal's informative soliloquy at the end of his first scene [103]; of
Brutus' hint to Cassius not to be deceived:

> Vexed I am
> Of late, with passions of some difference,
> Conceptions onely proper to my selfe,
> Which give some foyle (perhaps) to my Behaviours:
> But let not therefore my good Friends be greev'd
> (Among which number *Cassius* be you one)
> Nor construe any further my neglect,
> Then that poore *Brutus* with himselfe at warre,
> Forgets the shewes of Love to other men.[104]

Hamlet gives us a similar lead when he tells us right at the beginning
of his part

> I have that Within, which passeth show . . .[105]

and Iago, before proceeding to deceive all his acquaintance, gives us
in the audience explicit warning that

> when my outward Action doth demonstrate
> The native act, and figure of my heart
> In Complement externe, 'tis not long after
> But I will weare my heart upon my sleeve
> For Dawes to peck at; I am not what I am.[106]

In such cases, no doubt, the actor took care to remind the audience
occasionally in his performance of the poet's anticipatory hint.

[102] *Troilus and Cressida*, IV. v. 14 ff.; 55 ff. [103] I *Henry IV*, I. ii. 217 ff.
[104] *Julius Caesar*, I. ii. 39 ff. [105] *Hamlet*, I. ii. 85.
[106] *Othello*, I. i. 61 ff.

It is not only the general character of his figures and their habitual traits and mannerisms that Shakespeare gives us (and his colleagues) in his poetry, but also an indication of their appearance and behaviour at particular moments. It seems, indeed, an important point of technique arising from the conditions of performance: the detailed description takes the place of the facial expression visible with the make-up and strong lights of the modern theatre. Shakespeare at least (if not his fellow-dramatists) has a habit of leaving nothing to chance: his poetry supplies the place of the cinema's "close-up", and as with the atmospheric description, he can do far more than merely supply a photographic impression. When Richard of Gloucester springs the news that his brother Clarence is dead, the actors look their horrified surprise, and we are not allowed to miss the fact:

> *Buc.* Looke I so pale Lord *Dorset*, as the rest?
> *Dor.* I my good Lord, and no man in the presence,
> But his red colour hath forsooke his cheekes.[107]

When "High-reaching *Buckingham* growes circumspect", the new-crowned King Richard's dangerous mood is underlined for us:

> The King is angry, see he gnawes his Lippe.[108]

The aspect of Caesar's companions after the *contretemps* of his fit in the market-place is defined in close detail by Brutus:

> The angry spot doth glow on *Caesars* brow,
> And all the rest, looke like a chidden Traine;
> *Calphurnia's* Cheeke is pale, and *Cicero*
> Lookes with such Ferret, and such fiery eyes
> As we have seene him in the Capitoll
> Being crost in Conference, by some Senators.[109]

We have had occasion to notice the serial portraiture of the visitation of the Ghost to Gertrude's closet.[110] There is a vivid momentary glimpse of Iago's hypocrisy when Othello bids him give an account of the brawl he has engineered:

> Honest *Iago*, that lookes dead with greeving,
> Speake: who began this? [111]

The appearance of Desdemona as she lies asleep in bed has been quoted above.[112] The complementary picture as she lies dead wrings the heart of all that hear it:

[107] *Richard III*, II. i. 84 ff.
[108] *Richard III*, IV. ii. 27.
[109] *Julius Caesar*, I. ii. 182 ff.
[110] See above, pp. 173 f.
[111] *Othello*, II. iii. 179 f.
[112] See above, p. 169.

> Now: how dost thou looke now? Oh ill-Starr'd wench,
> Pale as thy Smocke: when we shall meete at compt,
> This looke of thine will hurle my Soule from Heaven,
> And Fiends will snatch at it. Cold, cold my Girle?
> Even like thy Chastity.

Beside these two "close-ups" of Desdemona, we may set two more of Othello himself. As he bends over her in bed, her terrified voice says:

> you're fatall then
> When your eyes rowle so.

and asks him

> Alas, why gnaw you so your nether-lip?
> Some bloody passion shakes your very Frame.

These descriptive phrases are an essential part of the stagecraft of this playhouse: Othello's face at this moment could hardly be visible to his audience. It is he himself who gives us the last glimpse of his agonised countenance when he bids the ambassadors, when they return to Venice, speak

> Of one, whose subdu'd Eyes,
> Albeit un-used to the melting moode,
> Drops teares as fast as the Arabian Trees
> Their Medicinable gumme.[113]

Moreover, just as with the general character, so also with the particular moments, it seems that Shakespeare thought it necessary to warn us against being misled. The young King Henry VI in an early and characteristically unsuccessful attempt to keep the peace between Somerset and York, causes deep offence to the latter by wearing the red rose. After his departure, Richard of York begins to express his feelings, but breaks off with enigmatic restraint. His silence is interpreted for us by Exeter, whose chorus-like soliloquy closes the scene:

> Well didst thou *Richard* to suppresse thy voice:
> For had the passions of thy heart burst out,
> I feare we should have seene decipher'd there
> More rancorous spight, more furious raging broyles,
> Then yet can be imagin'd or suppos'd.[114]

At a mature stage of the poet's development, we see the same process at work in Horatio's anticipatory description of Ophelia's madness:

[113] *Othello*, V. ii. 271 ff.; 37 f.; 43 f.; 347 ff.
[114] 1 *Henry VI*, IV. i. 182 ff.

> She speakes much of her Father; saies she heares
> There's trickes i'th'world, and hems, and beats her heart,
> Spurnes enviously at Strawes, speakes things in doubt,
> That carry but halfe sense: Her speech is nothing,
> Yet the unshaped use of it doth move
> The hearers to Collection; they ayme at it,
> And botch the words up fit to their owne thoughts,
> Which as her winkes, and nods, and gestures yeeld them,
> Indeed would make one thinke there would be thought,
> Though nothing sure, yet much unhappily.[115]

We have here a hint to the boy-actor as to how to play the mad-
scenes, but also a hint to the audience how to take them—how to
read between the lines. Othello, already convinced of Desdemona's
guilt and determined to kill her, is obliged to conceal his intention
when he meets her. "How is't with you, my Lord?" she asks, and he
replies "Well, my good Lady"; then he mutters to himself, "Oh
hardnes to dissemble!" [116] We must be told that he is keeping up the
pretence. For the same kind of reason, Cordelia must confess to us
her true feelings and express her love for her father before she seems
cruelly casual in her obstinate refusal to respond to his demands.
After Goneril's hypocritical protestation, she whispers aside:

> What shall *Cordelia* speake? Love, and be silent—

And when Regan has followed suit—

> Then poore *Cordelia*,
> And yet not so, since I am sure my love's
> More ponderous then my tongue.[117]

We might almost wish she would not spoil in advance the dramatic
effect of her "Nothing my Lord": but to Shakespeare's judgment the
conditions seem to demand that she shall not mislead the audience
by her apparent heartlessness. Likewise Kent must not appear in his
disguise without telling us who he is and what he is up to:

> If but as well I other accents borrow,
> That can my speech defuse, my good intent
> May carry through it selfe to that full issue
> For which I raiz'd my likenesse. Now banisht *Kent*,
> If thou canst serve where thou dost stand condemn'd,
> So may it come, thy Master whom thou lov'st,
> Shall find thee full of labours.[118]

[115] *Hamlet*, IV. v. 4 ff. The Folio ascribes the speech to *Horatio*, the 1604–5
Quarto to *A Gentleman*. [116] *Othello*, III. iv. 34 f.
 [117] *King Lear*, I. i. 64, 78 ff. [118] *King Lear*, I. iv. 1 ff.

Edgar, too, tells us in advance of his intended disguise: his vivid and circumstantial description of "poore *Turlygod*, poore *Tom*" adds greatly to the impression made by his sudden appearance from the hovel in the storm; we then invest his figure with the poetical painting previously given, and we have moreover the additional pleasure which comes from a surprise that might have been foreseen.[119] Again the nameless Gentleman who meets Kent in the storm, prepares us for the appearance of the King and the Fool, and his anticipatory description of "the Foole, who labours to out-jest His heart-strooke injuries" [120] is as important to our understanding of the sequel as is Horatio's pre-view of Ophelia. At the climax of Lear's madness, Edgar is our interpreter, bidding us understand the old King's words as

> matter, and impertinency mixt,
> Reason in Madnesse.[121]

A specially interesting case of this phenomenon is the often misunderstood episode of the announcement of Portia's death in *Julius Caesar*.[122] The stirring quarrel and reconciliation of Brutus and Cassius is followed by the seemingly ridiculous interruption of the jigging poet who tries to give his canting advice to the generals. Plutarch is the source of this episode, but Shakespeare has turned it to splendid dramatic advantage. For while Cassius laughs at the intruder, Brutus explodes in quite unreasonable rage. The contrast with his former restraint is so astonishing that Cassius says, "I did not thinke you could have bin so angry." Brutus explains the reason: Portia is dead. His words are measured: it is the impulsive Cassius who breaks out with "O insupportable, and touching losse!" Now Shakespeare is anxious to make us see the greatness of Brutus' longsuffering: but stoical restraint is a difficult thing to project in the poetic drama—for the poetic drama relies for its effects upon the spoken word, and the stoic is by nature short of speech. The cinema camera can register the silent suffering of stoicism by the twitching of an eybrow and the compressing of a lip. But how does the poetic dramatist achieve his purpose? Shakespeare does it here by the elaborate process of repeating the announcement, so that we in the audience can watch Brutus under the stress of his emotion, and feel with him as he says:

> Why farewell *Portia*: We must die *Messala*:
> With meditating that she must dye once,
> I have the patience to endure it now.

[119] *King Lear*, II. iii; III. iv. 44. [120] *King Lear*, III. i. 16 f.
[121] *King Lear*, IV. vi. 179 f. [122] *Julius Caesar*, IV. iii. 128–94.

Messala's comment is in itself an explanation of Shakespeare's intention:

> Even so great men, great losses shold indure . . .

and Cassius' following words help also to interpret for us—

> I have as much of this in Art as you,
> But yet my Nature could not beare it so . . .

by which he means, I think, "I can act a part as well as you, but I couldn't bear the grief in the first place." Reading the play in detachment in our armchair, we have time to calculate that there is some disingenuousness in Brutus' deception of Messala. But, in the theatre, we are carried away by the immediate emotional effect, and ready to accept the poet's interpretative comments. A less elaborate and perhaps more satisfactory treatment of the theme of stoical restraint occurs in *Macbeth*: we shall see in due course how the descriptive "close-up" method is applied to Macduff, when he hears the news of the murder of his family.[123]

Before leaving the subject of Shakespeare's creation of character, it is proper to draw attention to a style of characterisation which is fundamentally different from the objective portraiture of most of the early and middle-period plays. Capulet, Hotspur, Cassius, Fluellen, may stand as a typical cross-section of the objective trend: we might meet them any day, and we should recognise their mannerisms, their tastes, their words, their tone of voice. Even the principal figures, Prince Hal, Benedick, Orlando, have an individual personality which brings them within our ken; and certainly the women, Rosalind, Viola, Portia of Belmont, Beatrice. The kind of character—one may not call it a type—culminates in Hamlet, whom we all feel that we know as an intimate friend. If we think now of Othello, Macbeth and Antony, of Lady Macbeth, of Goneril and Regan—these figures seem to be Olympian in stature, unapproachable, remote; without the common touch, and yet surprisingly no less potent to cast a spell upon us. Even Lear, full of changes as his age is, even Cleopatra, with her infinite variety, seem conceived on a scale quite different from the earlier kind, which nevertheless persists among the minor figures side by side with the new kind. It is unnecessary at this point to do more than mention this essential difference and suggest that it arises from a fundamental change in Shakespeare's dramatic purpose and method, dating from the years that immediately follow *Hamlet*. A full analysis of this change is outside the scope of this book. But the suggestion

[123] See below, p. 304.

will be followed up later in this chapter when we consider the development of the technique of pervasive themes, and study briefly the crucial years of experiment, the period of the poet's "Withdrawal-and-Return". We shall notice then that the new method of characterisation is no less than the old a *poetic* creation, that it is indeed still more closely bound up with the art of the poet who was constantly alert to discover new means of expressing the mystery of things in terms of his poetic drama.

(v) *Creation in Words—of the Action itself*

We have more than once had cause to notice the method of presenting episodes of the plot (whether prior to the action or during it) by means of narrative description, in the manner of the Messenger Speech of Greek tragedy.[124] It is enough here to remind the reader of one or two striking examples, to illustrate the fact that in Shakespeare's playhouse it was part of the habitual technique to create in words—that is to say, by poetical means—not only atmosphere and character but also the action itself. Tyrrell's conscience-stricken tale of the murder of the young princes in the Tower is one such "Messenger Speech".[125] Hotspur's account of the aftermath of Holmedon Field, when he was "so pestered with a Popingay", is such another. Another is Morton's report of the defeat and death of Hotspur.[126] King Hamlet's ghost in his detailed description of his own poisoning provides an essential element in Shakespeare's presentation of his story; its dramatic importance can be measured when later on we watch the Players' travesty of the same scene under the eyes of the usurping murderer.[127] Queen Gertrude's picture of Ophelia's death, Salarino's of the parting of Antonio from Bassanio, Othello's unvarnished tale of his wooing, the bleeding captain's speech in the opening of *Macbeth*, Ariel's account of the shipwreck he has caused [128]—these speeches all take the place of visible action. In the medium of the cinema, for instance, they would be represented visually—perhaps by a "flashback". On Shakespeare's stage there is one reason or another why they cannot be so represented: it may be the practical difficulty of exhibiting drowning or shipwreck; it may be simply that the plot is long enough without further action, as for instance it would be inconvenient to begin *Othello* so far back as the time of Desdemona's wooing; or, as in the case of *The Winter's Tale*,

[124] See above, pp. 107 f., 131. [125] *Richard III*, IV. iii.
[126] 1 *Henry IV*, I. iii. 29 ff.; 2 *Henry IV*, I. i. 105 ff.
[127] *Hamlet*, I. v. 59 ff.; III. ii. 270 ff.
[128] *Hamlet*, IV. vii. 167 ff.; *The Merchant of Venice*, II. viii. 36 ff.; *Othello*, I. iii. 128 ff.; *Macbeth*, I. ii. 7 ff.; *The Tempest*, I. ii. 196 ff.

the story has already carried the poet over four and a half acts, and there is not time to show in action both the reunion of Leontes and Polixenes and Paulina's resuscitation of Hermione; so three anonymous but eloquent Gentlemen are entrusted with the task of bringing before our eyes the meeting of the two Kings—"a Sight," says one of them, "which was to bee seene, cannot bee spoken of," and proceeds to speak of it so graphically that we do indeed see the occasion: "There was casting up of Eyes, holding up of Hands, with Countenance of such distraction, that they were to be knowne by Garment, not by Favor. Our King being ready to leape out of himselfe, for joy of his found Daughter; as if that joy were now become a Losse, cryes, Oh, thy Mother, thy Mother: then askes *Bohemia* forgivenesse, then embraces his Sonne-in-Law: then againe worryes he his Daughter, with clipping her. Now he thanks the old Shepheard (which stands by, like a Weather-bitten Conduit, of many Kings Reignes). I never heard of such another Encounter; which lames Report to follow it, and undo's description to doe it." [129] In the handling of such "Messenger Speeches", unless producer and actor realise—and unless the audience are made to realise—that the narrative is an essential part of the action of the play, and not just fine speech (beautiful poetry, brilliant prose, but static and rather long and therefore perhaps to be abridged or cut), then the play is marred. It has already been pointed out that the unlocalised stage by its very neutrality of aspect helps to bring them to life, and it has been suggested that the miming of the Chamberlain's Men would also contribute to this end. Meanwhile we must recognise that the poet himself has done his part of the job with deliberate intent and with his habitual skill.

Moreover, it is not only scenes that take place off-stage that are so treated: but, as with the "close-up" method defined above, in reference to characterisation, so too the visible action is illuminated by the dialogue so that we can feel its force more fully than, in the conditions of the Globe, we can by the aid of the eye alone. The scene of the blinding of Gloucester in *King Lear* [130] is a case in point, played as it probably was at a distance in the Chamber. There is a ruthless insistence in the *verbal* presentation of Gloucester's torment, contained in such phrases as "Binde fast his corky armes . . . Hard, hard . . . To this Chaire binde him . . . 'tis most ignobly done To plucke me by the Beard. . . . These haires which thou dost ravish from my chin . . . (*Gloucester speaking of Lear*) I would not see thy cruell Nailes Plucke out his poore old eyes (*but the words reflect upon his*

[129] *The Winter's Tale*, V. ii. 46 ff. [130] *King Lear*, III. vii.

own predicament) . . . Fellowes hold ye Chaire, Upon these eyes of
thine, Ile set my foote. . . . One side will mocke another: Th'other
too . . . Out vilde gelly: Where is thy luster now? . . . All darke and
comfortlesse?" This grim catalogue will make it clear that Shake-
speare is determined to create the action in his words: the objective
vision contained in these phrases, and reinforced by the bullying
rhythm of the inquisitors' insistent "Wherefore to Dover?" make the
scene one of the most terrible in all the annals of the stage: and it
will be noticed that the terror is multiplied by the fact—already
familiar to us in his treatment of atmosphere and character—that
the poet not only states what we see but also prompts our feelings
towards the action.

We have already studied the objective creation of atmosphere in
the scene of the attempt on Cassio's life. Another of Iago's con-
trivances is no less remarkable—the drunken brawl in which Cassio
loses his reputation. That in a scene of such swift and complicated
action it is quite clear (without stage-directions) what is happening
is a measure of Shakespeare's uncanny skill in the poetic drama. But
it is not only the bare narrative which is worth study but also the
overtones by which Iago gives his calculated sinister twist to the
bare facts: of Cassio's drunkenness he says—

> I fear the trust *Othello* puts him in,
> On some odde time of his infirmitie
> Will shake this Island.

He whispers to Roderigo—

> go out and cry a Mutinie . . .

and cries aloud to any that will hear—

> Heere's a goodly Watch indeed.
> Who's that which rings the Bell: Diablo, hoa:
> The Towne will rise.

The measure of his success is the eloquent anger of Othello:

> For Christian shame, put by this barbarous Brawle:

and

> Silence that dreadfull Bell, it frights the Isle,
> From her propriety.

and his surprised reproach to Montano—

> What's the matter
> That you unlace your reputation thus,
> And spend your rich opinion, for the name
> Of a night-brawler?

and his concise indictment of the whole affair:

> What in a Towne of warre,
> Yet wilde, the peoples hearts brim-full of feare,
> To manage private, and domesticke Quarrell?
> In night, and on the Court and Guard of safetie?
> 'Tis monstrous . . .[131]

Here we have a capital example of Shakespeare's double process, Iago creating the action and Othello interpreting it for us— prompting us what to think. This power of *interpreting* the action is another strength of the poetic drama; in the less eloquent realism bred of the conditions of the picture-stage, such interpretation is left to the capricious and often inert imagination of the spectators.

(vi) Transcending the Visible Scene

The poetic drama does not stop there in its power to cast a spell upon the audience. Shakespeare learnt that his playhouse and his poetical medium could create the illusion of things invisible to mortal sight, and could transcend even the suggestion of a visible scene. The appearance of the Ghost in *Hamlet* is very vivid to us: we see him before our eyes, and he is given an objective portraiture, which is very moving, in the words of those who watch him on the Platform: but more moving still is what we *cannot* see—the rising from the tomb. When young Hamlet asks his dead father to tell

> Why thy Canoniz'd bones Hearsed in death,
> Have burst their cerments, why the Sepulcher
> Wherein we saw thee quietly enurn'd,
> Hath op'd his ponderous and Marble jawes,
> To cast thee up againe?

and when the dead King hints at the secrets of his prison-house, the "eternall blason" which "must not be To eares of flesh and bloud", then indeed we begin to find our disposition shaken

> With thoughts beyond the reaches of our soules.[132]

It cannot be too strongly stressed that the unlocalised Platform of the Globe gives a sharp reality to such transcendental thoughts which will be blurred and blunted by any conflicting attempt to define the battlements of Elsinore.

The theme of mortality and the state of man after death is, of course, recurrent and pervasive in the play. Hamlet—like his

[131] *Othello*, II. iii. 132 ff.; 158, 161 ff.; 174, 177 f., 195 ff., 215 ff.
[132] *Hamlet*, I. iv. 47 ff.; I. v. 13 ff.

creator, perhaps, and many of his contemporaries—is much con-
cerned with "the dread of something after death". The too-familiar
soliloquy "To be, or not to be . . ." carries us, quite unexpectedly
(for the immediately preceding scenes are concerned with the
manœuvres in the duel of wits between the King and Hamlet),
away from the intrigues of the Danish court to a contemplation of
this world and the next. The transcendent vision, it may be noticed,
is based on an objective ground: the "Whips and Scornes of time"—

> The Oppressors wrong, the poore mans Contumely,
> The pangs of dispriz'd Love, the Lawes delay,
> The insolence of Office, and the Spurnes
> That patient merit of the unworthy takes,

are modern Elizabethan, and indeed still topical to-day: but the
next moment we are peering into

> The undiscovered Countrey, from whose Borne
> No traveller returns . . .[133]

Three years after writing *Hamlet*, Shakespeare was able to carry his
audience still more surely away from the Platform, in Claudio's
terrified vision of impending execution:

> I, but to die, and go we know not where,
> To lie in cold obstruction, and to rot,
> This sensible, warme motion, to become
> A kneaded clod; And the delighted spirit
> To bath in fierie floods, or to recide
> In thrilling Region of thicke-ribbed Ice,
> To be imprison'd in the viewless windes
> And blowne with restless violence round about
> The pendant world: or to be worse then worst
> Of those, that lawlesse and incertaine thought,
> Imagine howling, 'tis too horrible.[134]

Othello transports us in a moment from the bedside of the murdered
Desdemona beyond all visible circumstance as he cries:

> when we shall meete at compt,
> This looke of thine will hurle my Soule from Heaven,
> And Fiends will snatch at it. Cold, cold, my Girle?
> Even like thy Chastity. O cursed, cursed Slave!
> Whip me ye Divels,
> From the possession of this Heavenly sight:
> Blow me about in windes, roast me in Sulphure,
> Wash me in steepe downe gulfes of Liquid fire.[135]

[133] *Hamlet*, III. i. 56 ff. [134] *Measure for Measure*, III. i. 116 ff.
[135] *Othello*, V. ii. 272 ff.

But it is not only in connection with death and the world to come that Shakespeare lifts us beyond the horizon of the eye. The vast conception of the storm in *King Lear* is interesting as an example of the poet's transcendent mood. There is a characteristic contrast between Lear's picture of the storm and Kent's, which makes the point clear. Kent speaks for the most part literally:

> Since I was man,
> Such sheets of Fire, such bursts of horrid Thunder,
> Such groanes of roaring Winde, and Raine, I never
> Remember to have heard.[136]

Lear sees

> Sulph'rous and Thought-executing Fires,
> Vaunt-curriors of Oake-cleaving Thunder-bolts . . .

he bids the thunder

> Strike flat the thicke Rotundity o'th'world . . .

He addresses the tempest, and cries

> I taxe not you, you Elements with unkindnesse . . .

and speaks of their "high-engender'd Battailes".[137] His imagery lifts the drama off the plane of the visible, to the range of poetical sublimity. Kent is creating the atmosphere by Shakespeare's habitual method; he is making us see a scene that is not there. But Lear goes one further: he sublimates the scene that Kent merely creates. Kent says, "Pretend this is a thunder-storm"; Lear makes the thunderstorm part of a great poetical vision which transcends visual pretence and can exist only in the imagination. We have all seen sheets of lightning and heard bursts of thunder, but we have never known the thunder to "Strike flat the thicke Rotundity o'th'world". Moreover, to explain this transcendent vision in a paraphrase is an impossible task; the only words that will do it are Shakespeare's own. There is a like contrast, as we shall see on a later page, between the words of Macbeth immediately after the murder of Duncan and those of his wife.[138]

Once again it is pertinent to realise that this transcendental mood belongs properly to the poetic drama, that it can hardly be achieved by other means: and again we may note the paradox that often in the furthest reaches of Shakespeare's imaginative inspiration, we find ourselves (expressly or by implication) closest to the objective detail

[136] *King Lear*, III. ii. 45 ff. [137] *King Lear*, III. ii. 4 ff.; 16 ff.
[138] See below, pp. 289 f.

of Elizabethan modernity or to the conventional setting of the Globe
Playhouse. The whips and scorns of the poet's own time stand side by
side with the undiscovered country. When Hamlet speaks his prose-
poem of disillusionment with the beauty of the world and the
excellence of man, he uses the images of frame, canopy and roof,
which his audience would see before them in the playhouse. When
Macbeth contemplates the hopelessness of life, his thought turns to
the

> poore Player,
> That struts and frets his houre upon the Stage,
> And then is heard no more.

Granville-Barker expresses this truth when he writes of Shakespeare's
"peculiar gift of bringing into contribution the commonplace traffic
of life. However wide the spoken word may range, there must be the
actor, anchored to the stage. However high, then, with Shakespeare,
the thought or emotion may soar, we shall always find the trans-
cendental set in the familiar".[139]

(vii) The Architecture of the Play

This reconsideration of the detail of Shakespeare's poetic creation
may now lead us to revise our opinion of his long-range composition.
Amid a universal chorus of praise for his tactical triumphs, it is
possible to detect a fairly general opinion that his strategy is weaker:
that is certainly the inference one must draw from the somewhat
lighthearted way in which his plays are still carved about to suit the
taste of his producers. It is well to clear our heads upon this point;
and by way of beginning, to recognise that there is some strong
evidence on the other side, tending towards the belief that Shake-
speare is seldom diffuse and desultory, and that the thread of
dramatic tension is broken less often than is usually supposed. There
is, for instance, a school of thought represented by J. Semple Smart,
Peter Alexander and E. M. W. Tillyard which recognises Shake-
speare's authorship of all three parts of *Henry VI* as well as *Richard III*
by virtue of the masterly architectural sense with which the com-
plicated theme of this series of plays is handled. "Shakespeare
planned his first historical tetralogy greatly," writes Tillyard,[140]
"reminding one of Hardy in the *Dynasts*. When we consider how
deficient his fellow-dramatists were in the architectonic power, we
can only conclude that this was one of the things with which he was

[139] Granville-Barker, *Prefaces to Shakespeare*, First Series, xxxv.
[140] E. M. W. Tillyard, *Shakespeare's History Plays*, 160 f. See also his Preface, vii.

conspicuously endowed by nature. Far from being the untidy genius, Shakespeare was in one respect a born classicist."

I need not enter further upon this controversial ground than to express agreement with the main contention [141]: meanwhile let us examine this "architectonic power" in an example which we have already studied in considering the battle sequences.[142] The Dauphin is invading England and• has the support of some of King John's nobles. A cross-stage wrangle ends with mutual defiance between the Dauphin and Faulconbridge:

> *Dol.* Strike up our drummes, to finde this danger out.
> *Bast.* And thou shalt finde it (Dolphin) do not doubt.

The conventional *Alarums* mark the onset, but the battle never surges on to the Platform itself. Instead, Shakespeare keeps us, on the fringes of the fighting, always in touch with the important issues. John asks Hubert how the day goes, and Hubert answers, "Badly I feare." The King complains of a fever. A messenger brings good tidings of the wreck of the Dauphin's supply ship, but the King is too ill to welcome the news: he bids them carry him to his litter to Swinsted Abbey. The revolted English lords appear and inform us that

> That misbegotten divell *Falconbridge*,
> In spight of spight, alone upholds the day.

The French Count Melun staggers on to the Platform, "Wounded to death", and warns them of the Dauphin's intention, if he wins the day, to quit treachery with treachery and cut off their heads. His eloquent speech includes a passage of scene-painting which in its power to evoke overtones of emotion is a forerunner of the "setting Sunne" of the plains of Philippi:

> if *Lewis* do win the day,
> He is forsworne, if ere those eyes of yours
> Behold another day breake in the East:
> But even this night, whose blacke contagious breath
> Already smoakes about the burning Crest
> Of the old, feeble, and day-wearied Sunne,
> Even this ill night, your breathing shall expire,
> Paying the fine of rated Treachery,
> Even with a treacherous fine of all your lives . . .

[141] And to draw attention to Charles Knight's admirable essay on the same subject in the Imperial Shakespeare, vol. iii, 41 ff., where a like opinion is supported with a great weight of internal evidence.

[142] *King John*, V. ii. *fin.*, iii., iv., and v. See above, pp. 90 f.

After Melun has explained that his love for Hubert and

> this respect besides
> (For that my Grandsire was an Englishman)
> Awakes my Conscience to confess all this . . .

Salisbury voices for his fellow "Revolts" their joy in the chance of
returning to their allegiance. Then he offers his arm to Melun,
painting in "close-up" the agony of the dying man:

> My arme shall give thee helpe to beare thee hence,
> For I do see the cruell pangs of death
> Right in thine eye.

No sooner have they left the Platform than we are shown the
Dauphin in high spirits, still ignorant of what we have heard and
seen. The end of the day's engagement is briefly and fully summed
up in less than twenty-five lines: again the atmospheric painting is
turned to dramatic purpose:

> *Dol.* The Sun of heaven (me thought) was loth to set;
> But staid, and made the Westerne Welkin blush,
> When English measure backward their owne ground
> In faint Retire: Oh bravely came we off,
> When with a volley of our needlesse shot,
> After such bloody toile, we bid good night,
> And woon'd our tott'ring colours clearly up,
> Last in the field, and almost Lords of it.

> *Enter a Messenger*

> *Mes.* Where is my Prince, the Dolphin?
> *Dol.* Heere, what newes?
> *Mes.* The Count *Meloone* is slaine: The English Lords
> By his perswasion, are againe falne off,
> And your supply, which you have wish'd so long,
> Are cast away, and sunke on *Goodwin* sands.
> *Dol.* Ah fowle, shrew'd newes. Beshrew thy very hart:
> I did not thinke to be so sad to night
> As this hath made me.

There is a sure selection of emphasis in this sequence, an insistent
relevance, which we must recognise as characteristic of Shakespeare
even from his earliest years. He sees here that there is no dramatic
interest in the battle itself: it is the incidental circumstances that are
important in his story—King John's sickness and withdrawal to
Swinsted, Melun's dying confession and the chance for England's
princes to come home again, the Dauphin's reception of the news of
their falling-off and of the wreck of his supply ships. To these points

he sticks with an insistent relevance: and meanwhile by shrewd atmospheric painting preserves the illusion of battle in the neighbourhood.

If we put the plays back into the playhouse for which they were devised, much that now seems irrelevant to their structure will fall automatically into place. In the course of our argument, it has become clear that many passages which seem on the picture-stage unnecessary ornaments (and which therefore might be cited as evidence of desultoriness) are in fact essential elements in the technique of Shakespeare's poetic drama. Such, for instance, is Oberon's description of Titania's bank "where the wilde time blowes", necessary to convert a familiar property-bank into a couch fit for a fairy queen. Such too—as we have seen—are the hunting speeches of Theseus and Hippolyta, which are needed to change the scene from the moonlit wood to the dew of morning. Such are the passages of character-drawing and "close-up" description of mood and facial expression: and the anticipatory descriptions of Kent and Edgar and the Fool in *King Lear*: and the many speeches which create the action in "Messenger Speech" form. Such too is the opening dialogue of *The Merchant of Venice*, in which Solanio and Salarino, "cursed by actors as the two worst bores in the whole Shakespearean canon", paint for us the background of Venetian magnificence against which the figures of Antonio and Bassanio stand in sharp relief.[143] We must recognise that Shakespeare sometimes considers it fair game to reveal a character in typical speech, at first appearance or not much later, even if the speech does not forward the plot of the play: *Romeo and Juliet*—an early play, with less technical subtlety than ebullient inspiration—shows examples of this phenomenon in the introduction of the Nurse, Mercutio, and Friar Lawrence.[144] All these passages are necessary to the structure of the play, and it seems reasonable, therefore, to suppose that, in their native element, the plays would be remarkable for an insistent relevance rather than for a diffuse and episodic carelessness of structure.

In *Romeo and Juliet*, *Julius Caesar* and *Twelfth Night* there is a masterly directness of narrative exposition which hardly needs illustration: and if, even from quite early days, Shakespeare had this architectural gift in the handling of his material, it seems reckless to assume that he was often unable or unwilling to use it. The producer will do well to be humble here, to ask himself what Shakespeare is driving at, before he begins to patch what he supposes to be a

[143] See above, p. 55; and Granville-Barker's *Prefaces to Shakespeare*, Second Series, 80 ff.

[144] *Romeo and Juliet*, I. iii. 16 ff.; I. iv. 55 ff.; II. iii. 1 ff.

careless job, for more exacting modern tastes. There are, of course, some baffling scenes. We know that clowning "hath a priviledge", especially in the days of Kemp, though we may guess (from the familiar censure in *Hamlet*) that Shakespeare was reluctant to accord it. Such a scene as Launcelot Gobbo's wit-snapping at Belmont [145] seems to have no better justification than that Kemp has had too few opportunities to play the fool (it is as irrelevant as the turn of the juggler or the acrobat in pantomime); unless, indeed, it is needed for the benefit of the stagehands to set the court-scene in the Study. On a higher level of art, Shakespeare may perhaps be accused of being led sometimes into irrelevancy by Armin's theorising on folly: and even Touchstone has an intolerable passage on the old cuckold joke.[146] Many topical quips make the comedy out of date, as for instance the caricatures of that excellent butt Ben Jonson, which probably underly the figures of Ajax, Nym and Jaques.[147]

Serious passages, too, sometimes lose their force owing to the natural change in popular interest with the passing of the years: it is perhaps surprising how little has proved ephemeral. The opening act of *Henry V* is a problem. The first two scenes, up to the arrival of the French ambassadors, seem to hang fire, and to throw away all the advantage which the Prologue has sought and gained. In such cases, common sense will not fall to abusing Shakespeare: he has already proved in other history plays that he knows his job. We must understand that his audience were really interested in history and historical theory, and we can admire the objective detachment of his presentation of the clerics' unscrupulous policy, the swift and vivid recapitulation of the King's reformed character, the King's grave and dignified charge to the Archbishop, the Archbishop's evocation of the Black Prince's prowess, and the lecture on the honey-bees—a *tour de force* on a favourite theme. For the rest, a producer of to-day must cut in such a way as to keep the general sense without the long detail: at all costs he must not seek a comic diversion by such an expedient as caricaturing the Archbishop's exposition of the Salic Law.[148]

We are at liberty to cut unless the historical material is vital to the structure of the play. It is hardly surprising that more often than not it *is* vital. Tillyard has made it clear how compact and close-woven is the tapestry of themes in the first tetralogy—*Henry VI* and *Richard III* —and finds dramatic justification for such "history lessons" as York's recital of his claim to England's crown.

[145] *The Merchant of Venice*, III. v. 1–70. [146] *As You Like It*, III. iii. 50 ff.
[147] E. K. Chambers, *William Shakespeare*, vol. i, 72.
[148] *Henry V*, I. i and ii. 1–220.

> *Edward* the third, my Lords, had seven Sonnes:
> The first, *Edward* the Black-Prince, Prince of Wales;
> The second, *William* of Hatfield . . .

so it goes on relentlessly for fifty lines until Salisbury and Warwick, weighed down with the logic of genealogy, fall to their knees, anxious to be the first

> That shall salute our rightfull Soveraigne
> With honor of his Birth-right to the Crowne.

"This scene," writes Tillyard, "is one of those stiff, factual expositions, full of resounding names, that must have been listened to breathlessly by an audience for whom the questions of titles and successions were a living issue, and the Wars of the Roses a terrible spectacle of what could so easily happen again. The bare exposition, granted a solemn versification, was enough; the bare facts had their own momentum; realism would be inappropriate, almost impious." [149] There is a danger always present in considering the history plays: if we cut, or minimise the emphasis of, the historical substance, we distort the structure of the whole play. The first part of *Henry IV* makes nonsense, if Prince Hal is not in the centre of the picture. Shakespeare made no mistake in the planning of this first part, even if in *Part Two* he did allow Falstaff (after he had won fame in *Part One*) to loom too large. It is easy to forget that even Falstaff had to make his reputation. In the first scene in which he appears he is not at the top of his form [150]: many an actor of the part must have been glad to have got that scene behind him, so that he can proceed to the easy victories of Gads Hill and the Boar's Head. The reason for the modest start is surely this, that Shakespeare is at pains in the first scene to introduce his leading character, Prince Hal (his leading player, too; for the part was Burbadge's); and Falstaff as the Prince's "mis-leader of Youth" is only incidental to that presentation. The business of 1 *Henry IV* is the history of the madcap Prince winning his spurs at Shrewsbury and saving his father from a most dangerous rebellion: Falstaff enters the play as a means of exhibiting the Prince's riotous youth, and for all his independent vitality, he does not (in *Part One*) exceed his brief; he has no scene which is unrelated to the Prince's affairs; it is only in *Part Two* that he goes off to pursue his own fortunes. Prince Hal (in *Part One*) is the centre of interest, and for this reason if for no other, your Burbadge must play him.

Even outside the strictly historical plays, the point holds good. One must beware of *injudicious* cutting in *Hamlet*, which for practical

[149] E. M. W. Tillyard, *Shakespeare's History Plays*, 180. 2 *Henry VI*, II. ii. 10 ff.
[150] 1 *Henry IV*, I. ii.

reasons must, of course, often be cut. At all costs we must not
eliminate the public background and make the play—as it so often
wrongly appears—a private psychological study. We must give due
weight to the historical exposition, which Shakespeare cunningly
inserts after the dramatic impact of the ghost's first appearance, and
(just when there is a danger of the audience's attention wandering)—
"loe, where it comes againe".[151] There is a wealth of implication in a
chance word of Laertes to his sister about Hamlet:

> Hee may not, as unvallued persons doe,
> Carve for himselfe; for, on his choyce depends
> The sanctity and health of the whole State.[152]

It is when we start cutting that we most realise Shakespeare's
insistent relevance: there is so little that we can spare. Anyone who
has seen *Hamlet* in its entirety will realise how much clearer the
design of the complete play is than the abbreviated versions we
normally see. If the play is not *badly* cut, Fortinbras' final entry will
have a proper inevitability about it. Almost the last articulate pre-
occupation of the dying Prince is with the public weal, and the
public view of his career.

Always we must consider what Shakespeare's main design is. It is
usually supposed that Angelo's is the principal part in *Measure for
Measure*: this is against the evidence of the statistics, for while Angelo
has but 320 lines to speak, the Duke has 884.[153] After Angelo's
declaration to Isabella, there is nothing for him to do except await
his humiliation. Perhaps the truth is that we have strayed away from
Shakespeare's professed purpose. Early in the play the Duke gives to
Friar Thomas an involved but definite explanation of his intention
in disguising himself: it is in the main a public motive, concerning
the obsolete decrees of his city where

> libertie, plucks Justice by the nose;
> The Baby beates the Nurse, and quite athwart
> Goes all decorum . . .

and only secondarily is he interested in the private problem of his
"precise" Deputy who

> scarce confesses
> That his blood flowes: or that his appetite
> Is more to bread then stone: hence shall we see
> If power change purpose: what our Seemers be.[154]

[151] *Hamlet*, I. i. 70 ff. [152] *Hamlet*, I. iii. 19 ff.
[153] Baldwin gives Angelo to Burbadge and the Duke to Cundall. But is it
possible that Burbadge played the Duke, and gave him the necessary stature and
authority to preserve the balance of Shakespeare's design?
[154] *Measure for Measure*, I. iii. 29 ff.; 51 ff.

In fact, the state of Vienna is at least equally important with the state of Angelo. It is largely Shakespeare's doing that we get the balance wrong. He gives us a powerful exposition, always insistently relevant and mainly concerned with Angelo, and then after two and a half acts of compelling tragedy he seems to lose interest and grip in the mechanical contrivance of his dénouement: the dejected Mariana of the moated-Grange is introduced in prose which looks oddly in the Folio text after five pages of continuous verse and which seems to symbolise the relaxed tension of the writing.[155]

It is well to mention here in parenthesis that *Measure for Measure* belongs to the period of Shakespeare's writing which follows upon *Hamlet*, a period which we shall study more closely in a later section of this chapter.[156] An attempt will there be made to explain the manifest fact that between 1601 and 1604 the poet's creative energy was in some measure in abeyance, that *Troilus and Cressida* (1601–2), *All's Well That Ends Well* (1602–3), and *Measure for Measure* (1604–5), all show signs of tiredness and exhausted inspiration. But in all these plays there are traces of the restless experimentation which is characteristic of Shakespeare's mind, and *Measure for Measure*, the last play of the interval, closely followed by the triumphant *Othello*, must be treated as a vigorous, if not wholly successful, attempt to present the conflict between licence and discipline in its public as well as its private context.

Apart from the rare times of exhaustion and uneasiness, when (as normally) Shakespeare is on top of his form, the producer of a particular play must certainly make it a matter of first importance to settle what his author is driving at. The poet himself would presumably have been asked for an explanation at rehearsal at the Globe. With so volatile and restlessly experimental an imagination, it is no good assuming that one knows. One of the most remarkable things about the canon is the fact that Shakespeare so seldom repeats himself. *As You Like It* is a case in point. There is obviously nothing amiss with his inspiration at this time: the companion-play *Twelfth Night* makes this plain, and *Julius Caesar* in the same year. The digressive, episodic manner of *As You Like It* is not due to inability, not therefore unintentional. At first sight there is little of the insistent relevance of the companion-plays. The Duke Senior and Jaques *do* nothing: whole scenes and prolonged dialogues are built of nothing but talk and song.[157] But here Shakespeare is dramatising (in a vein of satire) a frame of mind, a whole way of life, pastoral

[155] *Measure for Measure*, III. i. 182 ff.
[156] See below, pp. 267 ff.
[157] See *As You Like It*, II. v.; II. vii. 1–87; 136–66.

escapism; the plot is left to Rosalind, Orlando and the shepherds. He was also preoccupied, I think, during the composition of this play, with conversations with Armin on the art of fooling. Touchstone is an object-lesson from Armin's text-book. The play is full of cadenzas, which are quite in place in this pastoral satire. The "seven ages" of man is a cadenza, needed to fill a gap while Orlando goes to fetch Adam: another is Rosalind's on Time travelling in divers paces: Jaques again discourses *ad lib.* on melancholy; Touchstone on quarrelling by the book (the Retort courteous, the Quip-modest, the reply Churlish, and so forth)—this last again to fill a gap in the action.[158] The songs, moreover, are, unlike those of most of the other comedies, a loosely-knit *comment* on the action, rather than an integral part of it: they make the play Shakespeare's nearest approach to the operetta or the musical comedy of modern times. It is a play for the civilised palate, for the "highbrow", like *Love's Labour's Lost*, and of both these collector's pieces it may be said that "Time ambles withal". The substance of *As You Like It* is hard to define: no doubt it is of more than one kind—satire of court life and also of the pastoral escape from court life; variations on the theme of love; a study of different kinds of folly (in the last two particulars it is a pair with *Twelfth Night*, and not unlike *Love's Labour's Lost*). Talk with Armin seems a likely background to this period of Shakespeare's composition. But if it is hard to state in precise terms the subject of the play, yet its dramatic interest never flags: the poet meanders, perhaps, but he meanders with conviction and determination, and there is never any good reason to doubt what effect he is aiming at at a given moment. He sticks to the point, and continuously fixes the attention of his audience.

This power of fixing and holding the attention of his audience is one of the most potent elements in his art. He proceeds from one point of emphasis in his story to the next with that immediate continuity which can only be achieved in the conditions of his playhouse. The insistent relevance of his writing and the speed of his transitions from one point to another compels us to experience the drama with his actors and prevents us from thinking over our experience while it is in progress. Some of the not infrequent charges of inconsistency and confusion arise from a neglect of this simple truth: such, for instance, is the notorious absurdity in *Othello* of the fact, obvious but only to the armchair calculator, that there is no possible opportunity for the suspected adultery of Cassio and Desdemona; such too the inexplicable mystery of the first contemplation of regicide by

[158] *As You Like It*, II. vii. 139 ff.; III. ii. 328 ff.; IV. i. 11 ff.; V. iv. 71 ff.

Macbeth and his Lady, when "Nor time, nor place Did then adhere". We can see the spellbinding process in a sequence of *Hamlet*. When the Prince asks Horatio what is his affair in Elsinore, Horatio reluctantly answers

> My Lord, I came to see your Father's funerall.

From Hamlet's previous soliloquy we know that this must have been nearly two months ago. The incongruity seems an absurd one, if we have time to reckon the distance from Wittenberg: but in fact Hamlet drives all calculation from our minds with his bitter retort:

> I pray thee doe not mock me (fellow Student)
> I thinke it was to see my Mothers Wedding.

It is not enough here to give the negative explanation and say that this is an example of "dramatic time", and that the audience in the playhouse have no chance to think out the absurdity. We must ask also, what is the positive reason for Horatio's statement? I think the answer is that Shakespeare is intent on dramatising the "wicked speed" of the wedding all through this sequence of the play—in Claudius' opening apologia, in Hamlet's soliloquy, and still in the beginning of the dialogue with Horatio. The continuity is in the theme, which is kept before our notice with insistent relevance. The juxtaposition of Horatio's line and Hamlet's retort is clinched by the sequel, with its epigrammatic irony:

> *Hor.* Indeed my Lord, it followed hard upon.
> *Ham.* Thrift, thrift, *Horatio*: the Funerall Bakt-meats
> Did coldly furnish forth the Marriage Tables . . .[159]

The strength of Shakespeare's architecture lies largely in his insistent relevance and his unflagging continuity. It will be worth while to study more closely the mechanics of this continuity.

(viii) Continuity

It has already been seen, in considering the problems of scene-rotation, that the swift continuity possible in this playhouse was a great asset to the poet. Shakespearian producers have learnt, within the memory of this generation, to value a speedy passage from scene to scene, but we still do not achieve that absolute immediacy of transition which is characteristic of Shakespeare's own theatre. Even

[159] *Hamlet*, I. ii. 176 ff.

the sudden black-out, the lowering of a fore-curtain to allow of a "corridor-scene", even the insertion of a musical "join", breaks the continuity and dissipates the concentration of the audience. Any such expedient on the picture-stage throws the audience, as it were, back upon itself: the spell is interrupted as it is when the cinema-projector breaks down. In the Globe the audience are always crowded round the great central Platform: the main field of action is never withdrawn from their sight. There is an atmospheric difference, which only experience can prove. We can see the normal practice of the playhouse in a vivid simile from *Richard II*:

> As in a Theater, the eyes of men
> After a well grac'd Actor leaves the Stage,
> Are idlely bent on him that enters next,
> Thinking his prattle to be tedious . . .[160]

and we can also see in these lines the poet's problem stated in its simplest terms: how is he to keep the interest of his audience, and sustain the continuity of his dramatic tension? It is difficult to formulate the methods of genius, but some general principles of procedure can be detected in Shakespeare's tackling of this problem.

Though, as we have seen in *As You Like It*, we must be wary in making such an assumption, the logical sequence of events, the continuity of plot, is usually the main thread upon which the play is strung. This continuity of plot has nothing to do with realism of time: Shakespeare, as Granville-Barker points out, "knew that, once away from watches and clocks, we appreciate the relation of events rather by the intensity of the experiences which unite or divide them in our minds than by any arithmetical process".[161] For instance, the dispersal of Capulet's dancing-party so soon after its inception reads abruptly on the printed page, but is quite plausible in the theatre: in the interim, the first meeting of Romeo and Juliet "stops the clock". Shakespeare cunningly leads us on from one point of interest to another: we are told what to expect and we welcome it when it comes.[162]

His simplest method of progress is by the direct method. When King Henry VI hears of the magic practices of the Duchess of Gloucester, he says:

> To morrow toward London, back againe,
> To looke into this Business thorowly. . . .

[160] *Richard II*, V. ii. 23 ff.
[161] Granville-Barker, *From Henry V to Hamlet*, 17.
[162] *Romeo and Juliet*, I. v. 20–131.

There follows the scene in which York expounds his claim to Salisbury and Warwick, and no sooner do they leave the Platform than (the Folio tells us):

> *Sound Trumpets. Enter the King and State,*
> *with Guard, to banish the Duchesse.*
>
> *King.* Stand forth Dame *Elianor Cobham,*
> *Glosters* Wife.

We know where we are at once.[163] This admirable directness of procedure is a conspicuous feature of *Richard III*. Turning page after page of the Folio, one is left with the impression that the main sequence of the play is acted out on the naked Platform, and the continuity of subject is very close and direct between one scene and the next. This direct method makes the very freest use of the un-localised Platform, as we have already seen in Chapter III. The maskers approaching Capulet's feast *march about the Stage, and Servingmen come forth with their napkins:* at once the Platform is transformed from the street into the hall of Capulet's house. In *Julius Caesar*, by a like method, we proceed from the streets into the Capitol, and from the open air into Brutus' tent.[164] Hamlet follows the beckoning of his father's ghost out by one end of the Tarras, and reappears six lines later—with a shift of focus as rapid as that of the cinema-camera—by one of the stage-doors on to the Platform: we know that the Platform is the "more removed ground" of Marcellus' fears.[165] Sometimes the scene is changed for us by the logic of the *dramatis personae*. We studied above the sequence in 1 *Henry VI* where Talbot at Bordeaux waits in vain for reinforcements from York and Somerset.[166] In *As You Like It*, it seems probable that the Study contained but one symbolical setting of woodland furniture, and that the presumption of different locality was left for the audience to infer from the appearance of different groups of characters: the Chamber would of course be reserved for the interruptions of the woodland sequence at Duke Frederick's court. Venice and Belmont are likewise simply differentiated by the presence of Antonio and Shylock on the one hand and of Portia on the other: Cleopatra means Egypt, Octavius Rome, and our imagination is not too severely strained by Pompey's galley, and by Ventidius' outlandish and gruesome triumphal procession in Parthia. The eyes of the audience, "idlely bent on him that enters next", see Kemp and Cowley *with the watch*, carrying "bills" and a lantern, and are in no

[163] 2 *Henry VI*, II. i. 199 f.; II. iii. 1 f. See above, pp. 34 f.
[164] See above, p. 104. [165] *Hamlet*, I. iv. 86 ff.; I. v. i.
[166] See above, p. 104.

doubt of their business as the night-patrol of the Messina con-
stabulary: if they see the Sheriff and halberds, and a dignified
prisoner, they can guess the road to execution. The street-sequences
of *The Merry Wives of Windsor* and *Troilus and Cressida*, and the
prison-sequences of *Measure for Measure* employ such a direct
method, and are based, as we have seen, on the existing architecture
of the Tiring-House. So too in the battle-sequences the plotting of
entries follows a method of logical directness which is always
sustained in the dialogue. We have seen too how in a large part of
Much Ado About Nothing the method dispenses with locality altogether:
the thread of connection is not geographical at all, but consists of the
logical course of the intrigue.[167]

There are—one may notice in passing—some shrewd strokes of
juxtaposition which, if the continuity, as usually in the modern
theatre, is broken, fail of their intended effect. There is a genuine
thrill in *King John* where the pusillanimous would-be murderer finds
out suddenly from Hubert that his victim is not dead:

> Doth *Arthur* live? O hast thee to the Peeres,
> Throw this report on their incensed rage,
> And make them tame to their obedience.

He hopes that he may yet make all well with his revolted nobles:

> Oh, answer not; but to my Closet bring
> The angry Lords, with all expedient hast,
> I conjure thee but slowly: run more fast.

He is sitting on his throne in the Study, with Hubert at his elbow.
The curtain draws upon him, and immediately—

> *Enter Arthur on the walles.*

Dressed as a ship-boy, the poor Prince appears on the Tarras, and
hurls himself to death below.[168] There is a stroke of irony, surely not
unconscious, in the sequence of King Henry IV's restless soliloquy

> How many thousand of my poorest Subjects
> Are at this houre asleepe?

close upon Falstaff's "Now comes in the sweetest Morsell of the
night . . ." [169] There is no setting better than Shakespeare's play-
house to bring out the mischievous anti-climax which appears thus
in the Folio:

[167] See above, p. 106. [168] *King John*, IV. ii. 260 ff.; IV. iii. 1 ff.
[169] *2 Henry IV*, II. iv. 401; III. i. 4 ff.

The Game's afoot:
Follow your Spirit; and upon this Charge,
Cry, God for *Harry*, England, and S. *George*.
Alarum, and Chambers goe off.
Enter Nim, Bardolph, Pistoll, and Boy.
Bard. On, on, on, on, on, to the breach, to the breach.
Nim. 'Pray thee Corporall stay, the Knocks are too hot . . .[170]

Likewise Edgar's soliloquy in which he compassionates King Lear
with the exclamation "He childed as I fathered" is given a bitter
twist of tragic irony by the immediate sequel up aloft in the Chamber
of the blinding of his deluded father.[171] We shall see in the next
chapter how the episode of Banquo's murder gains in dramatic
effect as Macbeth's words from the Tarras

> Good things of Day begin to droope, and drowse,
> Whiles Nights black Agents to their Prey's doe rowse . . .

are followed immediately by the stealthy entry of the murderers on
the Platform below.[172]

Sometimes one notices a kind of pendulum-swing of alternation in
the course of a prolonged sequence. Thus in *Twelfth Night* for most
of the third and fourth acts the interest is provoked first by the gulling
of Malvolio and then by Sir Andrew's challenge to Viola: when one
theme is temporarily played out, the other is called in to sustain the
tension. In *All's Well That Ends Well* the exposure of Parolles
alternates with the stratagem against Bertram. The most skilful use
of this seesaw movement ends in the combination of the two, as
when the alternation of Venice and Belmont culminates in Portia's
appearance in the Venetian court. A capital example of this pro-
cedure is the elaborate dénouement of 2 *Henry IV*.[173] The dying
King's last words are still echoing in the theatre, when we are trans-
ported to Gloucestershire, where Falstaff for his own ends is paying
Shallow a return visit: the inimitable Davy sets the scene for us and
also helps to make clear that Falstaff passes for an influential
person—"Doth the man of Warre, stay all night sir?" he asks his
master. "Yes *Davy*," replies Shallow: "I will use him well. A Friend
i'th'Court, is better then a penny in purse." Pausing to soliloquise
before he goes in to accept the offered hospitality, Falstaff says: "I
will devise matter enough out of this *Shallow*, to keepe Prince *Harry*

[170] *Henry V*, III. i. 32 ff.; III. ii. 1 ff.
[171] *King Lear*, III. vi. 111 ff.; III. vii.
[172] *Macbeth*, III. ii.. 52 f.; III. iii. See below, p. 298.
[173] 2 *Henry IV*, V. i.–v.

in continuall Laughter ... O you shall see him laugh, till his Face be
like a wet Cloake, ill laid up." Without interruption the Earl of
Warwick and the Lord Chief Justice transport us by their very
presence back to London. The King is dead, and the Lord Chief
Justice wishes he were too; for he has had occasion to incur the
enmity of his successor. Warwick agrees

> Indeed I thinke the yong King loves you not ...

and Prince Hal's younger brothers are no more encouraging about
his prospects; Clarence goes so far as to say

> Wel, you must now speake Sir *John Falstaffe* faire,
> Which swimmes against your streame of Quality.

When Prince Hal appears, of whom Falstaff has just said "you shall
see him laugh, till his Face be like a wet Cloake", he finds himself
surrounded by sad and suspicious glances. Shakespeare cannot resist
making him play "cat and mouse" with the Lord Chief Justice, but
after a noble apologia the Justice is confirmed in his office and
invited to be "as a Father" to the young King. We return at once
back to Gloucestershire for the delicious mellow comedy of wine and
dessert in Shallow's orchard, which is interrupted by Pistol's news
that the old King is as dead "As naile in doore". Falstaff calls for
his horse:

> Master *Robert Shallow*, choose what Office thou wilt
> In the Land, 'tis thine. *Pistol*, I will double charge thee with Dignities.
> *Bard.* O joyfull day:
> I would not take a Knighthood for my Fortune.
> *Pist.* What? I do bring good newes.
> *Fal.* Carrie Master *Silence* to bed: Master *Shallow*, my Lord *Shallow*, be
> what thou wilt, I am Fortunes Steward. Get on thy Boots, wee'l ride all
> night. Oh sweet Pistoll: Away *Bardolfe*: Come Pistoll, utter more to
> mee: and withall devise something to do thy selfe good. Boote, boote,
> Master *Shallow*, I know the young King is sick for mee. Let us take any
> mans Horsses: The Lawes of England are at my command'ment.
> Happie are they, which have beene my Friendes: and woe unto my
> Lord Chiefe Justice.

With horrible suddenness we see Quickly and Dol Tearesheet being
dragged to prison by the Beadles. Then the Grooms strew the Plat-
form with rushes: then Falstaff and Shallow appear in the crowd,
all travel-stained: "O if I had had time to have made new Liveries,"
Falstaff says to Shallow, "I would have bestowed the thousand
pound I borrowed of you."

> *The Trumpets sound. Enter King Henrie the Fift . . .*
> *Fal.* 'Save thee my sweet Boy.
> *King.* My Lord Chiefe Justice, speake to that vaine man.
> *Ch. Just.* Have you your wits?
> Know you what 'tis you speake?
> *Falst.* My King, my Jove; I speake to thee, my heart.
> *King.* I know thee not, old man: Fall to thy Prayers . . .

As the procession passes on, Falstaff turns to his dupe:

> Master *Shallow*, I owe you a thousand pound.

The Lord Chief Justice, returning, gives the *coup de grâce*. The building of this alternating climax is a masterpiece of stagecraft: for its full effect the immediate continuity of the Globe stage is needed.

Shakespeare often sustains the interest by a method which may be described as keeping a rod in pickle. "Go you before to *Gloster* with these letters," says King Lear to the disguised Kent; "acquaint my Daughter no further with any thing you know, then comes from her demand out of the Letter, if your Dilligence be not speedy, I shall be there afore you." "I will not sleepe my Lord," replies Kent, "till I have delivered your Letter." Our curiosity is roused about the coming visit to Regan: we are ready to understand at his next appearance where Kent is and why—and we expect Lear to follow him closely at the heels.[174] Gloucester, asking the disguised Edgar's guidance to Dover, tells us

> There is a Cliffe, whose high and bending head
> Lookes fearfully in the confined Deepe:
> Bring me but to the very brimme of it,
> And Ile repayre the misery thou do'st beare
> With something rich about me: from that place,
> I shall no leading neede.

Thus we are ready to recognise the Platform as the brink of Edgar's imaginary cliff, when we next see him leading his blind father on to the Platform: and meanwhile we dwell with interest on the prospect of such a scene.[175] We are cleverly kept in suspense for two and a half pages of the Folio from Hamlet's first statement of his intention

> To put an Anticke disposition on

to his next appearance: meanwhile Ophelia's story of Hamlet's distracted visit and the King's hints of Hamlet's "transformation"

[174] *King Lear*, I. v. 1–5; II. ii. 1 ff.
[175] *King Lear*, IV. i. 74 ff.; IV. vi. 1 ff.

keep our interest alive.[176] A very clear example of this rod-in-pickle method can be found in a speech of Polonius to the King immediately after the "nunnery-scene":

> My Lord, do as you please,
> But if you hold it fit after the Play,
> Let his Queene Mother all alone intreat him
> To shew his Greefes: let her be round with him,
> And Ile be plac'd so, please you in the eare
> Of all their Conference. If she finde him not,
> To England send him: Or confine him where
> Your wisedome best shall thinke.

At this moment Shakespeare has our curiosity aroused about three possible developments in his plot—the play to "catch the Conscience of the King", Hamlet's interview with his mother (we have never seen them alone together, and the issue cannot be other than dramatic), and the possibility of his being shipped to England.[177]

Other still subtler devices for knitting together the continuity, and holding continuously the concentrated interest of his audience, were in Shakespeare's armoury. We have already seen, in considering the skilled speech of the Chamberlain's Men,[178] the powerful effect of rhythm in preserving the tension over long periods. The rhythmic tension is often deliberately relaxed at the end of a scene, not seldom with the conventional cadence of a couplet: but it is interesting to notice that sometimes the musical movement is intended to continue. Mercutio and Benvolio hunting for Romeo after Capulet's dance are foiled in their search; Mercutio mocks at him for his supposed love for Rosaline, but grows tired of his own joke, and Benvolio agrees that there is nothing for it but to go to bed:

> for 'tis in vaine
> To seeke him here that meanes not to be found.

When they have gone, Romeo, in hiding in Capulet's orchard, murmurs

> He jeasts at Scarres that never felt a wound.

Romeo's words show that he has heard the previous dialogue of his friends, and his rhyme confirms the swift continuity of his speech after Benvolio's. The change of "scene" from street to orchard is taken in the stride of a rhymed couplet.[179] We have yet to see the

[176] *Hamlet*, I. v. 172; II. i. 77 ff.; II. ii. 5. [177] *Hamlet*, III. i. 189 ff.
[178] See above, pp. 119 ff.
[179] *Romeo and Juliet*, II. i. 41 f.; II. ii. 1. The lineation of the folio, which I have altered, obscures the point.

opening scenes of Lear's storm in their native element, the Platform of the Globe: but when we do, it is to be hoped that we shall be allowed to feel the rhythmic continuity of such transitions as that from Cornwall's

> Shut up your doores my Lord, 'tis a wil'd night,
> My *Regan* counsels well: come out o'th'storme

to Kent's

> Who's there besides foule weather?

and that when, with Kent and the Gentleman parting at opposite Stage-Doors, Lear and his Fool emerge from the Study curtains, "Contending with the fretfull Elements".[180] The great rhythmic movements in verse of the mature tragedies are among Shakespeare's unquestioned masterpieces. No less magical in their own vein are the rhythmical movements in prose of the comedies—with Rosalind and Orlando, Beatrice and Benedick, Hal and Falstaff. That much more art goes into the making of them than their spontaneity suggests, is shown by the fact that in the hurriedly composed *Merry Wives of Windsor* the rhythmical flow is conspicuously absent. There are many capital phrases, but for the most part they are in isolation; Falstaff's account of his experiences in the buck-basket is exceptional in this play, but for rhythm it hardly compares with Mistress Quickly accusing Falstaff of breach of promise, or recounting the tragi-comic tale of his death.[181]

(ix) Pervasive Theme

This device of rhythmical continuity, it will be noticed, is an exclusively poetical one, a property of the poetic drama. So likewise is the next object of our study, Shakespeare's deliberate use of the method of pervasive themes. Even in the first historical cycle—the three parts of *Henry VI* and *Richard III*—the use of repeated themes is a conscious item of the author's means to give architectural unity to his subject. Tillyard makes this clear in his *Shakespeare's History Plays*, naming among others the theme of "order and degree" and showing how it is worked out in the repetition of symbols. "Warwick's dying soliloquy at Barnet," he says, for instance, "is full of the traditional commonplaces associated with degree. Speaking of himself, he says—

[180] *King Lear*, II. iv. 311 f.; III. i. 1 ff.; III. i. 55; III. ii. 1 ff.
[181] *The Merry Wives of Windsor*, III. v. 98 ff.; 2 *Henry IV*, II. i. 95 ff.; *Henry V*, II. iii. 9 ff.

> Thus yields the cedar to the axe's edge,
> Whose arms gave shelter to the princely eagle,
> Under whose shade the ramping lion slept,
> Whose top branch overpeer'd Jove's spreading Tree
> And kept low shrubs from winter's powerful wind.

Warwick is thinking of his own power in making and unmaking kings. He is not the oak, the king of trees, but a cedar overtopping the oak; and he refers to a whole sequence of primates in the chain of being: God or Jove in heaven, the King on earth, the lion among beasts, the eagle among birds, and the oak among plants." [182] These themes, and the imagery which sustains them, are derived from the poet's models and are the commonplaces of contemporary political and historical theory: they are the bricks ready to hand, and it is the dramatist's chief task to build them into his architectural structure. Comparison with the later historical cycle—*Richard II*, *Henry IV* and *Henry V*—is instructive here. Inevitably, with the Tudor interpretation of history, there are patterns of orthodoxy in the treatment of this period too. The theme of regicide is prominent on the lips of the uneasy Bolingbroke, particularly the notion of crusade for penance, which dominates his dying thoughts: when he hears that the room where he was first taken ill is called Jerusalem, he says:

> Laud be to heaven:
> Even there my life must end.
> It hath beene prophesi'de to me many yeares,
> I should not dye, but in *Jerusalem*:
> Which (vainly) I suppos'd the Holy-Land.
> But beare me to that Chamber, there Ile lye:
> In that *Jerusalem*, shall *Harry* dye.

The notion of retribution for Richard's murder recurs unexpectedly in King Henry V's prayer on the eve of Agincourt:

> Not to day, O Lord,
> O not to day, thinke not upon the fault
> My father made, in compassing the Crowne.[183]

These themes, like those in the earlier cycle, stand ready to hand and are an intrinsic part of the dramatist's material. But, side by side with these, we can detect also themes of his own creation, whose repeated emphasis is the poet's deliberate choice in order to give dramatic life to his play. I would instance the very interesting case in *Richard II* of the theme of the earth. We have seen above [184] how on

[182] E. M. W. Tillyard, *Shakespeare's History Plays*, 150 ff., 189 f. The quotation is from 3 *Henry VI*, V. ii. 11 ff.

[183] 2 *Henry IV*, IV. v. 234 ff.; *Henry V*, IV. i. 312 ff. [184] See above, p. 201.

his arrival at Barkloughly Castle after his crossing of the seas from Ireland, Richard salutes the "Deere Earth" in an elaborate address which invests the Platform with poetic life. "Mock not my sencelesse Conjuration, Lords," he ends; "This Earth shall have a feeling . . ." The despairing King returns to this theme in a famous speech in the same scene:

> No matter where; of comfort no man speake:
> Let's talke of Graves, of Wormes, and Epitaphs.
> Make Dust our Paper, and with Raynie eyes
> Write Sorrow on the Bosome of the Earth.
> Let's chuse Executors, and talke of Wills:
> And yet not so; for what can we bequeath,
> Save our deposed bodies to the ground?
> Our Lands, our Lives, and all are *Bullingbrookes*,
> And nothing can we call our owne, but Death,
> And that small Modell of the barren Earth,
> Which serves as Paste, and Cover to our Bones:
> For Heavens [*read* Gods] sake let us sit upon the ground,
> And tell sad stories of the death of Kings . . .

The later speech gains an extra force from the elaborate atmospheric and emotional painting of the former. In the next scene Bolingbroke, claiming the restoration of his lands, utters his purpose thus:

> If not, Ile use th'advantage of my Power,
> And lay the Summers dust with showers of blood,
> Rayn'd from the wounds of slaughter'd Englishmen:
> The which, how farre off from the mind of *Bullingbrooke*
> It is, such Crimson Tempest should bedrench
> The fresh greene Lap of faire King *Richards* Land,
> My stooping dutie tenderly shall shew.
> Goe signifie as much, while here we march
> Upon the Grassie Carpet of this Plaine . . .

The same insistence on the land and the grass of pasture appears in Richard's reply:

> Tell *Bullingbrooke*, for yond me thinkes he is,
> That every stride he makes upon my Land,
> Is dangerous Treason: He is come to ope
> The purple Testament of bleeding Warre;
> But ere the Crowne he lookes for, live in peace,
> Ten thousand bloody crownes of Mothers Sonnes
> Shall ill become the flower of Englands face,
> Change the complexion of her Maid-pale Peace
> To Scarlet Indignation, and bedew
> Her Pastors Grasse with faithfull English Blood , . ,

and the theme underlies the strained conceits of his resigned offer to give

> my large Kingdome, for a little Grave,
> A little, little Grave, an obscure Grave.
> Or Ile be buryed in the Kings high-way,
> Some way of Common Trade, where Subjects feet
> May howrely trample on their Soveraignes Head:
> For on my heart they tread now, whilest I live;
> And buryed once, why not upon my Head?
> *Aumerle*, thou weep'st (my tender-hearted Cousin)
> Wee'le make foule Weather with despised Teares:
> Our sighes, and they, shall lodge the Summer Corne,
> And make a Dearth in this revolting Land.
> Or shall we play the Wantons with our Woes,
> And make some prettie Match, with shedding Teares?
> As thus: to drop them still upon one place,
> Till they have fretted us a payre of Graves,
> Within the Earth: and therein lay'd, there lyes
> Two Kinsmen, digg'd their Graves with weeping Eyes?

The theme is echoed later in the Queen's words, as she waits to watch her husband's passing to prison:

> Here let us rest, if this rebellious Earth
> Have any resting for her true Kings Queene . . .

and in the King's dying speech, when he expresses the sin of regicide which is to dwell lifelong in the conscience of the usurper:

> *Exton*, thy fierce hand,
> Hath with the Kings blood, stain'd the Kings own land.[185]

How much of this notion Shakespeare derived from his models I do not know: the elaborate repetition of the theme shows that it was often present in his mind as he planned his play. More certainly his own was a theme which recurs in 1 *Henry IV*, and which circulates round the words "honour", "plumes", "favours". It is stated emphatically in Prince Hal's recantation before his father, when he declares that he will

> in the closing of some glorious day,
> Be bold to tell you, that I am your Sonne,
> When I will weare a Garment all of Blood,
> And staine my favours in a bloody Maske:
> Which washt away, shall scowre my shame with it.
> And that shall be the day, when ere it lights,

[185] *Richard II*, III. ii. 6 ff., 144 ff.; III. iii. 42 ff., 91 ff., 153 ff.; V. i. 5 f.; V. v, 10 f.

> That this same Child of Honor and Renowne,
> This gallant *Hotspur*, this all-praysed Knight,
> And your unthought-of *Harry* chance to meet:
> For every Honor sitting on his Helme,
> Would they were multitudes, and on my head
> My shames redoubled. For the time will come,
> That I shall make this Northerne Youth exchange
> His glorious Deedes for my Indignities . . .

It receives vigorous reinforcement in Vernon's answer to Hotspur's
question about "The nimble-footed Mad-Cap, Prince of Wales":
Vernon had seen Hal and his comrades

> All furnisht, all in Armes,
> All plum'd like Estridges, that with the Winde
> Bayted like Eagles, having lately bath'd,
> Glittering in Golden Coates, like Images,
> As full of spirit as the Moneth of May,
> And gorgeous as the Sunne at Mid-summer,
> Wanton as youthfull Goates, wilde as young bulls.

In the following scene, when we see the Prince and Westmoreland
on their way to the war, no doubt the company's wardrobe was well
ransacked for the means to live up to Vernon's description. The
theme is reflected in two distorting mirrors, first early in the play by
Hotspur with his impulsive ambition

> To plucke bright Honor from the pale-fac'd Moone—

and secondly on the eve of battle itself by Falstaff's celebrated
"Catechisme". But it comes to a dramatic fruition in the chivalrous
gesture of Prince Hal as he kneels by the dead body of his rival
Harry, and covers his face with the plumes from his own helmet:

> If thou wer't sensible of curtesie,
> I should not make so great a shew of Zeale.
> But let my favours hide thy mangled face,
> And even in thy behalfe, Ile thanke my selfe
> For doing these fayre Rites of Tendernesse.[186]

This theme, it seems to me, is deliberately imposed by the poet upon
his material, not (as earlier) taken from the material, or from the
stock interpretations of the historians. It is devised, in the manner of
a *leit-motif*, to create an emphatic and pervasive impression in the
mind of the audience: its effect is a poetical one, made by the words,

[186] I *Henry IV*, III. ii. 133 ff.; IV. i. 95 ff.; IV. ii. 54; I. iii. 202; V. i. 128 ff.;
V. iv. 94 ff. See Dover Wilson, *The Fortunes of Falstaff*, 66, and the reference on his
p. 137 to an article by H. Hartman. See above, p. 59.

which invest the no doubt familiar plumes of the company's ward-robe with a new dramatic force.

The practice, though it perhaps arises naturally out of the habitual patterned interpretations of the historians, is not confined to the histories. In the same year as *Richard II, A Midsummer Night's Dream* shows in a still more striking way how the repetition of themes and images can invest the stage with atmosphere. The theme of moonlight, for instance, is established by constant repetition, right from the opening speech of the play, and well before there is any suggestion of the elopement to the wood.[187] The woodland imagery rises naturally from the subject, but it is thick-sown, to transform the Platform into a wood. We can catch the poet seeking his opportunity when Titania, winding Bottom in her arms, says

> So doth the woodbine, the sweet Honisuckle,
> Gently entwist; the female Ivy so
> Enrings the barky fingers of the Elme.[188]

She is describing her own doting embrace, but she is also keeping us conscious of the wood. Did Shakespeare about this year of 1595–6 become more fully aware of the poetical weapon of theme-repetition, or can we detect it already the year before in *Romeo and Juliet's leit-motif* of "the stars"? It is in the following year that *The Merchant of Venice* shows us, as we have seen, the pervasive Venetian colour sustained by Solanio and Salarino. In *Julius Caesar* the "Capitoll" exemplifies the force of a single word in reiteration to evoke drama, and the latter half of the play is dominated by the theme of "*Caesars Spirit ranging for Revenge*".

Hamlet introduces the highly-organised technique of a prevailing tissue of imagery.[189] Hamlet's urgent plea to his mother after the Ghost's visitation to her closet—

> mother for love of grace,
> Lay not that flattering unction to your soule
> That not your trespasse but my madnesse speakes,
> It will but skin and filme the ulcerous place
> Whiles ranck corruption mining all within
> Infects unseene, confesse your selfe to heaven,
> Repent what's past, avoyd what is to come,
> And doe not spread the compost on the weedes
> To make them rancker—[190]

[187] See my *Moonlight at the Globe*, 27, and note 1.

[188] *A Midsummer Night's Dream*, IV. i. 48 ff.

[189] The reader is referred to Caroline Spurgeon's *Shakespeare's Imagery* for a classification and analysis of the poet's images.

[190] *Hamlet*, III. iv. 144 ff.

contains two of the commonest themes that run through the play—
on the one hand, foul disease, the imposthume, sores and boils,
diseases desperate grown; on the other, the unweeded garden that
grows to seed, possessed merely by things rank and gross in nature.
The poet interprets his story through this prevalent imagery, and the
whole drama of that something rotten in the State of Denmark—the
disjointed time which Hamlet is born to set right—is coloured by it.

But it is not till the great tragic period that this method is per-
fected. *Othello* shows it fully developed and it is worth collecting some
of the main examples of its use. We can distinguish two forms—the
leit-motifs often contained in a single word or phrase, and the
pervasive imagery, in which images drawn from the same range of
ideas are built up into a structure of cumulative dramatic force.
The "Capitoll" of *Julius Caesar* is a *leit-motif*, the "disease" and
"weeds" of *Hamlet* are pervasive imagery. "Lieutenant" is one such
leit-motif in *Othello*. It is established as a motive in the drama in
Iago's opening tirade, when he tells Roderigo that Cassio whom he
despises has gained preferment over himself:

> He (in good time) must his Lieutenant be,
> And I (blesse the marke) his Mooreships Auntient.
> (I. i. 32 f.)

The invidious distinction between the lieutenant and the ensign is
kept before our notice. In the torchlit encounter in the streets
Othello recognises Cassio as "my Lieutenant", and Cassio addresses
Iago as "Aunciant" (I. ii. 34, 49). When later at Cyprus Iago has
managed to "fasten but one Cup upon" Cassio, he humours his
drunkenness with repetition of the title

> It's true, good Lieutenant.

and (when Cassio hopes "to be saved")

> And so do I too Lieutenant.

There is a stroke of irony in Cassio's quarrelsome retort:

> I: (but by your leave) not before me. The Lieutenant is to be saved
> before the Ancient.
> (II. iii. 109 ff.)

When Iago's contriving has lost Cassio his reputation and his office,
and yet persuades Cassio that he is his good friend in adversity, the
leit-motif returns with shrewd effect at their parting: "good night
Lieutenant, I must to the Watch." "Good night, honest *Iago*" (II.
iii. 342 f.). Here there is a counterpoint with another *motif*—that of

the "honest" Iago. The "lieutenant" *motif* reaches its ultimate climax at the terrible end of the temptation-scene, when Othello, bent on destroying both Cassio and Desdemona, says to Iago:

> Now art thou my Lieutenant.

and his tormentor with grim irony replies—

> I am your owne for ever.
> (III. iii. 479 f.)

The word "honest" is of course another example. It would be tedious to quote every instance of its use (it is constantly applied to Iago), but we may note its sinister introduction, when Brabantio yields his daughter to Othello with the words

> Looke to her (Moore) if thou hast eies to see:
> She ha's deceiv'd her Father, and may thee . . .

and Othello replies

> My life upon her faith. Honest *Iago*,
> My *Desdemona* must I leave to thee . . .
> (I. iii. 294 ff.)

We have seen above the irony of Cassio's use of the adjective. Desdemona, pleading with her lord for Cassio's reinstatement, says:

> For if he be not one, that truly loves you,
> That erres in Ignorance, and not in Cunning,
> I have no judgement in an honest face.
> (III. iii. 48 ff.)

How little her judgment is, we see later by her implicit trust in Iago's honesty. As Iago begins to sow the seeds of suspicion in Othello's mind, he draws from his victim the information that Cassio helped him in his wooing of Desdemona.

> *Iago.* I did not thinke he had bin acquainted with hir.
> *Oth.* O yes, and went betweene us very oft.
> *Iago.* Indeed?
> *Oth.* Indeed? I indeed. Discern'st thou ought in that?
> Is he not honest?
> *Iago.* Honest, my Lord?
> *Oth.* Honest? I, Honest.
> *Iago.* My Lord, for ought I know.
> (III. iii. 99 ff.)

It is not long before Othello is moved to say

> I do not thinke but *Desdemona's* honest.
> (III. iii. 225)

The climax to which Shakespeare is building this word is the moment when, after Desdemona's death, Othello tells Aemilia that her husband knew it all. "My Husband?" she says over and over again in bewildered horror, till at last the Moor cries

> What needs this itterance, Woman?
> I say, thy Husband . . .

and as she persists in her question—

> He, Woman;
> I say thy Husband: Do'st understand the word?
> My Friend, thy Husband; honest, honest *Iago*.
> (V. ii. 148 ff.)

The "Handkerchiefe" is another such *motif*, with its climax in the scene where Desdemona's plea for Cassio makes a counterpoint of the simplest terms:

> Pray you let *Cassio* be receiv'd againe.
> *Oth.* Fetch me the Handkerchiefe,
> My minde mis-gives.
> *Des.* Come, come: you'l never meete a more sufficient man.
> *Oth.* The Handkerchiefe.
> *Des.* A man that all his time
> Hath founded his good Fortunes on your love;
> Shar'd dangers with you.
> *Oth.* The Handkerchiefe.
> *Des.* Insooth, you are too blame.
> (III. iv. 88 ff.)

The pervasive imagery is perhaps harder to define, but in this play it is largely concerned with the background of mysterious romance and chivalry against which Othello's person stands in relief. Without it the story might seem merely a sensational melodrama, a newspaper "tragedy". It is best described in the poet's own words. Othello is already "sketched in" before his first entry: in this respect he is noticeably different from his predecessor on the tragic stage, who is only referred to almost casually at the end of the first scene as "yong *Hamlet*". Here we have Iago's bitter discussion of him, with its reiteration of "the Moore", "his Mooreship"; the "bumbast Circumstance, Horribly stufft with Epithites of warre"; mention of Rhodes and Cyprus and "others grounds Christen'd, and Heathen"; Roderigo's "the Thicks-lips"; Iago's more obscene descriptions to Brabantio; and the mention of his importance to the State as General in the prospective Cyprus wars. All this is given us

before Burbadge's appearance on the Platform. Soon after his
arrival he tells us

> I fetch my life and being,
> From Men of Royall Seige.
>
> (I. ii. 21 ff.)

Brabantio's suggestion that his daughter has been enchanted with
foul charms, bound in chains of magic, helps to hint at the mysterious
background of Othello's past. So too, of course, does the round,
unvarnished tale that refutes the charge—

> the Storie of my life,
> From yeare to yeare: the Battaile, Sieges, Fortune,
> That I have past.
> I ran it through, even from my boyish daies,
> To th'very moment that he bad me tell it.
> Wherein I spoke of most disastrous chances:
> Of moving Accidents by Flood and Field,
> Of haire-breadth scapes i'th'imminent deadly breach;
> Of being taken by the Insolent Foe,
> And sold to slavery. Of my redemption thence,
> And portance in my Travellours historie.
> Wherein of Antars vast, and Desarts idle,
> Rough Quarries, Rocks, Hills, whose head touch heaven,
> It was my hint to speake. Such was my Processe,
> And of the Canibals that each other eate,
> The *Antropophague*, and men whose heads
> Grew beneath their shoulders.
>
> (I. iii. 129 ff.)

Already, before this, he has told us

> since these Armes of mine, had seven yeares pith,
> Till now, some nine Moones wasted, they have us'd
> Their dearest action, in the Tented Field:
> And little of this great world can I speake,
> More then pertaines to Feats of Broiles, and Battaile.
>
> (I. iii. 83ff.)

There follow such echoes as

> The Tirant Custome, most Grave Senators,
> Hath made the flinty and Steele Couch of Warre
> My thrice-driven bed of Downe . . .
>
> (I. iii. 230 ff.)

and

> 'tis the Soldiers life,
> To have their Balmy slumbers wak'd with strife.
>
> (II. iii. 259 f.)

Prominent in the series must be the famous "farewell" speech:

> Oh now, for ever
> Farewell the Tranquill minde; farewell Content;
> Farewell the plumed Troopes, and the bigge Warres,
> That makes Ambition, Vertue! Oh farewell;
> Farewell the neighing Steed, and the shrill Trumpe,
> The spirit-stirring Drum, th'Eare-piercing Fife,
> The Royall Banner, and all Qualitie,
> Pride, Pompe, and Circumstance of glorious Warre:
> And O you mortall Engines, whose rude throates
> Th'immortall Joves dread Clamours, counterfet,
> Farewell: *Othello's* Occupation's gone.
> <div align="right">(III. iii. 348 ff.)</div>

and the "Sacred-vow" of revenge—

> Like to the Ponticke Sea,
> Whose Icie Current, and compulsive course,
> Nev'r keepes retyring ebbe, but keepes due on
> To the Proponticke, and the Hellespont:
> Even so my bloody thoughts, with violent pace
> Shall nev'r looke backe, nev'r ebbe to humble Love,
> Till that a capeable, and wide Revenge
> Swallow them up.
> <div align="right">(III. iii. 454 ff.)</div>

With its heartrending irony, Desdemona's answer to Aemilia's question "Is he not jealious?" reminds us once again of the romance of his distant upbringing:

> Who, he? I thinke the Sun where he was borne,
> Drew all such humors from him.
> <div align="right">(III. iv. 30 ff.)</div>

The theatrical trick of the handkerchief is touched with poetry so that it too becomes part of the romantic and mysterious background. We hear of the Egyptian Charmer who gave it to Othello's mother: the story of its potency in love raises it from a stage-trick to material of tragic import:

> There's Magicke in the web of it:
> A Sybill that had numbred in the world
> The Sun to course, two hundred compasses,
> In her Prophetticke furie sow'd the Worke:
> The Wormes were hallowed, that did breede the Silke,
> And it was dyde in Mummey, which the Skilfull
> Conserv'd of Maidens hearts.
> <div align="right">(III. iv. 70 ff.)</div>

Iago's affected surprise at hearing of Othello's "strange un-quietnesse"—

> Can he be angry? I have seene the Cannon
> When it hath blowne his Rankes into the Ayre,
> And like the Divell from his very Arme
> Puff't his owne Brother: And is he angry?
> Something of moment then:
>
> (III. iv. 133 ff.)

looks forward to Lodovico's comment on Othello's striking his wife—

> Is this the Nature
> Whom Passion could not shake? Whose solid vertue
> The shot of Accident, nor dart of Chance
> Could neither graze, nor pierce?
>
> (IV. i. 276 ff.)

In the last scene, left alone with the dead bodies of Desdemona and Aemilia, Othello hunts for and finds "a Sword of Spaine, the Ice brookes temper"; with this in hand he compels Gratiano to look in on him:

> Behold, I have a weapon:
> A better never did it selfe sustaine
> Upon a Soldiers Thigh. I have seene the day,
> That with this little Arme, and this good Sword,
> I have made my way through more impediments
> Then twenty times your stop. But (oh vaine boast)
> Who can controll his Fate? 'Tis not so now.
> Be not affraid, though you do see me weapon'd:
> Heere is my journies end, heere is my butt
> And verie Sea-marke of my utmost Saile.
> Do you go backe dismaid? 'Tis a lost feare:
> Man but a Rush against *Othello's* brest,
> And he retires.
>
> (V. ii. 258 ff.)

Then the final speech—

> Soft you; a word or two before you goe—
>
> (V. ii. 337 ff.)

with its variety of outlandish colour (the Indian who threw a pearl away richer than all his tribe; the Arabian trees dropping their medicinable gum; the turbaned Turk in Aleppo) brings home the background imagery full circle, and makes his death-stroke seem indeed the last page in "the Storie of my life", the last of his "most disastrous chances", the "journies end. . . . And verie Sea-marke of my utmost Saile".

If we turn to *King Lear* we find *leit-motifs* akin to *Othello's*: the "hundred Knights" are like the "handkerchief"; "dotage" like "honest Iago"; "plainnesse" couples Cordelia's sincerity with Kent's. But the pervasive imagery is more subtle and more potent even that that of the earlier play. It circulates not round the principal person like the background imagery of Othello, but round an idea inherent in the play's story, or rather more exactly round the single *word* "nature" and its overtones—natural, unnatural, monster, bastard—and a strangely wider sense of the word including the nature of man and the nature of the universe. It is perhaps best to list the main instances of this pervasive imagery and ask the reader to draw his own conclusions.[191]

Lear asks his daughters which loves him most—

> That we, our largest bountie may extend
> Where Nature doth with merit challenge.
> <div align="right">(I. i. 54 f.)</div>

After Cordelia's disgrace, he speaks of her as

> a wretch whom Nature is asham'd
> Almost t' acknowledge hers.
> <div align="right">(I. i. 215 f.)</div>

France, astonished, asks how Cordelia could

> Commit a thing so monstrous, to dismantle
> So many folds of favour: sure her offence
> Must be of such unnaturall degree,
> That monsters it . . .
> <div align="right">(I. i. 220 ff.)</div>

Edmund's soliloquy at the beginning of the second scene has a new interpretation of the word "Nature", whom he invokes as his "Goddesse", to whose law his services are bound. His spirited advocacy of bastardy ("Now Gods, stand up for Bastards") certainly belongs to the pervasive train of thought (I. ii. 1 ff.). Gloucester, hearing of Edgar's supposed treachery, calls him "unnaturall" and says "He cannot bee such a Monster". His superstitious interpretation of the late eclipses in the sun and moon speaks of the King's tyranny to Cordelia as falling "from byas of Nature" (I. ii. 84, 105, 115 ff.). Enraged by Goneril, Lear calls her "Degenerate Bastard",

[191] Since this chapter was written, my attention has been drawn to John F. Danby's *Shakespeare's Doctrine of Nature* (*A Study of King Lear*), published in 1949. The reader is referred to this book as containing a close and full analysis of the contrasted meanings of the word "nature" in this play, set in their historical perspective of contemporary thought.

and takes the imagery a step further when already the truth begins
to break in upon him:

> O most small fault,
> How ugly did'st thou in *Cordelia* shew?
> Which like an Engine, wrencht my frame of Nature
> From the fixt place . . .
>
> <div align="right">(I. iv. 290 ff.)</div>

His terrible curse upon Goneril is addressed to Nature:

> Heare, Nature, heare deere Goddesse, heare:
> Suspend thy purpose, if thou did'st intend
> To make this Creature fruitfull . . .

and he proceeds

> If she must teeme
> Create her childe of Spleene, that it may live
> And be a thwart disnatur'd torment to her.
>
> <div align="right">(I. iv. 299 ff.)</div>

Alone with the Fool, waiting for his horses, he mutters

> I will forget my Nature, so kind a Father?

and the cry is wrung from him

> To tak't againe perforce; Monster Ingratitude!
>
> <div align="right">(I. v. 36, 44)</div>

Edmund, still deceiving his father, speaks of Edgar's "unnaturall
purpose", and Gloucester, thanking him, calls him "Loyall and
naturall Boy" (II. i. 52, 86). Later Cornwall praising the villain says
"Natures of such deepe trust, we shall much need"(II. i. 117). In a
comic vein, the disguised Kent says to Oswald "you cowardly
Rascall, nature disclaimes in thee: a Taylor made thee" (II. ii. 58).
Lear, exasperated by the refusal of Cornwall and Regan to see him,
yet tries to find excuses for the discourtesy—

> may be he is not well,
> Infirmity doth still neglect all office,
> Whereto our health is bound, we are not our selves,
> When Nature being opprest, commands the mind
> To suffer with the body . . .
>
> <div align="right">(II. iv. 106 ff.)</div>

Regan, excusing her sister's treatment of their father, says

> O Sir, you are old,
> Nature in you stands on the very Verge
> Of his confine . . .
>
> <div align="right">(II. iv. 148 ff.)</div>

Lear, drawing an invidious distinction between the two sisters, says to Regan

> Thy tender-hefted Nature shall not give
> Thee o're to harshnesse . . .

and adds

> Thou better know'st
> The Offices of Nature, bond of Childhood,
> Effects of Curtesie, dues of Gratitude . . .
> (II. iv. 174 ff.)

The sense shifts, though the word persists, in Lear's outburst before he rushes forth into the storm:

> O reason not the need: our basest Beggers
> Are in the poorest thing superfluous,
> Allow not Nature, more then Nature needs:
> Mans life is cheape as Beastes. Thou art a Lady;
> If onely to go warme were gorgeous,
> Why Nature needs not what thou gorgeous wear'st,
> Which scarcely keepes thee warme, but for true need:
> You Heavens, give me that patience, patience I need . . .
> (II. iv. 267 ff.)

The former sense returns in his almost incoherent cry

> No you unnaturall Hags,
> I will have such revenges on you both,
> That all the world shall——
> (II. iv. 281 ff.)

Out in the storm, Lear bids the thunder

> Cracke Natures moulds, all germaines spill at once
> That makes ingratefull Man.
> (III. ii. 8 f.)

Kent, characteristically nearer to earth, says of the weather

> Mans Nature cannot carry
> Th'affliction, nor the feare.
> (III. ii. 48 f.)

Gloucester privately to Edmund disapproves of the "unnaturall dealing" of Lear's daughters, and Edmund hypocritically agrees: "Most savage and unnaturall" (III. iii). Kent repeats his former view, as he tries to persuade Lear to shelter in the hovel:

> Here is the place my Lord, good my Lord enter,
> The tirrany of the open night's too rough
> For Nature to endure.
> (III. iv. 1 ff.)

It is the thought of his unnatural daughters ("Filial ingratitude")
that leads Lear towards madness—

> O that way madnesse lies, let me shun that:
> No more of that.
>
> <div align="right">(III. iv. 21 f.)</div>

So as he contemplates the naked Bedlamite beggar, who is Edgar in
disguise, he cries

> nothing could have subdu'd Nature
> To such a lownesse, but his unkind Daughters.
>
> <div align="right">(III. iv. 69 f.)</div>

"Pelicane Daughters" he calls them, thinking of the young birds
that drink their parent's blood. The Nature of Man is visibly
symbolised in the naked Edgar. Lear, fascinated by the sight, says
"Is man no more then this? . . . Thou art the thing it selfe; un-
accommodated man, is no more but such a poore, bare, forked
Animall as thou art" (III. iv. 105 ff.). Gloucester utters a kindred
theme as he tells the King "Our flesh and blood, my Lord, is growne
so vilde, that it doth hate what gets it" (III. iv. 149 f.). Edmund,
the hypocrite, pretends a dilemma as he says to Cornwall "How my
Lord, I may be censured, that Nature thus gives way to Loyaltie,
something feares mee to thinke of "(III. v. 3 ff.). Nature would
lead him to side with his father: loyalty gives him the excuse to
traffic with reigning authority. In the heartrending scene where
Lear fancies himself to be arraigning Goneril and Regan before his
bench of justices, he penetrates near to the core of this theme with
the words "Then let them Anatomize *Regan:* See what breeds about
her heart. Is there any cause in Nature that makes these hard-
hearts" (III. vi. 80 ff.). When Lear at last finds rest, Kent tells us
that "Oppressed nature sleepes", and regrets the immediate need to
disturb him again (III. vi. 106). Gloucester, deprived of his eyes,
calls upon Edmund for revenge. It is the unnatural Edmund who is
implored to

> enkindle all the sparkes of Nature
> To quit this horrid acte . . .
>
> <div align="right">(III. vii. 86 f.)</div>

and we should not miss the comment of the servant on *Regan*
(omitted in the Folio): "If she live long, & in the end meet the old
course of death, women will all turne monsters" (III. vii. 100 ff.).
Albany, for once speaking home truths to Goneril, states the moral
of her conduct:

> That nature which contemnes ith [*read* its] origin
> Cannot be bordered certaine in it selfe,
> She that her selfe will sliver and disbranch
> From her materiall sap, perforce must wither,
> And come to deadly use.
> (IV. ii. 32 ff.)

and declares his conviction—

> If that the heavens doe not their visible spirits
> Send quickly downe to tame this vild offences, it will come
> Humanity must perforce pray on it self like monsters
> of the deepe.
> (IV. ii. 46 ff.)

Cordelia, seeking the means to restore her father's "bereaved Sense", is told that

> Our foster Nurse of Nature, is repose,
> The which he lackes . . .
> (IV. iv. 12 f.)

Here the anonymous speaker is using the familiar word in the simple sense in which Kent has more than once employed it. Lear in the height of his madness, "Crown'd with ranke Fenitar, and furrow weeds", declares "I am the King himselfe", and adds pertinently "Nature's above Art, in that respect" (IV. vi. 87). His raving about Adultery and Luxury discloses its relevance in the words "Let Copulation thrive: For Glousters bastard Son was kinder to his Father, Then my Daughters got 'tweene the lawfull sheets" (IV. vi. 117 f.). The fact that we know it is not true about Edmund—and that Gloucester too, who hears him, at last knows the truth—adds tragic irony to the King's disjointed moralising. Blind Gloucester, who recognises the King in spite of his madness, cries

> O ruin'd peece of Nature, this great world
> Shall so weare out to naught.
> (IV. vi. 138 f.)

As Lear runs away from his pursuers, a Gentleman makes comment:

> Thou hast a Daughter
> Who redeemes Nature from the generall curse
> Which twaine have brought her to.
> (IV. vi. 210 ff.)

Cordelia, speaking of her father and again using in Kent's presence his simpler meaning of the word, begs the kind Gods to "Cure this great breach in his abused Nature" (IV. vii. 15). And there,

strangely enough, the imagery fades away. The sublime simplicity of Lear's waking and of the very end of the play makes no direct or implied reference to the pervading theme. One may say, perhaps, that it is immanent in the situation and that the poet knows when to leave it unstated. One may also perhaps confess that the winding-up of the sub-plot of the play is protracted and sometimes clumsy, and, with inspiration temporarily sagging, Shakespeare found that the material would not evolve to its end in his newly wrought medium. *Othello* is more satisfactory for the sustaining of the climax, and *Macbeth* (in the abbreviated form in which we have it) a close second. And of *King Lear* let it be said that the play, like the old King himself, is redeemed past criticism by the last seventy lines.

I have thought it worth while to risk wearying my reader's patience with such lengthy quotation, because there is no other way of stating the point that must here be made. It is not an easy point to make, because the explanation does not reveal itself in a logical statement; that, for instance, Shakespeare uses the word "nature" thirty or forty times in the one play. It is clear that he uses the word in several senses: but that does not invalidate the fact that the word is pervasive; and, moreover, it will have been seen that in some examples the different meanings of the word merge or pass into each other. What we must remember is that Shakespeare the poet was fascinated by words themselves, that he delighted in their ambiguity, that he was used to playing with their varied senses. And it seems to me impossible to escape the suggestion that he had this *word*—and its kindred of words—(in Miranda's phrase) "beating" in his mind as he conceived the play. The *word* is the thread on which the unity of the play is strung together. To achieve unity and continuity thus is a verbal, a strictly *poetic* device. It is Shakespeare's crowning discovery in his search for the means to express drama in poetry. That Aeschylus had made the same discovery two thousand years before him does not lessen Shakespeare's claim to original invention. For with the new conditions of the Elizabethan playhouse and the Elizabethan dramatic convention, the discovery had to be made afresh. It is perhaps still this side idolatry to declare that Shakespeare's medium with its vastly greater flexibility enabled him to surpass the masterpieces of his predecessor.

That there is a fundamental difference between these two great dramas (and their successors, *Macbeth* and *Antony and Cleopatra*), and the earlier plays of Shakespeare, perhaps no one will deny. The sharp, intimate, objective focus is changed for remote classical panorama. Burbadge and Heminges and Lowin have suffered a sea-change into something rich and strange. Burbadge's Othello and

Lear are individuals, but less personally known to us than his Hamlet; Heminges's Kent is recognisable at once as a man we honour and admire and grow to love, but his Polonius had independent life of a different kind. The independence has gone, and therein perhaps lies the clue: the new characters are not independent of the drama in which they take part; they are closer knit in its texture, they serve the whole conception of the dramatist, and the result is a closer unity in the drama itself. *Othello, Macbeth, Antony and Cleopatra* are homogeneous dramatic poems—and so is four-fifths of *King Lear*. Each story in itself is conceived poetically, and a unified work of art is the outcome. The change—can we doubt it?—was a deliberate choice on the part of the dramatist, and it was made, not without labour and misgiving and temporary frustration, in the years between *Hamlet* and *Othello*.

(x) *Withdrawal-and-Return*

The years 1602 to 1604 make a startling impression even on a casual glance at Chambers' chronological list.[192] For the previous ten years there is a steady average of two plays a year (with two instances of three in the twelvemonth): then a year in which *Troilus and Cressida* is all the output—a baffling, bitter play, pricking the bubble of legendary chivalry, a satire but not in the happy vein of *As You Like It*, which runs so easily into poetry. There is certainly much cunning poetry in the scene of the first meeting of the lovers, when Troilus stalks about Cressida's door

> Like a strange soule upon the Stigian bankes
> Staying for waftage . . .

and in her presence murmurs

> You have bereft me of all words Lady.

The words—eloquent words—follow, but the verse is uneasily mixed with prose in the opening of the duet, and the presence and comments of Pandarus, and the ironical hints of Cressida's fickleness, make the scene—however subtly interesting—an awkward theme for poetical expression. Still, Shakespeare takes his opportunity: the sincerity of Troilus and the feigning of Cressida (after all, poetry is feigning) make equally fine protestations in sonnet form—"As true as *Troylus* . . ." "As false as *Cressid*." [193] Ever and anon, too, the speeches of Ulysses and Hector and Troilus soar from eloquence

[192] See Appendix I, p. 318.
[193] *Troilus and Cressida*, III. ii. 9 f.; 55; 179 ff., 191 ff.

into poetry. There is poetical evocation of character, as we have seen, in Ulysses' portraits of Diomed and Cressida: and of atmosphere in Hector's modest pride as he gazes across the playhouse yard at the walls of Troy. But the bitter mood that pervades the play is of a kind to choke the spring of poetry. Moreover, there are plain indications that the poet is tired and in need of a rest. There are hackneyed repetitions of old gambits and old situations. Nestor's defiance of Hector recreates Shallow's more vivid bravado; Hector's encounter with Thersites in battle is but a faint echo of Falstaff's with the Douglas; the battle itself is a muddle, for there are too many celebrities, and nothing happens to any of them except Patroclus (whom we do not see) and Hector, whose killing has surprisingly little dramatic force. More striking still, as a sign of exhaustion in the poet, is the fact that Troilus, in his agony at discovering that Cressida is false, betakes himself to voluble conceits in the style of Shakespeare's immaturity.[194]

Next year there is a still more pronounced flagging of inspiration: it is generally agreed that *All's Well That Ends Well* is the feeblest play in the canon. It gives the impression of hack-work, with much repetition of old devices. But some of the speeches of Helena should make us pause before we catch at this rare opportunity of pronouncing against Shakespeare. Hear her speak in soliloquy of her secret love for Bertram:

> 'Twas prettie, though a plague
> To see him everie houre [*read* houre;] to sit and draw
> His arched browes, his hawking eie, his curles
> In our hearts table: heart too capeable
> Of everie line and tricke of his sweet favour.
>
> <div align="right">(I. i. 104 ff.)</div>

The syntax of her next soliloquy is less remarkable, but the obscurity of thought is new in Shakespeare: how can the audience at first hearing take in her meaning?

> Our remedies oft in our selves do lye,
> Which we ascribe to heaven: the fated skye
> Gives us free scope, onely doth backward pull
> Our slow designes, when we our selves are dull.
> What power is it, which mounts my love so hye,

[194] *Troilus and Cressida*, I. iii. 296 ff.; V. iv. 28 ff.; V. ii. 144 ff., 160 ff. It should perhaps be mentioned that Baldwin declares that "the play was evidently not constructed originally for the Shakesperean company. The abnormal number of major parts suggests that the play may have been cast originally for the abnormally large Admiral's company" (T. W. Baldwin, *Organization and Personnel of the Shakesperean Company*, footnote to table opposite p. 229).

> That makes me see, and cannot feede mine eye?
> The mightiest space in fortune, Nature brings
> To joyne like, likes; and kisse like native things.
> Impossible be strange attempts to those
> That weigh their paines in sence, and do suppose
> What hath beene, cannot be. Who ever strove
> To shew her merit, that did misse her love?
>
> (I. i. 235 ff.)

It takes no great subtlety of ear to detect an originality of rhythm and diction in these lines later in the play:

> I do presume sir, that you are not falne
> From the report that goes upon your goodnesse,
> And therefore goaded with most sharpe occasions,
> Which lay nice manners by, I put you to
> The use of your owne vertues, for the which
> I shall continue thankefull.
>
> (V. i. 12 ff.)

We can indeed hear a faint prophetic echo of *The Tempest* in this speech. But the play shows an odd mixture of styles, the formal couplets of an earlier period are suddenly interrupted by the realistic vigour of the King's charge to Bertram:

> My Honor's at the stake, which to defeate
> I must produce my power. Heere, take her hand,
> Proud scornfull boy, unworthie this good gift,
> That dost in vile misprision shackle up
> My love, and her desert: that canst not dreame,
> We poizing us in her defective scale,
> Shall weigh thee to the beame: That wilt not know,
> It is in Us to plant thine Honour, where
> We please to have it grow.
>
> (II. iii. 156 ff.)

Later in the story, Helena's despairing letter to the Countess is couched in the exact shape of a sonnet (III. iv. 4 ff.). There is perhaps an attempt at a running theme in the contention between the arrogant assurance of youth, as exemplified in Bertram, and the mellow wisdom of age, in the persons of the *Old* Countess, *Old* Lafeu, and the King of France who speaks for the older generation in recalling the words of Bertram's dead father:

> Let me not live (quoth hee)
> After my flame lackes oyle, to be the snuffe
> Of yonger spirits, whose apprehensive senses
> All but new things disdaine . . .
>
> (I. ii. 58 ff.)

But the conception is tentative, and indeed the play never catches fire.

The total silence of the ensuing year is a logical sequel to this flagging of inspiration. It is usual to seek some external reason for this silence and for the following tragic period: personal misfortunes in the poet's life are hinted at rather than specified; or the tragic fall of Essex, which may indeed have touched Shakespeare as well as any other sensitive or intelligent person as a public calamity; and the consequent gloom which overcast the end of the old Queen's reign, together with the anxious uncertainty about the succession—all this may well have checked the optimism of animal spirits in a man nearing forty. But is it not more likely that an artist's inspiration may have come to a temporary halt owing to a reason connected with his art? Is it not probable that the restlessly experimental Shakespeare found himself after writing *Hamlet* at an impasse in the development of his poetic drama? And if after a couple of years of baffling struggle he emerges into a full-flowing inspiration of a new order from his past achievement, may we not justly borrow a phrase from Professor Toynbee and call the inexpressive years a period of "Withdrawal-and-Return". In his *Study of History*, Toynbee has drawn attention to a movement in the lives of the greatest men, whether saints, scholars or poets, to which he attaches this descriptive phrase.[195] It would not be surprising—it would be just what we should expect—to find that some such break occurred in Shakespeare's artistic development. Such a break, indeed, is admitted by all critics to be apparent after the great achievement of *Hamlet*. "After *Hamlet*," says Chambers, "came a group of plays which, to some readers at least, show Shakespeare in a rather uncomfortable mood: the bitter comedies of *All's Well* and *Measure for Measure*, and *Troilus and Cressida*, the comedy, if you will, but rather, as I think, the tragedy, of disillusionment with the world's ancient ideals of heroism and romance." [196] Granville-Barker hints at the fundamental change in a sentence of his lecture, "From *Henry V* to *Hamlet*", when he asks: "Did Shakespeare, when with *Henry V* he came to the end of all he could find to his purpose in the technique of the drama as his contemporaries and masters understood it, when, passing over that bridge which is *Julius Caesar*, he found in the working out of *Hamlet* the technique best suited to his genius, did he then and thereafter take the wrong road? . . . Frankly,

[195] Professor Arnold J. Toynbee, *A Study of History*, vol. iii, 248 ff. It is curious that after mentioning Dante as an example of a creative poet, Toynbee then gives Hamlet as an instance of a character from fiction: but he does not make allusion to Shakespeare himself.

[196] E. K. Chambers, *Shakesperian Gleanings*, 50.

I am for Shakespeare the playwright and Yes . . . But . . ." [197] The scope of that excellent essay causes an arbitrary line to be drawn after *Hamlet:* otherwise one might get a truer vision of the sequel, where the technical problems raised by the poet had to be worked out.

After the "withdrawal" the first play of the "return" continues in one respect at least the tentative experimenting of *All's Well That Ends Well.* The new obscure-conciseness of diction, which appeared once or twice in that play, is already the order of the day in *Measure for Measure.* Claudio, on his way to prison, asked by the outspoken Lucio if his offence is that of getting Juliet with child, replies:

> Unhappely, even so.
> And the new Deputie, now for the Duke,
> Whether it be the fault and glimpse of newnes,
> Or whether that the body publique, be
> A horse whereon the Governor doth ride,
> Who newly in the Seate, that it may know
> He can command; lets it strait feele the spur:
> Whether the Tirranny be in his place,
> Or in his Eminence that fills it up
> I stagger in: But this new Governor
> Awakes me all the inrolled penalties
> Which have (like un-scowr'd Armor) hung by th'wall
> So long, that nineteene Zodiacks have gone round,
> And none of them beene worne; and for a name
> Now puts the drowsie and neglected Act
> Freshly on me: 'tis surely for a name.
>
> (I. ii. 166 ff.)

One wonders what the Chamberlain's Men (now the King's Men) made of this new style of speech? Whether they took to it, or whether it needed some coaxing from the poet? It is a problem play: indeed, Shakespeare states a double problem in the early scene between the Duke and Friar Thomas; the Duke wants to see the effect of strictness upon the lax state, but also the effect of power upon Angelo— "hence shall we see If power change purpose: what our Seemers be" (I. iii. 53 f.). The personal problem presents itself so forcibly in Shakespeare's mind that he is carried away by it: Angelo and Isabella possess him for three splendid acts. But the other problem, the public problem, is intended to bind the play together, and the Duke is meant to be the central figure: indeed, as it stands, his part is more than twice as long as Angelo's. The play is broken-backed; after Angelo has done his worst, there is nothing for him to do except

[197] Granville-Barker, *From Henry V to Hamlet,* 22.

await retribution. And the Duke's purpose wavers, perhaps because Shakespeare found it essentially undramatic. The last act is ingenious, but so long protracted that the ingenuity defeats its own ends. There is what ought to be a great moment—Isabella (at Mariana's request) pleading for Angelo, although she still thinks Claudio is dead—yet even that moment does not come off as greatly as it should (V. i. 444 ff.). And in the sorting out of individual fortunes, comedy-wise, we lose sight of the Duke's first purpose—to observe the government of his state in detachment.

It is impossible to dismiss the impression that Shakespeare lost interest and concentration half-way through his play. But it is a magnificent failure: the first three acts lead logically on to the splendours of the tragic period. Isabella's pleading introduces a new philosophical note characteristic of the play: wisdom is distilled in poetry when she speaks of

> man, proud man,
> Drest in a little briefe authoritie,
> Most ignorant of what he's most assur'd,
> (His glassie Essence) like an angry Ape
> Plaies such phantastique tricks before high heaven,
> As makes the Angels weepe:
>
> (II. ii. 117 f.)

and warns Angelo that

> Authoritie, though it erre like others,
> Hath yet a kinde of medicine in it selfe
> That skins the vice o'th' top . . .
>
> (II. ii. 134 ff.)

Ulysses is commonplace to this, so is even Brutus, and Hamlet does not often go as deep. Whether it is as good drama depends, perhaps, on the taste of the spectator, but in its later development in the great tragedies, this depth of poetical insight carries all before it. The whole drama of the relationship of Angelo and Isabella and Claudio is worked out by poetical means. It is foolish to complain that Isabella is inhuman or that Angelo is "a type": the dilemma (poetically created and sustained) has vitality enough. It should be realised that the spoken word sustains the tension by which the theme rises to its tragic proportions. The spoken word is more important than ever in Shakespeare's scheme. We in the audience must listen ever more and more attentively, and the actor can rely less and less upon miming to make his speech clear: his voice becomes his chief instrument for this play, as for the great tragedies. That the Duke's half of the play—the latter half—falls away from the tragic tension,

is due largely to the fact that his problem could not find expression, as the personal problem did, in poetical terms.

Then in the same year comes the wholly triumphant *Othello*, with its relentless compression, its unflagging tension, its poetical unity. The full flavour of the new magic is already present in the opening dialogue. Iago's speeches are an excellent example of the new conciseness; as a good speaker delivers them, we get much more than plain sense from them; they breed drama by poetical means: one specimen must suffice here, for the scope of the present enquiry will not admit of more than a hint of the extent of Shakespeare's new-found power:

> Three Great-ones of the Cittie,
> (In personall suite to make me his Lieutenant)
> Off-capt to him: and by the faith of man
> I know my price, I am worth no worsse a place.
> But he (as loving his owne pride and purposes)
> Evades them, with a bumbast Circumstance,
> Horribly stufft with Epithites of warre,
> Non-suites my Mediators, For certes, saies he,
> I have already chose my Officer. And what was he?
> For-sooth, a great Arithmatician.
> One *Michaell Cassio*, a *Florentine*,
> (A fellow almost damn'd in a faire Wife)
> That never set a Squadron in the Field,
> Nor the devision of a Battaile knowes
> More then a Spinster. Unlesse the Bookish Theoricke:
> Wherein the Tongued Consuls can propose
> As Masterly as he. Meere pratle (without practise)
> Is all his Souldership. But he (Sir) had th'election;
> And I (of whom his eies had seene the proofe
> At Rhodes, at Ciprus, and on others grounds
> Christen'd, and Heathen) must be be-leed, and calm'd
> By Debitor, and Creditor. This Counter-caster,
> He (in good time) must his Lieutenant be,
> And I (blesse the marke) his Mooreships Auntient.[198]

It would need a long analysis to point out how much of the tragedy is already latent in the fully-charged poetry of this one speech. And analysis would hardly be so potent a proof as the speech itself. The miracle is that this rich poetical content is sustained throughout the whole play, and throughout most of *King Lear* and *Macbeth* and *Antony and Cleopatra*, till the exhausted poet was forced to pause and draw breath again. Yet we must not fail to realise, as a perusal of

[198] *Othello*, I. i. 8 ff.

the many examples from *Othello* and *King Lear* quoted in the course
of my argument will show, that, in the full flood of his new-found
mastery, Shakespeare still grounded his play in the playhouse for
which he was writing; that his new-created style of poetic drama
fitted the Globe as well as the old; and that for its full enjoyment it is
still necessary to present it once again in the conditions of its first
production.

(xi) The Poetic Drama

It is now time to summarise this chapter, in which an attempt has
been made to show that Shakespeare's poetic drama springs from
the playhouse for which he wrote it. His dramatic vision, such is the
argument, was grounded in this playhouse: it was regulated to the
capabilities and needs of the company of which he was a member:
it helped to establish their tradition of acting, and (mutually) was
helped by them in its own development. It was based on a sub-
structure of objectivity—practical, of the playhouse, and modern,
that is to say, Elizabethan. Moreover, Shakespeare's turn of mind
was such as to revel in making opportunities out of the very limita-
tions of his medium. He realised that his chief and sharpest weapon
was the spoken word, and discovered that it could be used for all
manner of purposes in his playhouse: to give life to properties and
furniture, to the stage itself, its permanent features and its imagined
environs; to create the circumstances of a scene, the illusion of
neighbouring space, of up-and-down-hill, of dizzy height; and the
atmosphere of a scene, sunrise, sunset, hot noon, storm, moonlight,
darkness, and the timeless hour of the visitation of ghosts; and
further not only to create the atmosphere, but also to comment on it,
and prompt the reactions of the audience to it; to create character
likewise—habitual character, both open and concealed, and
momentary mood by the method of "close-up" description—and to
comment on it and prompt the audience's reaction; and to create
the action itself, and again comment and prompt the audience. He
learnt, moreover, that with his poetical medium he could transcend
the visible scene and use the same conventional Platform and
Tiring-House as a vehicle for thoughts beyond the reaches of our
souls.

We have seen cause to revise our opinion of Shakespeare's archi-
tectural powers, realising that much that seems diffuse and desultory
in the theatre of to-day was part of the essential technique of his
stagecraft in the conditions of his playhouse; that a producer must
therefore consider, in the first place, what is the main design of each

play and be careful of his cutting. We recognised an insistent relevance in most of the poet's construction, and examined his means of achieving continuity—the direct method, the method of alternation, the "rod-in-pickle" method; the power of rhythm to sustain the tension; the technique of pervasive motif, and the kindred device of pervasive imagery.

A large part of this equipment was already at Shakespeare's command by the time he wrote *Hamlet.* But we are led to realise that *Hamlet* is not the last word, and we postulate in the years immediately succeeding that play a period of "Withdrawal-and-Return" during which the poet discovered by anxious and laborious experiment new possibilities in his chosen medium. The ensuing period of the great tragedies throws still more emphasis upon the spoken word, with a new conciseness and pregnancy of expression, a highly organised texture of pervasive theme and imagery, admitting of counterpoint and rising to climaxes, and a still wider exploration of the transcendental.

Yet the new drama is still within the compass of the Wooden O, can still be most easily shown within the girdle of these walls; and the familiar images are there to remind us—the Cue and Prompter of *Othello*, the great stage of Fooles of *King Lear*, the poore Player of *Macbeth.* The argument of the preceding pages is of no avail if it does not justify the presumption that *Othello*, *King Lear* and *Macbeth* are all devised for and admirably adapted to this stage, and can therefore only achieve their full effect if played upon it in the tradition of the Chamberlain's Men. The proof of the pudding is in the eating, and the argument cannot be clinched unless and until we see the Globe rebuilt and the repertory recruited and trained once more.

The conjectural generalisation of the latter sections of this chapter lacks the tonic criticism which only practical experience in such a playhouse can give. It will therefore be a refreshment, perhaps to the reader no less than to the writer, to return from the general to the particular. The last chapter of the present investigation takes the form of some production notes on *Macbeth.* I choose this play not only because I have twice produced it in conditions approximating to those of the Globe, but also as a sustained example of Shakespeare's poetic drama in its full maturity of development.[199]

[199] Any contemplation of the sequel to the tragic period, when the acquisition of the Blackfriars Theatre alters the picture, is irrelevant to the present study.

6

MACBETH AT THE GLOBE

THE object of the following notes is not to provide an alternative commentary on the text of the play, but to supplement the many already in existence; nor is it intended to furnish a complete "acting edition", but rather to point out some of the differences from the normal practice of to-day which would arise from presenting the play in its original setting, and to apply the argument of the foregoing pages to a specific example. For this last reason, at the end of most of the notes appears an italicised reference to one or other section of the preceding chapters, so that a student of *Macbeth* (whether producer or player or of the audience), if he wishes confirmation of this or that point, may glance back to the fuller explanation above.

Our only prompt-book for *Macbeth* is the Folio text: it is not possible to discuss here the problem of the copy for that text—since there is no other available, we must use it and assume that it has been cut from the original normal length. There is support for the view that the cutting was done by Shakespeare himself: certainly the result (in spite of loose ends) remains a masterpiece of sustained tragic tension. Dr. Richard Flatter, in his *Shakespeare's Producing Hand* (page 94), expresses his belief that "the text of *Macbeth* is the only one of which we may assume with any measure of certainty that it shows no traces of 'editorial' interference", and speaks of it as "the only play from which the real yard-stick of Shakespeare's diction can be obtained". He devotes four chapters of his book to the play, and no producer can afford to ignore these chapters.

COSTUME. Substructure Elizabethan. A touch or two of tartan plaid over the Elizabethan styles will help to create the national atmosphere, but the kilt is an anachronism of the wrong kind, introducing a note of a later civilisation (than Shakespeare's). The play is no more Scottish than *The Merchant of Venice* is Venetian, less so than *Julius Caesar* is Roman, but more so than *A Midsummer Night's Dream* is Athenian. The weather and the scene-painting is north of the border, but the Porter is not another Jamy: he is pure Bankside.

And Macduff, for instance, has less feeling of Scotland than the Douglas of 1 *Henry IV.*

(*Costume*, pp. 53 ff.)

For casting, Baldwin gives us (among others):

Macbeth	Burbadge
Banquo	Lowin
Malcolm	Cundall
Ross	Heminges
Macduff	Sly
Duncan	Shakespeare
The Porter	Armin
The Old Man	Cowley
Lady Macbeth	Edmans

(*The Repertory*, pp. 156 ff.)

ACT I, *Scene i*

It would be difficult to imagine a better start, both for exposition of necessary information, and for atmospheric effect. The weird sisters preside over the opening of the play, rather than take part in it. Locality unspecified. Positioning: probably one at either end of the Tarras, the *first* witch being in the Music Gallery above—a triangular group in mid-air. They thus give the illusion at the end of the scene of parting with each other, R and L of Tarras, and into the Music Gallery curtains. The action of the play proper begins at once on the Platform below them.

(*Scene-Rotation*, pp. 31 ff.)

ACT I, *Scene ii*

. . . *meeting a bleeding Captaine.* The significant fact at once emphasised in Duncan's opening words: *What bloody man is that?* The description is an example of the "close-up" method.

(*The Prompt Book*, pp. 25 ff.)

7 The bleeding Captain's narrative shows the Messenger-Speech method: he does not speak in character, his gashes do not persistently cry for help, but he most powerfully evokes by speech and miming the battle itself, without which Macbeth would not have his stature (nor Banquo his). It is characteristic of the method that at the time of speaking the issue is still in doubt, so that in a sense the battle sways to and fro (stands doubtful) before our eyes. A similar effect can be seen in 1 *Henry IV* (I. i) where Westmoreland's description of Holmedon

is left in the air, for the King (*via* Sir Walter Blunt) to complete. It is also significant that the music-cue at the beginning of the scene is *Alarum*, indicating that the battle is still in progress, not *Flourish*.

(*Creation in Words—of the Action*, pp. 226 ff.)

The themes of "blood" and "darkness" and "sleep" are pervasive in this play. Bradley has collected many of the examples in his *Shakesperian Tragedy*, 333 ff.

(*Pervasive Theme*, pp. 249 ff.)

Heath Set in Study

49 Is it only accidental that the tenses at the beginning of Ross' recital are in the present? It is as if the battle itself were taking place *at this moment* before our eyes. The scene is not "a camp near Forres": it is unlocalised, and presents the action of the battle in poetic form. An interesting point suggests itself after contemplation of the bleeding Captain's and Ross' speeches: presumably this kind of unlocalised scene *must* take place *on the Platform*. The effect of playing on any of the other stages is to suggest (if not represent) a locality.

(*Creation in Words—of the Action*, pp. 226 ff.)
(*Locality and Unlocalisation*, pp. 103 ff.)

If the suggestion is right that the essentially unlocalised I. ii must be on the Platform, then we get the following rotation for Act I:

Scene i *Tarras* and *Music Gallery.*
ii *Platform.*
iii *Study* and *Platform* (heath-set in *Study*).
iv *Platform.*
v *Chamber.*
vi *Platform.*
vii *Study* and *Platform.*

(*Scene-Rotation*, pp. 31 ff.)

Act I, *Scene iii*

The set in the Study will contain gaunt bushes, their shape chosen to indicate that the wind is blowing strongly *towards* the

How farre is't call'd to Forres?

point of Macbeth's entry. The grave-trap will be open ready to receive one of the disappearing sisters, and will perhaps be disguised with a turf-bank or stone.

(*Furnishing and Properties*, pp. 38 ff.)

4 With masterly compression, the malignancy of witchcraft is *dramatised* for us in the short story of the Master of the Tiger (Messenger Speech method). First witch should mime for us the rump-fed ronyon's munching, and perhaps also the voyage in the sieve. No amount of make-up can create an equally horrible effect.

(*Creation in Words—of the Action*, pp. 226 ff.)
(*Miming*, pp. 125 ff.)

32 *The weyward Sisters, hand in hand* . . . the rhythmical incantation accompanies a ritual dance with which the three mark out in

the centre of the Platform a charmed circle for Macbeth to step into. *Peace, the Charme's wound up.* They retreat hastily to the perimeter outside the Stage-Post on the opposite side from the Door of Macbeth's entry.

<div align="right">(Positioning, pp. 131 ff.)</div>

38 In the vast depth and width of the Platform it is possible to give an impression of the four distinct phases in the approach of the two generals to the expectant witches—*So foule and faire a day* . . . (spoken to Banquo, unaware that there is anyone in sight). *How farre is't call'd to Soris [read Forres]?* . . . (shouted through the fog at the distant figures). *Live you, or are you aught* . . . (spoken at close range). *Speake if you can* . . . (spoken by Macbeth, from the charmed circle which the witches have just made). While Macbeth moves almost at once into the circle, reacting from the spell with a shudder, Banquo's course is forward from the door round the perimeter, outside the Stage-Post opposite to that near which the sisters huddle.

<div align="right">(Positioning, pp. 131 ff.)</div>

39 *What are these, So wither'd, and so wilde in their attyre.* . . . Banquo's description of the witches is the familiar "close-up" technique. The minute portraiture is part of the poet's character-drawing, and if the actor realises this he will give the lines their dramatic force, and not make the speech sound like a rather long-winded version of Macbeth's impatient question, *what are you?* Further examples in this same scene (also in Heminges' part) are *Good Sir, why doe you start, and seeme to feare Things that doe sound so faire?* and *he seemes wrapt withall;* as likewise, after the entry of Ross and Angus, *Looke how our Partner's rapt.*

<div align="right">(Creation in Words—of Character, pp. 217 ff.)</div>

78 *Witches vanish.* No difficulty at the Globe, with the grave-trap in the Study, and the two minor traps at the back of the Platform. Nor is it anyway hard to achieve a plausible illusion, without traps, in the distant Study: plenty of smoke, and Macbeth's stretched cloak does it. I imagine a serial departure, with Macbeth addressing each in turn: *Say from whence* . . . *or why* . . . *Speake, I charge you.*

116 *Glamys, and Thane of Cawdor* . . . *Thankes for your paines. Doe you not hope.* . . . In these five lines Macbeth takes up three separate positions: alone, then towards Ross and Angus, then privately to Banquo. Banquo, after his warning reply, retires to speak to

the others at the back of the Platform: Macbeth remains forward centre, in the middle of his audience. His isolation from the others is helped by Banquo's whispered comments *Looke how our Partner's rapt . . .* etc. Banquo, at *Worthy Macbeth . . .* comes forward to his colleague; then Macbeth crosses with his apology to Ross and Angus, but turns back again to Banquo (now forward) for the intimate exchange of the last five lines of the scene.

(*Positioning*, pp. 131 ff.)

ACT I, *Scene iv*

35 *Sonnes, Kinsmen, Thanes . . .* an example of the address to the whole playhouse over the heads of the stage-company: the audience are included among *you whose places are the nearest*, and are thereby taken up into the action of the play.

(*Positioning*, see especially p. 146; see also pp. 88 f.

48 *The Prince of Cumberland: that is a step . . .* a clear case of the normal soliloquising position, with another conversation upstage.

(*Positioning*, see especially p. 137)

The *incidents* of this scene are: (1) Cawdor's execution—unnecessary, but the ironical point of the juxtaposition of . . . *absolute Trust. O worthyest Cousin* is what Shakespeare is aiming at; (2) *The Prince of Cumberland;* (3) *my Wife*.

(*The Architecture of the Play*, see especially pp. 233 ff.)

ACT I, *Scene v*

After Macbeth's . . . *make joyfull The hearing of my Wife, with your approach*, the following scene begins with the instruction *Enter Macbeths Wife alone with a Letter*. You can almost see the train of thought forming in Shakespeare's mind.

(*The Prompt Book*, pp. 25 ff.)
(*Continuity*, pp. 241 ff.)

The furniture of the Chamber is a domestic Elizabethan interior—which may of course include pieces of an *earlier* date. The Chamber has to serve for such domestic scenes at Inverness, at the royal palace, at Macduff's castle, and finally at Dunsinane. There is no reason to make elaborate differentiation: the position of tables and chairs should merely suit the plotting of each scene. In this case, a table and chair are the only necessities: Lady Macbeth may well be discovered reading

her letter at the table, rising to her feet perhaps on the words *haile King that shalt be*.

<div align="right">(<i>Furnishing and Properties</i>, pp. 38 ff.)</div>

13, 38 If it is true that Lady Macbeth speaks from the Chamber, it is interesting that both her soliloquys in this scene are, unlike Macbeth's reflective broodings, addressed to *hearers* (absent or imaginary)—the first to her husband, the second to the *Spirits, that Tend on mortall thoughts . . . you murth'ring Ministers . . .* and to *thick Night.* This is in line with the fact that Prince Hal's "I

Haile King that shalt be

know you all . . ." is spoken from the Chamber, while Hamlet's reflective brooding is usually delivered from the Platform.

<div align="right">(<i>Positioning</i>, see especially pp. 140 ff.)</div>

16 *Glamys thou art, and Cawdor, and shalt be What thou art promis'd:* the repetition of Glamys-Cawdor-King as a triple climax is a convenient dramatic symbol, a *leit-motif* of the same kind as the "Handkerchiefe" in *Othello.* She repeats it in this same scene when she greets her husband as *Great Glamys, worthy Cawdor, Greater then both, by the all-haile hereafter.* The *motif* begins with the salutation of the witches, and comes to a head in Macbeth's imagined cry of *Glamis hath murther'd Sleepe, and therefore Cawdor Shall sleepe no more: Macbeth shall sleepe no more* (II. ii. 43 f.).

<div align="right">(<i>Pervasive Theme</i>, pp. 249 ff.)</div>

39 *The Raven himselfe is hoarse, That croakes the fatall entrance of Duncan Under my Battlements.* Up aloft on the Tarras, she points with a malignant gesture downwards to the Platform below her. We have not forgotten her words when, two minutes later, Duncan is entering the castle under this Tarras rail. The device sustains the continuity of dramatic tension.

(*Scene-Rotation*, pp. 31 ff.)
(*Continuity*, pp. 241 ff.)

42 *Unsex me here* . . . see note below on I. vii. 54 ff.

58 The lineation and punctuation of the Folio is worth reproducing here, as an example of the expressiveness of the prompt-book:

> . . . I feele now
> The future in the instant.
> *Macb.* My dearest Love,
> *Duncan* comes here to Night.
> *Lady.* And when goes hence?
> *Macb.* To morrow, as he purposes.
> *Lady.* O never,
> Shall Sunne that Morrow see.
> Your Face, my *Thane*, is as a Booke, where men . . .

The regular rhythm is suspended when Macbeth begins to speak: it is not resumed until the words *Your Face, my Thane.* . . . In a musical score the effect would be marked by a series of pauses. The Book-Keeper has his rhythm marked just as distinctly by various punctuation and lineation.

(*The Prompt Book*, pp. 25 ff.)

63 *Your Face, my Thane, is as a Booke, where men May reade strange matters.* . . . The continuity of much of the early part of the play is sustained by the insistent focus on Macbeth's mind, his thoughts, his conscience. This appears not only in the fact that many of his early utterances are in soliloquy or aside, but also in the *content* of the passage which begins *This supernaturall solliciting* . . . (where the theme is heavily underlined), and in Lady Macbeth's character-sketch: *yet doe I feare thy Nature* . . . and in her "close-up" of his brooding: *Your Face, my Thane* . . . The comment, after the previous pregnant exchange, would not be necessary under the strong lights of the modern theatre, or in the "close-up" focus of the cinema, where a significant frown would be enough. Here, her subsequent warning to *Looke like the time* adds dramatic plausibility.

(*Continuity*, pp. 241 ff.)
(*Creation in Words—of Character*, pp. 217 ff.)

66 *looke like th'innocent flower, But be the Serpent under't* . . . This turns
out to be an anticipatory poetical description of LadyMacbeth's
own behaviour in the following scene. Once again Shakespeare
seems to leave nothing to chance. Moreover, he strengthens
his continuity thus.

(Creation in Words—of Character, pp. 217 ff.)

Act I, *Scene vi*

The King's three entries are quite logically differentiated in the
musical instructions—*Alarum*, for battle (I. ii), *Flourish*, for the
state occasion (I. iv), *Hoboyes*, for the more informal progress
(I. vi). In general, the musical score of this play is divided
between these three categories: the drums and trumpets for the
military contexts at beginning and end; the trumpets and
cornets for the state occasions; the *hoboyes* (or reed band) for the
informal scenes of journeying and banqueting. The reeds can
perhaps indicate an affinity with the bagpipes; otherwise the
music is best kept conventional, and in period, preserving the
triple distinction of mood suggested above.

(Music, pp. 62 ff.)

3 There is an obvious effect of dramatic irony in the atmospheric
description of the Castle with its *pleasant seat* and of the *Temple-
haunting Barlet* [read *Martlet*], which proves *By his loved Mansonry,
that the Heavens breath Smells wooingly here.* Note that Banquo's
contribution is not "in character"—not merely that there is no
hint of the nature-lover in his personality, but there is not even
any dramatic reason for stressing his serenity of mind at this
moment: both before and after this scene, he voices foreboding.
The words here are more important than the speaker—as not
infrequently in the poetic drama.

(Creation in Words—of Atmosphere, pp. 198 ff.)

10 There is a *leit-motif* in the words "host" and "hostess", which
will have been gently stressed by the poet himself, if he is play-
ing the part of Duncan: *See, see, our honor'd Hostesse . . . Faire and
Noble Hostesse We are your guest to night . . . Conduct me to mine
Host . . . By your leave Hostesse.* The theme is repeated in Mac-
beth's following soliloquy: *Then, as his Host, Who should against
his Murtherer shut the doore, Not beare the knife my selfe* (I. vii. 14).
It is echoed again later when Banquo presents to Macbeth the
diamond with which Duncan greets his wife *By the name of most
kind Hostesse* (II. i. 16).

(Pervasive Theme, pp. 249 ff.)

ACT I, *Scene vii*

The Folio direction gives all that is necessary in Shakespeare's playhouse to change the scene from the approach to the castle to the interior. The insistent continuity of the plot demands here only that we should feel ourselves outside the banqueting-hall. This is done quite simply by the process of opening the Study curtains (to reveal a set which will afterwards serve for the scene of the murder and its discovery; see below, on II. ii. 1) and following the Prompt Book. *Ho-boyes. Torches. Enter a Sewer, and divers Servants with Dishes and Service over the Stage. Then enter Macbeth.* In fact, the comedy gang of the company

Dishes and Service over the Stage

make a brief appearance, one no doubt unpunctual, another caught tasting the dish he carries: there is a detailed model in the domestic staff of Capulet's household, Potpan and his fellows. They will form up for inspection by the Sewer, before marching into the banquet-hall: noises of merriment from inside the Tiring-House will become suddenly louder and more hilarious as they disappear, and will be hushed all at once as an unseen door bangs shut: Macbeth comes swiftly on to the Platform in the sudden silence.

(*Prompt Book*, pp. 25 ff.)
(*Effects*, pp. 69 ff.)

The locality of the scene is "outside the banquet-room"— nothing else, and we see here both the merits of an unlocalised

stage, and Shakespeare's unerring sense of the relevant. The subject-matter of the scene is *the proposed murder*: Macbeth's soliloquy presents it—by speculation on the consequences, by considering its special wickedness in the circumstances, and by a highly poetical passage of transcending imagery depicting its full horror in the sight of heaven. He has no adequate spur, but Lady Macbeth comes to apply the goad of her overwhelming rhetoric. For this theme the ideal locality is outside the banquet-room, where the King-kinsman-guest is being entertained. The advantage of the unlocalised platform is shown by the passage later in the scene where Lady Macbeth takes us in imagination (for the first time in the play) to the death-chamber of Duncan (see below, on II. i. 16). The scene closes—in the last two lines—with a reminder of the banquet, no doubt accompanied by noises off. We simultaneously return from *horrible Imaginings* to the genial reality of the feast.

(*Locality and Unlocalisation*, pp. 103 ff.)
(*The Architecture of the Play*, pp. 232 ff.)

1 ff. Macbeth's soliloquy dramatises the deed in advance, so that we feel the horror of it still more when it comes. It is brought within range of divine censure by the mention of time and the life to come, and still more forcibly by the transcendental images of the climax. The idea, so often expressed, that Macbeth is himself a poet contains, I think, a fallacy: it is true that he is represented as prone to brooding and musing and becoming "wrapt", as having a restless conscience which causes him to debate his murder before he commits it and to suffer torments afterwards: but the poet is Shakespeare himself who seeks to represent these inward struggles in terms of the poetic drama. In respect of poetical *expression* Macbeth is no different from Othello, Lear and Antony.

54 Lady Macbeth's lines about her Babe are a *dramatisation* of her unsexing. They bear as little relation to an actual child, as Othello's jealousy to an actual opportunity of adultery. Shakespeare wants Othello jealous, and he wants Lady Macbeth unnaturally unfeminine. It is vain speculation to draw inferences about Macbeth's family. The deliberate disclaimer of feminine nature, like her earlier prayer to be unsexed (I. v. 39), is in a sense a tragic parallel to the male disguises of the comedies. Shakespeare seizes the opportunity that his story

offers him of exploiting his material: the boy Edmans can play
this part without inhibition.

(*Creation in Words—of Character*, pp. 217 ff.)

(*The Boy Actors*, pp. 163 ff.)

78 *As we shall make our Griefes and Clamor rore, Upon his Death?* . . .
the anticipatory description helps in the plotting of the scene of
the discovery of Duncan's murder. This roaring is Macbeth's
style in the sequence which begins *Had I but dy'd an houre before
this chance* . . . (II. iii. 73 ff.)

(*The Method in Practice*, pp. 175 ff.)

ACT II

Scene-Rotation as follows:

Scene i *Platform* alone: night-exterior painted immediately by the
torch and by the words of Banquo and Fleance.

ii *Study* and *Platform:* the opening of the curtains indicates
that Lady Macbeth is *inside* the castle.

iii *Study* and *Platform:* continuous from II. ii.

iv *Platform* alone.

(*Scene-Rotation*, pp. 31 ff.)

ACT II, *Scene i*

The darkness is drawn with a few swift strokes: it is a *dramatic*
darkness, made so by Banquo's yawning line *A heavie Summons
lyes like Lead upon me*, coupled with his unwillingness to sleep,
and the sinister prayer: *Mercifull Powers, restraine in me the
cursed thoughts That Nature gives way to in repose:* also by the
sudden alarm of *Give me my Sword*.

(*Creation in Words—of Atmosphere*, pp. 198 ff.)

16 It is part of Shakespeare's intention to keep constantly before
our mind's eye the apartment in which Duncan is sleeping: we
have already had a glimpse of it when Lady Macbeth outlined
her plan to her husband: *when Duncan is asleepe, (Whereto the
rather shall his dayes hard Journey Soundly invite him), his two
Chamberlaines* . . . *when in Swinish sleepe, Their drenched Natures
lyes as in a Death, What cannot you and I performe upon Th' un-
guarded Duncan?* (I. vii. 61 ff.). The vision accumulates in a
running series, and we have a reinforcement here in Banquo's
words: . . . *shut up in measurelesse content*. The unlocalised Plat-
form helps us to visualise such pictures, which are painted in
the words.

(*Locality and Unlocalisation*, pp. 103 ff.)

33 The *Dagger of the Minde* is another skilful device of this magical
art of poetic drama. Requiring the most expert miming from
Burbadge, it is a poetical means of making us visualise the very
act of murder with its objective details (*The Handle toward my
Hand . . . And on thy Blade, and Dudgeon, Gouts of Blood*) much
more vividly than we could by merely seeing the actor plant
his property-dagger wide of his victim's ribs.

(*Creation in Words—of the Action*, pp. 226 ff.)
(*Miming*, pp. 125 ff.)

49 *Now o're the one halfe World* . . . the imagery of this passage takes
us right off the Platform to a hemisphere of night-prowling
villainy. We follow this best when we are not pinned down by
a suggestion of locality. It is the method of the white-screen
upon which the poet's images are projected in rapid succession
(see above, p. 108). The compactness is astonishing, as, for
instance, when *wicked Dreames* echo Banquo's prayer just
uttered (*restraine in me the cursed thoughts* . . .), and *The Curtain'd
sleepe* takes us back to Duncan's apartment: *Witchcraft* recalls
the weyard sisters: *the Wolfe, Whose howle's his Watch*, gives
Burbadge a chance to curdle our blood with vocal imitation of
the sinister night-cry: *Murther's stealthy pace* sets him prowling
round a Stage-Post, and *Tarquins ravishing sides* [read *strides*]
take him half-way to his foul purpose behind the Study
curtains. With the imperceptible cunning of genius, Shake-
speare returns us to the Platform and the reality of Macbeth's
situation, in the words *Thou sowre* [read *sure*] *and firme-set Earth.*
. . . On the invitation of the bell, Burbadge disappears between
the Study curtains: his dagger visible behind his back, he goes
to his murder charged with all the force, both realistic and
transcendental, that poetry can raise.

(*Speech*, see especially pp. 113 f.)
(*Locality and Unlocalisation*, pp. 103 ff.)

ACT II, *Scene ii*

I fancy that the Study curtains are opened at the beginning of
the scene, as soon as Macbeth has had time to leave the Study.
The effect is to carry us indoors. Lady Macbeth appears in the
Study and remains there for her opening words. Macbeth
perhaps steps on to the Tarras at the moment where his entry is
marked in the Folio (l. 9): he is in a panic-stricken and head-
long flight, with the imaginary voice still ringing in his ears
"Sleep no more". This is surely the explanation of his strange
cry *Who's there? what hoa?*—the last thing you would expect

from a murderer immediately after his crime. Meanwhile, of course, Lady Macbeth, in the Study, cannot see him on the Tarras. Macbeth reappears in the Study five lines later, and his previous momentary appearance makes clear both *his* words *Didst thou not heare a noyse?* and her *Did not you speake?*

(Positioning, pp. 131 ff.)

The Furniture of the Study at the beginning of II. ii is the same as for I. vii—interior, with a touch of primitive Scotland in the shape perhaps of antlers of a stag, and hunting spear. The habitual doorway of the Study would be visible, and through it the beginning of the flight of steps which leads up to Duncan's apartment. A burning candle by the doorway helps the illusion of deep midnight, and makes a dramatic point if it is extinguished by Lady Macbeth as she drags Macbeth away, with the words *be not lost So poorely in your thoughts.*

(Furnishing and Properties, pp. 38 ff.)

4 . . . *it was the Owle that shriek'd, The fatall Bell-man, which gives the stern'st good-night.* The poetic creation of atmosphere is turned, as so often, to dramatic use, in the sinister phrase *the stern'st good-night.* The topicality of the *fatall Bell-man* would hit home in 1606—now, of course, only among examination candidates!

(Creation in Words—of Atmosphere, pp. 198 ff.)
(Objectivity of Vision, pp. 189 ff.)

27f. The *two lodg'd together,* who cried *God blesse us* and *Amen* are surely Donalbaine and his companion (? Malcolm) *i'th' second Chamber—not* the grooms. I do not know whether the commentaries make this clear.

36 The voice that cried *Sleep no more* takes us right away from the visible scene into the conscience, the hurt mind, of the murderer himself. It is built on the image of Duncan *shut up in measurelesse content,* resembling Lady Macbeth's father—the picture of innocent sleep. But the force of the poetry piles on the idea of murdering sleep itself, so that, as the bloody instructions return to plague the inventor, *Macbeth shall sleepe no more.* The web of imagery, so close woven, is of the essence of this poetic drama. Sleep is one of the most pervasive strands in the pattern.

(Pervasive Theme, pp. 249 ff.)

A clear example of the contrast between the objective and the transcendental vision of Shakespeare lies in the speeches of Macbeth and his wife in this scene. She gives us a wonderfully

vivid objective picture (projected in advance also in I. vii) of the circumstances of the murder, which we never actually see. But Macbeth is all the time translating the scene into transcendent terms—*Glamis hath murther'd Sleepe; this my Hand will rather The multitudinous Seas incarnadine; Wake Duncan with thy knocking* (Bradley makes the point in his *Shakespearian Tragedy*, 355, 374). It is interesting to note that both are legitimate

Be not lost So poorely in your thoughts

effects of the poetic drama—both the objective atmospheric painting of the Lady, and the transcendent interpretation of her Thane.

(Transcending the Visible Scene, pp. 229 ff.)

72 *be not lost So poorely in your thoughts.* The phrase is another example of the "close-up" method of character-creation (see on I. v. 60, above).

(Creation in Words—of Character, see especially pp. 221 f.)

The whole scene (II. ii) between the guilty pair after the murder is a perfect example of the sustained rhythm which is Shakespeare's most powerful device for casting a spell upon his audience. Performance of this scene must be based upon the

continuous rhythm of the verse, with its implied changes of pace and tread, and its subtlety of pause and renewal of *tempo*. Gesture, movement, and miming must flow from this rhythm: any "business" that holds it up or distorts it should make the producer cry *"Pox, leave thy damnable Faces, and begin."*

<div align="right">(<i>Speech</i>, see especially pp. 119 ff.)</div>

Act II, *Scene iii*

The Devil-Portering scene is an excellent example of Shakespeare's objective method. Wanted: (*a*) someone to open the gate at the south entry; (*b*) time for Macbeth to change his clothes; (*c*) some temporary relief of the tension. The solution presents itself in the person of Armin. Then follows the habitual brilliant opportunism: the stock comic gambit of the drunken servant develops into the ironical fantasy of the porter of Hellgate; and then by a sort of inversion the detail of the porter's speech is objectively topical—the Farmer, the Equivocator, the Taylor, all "music-hall" jokes. I can see no reason for thinking this episode un-Shakespearian; on the contrary, it is characteristic, like the "little Yases" and the touch of mad Hamlet being sent to England—" 'Twill not be seene in him, there the men are as mad as he."

<div align="center">(<i>Objectivity of Vision</i>, pp. 189 ff.)</div>
<div align="center">(<i>Opportunity Snatched from Necessity</i>, pp. 196 ff.)</div>

The dialogue between Macduff and the Porter, neither edifying nor very amusing (though no doubt helped by Armin's playing), serves nevertheless a necessary purpose—of making the night pass into early morning, an hour when Macduff could reasonably *call timely on* the King. An interesting feature of this passing night is the way that Lennox colours it in retrospect: the unruly night is nowhere indicated up to this point, and it would be inappropriate to the oppressive silence of II. i and II. ii to punctuate with storm noises. Perhaps the first indications of boisterous weather would be given by the backstage men at the moment when the Porter opens the door to Macduff and Lennox. For a parallel example of a storm *dramatically* organised, see above, p. 70, where the effects in *Julius Caesar* are considered. Lennox's descriptive speech (*The Night ha's been unruly . . .*) gives the cue for Macbeth's ironical *'Twas a rough Night:* it also serves as a *crescendo* leading up to Macduff's *O horror, horror, horror;* and prepares us for the atmospherics of II. iv, the dialogue between Ross and an Old Man.

<div align="right">(<i>Effects</i>, pp. 69 ff.)</div>

56 *This is the Doore.* Presumably Macbeth indicates the permanent door in the Study, through which he himself ascended to Duncan's room. The main Doors of the Platform have each an identity at this moment: from one the Porter has emerged, as from the servants' quarters; the other leads from the gate at the south entry, through which Macduff and Lennox were admitted into the Castle.

(*Plotting Entries*, pp. 72 ff.)

70 Note that in the moment of rousing the house it is part of the technique of *poetic* drama to present us with the picture of the household asleep: that is the effect (and presumably the purpose) of such lines as . . . *Shake off this Downey sleepe, Deaths counterfeit,* . . . and *What's the Businesse? That such a hideous Trumpet calls to parley The sleepers of the House?*

(*Creation in Words—of the Action*, pp. 226 ff.)

87 The Alarum bell, as in the Cyprus-brawl of *Othello*, and again in the last act of this play, adds its note to the confusion of the scene, and frights the playhouse from its propriety.

(*Effects*, pp. 69 ff.)

108 Once again the adaptability of the unlocalised Platform is shown when Lennox and Macbeth present us with a further and still more graphic description of Duncan's chamber. Between them Cooke and Burbadge must evoke the scene, and Lady Macbeth's faint is all the more plausible if they succeed. Lennox's previous speech about the unruly night suggests that Cooke could be relied upon for this kind of graphic evocation. A later scene (III. vi) proves that he had other talents as well.

(*Locality and Unlocalisation*, pp. 103 ff.)

132 She *really* faints, of course. The strain of her visit to the death-chamber is a principal cause of her startling collapse and it will be noticed that it follows immediately upon Macbeth's circumstantial description of the scene of murder. Moreover, it is difficult to think of any device by which the boy-player could indicate pretence: we may at least think it likely that if Shakespeare had intended a sham faint, he would have made the fact somehow clear to the audience *in the spoken dialogue*. The irony of Lennox in III. vi hints at a possible method.

(*Creation in Words—of the Action*, pp. 226 ff.)
(*Creation in Words—of Character*, see especially pp. 222 ff.)

132 *Looke to the Lady: And when we have our naked Frailties hid . . . a* fine wild scene with the Thanes in dishabille: the nightgowns are, of course, not nightshirts, but rather the Elizabethan equivalent of dressing-gowns: the servants half naked. The fainting Lady is one focal point up-stage and surrounded by Thanes and servants, so as not to distract from the whispered conversation of Malcolm and Donalblain, right forward at the centre of the octagon; Macbeth no doubt prominent on the perimeter, outside one of the Stage-Posts, with a grim eye of menace on the two princes. How much easier to plot at the Globe than on a picture-stage!

(Positioning, pp. 131 ff.)

Looke to the Lady

ACT II, *Scene iv*

5 *Thou seest the Heavens, as troubled with mans Act, Threatens his bloody Stage: byth' Clock 'tis Day, And yet darke Night strangles the travailing Lampe . . .* There is an unnatural darkness instead of daylight: Ross speaks of this as a sign of divine anger, and his transcendental interpretation is expressed in the familiar objective metaphor of the playhouse: no doubt Heminges embraces with his gestures the canopy of "the Heavens" and the Platform on which he stands.

(Objectivity of Vision, pp. 189 ff.)

The Platform is unlocalised, and though we are led to infer from the Old Man's opening speech, which recalls Lennox's description of the unruly night (II. iii. 36 ff.), that this is the

morning after the murder, the scene is in a sense timeless because the day is unnaturally turned to night. It seems therefore like a choric interlude, giving information about the "official view" of the murder, the sequel of Macbeth's succession, and (by the pregnant reticence of Macduff) the attitude of those *That would make good of bad*. Once again, the neutral Platform is the ideal setting for such a scene. (If there is to be an interval in the course of the play, the rhymed couplet of the Old Man's pious wish makes a good cadence, and the disclosure of the royal throne in the Study a sufficiently striking dramatic effect to recapture the interest of the audience.)

<div align="right">

(*Locality and Unlocalisation*, pp. 103 ff.)
(*Continuity*, pp. 241 ff.)

</div>

ACT III

Scene-Rotation as follows:

Scene i *Study* and *Platform*: the Study contains the royal "state": it is in fact the stock throne-room set; seen with great effect for the first time in the play as Banquo says *Thou hast it now*.

 ii *Chamber*: for it is Lady Macbeth's apartment, to which she invites the King for a few words. Macbeth's invocation of the night from aloft on the Tarras, and the immediate sequel of the murderers' stealthy appearance on the Platform, is a master-stroke of continuity only possible in the conditions of Shakespeare's playhouse.

 iii *Platform*: the murderers will no doubt use the Stage-Posts for their ambush, hiding *in front* of them (in company with the audience).

 iv *Study* and *Platform. Our Hostesse keepes her State*: i.e. she remains seated on the throne in the Study—it is in fact the same throne-room set as in III. i. *Banquet prepar'd* means the carrying of table and stools forward on to the Platform (see above, pp. 42 f.).

 v It is usual to omit the Hecate scene as un-Shakespearian. Presumably, as it is in the Folio, it was at some period performed at the Globe: positioning difficult, perhaps Hecate on the Tarras, with witches below—the music appropriately comes from the gallery aloft *in a Foggy cloud*. The scene can hardly have belonged to Shakespeare's original conception: one reason for its insertion might have been the mechanical one of giving time to the stagehands for the change from throne-room to Witches' cave. In practice it should prove unnecessary, for the removal of

the banquet after III. iv, which takes place in view of the audience, gives extra time also for scene-shifting operations in the curtained Study.

vi *Tarras:* Disregarding the Hecate scene, the Book-Keeper has to place this short dialogue between two scenes of Platform-cum-Study. The Tarras is convenient here, and the entry can be given a natural air if Lennox discovers a solitary piper entertaining the servants below as they finish their clearing of the banquet. The two Thanes will

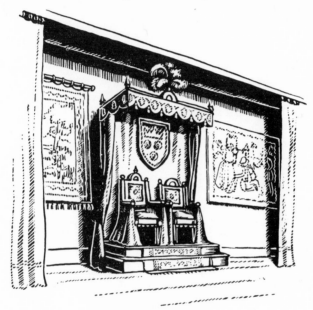

Thou hast it now

seem to be in the musicians' gallery of the banquet-hall, and this supposition lends, perhaps, an extra point of emphatic gesture to the hope that *we may againe Give to our Tables meate, sleepe to our Nights: Free from our Feasts, and Banquets bloody Knives.* The speaker gesticulates to the Platform below him, which has just been the scene of a ghost-ridden banquet.

(*Scene-Rotation*, pp. 31 ff.)

Act III, *Scene i*
The Study is furnished with the usual throne-room set familiar from the history plays: steps up to a dais on which stands the

"state" capable of accommodating both King and Queen; carpets on steps and floor, tapestries hung all round on the three walls; an overhanging canopy (see above, p. 39). The first sight of the throne has a dramatic effect in this story of usurpation comparable to that in *Richard III*, IV. ii.

(*Furnishing and Properties*, pp. 38 ff.)

1 The theme of the "second movement" is quickly stated— Banquo, and in particular Banquo's issue—and (at least in the extant form of the play) is worked out with insistent relevance and continuity.

(*The Architecture of the Play*, pp. 232 ff.)

10 Bradley would have it that Shakespeare's characterisation of Banquo makes him something like an accessory after the fact (see *Shakesperian Tragedy*, 384 ff.). If he is right, then it looks as if some important material has been omitted from our existing version of the play. A study of the "close-up" method of characterisation outlined above suggests that Shakespeare would not normally have left the point ambiguous. If he had wished to show Banquo as a double-dealer, he would have given us the hint on the lips of Banquo himself or some other character. It may be, for instance, that some lines have dropped out after the words . . . *And set me up in hope.*

(*Creation in Words—of Character*, see especially pp. 222 ff.)

11 *Senit sounded.* The usual sign of a big formal entry, with the appropriate pomp and circumstance to indicate that Macbeth and his Lady have achieved the object of their ambition.

(*Music*, see especially pp. 63 f.)

14 The dialogue between Macbeth and Banquo on the subject of the *solemne Supper*, which culminates in Macbeth's words *Faile not our Feast*, and Banquo's reply—*My Lord, I will not*—is a good example of the "rod-in-pickle" method by which Shakespeare suspends our interest and preserves the continuity.

(*Continuity*, see especially pp. 247 f.)

48 *To be thus, is nothing . . . Our feares in Banquo sticke deepe.* There can be no better background for this soliloquy than the royal "state" on which Macbeth sits in his King's robes, wearing his fruitless crown, and grasping his barren sceptre. The setting is more properly one of circumstance than of locality.

(*Locality and Unlocalisation*, pp. 103 ff.)

55 ... *and under him, My Genius is rebuk'd, as it is said Mark Anthonies was by Caesar.* We look over the poet's shoulder and see him turning the pages of his Plutarch, and dwelling on the theme of his next play—*Antony and Cleopatra.*

The soliloquy has a cumulative rhythm, with a great *crescendo* at the end. The last sentence should, I think, be pointed thus: ". . . come Fate into the *Lyst*"—i.e. rather than have Banquo's children succeed me, I'll *fight* against the witches' prophesied fate.

(*Speech*, pp. 111 ff.)

It is, I think, characteristic of the intensely concentrated relevance of Shakespeare's dramatic method that the question of the succession is not explored beyond its relation to Banquo and Fleance. As others have pointed out, Macbeth's own issue is left almost without comment: Lady Macbeth knows the love of an infant at the breast (I. vii. 54 ff.); Macduff perhaps speaks of Macbeth when he cries *He ha's no Children* (IV. iii. 211): more we are not told. See above, on I. vii. 54 ff.

(*The Architecture of the Play*, see especially pp. 240 f.)

74 In the scene of Macbeth's persuasion of the murderers, there is less than the usual objectivity: . . . *it was he, in the times past, which held you so under fortune, Which you thought had been our innocent selfe . . . How you were borne in hand, how crost . . . whose heavie hand Hath bow'd you to the Grave, and begger'd Yours for ever—* what sort of circumstances do these phrases suggest? It looks as if Shakespeare decided that to give detailed substance to the complaints of the cut-throats would carry him and us too far from the main theme. But as it is, he has not been able to create the necessary effect briefly. His inspiration momentarily flagging, he falls back upon his technique: for the scene is carried along not only by the melodrama inherent in the situation but also by the rhetorical and rhythmical energy of Macbeth's speeches.

(*Speech*, see especially pp. 117 f.)

131 ... *for't must be done to Night, And something from the Pallace . . . that darke houre* . . . the anticipatory sketching of Banquo's murder helps to create the atmosphere of the murder-scene in advance, and is also a "rod-in-pickle" for the continuity.

(*Creation in Words—of Atmosphere*, pp. 198 ff.)
(*Continuity*, see especially pp. 247 ff.)

Act III, *Scene ii*

The furniture of the Chamber, though representing what is
actually a different room (the royal palace, not Inverness),
need not differ from that in I. v. It is still an apartment private
to Lady Macbeth. The "women's quarters" in the Elizabethan
playhouse are habitually in the Chamber aloft.

(*Furnishing and Properties*, pp. 38 ff.)

The scene is a masterpiece. It preserves and indeed enhances
the tension of expectation of Banquo's murder. It shows us
Lady Macbeth's disillusion, and the unexpected but in the
event obviously probable change of relationship between her
and her husband, and the growing feverish energy of Macbeth
(following on *Come Fate into the Lyst*, we now have *But let the
frame of things dis-joynt . . . So shall I love, and so I pray be you . . .
Then be thou jocund . . .* etc.). It is full, moreover, of the most
powerfully dramatic poetry; especially the bloodcurdling in-
vocation of night at the end. Imagine Burbadge speaking this
from the Tarras rail in front of the Chamber, while the night
gathers below on the Platform. Note how, once again, together
with the atmosphere itself, the appropriate emotional reaction
is suggested to us—most subtly this time—in the words *Come,
seeling Night, Skarfe up the tender Eye of pittiful Day.* To *seel* is a
technical term in falconry for the sewing up of the eyelids of a
young hawk to make him used to the hood. Would Burbadge
have illuminated the metaphor with a gesture, easily recog-
nisable to his audience?

(*Creation in Words—of Atmosphere*, pp. 198 ff.)
(*Positioning*, pp. 131 ff.)

Act III, *Scene iii*

Having invoked the night, Macbeth retires into the Chamber
to escort his wife: he leaves his spell behind him, and the
atmosphere is already half created for the Murtherers. The
effect is almost of his presiding over the murder, and is com-
parable to Lady Macbeth's *fatall entrance of Duncan Under my
Battlements* (I. v. 37 f.). The matter is clinched by the lines of
the First Murderer, *The West yet glimmers . . .* etc. Once again
our emotional reponse is prompted for us—*Now spurres the lated
Traveller apace, To gayne the timely Inne.* We too want to get under
cover, in case there are cut-throats on the prowl.

(*Continuity*, see especially p. 245)

The problem of the Third Murderer is unsolved, and it is not the kind of loose end that Shakespeare usually leaves; for most of his loose ends are such as would be overlooked in performance; here the point is emphasised in the dialogue. Something may be missing from our cut version of the play. But it is worth remarking that there is a purely mechanical reason why a third is necessary: if the scene is played on the Platform, Banquo's body must be carried off, and it takes two to carry him expeditiously; not only that, but the light struck from the hand of Fleance must also be removed before the change of locality to the ensuing banquet scene. One of the trio must pick up the light. The suggestion is sometimes made that Macbeth is himself the third murderer: but as he leaves the Chamber on the last line of the preceding scene, continuity and the "law of re-entry" make the suggestion impossible (see above, p. 75).

Unlike the earlier dialogue with the murderers, the scene of Banquo's murder itself is fully furnished with objective detail— the glimmering western sky, the sound of horses, the call for light, Banquo the last-comer *within the note of expectation*, the horses going about (with appropriate imitation off-stage), the usual walk to the palace gate, *It will be Rayne to Night*, and the savage, ironical retort, the striking out of the light, the escape of Fleance. Every detail is clear to the audience partly because in the daylight of the playhouse they can in fact see what is happening, partly because the words themselves present all the significant items. The graphic realism of the scene can be compared with the robbery on Gads Hill in 1 *Henry IV* and the attempt on Cassio's life in *Othello*.

<div style="text-align:right">

(*Creation in Words—of Atmosphere*,
see especially pp. 203 ff., 208 ff.)

</div>

ACT III, *Scene iv*

The banquet-scene presents an interesting problem of positioning. Note the data: *Our selfe will mingle with Society . . . Our Hostesse keepes her State . . . Both sides are even: heere Ile sit i'th'mid'st. . . .* Besides, the murderer's appearance at the door has to be accommodated. The Study is furnished as in III. i, Lady Macbeth sitting alone upon the "state". The *Banquet* is *prepar'd* on the Platform, between the two Stage-Posts, Macbeth's place being central. Bright lights on the table and perhaps in brackets hooked on to the Stage-Posts help to dazzle the eyes of the audience when the Ghost appears. The whispered colloquy with the murderer will be on the perimeter

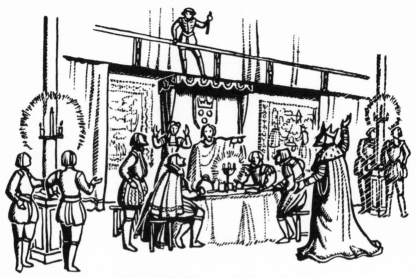

Never shake Thy goary lockes at me

outside one of the Stage-Posts. *Enter the Ghost of Banquo, and sits in Macbeths place:* this instruction of the Folio looks like a straightforward entry perhaps through one of the arrases at the side of the Study. Macbeth's speeches to the Ghost on both its appearances, and the interjections of Lady Macbeth are so long extended that it is difficult on a shallow stage to make them plausible: the difficulty largely disappears on the Globe Platform where there is room for manœuvring both in front of the banquet-table and up-stage between it and the Study.

<div align="right">

(Positioning, pp. 131 ff.)

</div>

Though there is no cue in the Folio, Musicians on the Tarras (during the preparation of the Banquet and for the formal entry of the King and Queen and their guests) would give the impression of a musicians' gallery in the great hall of an Elizabethan house. For the necessarily lengthy process of preparation and removal of the banquet, some informal music is a help. Hoboyes—the reed band—rather than trumpets.

<div align="right">

(Music, see especially pp. 64 f.)

</div>

Examples of the "close-up" method of description are plentiful in this scene: *never shake Thy goary lockes at me* (50). *Why do you make such faces?* (67) *Thou hast no speculation in those eyes Which thou dost glare with* (95) . . . *you can behold such sights, And keepe the naturall Rubie of your Cheekes, When mine is blanch'd with feare* (114).

Such description is often a clue to the actor whose part is being described, but the speaker too must give reality to the poetical characterisation.

(*Creation in Words—of Character*, see especially pp. 221 ff.)

122 The end of the scene, the *coda* between Macbeth and Lady Macbeth, shows the poet's technique at its busiest. It is full of pervasive themes—blood, darkness (the night at odds with morning), sleep—and there are two "rods-in-pickle" in the mention of Macduff's refusal and the projected visit to the Weird Sisters. It is strange that theatrical tradition presents both Macbeth and his wife as weary at this point: *she* is indeed exhausted, but he is already *possessed* with the diabolical energy which, though it alternates with heart-sickness, yet carries him through to the climax of the battlefield.

(*Continuity*, pp. 241 ff.)

The table, stools and lamps and the remains of the banquet must be removed at the end of the scene. The operation can be conducted without offence, with some mildly diverting business, by the comic gang of servants (on this occasion with their tails between their legs). It is after all a no more complicated manœuvre than the *Dishes and service* of I. vii, or the preparation of the banquet at the beginning of this scene. The comic business was probably "in the repertoire"—e.g. Capulet's servants (*Romeo and Juliet*, I. v. 1 ff.; IV. iv. 13 ff.) and Aufidius' (*Coriolanus*, IV, v. 1 ff.). It gives more time for the scene-change in the Study to the Witches' cave, getting the noisy business of shifting the throne-set over before the Lennox scene begins. A solitary piper on the Tarras can accompany the removal of the banquet, and when Lennox and his fellow lord appear on the Tarras they can dismiss the piper with a gesture.

(*Scene-Rotation*, pp. 31 ff.)

ACT III, *Scene vi*

The scene (like II. iv) is narrative in effect. It implies, with a veiled but pungent irony, the gathering of suspicion and revolt. Young Cooke, graduating from female parts, which include Queen Margaret and Katharine the Shrew, needs more than ordinary skill of speech to make the most of Lennox (see above, on II. iii. 83 ff.). The theme of the sorrows of Scotland, predominant in the rest of the play, is clearly and forcibly enunciated by his partner. The prayer that *we may againe Give to our Tables meate, sleepe to our Nights* . . . comes appropriately

from the gallery above the recent ghost-ridden banquet. There is a "rod-in-pickle", for we are led to expect Macduff's visit to the English court, whence *a swift blessing May soone returne to this our suffering Country.*

(*Continuity*, pp. 241 ff.)

ACT IV

Scene-Rotation as follows:

Scene i *Study* and *Platform:* The cauldron possibly in the grave-trap, but more probably in the centre-trap on the Platform (its appearance and descent concealed by the Weird Sisters). The show of eight kings in the Study. Macbeth and (later) Lennox enter by a stage-door, to detach them from the cavern.

ii *Chamber:* A domestic scene, in Lady Macduff's apartments.
iii *Study* and *Platform:* Indication in Study of the English court—perhaps an easily recognisable blazonry.

(*Scene-Rotation*, pp. 31 ff.)

ACT IV, *Scene i*

There need be no elaborate furniture in the Study for the Witches' cavern. Dark curtains draped for a cave-mouth. The cauldron in the centre-trap (with smoke rising round it) must be wide enough to allow the apparitions to rise through it from Hell below.

(*Furnishing and Properties*, pp. 38 ff.)

It seems that the Apparitions from the cauldron are plainly visible to the audience, for except for the third who *weares upon his Baby-brow, the round And top of Soveraignty* there is no "close-up" description in the dialogue: for once we must rely upon the stage-directions of the Folio. The show of eight kings, on the other hand, is minutely described (in such a way, indeed, as to suggest that the preceding stage-direction is wrong in bringing Banquo on last of the procession). The contrast indicates the probability that whereas the Cauldron was on the Platform, the Show was more remote in the Study.

(*Positioning*, pp. 131 ff.)
(*Creation in Words—of Character*, see especially pp. 221 ff.)

132 It seems possible that the vanishing of the Witches is done by the simple expedient of drawing the Study curtains, and leaving Macbeth outside, for his final colloquy with Lennox.

(*Positioning*, pp 131 ff.)

147 *The very firstlings of my heart shall be The firstlings of my hand . . .*
This deed Ile do, before this purpose coole. And so straight on to the
scene (in the Chamber) of Lady Macduff's murder. The swift
continuity is a deliberate dramatic stroke.

(*Continuity*, pp. 241 ff.)

Act IV, *Scene ii*

Enter Macduffes Wife, her Son and Rosse. The prompt-book
reflects the words of the preceding speech . . . *give to th'edge
o'th'Sword His Wife, his Babes . . .*

Upon his Baby-brow, the round And top of Soveraignty

The furniture will be different from Lady Macbeth's apart-
ments, but the difference need not be stressed. This is a typical
Chamber scene, essentially (and in this case pathetically)
domestic: the tyrant's cruelty penetrates to the privacy of home
life. There is an obvious but effective stroke of irony in the
contrast between the beginning of the scene where Lady
Macduff is bitter against her husband, and speaks of him as a
traitor, and the climax when she stands up for him, and the
Boy in denying that he is a traitor meets his death.

(*Scene-Rotation*, see especially pp. 32 f.)

Act IV, *Scene iii*

The longest scene in the play, and seemingly out of proportion
in the main architectural design. Is it possible that when the
play was cut we lost material about Macduff and Malcolm

which would have put it into perspective? Shakespeare, for
instance, never explicitly answers the question *Why in that raw-
nesse* he left *Wife, and Childe . . . Without leave-taking* (26).
Nevertheless, in a larger design the scene cannot be called
irrelevant, providing as it does a vivid picture of Scotland's
distress under tyranny when even the good men must suspect
each other. The public aspect of the story becomes increasingly
important as the play proceeds. It is Malcolm's elaborate
deception which seems to strike a false note. Shakespeare found
it in Holinshed and set his hand to it, falling back, as even the
greatest artists will do, when his material fails to inspire him,
upon his long-learnt technique. If even Shakespeare's rhetorical
skill cannot make Malcolm's lying and Macduff's credulity alto-
gether plausible, yet it must be admitted that in practice, even
on the modern stage, this dialogue usually holds the attention,
and the fine climax of the scene sets the audience applauding
the three actors, and sweeps on to the dénouement of Act V.

(*The Architecture of the Play*, pp. 232 ff.)
(*Speech*, see especially pp. 117 ff.)

139 The brief episode of the English Doctor's entrance is an
example of Shakespeare's opportunism turned to a somewhat
undignified end—flattery of King James. Nevertheless, we
should not miss the fact that it also has a place in the poet's
dramatic design. The theme of sickness and the need for heal-
ing pervades the last act of the play, and this is a striking
enunciation of the *motif*.

(*Pervasive Theme*, pp. 249 ff.)

One must not forget as a reason for the length of this scene the
practice of resting the chief actor (and his audience) round
about the fourth act of a tragedy. *Othello* is the only one of
Bradley's "big four" that does not follow this practice—and the
only one that does not sag a little at this point; the best-con-
structed, therefore (but perhaps Burbadge would not agree!)

(*The Architecture of the Play*, pp. 232 ff.)

203 An interesting example of the "close-up" method is Malcolm's
description of Macduff's silent reception of the news: *What man,
ne're pull your hat upon your browes: Give sorrow words; the griefe
that do's not speake, Whispers the o'refraught heart, and bids it breake.*
A stoical silence without comment is not permissible in Shake-
speare's technique. His handling of Brutus' stoicism has been
remarked above.

(*Creation in Words—of Character*, see especially pp. 224 f.)

Act V
Scene-Rotation as follows:
Scene i *Chamber.*
ii *Platform.*
iii *Chamber.*
iv *Platform.*
v *Tarras* and *Chamber.*
vi *Platform.*
vii *Study—Platform.*
viii *Study—Platform.*

(*Scene-Rotation*, pp. 31 ff.)

Act V, *Scene i*

The furnishing of the Chamber again needs no special differentiation: the mere fact of the scene's being in the Chamber gives it the touch of domestic intimacy which suits its particular pathos. A table is necessary, for Lady Macbeth to put the taper on; she needs both hands for her miming. Perhaps the writing materials of the Gentlewoman's description could be indicated. What is meant by *unlocke her Closset?* A little desk?

(*Furnishing and Properties*, pp. 38 ff.)

It is by now a commonplace to say that Shakespeare can create darkness out of daylight. In this scene we notice also the familiar method of an anticipatory description, so that by the time Lady Macbeth enters, we understand at once that she is asleep (with *A great perturbation in Nature*) and imagine her carrying out the actions described by the Gentlewoman before her appearance. The Gentlewoman's sinister refusal to report what her mistress has *said*, keys us up to tense expectation of her words. There is also the "close-up" of her appearance and actions after she enters—*You see her eyes are open . . . I but their sense are shut . . . Looke how she rubbes her hands . . . thus washing her hands.*

(*Creation in Words—of Character*, see especially pp. 221 ff.)

The words of the sleepwalker are an elaborate development of the mimed "Messenger Speech" method. For Lady Macbeth, in the intervals of washing her hands, is re-enacting scenes which we have witnessed and others which we have not. The player—if he were a Ruth Draper of a boy—could recall to us previous moments of his own and Burbadge's performances,

with the words *no more o' that: you marre all with this starting* and
Wash your hands, put on your Night-Gowne and *To bed, to bed:
there's Knocking at the gate: Come, come, come, come, give me your
hand*—and could also suggest other moments which we can
imagine and infer but have not seen, with *One: Two:* (the
clock? or the bell which tells Macbeth that his drink is ready?)
Why then 'tis time to doo't, and . . . *who would have thought the olde
man to have had so much blood in him* (which recalls *My Hands are
of your colour* . . . and the previous visit to Duncan's apartment,
Had he not resembled My Father as he slept, I had don't). The player
must remind us of these earlier moments in the play, must light
up for us all these close-woven strands in the poet's tapestry. It
is an effect of the *poetic drama*, and can only be made through
the voice and miming. The passive childish whimper of the
traditional sleepwalking scene makes nothing of this most
powerful and strenuous poetical evocation.

(*Miming*, pp. 125 ff.)
(*Creation in Words—of the Action*, pp. 126 ff.)

The Doctor and the Gentlewoman *stand close* on the extreme
edge of the Tarras (possibly even in one of the Window-
Stages). Perhaps they enter with a light, and extinguish it as
Lady Macbeth appears: there is atmospheric force in the sight
of smoke blowing off their extinguished candle, as the other
light focuses attention on the Chamber.

(*Positioning*, pp. 131 ff.)
(*Effects*, pp. 69 ff.)

Act V, *Scene ii*

The climax of the play, on the battlefield, is—as we have now
learnt to expect—no anti-climax in the Globe playhouse, such
as it inevitably is on the picture-stage. The pattern of the
sequence is admirably adapted to the multiple stage, for
Macbeth is on the defensive at Dunsinane, and so is quite
logically penned in the upper stages, while the attackers move
ever nearer to him on the Platform level. In this way the sleep-
walking scene is an admirable prelude to the battle-sequence,
for both in V. iii and V. v the haunting presence of the sick
Queen is prominent. This is an additional reason for placing
the sleepwalking scene in the Chamber, which therefore
becomes associated with the sickness of Lady Macbeth. In-
evitably for the climax Macbeth sallies forth from the castle to
fight his enemies on the Platform. The sequence is made

doubly easy for the audience to understand by the prophecies of the Witches' apparitions. We expect the gathering of the attackers at Birnam, we know Macbeth is in Dunsinane, we have been told that Macduff is Macbeth's great danger.

(*Battle Sequences*, pp. 83 ff.)

Producer and actors should not fail to notice (otherwise the audience will miss it too) the very cunning texture woven from the themes of sickness and healing. They are of course strongly prominent in the sleepwalking scene. In V. ii Malcolm is spoken of as *the Med'cine of the sickly Weale* (27). In V. iii Macbeth passes from the contemplation of the Queen's *minde diseas'd* (and his own?) to the equally desperate *If thou could'st Doctor, cast The Water of my Land, finde her Disease, And purge it to a sound and pristine Health* (50) . . .

(*Pervasive Theme*, pp. 249 ff.)

The Scottish and the English soldiers will presumably be differentiated in uniform. At present, all Scottish.

(*Costume*, pp. 53 ff.)

Drum and Colours. We are shown the Scots at home marching to meet the *English powre*, under Malcolm, Seyward and *the good Macduff*. The scene is informative and suggestive of mood—the speeches (as in the opening of I. vi and in III. vi) more important than the speakers. *Neere Byrnan wood Shall we well meet them* (5). We have a hint of the "match-card" technique (see above, pp. 88 f.)—Donalbain not there, but emphasis laid on Seywards Sonne (9), who has his moment of glory in the sequel. Macbeth, we hear, fortifies Dunsinane (12). There is an anticipatory description of Macbeth's frame of mind—*Some say hee's mad: Others, that lesser hate him, Do call it valiant Fury* . . . (13). Shakespeare does not pronounce judgment, but leaves us to interpret what we see and hear in the following scenes.

(*Battle Sequences*, pp. 83 ff.)

Act V, *Scene iii*

The elements of Macbeth's decline are distilled in terms of poetic drama. The static themes of desperate confidence in the witches, disillusioned ambition, and uneasiness about his wife's breakdown, are woven together with the dynamic material of *Reports* such as that of the *cream-fac'd Loone*, and the purposeless putting on and shaking off of his armour. The veiled censure of the Doctor's speeches makes an admirable foil.

11 We have a vivid "close-up" of the panic-stricken servant in
 Macbeth's abuse—*cream fac'd Loone; that Goose-looke; Go pricke
 thy face, and over-red thy feare Thou lilly-liver'd Boy; those Linnen
 cheekes of thine; Whay-face.*
 (*Creation in Words—of Character,* see especially pp. 221 ff.)

ACT V, *Scene iv*

 Still Malcolm's marching drum: the English uniforms mingle
 with the Scottish: we are at *The wood of Birnane* (4), and orders
 are given for the famous stratagem.
 (*Battle Sequences,* pp. 83 ff.)

ACT V, *Scene v*

 As Malcolm's drum fades away, *diminuendo*, it is answered by
 the new note of Macbeth's drum *crescendo* (see above, p. 65,
 where the lines of Faulconbridge in *King John* are quoted which
 describe such a rivalry of drums). Macbeth, Seyton and the
 soldiers are now all in their armour and appear on the Tarras:
 the *Banners on the outward walls* (1) would perhaps be displayed
 in the Window-Stages—to be lowered at the appropriate
 moment, when the attackers enter the Castle. The curtains of
 the Chamber are perhaps half drawn, and the *Cry within of
 Women* (7) would be heard from the Chamber, which we now
 associate with the sick Queen.
 (*Battle Sequences,* pp. 83 ff.)

9 *I have almost forgot the taste of Feares . . . I have supt full with
 horrors . . .* Macbeth's lines as he waits to hear the reason for the
 cry, create for us in the audience the appropriate thrill of
 horror—though he is denying it to his disillusioned self. The
 denial also paves the way for what would otherwise seem an
 inadequate comment—*She should have dy'de heereafter.* The
 method is the same as when Cordelia tells us *beforehand* that in
 answer to her father's question she will "Love, and be silent".
 Shakespeare does not leave us guessing: the drama is *complete*
 in the words. *There would have been a time for such a word:* Quiller-
 Couch (*Shakespeare's Workmanship,* 50) stresses *There,* and I
 agree with him that this was probably Shakespeare's pointing.
 (*Creation in Words—of Atmosphere,* see especially pp. 215 ff.)
 (*Creation in Words—of Character,* see especially p. 223 ff.)

19 *To morrow, and to morrow, and to morrow . . .* Here is again one of
 those passages which carry us right away from any visible
 scene or set of circumstances. It is interesting that precisely

here, Shakespeare once again thinks of the Player and the Stage as an image of Man upon The Earth. Macbeth's gesture to illustrate the *poore Player, That struts and frets his houre upon the Stage*, points downward to the Platform beneath him: but the effect is enhanced, of course, by the fact that Burbadge at this moment steps, as it were, out of his part and lets us remember that he is himself *a poore Player* . . .

> (*Transcending the Visible Scene*, pp. 229 ff.)
> (*Objectivity of Vision*, pp. 189 ff.)
> (*Opportunity Snatched from Necessity*, pp. 196 ff.)

46 *Arme, Arme, and out* . . . The death of his wife and the news of Birnam Wood coming to Dunsinane combine to drive Macbeth out into the field. The Alarum bell, used for the second time in the play, makes a stirring contribution to the gathering climax.

Act V, *Scene vi*

The Platform is suddenly filled with the foliage of Birnam Wood—a dramatic spectacle—and the throwing down of the *leavy Skreenes* helps to quicken the pace.

Seyward and his son and the English soldiers go out by one door, the Scottish by the other.

9 As in other battles (e.g. Shrewsbury Field in 1 *Henry IV*) the ceremonial trumpets give the signal, *Those clamorous Harbingers of Blood, & Death*. We proceed straight to the direction *Alarums continued* (? i.e. "prolonged").

> (*Music*, see especially pp. 65 f.)

Act V, *Scene vii*

At this point, it seems likely that the Study curtains were thrown open to reveal the gate of Macbeth's castle, with perhaps a portcullis hanging under the Tarras. Macbeth himself stands at bay before the gates.

> (*Scene-Rotation*, pp. 31 ff.)

1 *They have tied me to a stake, I cannot flye, But Beare-like I must fight the course.* There is a touch of objectivity in Macbeth's metaphor. Though the Globe was not used for bear-baiting, other playhouses were, and it would not be hard for the audience to make the imaginative comparison with what to them was a familiar sight in a familiar setting. Macduff's mockery—*Wee'l*

have thee, as our rarer Monsters are Painted upon a pole, and under-
writ, Heere may you see the Tyrant (54 ff.)—is a similar effect.

(*Objectivity of Vision*, pp. 189 ff.)

The battle itself follows the simple Homeric structure. Young
Seyward, singled out in V. vi. 2—*You (worthy Unkle) Shall with
my Cosin your right Noble Sonne Leade our first Battell*—is the
Patroclus. His body is removed, for we hear later that he has
been *brought off the field* (V. vii. 73): presumably, therefore,
there are some *excursions* as well as *alarums*, either at line 13 or
line 23, or at the end of this scene.

(*Battle Sequences*, see especially pp. 91 f.)

14 *That way the noise is . . . There thou should'st be, By this great clatter,
one of greatest note Seemes bruited.* The backstage gang are kept
busy, but the Book-Keeper working with the prompt-book,
would no doubt see that they worked with discretion. The
words must always be audible, or the shape of the play's
climax is marred.

(*Effects*, pp. 69 ff.)

24 *This way my Lord, the Castles gently rendred.* The formal entry into
the Castle, after surrender, is made, of course, through the
gates visible in the Study. Victorious soldiers no doubt appear
in the window-stages and dip the tyrant's Banners, planting
those of Malcolm and Seyward on the Tarras. Macbeth's next
entry and that of Macduff would probably be made through
the two stage-doors on to the Platform.

(*Plotting Entries*, pp. 72 ff.)
(*Battle Sequences*, pp. 83 ff.)

30 Macbeth's diabolical energy, his *valiant fury*, continues to his
last line: Burbadge would make the welkin ring indeed with
the grandeur of his end. The rhythmical climax of his final
speech is unmistakable: the actor who misses it, mars all.

(*Speech*, see especially pp. 119 ff.)

63 The Folio's *Enter Fighting, and Macbeth slaine*, seems not to
chime with Malcolm's statement that *Macduffe is missing.* It
seems like a later alteration of the original ending. It is difficult
to see how the decapitation could have been made plausible.
Retreat, and Flourish. This is the normal end of a battle sequence,
and the contrasted trumpet calls would no doubt be easily
recognisable to the audience.

(*Battle Sequences*, pp. 83 ff.)
(*Music*, see especially pp. 65 f.)

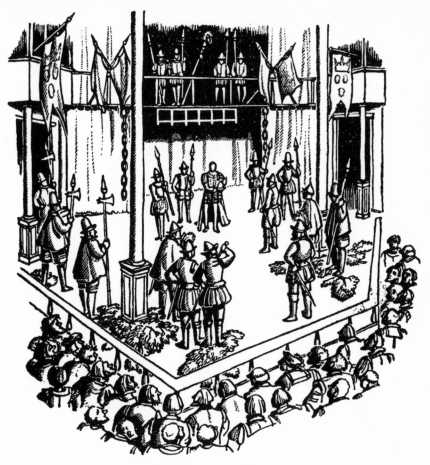

Th'Usurpers cursed head

68 The brief dialogue between Seyward and Rosse is beautifully written. Rosse has already done something of the same kind in breaking bad news to Macduff (IV. iii. 172 ff.). It seems to have been one of Heminges' accomplishments: he had played Exeter in *Henry V* and described the affecting deaths of Suffolk and York (*Henry V*, IV. vi. 7 ff.). It was he, too, who had just played Kent in *King Lear*.

(*The Repertory*, see especially pp. 157 f.)

84 No squeamishness, I think, in the portrayal of *Th'Usurpers cursed head*, which would be the most prominent feature of the end of the play; fixed on a pole, perhaps, and lashed to the

middle of the Tarras rail, like the familiar sight of traitors'
heads on London Bridge.

(Furnishing and Properties, pp. 38 ff.)

The finale a fully crowded scene. Malcolm central, with
Macduff and Siward near him: the Thanes grouped by the
two Stage-Posts; some soldiers round the perimeter, others on
the Tarras with Macbeth's head and the banners. The departure
is processional through the Castle gates, to the accompaniment
of a *Flourish.* The tyrant's head remains when all others have
withdrawn into the Tiring-House.

(Positioning, pp. 131 ff.)

EPILOGUE

Till the Globe is Rebuilt

THIS, then, is the contention. The wonderful detail of Shakespeare's stagecraft is waiting still to be revealed: it has not been seen in practice since his own day. More than that, the broad architectural design of his plays is habitually obscured, because we have not understood the nature of his poetic drama. That poetic drama was designed for, and evolved from, the unique conditions of performance in the Elizabethan theatre. Shakespeare's genius consisted not only in the creation of pure poetry and in the deeply sensitive understanding of the human heart, but also in transforming his theatre by poetical means into a whole world of the imagination. He was a practical man of the theatre, as few poets have been; he was a poet of genius, as few dramatists have been; and he found ready for his art, the perfect vehicle for poetic drama, in the Globe Playhouse.

Is the case then proven, that if we want to experience the whole genius of Shakespeare, we must reconstruct the conditions of performance at the Globe? We must rebuild the Globe, in London certainly, in Stratford too, perhaps, and wherever an audience will meet to support a Shakespearian repertory. Rebuild the Globe! At the moment of writing, the slogan shrivels on the paper before the ink is dry. We cannot be adventurous with bricks and mortar in the spirit of the Chamberlain's Men shouldering the timbers of their theatre. The Muses come late on the list for a building permit. Nevertheless, a palatial concert-hall already rises on Bankside, and the project of a National Theatre is to-day much canvassed. The recovery of the national dramatist would certainly not cost as much as either.

What can be done meanwhile? Little, perhaps, in the present conditions, by the theatre of West End London—inextricably committed to the picture-stage and to the practice of long "runs" with hand-to-mouth recruiting and small chance of a continuous tradition of acting. More by repertories—whether professional or amateur—and by universities and schools where the tradition if not continuous can be hereditary. The Maddermarket Theatre at Norwich, for many years a solitary prophetic voice, shows the power of such a tradition of repertory. News comes over the Atlantic of a series of

Elizabethan performances of Shakespeare at Illinois University, the staging based upon the scene-rotations of John Cranford Adams, each production drawing larger audiences than its predecessor. Since 1941 there has been a series of performances in the semicircular Speech Room at Harrow School, where it is possible to reproduce the dimensions and central position of the Platform in a building no larger and no less intimate than Shakespeare's Globe. Every now and then letters come through the post telling of producers, at schools and elsewhere, who have tried or who want to try a similar experiment. The belief grows—and it is a simple faith—that the best way of producing Shakespeare's plays is his own. It seems possible that in time the body of opinion will grow so strong as to create the demand for a full-scale professional undertaking on these lines. More power, therefore, in the interim, to all those who will help to create the demand.

It must, of course, be a matter of improvisation and makeshift, of making the best of existing circumstances. One needs sometimes to be Napoleonic in ignoring precedent—turning one's back on a convenient and well equipped picture-stage ready at hand, and choosing instead a bare hall with a wide floor to manœuvre on. I came across an octagonal cattle-ring in the Border country which could (without further ado) have housed a performance of *Macbeth*. But we cannot always be lucky enough to find an octagonal or circular building. Perhaps it will be helpful to recapitulate the conditions which are most necessary.

First, an auditorium which is not too big: the Globe was only 84 feet in outside diameter, and the sense of crowded intimacy is extremely important.

Secondly, a broad and deep Platform, jutting out right into the middle of the audience: this is the main acting arena: it cannot be concealed from view: it is unlocalised, but can take its locality from the dialogue or from the setting of the inset. If possible, two pillars towards the front, which will help in the grouping and in other ways.

Thirdly, at the back of this Platform the Tiring-House can be represented by curtains: there must be a clear and spacious entry at each end of the curtain to represent the Globe stage-doors. Between the two doors an inset should be available, which can be hidden or exposed by parting the curtains: this represents the Globe Study.

Fourthly, any of the other features of the Globe Tiring-House that can be imitated—the Tarras, the Chamber, the Window-Stages— will help the scene-rotation. So, too, the trap-doors—especially that in the main platform, which gives access to Hell. But in practice it is

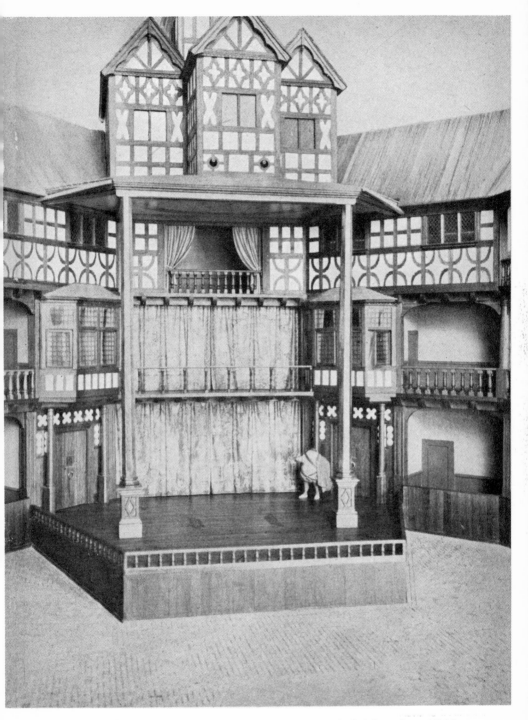

A new model of the Globe Playhouse made by John Cranford Adams for exhibition
in the Folger Library, Washington

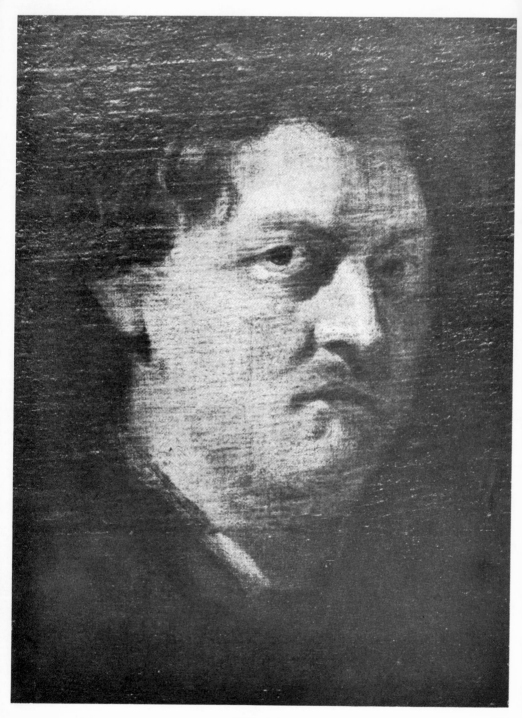

William Sly
(*from the picture in the Gallery of Dulwich College*)

possible to do without these features, their need being supplied by other makeshift devices. The important thing here is to achieve that swift-running continuous action—the long rhythm of the play—which was so skilfully contrived by Shakespeare on the multiple stage of the Globe with its seven acting areas.

Fifthly, it is essential that the performance should be in steady daylight—or if that is not available, in a steady light representing daylight. No lighting effects, as we know them, except such as can be achieved by the use of torch, candle or fire. This requires faith—but it works triumphantly, even in such plays as *A Midsummer Night's Dream* and *Macbeth*—and some bravery too; for it is half the battle to have the audience sitting in the same light as the players; the actor's courage will be rewarded by the astonishing intimacy thus created between himself and his audience.

Sixthly, music should be used only for an explicit dramatic purpose: no overtures and incidental music: the indications are mostly given by Shakespeare or his colleagues in the Quartos or the Folio (which should for all purposes be used as Prompt Book). A fairly safe test is that the music should always be heard by the actors on the stage (or by some of them), never treated as incidental music, as a private comment passed from the orchestra to the audience. It should be in period—that is to say, Elizabethan—and this is no hardship, for the choice is wide and varied. But let it be remembered at the same time that Shakespeare is much inclined to experiment, to improvise and to be opportunist, both in style of music, and in instrumentation. Modern idiom, and modern harmony, and modern instrumentation should be avoided, since there is nothing that more quickly strikes irrelevant overtones than a musical anachronism. But one need not be pedantic in this matter: modern strings and modern wind can imitate the older style.

Seventhly, the costume likewise should avoid a post-Elizabethan style. The substructure should be Elizabethan—indeed, in many plays the whole wardrobe will be Elizabethan—but on top of this, one should superimpose the *Elizabethan's idea* of a Roman, a Scotsman, a fairy or a monster. Both in costume and furniture, one should remember to see the story through Elizabethan spectacles. The result is to make the characters fully alive instead of archaistic. The Babington-plot conspirators in *Julius Caesar* are an excellent case in point.

Eighthly, the repertory company should be trained as a team, in the acting tradition of the Chamberlain's Men. The choice of personnel should be made with some consideration for the "lines" of the Chamberlain's Men—we must have a Burbadge, a Pope-Lowin,

a Kemp or an Armin, a Heminges, and so forth. We must have three or four boy-actors with the necessary skill or aptitude. The whole company should be trained especially to manage the great subtleties and the wide range of Shakespeare's speech: this should be their *first* accomplishment. Then they should be expert mimes, able (in the manner of the *Compagnie des Quinze*) to make us see more with the mind than we can with the eye. They should learn the special opportunities of the deep-perspective grouping on the Globe stage. They should understand the special quality of Shakespeare's characterisation—they should in fact learn to play their part in the drama, and to play it through Shakespeare's own medium, the medium of the spoken word.

These are the essentials, and granted these, there is still plenty of latitude for the creative imagination of the modern producer: only he must by implication subordinate his own imagination to that of Shakespeare himself. To follow his lead is, as I know by experience, an exhilarating adventure. Stand in imagination—since you cannot in reality—upon the Globe Platform, and ask yourself what did he do—what did the Chamberlain's Men do—at this point or that? The answer is almost always there, stated or implied in the text of the play, and the search, if not easy, is an absorbing and rewarding one.

I have a vivid picture in my mind of the poet pacing that Platform sometimes of a morning, when the playhouse was empty, and planning to himself what next he will transform it to; how next he will give to airy nothing a local habitation and a name. I am sure that he thought continually in terms of this theatre and understood how to use it as no one else has since, and learnt how wonderfully expressive a medium it could be for poetic drama—how much more expressive than our flat picture-stage can ever be. And I am sure that he thought of it as an excellent little world in which he and his fellow-players could "hold the mirror up to nature". I am not *so* sure, but I like to believe, that with his fondness for the double-meaning, he put his tongue lovingly into his cheek as he penned, at Stratford, at a distance from his old friends and colleagues in London, Prospero's familiar lines:

> The Clowd-capt Towres, the gorgeous Pallaces,
> The solemne Temples, the great Globe it selfe,
> Yea, all which it inherit, shall dissolve,
> And like this insubstantiall Pageant faded
> Leave not a racke behinde . . .

The great Globe itself dissolved in 1644, and though three hundred

years of general acclamation have since passed, we have never seen the full splendour of the art we profess to admire. The Globe has not been rebuilt—not yet. When it is, if it is, I have little doubt that some of to-day's poets will be quick to delight in it, to walk with the freedom of Shakespeare himself, to feel themselves as broad and general as the casing air, whereas hitherto they have been cabined, cribbed, confined, bound in to the oppression of the proscenium arch.

APPENDIX I

E. K. Chambers' conjectural chronology of the plays is as follows (*William Shakespeare*, Vol. I, 270, 271):

1590–1 *2 Henry VI. 3 Henry VI.*
1591–2 *1 Henry VI.*
1592–3 *Richard III. Comedy of Errors.*
1593–4 *Titus Andronicus. Taming of the Shrew.*
1594–5 *Two Gentlemen of Verona. Love's Labour's Lost. Romeo and Juliet.*
1595–6 *Richard II. A Midsummer Night's Dream.*
1596–7 *King John. The Merchant of Venice.*
1597–8 *1 Henry IV. 2 Henry IV.*
1598–9 *Much Ado About Nothing. Henry V.*
1599–1600 *Julius Caesar. As You Like It. Twelfth Night.*
1600–1 *Hamlet.*[1] *Merry Wives of Windsor.*
1601–2 *Troilus and Cressida.*
1602–3 *All's Well That Ends Well.*
1603–4 ——
1604–5 *Measure for Measure. Othello.*
1605–6 *King Lear. Macbeth.*
1606–7 *Antony and Cleopatra.*
1607–8 *Coriolanus. Timon of Athens.*
1608–9 *Pericles.*
1609–10 *Cymbeline.*
1610–11 *The Winter's Tale.*
1611–12 *The Tempest.*
1612–13 *Henry VIII. Two Noble Kinsmen.*

[1] In his *Shakesperian Gleanings* (p. 68) Chambers revises the ascription of *Hamlet* and puts it in 1601.

APPENDIX II

Twelfth Night shows how it is possible to devise a neat scheme of scene-rotation for a neatly-constructed play. I suggest the following plan:

I. i (Orsino): *Chamber.* I. ii (Viola and Sea-Captain): *Platform.* I. iii (Toby-Maria-Andrew): *Study* and *Platform.* I. iv (at Orsino's): *Chamber.* I. v (Olivia-Viola-Malvolio): *Study* and *Platform.*

II. i (Antonio-Sebastian): *Platform.* II. ii (Viola-Malvolio in Street): *Platform.* II. iii (drinking scene): *Study* and *Platform.* (with centre-trap open for cellar). II. iv (at Orsino's):
Chamber. II. v (Box tree): *Study* and *Platform.*

III. i (Viola-Feste-Toby-Olivia): *Study* and *Platform.* III. ii (Toby, etc.): *Study* and *Platform.* III. iii (Sebastian-Antonio): *Platform.* III. iv (cross-garters, duel, arrest): *Study* and *Platform.*

IV. i (Sebastian-and-Olivia): *Platform* and *Study.* IV. ii (Sir Topas): *Platform* (with wicket, and bay-window above). IV. iii (Sebastian-Olivia): *Platform* (other door).

V. i *Study* and *Platform* (at Olivia's; "if you will let your Lady know I am here to speak with her . . ." (45) and "Heere at my house" (331)).

Thus the Duke's scenes (the static scenes, with a minimum of movement) are all in the *Chamber* (until he visits Olivia at the end), and the *Study* needs but two sets: Olivia's apartment (I. iii and v; II. iii); garden-set (II. v.; III. i, ii, iv; IV. i; V. i). An interval after II. iv makes easy the transformation of the Study from Olivia's apartment to the garden-set.

APPENDIX III

A selection from T. W. Baldwin's conjectural cast-lists is given below. For the complete lists the reader is referred to *Organization and Personnel of the Shakespearean Company*. Baldwin's chronology differs (especially in the early years) from that of Chambers, which I have adopted as representative of the orthodox view. The asterisks indicate those characters whose casting is based on external evidence; (w) after the date means "winter" and (s) "summer".

	Richard III 1593 (w)	A Midsummer Night's Dream 1594 (s)	King John 1595 (s)	Richard II 1595 (w)
PHILLIPS	Edward IV	Theseus	King Philip	Bolingbroke
BURBADGE	*Richard III	Demetrius	John	Richard II
POPE	Buckingham	Quince	Philip	Mowbray
LOWIN				
BRYANE	Stanley	Philostrate	Pandulph	Gaunt
CUNDALL	Richmond	Lysander	Salisbury	Northumber- land
OSTLER				
HEMINGES	Hastings	Egeus	Hubert	York
SLY		Flute	Lewis	Harry Percy
UNDERWOOD				
SHAKESPEARE				
KEMP		Bottom		
ARMIN				
COWLEY			Robert	
PALLANT	Clarence			
BELT				
COOKE	Margaret	Helena		
TOOLEY	Elizabeth	Puck		
GOFFE	Anne	Oberon	Constance	Queen
ECCLESTON	Duchess of Y.	Hermia	Q. Elinor	D. Gloucester
GILBURNE	Prince Edward	Titania	Arthur	D. of York
NED SHAKE- SPEARE	York	Hippolyta	L. Faulcon- bridge	
WILSON				
CROSSE				
EDMANS				
RICE				
SANDS				
ROBINSON				

	1 *Henry IV* 1596 (s)	2 *Henry IV* 1596 (w)	*The Merchant of Venice* 1597 (s)	*Romeo and Juliet* 1598 (s)
PHILLIPS	Henry IV	Henry IV	Gratiano	Benvolio
BURBADGE	Hal	Hal	Bassanio	Romeo
POPE	Falstaff	Falstaff	Shylock	Mercutio
LOWIN				
BRYANE	Worcester	Scroop	Morocco	
CUNDALL	Northumber-land	Northumber-land	Antonio	F. Laurence
OSTLER				
HEMINGES	Glendower	Chief Justice	Salarino	Capulet
SLY	Hotspur	Lancaster	Lorenzo	Tybalt
UNDERWOOD				
SHAKESPEARE			Duke	Escalus
KEMP		Shallow	Launcelot	*Peter, etc.
ARMIN				
COWLEY		Silence	Gobbo	Sampson
PALLANT				
BELT				
COOKE				
TOOLEY				
GOFFE	L. Mortimer	L. Northumb.	Portia	Juliet
ECCLESTON	Mrs. Quickly	*Mrs. Quickly	Nerissa	Nurse
GILBURNE	L. Percy	L. Percy	Jessica	L. Capulet
NED SHAKE-SPEARE	Francis	Doll		L. Montague
WILSON				
CROSSE				
EDMANS				
RICE				
SANDS				
ROBINSON				

	Much Ado About Nothing 1598 (w)	Henry V 1599 (s)	Julius Caesar 1599 (w)	As You Like It 1600 (s)
PHILLIPS	Don John	Constable	Cassius	Frederick
BURBADGE	Claudio	Henry V	Brutus	Orlando
POPE	Benedick	Fluellen	Casca	Jaques
LOWIN				
BRYANE				
CUNDALL	Don Pedro	Canterbury	Antony	Oliver
OSTLER				
HEMINGES	Leonato	Exeter	Caesar	Duke Sr.
SLY	Borachio	Dauphin	Octavius	Silvius
UNDERWOOD				
SHAKESPEARE	F. Francis	Charles	? Poet Cinna ? Cicero	*Adam
KEMP	*Dogberry			
ARMIN				Touchstone
COWLEY	*Verges			William
PALLANT				
BELT				
COOKE				
TOOLEY				
GOFFE				
ECCLESTON	Beatrice			
GILBURNE	Hero	Katherine	Portia	Celia
NED SHAKE-SPEARE	Margaret	Alice	Calphurnia	Rosalind
WILSON	Balthazar	Isabel	Lucius	Phebe
CROSSE	Ursula	Mrs. Quickly		Audrey
EDMANS				
RICE				
SANDS				
ROBINSON				

	Twelfth Night 1600 (w)	Hamlet 1603 (s)	The Merry Wives of Windsor 1603 (w)	Othello 1604 (s)
PHILLIPS	Malvolio			
BURBADGE	Orsino	*Hamlet	Ford	*Othello
POPE	Toby			
LOWIN		Claudius	Falstaff	Iago
BRYANE				
CUNDALL	Antonio	Horatio	Page	Cassio
OSTLER				
HEMINGES	Fabian	Polonius	Host	Brabantio
SLY	Sebastian	Laertes	Fenton	Roderigo
UNDERWOOD				
SHAKESPEARE	Sea-Captain	*Ghost		Duke
KEMP				
ARMIN	Feste	1st G. D.	Evans	Clown
COWLEY	Aguecheek	Osric	Slender	
PALLANT				
BELT				
COOKE		Rosencrantz	Caius	Lodovico
TOOLEY				
GOFFE				
ECCLESTON				
GILBURNE	Olivia	Fortinbras		
NED SHAKE-SPEARE	Viola			
WILSON		Ophelia	Mrs. Page	Desdemona
CROSSE	Maria	Gertrude	Fairy Queen Mrs. Quickly	Emilia
EDMANS			Mrs. Ford	Bianca
RICE			Wm. Page	
SANDS			Anne Page	
ROBINSON				

	Measure for Measure 1604 (w)	King Lear 1605 (w)	Macbeth 1606 (s)	Antony and Cleopatra 1606 (w)
PHILLIPS				
BURBADGE	Angelo	*Lear	Macbeth	Antony
POPE				
LOWIN	Lucio	Gloucester	Banquo	Enobarbus
BRYANE				
CUNDALL	Duke	Edgar	Malcolm	Caesar
OSTLER				
HEMINGES	Escalus	Kent	Ross	Pompey
SLY	Claudio	Edmund	Macduff	Menas
UNDERWOOD				
SHAKESPEARE	Peter		Duncan	Lepidus
KEMP				
ARMIN	Pompey	Fool	Porter	Clown
COWLEY	Elbow	Oswald	Old Man	
PALLANT				
BELT				
COOKE	Provost	Cornwall	Lennox	
GOFFE		Albany		
TOOLEY				
ECCLESTON				
GILBURNE		?King of F.	?Siward	?Agrippa
NED SHAKE-SPEARE				
WILSON	Isabella	Goneril		
CROSSE	Overdone			
EDMANS		Regan	L. Macbeth	Cleopatra
RICE	Juliet		Hecate	Charmian
SANDS	Mariana	Cordelia	L. Macduff	Octavia
ROBINSON			Son	

GENERAL INDEX

INDEX OF CHARACTERS

(For characters in *Macbeth*, see also pp. 276–312)

INDEX OF PASSAGES

The following Index is a select list of those passages on which my comments may perhaps be helpful to producers:

McBride, Henry

704.9
mcB

AUTHOR

The Flow of Art

TITLE

DATE DUE	BORROWER'S NAME

INDEX

A

"Absence of Mabel Dodge" (Dasburg) 54
"Abstract" (Kandinsky) 335
Abstract art 264–65
Academy of Natural Sciences (Philadelphia) 134
"Actaeon Pursued by His Dogs" (Manship) 209
"Ada Rehan" (Sargent) 199–200
Adams, Henry 27, 427, 428
"Adirondack No. 7" (Homer) 332
African art, Stieglitz and 70–71
Aldrich, Mildred 7, 41–42, 431
American art, essay on 163–66
American Art Association 60
American Club (Paris) 338
"American Gothic" (Wood) 25
Amiel, Henri Frédéric 34
Amster, Frederick 315
"Amy Folsom" (Duveneck) 359
Anderson, Sherwood 191, 287, 353
Anderson Galleries 166, 182, 212
Angell, Norman 441
Angus, R. B. 115, 118
"Annunciation" (De Chirico) 238
Apollinaire, Guillaume 20, 409
 "Bestiaire" 144
Arensberg, Mr. and Mrs. Walter 9, 156–59, 292
Armory Exhibition of International Art 19, 20, 33, 35, 36, 39, 43, 52, 55, 56, 75, 124, 189, 216, 249, 294, 335, 429–30, 440
 MOMA compared to 369, 372
 Exhibition at Museum of Modern Art 333–36
 Weber's "Comprehension . . ." 94, 95–96
Arno, Peter 244–46, 320
Arp, Hans 336, 423–24
Art Center 214, 215
Art in America 119
Art News, The 26, 432, 438, 443
"Art photography" 162–63
Art Students League 3, 103, 233, 433
"Artists Judging Works of Art" (Bellows) 113
Artists and Artisans Institute 3, 17, 18

Arts, The 9
Ashley, Minnie (Mrs. William Astor Chanler) 6
Ashton, Frederick 315
Askew, Mrs. Kirk 15, 311, 315
"Assia" (Despiau) 373
Association of American Painters and Sculptors 19
Ault, Mr. and Mrs. Lee 410
Austin, A. Everett, Jr. 313
Austin, Mrs. A. Everett, Jr. 312
Averell House 304

B

Babcock Galleries 384
Bacon, Peggy 26
Bahr, A. W. 95
Baker, J. Bryant 225
Bakst, Leon 35–38
 "Sultana" 35
Balken, Edward 325
Ballet Russe 36–38, 175–76
Balthus, Balthasar Klossowsky, a.k.a. 365–66
 "Summer" 365–66
Bandinelli, Baccio 328
Barlach, Ernst 278
Barnard, George Grey 168
Barnes Foundation 433–38
Barr, Alfred 315, 370, 432–33
Barrès, Maurice 261
Barye, Antoine Louis 412
Bastien-Lepage, Jules 148
"Bathers" (Cézanne) 431
"Battle of the Lights, Coney Island" (Stella) 54, 55
Baudelaire, Charles 5, 16, 208, 231, 258, 393
"Bay, The" (Demuth) 70
Baziotes, William A. 443
Beardsley, Aubrey 48, 271
Beaton, Cecil 350, 351
Beaux, Cecilia 415
"Beatrice Goelet" (Sargent) 196, 197
Becker, John 311–12
Beckmann, Max 24, 277–78, 372
Belling, Rudolph 278
Bellini, Giovanni 350
Belloc, Hilaire 216

447

ENVOI

SHORTLY BEFORE *Henry McBride's death the Archives of American Art had asked for an interview to have a voice recording made of his thoughts on art. To have to speak while a recording machine was whirling away in the room frightened him, and he responded that he felt he was then too old and that one could place greater reliance on his written word.*

But a book with some of his writings Henry McBride did wish. During the late nineteen fifties he had consulted with Daniel Catton Rich about a reprint of his best contributions to The Dial. *A selection was made but it became apparent that these essays alone covered too short a period to reflect the scope of his work.*

After Henry McBride's death I reopened the subject with Dan Rich, who agreed to review all of Henry McBride's writings, both for the Press and for Art publications. It was a long and often unavoidably interrupted effort. Writings over a period of more than forty years had to be read and selections made. Regrettably, many important pieces had to be eliminated. The final choice forms the pages of this book — an always interesting, witty and informative story of the flow of art of Henry McBride's time.

My appreciation goes to Daniel Catton Rich for the fine selection he made, but also to my friends, Harold Ogust and Andor Braun, with whose help this book has now become a reality, fulfilling Henry McBride's most cherished wish.

Maximilian H. Miltzlaff

stumble over references to Matisse, Juan Gris, Picasso, Léger, etc., etc., before arriving at the exhibitor's part of the work. I refer of course to the exhibition of "Fifteen Americans" at the Museum of Modern Art, and this may surprise you, for I have been told at the Museum that the show did not enjoy a "good press." This must have been, I am persuaded, because the press saw it only once, for the extremely large canvases of Jackson Pollock, Mark Rothko, Bradley Walker Tomlin and Clyfford Still are certainly breath-taking and bewildering at first contact. They take seeing. As far as I have heard, the accounts of them which you have already read in *Art News* are the only ones to grant the exhibition the importance which I, too, am convinced it has. The trouble hinges, of course, on this question of size. How big can you get with impunity? Immensity must be distinguished from inflation, a very bad word especially in these days; and simplicity, desirable as it is, must be kept away from the abyss where it vanishes into nothingness. But Tomlin, Pollock and Rothko use size as a weapon, and this is especially the case with Rothko, who unites it to simplicity to suggest the serenities and possibilities in vast regions on earth where people are not. Or, perhaps he merely looks at us from another planet. Dissenters there are to his right to do this sort of thing, and there will be many more to claim these gigantic pictures to be part of the irrepressible American braggadocio that Dickens and Kipling accused us of years ago; but for my part I conclude that when big sizes and largish styles say something, then big sizes and largish styles are justified. And Pollock, Rothko, Tomlin, Still, Lippold, Kiesler and Baziotes, in their various ways, say plenty. And at this, I hold, a new cycle begins.

Art News, June, July, August 1952

us, looking about to see what we could salvage from the ashes in 1918, secretly began to feel that what had been lost to the world in Europe would eventually be refound in America.

On their return, however, the prodigals complained that America had become a much harder place to live in than it used to be, and there did seem to me to be some truth in the accusation. The consolations of Greenwich Village, as I have already said, appeared diminished and in the more frequented parts of the metropolis the eye was hemmed in by hardness in every direction and the extraordinary newness of everything prevented the play of fancy. It was difficult to grow attached to a skyscraper and the streets had nothing else to offer. Years before this, Lord Houghton (Monckton Milnes), when visiting Walt Whitman had said: "Your people do not think enough of themselves. They do not realize that they not only have a present but a past, the traces of which are rapidly slipping away from them." Were he to revisit us now from the Shades he would more than think his prophecy confirmed by fact. New York has destroyed its past. It must be for that reason — for the total lack of mellowness — that our artists since the war turn more and more to hardness as a method of expression, and hardness, say what you will, is not lovable. Not only that but it constitutes a positive danger, keeping the nations with whom we would most like to be friendly at arm's length. André Siegfried has lately been studying the tendencies of civilization as they are manifested here in the United States, and in the last of his articles to appear in the *Figaro*, January 10, 1952, one finds this significant passage: "Il y a un idéalisme américain, c'est incontestable, mais il s'alimente d'appels matériels et s'exprime guère qu'en mesures quantitatives. De là vient, je crois, l'èchec de la propagande américaine dans le monde. L'esprit human demande encore autre chose."

Think that over, fellow-citizens. . . . Had this little memorandum of changes occurring within fifty years been attempted a month ago I should probably have ended it upon the above lugubrious note, and I should certainly not have used the word "cycle" in the beginning without some hope of justification for it, since that word suggests a return to a point completing a circle, but at the moment of this writing something of the sort seems to have happened. A few American artists, at long last, seem to have gone completely native, and for the first time since these wars, it has not been necessary to

younger then and more in contact with "goings-on," but I do believe more actually was going on, of a social nature, I mean, and that the artists had more fun. There was a closer link between artists and people-in-general than I can detect now. Mr. Chase gave a party for the great Carmencita in his studio the like of which has not been seen since (for Carmencitas are not frequent); Mr. Saint-Gaudens, so the medallist John Flanagan told me, occasionally asked in a lot of friends for a concert by a string quartet; and the excited attendance of "important people" at the Academy when a new Sargent portrait came along are part of my remembrance; and the second part of it is of a greater animation in Greenwich Village than exists there, I fear, at present. It is true, e.e. cummings still lives in Patchin Place and Edgar Varèse still resides on Sullivan Street, but the happenings in the Village life do not echo around the town as they used to. What "occasions" they were, to be sure, when *Emperor Jones* and e.e. cummings' *Him* were first played in the Provincetown Theater, and what a lot they did for the denizens of the quarter! And où sont les neiges d'antan?

Like all the other sinners of forty years ago I used to go abroad every summer and thought nothing of it until 1913, when, going over as a journalist I was obliged to look a little more concernedly at what I saw. Confronted with the mobs of American art students at the Cafés du Dôme and Rotonde, filling the sidewalks completely and at times making even the roadway impassable, suddenly the scales fell from my eyes and the spectacle shocked me. What are we all doing here? I asked myself angrily. Have we no life of our own that we must come here to find out what life is all about? — for there was scarcely a pretense that it was technique that the students were after. By that time it had been generally agreed that all the A.B.C.'s of painting and sculpture could be learned in America as well as elsewhere, and so at once on my return I began scolding about the truants I had seen. I even went so far as to print a lot of their names, begging them, like a holy missioner, to come back into the fold ere it was too late. Naturally none of them heeded the outcry. However, home they did come the very next year when the great war burst upon us. Convinced as I am that war consumes spirit as avidly as it does property and that Sir Norman Angell is quite right in declaring that no one ever wins a war, nevertheless most of

from America because the "voices there were too rough,"
fled finally himself because of the leanness of the New Eng-
land background against which he had been so uncomfort-
ably but prosperously lodged for so many years. Although
not quite a churchman, he yearned for the neighboring pag-
eantry of the Church and is even now happily and unrepen-
tently ensconced in a nursing home in Rome and breathing
in the picturesqueness of ecclesiasticism and the sense of
the past "for free," as we say, and without any special obliga-
tion to attend Mass. This wears only a slight aspect of cheating
for, after all, Mr. Santayana was born a Spaniard and brought
to the States quite as much as he took away. By the same
token, and for the same reason, the voice of criticism is seldom
raised against the painter John Singer Sargent, for without his
own consent he was born, truly of American parentage, but
in Italy, and actually, if not legally, was a European ever after.

But in regard to Kenyon Cox, thought by some, fifty years
ago, to be an American Ingres; William M. Chase an American
Manet; and John Twachtman, Alden Weir and Childe Hassam
doing the Pissarro, Monet and Sisley stuff for us — the case is
very different. All of them, vigorously advertised as evangelists
of the foreign method of painting, ended in becoming self-
conscious mannerists. It is true all of them were gifted and
Twachtman and Weir were genuinely poetical, but their bor-
rowed clothes did not fit them so well as they supposed and
Albert Ryder, who knew next to nothing of foreign fashions
and was poet first and painter second, was already taking rank
above them in the public estimation. Their heyday was already
declining in the period just before the first great World War,
which was also the period when I was called in to look at their
work professionally for the *New York Sun;* and it seems rather
cruel, looking back at it from a distance, to note how brusquely
they were shuffled off the pages of the newspapers to make
room for the sensations of the famous Armory Show of 1913.
Those of them still surviving at the time expressed their horror
at the work of the Post-Impressionists and oncoming Cubists
in screaming words which did no good. Their time was up and
almost before we knew it they were buried in museums or in
remote private collections and had dropped out of casual studio
conversations.

With their eclipse something else dropped out of New
York life which I can't help regretting. It may be that I was

lacked they certainly had the quality of being to the manner born.

Actually, in those still youngish days of myself and my artist-friends, we knew too little of the Hudson River people to despise them. What we felt for them was merely vague indifference born of a superciliousness handed down by the snobs of preceding generations and accepted by us unthinkingly. Supposedly they were pathetic specimens unworthy of serious consideration and so we didn't bother with them. Who wished this evil-thinking upon us? Who launched a thousand ships to foreign shores to accommodate the mad rush of tourists, once we had learned to be ashamed of our Hudson River? I never did find out, but I suspect the seeds of it came over in the *Mayflower* and have lurked suspiciously in the byways ever since. Certainly as far back as I go in my studies I find traces of it. In 1843 the brilliant Margaret Fuller spent a *Summer on the Lakes* and wrote a book about it, visiting by boat Cleveland, Chicago and even remote Mackinaw. She was fascinated by the Indians and enraptured by the unspoiled beauty of the suburbs of the settlements, but being *über alles* a feminist, she wept copious tears over the tragic fates of the lady-wives of settlers, when they were ladies, as sometimes they were; for, being one herself, she knew precisely what the poor things were giving up for the sake of their exploring husbands, and in concluding her estimate of their predicament said this: "Everywhere the fatal spirit of imitation, of reference to European standards, penetrates and threatens to blight whatever of original growth might adorn the soil." This was in 1843, mind you, long before the flight of Henry James, George Santayana and boat-loads of lesser lights led worried observers into suspecting that, after all, our design for living, wonderful as it was, was not complete enough to satisfy all the requirements of the soul nor even the requirements of certain specialized eyes. Henry James, so Edith Wharton reported, "often bewailed to me his total inability to see the 'material,' financial and industrial, of modern American life." Wall Street and everything connected with the big business world remained an impenetrable mystery to him, and knowing this, he felt he could never have dealt with the American scene. George Santayana, after confessing that he never had much sympathy with those aesthetic souls that fled

been. There might, though, be some available notes in Dr. Dewey's diary — if he has one. I shall continue to look in that direction.

Art News, September 1951

HALF A CENTURY OR

A WHOLE CYCLE

IN THE first decade of this century when *Art News* was extremely young (born 1902), the term Hudson River School, as applied to American art, was a term of reproach, meaning not so much *native* as *native without style,* or — as we would say in the present state of our sophistication — *hick.* Style was something to be purchased in Europe, preferably in Paris where the most celebrated emporiums for it were located; and those who had already got some of it were the heroes of our preoccupation. That these heroes of fifty years ago, whose names were signed to the pictures that always got the best places in the National Academy exhibitions of those days, no longer "occupy" us, or at least not much, and have been succeeded at long last by a militant group of young painters and sculptors who boast the exactly opposite tentatives of wishing to separate from Europe rather than to cling to it, indicates that something like a cycle in our history has been achieved. Are we not now in 1952 peremptorily demanding and hesitantly claiming from our men the very qualities which once we refused to acknowledge in the works of our despised predecessors of the Hudson River School? For whatever else they

floor and leaning against the wall; (2) the Matisse portrait of a Riff chieftain, which remains to this day one of my favorite Matisse masterpieces; and (3) the group of remarkable Soutines which gave me my first inkling of this artist's stature. By the time the dinner hour arrived we had all made sufficient discoveries to put us in a holiday mood and the table-talk was animated in the extreme. The dinner itself was admirable in every way, good food, more of that fabulous whisky (of which the Doctor was said to have an unlimited supply) and the sense borne in upon all of us that we were participating in a really exceptional occasion. If there had been the faintest touch of eccentricity anywhere in this entertainment I failed to notice it.

Again a few years passed and again I got an invitation to come see the collection, but this time, to my grief, I could not accept. The young Pinto boys (two of them, I think) were given a show in the Bignou Gallery and Dr. Barnes himself supplied the introduction for the catalogue. In my little notice of the show in the *New York Sun*, I saw fit to quote about an inch from Dr. Barnes' remarks. This pleased him inordinately and immediately he wrote asking me down for any week-end in May I chose, saying I could have the entire museum to myself after the pupils had left on Saturday, and adding that all that I wished of the famous Scotch would equally be at my command. This would have been the perfect chance to study both the collection and its owner, but unfortunately all my week-ends that May were already irreclaimably taken — and the opportunity never came again.

This is the sum of my experience with Dr. Barnes, not very illuminating, as I have already said, but showing at least that he could be kind and gracious. I suspect there were more of these private graces than he has been given credit for, and so I hope, when the biographers do get busy they will minimize the psychiatric approach, for so far we have had almost nothing but that, and play up the revelations that may be wormed from Dr. Dewey, Mr. Bullitt and Miss Cornell. How inestimable and clarifying a boon it would have been, in a situation like this, had there been by chance a dictaphone record of one of Miss Cornell's conversations with the Doctor on the subject of the difficult art of Soutine! But I don't imagine the fates arranged anything so satisfactory for us as that would have

Glackens had helped in making the first purchases for the Foundation, so it was reasonable to suppose that the Doctor might have said something to somebody.

However, time passed along. Quite a lot of time passed along, and then one morning I was both pleased and astonished to receive an invitation to be Dr. Barnes' guest at Merion upon the occasion of a reception to be given there for Vollard, the famous Parisian expert and dealer who first exploited the work of Cézanne. The invitation added that M. Vollard would honor us with an address – a double excitement and pleasure. I accepted at once though pondering somewhat upon my possible status as a guest. The invitation, I knew, I owed to Étienne Bignou whose galleries both in Paris and New York had always been closely allied to Dr. Barnes; but did the latter know? I wondered, and therin did the Doctor injustice. He never took chances on things like that. He knew precisely who his guests were to be. We were a rather gay party going down, almost filling a Pullman, and being met at North Philadelphia by a flock of motors which whisked us quickly to Merion. In one of these motors I had my first and only chat with Professor John Dewey, but at this late date I can't recall a word we may have said to each other – which makes me slightly ashamed of myself. At the gates of the Foundation we met with a hearty welcome and I found myself being greeted by name. Mrs. Barnes, too, made a point of seeking me out and being particularly kind, so that it became apparent that the former villain was now looked upon as a friend. M. Vollard's address was given in French, very rugged and invincibly bourgeois, like himself, and as soon as he sat down M. Bignou repeated it in meticulous English for the benefit of the Foundation's pupils, all of whom were in attendance. After these pupils had retired, the New York guests were allowed to wander at will through the many galleries and those who wished were fortified by glasses of whisky (and soda) of a quality not often met with. I reserved my allowance until after I had made the tour of the rooms for it was then I needed fortifying. Truly the collection, on first acquaintance, is a staggering one; but I won't go into it now further than to say that the three high points for me were: (1) the meeting again with the Cézanne *Card Players* which I had seen many years previously in Paris at the little Vollard gallery, carelessly stacked on the

My own acquaintance with the Doctor was not particularly illuminating. It began stormily enough, but ended after many years in an atmosphere of aimiability. I first heard of him in the early years when I was writing for *The Dial*, then edited by Scofield Thayer who was so princely in his attitude towards his writers that he never eliminated a comma from their copy without first consulting them by telephone. So I was vastly surprised one day to be called up and informed that *The Dial* would be obliged to cut out a little anecdote from my Paris letter involving Braque, Dr. Barnes and Gertrude Stein. I protested, thinking the story innocent enough and knowing that anything about Gertrude always, as we say, "went over big," but I protested in vain. I was told that the situation was unexplainable, but very serious, and that anything about Dr. Barnes could not be printed just then. It appeared that Dr. Barnes was at war with *The Dial*, threatening death and destruction, to the magazine and ready to use any means to accomplish his ends, and as a matter of fact, it is to the strain of this conflict that I have always attributed the nervous collapse of Scofield Thayer which followed shortly after and brought on in its turn the death of *The Dial*.

However, all that was not my affair. My moment came later. When the memorial show to William Glackens occurred at the Whitney Museum I gave an adverse report of it in the *New York Sun*, holding in short, that a first rate illustrator had become lost when the artist took up painting. I admired somewhat the first big picture put forth by Glackens, the *Chez Mouquin*, but the long string of imitation Renoirs that followed after it, and which were his chief claim to attention, were not for me. This comment created a commotion. The group of painters most closely united to the Whitney Museum, all of whom adored Glackens, for it seems he really was an adorable person, decided not to like me for a while and, furthermore, the news came to me, from that source, that the great Dr. Barnes of Philadelphia was also much annoyed. The specific message said that he was actually preparing two heavyweight boxers (one would have been enough) to come over to New York to give me a horse-whipping. This threat was too barbaric to be alarming and I paid no attention to it; and of course nothing of the sort happened. It probably was just one of those rumors with which Greenwich Village in those days was rife. But everybody knew, of course, that

when the time comes to sum up the man's achievements and do justice to him. This time has come, of course, but just at the moment there is such a confusion of distorted anecdotes being hurled about that one hesitates to choose among them and there is the temptation to throw them all into the discard. And yet – and yet – the paralyzing terror which the amazing Doctor managed to put upon the entire American art world of this generation is something that will not fade quickly from the memory, and the chances are that in the final story it will assume an importance and an interest quite comparable to that of the great collection which he assembled, remarkable as that collection is.

So the biographers who are already, no doubt, sharpening their pencils and oiling their typewriters, will need plenty of help from the honest and unprejudiced persons whose contacts with the Doctor were beneficial in order to offset somewhat the defamations of those whose feelings got hurt when they were turned away with contumely at the doors of the Foundation in Merion. Oddly enough the small group of very distinguished citizens who were known to be on good terms with Dr. Barnes, including Professor John Dewey of Columbia, his late Excellency and still excellent Billie Bullitt of Philadelphia and Miss Kit Cornell of the New York stage, never, to my knowledge, came to his defense publicly when the victims of the Doctor's vituperation wished to vituperate back. I suppose he instructed them not to. I can easily imagine him saying: "I can handle this." And he did, marvelously effectively. I have known many brave and clever men who thought it the better part of valor to run for shelter when the Doctor began speaking up. Among these, for instance, was the famous John Quinn, equally astute as a lawyer and as a collector. His collection, in its day, was just as notable as that of the Barnes Foundation in this. He knew all the tricks of the law courts, was of the militantly Irish type, was accustomed to taking charge of the case when artists got into difficulties of any kind, and yet once on coming into collision with Dr. Barnes he decided, after thinking the matter over, that it would be wiser to keep out of the argument rather than win it, though certain that he could. This remained the model behavior which lasted for some time and those who ignored this pattern invariably came to grief. When the affair was over they always wished they hadn't.

tactics of handball to the brushwork of the ancients, and thus coming upon his Hiroshima effects honestly. Peering over the heads of the students to see a portion of a Pollock, I thought it might be the one I had seen and admired at the Whitney Museum last year, but could not be sure, and part of another might have been the masterpiece that Mr. Hess commended in the current show of abstracts at the Museum of Modern Art. Paleontologists, of course, can reconstruct the whole animal for you from a mere segment of bone, but art critics have to have the whole picture in order to come to an opinion about it. For my part, on these occasions, I use the word "masterpiece" relatively, calling it Mr. Pollock's masterpiece, but not necessarily the world's masterpiece, though if the world later on insists upon it, as Hiroshimas both real and pictorial become more frequent, I shall assent to it amiably. For I take the world as I find it, not as I would wish it. I confess I enjoy this present student excitement about Jackson Pollock, whether it materializes into something more solid than excitement or not, and the more particularly, since Mr. Laurence Campbell, of the League's staff, tells me that the artist was once a pupil of Thomas Hart Benton! This wild departure of pupil from master puts a certain cachet upon Pollock. As a rebel he runs true to form and consequently will be watched.

Art News, March 1951

DR. BARNES R.I.P.

NOW THAT Dr. Barnes is dead all the tongues are loosed. . . . People can say anything, without fear of those dreadful reprisals — and believe me they will. That will be the danger

recognized the finality of its characterization. Any child, of course, can see the oddities in the drawing of the face, the appraising eye lifted so curiously, and the general mask-like effect of the whole, but Picasso knows all there is to know about facial construction and did what he did consciously. Evidently he was already toying with the scheme of "several aspects at once" that he brought to such riotous conclusions in the Dora Maar series of portraits put forth not so long ago. In any case, this Gertrude Stein portrait keeps her strangely alive and enables her to dominate any room in which she finds herself – much as she used to do at 27 rue de Fleurus.

Art News, February 1951

JACKSON POLLOCK

WISHING TO see the Jackson Pollock paintings at the Parsons Gallery I found it necessary to employ football manoeuvres to get in, the room being already so crowded. The scene if photographed might have been mistaken for an alcove of the Stock Exchange upon a busy day, but the disputants unmistakably were art students, not brokers. (You can always tell them.) For the most part they had turned their backs upon the pictures and were not pontificating about them but rather imploringly asking each other how they, too, could do masterpieces such as these on display. I felt like telling the nearest questioner that if he had been the constant reader of *Art News* that he should have been, he would have known exactly how to do them, for Mr. Alfred Barr explained away last spring to our readers how Mr. Pollock placed his canvases flat upon the floor and dripped paint on them from a height, uniting the

birth in Spain, "ready-made" in those undoubtedly cubic houses imbedded in the Spanish hills, rather than in the famous remark of Cézanne's which is usually credited with starting the boys off on that tangent. She often expatiated at great length on this topic and wrote about it, too, convincing practically everybody of this theory except myself. Two admirable examples of the real cubism, by Braque and Picasso, done in the early period when the two were working at the formula along such similar lines that their productions were not easy to tell apart, hung near by, and came in handy for the arguments. The large sprawling nude by Matisse, now called *Blue Nude*, in the Cone Collection of Baltimore, was already one of Gertrude's items, I think, but am not sure, for I may have begun my acquaintance with it the day Gertrude piloted Mildred Aldrich and me out to the Matisse studio at Clamart where it then was. Mildred, who didn't quite like the picture, squirmed with embarrassment not knowing what to say to the artist awaiting her comment. Finally she blurted out: "I don't think I could take that pose." And when Matisse, who had almost as much embonpoint as she had, retorted: "Et moi non plus," we laughed, and the situation eased. Back again at 27 rue de Fleurus, I took great satisfaction in such small things as the *Man with a Pipe* (lent to Yale from the Harriman Collection), a study by Cézanne for his great picture of *The Card Players;* the small study of *Bathers* also by Cézanne (lent by the Cone Collection); and a maquette by Picasso of colored cut papers posed, in a glass box, in recession to each other like old fashioned stage-sets, and managing to retain the Picasso painting-touch just the same. Also, Gertrude once showed me a portfolio of Picasso landscape drawings, studies of trees and bushes by a river bank, done in the leafless winter-time, and quite remarkable. I have never heard what became of them nor have I ever heard them mentioned. Probably Alice Toklas still guards them.

But most remarkable of all these pictures and the one most meriting the term "masterpiece" is the portrait of Gertrude herself by Picasso. This strange, powerful, insistent, unforgettable work always brings to mind that sometimes-heard axiom: "A masterpiece is not a masterpiece at the moment of its creation, but becomes one as it ripens with time." Certainly this one startled all observers at first glance save the one who counted most, the sitter for it, who, true to form, instantly

ended and everybody in America had said something witty about Marcel Duchamp's *Nude Descending a Staircase,* the crowds of pilgrims became too dense for even Gertrude's energy to cope with, and her "Saturday Nights" gradually became less frequent and certainly less tumultuous. By the time I reached them, in 1912 or 1913, an evening party with Gertrude Stein and Alice Toklas (Leo Stein had already lost the faith and deserted the ship) was much like a party anywhere else though, of course, livelier. What made it lively was the presence of all the striking new young artists in Paris talking shop, the pleasantest kind of talk there is for those who talk it.

But there were no altercations. How could there be? Everybody had been vindicated. Cézannes had suddenly increased in price and the Metropolitan Museum, much against its will, had been obliged to buy one. Furthermore, the better dealers everywhere knew that works by Picasso and Matisse were merchandisable. But the stampede to acquire them got in the way of further Stein purchases. A year or two later when I happened to cite one of them to Gertrude as a "good buy," she shrugged her shoulders and said: "Of course I'd love to have it but I can no longer afford Picassos. They've grown too expensive. You seem to forget that when we formed our collection all our artists had their reputations to make and we had practically no competitors. Now, it is very different." There was no reproach, no sadness to this remark of hers. Jubilation rather. Apparently she delighted in this emphatic confirmation of her taste. What differentiated her from all other collectors was the fact that she collected geniuses rather than masterpieces. She recognized them a long way off. She spotted them when young. I don't know how old Picasso was when the bell began ringing in Alice Toklas' bosom at her first encounter with him, but I do know that it was a long time after that before the bells began ringing in any New York bosoms. Consequently this very delightful and truly informing art collection was notable more for early discernment than for final achievement. It was not rich. It did not contain a *Guernica,* a *Three Musicians* or a *Seated Woman,* but it basked in all sorts of premonitions of the masterpieces, such as these, that were to come along later.

For instance, there were the views of Spanish towns by Picasso which convinced Gertrude that cubism had had its

PICTURES FOR A PICTURE

OF GERTRUDE

THE "HOMAGE" to Gertrude Stein offered by the Yale University Art Gallery is a pretty gesture certain to captivate the fancy of the great American public which so unexpectedly took Gertrude to its heart without waiting to understand her, and the only pity about it is that she cannot be there among as many of the pictures from her collection as the Gallery found possible to reassemble in New Haven in this effort to do her honor as a collector. Or will she not be there? Those who ever knew her, those privileged ones who managed to meet her in the sacred precincts at 27 rue de Fleurus, will not be sure. Certainly, as long as they live, they will not, in their mind's eyes, ever separate Gertrude from the pictures she defended so valiantly in words that echoed around the world in the years just before the first of our great wars.

As a collection, Gertrude's, in proportion to its size and quality, was just about the most potent of any that I have ever heard of in history. To be sure, there was that unholy row in fifteenth-century Florence when Leonardo and Michelangelo made marvelous battle drawings in rivalry with each other, but since then there had been no comparable uproars of talk until certain early-twentieth-century Philistines attempted to tell Gertrude Stein and her brother Leo that their pictures by Cézanne, Picasso and Matisse were not art! ! ! Then, in effect, all H___ broke loose. It was the battered and bruised Philistines returning from these unequal contests to America who proved to be the most effective agents in spreading the gospel of modernism on this side of the ocean. Their distorted accounts of what happened, instead of damning Gertrude and Leo forever, "launched a thousand ships" in the direction of Paris, for most of those who heard the stories realized that however good or bad modern art might be, it was distinctly evident that lots of fun could be had on the rue de Fleurus and they wished to be in on it. After the Armory Show had

fore, and eventually several winners in the arguments will be recognized as heroes, will take on the attitudes of heroes — and the movement will be on. Marcel Duchamp will not be the only one to be surprised. We shall all be surprised for none of these heroes will be the ones the guessers expect. Henry Adams makes it quite plain that such matters are unguessable. But having mentioned Henry Adams and having cited the word "masses" another and more dubious suspicion enters my head. Since it seems we are destined to be fooled anyway, perhaps we have been fooled already. Perhaps these newcomers are already here and have already made their "play" — as they say at Monte Carlo. I am thinking of all that connotes with that word "masses." With the increasingly evident reluctance of "labor" to labor, it appears possible in the future that all the extras to mere living we shall do for ourselves or do without. We shall be our own cooks, our own ditch-diggers, and if we yearn for paintings will be obliged to paint ourselves. Something on this order is suggested by the vast army of Sunday-painters now beating on the museum doors and claiming fraternity with Poussin.

Somehow the prospect does not allure me much. For one thing I should immediately lose my job. There would be no demand for critics in such an era, and with no one howling for a standard, shortly there wouldn't be one. I shouldn't like that. You wouldn't either, dear reader; but, as Carl van Vechten once coldly suggested to me, on my complaining that I didn't care for Mary Garden's voice production, "Perhaps, you'll have other pleasures."

Art News, September 1950

I am here to tell you that there won't be one. Revolutions are démodé. There is no real need for them. They did not use to have them. They are modern inventions . . ."

There was a protest here from several voices at once, like those protests you hear in the Opera Quiz during the Metropolitan broadcasts, and after the hubbub had subsided a bit, Marcel, with a slightly fatigued air, consented to agree that Delacroix had been a real enough revolutionary, cutting sharply away from the official patterns of his time, but he positively refused credence to any earlier art-rebels and insisted again that revolutions had been overdone, stylized like modern business tricks and would not bear intelligent analyses. "This is a time of peace," he added. "Why not prolong it?"

As to all this I was not quite convinced. Not that I have any objections to "peace," though the word has taken on curious overtones at this particular period, but in the regarding of revolutions as obsolete I remained sceptical. I seem to be two-sided on the subject. Actually I think a conscious effort at usurpation, like the tactics of some of our politicians aspiring to the presidency, are always suspect, but on the other hand the world does turn 'round, and every so often an apparently new outlook upon life is reached, and in spite of the fact that dry-as-dust critics a century later looking at the affair un-enthusiastically are certain to say "plus ça change, plus c'est la même chose," nevertheless something that resembles a revolution may be distinguished on the faded records. However, in my experience — and I've seen two of them — the final triumph of the Impressionists and the still more emphatic triumph of the Post-Impressionists — the real business of the revolution seems to work underground, like the mysterious forces described in Henry Adams' *Rule of Phase as Applied to History*. They are invisible to the most acute observer and yet they overwhelm the world in the end with new necessities, new habits and even new religions. They seem to emanate from the masses who remain unaware of what they are putting forth.

Consequently this peace which Marcel talks about completely passes my understanding. To me it looks merely like fatigue, wartime fatigue. It's the price France is still paying for those two infernal wars. As soon as she gets her breath, as soon as we all get our breath, the Old Nick that is within us human beings will begin to stir again, altercations will arise, fists will bang the tables in cafés none of us have heard of be-

ing, and of course the Sweeneys, both Laura and James, are far too civilized to attempt to outshine a dinner guest.

Yet several days later I found myself still pondering over some of the things that were said and regretting that I had not jotted them down promptly and exactly. For a day, or for two days, I can remember a conversation, if I have really listened to it, with a fair degree of accuracy; but when a week passes by the whole thing becomes generalized and if I now try to recall some of the assertions that were made I am not at all sure I can tie them to the individual who uttered them.

Being what we were, two painters, two critics and the wife of a critic, it was inevitable that our talk should be shop-talk. I may have begun it when quitting the cocktail table for the dinner table by apologizing to Marcel for having stated in one of my reviews that most of the hurrahs for the sculpture of the Italian Marini had in reality been leveled at Paris in reproach for not having recently produced anything comparable. Marcel, living in New York, is the acknowledged but unofficial ambassador of good will from France to this country and so, if there were any inaccuracies in this surmise of mine, he would be the one to know it. But he readily enough confirmed my suspicion, agreeing that Marini was strong and worthy of all praise, but that there did seem to be a hint of something political in the excess of applause that was lavished upon him. If this were so — if it were true that a group of malcontents with Paris had crystallized here, then the obvious retort of Paris would be, someone suggested (probably Dali), instantly to produce a new genius to confute them. But Marcel, whose lean face had become slightly suffused with pink as though he found discomfort in the line our talk had taken, smiled cynically and said that geniuses were never produced by prestidigitation in any country. "Besides," he added, "we in France have no immediate need for new ones being so very content with the large supply we still have." It was the ambassador speaking.

He then went on to make the assertion that has been troubling me slightly ever since. He said: "You speculators think the time has come to say au revoir to Picasso, Matisse, Braque, Dufy et al., and you are eager to make acquaintance with the new boys who will astonish us and, of course, shock us in some new and unexpected fashion. You know that theoretically the revolution is due and you are impatient for it, but

JACKSON POLLOCK

THE NOTE of advance is sounded at once in the entrance hall by Jackson Pollock. For the first time I looked with respect and sustained interest upon one of his pictures. Previous works by him which I had seen looked as though the paint had been flung at the canvas from a distance, not all of it making happy landings. Even the present one has a spattered technic, but the spattering is handsome and organized and therefore I like it. The effect it makes is that of a flat, war-shattered city, possibly Hiroshima, as seen from a great height in moonlight. There is sparkle to the color and hints of a ribbon of a river holding the glimpses of the city together. The composition looks well in the entrance hall and will be the most discussed picture in the show.

The New York Sun, December 23, 1949

CONVERSATION PIECE

THE CONVERSATION at the James Johnson Sweeneys' dinner was not particularly brilliant. In fact it was not at all brilliant. Neither Marcel Duchamp nor I am inclined that way, preferring to talk quietly and speculatively (unless forced) and Salvador Dali was probably too tired from a hard day's paint-

by means of strange words. So I will be as clear and as brief as possible on the subject of Jean Arp.

He ranks today among the twelve most prominent artists of modern Europe. Like Brancusi, like Mondrian, he aims at reducing life to the simplest possible terms. Like both the others he gets it so very simple at times that it is no wonder that outsiders think it isn't art at all. Some of his upright figures in the present show look like the bone your dog drags home. Others resemble stones found upon the beach washed into smoothness by countless ocean waves. The pebbles on the beach, we all know, are not art. Pure nature is not art. The contamination of human interference must enter in before art occurs.

Arp's first pieces to become known here looked like enlarged replicas of rain-drops on the window pane, rounded, amorphous shapes that, though very slight, somehow fixed your attention. Almost subconsciously you recognized something in them, a something that might possibly change at any moment into something else; in other words, the quality of life.

At first, like most observers, I was skeptical about these pieces, but in subsequent encounters I had two "recognitions" which induced me to look upon Arp with respect. I will tell you them – and then let you go, for this time.

The first was at a Modern Museum show of applied art where some glass bowls for flowers had shapes obviously derived from Arp and were quite good looking. So I said to myself: "Ho, ho, one must really hand it to Mr. Arp. After all he has something." The second occasion occurred in the home of a private collector where a relief by Arp hung on the wall above the open fireplace. It was the suggestion of flames leaping up that no doubt helped the association, but anyway the shapes of the Arp relief had a curious buoyancy as though they, too, would stir and ascend. Again I spoke to myself and said, "Ho, ho, Mr. Arp. So that's it."

These still may seem slight matters to you, gentle reader, but don't be too sure in the Atomic Age, that anything is slight.

The New York Sun, January 21, 1949

upon pioneers. Some one had to do the rough work, and certainly he did his share.

Without him we never would have had a Ralph Blakelock or a Winslow Homer. It would only be necessary to place the Blakelock "Moonlight" owned by the Toledo Museum beside one of these by Thomas Cole to see the enormous difference there is between pre-Civil War and post-Civil War aesthetic thinking in America.

The New York Sun, January 14, 1949

ARP

EXPLANATIONS do very little explaining in regard to modern art, and arguments seldom convince. In fact I have never known nor heard of a conventional art lover won to modernism by talk. The only way the "twain do mix" is by possession, and if only the old-timer can be induced to own one of the things and live with it a while, then the chances are he will shortly join the parade of worshipers along with his youthful friends.

The main army of the modernists is made up of those who insist upon being modern at all cost, of those who instinctively seek for the accent of today in every department of living. Such, of course, will not have to be coaxed to study the work of Jean Arp, lately arrived in this country, and now showing in the Buchholz Gallery. They know all about him and adore him already. The trouble will be with "those others."

And it is with "those others" I mostly have to deal. Well, I have no intention of worrying them any more than they are worried — for it must be a worry to feel that they are out of touch with their own period — nor to throw dust in their eyes

certainty by accumulated evidence of His Presence. In other words, young countries have particular difficulty acquiring the habit of perfection since not enough people have as yet struggled for it and it is inconceivable that a lone first explorer in a new country – however gifted, should stumble upon it accidentally or recognize it if he did.

Looking back in a detached way at recorded history, we now can see easily enough why Adam's mistake in the Garden of Eden was inevitable. A standard of behavior, a sense of style, a knowledge of what art really is can only be built upon a vast amount of experience; upon, if you like, a vast amount of corrected mistakes.

Thomas Cole, like Adam, knew an Eden when he saw one and he found it in the Catskills in the 1830's, and like Adam again, failed to cope with the attractions of the place. He couldn't resist any of them – and that was his undoing.

When he came to painting his pictures of this Eden he hadn't the courage to leave anything out. He put every stick and stone into his compositions and the crags and waterfalls, believe me, lost nothing in his way of telling of them.

This was all right, of course, but unfortunately it wasn't great art. For a long time our people thought it was. They were delighted to have such a fuss made over their own rocks and rills, as who wouldn't be? and in that period of ardent aspiration and large programs for the future the difference between a super-salesman and a St. John of the Wilderness was not easily made out.

It required several generations of yet more strenuous aspiration before the general populace and a few painters in particular began to realize that art was chiefly a matter of choosing, and that a genuine artist ought to have something of the divine in his make-up. We apply the term "creator" to them, well aware that the same term is applied to the Sublime Creator of the Universe. They too must stand up to nature as though they owned it.

Thomas Cole did a certain amount of arranging in his pictures but very little elimination. Hence the grandeur of statement that you get in the best of Claude Lorrain, Turner and Constable – a grandeur that suggests that God is speaking through these men – is lacking in his work. Recognizing this, we do not, however, relinquish any part of our ancient affection for Thomas Cole. We owe him the gratitude we bestow

a sharp look at another who lurks behind a corner. Somehow that doesn't seem sufficiently important. What actually interested this would-be enthusiast was the way the girders of the elevated were drawn. They were done beautifully. But why go all the way down to Doyers street just to see girders?

As for Rowlandson, I suppose he did get through the Pearly Gates finally, but there is no use pretending he has as many stars in his crown as Daumier. It takes a lot of purifying before such habitual vulgarity is washed away, and I hope Reginald Marsh will give this problem some of his attention. His dancers in the "New Gardens" pictures look like lost souls. I suppose very pretty young girls dance occasionally with disreputable old gentlemen, but certainly the artist, in such cases, should do something about it. Reginald Marsh does nothing. He simply doesn't care. Daumier would have sailed right in and rescued all those girls.

The New York Sun, December 10, 1948

THOMAS COLE

THE THOMAS COLE revival at the Whitney Museum presents an awkward problem for critics. Pushed away from Europe as we have been during the recent years and compelled, in our search for spiritual guidance, to go out into the woods and look for gods of our own, there has developed a tendency — some call it patriotism — to think that very good gods lurk behind every tree.

But gods are not so plentiful as that and they do not lurk behind trees. God lives in the bosoms of the seekers for God and He becomes manifest only when belief is confirmed into

REGINALD MARSH'S DRAWINGS

THERE DOES seem to be an increase of style on the part of Reginald Marsh in the drawing he now shows in the Frank K. M. Rehn gallery, an increase in what we call — for lack of a better term — lyricism; and an increased effort toward simplification of statement.

If I say we could do with still more of the same it will sound no doubt like the perpetual scoldings of the critics but, que voulez vous? the critics must scold and scold until Reggie Marsh becomes as great as Daumier and Heaven knows he has not reached that point as yet. Rowlandson, perhaps. It may be he is edging in on Rowlandson, but not Daumier; and it is the very great kind of greatness we are yearning for in these United States and we don't see why Reginald Marsh shouldn't make an extra effort in that direction as well as any one else.

The angels in Heaven, who are not critics, rejoice in any sinner that repenteth but in the arts repentance is not valid unless followed by good works. St. Peter, who is a critic if there ever was one, will say to Reg: "Show me what you've done." Now you can't fool St. Peter. He has already seen the famous drawing called "La Soupe a Quatres Sous" and he knows that the "Bowery at Doyers Street" is not in the same class. So he will say to Reg: "Son, you're not ready for this place yet. You've got to simplify, simplify, simplify. Better stay in Purgatory a while until you do better."

This, of course, is hard advice to an artist who specializes in drawings of the millions on the summer beach of Coney Island, but simplifying the millions doesn't mean doing away with them but organizing them. There is an artist called Raffet who painted whole armies and who got by St. Peter almost as easily as Daumier and all he did was to give you the whole army in one impact on the eye so that in a shuddering glance you knew what the whole thing was about.

In the "Bowery at Doyers Street" you don't quite know what it is about. You see that it is sordid. The isolated men scattered through the street are unwashed. One of them gives

420

Museum of Modern Art (shown also in the Cleveland Museum) will be apt to strike the general public as a revelation, as news; for though a few enterprising American collectors have known these pictures for a dozen years or more, the layman has been unaware of all this loveliness. The event, in fact, may be said, to have brought the real Bonnard to us for the first time and to have made him international.

The career is shown very completely in the present exhibition and contains lessons for the collectors, the art critics, the art promoters, and the art students. It begins with a room full of the non-sensational early paintings which left us all so cold years ago but which contain, nevertheless, hints here and there of the Bonnard that was to be. Pictures No. 2, No. 4 and No. 5, near the door as you enter, are as much Bonnard as any that were to occur later, though of course without the famous ripeness.

It was not until I reached the 1914 pictures that I jotted in my catalogue "Here it comes," meaning the mellowness, but after that it came with a rush and all the pictures had it. I find I can't quite define "mellowness" satisfactorily, but anyway some of its attributes are ease in the presence of grandeur, freedom from frenzy and a general tonal balance of perception. Bonnard was not interested in proselyting for schools or theories, and I don't believe he was much concerned with the methods of rival artists, yet all the same, echoes from the outside world creep into his style here and there pleasantly and without in the least interfering with the general Bonnard spirit. By echoes, I mean some of the big spatial divisions in the delightful "window" pictures which remind one slightly of Mondrian, the "Table with Music Album" which suggests Matisse, the "Checked Table Cloth" which was some Paul Klee resemblances, and finally the long row of landscapes which are practically and adorably abstract.

The New York Sun, May 14, 1948

BONNARD

AT THE MUSEUM OF MODERN ART

WHEN AGE descends upon a human being, and the circum-
stances are otherwise propitious, mellowness results. It does
not always happen but clearly this is nature's intention. This
is argued because of the blessings which follow in the wake of
mellowness. The moment an individual is seen to have ripened
properly then people immediately begin to love him.

Among the artists this has been proven true recently by
Renoir and now even more noticeably by Bonnard. Renoir had
a long lifetime of being admired but in Bonnard's case, owing
to his shyness and to his intense objection to being considered
a public character it was only slowly realized that a bloom had
come to this quiet artist's color that was altogether exceptional
and that this, added to his devotion to the strictly bourgeois
ideals of French living (his subjects, you might say, seldom
got far away from the buffet and almost never outside the
dining room) constituted him a patriot of the first order.

He had been neglected in his early days because of the
excitements over Cézanne and the post-impressionists and be-
cause he did not seem to deny sufficiently the Monet-Manet
period which had just passed into history nor promise excite-
ments of his own. Excitement, in fact, was not Bonnard's
speciality, and the neglect, in consequence, was a blessing in
disguise, allowing the artist to consult his own taste un-
molestedly and to perfect his way of saying in paint that this
world was a really delightful place to live in and that France
occupied one of the most delectable corners in it. Once arrived
at this point it was seen that he had ripened, had become quite
mature in fact, and was presenting phases of French life in a
way to make him one of the outstanding artists of the period.
It was impossible not to love him for this and so the public im-
mediately proceeded to do so.

But because of this hesitancy in becoming a public per-
son the memorial exhibition of the Bonnard paintings in the

418

The argument is this; Jean-Paul Sartre says that painters put distant figures into their pictures and if you approach you may get nearer the canvas but you do not get nearer those figures. This seems to him a desirable arrangement, as no doubt it is, but he adds that the sculptors in the museums do not practice this virtue. As you advance upon their work they confront you with such a multiplicity of planes and relationships of parts that the essence of the whole performance vanishes in a cloud of confusion.

This sounds like going to some trouble to get into trouble and when you see the actual Giacometti sculptures in the Pierre Matisse Gallery the argument sounds more far-fetched than ever.

For these sculptures are the queerest that have ever come to us from abroad with such high recommendations. They are thin to the point of stringiness and do not invite you to touch for they have been built in sticky white plaster which results in picky surfaces. Happily you are not asked to touch. M. Sartre insists that the sculptor gives you only a distant view of people and you are not supposed to go near. If you did they would still seem to be far off. Also they are intangible and "have the ineffable grace of seeming perishable." They certainly have that. Just like human beings. Just like New York architecture.

M. Giacometti himself usually destroys them, looking on them as sketches and never quite satisfied with them. This sounds very engaging and is probably what entranced Jean-Paul Sartre. The childlike artist is always irresistible. But lately some of his friends have stayed his hand and hid his hammer. M. Giacometti could do with a little cash. It was thought the time had come to sell some of them.

No doubt the Modern Museum will buy one; also the Chicago Institute; also the Walker Gallery; also those several museums in California; also the Henry Cliffords of Philadelphia; for these very odd statues, combined with the reasonings of Sartre, are the kind that make talk and talks seems to be a modern necessity. As Jacques Prevert says of the musicians in one of his poems:

> "Tout le monde parlait
> Parlait, parlait;
> Personne ne jouait."

The New York Sun, January 23, 1948

GIACOMETTI'S

FIRST AMERICAN EXHIBIT

JEAN-PAUL SARTRE, it would appear, is attempting to carry the entire intellectual and cultural weight of modern France upon his shoulders. Jacques Prevert, who may turn out, in the end, to be the greater genius of the two – for genius is not to be measured by size and weight, as David taught Goliath several thousand years ago – is of no help at all in the present emergency.

Jacques Prevert has no inclination whatever to carry weights upon his shoulders. On the contrary he takes the grossest materials and blows them into shimmering bubbles which spatter so lightly against the walls of the Bibliothèque Nationale that the institution is not even aware that it has received a permanent dent. Jean-Paul Sartre, on the other hand, never disguises the weight of any enterprise he undertakes, and when he wishes to disconcert the directors of the Musée de Luxembourgh (for art and ethics are alike his province) he marshals every Gatling gun available for the purpose.

But I see I am about to mix my metaphor up, for the sculptor Giacometti is the least like a Gatling gun of any sculptor ever heard of, though he does sound like one in the detonations M. Sartre utters in his behalf. This is because M. Sartre uses the word "space" in his analysis of the sculpture in the catalogue for the first exhibition of the artist's work in the Pierre Matisse Gallery.

M. Sartre says that Giacometti destroys "space" which is almost as horrifying a thing to say as to say that he destroys the precious atom. Now "space" is a bad word and I know several scientists of repute who will get up and stamp out of the lecture hall in protest whenever the word is mentioned. Particularly that business of "space turning upon itself" is repellent. M. Giacometti not only turns upon himself but upon everything else, repudiating everything that has gone before him, including the lovely and majestic contours of Maillol.

struggle that meant life or death to them and doubtless they were well enough aware of the advantages of having a rather rich American lady as a member of their party. She was indeed an appreciable help. She not only did some buying of their works but induced some of her American friends to do likewise.

It was in this way that the famous Havemeyer collection came about. Mrs. Havemeyer was obliged, so she once told me, to keep most of her novel purchases made through the agency of Miss Cassatt, closeted until her friends and the public in general got used to them, but this finally did come about and in the end they became one of the chief glories of the Metropolitan Museum.

Rainer Rilke said in one of his famous letters that all women artists have to have at least one masculine shoulder to lean upon. Miss Cassatt leaned upon Degas, just as our Miss Beaux leaned upon Sargent. It shows chiefly in the drawing, which is always clearly and cerebrally understood. Otherwise her work is feminine enough. In fact she is the most feminine of all the women painters who have managed to get acknowledged on both sides of the ocean.

She became a specialist in maternity cases and in her madonna-and-child pieces it is the child who is invariably chief protagonist. These children have a peculiar and winning vitality. This naturally invites analysis and it gets it in the catalogue quotation of a mournful remark made by the artist in old age about having "mothered children only in painting." Certainly in art she mothered them well.

The New York Sun, October 31, 1947

MARY CASSATT

UP AT the Wildenstein Galleries they are saying that this present one is the first big one-man show that Mary Cassatt has ever had here. This must be so, for of course they must know what they are talking about, yet it does not represent a belated vindication of the artist nor a restoration to public attention, for she has never needed the one nor been without the other.

In my own somewhat long term of watching our public's behaviour toward its artists I have never known a time when there were not plenty of Mary Cassatts around, always well placed, and always respected.

"Respected," I believe, is the word. Not a creative talent, not path blazing, not the head of a significant and far-expanding school; but a sensitive, submissive and quite intelligent member of one that had already been launched when she came upon the scene.

Hard knocks in abundance had been administered to Manet and Degas, two impressionist chieftains who were formative influences upon the style Miss Cassatt was to have, and when it developed later into recognizable shape and she was invited to join the impressionists and show with them, there was still enough public antagonism against the group to give her a militant feeling in accepting the challenge.

But she was enchanted to be "in it." She said: "At last I could work with absolute independence without considering the opinion of a jury. I hated conventional art; I began to live." Americans as a rule adore being in on any movement. It is one of our frailties and it is what gets us into most of our scrapes, but Miss Cassatt got into no scrapes because of her espousal of a debatable cause. The animosities of the critics continued to be leveled at Manet and Degas and Monet and I have no record of any insults hurled at Miss Cassatt, though doubtless she got talked to severely by her conventional friends in Paris.

Her new confreres, Degas, Manet, Monet, Pissarro, et al, were entirely artistic personages and not to be accused of political-mindedness, yet they were engaged after all in a

414

I am a bit ashamed to be saying it again, yet it has to be repeated each time the Winslow Homer sermon is preached. They all could do the water, but knowing only how to do water, there was no contest. Homer alone comprehended granite.

Rising to greatness with the solution of this problem of opposing forces, it appears now that the sea had no further secrets from this artist. Certainly he rose to each great task in turn and conquered it with strange ease. In such pictures as "Eight Bells," "The Lookout," the "Signal of Distress," &c., it is no longer the rocklike cliffs against the sea but rocklike men against the sea — and essentially the painting formula is the same. It is impossible to say that they are greater than the seacoast pictures because all of them, both sets, are upon a superhuman level. All of them are what we call masterpieces and must be known as such wherever in the world they may be shown.

Like most of those who now look upon Homer with awe, I have had to go backward in my acquaintance with him, for I began at the top with the famous watercolors and the seapieces I have mentioned and only learned of the Civil War pictures and the various domestic scenes much later, but I am happy to report that I loved them all without exception. In seeing them I had the advantage of already knowing Homer to be great, for, as I said last week in my note upon the Picasso show, in the case of a great man it is necessary for the intelligent to go along with him wherever he goes.

With Homer this presented no difficulty. On the contrary, the simple and unpretending honesty of the early performances makes the later metamorphosis into the great style all the more dramatic and astonishing. How did Homer's painting language become so flexible? It seems like a blessing descending on him from on high. Every brush stroke in the "Signal of Distress" says what the whole picture says. How did he fix upon such perfect types for his woodsmen hunters and guides? The picture of the "Hound and Hunter," owned by Mr. Clarke and the watercolor version of the same theme, owned by Mr. Henschel, are such miracles of excitement and art and such sound Americanism to boot, that were I to write this article over again, I should be tempted to devote it entirely to them. But as a matter of fact, I feel that way about each item in the show.

The New York Sun, February 21, 1947

WINSLOW HOMER

IT CAN be done here. We can produce great art. Winslow Homer is the answer. As time goes on it becomes increasingly evident that he is our best man, the one who puts most into pictures of that which Americans have got out of life. There is a show of them now on at Wildenstein's; and believe me it is a show. Attendance at it should be made compulsory by law. It would strengthen the country.

We have everything necessary to the incitement of the production of masterpieces. We have birds equal to the skylark that Shelley heard, we have mountain lions equal in grace to those that Barye sculpted and Delacroix drew, we have snakes (heaven save us!) equal to the one that twirled around the Laocoon, and we have horses quite as beautiful as those on the inside relief of the Arch of Tito in Rome. We have everything save the will to do or die for beauty; but so far, and in spite of Walt Whitman's strident shouts to the poets to be up and at it, Winslow Homer is the only one to respond with the required measure of creative energy.

What did Winslow Homer have in the way of equipment? Above everything else — valiance! I once asked a musician what were the simple essentials to a musical piece. After thinking a moment he replied: "Two ideas that oppose each other and after a while one of them wins out!" When I repeated this to other musicians they invariably laughed. Definitions in art are always perilous, and always disputed. Perhaps that's the fun of them; but in any case I thought there was something in my friend's idea and I saw myself applying it nicely to Winslow Homer's work.

What were his two ideas? Water and rock. He saw the primeval conflict between those two elements and matched himself grandly to the portrayal of it. Something in the invincibility of his own soul finally taught him what a rock was. It is the difference between him and his 1,000 imitators that they have never felt the savage defense of those Maine rocks against the always attacking sea. I have said this so often that

412

May, of Baltimore and Blanche Knopf, of New York. Always interested in how movements start, I asked Pierre Matisse what arguments he used to persuade Mrs. Knopf to buy the "Pink Cow" by Dubuffet which she lends to the present exhibition. "No argument at all," Pierre replied. "No persuasion. She bought it all by herself in Paris. I merely brought it over for her." And there, I suppose, you have the explanation. Paris! Everything seems to clear in Paris. So many things back up the artist there and help you to understand.

What makes Dubuffet difficult for us Americans is his extreme nonchalance in regard to facts. Grandma Moses deals in facts; nice facts of course, but still facts; but Dubuffet takes as many liberties with the facts as a musician does with the theme that starts him off. He plays with them like an adult child – if you know what I mean. What wins the attention of those who are caught in his charms are his richly faded colors, his plastic touch and a lambent wit that is so hard to define that it might as well be dubbed abstract.

Dubuffet started as a gifted and flippant amateur whose artistic exploits amused his literary friends so much that they had to write about them; and this easy publicity aroused in turn the envy of certain other artists who didn't have it; so much so that they said things in rebuttal. In a brochure that has just arrived from over-seas the artist defends himself delightfully and irresistibly. He admits everything he is accused of and answers, practically, "so what?"

He begins every paragraph with "il est vrai que . . ."; and the first one is: "It is true that the method of design employed in these paintings is totally aloof from the kind of expertism generally found in pictures by professionals and it is also true that no one would need to undergo special studies or to have in-born gifts in order to do things like them. To that I reply that I find such studies and gifts exceedingly tiresome, their effects tending to suppress all spontaneity, to cut all communion, and to swamp the work with ineffectiveness. The most gracious way to talk is perhaps, after all, to use the simplest words; and to walk beautifully is it necessary to have longer legs than other people, or to walk upon one's hands?"

What can you say against that? Obviously nothing. It seems to be the perfect justification for the perfect primitive.

The New York Sun, January 10, 1947

would make up to explain myself, and those which others elaborate in connection with my work are nonsense. My paintings are my reason for my existence, my life and that's all."

The New York Sun, April 13, 1946

DUBUFFET

THE LATEST news from Paris is not exactly reassuring to those who hoped the war would put an end to "all that nonsense of cubism" and give us back something — if not pure Greek — then at least as near to it as Hiram Powers got with his American Greek Slave of years ago. It happened that way with the original French Revolution you know, but this recent World Revolution seems to have been different.

Bulletins from the city of light proclaim the painful fact that art is now no easier for dull people than it has been these twenty years past.

We got sufficient warning in the Henry Moore show of sculpture, for though this English artist softens his French with the accent of "Stratford-atte Bowe" he never attains the placidity reached by our Hiram Powers. On the contrary he provokes thought. And now we meet the paintings at Dubuffet (in the Pierre Matisse Galleries), the first French artist to emerge with a challenge from the war-chaos, and find that he is by no means a classic David. Far from it. He is a primitive, a conscious, determined, willful primitive; but no more like our Grandma Moses than Henry Moore is like Hiram Powers. Very dull people will never have a chance with him.

But the bright ones are already keen upon his trail. The Lee Aults have already bought one; and so has Mrs. Sadie A.

other things floating in the air. It was thought to be an effort at eccentricity, and especially since the colors were raw to the point of barbarity.

But the complete showing vindicates the artist. It is curious to note how thoroughly it does so. The artist, it seems is a poet. He is a first-rate colorist. He is an expert painter. He does whatever he sets out to do, and if there should be any trouble in the doing of it, he manages to conceal the effort from the spectator. The repetition of the cows, roosters and fiddlers up in the air is no more wearisome than the aspect of Fujiyama in the background of the Hokusai prints, for the symbol is not so much the real thing in the picture as the presence of the artist invisibly but persistently there. He is charmed with the jugglery he is able to do with his toys; his excitement is catching, his behaviour as a painter alluring.

What amazes and touches the beholder is the Russianism that this artist carries with him into distant lands. His latest pictures, after five years of New York, are as undiluted Russian as the earliest known ones, and though I had occasion to re-mark only a few weeks ago that the new pictures had an in-creased suavity in the brush-stroke that might be a concession to our rage for refinement, nevertheless the essential matters in the work were as Russian as Gorki. And if you ask how we Americans can assay the true Russian atmosphere, I can only say that we always do. Genuineness may be recognized when nothing else is. New Yorkers laughed with instant glee at the drunken peasants in the Shostakovitch opera, "Lady Macbeth From Minsk," done some years ago, knowing them to be the real thing. If you remember them at all, you must recall how perfectly Chagall they were. Chagall corroborates all the Russians.

James Johnson Sweeney, who arranged this exhibition, writes a documented history of the painter for the catalogue, giving details of the early village life, and of the later recog-nitions of the artist in Paris by the poets Cendrars and Apollinaire. In discussing the impossibility of charting the no-man's-land in which imaginative artists work, he quotes this excellent remark by André Lhote: "It is the glory and the misery of the artist's lot to transmit a message of which he does not possess the translation," and follows this up with Chagall's refusal to explain his work; "They are only pictorial arrangements of images that obsess me. The theories which I

type of morality even when we have no slightest intention of practicing it ourselves. We prefer to have the other fellow do it. Hurray for Charles Sheeler.

The New York Sun, April 13, 1946

CHAGALL

AT THE MUSEUM OF MODERN ART

MORE THAN most artists who have had one, Marc Chagall profits by the retrospective show of his paintings in the Modern Museum. He has never entirely lacked appreciation in this city for his works came with the stamp of Parisian approval upon them and collectors promptly appeared with sufficient courage to buy them, but the single pictures in occasional shows never quite explained the artist to a public that is always just a bit afraid of fantasy – his specialty.

With this big exhibition, where the artist carries you right out of this world into the realms of imagination where everything is as startling as it was to Alice in Wonderland and where anything can happen and does happen, he takes you with him easily. It is likely he will take most of us with him this time, not even those escaping who used to be known as the "lower classes," for really Chagall isn't above the heads of anybody and plays continually with the elementary mental pasttimes of humanity.

When his first examples appeared here there was some skepticism about the cows leaping over house-tops, about the figures with two faces and those with none at all, about the drunken fiddlers at the weddings, and the candelabra and

Why is this? I ask the question – but hesitate to answer it.

The new Charles Sheeler pictures in the Downtown Galleries go, at times, beyond tenseness into hardness. Americans don't seem to object to that trait either. Certainly they accept it without a whimper in the sculptures of Paul Manship, and the mechanics in the abstracts of Stuart Davis which offend me seem to offend no one else. At least, mine were the only outcries.

But are we drifting as a nation into general hardness? It's my country and, of course, I intend to stick along with it no matter what happens but I must confess I don't like hardness. I don't like bleakness and bareness and if Charles Sheeler has been holding the mirror up to nature and if half these things he says are true then he's got me worried. For myself I like a little fun once in a while. People who cannot occasionally play might just as well be Germans; or so I think.

Charles Sheeler, however, is a natural-born ascetic. He is what the cross-word puzzlers call an "essene." He is now much more essene than he used to be. When he first did those Bucks county barns in watercolor they were tense and taut, it is true, but they also had a neatness that verged upon elegance. When he was sent for by Henry Ford to photograph the smokestacks and engines of Detroit he did them with undeniable elegance. I remember that I was a bit scared at the time, thinking "this is the end of painting when machines can be made to flower into elegance in this fashion."

And now I am still more scared for Charles Sheeler seems to be spurning even this elegance of his. He is stripping all the garments from art. He paints a Shaker barn as though he himself were a Shaker. He is like a Mondrian who dispenses with charm. He refuses to beguile you in any way. He merely says: "Here is the thing, take it."

And the docile American public do take it. They now buy "things." All present indications imply that Charles Sheeler will not die, neglected, in a garret. On the contrary he will probably finish in a suite at the Waldorf – which, of course, would be O.K. with me – for I am a sentimentalist and love to see virtue rewarded – and what I think "gets" the American public in this intrigue with Charles Sheeler is, just as it was in the case of Mondrian, an admiration for his unflinching integrity.

We can always be counted on to cheer for the highest

True to his method of working, Léger saw last year a group of bicyclists in repose who impressed him, much as the divers had done, as being good material, and both the exhibitions now open illustrate his preoccupations with this idea. Already his larger variations on this theme have the power and thrust of ancient stained glass windows but even the first and smaller versions are welded into such firm and secure compositions that they make a valuable contribution to any wall.

It is the fashion to speak of the stained-glass quality of these productions, but no other term so truly describes these big groups of figures with wide bands of violent color traversing them in a way that seems both grand and natural. You don't question the colors that refract from an old window; and the Léger colors, too, have an authority of their own. But if you do happen to concern yourself with these bicyclists as people (most amateurs of modernism are so engrossed with the general style that they pay no attention to such details), you will observe them to be Parisians. What there is that makes the Parisian bicyclists so different from ours I can't say precisely, but the difference is there in the Léger pictures; introduced all unconsciously, no doubt, by the artist.

The New York Sun, April 14, 1945

CHARLES SHEELER

CHARLES SHEELER'S work is tense, taut and tight. It is always serious. It is quite American. "Tense, taut and tight" are not altogether complimentary terms to be applied to paintings, but Charles Sheeler gets away with them. His pictures are liked – and by Americans.

THE WORK OF LÉGER

FERNAND LÉGER, like those two celebrated Helen Hokinson ladies in the New Yorker, found himself "couped up in America" in 1939 because of the outbreak of the war. Unlike the two ladies he made no moan but settled down quietly to work and has been here, perforce, ever since. Two galleries now show his winter's work; the Valentine Gallery, 55 East 57th street, and the Samuel Kootz Gallery, 601 Madison avenue.

Before venturing upon this unexpectedly prolonged visit to America, Léger had been thought the nearest of our kin, spiritually, in the European art circles, for we were machine-mad and machine-minded and Léger admired our machines so much that he began thinking and painting in terms of the machine and very soon evolved decorations and murals that quite justified the "machine age." As real love is generally reciprocated a great deal of honest American affection began to be felt in return for this artist and I suppose that was the attraction that brought him over here in 1939. The "rapport" thus established still exists and Léger has many stanch American admirers but, oddly enough, the liaison with American thinking is not so apparent as it used to be and with each year of his stay, his production has grown more French. This year it is very French.

Perhaps it's not so odd after all. A psychologist would probably think it natural enough that a Frenchman "cooped-up in America" the while his own country were overrun by enemy troops would brood exclusively upon such a condition. At any rate this one, apparently, has.

The last big New York exhibition of Léger concerned itself with a theme, "Les Plongeurs," that he brought with him, having seen a group of swimmers diving from the docks, as he was leaving; and the whole show was an expansion of this one theme into many directions, constantly varied, never fatigued, and culminating in an apotheosis of the subject so complete and satisfactory that it left nothing more to be said about "Les Plongeurs."

405

able to resist the flattery of the injudicious. As it was, they sank into that saddest of all classes — the "might have beens."

When Morris Graves first appeared at the Modern Museum a few years ago he had a good press and, in general, a sympathetic reception but not enough praise to turn his head. I forget what I wrote about him but I recall thinking that his advent would not have been so surprising in the Natural History Museum as it definitely was in the Modern Museum for his work suggested that he was the child of a lady ornithologist by a geologist father. The birds and other creatures that he drew had the curious air of being "specimens" flattened but on paper for the purposes of scientific study. But they were something new. It was apparent that the young artist had had an odd mental bringing up, and a still odder way of recording his experiences. But this, of course, was all to the good.

In the new show in the Willard Gallery the ornithology and geology are shelved somewhat to permit Morris Graves to emerge on a larger scale as artist. They are still there, however, but used dramatically and painted with a bold authority that is most impressive. The thinking in these pictures is sometimes early-Pliocene and sometimes still earlier than that with a suggestion of alarm and even cruelty in the insistence on handsomeness in a rumbling period when human beings had not yet dared to grace the earth.

But if the thinking be so remote, the morals that are drawn are strictly contemporary — and so is the treatment. The big mural "Under the Grinding Rivers of the Earth" is terrifying at first glance but the primeval fish escaping from danger down in one corner, provides an escape for the observer as well. "Ha, he is getting away. He's defeating those clashing forces. Maybe I too can defeat the clashing forces," he repeats to himself in the language that has been taught us by psychologists; and he ends in thinking the artist a poet and the picture beautiful.

The New York Sun, February 3, 1945

should have mentioned that word "abstract" sooner but probably if you didn't already know, you guessed.

The New York Sun, May 6, 1944

MORRIS GRAVES

THE TWO Morris Graves items in the Whitney Museum exhibition gave a definite hint that this young Lochinvar of the West had moved up a step in his rating as an artist. The current group of new paintings in the Willard Gallery, confirms this impression. Morris Graves is now some one for serious art lovers to know.

It is with a bit of trepidation that this cautious commendation is bestowed. It may be that he is still too young to be praised openly even though he does deserve it, for as soon as the barrage of publicity opens up on a young American artist the chances are nine to one that he will go to rack and ruin promptly, no matter how gifted he may be. Somehow, in this climate, early success is practically fatal.

So I would not wish to do any harm to Morris Graves.

In the course of a generation or so of careful watching this department has observed at least a dozen men emerge into the spot-light of public attention and then wilt away into the second-rate ranks of comparative obscurity; and all this because they couldn't stand being constantly looked at, nor resist the impulse to capitalize upon the publicity while the publicity was good. Had they been given ten or fifteen years more in which to get acquainted with the world and to find out what they really wanted to say about it they might have been better

intimate you are with them the greater your chances for liking their work, and the way to get intimate with them, most people agree, is to study their drawings, but the André Masson drawings in the Buchholz Gallery are so severe that some timid inquirers will certainly draw back in alarm; and when they go farther and peer into the "Nocturnal Notebook" then they will really be frightened.

The trouble is that André Masson is an intellectual. This term when leveled at a painter is often a reproach, but I do not mean it to be such in his case. The ordinary intellectual gets his effects self-consciously and therefore is not an artist at all. But André Masson is not that sort. He is a genuine painter and colorist and a mystic as well, and that is what makes it so extraordinary that he can skeletonize his thought as he does in the "Nocturnal Notebook." He says he made them all on a sleepless night in May and it is evident that his "subconscious" was struggling with the problem of the beginnings of all life. His germinating seed and waving grass stems could really be dated in the year one and though it is all very well for George Santayana to talk about the Essences toward which we are all drifting, only the sternest realists care to consider the Essences from which we took birth. We pretend we like to know all — but as a matter of fact we don't.

But the moment André Masson starts to dress up these ideas we begin to lose some of our fright, and by the time we reach such drawings as the "Nude Under the Star," the "Cat," the "Cleft Earth" and "Shadow and Light," the chances are, unless we put strict rein upon our feelings, that we shall be admiring them unreservedly, for the artist knows all about textures, and soft gray tints, and dramatic contrasts and fiery lines, and, hypnotized by all these attractions one soon forgets the stark skeleton with which the artist started.

Back in the Paul Rosenberg Gallery there are no skeletons. Everything is gala. The thoughts back of each picture are, you may be sure, as forthright and rugged as the argument in a poem by John Donne (M. Masson is an admirer of that genius, it seems), but by the time the canvases arrived in the Rosenberg Gallery they were blooming with all the colors of the rainbow and the flowers of the garden. They were calculated to feed the mind indefinitely and I think they succeed. They are abstract compositions of great distinction. I suppose I

evolution of abstract art, his paintings do appeal to the edu-
cated. Would you prefer not to be educated? And as to that, I
can't even see why they should necessarily offend Count
Tolstoi's peasants. They could get from the pictures what they
used to get from the stained glass windows in the cathedrals
and if they should fail to estimate the reserve of mysticism
that appeals to the initiate and which continually feeds the
imagination of those who have imaginations – then it is just
too bad for the peasants. Or perhaps they'll get it in their
next reincarnation. I believe we were all peasants once.

The New York Sun, April 22, 1944

ANDRÉ MASSON

ANDRÉ MASSON has long been conspicuous among the modern
painters of France but stay-at-home Americans have not had
sufficient opportunities to see on what his reputation depends.
This situation is now corrected. The Paul Rosenberg Gallery
shows his recent paintings and the Buchholz Gallery not only
shows his drawings but issues a special book of drawings
called: "Nocturnal Notebook."

Of the two exhibitions the student is recommended to
study first the paintings in the Paul Rosenberg Gallery, for
there you will find the artist in full dress, attired in the utmost
splendor, as though for a coronation ceremony or something
of that sort; and curiously enough, André Masson is much
more winning when all dressed up for Sunday than he is when,
discarding all his garments he finds himself tout nu and con-
fronted with all the mysteries of life.

As a rule it is just the other way with artists. The more

they say, is all set – is provided by the display in the Jacques Seligmann Galleries, 5 East 57th street. It is all to the good.

The show is devoted to the development of a single theme, "The Divers," told over and over again, with great force, simplicity and directness, and never with so much force and simplicity as in the final big composition for which all the others in the show were preparation. It is astonishing that so much liveliness and variety can be provoked by the exploitation of one single idea. It reminds one of the well-known song by Cornelius, "Ein Ton," only much more overwhelming, naturally, for its cumulative effect.

It also gives the reply direct to all the silly people who say that "any child can paint these modern things." No child has yet painted anything like these Légers; nor ever will. No child has such clear concepts of things seen in nature and adds to this clarity the resolution to pursue the image to its final, stylized and acceptable form.

Go see these "Divers," s'il vous plait. I shall be curious to see if they overwhelm you, too. I shall be curious to see if, as the late Count Leo Tolstoi would have said, they "affect" you; for this great moralist held that "there is one indubitable sign distinguishing real art from its counterfeit – namely, the infectiousness of art." Do you suppose you could be affected or infected by Léger's art? If not affected, would you then call it counterfeit and align yourself with Count Tolstoi?

Poor Tolstoi had the noblest principles and the falsest applications of them of any one who ever wrote about art. Not even Ruskin had such facility in making mistakes. Don't forget that it was Tolstoi who said that Shakespeare's Hamlet was a sham, an imitation of a work of art, and that Beethoven's Ninth Symphony was not a whit better. Do you still cling to Tolstoi rather than to Léger?

The fact is there are truths that relate to every stage of human progress from first to last, from the lowest to the highest, and in Count Tolstoi's morbid preoccupations, in the later years of his life, with the miseries of the very poor he practically repudiated the satisfactions of an educated taste. The reforming zeal had so hipped his vision that about all that remained to him was folklore art, which is all very well but by no means the whole story.

Now, Fernand Léger is neither a Shakespeare nor a Beethoven, but in the present moment in the history of the

himself to actual people rather than to the harmonies that flit occasionally like music through their heads?

At any rate, something like that is what has happened to his pictures. They are of people. They are heavily stylized, so heavily stylized that they come dangerously near to being wooden, like the marionettes that appear in certain of Eugene O'Neill's plays and in certain minor ballets. Could the artist, the startled observer asks, have picked up a germ in Mittel-Europa? Or is he merely addressing his remarks to Mittel-Europeans in a properly heavy language?

This is confusing. Added familiarity with these pictures may supply the answers to the questions they propound, but in the meantime it is impossible not to regret the lack of the elegance that used to be the artist's hallmark. It may be said that when a prisoner of war is cutting his way through barbed wire fences elegance of deportment is the last thing he thinks of. "Etiquette is suspended for the evening." Those who know Hélion know that it could only have been suspended for that evening. Elegance is his middle name. Of his former graces he employs for these descriptions of his recontacts with society only dynamics and certainties of composition. As far away as the pictures may be seen they hold together perfectly and say what they have to say emphatically.

The New York Sun, March 18, 1944

LÉGER'S DIVERS

A SECOND opportunity to see recent works by Fernand Léger, the modern French master of the abstract, who may be going back to the home country any day now — since the invasion,

to self-discipline could be gauged in his austere face. He looked like his own pictures. It could be judged that he lived an intense mental life and weighed all the world's values on scales of his own. At the same time and in spite of his age he looked on life with unfatigued eyes. Mme. Martin, the Brazilian ambassadress, herself an artist and young enough to take a certain pride in claiming to be what the psychics call an "old soul," asserted that Mondrian himself was definitely a "young soul." Mondrian smiled at this accusation sadly, uncomprehendingly; but made no denial. Youthfulness of soul is never aware of itself so perhaps the lady was right.

The New York Sun, February 5, 1944

JEAN HÉLION

THE DIFFICULTY with the Jean Hélion exhibition in the Paul Rosenberg Gallery is that there is some perplexing psychology mixed up with it. It represents a very great change of attitude toward his work and the change apparently has something to do with Hélion's captivity in Germany. But what?

Did those two years of physical hardship and mental anguish bring him, as the saying is, "back to earth"? Did his complete separation from the life-stream of Paris, from communion with his fellow-modernists, from civilized habits of all kinds, cause him to lose the faculty of dreaming? Did the nightmarish activities which he recounted so vividly in his remarkable book, "They Shall Not Have Me," cause him finally to conclude that a landscape cannot be so important as the people in it? Did he vow in certain frantic moments during his agonizing efforts to escape that, if he did escape, he'd devote

that you would imagine the populace would be completely fooled by the constant clamor for fame. Yet it is not so. The public is never completely fooled and somehow sincerity and honesty shine out all the more brilliantly in the end against the dull background of the struggling incompetents.

What is required of the artist is that he have a life of his own. What is necessary to his style is that it be distinct. These two requirements, so obvious and so simple, are nevertheless difficult to attain in communities where mass-teaching is practiced and mob-thinking indulged in.

Mondrian's aim as an artist was to make a purely æsthetic appeal. His constant effort was for more purity, more simplicity and more precision. His early arrangements of straight lines on white surfaces were not without lyricism. The lines had the softened edges of the "artist touch" and the lyricism became symphonic when tones were introduced to hold the composition together in a largish manner.

The later pictures grew clearer and clearer, as though all the intense laboratory lights of modern science had been flung upon them. The "touch" was gone from them, Apparently it was not permitted; and the black lines divided the whites inexorably, inflexibly, and determined the amount of primary color to be used with a rightness that was unquestionable to the human eye. This painting of precision, like an instrument of precision, registered the intellectual atmosphere of today as aptly as Fra Angelico's purities measured the spiritual ecstasies of an earlier time.

It may be urged, and in fact has been, that style, when refined to this degree, is no longer the concern of the great public, and even so great an authority as Ernest Renan has said that no doctrine is suitable for wide public consumption unless it be sugar-coated with considerable myth. Absolute purity itself seems to be a myth and "the essences" into which, Santayana says, all human efforts eventually drift, become a matter for the consideration of the professors. Nevertheless professors and scientists are the rulers of these days – are they not running all the governments? – and it is enough for us private citizens to know that science approves of essences, purities and Mondrianic efforts.

I met Mondrian but twice, both times at small dinner parties with other artists where it was difficult to sound him out, but even without a word his severity of character and tendency

fails to tell you is that she is a natural-born decorator with an urgent, inner leaning toward the abstract; a leaning to which, being a 100 per cent American, she has never dared yield. Were she abstract she'd lose her public and, as she has a considerable public, naturally she hates to do that. So she holds the enormous pelvis bone up against the sky and puts in a nice round moon for good measure, and those who, unlike George Santayana, cannot reduce entities to essences may see, unmistakably, that it is a pelvis and a moon; and handsome at that.

But those few other Americans who apprehend the essences – I believe there are only twelve of us in the country, not including Einstein, who do – will notice that the pelvis is a subterfuge and that Miss O'Keeffe's real pleasure consisted in going all out for decoration with only a minimum of facts about life and death.

It's no wonder that George Santayana left the country. But it's Miss O'Keeffe's best picture to date.

The New York Sun, January 15, 1944

THE DEATH OF MONDRIAN

THE SUDDEN death on Tuesday of Piet Mondrian shocked a much wider circle than the little group who knew the artist personally, for all those who look on contemporary painting at all knew that he was one who had rigorous ideals and molded his life and his work to meet them.

There is so much that is loud, pretentious and false in the modern world, and the art of advertising is practiced so astutely by candidates who are not astute in any other direction,

GEORGIA O'KEEFFE

THE LEADING stars of the American Place are encouraged to write as well as to paint. This, I think, is a mistake. I agree with Sir Joshua Reynolds, whose slickest bit of wisdom was the advice he gave to one of his pupils: "An artist should sew up his mouth"; meaning, obviously, that what couldn't come out that way might come out in the painting.

But in spite of Sir Joshua and me, Georgia O'Keeffe has been and gone and done it. She has written a piece for her current exhibition explaining why she makes pictures from the bleached bones of the desert — and it is very good. It is practically a poem. If she had only taken a few lessons from Marianne Moore it might have been a real poem. But anyway it is very good. Here is part of it:

"A pelvis bone has always been useful to any animal that has it — quite as useful as a head I suppose. For years in the country the pelvis bones lay about the house indoors and out — always underfoot — seen and not seen as such things can be — seen in many different ways. I do not remember picking up the first one but I remember from when I first noticed them always knowing I would one day be painting them. A particularly beautiful one that I found on the mountain where I went fishing this summer started me working on them.

"I was the sort of child that ate around the raisin on the cookie and ate around the hole in the doughnut saving either the raisin or the hole for the last and best.

"So probably — not having changed much — when I started painting the pelvis bones I was most interested in the holes in the bones — what I saw through them — particularly the blue from holding them up in the sun against the sky as one is apt to do when one seems to have more sky than earth in one's world.

"They were most wonderful against the Blue — that Blue that will always be there after all man's destruction is finished. I have tried to paint the Bones and the Blue."

It's rather good, don't you think? But what Miss O'Keeffe

The present emergency is one of the most terrific that nature has ever experienced and it is only those among us most persuaded of nature's invincibility and power to recover from every rejection she gets at the hands of human-beings (and I'm not thinking so much of plucked eyebrows and painted finger nails as of the difficulties a tree has in growing on Fifth avenue and the general hardness with which we have chosen to sur-round ourselves) — and it is only such of us who feel this, I re-peat, who rejoice in Sandy Calder's ability to salvage from our unlikely modern materials an art-form that sways in the breeze like a bamboo reed on a river-bank.

For in spite of the fact that this artist builds his construc-tions of wire and wooden disks and metal tubes, he never fails to appeal for help, when beginning one, to Ariel or Boreas or whatever imp or god it is who presides over the laws of motion — and generally the help is supplied. His exhibition in the Modern Museum contains an astonishing number of proofs that nature never can be entirely thwarted and that even when at the last gasp, as I presume nature is at the moment, she can still supply to poets and to genuine artists the manna which the soul craves and upon which alone the soul thrives.

The Sandy Calder constructions lend themselves, just as a tree does, to the lights that change as the sun marches across the sky and yield to any invitation from the wind, and the vagrant eye is held to the incessant variations of shadows and groupings, wondering if ever they will fall, by chance, into disorder — but they never do. Invariably nature triumphs and one gets the idea that Sandy Calder is one of nature's pets. But that isn't so. He is simply a good artist.

The New York Sun, October 29, 1943

to think so. Well, it wouldn't be a bit more surprising for them
to have it than for us to have had it and lose it.

The New York Sun, May 7, 1942

CALDER

THE SANDY CALDER exhibition in the Museum of Modern Art
might just as well be called "Les Fleurs du Mal," for everybody
living, from Mrs. Roosevelt down (or up) knows that this is
the period "du Mal," the period in which advancement in
morality is not so evident as our increased cleverness in the use
of metals; and since, of all metal work, the Sandy Calder speci-
mens are the most flowerlike, you can readily see that this
artist has as much right to the title as Baudelaire had.

But Baudelaire used it first of course. Baudelaire, seen in
perspective, turns out to be a great moralist though his con-
tempoaries thought him just the reverse. He didn't recommend
the Mal of his own period for general consumption, but the
fact that he called it Mal shows that he knew what it was, so
the point is, and this is what makes him moral, that even from
the Mal he was able to pluck flowers.

There he was as truly moral as Emerson in his essay on
"Compensation" and by culling flowers from a world which has
a tendency to grow more and more metallic Sandy Calder
mounts to the same plane. It is the business of the artist to
do this, naturally. The good artist is invariably a moralist
whether he knows it or not and even if that were not his in-
tention, for in being a good artist he confirms nature, applauds
nature and, as the mariners say, "stands by" nature in every
emergency.

"Why, why?" the bewildered spectator asks, "must there be this eternal flux? Why cannot perfection, once it has been reached, remain? Why should Eve be shown the Garden of Eden and then so quickly dismissed from it? Why bother about the ideals we are never allowed thoroughly to test? Why should the great Pericles, with all his wisdom, shatter the most famous of all republics merely to defeat the Persians? Why were labor unions invented? Why? Why?" But see here, friend, go see the show and do your own moralizing, and above all, do your own weeping. I positively can do no more!

The painters, naturally, were the best that money could buy. John Singer Sargent was the prince of them. It got so, finally, that you simply had to be painted by him. He landed one year in New York, so he told a friend, already saddled with commissions to do sixteen "heads" at $5,000 per. But the constant struggle with pearls and laces and Worth costumes wore him out. By the time we had reached that other war and he tried to do a "President Wilson" for patriotic reasons he simply wasn't up to it. In the "Mrs. H. McK. Twombly," the "Hon. Mrs. Frederick Guest" and the "Mrs. Henry White," he was, however, particularly up to it, and it is easy to see why the ladies thought it indispensable to be painted by him.

Also, of course, there was Philip de Laszlo, who did pearls so well. See the "Mrs. Whitelaw Reid" on the present occasion. You must remember that imitation pearls in those days had not been brought to perfection. Mr. de Laszlo knew the difference between a $100,000 string and a $250,000 string, and made it apparent. And Boldini! Boldini apparently went into a whirlwind of emotions whenever he attempted a portrait of a fascinating American heiress. His brushes misbehaved in extraordinary ways at times. I always thought his best in that line was the one of "Mrs. Harry Lehr" which used to hang in the Paris residence. Where is it now, I wonder? And the portrait by Madrazo of the Countess Szechenyi's mother, "Mrs. Cornelius Vanderbilt," is still a charming production. And the vivid view of "Mrs. Philip Lydig," by Zuloaga, is just as apt to make you jump, as a rencontre with the lady herself would have done.

What a definite and glamorous period the "Golden Nineties" provided for us. Who'll be the next people to have such a place in the sun? The Russians? Vice-President Wallace seems

THE GOLDEN AGE IN AMERICA

IF YOU have tears to shed prepare to shed them now. The golden age of these Americas has definitely passed. The mirrored reflection of it is all we have left; and even with these so few years that have passed, how unbelievable it is that we were once so grand!

Go see the magnificent pearls and costumes in the portraits of the Golden Nineties Exhibition, now shown at the Hotel Gotham for the benefit of the Red Cross; you'll scarcely credit it else. Notice the sense of security in the ladies who supported the grandeurs of those days. Not one of them had ever heard of the name of Marx. Not one had read "Mein Kampf," nor even "One World." All believed implicitly in the permanence of incomes and the divine rights of the wives of American millionaries.

The "Age of Innocence?" Certainly. Why not? There were a few minor discrepancies in the plan of things, but not many. Occassionally the more finished exploits of Mrs. Jack Gardner in Boston, and the severe comments of Harry James, seemed to accuse New Yorkers of crudity, but once the dinner lists had been checked over by Harry Lehr, and the chosen guests for Mrs. William Astor's ball, had had a preliminary look at each other at the Monday night opera, they knew very well that they were, as we now say, "sitting pretty." It was the best of all possible worlds and New York was the center of it.

How fantastic it is that we, in this simple Jeffersonian republic, should ever have arrived upon such a plane of splendor and how still more fantastic that all of it now should have vanished like a dream! What a comment on life that is! The few remaining owners of fabulous strings of pearls now keep them in lock-boxes and the ladies who possess square-cut jewelled rings like those worn by the first Mrs. Clarence Mackay in the Boldini portrait would scarcely dare, these dark nights, to take them to the opera. The coach-and-fours no longer start from Holland House and for that matter, where on earth is now the Holland House?

I admit the Clifford picture has more points than mine. It has as many points as there are dots in the Milky Way on a clear night; and in the new era, to which we are being so rapidly propelled, no single individual may be permitted to have one drama all to himself, but groups of people will be sitting on the Clifford cushions and enthralled by two dozen dramas, all happening at once, and liking it better that way. The "mass era" may be upon us at any minute now.

My Matta is called "Opening of a Grain of Rice," but it wasn't the title of the picture that got me, it was just the drama, as snug and coy a drama as those we used to see in the Palais Royal, only much more serious. Nothing that ever occurred in the Palais Royal was ever serious. I suppose it's those billowy reds at the bottom of the canvas that associates the picture in my mind with the late King Alfonso's favorite theater. The actual opening of the grain of rice leaves me cold. I'm no Japanese. But I maintain the picture has drama.

I neglected to compare all the titles with the pictures, and now I am sorry for it, for I find one of them is called "Escarlata la mujer de Babylonia," and I certainly would like to know what that is all about. It sounds slightly risqué, don't you think? But fortunately it's one of the abstract ones, and practically everything passes the censor when abstract. It is one of the "oil-pencil" drawings, and all of these are spirited, and electrically colored and with contrasts of texture that the artist seems to manage just as easily in this difficult medium as he does in the regular oil-paints.

This is Matta's second exhibition in New York. The other one you didn't attend, but this one you will be obliged to attend, if only for the "cultural relations" angle of the affair. Matta is from Chile. But you'll enjoy it.

The New York Sun, April 3, 1942

MATTA AND THE HENRY CLIFFORDS

"THAT ONE," said I, pointing to the biggest Matta in the Matta exhibition at the Pierre Matisse Gallery, "might be sold, I should think, to the Cliffords."

"It has already been purchased," said Mr. Matisse, "by the Cliffords." You could have knocked me down, as they say, with a feather. I had no idea that I was so psychic. I had no idea that I knew the Cliffords so well.

But, after all, it is not so surprising that I should have guessed well on this occasion. In every sensational exhibition of the winter, the most important picture present, and the one that represented the greatest buying courage, has invariably been "lent by the Henry Cliffords." One gets to expect this. So perhaps I'm not so psychic. Perhaps I'm merely logical. But anyway this time definitely "a bell within me rang," as Alice Toklas would say. I intend to claim whatever credit attaches to it.

However, this close affiliation of mine with the Cliffords was no sooner established than it was brought to a sudden halt. Shortly after deciding that the vast canvas, with its display of daylight fireworks and showers of unmistakably precious jewels, was just the thing for them, and that their guests, eyeing this picture from comfortable sofas, would be so ecstasiated that they would never know whether their after-dinner coffee had been properly rationed with sugar or not rationed at all; shortly after deciding all this, I repeat, I turned my back on the Clifford Matta and walked over to another one which, were I buying a Matta this week, would certainly be my Matta.

It is much smaller than theirs, and not so fireworky, and yet more dramatic. I'm not saying which of us did the better choosing. I suspect the Cliffords of being "forward-thinking." I, on the contrary, am inextricably tied up with the present. I cannot think beyond today. I like drama, and I like my drama to lead up to one inescapable impact. I am a regular Joe Louis for that. When Joe passes there may be no more knockouts and everything may be decided on "points."

Aldous Huxley, and that is all very well but what is a date compared with the assurance that life is everlasting?

And anyway Rufino Tamayo makes a date, too. To connect him with Picasso and Braque relates him to the calendar as effectually as anything a stela could do. He is much the best artist to have come to us from Mexico. In the first place, he paints. And in the second place what he paints is steeped in poetry. Beside him both Rivera and Orozco seem like hardboiled and commonplace illustrators.

To attempt to choose the best performances in the present exhibition is idle for each picture seen separately seems to be in the No. 1 class, but the pictures that have animals in them do have a peculiar and quite special charm. The one of "Birds" gives me the impact of the tropics emphatically. For all I know it may have been painted in our Bronx Zoo, but given a Mayan to paint it, and at once you hear the raucous squawks of these uneasy aviators and begin thinking back a thousand years to the beginning of things.

The first excitement, however, for the amateur will be the recognition of the constantly varying color schemes of these pictures. It is curious and impressive to see each "arrangement" so individualized and yet so dominantly hallmarked by the personality of the artist. The variations in the key of brown in the "Woman With Guitar," the silvery blues in the Woman, and the reserve and strength of the "Red Mask" — these things are both original and distinguished.

New York Sun, February 13, 1942

TAMAYO

THOSE INTERESTED in cultural relationships with nations to the south of us would do well to take a look at the Rufino Tamayo paintings in the Valentine Gallery, 55 East 57th street. There's culture for you! Perhaps if we really see it, these Mayans (Rufino Tamayo is Mayan Indian) may begin to see us, too.

And that's what we want, isn't it?

For those who are merely pressing on the political end of the matter it may be a difficult lesson in comradeship, for the idiom that Tamayo uses is as curious to the modern eye as the original spelling in a poem by Chaucer — but once it is looked at frankly it turns out to be fully as rewarding. This artist presents the strange anomaly of an individual intensely alive to all the implications of contemporary æsthetics yet whose innermost, sacred feelings spring unmistakably from a Maya past that is so remote that it is practically beyond the reach of history.

Since it is indubitably honest, this mixture of modern refinement with ancient savagery is deeply touching. How does it come about? No one may say — least of all the artist. We talk of the changing times but this thread that stretches from a distant and invisible past and seems likely to continue into the equally invisible future is something to hold on to. It appears to defy time. Aldous Huxley, who has been down in this Maya country, says that "time was evidently at the very heart of the Maya religion. To grasp time intellectually seems to have been the first duty of the initiated few."

But the initiated few should have consulted their artists. When Rufino Tamayo uses color with the inventiveness of a Picasso and with all the elegance of a Braque and at the same time applies them to symbols that have been in uninterrupted use for thousands of years, you have a continuity that is delightful and reassuring both to gentleman and savage. Time marches on but the end of the world is not yet. Each famous stela in the Mayan jungle signalizes an important date, says

MONDRIAN'S FIRST ONE-MAN SHOW

PIET MONDRIAN, who is famous in two hemispheres, is having his first one-man show anywhere in the world at the Valentine Galleries. How to moralize on this circumstance is not easy. Are one-man shows, then, so unnecessary to fame? Perhaps we had better not go into that matter too deeply.

Mondrian is the most modern of painters. He deals in rectangles boldly constructed by unrelentingly black lines crossing upon a white ground and with patches of pure color inclosed sparingly here and there. This, you may be surprised to know, is the artist's attempt "toward the true vision of reality." Obviously plenty of definitions are required to elucidate this "vision" and Mondrian, in a supplement to the catalogue, supplies them. If you are as unprogressive as I think you are, dear reader, you are in for a considerable struggle with these definitions, but, my advice is, not to throw the catalogue away, but to keep it and ponder over it, and then go occasionally to see the Mondrian paintings. As William M. Ivins says of the Rembrandts at the Metropolitan Museum, words cannot explain them, and the only thing to do is to look at them. The same applies, with almost added force, to the works of Mondrian.

The New York Sun, January 23, 1942

My own enlightenment in regard to Blakelock (and that of many others as well) came with the dispersal at auction of the famous Catholina Lambert Collection, for in it were two pictures by Blakelock that were incontestably great. Both were shimmering moonlights with the foliage and the foreground linked in the dark shadows that the great Chinese landscapists so often affect and which has so much justification in nature. Both paintings went far beyond the domain of paint into the realm of pure poetry. The larger, and finer, of the two pictures, was purchased for the Toledo Museum, and the second one, which was almost as good, went to the late Senator Clark, and is now reposing, I think, in the Smithsonian Collection at Washington. I don't know of any better moonlights anywhere.

Once an artist's masterpieces lodge in a museum his reputation is safe, and his lesser examples and the dubious imitations of the "fakers" have a way of drifting off into the corners of the anterooms where they do harm to nobody. The chief difficulty in fostering the reputations of our great men, lies in the great distances between the cities, which entails more traveling than the great public is willing to undertake for its education. So, just because Toledo already owns a great Blakelock I would like to see that city own some more, for I am a great believer in massing the attack upon the public's consciousness. If I, I argue, as a young man would journey all the way to Madrid just to see the El Grecos, then surely the amateurs of the future would willingly journey out to Toledo to see the Blakelocks, if only Toledo had enough of them.

Particularly it would be excellent for the Toledo Museum to possess the "Sunrise, No. 9," for though this work is not great in itself it shows how the greatness was achieved. It provides the lesson for students of painting that I have referred to. It was painted when Blakelock was but 21, and there was no higher effort in it than to get at the "facts" of nature, but the artist went at this job so thoroughly and assembled so many facts, and organized them so intelligently, that he got a sound basis for his later romanticism. It's the same sober diligence that you see in the early work of Winslow Homer, in Degas, and in most masters whose later freedoms are tolerated. It's the freedom that comes from knowledge.

The New York Sun, January 16, 1942

On the contrary, it will be to verify the rumor that we have at least one artist of undoubted integrity in our midst. The humor that makes it "so amusing" to note how Whistler did "this little bit over in the corner," or Hokusai this fantastic tree, or Constantin Guys's way with an ankle, was not for him. As I said before, Mr. Dickinson never smiles. He looks out on the landscape, or at himself in the mirror, and has no intention of ameliorating anything. He is as implacable, in that respect as Thomas Eakins was, though Thomas Eakins had so much drama that you scarcely noticed he lacked humor. But Thomas Eakins was a recluse, too; you may remember.

The New York Sun, April 5, 1941

R A L P H B L A K E L O C K

FOLLOWING ITS recent Winslow Homer exhibition, the Babcock Galleries, 38 East 57th street, now call attention to another of the American old masters by arranging a Ralph Blakelock show. It's a small show but it will do. It shows the several periods of the artist's career; giving pleasure to patriotic collectors and providing lessons in the art of painting to students.

The several "top-notchers" in the collection explain the artist's reputation, a reputation that was seriously interfered with for a time by the flood of spurious "Blakelocks" that came upon the market during the artist's long last illness. The formula for the Blakelock moonlights and sunsets was so pronounced that, in a superficial way, it was easily enough imitated, and as the great Blakelock moonlights were safely hidden away in private collections, the general public became quite confused by the prevalence of the "fakes."

show in the Georgette Passedoit Galleries, 121 East 57th street. That, however, is all I ever care to know about an artist, that which his pictures tell me. In the present instance we certainly have an artist who leads an inner, Emersonian existence.

It is, in fact, so cloistered that I have a certain shyness, a sense of guilt, in opening the shutters, pulling the curtains to one side and thus exposing to the chilling, critical inspection of the world, the work of a citizen who has got along fairly well so far in private and who might go utterly to pieces if jostled too severely by the crowds on 57th street who instantly put a price-mark on anything that claims to be a work of art.

Such disasters have already occurred. I myself have killed several artists with kindness. If you don't know what I mean, I will explain. Years ago there was a young man who hated the world because he thought, mistakenly, that the world hated him. He consequently put so much venom into the landscapes he painted that I, recognizing the force of the expression, called special attention to them. Thereupon buyers appeared, money rolled in, comforts were indulged in, and the young man lost his hate. He then proceeded to paint a series of insipid, fatuous pictures that promptly cost him his new-found friends, and when he died, as he did not long ago, there were few to recall that he once had a chance at a career.

This whole modern business of instantly holding pictures up for appraisement as though they were stocks and bonds, and with the critic acting as salesman or possibly as school-master, is something the ancients didn't have to contend with, and may partly explain the unflinching quality of their work. They may have striven, it is true, to please "the duke," but one duke is easier to please than a committee, a jury, or the populace at large; and as Americans are always peculiarly self-conscious when attempting to be artists, it still remains the safest plan for them to be their own dukes; that is, to retire into strictest solitude and to paint for themselves alone.

So, if I say that Edward Dickinson's work lacks "allure," that is merely because I am on the witness stand and obliged to tell the truth, but it is not necessarily anything that Edward Dickinson himself should pay attention to. In fact, if his work in next year's exhibition should contain any traces of "allure" I should be horrified and should feel that I had killed yet another artist, for if anybody saunters up his alley at all it will not be "allure" that they are after.

the press of the multitude would be a menace; but I suppose nothing happened to them or Joe's friend would certainly have informed us of the disaster.

The New York Sun, March 22, 1941

EDWIN DICKINSON

ANY ONE sensitive to the art of painting ought to recognize good painting in the work of Edwin Dickinson. So I should think. Yet, though he has been exhibiting now for some time he appears not to be generally known. This is a situation that ought to be corrected. So I should think. But there are difficulties in the way.

In the first place, he is a serious painter. We all say we like serious painting – but do we? Perhaps Mr. Dickinson is too serious. Here is a man who paints as cleanly, as neatly, as progressively as Whistler yet who probably never smiles once as he perceives he has made a happy touch on the canvas and who holds himself dourly, unrelentingly to the completion of the task he has set for himself.

There is none of Whistler's hilarity. There are no concessions to the public in any way. There are no divertisements. There is nothing but the stanch integrity of a man determined to paint nature according to his lights. There is nothing but painting. Is that enough? It ought to be – if you like painting.

Mr. Dickinson is an ascetic. He is an early New England settler. He is a Quaker, or possibly even a Shaker. I hasten to add that actually I know nothing of the private life of this man. All that I say in regard to his character is pure surmise – garnered from the pictures themselves – which are now on

tion for the exterior of the edifice is not so unanimous, but in a museum, after all, it is the galleries that are the essential, and in this instance they are all right. Of course, the presence of such a tumultuous and picturesque mob made any study of the pictures difficult, but I had had two previous days of daylight for their inspection and knew that they were being shown as perfectly as they could be anywhere in the world.

It was gratifying, too, to see how neatly the gay modern crowd fitted into the background thus provided. Lots of the girls were gowned in brilliant reds and this may have helped in making the scene Goyescan, for in every direction I was constantly seeing "groups by Goya." The Goya motif was suggested, of course, by the wounded ladies being borne out on litters, but where, of all places, do you think they took them to recuperate? To the Goya Room — and I wondered that the Marquesa de Pontejos did not step down from her portrait to proffer advice and comfort to the stricken ladies stretched out so galantly on the marble floor beneath her — for she, too, had been to the wars.

I ought to add, I think, in justice to the architects, that these casualties should be attributed to the emotional stress of the times and not in any way to the air-conditioning system which seemed to me to be functioning perfectly.

Next morning, on the train bound northward, the groups nearest me were unmistakably Philadelphian. It is not so much the women as the men from that city who betrayed their place of habitat. I don't know particularly what it is — but you always know them. However, in any case, I should have "placed" them, for they had scarcely adjusted themselves in their cushioned seats before one of the men sung out to an acquaintance several seats further down the aisle: "What'd you think of Joe's flowers?"

That, of course, was the proof positive. The reference was to Mr. Widener's acacias. Mr. Widener, it seems, grows the most marvelous acacias of anybody, and as a gesture of friendship to a gallery to which he is already related, sent a whole forest of these beautiful plants to glorify one of the patios of the new museum. They were banked in great masses around the fountain and against the supporting columns, and the whole effect was, to put it mildly, as pretty as a picture. I thought of them during the "private view" and wondered if

the crowds parted, and a fainting lady was borne past on a stretcher. It was intensely dramatic. Just like a picture by Goya. Soon several other ladies fainted and were borne out on stretchers.

No men fainted. No thin ladies fainted. All the ladies who collapsed were bulky, so that with each casualty three people of ordinary size could get in to take the spot vacated. For that reason, and without any undue pushing on my part, I soon found myself within the coveted inclosure — and right next to Belle DaCosta Greene and Chester Dale.

The President looked pale and exceedingly worn. Dr. Devol, who was present in attendance upon Mr. Kress, said that it was merely a combination of fatigue and the Klieg lights, and that the announced vacation and a little rest would be sure to put him all right.

Belle DeCosta Greene insisted that the President, when mentioning the donors to the exhibition, had stuttered when pronouncing the name of Chester Dale. For such an expert and experienced broadcaster, this is almost inconceivable, yet I, too, had had the same impression, though as one of the fainting ladies was being borne past at the moment, with all attendant confusion, I could not be sure.

The word, of course, went out on the air and millions of people heard it, and if they decide that Miss Greene is wrong in this matter, I trust they'll not write in to me to say so. I have enough trouble attending to my own fan mail without bothering about hers. If she's wrong, let her stay wrong, I say.

Chester Dale himself certainly could not have stuttered even had he wished, for the sudden change from Miami to the icy blasts of the hurricane in Washington had completely bereft him of voice. Walter Damrosch, who thinks music and therapeutics to be closely allied, assured him that if he would keep saying "Em, Oou, Oh, Ah" he would soon have his voice back where it belonged, but Mr. Dale refused to take his first music lesson before such a vast assemblage. He whispered, for that was all he could do, that he was going straight back to Miami.

The galleries and corridors of the new building are exceedingly handsome and exceedingly effective in the showing of pictures. There seems to be no dissension from this. Amateurs and professionals agree in liking the equipment. Admira-

makes the gallery national. For Mr. Widener's great collection is already in the offing, waiting only for a proper opportunity to be moved into this new museum, and Chester Dale's contribution of some of his early American portraits to the present exhibition suggests that there may be further additions from that source. These earliest donors to a great enterprise will always be of special interest to connoisseurs, but when they shall be followed by the collectors of the future, as certainly they will be, then even the taxi drivers of Washington will realize that greater than any individual is the nation and greater than any possible private gallery will be the National Gallery — and that will be its name.

But you should have attended the private view Monday night: You really should have. It was something — and very American. When the great American public strives to attend an event that has been sufficiently advertised — and the opening of the Mellon-Kress collections had been well advertised — there is no stopping it. Pressure had been brought to bear from all quarters and, although ten thousand invitations had been issued, ten thousand were not enough.

On the Sunday afternoon before, venturing into one of the museum's offices to do a little surreptitious typewriting, I inadvertently overheard the telephonic plea of a Congressman for just a few more tickets for some of his constituents and marveled at the deft and charming way in which he was frustrated. I then saw that with such tact and finesse in the directorial division, the new National Gallery was certain to get on. Half of any museum's chances for success consists in the ability to say "no" delightfully.

Of the ten thousand invited, they say, and I believe it, that eight thousand attended. Coming down from the Sulgrave Club where David Finley had given a hundred of us a fortifying dinner, we were stopped several blocks away, marshaled into three lines of cars, and after that crept onward only by inches. A journey, ordinarily of ten minutes, required, on this occasion, fifty, and by the time we got inside the preliminary speaking had begun.

President Roosevelt was to make his acceptance speech in a gallery off the already famous rotunda with the black marble columns, but we late-comers were around the corner from it, and so far away that at first I thought myself doomed not to hear the chief speaker. But suddenly there was a stir,

WASHINGTON, MARCH 20. — "Grim-visaged war hath smoothed his wrinkled front and now instead of mounting barbed steeds to fright the souls of fearful adversaries" hath spent a quiet interval taking stock of benefits forgot; benefits bequeathed to us from former periods.

All Washington, from the highest to the lowest (I won't mention who the lowest is, and you all know the highest), spent the week worshiping in dazed amazement the sweet Madonnas and noble portraits of the "Mellon Collection" and if they moralized at all upon the extraordinary occasion of such a gift by such a private citizen to such a world then they must have decided that the true lesson of the event is something that will be revealed to us later. There was prodigious vocalization, but practically nothing said.

Certainly the Madonnas were inscrutable (probably because we now have so little faith) and the Van Dyke, Rubens and Goya grandees, precisely like those in real life who attended the private view Monday night, looked as though nothing special were happening and as though, in any case, this were certainly the best of all possible worlds.

Yes, they still call it the "Mellon Collection" — in Washington. I said to the taxi driver: "Take me to the National Gallery," and with a scowling glance he replied: "You mean the Mellon?" I said, never being much of a disputant, "Yes, the Mellon"; and off we went to it.

There is a certain justice in this. After all, it was Mr. Mellon's idea. He had the knack of acquiring first-rate works of art in a time when it was much less easy to acquire them than in good King Charles's time, and supplemented the knack with the intelligence to see that, in the end, such things rightfully belong to the public at large.

In the course of time, no doubt, Washington will realize that the gesture of Mr. Kress in giving his great collection to the nation is equally generous, and that in fact it is this willingness of his to add his pictures to Mr. Mellon's that truly

378

collection. However, Richmond's secret opinions will come to light, sooner or later, and the first outcries in the Richmond press will, doubtless, be lived down.

For instance, Isabelle Ziegler, the official critic for the Richmond News Leader, remarks of the "Mme. Cézanne" that Cézanne "was so afraid of women that he painted his not particularly appealing wife uncounted times," and that is a comment that will definitely interfere with Miss Ziegler's welcome when she returns to Paris after the war. Madame Cézanne most people agree, was thoroughly appealing, if you know what the word appealing means. She was certainly not a glamor girl but she did appeal. And for Henri Matisse, this critic was even more severe. "The fifteen works by Henri Matisse, chief of the hoodlums, and the artist whom polite people didn't even mention a few years back, seem almost without importance today."

Henri Matisse a hoodlum! That is an amusing idea, and sufficiently novel. The work that no doubt incited the remark is the big study for "La Danse," made in preparation for the famous mural decoration now in Moscow, and, as it happens, better shown in Richmond than I have ever seen it elsewhere. It is up in the air, where it belongs, with lots of space around it, and the primitive ease and assurance of the dancing figures are most impressive. If Miss Ziegler should change her mind about Henri Matisse later on, she will join the numerous company of those who have, for twenty years ago it was the fashion to say harsh things about him, although I don't believe he was ever dubbed "hoodlum" before.

The New York Sun, January 25, 1941

of best-sellers whose works I never read chiefly because there is so much stress in them that grace is totally lacking; but, at all events, "grace under stress" was the especial trait of the Virginians on the night of the first showing of the Walter Chrysler collection of extremely modern art, and therefore Richmond is a gentleman.

In fact the behaviour was too good. It was scarcely natural. In the case of a completely shattering experience the nerves even of a gentleman are entitled to an approximately 10 per cent shatter without leaving any aftermath of reproach but on the night of January 16 in Richmond there was no visible shatter whatever. Gov. Price was affability itself. Mayor Ambler looked absolutely unworried. Perhaps they had been tipped off in advance. Or perhaps they had been reading the evening papers, and in considering the imminent collapse of the whole known world had decided that the loss of their previous art conceptions was a mere detail.

The haute noblesse of the Southern capital had been fortified by an excellent dinner at the Governor's mansion before going to see the pictures but even so were unable to rise to the level of His Excellency's nonchalance. Their manners were unexceptional, as has been said — but one felt the tenseness. There were no loud shrieks of protest as on similar occasions in New York in times past. Everyone smiled nicely and commented in low voices careful not to injure the feelings of visitors from Manhattan and appeared to be looking at the pictures rather than at Mrs. Byron Foy's new dress. (I was mistaken in this. The Richmond newspapers next day contained masterly and appreciative analysis of Mrs. Foy's costume. "A heavy rolled collar was affixed halter fashion over the low decolletage," sounds quite as puzzling as the same writer's descriptions of the Picassos on display.)

In the midst of the party, one of the officials of the museum who had already been living with the pictures for some days, whispered to me: "You've got them stunned," but I, an outsider, could not see the evidence upon which he based his theory. To me it was just a nice party and attended by such remarkably good looking people that I afterward concluded that none but the good looking had been allowed in. So, with all these perfect manners functioning to the limit, it seems too soon to estimate the success of this event, for, obviously, it was Richmond that was being tested rather than the Chrysler

they do not matter in the least, but there is no question what-
ever as to the authenticity of the drama that this amazing
artist compels you to assist in; for that is what you do, and
why you pay no more attention to the details of the drawing
than El Greco did. And in the still more Grecoesque picture
of "St. John the Baptist," there is such a ferment of spirituality,
such a sense of almost anything being likely to happen at any
moment, that only a dull and completely lethargic person
could be aware that the famous "elongations" in draughtsman-
ship are also present.

They are always present in the best El Grecos. They are
there because the artist was worshipping the majesty of the
Saint's soul and not concerned with the exact physical mea-
surements of his body. Certain writers contend that these
elongations were intentional — but I do not think it necessary
to believe that. They cite the defense El Greco was once
obliged to make in a lawsuit in regard to this very matter, that
"to be dwarfed is the worst thing that can befall any kind of
a figure" but it is to be noted that this defense was made after
the picture was painted and only when someone else had
objected to the extreme height of his saints. There is very
little positive knowledge of El Greco's methods and principles
of painting, but practically all you need to know is there in
his pictures. He is his own best authority.

The New York Sun, January 18, 1941

MODERN ART IN RICHMOND

AT ALL events, Richmond is a gentleman (Richmond, Virginia,
I mean). The most acceptable of recent definitions of gentle-
manliness — "grace under stress" — is attributed to a purveyor

ess Mercati and to concentrate upon the question of souls irrespective of nationalities.

So then, to begin all over again, was El Greco a soul? I say he was all soul. I say that in all this period since the renaissance taught us how to paint no painter has been so spiritual as he. William Blake, it is true, walked more confidently with God but El Greco walked with the angels. It is almost a shame to have to admit it but there was certainly a touch of snobbishness in the way William Blake possessed God and tried to hurl God's thunderbolts upon erring mankind. El Greco wasted very little time condemning other sinners and occupied himself exclusively with worshipping. While there is no denying that William Blake saw a heaven that suited himself El Greco saw a heaven that suited everybody.

When the skies open up, in one of El Greco's great pictures, and one of the world's greatest masterpieces, and you see the angels preparing to receive the soul of Count Orgaz, then the most arrant pagans feel the need to bow down and worship. That, they concede, is heaven. Emily Dickinson and William Blake and John Sebastian Bach and the other pure spirits never seem to have been afraid of the descriptions of the hereafter that are to be found in Revelations but most of us lesser mortals get distinctly terrified at the goings and comings of the angels, at the falling stars, and the "seven bowls full of the last seven plagues," and the tree of twelve fruits whose leaves were "for the healing of the nations"; but when El Greco takes us by the hand, we willingly enter in, and with no more misgivings than when we go to Carnegie Hall for a Boston Symphony concert.

That's what El Greco's heaven was, I think; just a Boston Symphony concert. They say he had music with his meals, and most probably he had the musicians play all the time he was painting. That would explain why some of the passages here and there in an El Greco painting are rather jumpy, for the musicians in those days were not so mechanically proficient as they are compelled to be in the machine age, and it also explains why the look of ecstasy invariably brightens up the El Greco saints and why the miracles occur right here before your eyes. He painted to music.

In such a work as the "Expulsion from the Temple," which has been lent by the Minneapolis Institute of Art, there are countless little errors in draughtsmanship in places where

chaise's "Floating Figure," which is now for the first time shown in bronze. Lachaise's enormous "Man," in bronze, is also shown outdoors in the garden, along with the newly acquired "Assia," by Despiau, a gift to the Museum by Mrs. Simon Guggenheim; and many other notable bronzes.

The New York Sun, May 13, 1939

EL GRECO

WITH COUNTESS Mercati heading the list of sponsors there can be no doubt now but that El Greco is Greek. The matter has sometimes been disputed. Not the actual birthplace, of course. It seems reasonable to believe that he was born in Candia and Crete is sufficiently Grecian for passport purposes, but what does a passport tell you about its possessor's soul? And did El Greco have a Greek soul? That's the question.

The exhibition now on at Knoedler's for the benefit of the Greek War Association may help you to a conclusion but it is a conclusion, I may as well warn you, that each one concludes for himself. Especially in parlous times such as these when nations are here today and gone tomorrow birthplaces seem to have very little to do with souls. El Greco's soul certainly flamed up in Spain. Did that make him Spanish? Our onetime Jimmy Whistler loomed up as a world figure against the London background. Did that make him English? Is the celebrated Dr. Einstein still a German in spite of his flight to Princeton? It's all very puzzling and apt to lead us upon dangerous ground. And with Greeks and Romans again struggling for the same old territories they disputed so many centuries ago it will probably be wiser to concede the point to the Count-

soon be out of date. However, the museum's reply to all this is, that they intend to shift the partitions about later on, so with some expert shifters on the job, coziness may yet be attained.

As for the art thus exhibited, it provided in such liberal quantities and is of such a challenging quality that it is impossible to gauge it properly in the rush of this hasty review. The general public is sure to be excited by the display and the wits among them will doubtless fasten upon some eccentric items and play them up much as they did years ago for the Armory Show. For my part, I confess my two chief thrills occurred when meeting two old friends — the "Sleeping Gypsy" by Henri Rousseau, and the "White Girl" by Whistler — very dissimilar pictures, but both of them capable of arousing all the poetry that happens to be dormant, in the bosom of the beholder.

It was especially startling to remeet the "Sleeping Gypsy," for much has happened to the picture since the days when it formed part of the late John Quinn's collection and it has not only been the center, in Europe, of curious lawsuits involving the artist's rights in a picture even after it has been sold to someone else, but has also had doubts cast upon its attribution to Rousseau — doubts now happily dissipated. It remains one of the most amazing pictures of modern times, compounded entirely of the stuff of which dreams are made of, and owing nothing to the literary tricks of the more fashionable surrealists. It has been graciously lent by its present owner, Mme. E. Ruckstuhl-Siegwart of Switzerland; but wouldn't it be wonderful if she would concede it to us permanently — for a price?

"The White Girl" by Whistler, is lovelier than ever and has a fortunate light that makes her almost unbearably beautiful. She is in the alcove with several of Winslow Homer's grandest sea pieces, and this room takes on the character of a Salon d'Honneur and will prove a safe and consoling retreat for those who are entirely baffled by the flaming outlawries of Picasso, Matisse, Miró, Beckmann and Rouault. One of Picasso's very latest portraits, with both eyes showing full-size though the face is in profile, is included. This picture may very well happen to be heir-in-chief to the witticisms that used to be leveled, years ago, at Marcel Duchamp's "Nude Descending a Stair." Or, perhaps, this doubtful honor will be bestowed on Gaston La-

so it may well be that the outside may undergo changes, too. For instance, the museum is blessed with a backyard which is utilized for the showing of sculpture and which extends through to Fifty-fourth street, and since it happens that this rear wall of the building has a shade more of seductiveness than the front one it may eventually be turned into the main entrance façade. Why not?

However, it can't be conceded yet that even the rear wall reeks with charm. I went to a dinner party on Monday night at which someone interrupted the general talk but demanding if anyone knew the French word for "loveliness." I suggested "charme" and M. Louis Carré, who was present, suggested "tendresse," but neither of these definitions quite suited our inquirer. Neither do they suit the façades of the Modern Museum. Certainly, and with all due respect to M. Louis Carré, "tendresse" wouldn't do.

If the façade of the building confirms the suspicion that I have entertained this long while past, that New York simply cannot afford a curved line, the interior refutes the impeachment arrogantly, for the exhibition space is divided into innumerable alcoves that weave into each other like rose leaves on a larger scale. This provides the intimate approach to the pictures that is now deemed essential. I believe it was the late Dr. Bode who discovered that even the very best pictures can sometimes be quite nullified by the vastness of old-fashioned galleries, and since his time there has been a general effort to fit the rooms to the pictures instead of vice versa.

All through the present exhibition the intelligent effort can be felt to save each work of art from any interference from its neighbors. True, it is the most modern pictures that fare best. It struck me that I had never seen the celebrated "Canotiers" by Renoir, which has been borrowed from the Phillips Collection in Washington, look so faded and unforceful as it does on the present occasion. On the other hand, the Matisses and Picassos and Mirós burn with new fire. Before quitting the subject of the architecture temporarily — it will be much discussed — I must also add that these picture alcoves disdain coziness. Apparently, in the new museums, we shall be expected to stand up, look quickly, and pass on. There are some chairs and settees, but the machine-like neatness of the rooms does not invite repose. The old-time habit of sitting in front of a masterpiece for half an hour "drinking it in," as it were, will

To be sure, most of these artists have not remained idle all these years, and have gone on from wonders to more wonders; and in addition we know more about them and their special set of values than we used to know, and so Alfred Barr and the other rulers of the new museum have known where to seek the most significant productions by the new masters and have had astonishing luck in acquiring them for the present occasion – with the result that New York now has the opportunity to study the finest and most complete exposition of the "modern idea" that has yet been put together anywhere in the world.

It is certain to affect the public profoundly and in turn, like its famous predecessor, will make history. It has been designed not only to justify the building of the new museum, which it does emphatically, but to accompany the activities of Mr. Whalen's World's Fair and there is not much doubt that it will prove to be the most constructive effort in that direction put forth by any of our institutions.

Before going on to a recital of the "attractions" of the show it would be just as well to take a look at the new building, for, talking of heroes, that, after all, is the main one. The façade has been disturbing New Yorkers, even the most up-to-date of them, during all the months of its construction, by its stark and machine-made simplicity. It contained nothing, so it was feared, that resembled architecture in any way, but now that the scaffoldings have been removed and the chromium and glass have been polished up the extreme cleanliness of the affair mitigates somewhat the nudity, although the unregenerate will doubtless insist that the front calls loudly for some flagpoles or other ornament. Possibly one of those weird contraptions of Sandy Calder that he calls "mobiles" might save the situation. They had one once on the old building and there is no apparent reason why there shouldn't be one on the new, flopping around in the breeze and casting helpful shadows on the blank wall.

Philip Goodwin and Edward Stone, the architects, doubtless read humbly and prayerfully all that the most famous Le Corbusier ever said about houses being "machines to live in" and resolved to make the museum a machine to show pictures in and nothing more. Flexibility is one of the new items in the new architecture and everything inside the building may be changed around, as the necessity calls for changes, and

opening exhibition of the Museum of Modern Art, which is scheduled for next week, but the express stipulation of the artist that it should be shown for the benefit of political refugees prevented this arrangement.

The New York Sun, May 6, 1939

OPENING OF THE NEW

MUSEUM OF MODERN ART

THE CURIOSITY aroused by the factory-like façade of the new building of the Museum of Modern Art has at last been appeased. The structure is now finished and open for business. It houses a collection of paintings, sculpture, photographs, and designs that is fully as startling as itself, and by the time these words appear in print all the tongues in the art world of the city will be wagging furiously, for in spite of all the education in modernity that we have undergone not all of us, it seems, are as modern as we might be. We still have much to learn and this museum is here to show us.

The collection now shown is wonderfully like that of the famous and historic Armory Show. The atmosphere, at least, is the same, and although a quarter of a century has elapsed since that event, the whirligig of time presents no new shocks comparable to the old ones. That is to say, all those who were bullied by the Armory Show into an acceptance of a new viewpoint upon the pictorial world will not now have to change again. The chief heroes remain the same. Picasso and Matisse and Redon and Rousseau and Marcel Duchamp and Maillol and Lehmbruck are still on deck, and very much on deck.

more important — a work of art. Picasso is an ardent communist and in painting "Guernica" he was attacking Franco with might and main, but the futility of propaganda in the hands of an artist is once more illustrated, for always in the case of the good artist the genius of the painter takes charge of the situation and the politician in him disappears in the effort to turn out a good picture. People who see the picture in this country and who respond to its horror will see it simply as an argument against war in general. Picasso aimed it at one set of disputants but it puts the course upon all disputants. Death is very similar on both sides of the battle lines.

Technically the work is overwhelmingly clever. It is twenty-eight feet in width and the great reduction necessary in the photo reproductions destroys the surface variety that the picture has, though it does give an idea of the massive composition founded on a great triangle, with the lighted lamp at the apex of it, and not by accident, for nothing in the picture is an accident. With this vast mural are shown some of the many preparatory studies for it, all of them in bold, unerring lines that are amazing in force. Picasso is continually inventing. Apparently for every new set of emotions that creeps into his life he has to have a new set of symbols, and so we behold him prodigal, on the present occasion, with a group of revolutionary forms that no one on earth but he could have achieved, and all of them have a compelling authority that demands their acceptance into the new language that all the lesser artists will shortly be using.

For reasons of his own, Picasso did this picture in black and white. He can be a great colorist when he chooses to be and there seemed no special necessity to asbtain from color in the Spanish Pavilion — but, of course, he had his reasons. Even in the black and white artists will still find color, however, for there is an emphatic and lyrical play of values against values that runs all through the piece. It actually looks richer and more eloquent as it hangs now in the Valentine Gallery than it did in Paris, for the light that falls upon it is eminently becoming and emphasizes the unity of the design and its tremendous and dramatic thrust.

"Guernica" has already been exhibited in London and will doubtless be shown in some of our other cities before seeking permanent asylum in some museum. It had been supposed all along, by the prophets, that it would be the star item in the

PICASSO'S GUERNICA

WHAT, FROM any point of view, is the most remarkable paint-
ing to be produced in this area — the already famous "Guernica"
by Picasso — has arrived in this country and is being shown
in the Valentine Galleries for the benefit of the Spanish ref-
ugees campaign. This is the most sensational event in a
season that has not been too prodigal with excitements, and
to see it is an obligatory experience.

It was painted two years ago as a decoration for the
Spanish pavilion in the Paris World's Fair and it was instantly
recognized by most connoisseurs as an extraordinary achieve-
ment and destined without doubt to be regarded as Picasso's
masterpiece. Certainly it is the most stunning attack that has
yet been made upon the eyes and nerves of the art-loving por-
tion of the public.

It will be much talked about and long talked about. Years
after the present war fevers shall have been replaced by some
other kinds of fevers — for in the long history of the world
there never has been a time when human beings have not
itched with unholy desires of some sort, and so it seems likely
that we shall continue to be the bad numeros that we have
always been — years hence, I repeat, when we shall be able to
look on this present period with detachment, just because we
shall then be immersed in some other kind of deviltry, we
shall regard this "Guernica" as the most concrete and powerful
statement of the hatreds generated by these political wars of
the present.

It is full of war passion. It was begot out of the rage felt
by the artist when he learned of the destruction in the late war
of the old Basque town of Guernica. You don't have to be
especially susceptible to cubism to understand it. It is only
too plain. Death and destruction are furiously indicated and
the gestures of the victims have a largeness and a ferocity
unequaled in art since medieval times.

This sounds like propaganda and in fact the picture was
intended to be such, but it ended in being something vastly

367

qualities of its own — qualities the great Courbet would have frowned upon, qualities that may be grouped under the general catagory of wit. Courbet wouldn't have tolerated that little figure away back on the hills and so impossibly related to the figures in the foreground. He liked things to relate — definitely. But if you view this work through the doorway of the second gallery you will be delighted with the way young Balthus "relates" all the planes in his big landscape. He can "relate," too, in his fashion.

The paintings, however, are by no means the whole thing of this show. Probably the feature, for the literary-minded, will be the series of drawings made to illustrate the tale of "Wuthering Heights." The mere announcement that a young French artist has seen fit to do such drawings will be sufficient bait to lure the bookish to the rooms. What could any Frenchman get from a tale so firmly intrenched in the secret places of British consciousness as "Wuthering Heights"?

The answer is that it is a young Frenchman who does this. The word "young" in this connection becomes exceedingly troubling, and I confess again that I do not get all the connotations though recognizing that my very young friends get them all. Baffled octogenarians who have thrilled all their long years to the disorderly and un-British story by the half-savage, half-lady Emily Bronte must admit that the Heathcote and Catherine in the book have points of kinship with the untameable youngsters who are causing so much trouble in the world of today, but even so, that doesn't explain all the self-justification that the unkempt rascals seem to get from these drawings.

Needless to say, Emily Bronte herself might not have objected strenuously to these versions of her people, but Charlotte Bronte most certainly would. Charlotte you see, was the friend of Thackeray and loved to look at the pictorial world from his point of view. She would have admitted willingly enough that Heathcote and Catherine were wild but she would have had it expressed in the Quakerish terms of Thackeray's own drawings. Young Mr. Balthus of Paris, however, is no Quaker. Go to the exhibition and see for yourselves what he has done to the famous children of the moors. When he says they are wild, believe me, they are wild.

The New York Sun, March 25, 1939

BALTHUS

ABOUT THE only thing Paris has to offer in rebuttal to the on-
slaught of Salvador Dali is the work of young Balthus, and so
Pierre Matisse made a hasty trip across the ocean lately and
has just returned to open a Balthus show. He is no more than
just in time. The Dali excitement is raging furiously a few
doors further west on Fifty-seventh street, but perhaps the
Balthus offering may assuage it.

It has some peculiarities, too – if it is peculiarity that you
are after – but the chances are that you won't "get" it if you
are past forty. Perhaps even being past thirty-five may handi-
cap you. At any rate the quite young get certain overtones
from these pictures that are not easily apparent to their
seniors. Just what it is I can't tell you precisely, being, un-
fortunately, past the age myself; but it has something to do
with being young in a nasty way.

You know there are two kinds of young people – the nice
ones and the unpleasant ones. These unpleasant ones have a
strange kind of militancy. Not being content with being ter-
rible themselves, they seem determined to wreck the entire
world and make everybody else terrible. I have been told that
M. Balthus is a quite nice young man and I have every reason
to believe this in spite of the fact that his work does hold an
uncanny fascination for the other sort of young people. They
get in the corners of the gallery and gloat over it in a most un-
seemly way but, as I said before, if you are over thirty-five you
won't in the least know what they are gloating about. In that
case you will have to look at it "just as painting."

Fortunately you can do that. There is some painting there
for you to look at. M. Balthus is a sort of a young Courbet. He
sees nature in a broad, big way. Also people. He puts every-
thing down on canvas in a big way and is not afraid of colossal
undertakings. His enormous panel called "Summer" is am-
bitious beyond anything that has been attempted lately, but
the artist brings it off very well indeed. It is not as sturdy as the
same thing by Courbet would have been but it has excellent

1939–1952

scapes with a hot and arid stuffiness that is intolerable, and the very pigments themselves assume an unwieldy stickiness testifying to the labor involved.

When the visitor finally reaches the upper rooms where the black-and-white drawings are shown, all the embarrassments of this occasion are forgotten, for here are natural and spirited accounts of episodes in the life of the city, and even when these accounts are extremely complicated, as in the descriptions of parades in the streets and holiday festivities in the parks, there is a balance and security to the compositions and a spontaneity in the lines and a wit in the characterizations that make them all highly acceptable. Even here there is a tinge of Frenchiness to the style, for in the early days of Glackens's illustrative work it was practically impossible to be an artist in the United States without casting sheep's-eyes at what Forain and Steinlein and Willette and the rest of them were doing, but since Glackens really was a gifted draftsman in black-and-white he was able thoroughly to digest his borrowings and keep them submerged. Such indebtednesses are common to all artists, for one must begin somewhere in forming one's style and when the style is actually accomplished and the manner becomes personal then no harm is done. Glackens in illustration was, as we now say, "himself." His work in this line was much appreciated by editors and by the general public and doubtless will continue to be.

The New York Sun, December 17, 1938

the judgment very often in these cases. In the recent years this championship of theirs has insensibly diminished, but enough of it remains to make the task of talking sense in this matter extremely difficult.

For the truth is that Mr. Glackens was not a colorist and it was the desperate effort to correct this defect in his equipment that made him forget the chief business of a painter — which is to say something in paint — and led him into a self-conscious preoccupation with technic, and the moment any painter sinks into that morass he is no longer an artist.

The chances are that he would have enjoyed a much wider renown if he had clung to black and white illustration throughout his career, and there is also a chance that he might have gone somewhat further if he had remained content with the limited and gloomy palette that he used when first taking the brushes up, for one of the earliest of his canvases, the "Chez Mouquin" attained a degree of naturalness and ease that he was never again to equal.

But it is blackish, and all the pictures of the 1905 period, which are grouped together in adjoining galleries, are blackish. He must have been scolded by his friends for this dependence upon a black base, or, since impressionism was the reigning cult at that date, he may have scolded himself, for the succession of the pictures shows that he threw his pots of black paint out the window and became a violent impressionist almost overnight, trailing along abjectly in pursuit of the secrets of Renoir.

One cannot become a colorist by force of will, however. If that were so we should all be brilliant colorists. Glackens's disaster lay in the fact that he could not see form in color. When he applied the tints they too often lay flat on the surface of the canvas instead of rounding into the forms of nature. In the 1924 "Nude" the blue in the legs makes them quite unsolid and the pink of the cheek does not follow the curve of the cheek, and in the nearby portrait of a young woman the same misfortune of formless color takes the painting of the hand which sinks into a deadly blue. Glaring lapses such as these must have been visible to the artist himself and form the probable explanation for the sense of strain that seems to increase rather than to lessen as his struggle with recalcitrant color went on. The glaring reds and blues do not have the lightness and vivacity of the master impressionists but burden the land-

And still another technical problem recalled from the past by these pictures is the artist's use of bitumen. This paint was considered a scandal, especially by the early impressionists, who said it turned black, but there were those who claimed they knew how to use it. Apparently Duveneck knew how, for in the unfinished version of "Amy Folsom" the bitumen can be seen dripping rather pleasantly toward the bottom of the canvas and it has not turned black. Wasn't it the unfortunate Munkaczy whose pictures all turned inky black because of bitumen? Apparently he should have used it thinly like Duveneck.

The New York Sun, April 16, 1938

GLACKENS'S MEMORIAL EXHIBITION

THE STORY of William Glackens is the tale of a natural-born illustrator who turned to painting and plunged deeper and deeper into confusion as he pursued this new vocation. The memorial exhibition of the late artist's work, in the Whitney Museum of American Art, gives testimony to the valiant and unflagging spirit with which he strove to overcome fate, but also makes plain the tragic nonsuccess.

This is a bitter and unwelcome opinion to have to express, but since it seems altogether too likely that it will be also the opinion of the many it is just as well to say it and get it over with. Mr. Glackens was a charming man, by all accounts, who had a talent for friendship as well as undoubted gifts as an illustrator, and the affection felt for him by his fellow artists persuaded many of them that he was a genuine colorist as well as a creative painter — for the heart has a way of beguiling

pelled to step back and make way for several men, such as
Albert Ryder, Winslow Homer and George Fuller, who had not
been especially clever in acquiring studio tricks, but who had
made acquaintance with American life and its backgrounds
and knew how to get the native feeling into their pictures.

There was no campaign for these men (or as we now call
it, "ballyhoo"). On the contrary the excitement was all for the
returning stylists from abroad, but little by little, it dawned
upon everybody, including the experts, that the Homer, Ryder,
Eakins, Fuller, Blakelock paintings filled the bill. They were
homely, if you like; they lacked grace; but they "had some-
thing" — they were "us." By the time this was discovered it was
also discovered that these native sons were money-makers, as
far as the experts were concerned, and that settled the matter.

At the present moment, it must be confessed, the native
sons are carrying the business of being "homely" too far. They
are selfconscious about it and the Missourian, Texan and Cali-
fornian brands of patriotism are uncouth. Patriotism doesn't
have to be uncouth to be real. So it will not in the least harm
some of the rougher young painters of the day to take a look at
the Duveneck paintings, now that they are here, and see if
they cannot clarify some of their methods by comparing them
with Duveneck's. They will see readily enough, I believe, that
technic, even when very expert, is not enough; and that the
glibbest brush strokes in the world are unavailing if nothing is
said with them; but for all that clearness of technic is a help
to any artist and Duveneck had it.

Consequently, Duveneck's "studies," for they were always
that, will have an interest for painters for some time to come,
even though they do seem entirely "reminiscent" to the gen-
eral public. When the time comes, if it ever does, that we will
have greatness united to grace, then we may forget him; but
until then he at least reminds us of the grace.

In regard to his own accomplishment, he seems to have
reached his top stature in portraiture, and especially in those
of his fellow artists. He has done nothing much better than
the portrait of William Gedney Bunce. The unfinished "Lady
With a Veil" runs it a close second. But it is disconcerting to
see how trite the artist could be in such a composition as the
"Page Playing With a Parrot," and it is a testimony to the
prestige Duveneck once enjoyed that it should have been pre-
served all these years, though it does him disservice now.

but these drawings by Demuth remain the most distinguished contributions yet made to this kind of expression.

The New York Sun, December 18, 1937

DUVENECK

THE EXPLANATION for the comparative subsidence of a once prodigious reputation is afforded by the just-opened exhibition of the works of the late Frank Duveneck in the Whitney Museum of American Art.

Duveneck was a technician. He learned practically all the technic the old masters in Europe had to offer, but he had little use for the technic after he had learned it. He was a technician, but not an artist.

In the old days when all America was getting to Europe as fast as the steamers could carry them there Duveneck was a prince among his fellows. He was the quickest and the cleverest at ferreting out the secrets of the museums. When he was but 28 he had already painted the picture now called "Woman With Forget-Me-Nots" and it looks so like a Rubens that it might easily be mistaken for a Rubens. But so great was the craze in those days for learning how to paint in the way they painted in Europe that this reprehensible proceeding of painting "just like Rubens" was hailed as a triumph of virtuosity and the Duveneck studio in Munich and later in Florence was crowded with American pupils eager to do the like.

Years later these pupils and their friends were to awaken to the fact that what America really wanted was not painting à la Europe, but painting à la America, and they were com-

studies which radiated such an air of "sweetness and light," especially when owned, that their admirers quickly began to feel that Demuth could do no wrong.

At the same time this cubism, this calligraphy, and this symbolism are not especially creative and that is probably the reason why they are so little challenging. Cubism and calligraphy were simply part of the art-jargon in the period in which he grew up and he used them just as he used the current speech. Cubism was not necessary to him as it could have been, conceivably, to an artist who could accept the world on no other terms, but being very distinctly a citizen of the world he "played up" the fashions from Paris with a degree of amusement and certainly with great competence. He may be said to have translated cubism "into American," and to have added to it some of his native elegance.

Elegance was an insistent aspiration with him. He once told me that he admired Fragonard enormously and that the thought of Fragonard often guided his impulses. No reflections from Fragonard, however, are visible in his work, unless you think the French master helped the distant American to some of his clarity. There is certainly enough elegance in the still life of "Grapes and Turnips," shown in the entrance hall, to have guarranteed it an acceptance at the Court of Louis XIV in spite of the (perhaps) lowly turnips. In fact, these Demuth turnips are royal. No others in art match them.

The special concern of the students, however, is the opportunity provided by this event, to renew acquaintance with the Demuth illustrations to "The Turn of the Screw" and "The Beast in the Jungle," by Henry James; illustrations that startled the art world a generation ago and then were promptly whisked away into private collections. These drawings are done in scribbled lines that would have horrified the pedantic followers of the Atelier Gérôme if they had not already been somewhat quelled and defeated by the cubistic revolutionaries of the day, but unprejudiced younger observers were so impressed by the Demuth intensity of feeling in these drawings that they did not recognize that method as calligraphic and succumbed to the horror, and morbidezza, and general screwiness that the artist had extracted from the fearsome novels. Since that day a whole school of young Americans have practiced calligraphy with an assiduity worthy of the Chinese,

Possession and intimacy are necessary to a Demuth water color.

The Whitney Museum is a reconstruction from several dwellings that must have been exceedingly comfortable in their time, and certain of the galleries retain a warm and agreeable "residence" feeling. One of them, on the second floor, is a symphony in tones of rose, luxuriously carpeted and with perfect window curtains, and in this room the loveliest of the flower paintings are shown. Or is it that they are the best? Might it not be that the flower pictures relish their pleasant surroundings and perform well because of them? I am inclined to think that is it. The entire exhibition is seductive and, due to the clearness and distinction of the workmanship, is bound to be a popular success, but one or two of the rooms have the white walls that are necessary for strictly modern pictures, and on them some of the Demuth drawings have that jewels-in-a-museum look that has been referred to. Burglars who rob museums are, of course, very reprehensible persons, yet any method that brings a museum jewel back into private circulation is not altogether to be despised.

The anticipated public favor that is to be allotted to this exhibition is a curious instance of what an artist can do with his public once he has gained a public, for Demuth practiced many devices that are not forgiven to all American painters. For instance, many persons who condemn cubism as the sin of all sins, have openly admired the several water color versions of Sir Christoper Wren church steeples without seeming to be aware that the drawings are cubistic. It is quite refined and delicate cubism but it is cubism just the same. Then there are the series of illustrations to novels by Henry James and Zola which have acquired a great deal of local fame, and which some critics (myself included) rate as the best things that Demuth did, and yet they are calligraphic; and officialdom in America doesn't yet know what calligraphic draftsmanship is and consequently is bound to disapprove of it for at least ten years to come. On top of these there is a whole roomful of stylized symbols, headed by the "I Saw the Figure 5 in Gold," which looks so handsome, as now shown, that I'll wager any sum you mention that the average man from the street will forget to be mystified by it. And yet, as a rule we New Yorkers do not care for mystical pictures. This special permission to the artist to do as he pleased was won by the delightful flower

at once destroyed them as propaganda – if that had been the intention – and converted them into works of art. You no longer saw them as starvelings of humanity but as peculiar beings living a life of their own.

So there you have the two aspects of Maurer at which I stop. First, there was the life, which was admirable and wholly what an artist's life should be, and heroic enough to make you think him entitled to a degree of fame for that alone. Then, against this, is the feeling that the painter's style, peculiar though it is, did not wholly spring from the artist's own experiences with life. Finally, I offset this last reproach, since it seems to be a reproach in which all may share, for we Americans do not seem to be a nation of stylists in paint. So I have decided that Alfy Maurer will go on asking his questions. I do not think he will be dropped.

The New York Sun, November 27, 1937

DEMUTH MEMORIAL EXHIBITION

THE MEMORIAL exhibition in the Whitney Museum of the late Charles Demuth is astonishingly reassuring. All the drawings look valuable and desirable. This is largely because they are well shown. The Demuth water colors are unlike other American water colors and the Whitney Museum is unlike other American museums. The two go well together.

Demuth's art is precious or it is nothing. If you will see actual jewels in a museum you will know what I mean. Emeralds and diamonds that glow with conscious value upon a lady's finger suddenly become cold and lifeless when transposed to a vitrine in a museum.

without thought of the box office results. He deliberately turned his back on the easy career of an academician and whether you look upon this as sense or nonsense it clearly proves, at least, that he had the courage of his principles. This action alone won him the special attention of those who like to look upon the "artist as hero."

Unfortunately, Maurer lived in a period when it was obligatory for a young artist to go abroad and in Paris Maurer got into trouble. That is to say he landed in the midst of the revolution of the "Fauves" and learned that the right way to paint was to do all the things that the Beaux Arts professors said you shouldn't do. This turned Maurer into a semi-abstract painter. He never quite gave up a subject. He always had one, but he treated it with a freedom that was highly satisfactory to a young man who had gone abroad especially to acquire something with which to shock his fellow-Americans upon his return home.

That was the trouble that Maurer got into. He learned style, as travelers abroad are always doing, by wholesale. His new style was not so much a growth as a mere change of garments. He felt his original manner (which won him a prize at Pittsburgh) to be hollow, else he would not have discarded it and though he finally got used to his new Parisian style and said things in the end fullheartedly through it, yet there always remained in his painting the tingle of a foreign accent. This was not so much his fault as it was the fault of the period he belonged to. You remember, you weren't considered an artist in those days unless you did have a foreign accent. Duveneck, Chase, Twachtman, Hassam and so on down the line – all had mannerisms acquired from fashion-mongers abroad.

But Maurer did have some things to say and said them full-heartedly. He began doing the depressed (and compressed) young women who linked up with the movement to do away with frustrations and inhibitions that came in with the study of Sigmund Freud. Sherwood Anderson thought these young women were wronged factory-workers and was all for them, and the artist, for a while. Personally I was not so sure the young women were factory workers in distress. I suspected the curious compressions and elongations of their heads came about through the new aesthetic – the necessity to fit them to the elongated panels. In any case, weird and strange though they were, they were painted in a broad, assured manner that

ALFRED MAURER

ALFRED MAURER is dead but his pictures are still asking questions. It may be too soon to answer these questions definitely. It certainly is too soon to answer the most important one, i.e., as to the ability of these pictures to please on their own intrinsic merit; for as yet it is impossible to separate them from the charm of the dead man who painted them. But that they have the power to go on asking the question is something.

There is a small exhibition of the artist's work in the Hudson Walker Gallery and it concentrates on the "difficult" phases and ignores the flower paintings which present no problems. It even includes the early figure painting which won a prize at the Carnegie International years ago and which is so conventional that one wonders what inner light suddenly flared up in the painter's soul and induced him to swing so far to the left. Could it be that merely winning the prize scared him?

But I see I am putting too severe a test upon this work. It is too much to try to separate the man from his work. That, after all, is never done. It is the recognition of the man in the work, in fact, that gives it worth. What I meant to say is this: That I welcome the present opportunity to see if the paintings impress the new school of connoisseurs who know nothing of the artist's story.

Something of that story they will probably instantly guess from the sequence of the pictures themselves, for a certain wildness increases in the pictures as they go on and comes to a climax in the self-portrait and after that it is almost not news to announce that Alfred Maurer committed suicide. It is the idea of "Horla" over again, for Maurer's end, like De Maupassant's, was foreshadowed in his work.

Like all problems of the sort, the pros and cons are so inextricably mixed that it is difficult to unravel them. Maurer's career as an artist, for instance, was entirely honorable. He lived exclusively for his art and in sharp contrast to most of the painters of today who never lift a paint brush to canvas

other ballet company, the one that's just been doing "Coq d'Or" so nicely. But anyway it's a highly successful portrait and certain to create envy in the bosoms of other portraitists and also in the bosoms of the would-be sitters who do not all succeed in crashing the studio door. Mr. Tchelitchew cannot paint everybody, that's understood.

These frustrated sitters are counseled, by way of recompense, to take another look at the portrait of "Miss Edith Sitwell" – also in this exhibition – and then to ask themselves whether they really have the courage for this exalted kind of portraiture – for heroism of a sort is undoubtedly required. Miss Sitwell, being British, has withstood the temptation to be Slavic, but fell heavily for the other temptation that Satan – I mean Mr. Tchelitchew, of course, but of course I do not mean anything wrong by this – that Satan, I repeat, had to offer, and became even more medieval than Mr. Kirstein. She is shown in consultation with a recalcitrant Muse. She has paper and pen all ready, but the words will not come. She wears a loose-easy-going robe quite unlike the things Molyneux has been turning out lately for the Duchess of Windsor. But nothing helps. She has let her hair down. It is of no avail. The words will not come. And, incidentally, Miss Sitwell's hair, when let down like this is simply terrible.

Gazing at this debacle, one of Mr. Beaton's girl friends, herself most marvelously coiffured, was heard to murmer: "I wonder if this will bring Gertrude back to Pavel" – for one of the most deplorable tragedies in modern art history is the well-noised fact that when Miss Sitwell so enthusiastically "took Pavel up" in London, Miss Stein, with equal enthusiasm "let him down." But when internationally famous ladies, such as these, quarrel about their geniuses, nothing that mere men may do helps. The chances are, if this really is a gesture of the sort indicated, that Pavel will now lose the patronage of both. Mr. Beaton, who knows all parties to the intrigue, and loves them all, remained singularly calm at the party. Perhaps there's nothing to it. Or perhaps the Modern Museum will hastily buy the portrait and pack it away somewhere where Miss Sitwell will never encounter it. One must hope for the best.

The New York Sun, November 6, 1937

gone, for all the forty-eight persons in the highest social circles who are permitted to address Cecil Beaton by his Christian name had already seen the portraits in the artist's studio and passed upon them favorably.

Against such a decision as that, of course, there is no re-call. All forty-eight were present again in the Julien Levy Gal-leries on election day, along with Cecil himself, and about 418 other persons who do not have the honor of Mr. Beaton's acquaintance but who follow his lead in matters of art. Sherry was served. This had no bearing on the success of the oc-casion, as connoisseurs insist that they think more clearly after sherry than before, and they are probably in the right and in any case there was no real necessity for thinking, the thinking having been done already, and only enjoyment being called for, and this would come about naturally – the forty-eight being present – but undoubtedly the sherry assisted. So you may readily understand that there can be no exaggeration in stating that a good time was had by all.

It was, in fact, the first "occasion" of the winter, and there may not, in truth, be such another, for these brilliant per-sonages who made it are but birds of passage and will soon be flitting to Miami, Hollywood and that place in Idaho (isn't it?) where they ski. So it was lucky that all forty-eight could be present at the launching into the great world of Mr. Tchelit-chew's portrait of Lincoln Kirstein, the well-known writer and balletomane, for this is certainly the artist's masterpiece to date and probably the reason for the rush of the other celebri-ties to get painted by him.

It is painted in Mr. Tchelitchew's best Bellini manner with incredible niceties of touch, prodigal in invention, and charged with some, but not too much, psychology. The protagonist wears a scarlet and black jacket, probably part of his working clothes at the Mertopolitan Opera House and this it is, no doubt, that makes the picture recall Bellini so distinctly, for the garment compares gallantly with the best that Renaissance bravi could obtain, yet Mr. Kirstein got his, you may be sure, from one of the better department stores in this town, Mr. Kirstein being an exceptionally able young man. This review seems to be running into long sentences. You must bear with it. It's the Russian influence. Mr. Kirstein himself could not escape this influence and looks positively Slavic in the portrait; so much so that you might think him stemming from that

painting is to be found in our Metropolitan Museum, not even among the ancients. Every inch of the canvas is "painted," but I suppose you have to be an artist to know what that means. It means that each touch is sincere — from the artist's point of view. So much contemporary painting is perfunctory. There is nothing perfunctory about Soutine's work. It is meant. It may be meant hatefully, but it is meant intensely — and that is what you chiefly ask of an artist.

Now if I have cowed you at all by these remarks, the next thing you will be asking is: "How did he get that way?"

It will probably be answer enough to tell you that Soutine was the intimate friend of the lamented Modigliani. The tragic privations that finally proved too much for Modigliani have been so well publicized that there is no need to repeat the horrid details, but it sufficiently explains Soutine to say that he shared them. Paris still echoes with stories of the fantastic methods employed by the two tragedians in the effort to exist without money; and the stories are so shocking that one finally understands why Soutine cannot forgive — even after prosperity came to him personally — cannot forgive the world for the indignities he suffered.

The New York Sun, May 8, 1937

TCHELITCHEW'S PORTRAITS

LATE TUESDAY evening when the polls closed and the votes were counted in the Julien Levy Galleries it developed that Pavel Tchelitchew as well as Mayor LaGuardia had been elected. The results, in both instances, were scarcely surprising. In Pavel's case, certainly, the conclusion was fore-

But that doesn't prevent him from being a very great painter, just the same. One by one the Soutine paintings that first converted the Parisian connoisseurs and shook them out of their original dislike are coming to this country, and the more of them we see the more evident it becomes that Soutine must be ranked with the great. A new collection of his works has just been placed on view in the Valentine Gallery and in more ways than one they are amazing productions.

Even if I were to confine my remarks to a description of this artist's painting technic I could scarcely conceal from you that his manner is defiant to an outrageous degree, for the man begins a picture with his palette in the condition at which other artists leave off, and in fact he seems to work with the muddy leavings begged or filched from more prosperous neighbors, but before he gets well into the picture, believe me, he makes the colors shriek.

It may be muddy paint, but Soutine contrives to suggest that it is the kind of mud in which you find jewels. There is the gleam of something precious and valuable in the most unlikely places in the composition, just as there is in the best things of our Albert Ryder, though you feel that poor Ryder never knew how the valuables got there, but that Soutine did know precisely how they came there. But by this you mustn't take it that Soutine works exclusively in browns. On the contrary, he loves wild colors and has much wildness in every picture, but the loud and disreputable reds he uses look as though they had been dragged through the gutter before he got them.

As though this were not enough in itself to frighten good, innocent people, Soutine distorts. And he goes mad at intervals. He paints screwy-looking people with tiny heads like those you see in the circus freak shows, and he makes the eyes of some of them flare out at you so that you yourself can hardly return the glance, just at first, and the picture as a whole suggests that it has been partly melted in a furnace during one moment of its manufacture and then reassembled while still too hot to be held comfortably, and therefore the parts do not fit perfectly.

I see that you shudder at the description.

Yet I haven't told you the half.

But in spite of all this the man is great. No richer paintings than these have been shown here this winter. No richer

beat upon the soul like unearthly music. Artists who, like Dr. Faustus in the play, attune themselves to "worlds above the moon," would scarcely care to put into concrete form the visions of another artist. Houdon might, but Michelangelo certainly would not.

Yet the Richmond affection for both Miss Hoffman and the dancer were appreciably heightened Sunday night, March 7, when Mrs. John Kerr Branch opened her great house on Monument avenue to the flower of the city and a few interlopers from the North and gave them a "first showing" of a cinematic record of some of the Pavlova masterpieces, including the celebrated dance of the "Swan." The records were made in the later years of the artist's life and at a time when film technic had not reached present-day competence, yet the old, familiar spell enwrapped, unmistakenly, all those in attendance. . . . Their hushed subjection was marked. . . . And at that moment, so it seemed to me, the Pavlova reliefs were sold to the city of Richmond.

The New York Sun, March 13, 1937

SOUTINE – AND THE PUBLIC

IT SEEMS to be natural to begin an acquaintance with Soutine with a profound distaste for him, and this feeling persists long after the students discover that the affair is mutual and that Soutine detested you long before you detested him. Surely never was there a more crabbed – I believe that's the word the gypsies use to describe the quality – artist since the world began, and he is so contorted and twisted in his procedures that I shouldn't be at all surprised to have him turn out to be a gypsy in the end.

But heights and depths and widths are designations un-important in themselves, the main thing being the quality they measure. Who was the wise person who made the reassuring remarks about the wide rivers and the deep ones? Was it Schopenhauer? Or Emerson? Probably it was Thoreau. Any-way he made it clear that it was the "volume" that put the test on the rivers, the wide ones being just as valuable as the deep ones, when the last analyses of them were made by the power plants along their banks.

And so it is, of course, in this way that one judges Miss Hoffman's flights. She went all around the world, thus accumu-lating mileage that puts Houdon's and Michelangelo's timid peregrinations to shame, and returned safely home again laden with artistic spoil in the way of accurate transcriptions from the living, walking poems that still thrive in the far places of the earth; and also with tales of adventure which it was no trouble at all for her to transform into a best seller. Every-body in Richmond has read Miss Hoffman's "Heads and Tales," loves it and loves her in consequence.

Thanks to that book, the mystery of sculpture has been robbed of half its terror. One, in fact, might almost now live with sculpture. One could at least live with Miss Hoffman's reliefs glorifying "Pavlova and the Dance"; and Richmond probably will live with it, now that it seems how admirably it fits the room in the Virginia Museum where it is shown. But of that possibly more anon.

March 7. — It is not precisely "news" that Pavlova and Miss Hoffman were intimate friends. The intellectuals on both sides of the ocean who were irresistibly conquered by the great dancer always stepped aside willingly, nevertheless, to permit Miss Hoffman to offer their thanks officially. They felt, possi-bly, that though it might not be a matter of life and death to Pavlova to receive thanks, yet on the other hand it was cer-tainly a matter of life and death to Miss Hoffman to utter them. Uttering them was her career for a while. It enabled her for the first time to be articulate in bronze and her "Pavlova and Mordkin" followed the dancers around the circuit and finally became almost as familiar as they were. The piece has not, in the present writer's opinion, all the academic merits of the portraits of savages made for the Field Museum, for Pavlova, like Michelangelo, represented ideas, and it was the idea as she presented it and not the mask of the dancer that

gave out all the important jobs to artists. He brooded continually over an ideal state of living that was impossible to realize upon this earth. Houdon, on the other hand, accepted the world "as is." He was, in the Virginian sense, civilized. It was probably he who insisted that Washington should keep on his gloves in the famous portrait-statue in the rotunda of the Richmond Capitol. The gloves did not discommode Washington in the least.

No one quite believes, of course, the malicious remark of Henry Adams about the awkward appearance of Abraham Lincoln at his own inaugural ball, that "it was evident that Mr. Lincoln's white kid gloves quite spoiled the evening for him"; but just the same I recall no other of our Presidents save this Houdon Washington who wears white marble gloves for posterity. The visit to the Capitol to see this most important piece of staturay in all the Americas is necessarily a rite for all the Northern attendants upon Miss Hoffman's exhibition, since it emerges that her art ties up with Houdon's rather successfully. Anyway it leans more toward Houdon than toward Michelangelo.

Even natural-born Virginians might find it apropos and helpful to climb the Capitol steps for this purpose of comparison. Incidentally, it will be noticed that the busts of the seven other Presidents and the Marquis de la Fayette in the niches on the side walls pay no attention whatsoever to the Father of Our Country. They glance anywhere but at him! Each seems engrossed in his own affairs! Woodrow Wilson is more engrossed than any of the others. But after all it's not odd, this behavior of theirs. Being President of the United States is no cinch. It takes all of whatever you've got.

The best time to view the Malvina Hoffman sculptures is immediately after luncheon at the Commonwealth Club, where they have a way of doing oysters in a brownish-colored sauce and serving them with miraculous pancakes that put you en rapport with the higher flights of human fancy at once. Miss Hoffman's talent, however, is one to which one might easily adjust oneself even without the pancakes. It does not soar into the interminable ether where the breathing is difficult for most people, but goes great distances in a horizontal direction and with the utmost steadiness.

of breakfast (batter-bread, fishballs and café à la crème) a lady emitted the anxious cry: "We didn't finish hemstitching the cheesecloth."

"Does it matter?" asked another who seemed, to at least one impartial observer to be completely engrossed with the batter-bread (it is made with cornmeal into little round cakes, is softish in the middle and you put lots of butter on it and eat it with knife and fork. It's a superb confection).

"Matter? Absolutely, it matters. Of course it's got to be hemstitched. Let's go to the museum at once and get busy on it. We've still got time."

"Nonsense," said Miss Malvina Hoffman herself, "who ever'll notice whether it's hemstitched or not?"

"We will," exclaimed all the art critics en masse, "we'll notice it particularly."

"You would," returned Miss Hoffman, with a withering glance. "I forgot all about you," and then, in an aside to the anxious one, she added. "It had better be hemstitched."

And it was, perfectly; and hence there were no slightest little faults of any kind to be found in the Malvina Hoffman Sculpture Exhibition in the Virginia Museum of Fine Arts.

In Richmond, Malvina Hoffman is up against stiff competition. Richmond is by no means so easy to conquer as New York. The Richmond taste, these hundred years and more, has been founded on Houdon, and than Houdon there is no better taste the world over. Houdon, one might say, is all taste. Compared with the great Michelangelo, it is true, he is un peu academic. There is, however, no slightest hint of reproach to .Houdon in this. As I am always telling my friend Harry W. Watrous, who used to be president of the New York Academy of Design, the academic is a soul-necessity; especially here in America. Ninety per cent of us subsist upon it, thrive very well upon it. Henry Ford of Detroit says the same thing; though, naturally, Mr. Watrous didn't have to wait for us to tell him this — he knew it already.

All that is meant, in this connection, by the word "academic," is the difference that there is between fact and idea; Michelangelo representing idea and Houdon fact. Michelangelo was an impassioned, fiery individual who couldn't get along even with his own relatives, let alone the several popes who

able to obtain images sufficiently lucid and appetizing for an exhibit in New York."

The movement of the tiny shadows has been correctly apprehended in this picture, just as the artist says, but once the eye catches sight of "the accident of the meat while the sun was setting" then firm conviction seizes one that it will be hopeless to thresh this matter out with the Archbishop of Canterbury. Hieronymus Bosch? Yes, perhaps. But not Salvador Dali. He's too near our present predicaments.

The New York Sun, December 19, 1936

MALVINA HOFFMAN'S

SCULPTURES AT RICHMOND

À LA FIN, the hemstitching was perfect. For a time it seemed as though it were to be one of the major disasters of the year. Everybody was helping, but there was so much to do. Miss Anne Morgan was playing hookey, the other name for which is golf, and Mrs. W. K. Vanderbilt, who was substituting for her, was sent out hurriedly to the nearest shop to get more cheesecloth.

It takes yards, of course, when you are giving an exhibition. You always run out and have to have more. This time was no exception. The Malvina Hoffman Exhibition of Sculpture at the Virginia Museum of Fine Arts would be as nothing if more yards of cheesecloth were not available at once; so Mrs. W.K. flew to the bidding of necessity, and returned, as they say, "with the goods."

But the next morning, Saturday, to be exact, in the midst

realism, but by the time you have amassed a hundred such revelations, I feel pretty sure you will have sufficient material to take the measure of the movement completely.

But to get back to the Archbishop of Canterbury and the laity! I think it would reassure his Grace the Archbishop if somebody would inform him that there is a whole lot of the Academy in Mr. Dali's art. The criticism that is most generally leveled at the Academy is that it depends too much upon subject matter, but Mr. Dali certainly depends a lot upon subject matter, too. Indeed, there is more subject matter in one of Mr. Dali's works than in an entire Academy exhibition put together, even when the said Academy exhibition includes several compositions by Harry W. Watrous.

Mr. Dali's great masterpiece called "Suburbs of the 'paranoiac-critical' afternoon (on the outskirts of European history)" is calculated to keep any earnest student busy for an entire afternoon deciphering it. This picture is not only Mr. Dali's masterpiece, but it is the incontestable masterpiece of surrealism to date; and that statement is intended to convey the information that it also overtops anything that the old master in this line, Hieronymus Bosch, ever put forth in the way of horror. I don't know much about Hieronymus Bosch, but I have always suspected that he lived in a jittery time, something like ours, with all sorts of uncertainties about his finances, the state of his soul, &c., &c., and consequently had a perfect right to have nightmares. Besides, it was before the advent of Dr. Freud of Vienna, and he did not run the additional risk of being psychoanalyzed.

But, anyway, Mr. Dali goes him miles better. There are some shapes that look like arms clutching things in the picture, and if one thing in a dream is more disturbing than another, it is the fear that monstrous and incredibly forceful hands are about to clutch you; and Mr. Dali poses this amorphous shape in front of a landscape that out-vies those of Maxfield Parrish in literalness of detail, and here and there, in places where they horrify you most, the artist drapes bits of raw meat.

This must be the very picture that the artist described in a communication to the Academy and which was published in the Academy's Commonplace Book last month, as follows: "I used to balance two broiled lamb chops on my wife's shoulders and then by observing the movement of tiny shadows produced by the accident of the meat while the sun was setting, I was

DALI AND THE SURREALISTS

THE BEST place this week to overhear chance remarks – if you collect chance remarks – is the Julien Levy Gallery, 602 Madison avenue, for it is there that Salvador Dali, the surrealist, is showing his latest and most astounding pieces. Whatever else you may say about surrealism it sure is a great incentive to conversation, and the choice bits you overhear are always illuminating.

I meant to have taken along my notebook to the fashionable vernissage at the Modern Museum's show of surrealism last week in order to jot down the flotsam and jetsam of the occasion, but forgot to do so, and so my precarious memory only permits me to offer you two "overheards" from that event. Of course, I intend to haunt regularly the Julien-Levy-Salvador-Dali show, with my notebook, for these things that people say have their bearings upon the pictures, and will be very useful in judging the effect of this new art upon the laity. (That word "laity" reminds me, somehow, of the Archbishop of Canterbury. I wonder what the Archbishop of Canterbury would think of Salvador Dali's pictures.)

But first I must tell you what I heard at the Modern Museum. On the stairway of that institution there is at present shown an enormous mask, constructed by an artist named Wallace Putnam, and ornamented with a strange miscellany of household utensils, including a mousetrap, bits of wire, hair brushes, &c., and as I was going up I met an intensely respectable couple coming down. The man had a solid, substantial air, most probably a banker, a man with an instinctive feeling for values, and after gazing in awe-struck astonishment at the mask for a moment, he turned to his wife and said, unsmilingly: "Never throw anything away." Almost at the same moment two young men passed me on the stairway going up, and one of them had a wild look in his eyes. His friend asked him, in consternation, "What's the matter?", and he replied: "I don't know but I don't feel right." Of course, neither one of these "overheards" takes you very far into the depths of sur-

sion re-enforced by unusual energy naturally takes precedence over milder statements from the same source. There is such a thing, of course, as tearing a passion to tatters, of applying too much power to too frail a theme, as poor Caruso did in his last two breathless years with the "furtiva lagrima" that had previously been so exquisite; but Marin was fortunate in his rages to be raging against such things as Maine sunsets and New York skyscrapers; subjects, one must admit, that can stand any amount of pressure.

After the war, Marin calmed down much in advance of the rest of the populace, and his mountain views in New Mexico and his accounts of ships in distress off the coast of New England had a precision of statement that suggested a serene mind. There was still a certain amount of excitement in them, for Marin is an artist who catches fire from a motif, but it is a contained excitement like that in Gluck's Orfeo and vehemence was not allowed to interfere with elegance.

As elegance seems to be more in request than passion, it happens that Marin's later days have witnessed an increase in his public, and so it is not so strange to have an extended representation of his work in a public museum as it would have seemed once. Elegance, however, cannot have been a conscious pursuit of his, and it may occasion him some surprise to be told that he has it, for elegance, like style itself, is, or ought to be, unaware. . . . It's just the bloom on the peach — but it's what sells the peach.

The New York Sun, October 24, 1936

one among them who doesn't ask how it should be done but goes ahead and does it, gets their admiration at once. Marin, for all of his "apartness" seemed to respond to this approbation just like a regular human being and with each show he put on, his assurance gained and very soon he painted with an authority that at times was positively militant. When the young people told Marin he was "great," apparently he felt he had to be great.

There was also the obligation to justify "291." In the little gallery generaled by Mr. Stieglitz so much pulling down of the academy had been done that suddenly it dawned upon all the talkers and listeners that some building up had to be done, too. Marin, of course, was occasionally among the listeners and though no fingers were pointed directly at him, his subconscious got on the job and produced results.

The light-hearted singing troubadour who had come from Paris, changed into a serious dramatist almost over night. The little dancing boats in the harbor from which the artist had previously heard tinkling melodies, now bounced about on positively black waves and against gray skies; and the recurring tune sounded mighty like a dirge. The towering buildings of lower New York also occupied his attention and he did them in a perfect frenzy of appreciation of their significance and importance. He became an excited and exciting painter.

The war by this time had come upon us and had a lot to do with this nervousness of Marin. In personal contacts he seemed as cool and aloof as Voltaire is said to have been during the seven years' war, but when the year's supply of water colors was collected by Mr. Stieglitz for his annual Marin show, it was noticed that the passion in the drawings amounted to violence. Fortunately they were practically abstract and as the numbers of persons at that time in America capable of apprehending an artist's emotion when expressed in abstract terms was limited, no unnecessary increase in the current war fury could be traced to them. The drawings themselves, however, were certainly furious but I think it was merely Marin's response to the furiousness that was in the air.

In any case, there is an explosiveness about the "downtown series" of drawings and about a group of sunset pictures of the same period that sets them apart from the entire range of Marin's work and gives them an especial interest. Dynamics are not necessarily a value in themselves, but a pure expres-

he saw you coming in time, or any of his family coming, he much preferred to bolt into the nearest doorway, be it of a church or café, so long as it offered escape.

Nevertheless, I had several chats with him, the matter of which I have completely forgotten. Probably we didn't discuss art, for at that time I had no more thought of becoming an art critic than he had of becoming America's premiere aquarellist. But I liked him. There was no offense in his exclusiveness (or perhaps "apartness" is more descriptive). He was incorrigibly immersed in the business of interrogating nature for himself and had no time for interruptions.

He conformed completely to my idea of an artist, though I don't think I should have picked him out as one marked for worldly success. He already had the hatchet-hewn face that has since been made familiar to the world by Gaston Lachaise's portrait-bronze. Indeed I have never been able to see the slightest change in his lineaments made by the years and perturbations that have since rolled over our heads. He was born old and has remained young.

In Venice Mr. Marin was by way of being an etcher, and some of the prints achieved at that time still hold a place in the collections. Considerably later I heard of him in Paris as joining with a group of young American water colorists sponsored by or attached to the American Club of those days. The little show the young men put on got into the cables, and probably because of that bit of luck, quickly came to America.

When Marin shortly after appeared in the little gallery of Mr. Stieglitz at 291 Fifth avenue, he already had so distinct a style in the use of water color that the work of his Parisian companions automatically faded from the scene. By this time I even forget who they were. But distinct as was the Marin style at the time of his first New York exhibitions, there was nothing in it to disturb the sensibilities of the purists. The colors were sparkling and pleasant and practically every drawing could be called honestly a poem. It was a young man's irresistible lyricism that impelled them. They were not profound but they were natural and unforced.

There was much commendation for them, particularly upon the lips of young people. I recall no adverse criticisms. Possibly the water colors were not sufficiently challenging to upset official opinion; but the younger connoisseurs do not look for profundities from their own set but for assurance. The

A MARIN RETROSPECTIVE

THE LONG-AWAITED John Marin exhibition at the Museum of Modern Art, 11 West Fifty-third street, is now open to the public. It occupies the first and second floors of the building, with a special investiture — very spacious, and with the white walls that the Marin color schemes seem to demand, and so the public has an excellent opportunity to study water colors that have been in seclusion for some years, but which grew in fame in spite of this seclusion.

The collection was chosen and arranged by Alfred Stieglitz, who for so many years has been sponsoring this artist, and it has been recruited from the collections of the Gallery of Fine Arts at Columbus, Ohio; Fogg Art Museum, Metropolitan Museum, Phillips Memorial Gallery at Washington, D.C., and these individual connoisseurs — A. E. Gallatin, Philip Goodwin, Mr. and Mrs. Samuel A. Lewisohn, Georgia O'Keeffe, Fairfield Porter, Paul Rosenfeld, Mr. Bryner-Schwab, Robert H. Tannahill and Mr. Stieglitz himself.

Of all those who have ever been professionally concerned or interested in the doings of John Marin, I dare say I am his oldest acquaintance; and yet among all this gradually expanding group of those who pretend to know him, I also dare say I am the one who knows least of his personal idiosyncrasies.

This is not so much carelessness on my part as a willful preference — born in me the moment I began work as a critic of art — to form my estimate of a painting from the painting itself rather than from the manners of the artist at a dinner table. In fact I'm not certain I ever saw John Marin eat, though I once did live for a short time in the same house with him, and this long years ago, before the war, and before any of Mr. Marin's numerous biographers had ever heard of him.

It was in Venice where Mr. Marin, with his stepmother, father and brother, descended upon the hotel I was domiciled in, and where I am certain I saw others of the family eat. But Mr. Marin was more furtive. You didn't see him do anything if he could help it. When cornered, he was affability itself, but if

in full consciousness and full approval of the works that have
been mentioned and is now struggling with entirely new prob-
lems, and which are illustrated sufficiently in the exhibition to
enable those who wish, to take sides. These problems are posed
for the most part by a group of artists loosely ranked together
under the banner of "surrealism." Those who get farthest away
from nature in this new group, such as Hans Arp, Hélion and
Mondrian, ought, logically, to invite the most discussion; yet
since they vanish so far away from Mother Earth into the
realms where the planets speak to each other in esoteric terms,
the probabilities are that our public will not believe they mean
it and will not, consequently, get very much heated.

Paul Klee, the German, and Joan Miró, the Spaniard, on
the other hand, just because they do deal in more approach-
able matter and indulge in whimsicalities which we can fully
measure and appreciate, may come in for the onslaughts of the
Philistines – if the Philistines do get busy. Joan Miró's big
composition, in one of the upper rooms, is, in the present
writer's opinion, one of the greatest triumphs of surrealism,
and it is to be hoped that it may find its way eventually in the
modern museum's permanent collection.

The show, as a whole, however, is Pablo Picasso's. He
walks away with it, as might have been expected. In every
department he makes himself felt, but in several of his great
compositions on the second floor galleries he wins the battle
single-handed for abstract art and convinces the unprejudiced
that they are face to face with undoubted masterpieces.

There were a few murmurs to be heard on the occasion of
the private view that the battle need not have been fought in
quite so single-handed a fashion, but we can let such murmurs
pass. The "Trois Masques" would have helped the show, as
has been said, but then it was already exhibited in New York
on two occasions; and Léger, Hélion and Braque, who could
have been better represented, have been frequently exposed
here and are thoroughly admired by our "advanced" pupils.
Absolute perfection in exhibitions is not to be thought of here
on earth; and we ought to be satisfied with just a portion of
perfection. I am, at any rate.

The New York Sun, March 7, 1936

interesting step in the progress toward such masterpieces as "Les Trois Masques" and "The Seated Woman"; masterpieces, unfortunately, not included in the show and which would have been enough in themselves for a Salon Carré, had there been a Salon Carré.

By way of partial recompense for this brusqueness in presentation, the museum does very nicely by the Boccioni bronze, which is just around the corner in the next alcove. This is the bronze that was almost refused entrance into the country by the custom house officers on the score that it wasn't art. But it is, unmistakably. Any one can see that now, posed, as it is, in an agreeable light, and chaperoned by a big plaster cast of the Louvre's antique "Victory of Samothrace." The custom house people, by way of punishment, should be compelled to come to the show every day for a month and sit in front of the two pieces and learn definitely the difference between art and merchandise. The Boccioni bronze has the ripple and flow of life, of a figure moving in a breeze, or as Jimmy Savvo says so marvelously in the turn he is at present doing in one of the local theaters — "like a dream walking."

The cataclysmic crush to see the Van Goghs earlier this winter may have bred in the bosoms of the sponsors of this exhibition a desire for "a repeat," and though I fear, for reasons stated at the beginning of this article, that the wish may not be fulfilled for them, nevertheless there are a number of pieces here exposed, that might again arouse the mob spirit, were the proper combination of hysterics, scandal and vituperation marshalled against them.

For instance, the celebrated "Nude Descending a Stairway," by Marcel Duchamp, which once set this entire country by the ears, has a wall-panel all to itself, and must again enchant the young people of today in the manner in which it formerly enchanted their fathers, for it returns this time, if you please, a classic. A second classic is another glittering brass bird by Brancusi, to which also, the Customs House officials might pay a vist of etiquette, since once they were quite unkind to Brancusi. Still another reappearance is that of the gorgeous early "Abstract" by Kandinsky, which is as handsome and as fresh as when it first flashed upon startled New Yorkers at the Armory Show.

But reappearances are not apt to be inflammatory. The talkative part of the new generation seems to have grown up

ucators always will be attempting history while it's in the making!

For the new show is being historical about a thing that is not yet dead. Consequently, it is addressed to the professors and not to the impetuous, adorable, uninstructed public. It is very well done, I hasten to say, in so far as such a presentation can be well done. The sequences and derivations of the movement are very well indicated. The modern world has been effectively scoured for revealing examples and enough amazing productions have been recruited from the ends of the earth to keep the professors agog for several years to come and, incidentally, to assure alarmed citizens that the entire world is concerned in the matter. But though abstract art is here in plenty, "abstract beauty" is not placarded in a way to win new converts.

My contention is that the public is never concerned with statistics but with results. So a museum's business is always with the superlative successes in any chosen line, and with practically nothing else, leaving the sequences and the "lesser-examples-that-prove-things" to the schools for would-be professionals. It is for that reason that I have never been content with the Louvre since it abandoned that central Salon Carré that brought the people, before the war, face to face with its supreme possessions and really, more than anything else, gave world-wide fame to "Mona Lisa" and "The Man With the Glove." If you wish to educate the millions in art you must not confuse them at the beginning with lesser examples.

Being, however, one of the "professors" myself, I confess to taking both pleasure and instruction in the event, and even to admire the courage with which the directors of the museum smite the public in the eye on the very door-step, so to speak, of the show. Almost the first picture to be encountered is that terrific work by Picasso, called "The Dancer," painted almost thirty years ago, when the artist was trying to incorporate some of the demonic fury of the African carvings into his work, and succeeding so well that the picture is now likely to send any unsuspecting American lady who encounters it into what we call "the jitters." That, of course, is not the highest purpose in art, and perhaps it would have been more tactful to have prepared visitors for "The Dancer" by degrees. The initiated, it is true, who know that Picasso is the greatest figure in the modern movement, will look upon it as an

art. I no longer paint. I do not wish to see my name in print again. Yours very truly, Winslow Homer."

This matches the behavior of the aged and by the world forgot Herman Melville when a young enthusiast looked him up to tell him that "Moby Dick" was great and that something ought to be done about it. As gently as possible Melville assured the young man that he wasn't interested and that there was nothing to be done about it.

Homer, however, had never been forgot by the world, and had never suffered bitter disillusionment. He had, on the other hand, endured ill health for a number of years and had always been something of a recluse. He knew pretty accurately the merit of his work, and he knew it would last, but he knew also that his working days were over, that compliments in the situation in which he found himself had a hollow ring, and that when one had lived all one's life rigorously a special amount of seclusion befitted the ending of it.

The New York Sun, January 25, 1936

EXHIBITION OF ABSTRACT ART
AT THE MUSEUM OF MODERN ART

THE LONG-AWAITED Abstract Art Exhibition at the Modern Museum is now upon us. What will the public make of it? That's the question! Probably just what it makes out of all other problems involving complete wisdom and complete knowledge of contemporary affairs (including politics) — confusion! Complete self-knowledge is not available to the living and is only to be had, if then, in the obituaries; yet our ed-

was later on to be most admired in him – his robustness. His masculinity, naturally, was no offense to the men, and they rallied to him so heartily, and so quickly, that money troubles never came to him. A client seemed always in waiting for each picture to be finished.

Once definitely assured of his calling, Homer withdrew from the world and "hated to be bothered." His biographers assure us that he was invariably the gentleman, though certainly nonsocial. He saturated himself exclusively in the kind of life he was later to put on paper and canvas and went off for weeks at a time into the primeval forests with his brother. The wonder of the world was ever present to him, though he never said anything about this wonder. He put it all into his pictures. When he wrote letters he became the typical Yankee stoic. When he painted, however, the portals of heaven opened, and he saw nothing but beauty. His young hunters and old guides are marvelously beautiful and authentic as well. They are the real thing. They transfix you with their beauty and their intensity. It is not alone the scent of the woods that comes to you in such drawings as the "Adirondack, No. 7," and the "Canoeing in the Adirondacks, No. 17," but also there is the actual suspense of the hunt. No other painter before or since has had the courage so to sink his hunters into shadow, as Homer does in the "Canoeing," and at the same time keep them vital. It is a great masterpiece – and the European who doesn't know it doesn't know the half of it.

P. S. – I should like to go into the matter of the technic, if only to refute certain things Kenyon Cox said on this subject, but space limitations will not permit. Cox admired Homer greatly, but thought some exceptions could be taken to the drawing. This misapprehension resulted from not being an artist himself. Mechanical exactness is no help to an appreciation of the things of the spirit. Of this, perhaps, more anon.

P. S. No. 2 – Also I can't resist including in this too slight review a statement made by Winslow Homer late in life that has puzzled many. From Scarboro, Me., on July 4, 1907, he wrote this letter: "My dear Mister or Madam Leila Mechlin – I thank you sincerely for your interest in proposing an article on my work. Perhaps you think that I am still painting and interested in art. That is a mistake. I care nothing for

Botticelli. But something stepped between the dream and its realization. Perhaps it was the great war. In any case, it didn't happen, and Arnold Bennett has never had a successor. There has been no other prominent European coming here to see our Winslow Homers, and I don't believe that even Arnold Bennett bought one, though they were not so expensive in his day as they are now.

But should we worry about that? Don't make me laugh. If you know the Winslow Homer water colors yourself, you know that the reproach in this story is altogether too leeward. And if you don't know them, you now have the opportunity in the Knoedler Galleries of getting acquainted, and realizing to the full, what Europe is missing.

It seems that Winslow Homer was born a century ago, and this exhibition is by way of being a centenary. How remote that makes him seem! Yet the work itself seems near; nearer now, in fact, than it used to be, for we have had several generations in which to live in intimacy with it, to test it out in every way, and finally to see in it a kind of Americanism of which we may be vastly proud.

Winslow Homer was the first of our painters to speak authoritatively in the native accent. Like Walt Whitman, he looked on this country and saw that it was good. Like Walt, he celebrated with enormous gusto the manly viewpoint toward this section of the universe. The liaison between the work of the two men has been often remarked, yet it is not likely that they knew each other, or that the painter had ever heard of the poet. Walt Whitman, during the active part of Homer's life, was looked upon by Henry James, Lafcadio Hearn and other accepted stylists of the day with even less approbation than is given by the same types in contemporary life to Gertrude Stein. Yet Homer, like Whitman, was a poet. It was that quality in him that made him so supremely great.

It was that quality in him, too, that threw some of his early critics into confusion. Pure poetry has a way of confusing the beholder on first contact, simply because it is pure creation; and purity of any kind is the thing human beings seem most afraid of; partly, I suppose, because it accuses us who are not poets of nonpurity. Not that Winslow had hardships. His bad criticisms were all minor, and he paid no attention to them. Some of the ladies — Miss Mechlin and Mrs. Van Rensselaer among them — were frightened by the trait that

or more of work ahead which should be the crowning period of his life. Not to make the fullest use of such a talent would be heartless waste."

But T. S. Eliot dubbed the period "The Waste Land."

The New York Sun, October 26, 1935

WINSLOW HOMER'S WATERCOLORS

YEARS AGO I read, somewhere, of the Midwestern interviewers who surrounded the late Arnold Bennett when he arrived in Topeka in the course of his first lecture tour in America and who were astounded when he replied to one of their no doubt searchingly personal questions that the real reason he had come to this country was his desire "to see the Winslow Homer water colors."

This reply of his gave me untold pleasure and I was persuaded it was true, for none of the Topeka reporters in those days would have been capable of inventing such an original statement, and besides, none of them would ever have heard of Winslow Homer. The astonishing part of the affair, of course, was that Arnold Bennett had. It was the first case on record of a European acknowledging that there was such a thing in America as art, and the handsome extra flourish that "it was worth a trip across the ocean" made it doubly acceptable.

In those days Winslow Homer was my religion (and still is) and immediately I conjured up visions of the cultural balance to be established between us and Europe with hordes of Europeans coming over here to worship Winslow Homer in exchange for the hordes we were sending over to worship

when completed would rank among Lachaise's masterpieces — but the artist was not to live to see the idea realized. It was written that he was to be rejected of men, and so he was. Apparently the idea of the Philadelphia monument came nearer to the idea of "success" than the fates permitted, and so he was hastily snatched from the scene.

"In the 'David,' " so John Addington Symonds said, "Michelangelo first displayed that quality of 'terribilità,' of spirit-quailing, awe-inspiring force, for which he afterward became so famous. The statue imposes, not merely by its size and majesty and might, but by something vehement in the conception."

"Terribilità" is a good word and applicable to Lachaise. It was the thing in him that raised him to the heights. Lachaise alone among the sculptors of this generation is the one whom it is not ridiculous to cite in connection with Michelangelo. He was of that same giant breed. It was his terribilità that made him, if you must have a comparison, larger than the Frenchman Maillol. Maillol is a great sculptor and I admire him without reserve, but the beauty he evokes is pastoral, quiet, soothing, pagan. Lachaise, in the few pieces in which he rose to full stature, was more inflammatory. He was nearer, in class, to Rude than to Maillol. Comparisons are always insidious, and it may be even dangerous for a foreigner to rate Rude above Maillol, but, lovely as Maillol's carvings are, who is there who would exchange them for that one shattering relief of Rude's on the Arc de Triomphe?

Just a year ago, at the time of the Modern Museum's exhibition, Lincoln Kirstein wrote the following:

"One may hope that some really unselfish interests concerned with the fine arts will give Lachaise a commission for an even more important civic or public work. (Mr. Kirstein had been speaking of the Fairmount Park memorial.) Many possibilities suggest themselves. For example, there is no worthy memorial to Thomas Jefferson at the University of Virginia, a project which interests Lachaise intensely. There is no fitting monument to Herman Melville, or to Winslow Homer, or Thomas Eakins. John Reed is unhonored by Harvard College. There is no stone to the memory of Hart Crane, whom Lachaise knew and admired. Lachaise has twenty years

the collection was sold, and Lachaise told me himself that about all he got from the affair was my sympathetic account of it in The Sun. I do not repeat this boastfully but in despair. Were it not that I know that loftiness of feeling is never lost in this sluggish, unwieldly, careless but delightful old world of ours, and is invariably recognized in the end, I should forever abstain from serious art criticism.

But what a contrast there is between this icy reception of Lachaise's magnificent bronze goddess — I believe it was simply entitled "Standing Woman" — and the feverish interest of the Florentines in the productions of their sculptors in the days of the Renaissance. There was no quarrel here as to where the "Woman" should be publicly placed and worshiped as there was over the Michelangelo "David." There was no attendant mob of geniuses to instantly appraise and put a great value upon the work.

When the "David" was completed, so John Addington Symonds records, a solemn council of the most important artists then resident in Florence convened to consider where the statue should be placed. Opinions were offered by among others, Cosimo Rosselli, Sandro Botticelli, San Gallo, the architect; the illustrious Leonardo da Vinci, Salvestro, a jeweler; Filippino Lippi, David Ghirlandajo, the painter; Michelangelo, the father of Baccio Bandinelli, the sculptor; Giovanni, the father of Benvenuto Cellini; Giovanni delle Corniole, the gem cutter, and Piero di Cosimo, the painter and later on teacher of Andrea del Sarto.

What a society that was! They had their human frailties, of course, and the jealousies, back-bitings and political maneuverings that the flesh is heir to, but there was no possibility in a time when art was so important that any talent for it should be wasted.

Our Lachaise worked, for the most part, in isolation, continually beset with money difficulties that would have ended the career of any ordinary man before it had begun; and it was not until the present year that he received a commission for a public monument worthy of his immense ability. This was to be a group symbolizing the amalgamation of the races in America, and it was to be placed in Fairmount Park, Philadelphia. The accepted sketch clearly indicated that the work

THE DEATH OF GASTON LACHAISE

THE TAWDRY, ineffective funeral I would not have had otherwise. It was in the tradition. That's the way we buried Melville. That's the way we buried Poe. Greatness would not be greatness if it could be understood generally. Nor do I blame humanity for this poverty of vision nor cry out against God for it. It is merely the way things are.

Yet the word "genius" was uttered. There in a Broadway funeral "parlor" the word got uttered. Gilbert Seldes said it. Gilbert improvised a few words and set them to a note of bitterness. Yet the word "genius" was among them. That word will be remembered later. A great man passed from among us without the benefit of singing choir boys, without incense, without processions. There was no "corruptible" putting on the "incorruptible." There was no one even "weeping for Adonais." A few of us who knew that Gaston Lachaise was great sat there like wooden images in a Eugene O'Neill play and scuttled away the moment the crisp accents of Seldes ceased to be heard, to ruminate on greatness in America — and its recompense.

As far as Lachaise was concerned it might almost be said that of recompenses there were none, for genius is not truly paid with money but with comprehension. Not but that there had been some admirers! There always had been a few. Perhaps the most notable was E. E. Cummings, the poet; himself so slightly acknowledged as to be practically of no use. Then there was Gilbert Seldes and later on Lincoln Kirstein and Edward Warburg.

It was probably due to the influence of the two last named that the astonishing one-man exhibition of the Lachaise sculptures occurred in the Modern Museum last winter, an exhibition so overwhelming in its appeal that you would have thought that the whole world must have succumbed to it; but there were no signs of such a submission. Nothing from

sides like a communist's dream of "better housing." It was odd that Pittsburgh didn't appreciate these sincere tributes, but it didn't. Only last year at the Carnegie International, which included a large and splendid John Kane landscape, I urged it be purchased for the permanent Pittsburgh collection, but was told, "Not a chance."

Well, the chances are still less now, and for another reason. With the death of John Kane, all the pictures he had painted but had not sold were sent on to New York, and the present memorial exhibition in the Valentine Galleries is meeting with a pronounced success with our connoisseurs. Fourteen of the pictures had been sold by the opening of the show, including several that ought, in all justice, to be owned by the Carnegie Institute. Among these are the "Prosperity's Increase," a river scene with cheerful activity going on in every direction, a view of furnaces by the river, called, I think, "Monongahela Valley," and an admirable row of small houses along a city street.

Pittsburgh, however, should not be judged too harshly for its behavior in the case of John Kane. Let the city that has not done the like throw the first stone. But the truth is we have all done the like. New York has only recently done the right thing by Louis Eilshemius, and that slowness in justice is only one of several black marks against us. And you all recall the behaviour of the good citizens of Aix when Paris finally sent down word that that crazy fool Cézanne was a genius. Why, the Cézanne landscapes had been lying around under all the bushes, ready for any taker. But once they became valuable there were no more to be found under the bushes.

The New York Sun, February 2, 1935

all along, the Smoky City supposed John Kane's work a joke and the singling of it out for praise by the metropolitan critics was just a high-handed attempt, upon the part of these worthies, to bring shame upon the late Andrew Carnegie's home town.

John Kane was an ordinary house painter who took up painting late in life and without previous instruction. He was, I think, of Scotch-Irish descent, with the sturdiness of physique that that mixture of blood often presents, and a typical Scotch-Irish willingness to be "himself." In other words, he had character, plus a self-reliant and happy disposition. Apparently he loved the Pittsburgh that gave him a living and wholeheartedly adored the panorama that unrolled itself each day before his eyes. Finally there came the temptation to put down in paint the charms that had not often been noticed in a town that had not been much painted, and the results so gratified the house painter that he continued to paint pictures of Pittsburgh as long as he lived.

How the first one got into the Carnegie Institute's International Show of Paintings I have never learned, but I suspect it was due to the kindness of Edward Balken of the Institute's staff, who is the only Smoky City connoisseur that I know of, who owns a John Kane picture; but straightway the writers for the press picked the painting out for comment, and as time went on commented more and more about the house painter who had become a painter.

To do my confreres justice it was not so much the metamorphosis from house painter into artist that attracted their attention as it was the fact that the new man was, unquestionably, an artist. He was more than a painter, he was a poet in the use of paint. In the American section of the International Exhibition, where there were rows and rows of highly schooled paintings that contained little else than schooling, the meeting with the sweet feeling and novel approach of John Kane came upon one, as James Stephens, the Irish poet, once said, "like a breath of fresh air in a soap factory."

John Kane, of course, was unschooled in drawing, but he knew how to mix colors and apparently he was firmly convinced that Pittsburgh was just a piece of heaven on earth. He relished every bit of it, but particularly the activity of the river boats, the processions of railway trains, the smoky furnaces and the little cottages that dot the precipitous hill-

be." If Mr. Evergood just has to be loose, that's his own affair, and it's up to him to make us like it.

In the meantime, as I said before, he's having fun. It amuses him to startle straight-laced citizens, of whom, it seems, I am one, by flaunting his big picture of the Marathon dancers in our faces. With the entire universe going through the throes preliminary to the birth of "a higher morality," it seems incredible that such colossal inanities as the one depicted can have been permitted on the very eve of the "reformation." Yet having been, they remain on the record, and cannot be denied. Mr. Evergood spares us any accusations. He is not vitriolic like Toulouse-Lautrec. His silly boys and girls are not particularly vicious; they are just silly boys and girls.

Perhaps the Chicago Art Institute would care for the picture. It might give it a look at any rate. The Chicago Art Institute had the courage to acquire the "Moulin de la Galette" by Toulouse-Lautrec at a time when no other museum seemed to be interested, and it might be a steadying influence on young Mr. Evergood to see his picture subjected to the severe comparisons that neighborhood with such a materpiece would involve — and quite worth the small outlay necessary to the experiment.

The New York Sun, January 26, 1935

JOHN KANE'S MEMORIAL EXHIBITION

PITTSBURGH EVENTUALLY will be very proud of the paintings of John Kane, but perhaps not right away. It seems a bit soon for Pittsburgh to make a complete right-about-face, for,

strike 12 for him, but in such cases it comes very near to it, 11:45 or something like that – and any one maintaining so high an average of marksmanship as that may wake up some morning to find his name changed into Philip Evergreat. Stranger things have happened.

For Philip Evergood is a keen observer, with a healthy sense of fun and a willingness to take the brave old world the way he finds it. He is still young – or so one imagines from the run of his subjects, which have a hallmark of Greenwich Village written all over them – and possibly he hasn't settled into a style that is to be permanent, but in the meantime the method of painting is so lackadaisical that it is positively calligraphic – like scribblings on a wall.

In that, of course, Mr. Evergood follows the trend of the times. Classicism died in this town with Kenyon Cox. Or possibly it is fairer to say that Mr. Cox killed classicism. Anyway, it is more fashionable at the moment to draw like George Grosz and the late Jules Pascin and Mr. Evergood is in the fashion. Perhaps he carries looseness of execution too far. Perhaps he ought to pull in his belt several notches. But that's for him to decide.

If he really likes looseness so much as all that and insists upon it, if he is willing to die for looseness, then he probably can eventually put it over on us. The world is like putty in the hands of a strong man. (Or a strong woman. Just see how the first line defenses crumbled at the mere approach of Gertrude Stein). We are willing to put up with all sorts of eccentricities upon the part of our great people, once we are compelled to accept them as great.

But the great Toulouse-Lautrec, who interested himself as an artist in much the same things that interest Mr. Evergood, was far from being so loose as that, and I should think a young artist of today, even if he were dying with laughter at the things he saw at the Marathon dancing contest, would like to have as much clarity and precision as Toulouse-Lautrec would have had, in describing such an event. Or perhaps not. Who knows what the future is to be? Or the taste of the connoisseurs of the future? People may become so floppy that spines, bones and structures of all kinds, may become obsolete. But what an idiotic artist that would be who would alter his style for so politic a reason as that! He wouldn't be an artist at all. The only possible excuse for any style is that it "had to

country wrote letters protesting against such sacrilege. But what sacrilege? I vow, I can't see it. That, of course, is the trouble with psychonalaysis. It releases so many bad thoughts that amateurs fall into the error of thinking that all thoughts are bad. This is so much the case that many practical people, "ravi" as they are with Mr. Thurber's drawings, are beginning to feel that it is a pity that Columbus, Ohio, ever started to think. It seems such a shame that a nice, innocent American city should have been thrown into such confusion by the machinations of a remote Austrian scientist. On the other hand we should then never have made acquaintance with the art of Mr. Thurber which is a contingency not to be thought on. On the whole, selfishly, we conclude, "Let Columbus, Ohio, take care of herself. She got herself into this mess. Let her get out of it by herself."

But you noticed my use of the little word "art." I suppose that was what you were waiting for. Yes, Mr. Thurber's little drawings are actually art and of a very fine order. He is one of the two or three artists in our whole vast land to have evolved a style for himself. He is as distinct in this country as Thomas Nast and in Europe as Felicien Rops; but happily he is unlike either. He is unlike anybody. That is his great secret and his great charm.

The New York Sun, December 22, 1934

PHILIP EVERGOOD

PHILIP EVERGOOD is the excellent name of the artist now exhibiting in the Montross Gallery and he is deservedly so named. At least, he's almost always good — the clock doesn't always

discoveries and discoverers – that it should turn out to be called Columbus, Ohio.

But I see that this review – which is intended as a notice of the exhibition of the Thurber original drawings in the Valentine Gallery, if I ever get around to it – is already too literary; but then that is Mr. Thurber's fault, and how I got that way – just by looking at his drawings. He, too, is literary. I mean, of course, that when he discovered Columbus, Ohio, and incidentally all the rest of rural America, he discovered Columbus's soul, he found out what Columbus thinks – if you call it thinking.

That's rather a profound observation, that next to the last one, about the soul being what you think, but again the credit must be Mr. Thurber's. He plumbs the depths, and one can observe Columbus, Ohio, being turned inside out, as it is in his drawings, without becoming aware that he, too (or possible "she" – 'nay, probably she," as Noel Coward would say) has depths. That's how Mr. Thurber educates. He teaches us to recognize the Freudian fact that underneath the skin we are all alike! Even the difference between New York city and Columbus, Ohio – once you get underneath the skin – is not so great as you would have imagined.

Take, for instance, that midnight conversation from twin bed to twin bed, that out-eeries anything in that line in the poems of the late Thomas Hardy and in which the lady finally asks: "If they never found the husband's body could they do anything with the wife?" and watch the expressions on the faces of feminine art students as they take the full impact from the drawing. It's something too awful for the knowing and makes you want to put what is technically known as "the curse of Cromwell" upon Freud, who brought these thoughts to the surface instead of letting them rest in the depths where they belong. As it is every lady spectator instinctively recognizes the drama to be well within the limits of her own mental experiences. I, for my part, think the drawing should be entitled "The Mouse Trap," like the little play within the play that brought on all the trouble in Hamlet.

And there's that other one, of the young lady kneeling by her bed and concluding her exhortation with ". . . And keep me a healthy, normal, American girl." They say that that drawing stirred up considerable ennui for the publication in which it appeared and that conventional people from all over the

such, alas, the Dali clientele will not be formed. It's for the new people, I think, like the gentleman I told you of, who liked them spontaneously and didn't know why.

P. S. I think the work called "Javanese Manikin" is Salvador Dali at his best. I don't think he'll ever dig anything better out of his subconscious. It is extraordinarily weird and extraordinarily attuned to the scientifically deranged emotional life of the day.

The New York Sun, November 24, 1934

JAMES THURBER'S PSYCHIC ART

IF PETER ARNO may be said to have discovered the present city of New York, then with equal justice James Thurber may be said to have discovered Columbus, Ohio, and of the two discoveries the last named is by no means the least, since most New Yorkers are persuaded that New York would have been discovered anyhow and they are not at all certain that Columbus, Ohio, would ever have been heard of had not dear Mr. Thurber called attention to it.

Besides, in discovering Columbus, Ohio, Mr. Thurber discovered all the United States except New York city; all the "outlying districts" as it were. There are many cynics who claim that New York city is not America, and we who live here know what the cynics mean, even if we do not wholly agree with them, but no one has ever dared to say such a thing of Columbus, Ohio. Columbus, Ohio, in fact, is so 100 per cent, so precisely, in essence, what all the other towns west, north and south of Broadway, including Keokuk, Chicago, Spokane and Tulsa, aim to be, that it is simply uncanny — speaking of

You remember it, no doubt, with the apparently melted watch bending at right angles over the ledge, crystal, dial, hands and all. That was at the time when some of our more profound counselors were urging us to be a little mad, like the Russians, so that we might be better artists. Señor Dali, we thought, was overenthusiastic, but just the same, he was in the proper school, and so he was taken right in by our collectors.

The year after that, however, when a new invoice of Dali pictures arrived in this country, there was considerable consternation just at first, for the new compositions were thought – there is no harm in telling it now – risqué. However, for one reason or another, all the pictures sold, and quickly. I know one gentleman who told me he had never bought oil paintings before in his life, but he had been so thrilled by the Dalis that he could not resist the temptation to acquire two. But for all that, he hung the two paintings high up in an obscure corner of his sitting room so that he would not be obliged to explain them to his female relatives when they came to visit him. He could not explain them, anyway. He just liked them.

But lately, I understand, he has taken the two pictures down from their obscurity and placed them prominently in his parlor with spotlights on them, and all the other Dali collectors have done the same, for in the light of the new revelations of the current exhibition this art is found to be entirely O.K. It is psychoanalytic. Do you see? Everything goes – in psychoanalysis. It's all a dream. Do you see? It's nothing you have done or will do, but, as far as I can make out, it's something you have repressed. Therefore it's altogether to your credit. Especially when it is so marvelously painted as Señor Dali does it.

I dare say if you were to look at some of these highly finished miniatures through a telescope you would see these landscapes receding to endless perspectives, with each little hillock behind every other little hillock, all in impeccable gradations, just as in nature. When these qualities in the Dali oeuvre shall have been well advertised, you will find all the oldtimers dashing, or perhaps, "hobbling" is the word, to the gallery, in order to feast with their own eyes upon, at last, the destruction of this cursed cubism which has occupied the public attention too long and has just swelled up again this week at the Modern Museum into historic proportions. But of

time for some wise-cracks. None are to be had from him this
year. If the machine age is going to compel us to be solemn all
the time we should have been warned before going in for it
so heavily.

The New York Sun, April 28, 1934

SALVADOR DALI

THE FASHIONABLE, very disputed and very difficult exhibition
of the week is the Salvador Dali show in the Julien Levy
Gallery. And it is not cubistic, either. It seems that perfectly
straight, highly finished, beautifully colored painting can have
its difficulty, too, for Señor Dali is psychoanalytic. He doesn't
paint you from the outside but from the inside.

This innovation made an instant hit with the carefully
chosen and extremely "advanced" assembly at the private view
on Tuesday, and this in spite of the fact that psychoanalysis
had been considered "out" as a dinner-table topic, these two
years past. But we had never had it in pictures, you see. In
pictures it is different. It has a fresh and unexpected note.
Or possibly Señor Dali is an unusually good "control." Isn't that
what they call it? A "control?" In spiritualistic circles, I mean.
For obviously, it is his own self that he is analyzing all the time.

This starts Señor Dali off to a new kind of reputation
with us. This is his third. He has been a psychoanalyst all the
time, only we didn't know that. At first, when the strange
pictures began to come over, we thought him more than a
little mad. That example in the present show at the Modern
Museum called "The Persistence of Memory" was one of them.

dividual art patron is past, and that the recent activities in the way of Government purchases of art indicate the form that future art patronage is to take.

That may be as it may be. The future is something that I know little about, and in a time like this the present predicaments are sufficient to occupy one's entire attention. That the aristocratic patron is no longer care-free enough to do fancy buying is something we all have noticed and those who noticed it first are the artists who do explorative painting, like Mr. Davis and Mr. Marin. That we punish rather than reward the seekers after new truths in painting has been one of our characteristic traits, but it is a trait we must erase if we would attain worldwide prestige in the arts. It is the community with a sense of direction that dominates the rest of the world.

So, since the Government is not yet actively committed to art and the aristocratic patron has vanished entirely, the only hope remaining to Mr. Davis is to appeal to the consciences of the museum directors throughout the land. They are all engrossed in the acquisition of classic art, or in academic art, and most of them increase by way of bequests of pictures, but enough of them have funds to keep the conventional artists alive, and it is about time that they were made to realize that the innovators are essential to artisic progress. The Modern Museum will do wonders in the way of setting an example, once it gets under way, but in the meantime each of the many museums should have a little Luxembourg annex to its regular activities.

The present Stuart Davis exhibition in the Downtown Galleries shows him to be unfaltering in his allegiance to the abstract. He is the most resolute of our practitioners and the most expert. There isn't an item in the present collection that shows the least fumbling or uncertainty, and there isn't a picture that doesn't publish to the world the precise period in which it was done.

It is distinct in style, and after you grant that the original impulse to be abstract came from France, it is sufficiently American. Compared with the work of Léger, to which it comes nearest in manner, it diminishes in plastic qualities. Perhaps this is intentional. Certainly, if this be the machine age that they say it is, Mr. Davis has the right to be machinelike. The artist, however, also diminishes in humor, and that I deplore. A Stuart Davis of some years ago could be counted on every

that her neuritis had completely left her. I myself had a head-
ache before but none after taking. Would it be strange if the
opera should become a place of pilgrimage? It would be
stranger still to see the lobbies lined with votive offerings after
a six-month run of steady cures.

The New York Sun, February 10, 1934

NEW YORK BY STUART DAVIS

THE SLOW progress of Stuart Davis toward being a best-seller
is something to ponder over. It is either a reproach to him or
to us. Which is it? His work is clever, fashionable (that is — it
is in the fashion of the day) and widely known. Theoretically,
we ought to relish such clear-cut, workmanlike statements
with no nonsense about them. But do we?

Not to the extent of buying them in quantity, at any rate.
There are probably fewer Stuart Davis pictures in private cir-
culation than John Marins, and that is putting it pretty caus-
tically. John Marin is the most acclaimed artist living in
America today; and the least owned. The Davises and Marins
that are owned are kept, for the most part (the Phillips
Memorial Museum in Washington is a notable exception), in
strictest intimicy. The brave collectors who ventured into
modernism are not sufficiently brave, it seems, to come right
out in the open and boast of their purchases.

We need a type like the late Mrs. Jack Gardner who
thoroughly enjoyed blazing new trails and had enough social
magnetism to draw all the weaker elements of society into line.
But types like Mrs. Gardner are obsolete, and only this week a
lady who might have assumed the Gardner mantle had she
chosen, announced through the press that the day of the in-

remark and did remark the following: Mrs. Muriel Draper, Mr. and Mrs. Alfred Barr, Philip Johnson and his sister, Miss Theodate Johnson; Mrs. Murray Crane, Carl van Vechten, Fania Marinof, Edward Wasserman, Frederick Amster, Mrs. William Averell Harriman, Mary Lawton, Mr. and Mrs. James Johnson Sweeney and Mr. and Mrs. William Lescaze.

Hartford, Conn., 11:30 P.M.

The opera was an overwhelming, an inescapable success. The Virgil Thomson music was not in the least difficult but always clear; witty, caressing, unexpected, dramatic, just as the composer wished. The Gertrude Stein words, always helped by being read aloud, are extraordinarily amplified by being sung. The Florine Stettheimer settings and costumes are simply sublime. If I could think of a more powerful adjective I would use it, but "sublime" will have to do for the present. The Negro singers and dancers are artists of the very first quality. One easily believes that the least of them is equal to anything. In addition, they are unbelievably handsome and wear their costumes with an air. Frederick Ashton, the choreographer, produced one tour de force after another, the whole evening through, and Maurice Grosser made a miracle of a scenario as a base for the shining fabric of Gertrude's exalted inspiration. All this sounds like extravagant praise, but believe me, I haven't told you the half of it. New York is in for a rare sensation when this show comes to town, and Broadway will get enough ideas from its scenic investiture to last it for ten years to come.

In order to round out this little narrative, I may as well confess that when my two artificial roses came on in the second act I never noticed them. I was so engrossed in a study of the two Saint Theresas dressed in ravishing white, with the most fetching of sun-hats, though adequately spiritual as well, that I quite forgot my own modest participation in the scene. I was told afterward that the two roses adorned the Commère, in the loge overlooking the garden party.

I also ought to add that Mrs. Askew survived the opera handsomely. She confessed to having been much refreshed by it. In fact it may well be that "Four Saints in Three Acts" has curative properties. Helen Appleton Reed of Brooklyn, who rose from a bed of pain to attend the premiere, said afterward

abandoning a willfull seclusion of some years' duration to do
the decors for her friend Virgil Thomson's opera. Both looked
weary but happily confident. As a matter of fact, Virgil looked
as though he had just been run over by an automobile truck
in Taos in August (August being the dusty month down there).

Miss Stettheimer reported that the Negro singers were not
only acting like saints, but like angels. Very little temperament
was being shown in spite of the superhuman demands that
were being made upon the artists. It was true that a prima
donna had objected to a headdress that had been designed for
her. It was even true that the prima donna had flung the head-
dress at them when it was first presented to her, but Miss Stett-
heimer had had a long conversation with the artiste, and every-
thing was serene once more and the headdress was to be worn
in the second act.

Hartford, Conn., 5:45 P.M.

Miss Stettheimer has just called me up at the Heublein
Hotel to tell me she is quite exhausted and can do no more,
and would I be good enough to go to the nearest Woolworth's
and purchase two artificial roses for her, the best I could get.
The whole fate of the opera was at stake. They were necessary
to the second act. I said I would, and sallied forth.

Hartford looked gay, prosperous and attractive at that
moment, with the electric lights all glowing in the skyscrapers
(yes – there were skyscrapers) and the crowds of people hurry-
ing home from work and animating the rather wide boulevard
until it challenged comparison with the Cannebière of Mar-
seilles. I think Hartford could be my favorite town, next to
New York and Stockholm, if it wished. Indeed, if only the
lower part of that little park in front of the Hotel Heublein
could be flooded with water and made into a lagoon there
would be no doubt about it. I would then give it Stockholm's
second place.

I got the two roses. A very good buy. They were exceed-
ingly handsome.

Hartford, Conn., 7:45 P.M.

The dining room of the Hotel Heublein seems to be en-
tirely filled with New Yorkers. Parmi l'assistance one could

"Kiss" at once looks like the work of genius that it is, before such a background.

The Picassos, however, are the whole thing of the occasion. And rightly. Who is there, more than he, who represents modernity? It is possible, of course, that they may be a bit difficult in Hartford to others, in addition to the great social leader who has already been quoted, and to such the only advice I have to offer is that that was proffered by M. Paul Rosenberg's family to him: "Sois calme."

The Picasso paintings sum up very completely all the successive mental atmospheres current in a sensitive capital in the period of disintegration following the great war. Those not conversant with the events may reasonably be bewildered by the new accents invented to describe them — and there is no shame attached to that — but the bewilderment need not necessarily be lasting, for only a slight degree of intelligence promptly dissipates it. Of a truth, the period just past is as unmistakably reflected in the work of Picasso as the Mme. Dubarry-Louis XV period is in the work of Fragonard.

A. Everett Austin Jr., the director of the Wadsworth Atheneum, and the guiding force behind these unexpected and novel developments, is so young a man that he may resent being reminded of his youth, but one of the influential connoisseurs of New York, expressing regret at his inability to be present at an event so certain to become historic, was inclined to attribute Mr. Austin's success in bringing it off to just that — his youth. "The whole thing," he continued, "shows the necessity of getting some fresh air into our museums. The elderly business men who direct most of them without in the least knowing what the whole thing is about, are completely shown up by the exhilaration that Mr. Austin has thrown into the art situation. The two episodes of the Picasso exhibition and the Stein-Thomson opera are easily the most brilliant events that have ever been pulled off in an American museum of art."

Hartford, Conn., 3:30 P.M.

Just then Virgil Thomson and Florine Stettheimer emerged from the doors of the museum's theater where they had been struggling with the final touches to the opera. It was sensational, to those who knew, to find Miss Stettheimer thus

(he had seen a few rehearsals) that he appeared to float in the air. The only individual continuing in resolute self-possession was M. Paul Rosenberg, the great Parisian art dealer, whose contribution of Picassos to the museum's loan exhibition was making it the most important event of its kind anywhere in the world.

Asked if he had seen the startling news in the morning papers as to the fall of Paris at the very moment when Hartford. Conn., was rising above the horizons of the art world, he silently but dramatically produced a cablegram that he had just received from his family. It read as follows:

"Sois calme. Nouvelles beaucoup exagérés. Nous sommes tout à fait bien."

THEN THERE was the story they were telling about young Mrs. Austin, the wife of the director of the museum. It seems that at one of the pre-previews, a dowager of great importance and influence in Hartford society, being somewhat dismayed by the unexpected quality of the great Picasso compositions, said to Mrs. Austin: "But you wouldn't care to live with them, would you?" and when Mrs. Austin said that she "would" decidedly, the dowager walked away, saying: "Every one to his taste!"

But that evening, at the reception, with all the youth and beauty and chivalry of Hartford crowding in to applaud the new manifestations in art, the dowager, who had had time to readjust herself to the situation, and seeing Mrs. Austin in the official receiving line went up to her, and with an embrace, said: "Dear, loyal little woman!"

Hartford, Conn., 3 P.M.

The inside of the new wing to the Wadsworth Atheneum really is a masterpiece of museum installation. The outside is O.K., as they say, but the inside is special. "At last," said M. Paul Rosenberg, "there is one genuinely modern museum in the world."

The big entrance court is a matter of plain surfaces and those horizontal lines with which the new architects are proving that skyscrapers shouldn't be Gothic. The Brancusi

"FOUR SAINTS IN THREE ACTS"

AT HARTFORD

THE EXCITEMENT was intense. The excitement, naturally, had been intense for months past in New York, but on Wednesday in Hartford, on the eve of the world premiere of Virgil and Gertrude's opera, it reached a point when it became practically unbearable. Although in Hartford it still seemed a New York excitement. Whether or no any Hartfordtonians had caught the afflatus I had not been informed.

But already at noon at the chateau of the Cooleys, where hundreds of people were eating superb food that appeared from nowhere, like the manna in Bible times, Mrs. Kirk Askew of New York was telling her experiences. Mrs. Askew had stoically refrained from seeing any of the dress rehearsals of the "Four Saints," wishing it to burst upon her in full perfection at the premiere, but that morning in the Wadsworth Atheneum she had opened a door by mistake and there before her were the two Saint Theresas, the Saint Ignatius and all their attendants arrayed in such extraordinary beauty that all her feelings surged up within her till she thought her heart would break and she had to retire precipitately from the scene. Telling us this she added that she was not at all sure she would be able to stand the entire performance, to which we were looking forward so impatiently.

This, you must admit, almost parallels the historic adventure of Mme. Malibran, who fell in convulsions at the world premiere of Beethoven's Fifth Symphony and had to be carried, unconscious, from the hall!

Most of the cosmopolitans present at the luncheon had been subjected to the strain of two days of hearty hospitality, having come up for the opening of the new Avery Memorial wing to the Wadsworth Atheneum, as well as for the opera, and were showing signs of wear and tear. Pleasure exhausts one more completely than toil. Both the Julien Levys seemed completely shattered. John Becker had become so etherialized

However, two mistakes do not make a right, and once committed to the Rivera preachment, it seems a second error in tactics now to martyrize the artist by suppressing his work sensationally. They might have learned the proper procedure from the Modern Museum's other experience with mural decorators last year when some of the invited panels seemed to be insults deliberately aimed at the Rockefeller family. There must have been the temptation then to hide them, but the sportier influence finally prevailed and they were shown; and in the end it was the silly artists who were laughed at, for it was evident that half-baked mentalities are merely boresome and do not constitute a threat.

In the like fashion the Rivera panels, though probably not half-baked (one must do Mr. Rivera the justice to own that he, at least, has force), should have been shown. Of the two embarrassments that would have been the lesser. The communists, elated at the daring of planting their placards squarely in the faces of New York capitalists, would have made the most of the occasion, you may be sure, but the excitement would have been but a nine-day's wonder. If the murals proved to be good art, the good art would finally surmount all else that might be in the compositions, and would speak peacably to what Emerson called the "over-soul" of the community. If they proved not to be art then all the campaigning in the world could not make them so. To suppress them, however, plays right into the hands of the agitators. The howl that they will put up will now be tremendous. If there is anything that "they" know how to capitalize it is a supposed injustice — and they have needlessly been presented with one.

The New York Sun, May 13, 1933

the artist was dismissed on the score of using his task to preach communism. Whatever else may attach to the event, there cannot be a surprise.

When politics come in at the door, art flies out at the window. It is a matter of regret that in the war of opinions thus unleashed, serious considerations of art will not be of the least avail. People who have not seen Mr. Rivera's painting and who know nothing at all about art will immediately defend it, and people who also have not seen it and who also know nothing about art will immediately attack it; and both parties, obviously, will be in the wrong; for those who know even a little about art know that you cannot judge a picture without seeing it and they know, too, that the picture may not be properly seen until it be finished.

So any consideration given to the affair at this time must necessarily confine itself to the practical aspects of the "case." The initial mistake, as has already been hinted, occurred a long time ago, when Rivera was engaged to do the job. He was certainly the last man in the world who should have been considered, although it is equally certain that he is one of the most important artists now alive. He is important, however, as a Mexican; and he is in no wise fitted to speak to or for the northern Americans. He knows singularly little about us and that little has been gained, not by experience, but by reading the inflamed publications of the communists.

When he came up to New York in 1931 to submit sample jobs to the consideration of Radio City authorities, it was plainly apparent then that his attitude of mind was accusatory and it was also evident that he was thinking in terms of politics rather than in terms of art. The murals in Mexico, on which his fame rests, are tinged with politics, too, it must be confessed, but they emphasize beauty so insistently that the politics drop by the way. Propaganda is always dangerous to an artist and sometimes, when it is allowed to go to the head (as in the case of Émile Zola) it is fatal. Rivera's impulse on coming north has been more and more to "show us up" as capitalists; to be, indeed, an evangel rather than an artist. As all this was plain enough for anyone to see in the Rivera exhibition at the Modern Museum, the Radio City people seem to have been singularly innocent and ill-advised in awarding the great mural commission to a propagandist so violently opposed to the ideals of this country.

didn't think of psychology, Walt Disney didn't think of it, nor did the great public; but the great public fell for it instinctively without knowing what it was; and later on, the deep thinkers pondered over the matter and found out what it all was about and why; but the point is, that the great public didn't have to be told; they just liked it.

A reassuring thing to notice in Mr. Disney's work is, that success does not seem to have gone to his head. His recent films are as vivacious and as vital as the earlier ones; in fact, they seem to get steadily better. According to Eleanor Lambert, who has written an excellent miniature biography of the artist, Mr. Disney is thoroughly absorbed in perfecting the arrangements of the big studio in which he and his many assistants work, and she makes it clear that those arrangements are as complicated as any other cinematic activities in Hollywood. The arrangements are complicated, the results are not. That is the marvel of it. It is not everyone who keeps a firm clutch upon his soul, in the midst of the mechanics of Hollywood, but Walt Disney does. He is distinctly and typically a child of this age.

The New York Sun, May 6, 1933

DIEGO RIVERA

AND THE RADIO CITY SCANDAL

THE EXPECTED has happened. From the moment that Diego Rivera was engaged to do an enormous mural at Radio City it was foreseen that political difficulties had been invited. On Tuesday, a week in advance of the completion of the work,

Whitehead. My latest is Walt Disney. The moment I walked into the Kennedy Galleries, where the Mickey Mouse originals are shown, the bell rang sharp and clear.

Some people thought it was the fire engine passing by on the way to Union Square to sprinkle water on the communists – it was May 1 – but I knew better. I "was not mistaken." It was Walt Disney. He is a genius. Furthermore, he's the right kind of a genius. He's the people's genius. He's not telling any hard luck stories! He doesn't know anything about hard luck! The tsars of the cinema world fall all over themselves to get his productions because the tsars of the real world, the people, fall all over themselves to get into any movie where Mickey Mouse entertains. Since the decline of Charlie Chaplin as the people's favorite, he is It. Consequently, he has all the money he wants and doesn't know what you are talking about when you say the times are hard.

It reminds me of the remark of the tough young man to whom E. E. Cummings, in "Eimi," expressed surprise at the pleasant privileges that the "right" people now enjoy in Moscow, and who said: "Oh, if you're O.K. with the comrades, you can get anything you want – same as anywhere else."

All this ought to be food for thought for the disgruntled other artists who are forever complaining about the indifference of the great American public – only I am afraid it won't be. Those artists do not care for food for thought. They prefer other kind of food. Therefore they don't get any kind.

The idea is, all other news to the contrary, that this big public likes art and will lap it up as readily as a horse laps sugar from the hand; only, it knows what it wants and wants it when it wants it. The moment you try to bully the public, the moment you say, "Don't eat sugar. Sugar is vulgar. This is what you should eat," proffering still-life pictures of lemons and bananas in the style of Cézanne, the chances are the public will walk out on you, leaving you to eat your lemons and bananas yourself.

But don't imagine Walt Disney's cartoons are made of sugar. They are sugared but they are not all sugar. Underneath is the profoundest stuff of which poems and plays are made. They give you the drama of the eternal ego, the little hero and heroine with whom each member of the audience instantly identifies himself or herself. It is the same old psychology, of course, that used to be spent upon Charlie Chaplin. Charlie

royal," and for a truth, the effect was that of the costliest beauty to be obtainable anywhere.

The new gates for the Bronx Zoo, built in memory of the late Paul J. Rainey, are going to be very grand. They are rugged and masculine, and therefore won't shock the populace, as too much filigree might. The animals that perch here and there in the correctly spaced intervals of the ornament have been so simply seen and modeled that the affectionate caresses of the children throughout the ages to come cannot do them anything but good. The gate, in fact, is so sturdy that it looks as though it can stand anything the future has to offer.

The "Lincoln," a white plaster cast of the bronze that was placed at Fort Wayne, Ind., is amazing as workmanship. I don't think any errors will be found in it. The accessories, such as the tree stump, the ax and the dog, are quite free from fussiness. Everything that is there relates tellingly to the effect as a whole, and is designed to be impressive from a distance. As to Lincoln himself, Mr. Manship has no new ideas, and that is just as well. We have had almost too many new ideas about Lincoln of late. And anyway, people of today have enough things bothering them without being bothered by the things that bothered Lincoln.

The New York Sun, April 15, 1933

WALT DISNEY, THE ARTIST

GERTRUDE STEIN's friend, Alice Toklas, says that she has met three geniuses in her lifetime and that each time a bell within her rang, and she was not mistaken. I am that way myself. Alice's three geniuses were Gertrude, Pablo Picasso and Alfred

that criticism has interfered in the slightest degree. His career marches along, gaining cumulative force as though it were a thing in nature — as indeed I begin to suspect it is — and now he has reached the point when he is acknowledged to be the most successful sculptor in the country — the sculptor to whom all the important jobs naturally gravitate.

If you were to ask Mr. Manship for a self-criticism he probably would not use the word "hard." Although he is frankly indifferent when others use it, he himself would probably say, "I like to have things right." And "right" in Mr. Manship's own sense his work indubitably is. It is implacably "right," relentlessly "right," so extraordinarily "right" that sensitive and frail human beings get scared when they see it. After they get over their first fright they are usually able to take pleasure in an art that is so exactly fitted to the requirements of the nation that produced it.

For the times and the people are hard too. The average man when he wishes to boast will say: "I'm hard boiled, I am," and I have even heard ladies who own necklaces of genuine pearls and have had their portraits painted by Philip de Lazlo smilingly avow it. They simply mean by it that they "know what's what," that they are well aware of the values of the commodities they traffic in, and they also mean that they can't be bothered with inconsequential things, with idle vagaries, with soul probings and things of that kind. In short, they know "what's what."

The elite of this generation almost instantly recognized Mr. Manship to be their sculptor. They get from him what they would get in surgery from the highest priced surgeon of the day, in engineering from the very best engineer, and so on. The best surgeons and the best engineers do fine jobs, and they achieve a kind of handsomeness in their work that subtle thinkers in Europe have for some time been hailing as art. But the American elite did not wait for European approbation before adopting Mr. Manship. They joined forces with him the moment he swam into their ken. It was a case of instinct, and instinct is always swifter and more unerring than intellect.

The present exhibition is indeed made up of handsome material, handsomely shown. Mary Fanton Roberts, who viewed the collection at the same time that I did, and who is intensely susceptible to success in the abstract (as I am, too), murmured, as her gaze swept the room: "Royal. It is positively

I like best the "Tattoo & Haircut," the "Hotel Belmont" and the "14th Street Window." The "Tattoo & Haircut" is very far down on the Bowery. It is a bewilderment of signs and electric lights and furtive derelicts yet it hangs together admirably and the details can be read without effort. Even the bolts and beams of the Elevated Railway overhead have been indicated affectionately. The "Hotel Belmont" is not the Hotel Belmont you may suppose. It is, in fact, a hostelry for Negroes, and the clients of the hotel provide a dramatic panorama on the sidewalk. The "14th Street Window" pleases me, in spite of my refusal to believe that Mr. Marsh is a facile painter, because of its accomplishment. It has quite a number of aesthetic charms although it exploits a shop-window in which young lady models parade in costumes that are for sale at incredibly reduced prices.

The New York Sun, April 8, 1933

PAUL MANSHIP'S SCULPTURE

AT AVERELL House, 142 East Fifty-third street, all the recent work of Paul Manship, including his "Lincoln" and the Memorial Gate for the Bronx Zoological Park, are on view this week for the benefit of the relief fund of the unemployed architects and draftsmen. From April 17 to May 15 the exhibition will be free to the public.

Before this I have frequently referred to Paul Manship's sculpture as "hard" without in the least interfering with our private friendship. Mr. Manship takes criticism nicely. He is indifferent to it. That is as it should be. He has never found

Anyway, it is good in art. And that brings me back to the word "extol." I'll tell you how Mr. Marsh extols the Bowery.

Mr. Marsh is perfectly unmoral about it. He doesn't attempt to high-hat the Bowery. By some miracle of adaptation he manages to see the customers of the tattooing parlor, the frequenters of the burlesque shows and other attractions in the lower part of the city, as just plain human beings. He did not go down there to hunt villains or "to find evidence" or to reform anybody. Apparently Mr. Marsh thinks the Boweryites just as good as the uptown folk and a whole lot more picturesque. By clairvoyance, or sympathy or long acquaintance he has even adopted their standards of physical excellence, and so he translates into paint the beauties of the young lady actresses in the music halls and the young lady swimmers at Coney Island so that all must be convinced. I call that extolling. The beauty was there but we didn't see it. Now, thanks to Mr. Marsh, we see it.

It is, it is true, essentially innocent. Nothing very dreadful happens in any of the pictures. Mr. Marsh may arrive at a murder later on but as yet he has no inclination in that direction. Mae West, you may remember, did an almost-murder in "She Done Him Wrong" and lived to have a romance with the gentleman of her choice. Sooner or later on the Bowery things happen, and if Mr. Marsh lingers down there much longer, he may come up with something gruesome, but as yet, like Dostoevski in "Crime and Punishment" he allows the possibilities in criminology to be overshadowed by the greater interest of the merely human. As you watch you finally forget you are on the Bowery, just as in Dostoevski's jail you finally forget you are in jail.

Mr. Marsh has made strides as an artist. He doesn't paint easily and sometimes I suspect he tortures himself to paint, but it is his inner vision that has improved and by means of it he arrives unmistakably at his objective. In that way, and although so different, he links up with Albert P. Ryder. If you lifted your eyebrows, gentle reader, when I matched Mr. Marsh with Dostoevksi, you will be now lifting them still higher. I dare say, at the mention of Albert P. Ryder — yet I guess you get what I mean. If you go to the show you certainly will. It is in fact the reason that I put a value upon Mr. Marsh's work — that he gets you past the technique of the profession to the essential matters that concern an artist.

populace, or at least to that portion of it that takes delight, say, in the stained glass windows of Milan Cathedral. It has a stained glass quality. To be sure, there is no announced subject. But then the molten colors that are poured down on the cathedral floors tell no story, either, or at least every beholder gets a different story out of them.

The New York Sun, March 11, 1933

REGINALD MARSH'S BOWERY

THE REGINALD MARSH exhibition in the Frank K. M. Rehn Gallery deserves some kind of a medal. There is no Pulitzer Prize for the best exhibition of the year, but if there were this would win it. As there isn't, Mr. Marsh will have to be content with one of Walter Winchell's mythical orchids. I believe Mr. Winchell is the journalist who distributes orchids about promiscuously when pleased, and Mr. Winchell will surely be pleased with Mr. Marsh's work.

Mr. Marsh's work concerns itself with phases of the city life that are almost unknown to denizens of Broadway and the East Fifties. He extols (I'll explain that word "extol" later) the Bowery. Somehow the city is no longer Bowery-conscious as it used to be in the gay nineties when the youthful Harry Lehr took the aged Mrs. William Astor to a Houston street restaurant and shocked the "400" deliciously for a whole winter. Perhaps Mr. Marsh may revive the interest. His pictures, together with Mae West's film, "She Done Him Wrong," may again mass the limousines at vantage points along the Bowery where life may be observed in the raw. Apparently the Bowery is just as good – or perhaps I should say just as bad – as ever it was.

being what they are; yet in Paris there is so much art in the air, as it were, that you breathe it in unconsciously, and the first thing you know you look upon technic itself as a language and comprehend what an artist means when he plays one brilliant color off against another without deigning to fool you at the same time with a rather stupid anecdote.

Elegance, beauty, style and power are distilled so plentifully in Paris that they are appreciated even when distilled -- that is to say, "in the abstract." Stories are still told in Paris -- I don't mean that the anecdote is obsolete -- but certainly it is no longer permissible to tell an obvious story in an obvious way -- the out-and-out bores have at last been done away with. But the main "article de Paris" of this period, the thing you have to go to Paris to get, is the natural interest and sympathy with technic itself, for unless you are able to enter wholeheartedly into the game that the artist plays, you are bound to miss most of the significant things of this time. It is possibly a handicap under which the art of this day labors, but on the other hand, the comprehending connoisseurs in every period have been few; few but influential. In the end they win.

So, as it becomes more and more expensive to go to Paris, I advise those earnest citizens who fail "to get" Picasso not to bother about him. It's too bad that they do not get him, but then, on the other hand, these same citizens in an earlier generation would have been indifferent to Herman Melville, and, still earlier, to William Blake and Beethoven and all other innovating artists. To appreciate the genius of the immediate present one must have a flexible mind, one must be able to recognize power when divested of its familiar trappings. As this willingness to meet life half way is rare most people forego the pleasure.

From such delinquents, therefore, I would hide the two or three very strange Picassos in the present collection, for they will be bothered by them to no purpose. Picasso is a strong painter, with strong whims and fancies, and when he sets out to depict some extraordinary dream-ladies on a beach, dream-ladies seen in a fabulous scheme of perspective, it is, as the phase goes, "just nobody's business" save the comparatively few who have already been won to Picasso's charm and take interest in any solution he makes to any problem.

On the other hand, the big abstract decoration seen on the wall as you enter can be recommended to the general

MORE PAINTINGS BY PICASSO

THERE HAVE been so few French exhibitions this year, of a challenging nature, that the sudden appearance in the Valentine Galleries of a group of hitherto unseen Picassos, together with the Roy exhibition at Brummer's, the Derains at Knoedler's and the show at the Marie Harriman Gallery, give this one very much the appearance of being a "French Week."

Apparently starved for a little news from the City of Light, the students have crowded all these exhibitions, and the rather acrid discussions that may be heard remind one of the old times. The Picasso show, as it happens, is difficult. Picasso always was difficult, and, I suppose, always will be. Certainly he shows no disposition, as the years creep upon him, to begin his reminiscences, and steadily and alarmingly explores new territories. The fact that the very early Picassos no longer seem to threaten us with the immediate dissolution of the world, seems to afford no assurance that the new works which we are now called upon to judge, will not bring down fire and brimstone upon us. We are that timid.

The fact is, to keep up with Picasso, one must be upon the spot. He snatches things from the Parisian atmosphere like a prestidigitator and arranges them into his compositions with an authority that impresses – Parisians; but baffles inhabitants of remotely outlying nations who do not recognize the things snatched nor approve of virtuosity applied to material that seems to them so foreign to art. There is a small group in every community to whom the things of the spirit are an open book, and to these the manifestations of Picasso are in no way frightening, but these blithe beings are in the minority. Their friends and neighbors overwhelmingly say that they do not understand Picasso in the least, yet insist nevertheless that Picasso is a bad man and his art a menace to polite society. All this is really just because they do not understand.

And for "those who do not understand" the only thing I can prescribe is a short residence in Paris itself, a thing that is becoming more and more difficult to accomplish, the times

technic. I think it is better to articulate a truth distinctly rather than to stutter it forth. Of course it is the truth that is the essential, and a stuttered truth is infinitely preferable to a perfect manner that contains no truth, yet for all that, I'm for good articulation when possible.

I said all this once to a young friend who was contemplating going in for art and recommended Maurice Sterne as a teacher of drawing. Instead of hearkening to me, however, my young friend joined up with Kenneth Hayes Miller and has had a heavenly time studying but has not as yet learned how to draw. Of course, one may be the best draftsman in the world and not be able to tell others how to do it. Or, it may simply be that Maurice Sterne, as a teacher, lacks what doctors call "the bedside manner." Not having seen him in action, I cannot say. But it remains a mystery to me why young people do not follow him in droves in order to see how a figure is constructed in true proportion.

But I never try to force public opinion; and particularly not when it is young. Instead of that, when the mass of youngsters say they simply won't study drawing with Maurice Sterne I begin to inquire as to what they may possibly have on their side of the argument. All that I have been able to gather, to date, is that a style that is perfectly adapted to Piera della Francescan subjects may, after all, embarrass a young person who is intent on doing cabaret scenes. I can see that a tragedy in a speakeasy, expressed in the idiom of Pollaiuolo, might unintentionally be comic. It seems to be a case of "O tempora; O mores."

The New York Sun, February 18, 1933

for a few years of study. In 1908 to Greece and the monastery at Mount Hymettos. In 1911 to Egypt. In 1912 to Burma and Java. In 1914 back to the U.S.A. In 1917 to New Mexico. In 1918 to Anticoli, Italy. From 1918 to 1933 alternating between New York and Anticoli.

All this represents the struggle of an artist to find himself. It is a rather sad story, and Maurice Sterne is a sad person and there is a great deal of gloom and black paint in his pictures.

Consequently one must be kind. We must all be kind to Maurice Sterne. Worse than the not having a country is the not knowing what country one would like to have. On the occasion of the unveiling of his monument to the Early Settlers at Worcester, Mass., a lot of us New Yorkers went up to see it. As we filed in procession toward the big allegory in stone and bronze, my companion – a great friend of Maurice Sterne's, – said, on first catching sight of the monument, "How Italian!" I looked at him quickly to see in what sense he meant it. He meant it as a compliment. I immediately suppressed my wish to know if the Italians themselves would think it Italian. I immediately resolved to be as kind as possible to Maurice Sterne and to look on the bright side of everything. But sometimes the act of being kind involves nonthinking.

So I positively refuse to decide upon the nationality of Maurice Sterne. Many people, anyway, in the mental confusions following the great war, have begun to deplore nationality – to look upon it as a sin. In case such people have their way, in the future, then Maurice Sterne may ultimately become a great saint. I, on the other hand, intend to be a villain of the rankest description. I intend to be hundred per cent Yankee. So if that be treason to the new Utopia, make the most of it. In spite of Muriel Draper and Maurice Sterne I think America is just grand!

So, in looking on the bright side of Maurice Sterne, I'll say he is intellectual. Consequently, the part of his work that most attracts me is his drawing. Consequently, that portion of his exhibition that most impresses me is the section upstairs that is devoted to the studies for the pictures.

I have said frequently that nobody in America has a greater command over the mechanics of drawing than he, but, oddly enough, I've never been able to convince many young people of this. I hold that no matter what turn we may give to our expression it is useful to have possession of an adequate

gentleman" is also obsolete, for the word "gentleman" is still frequently upon our lips and is, at intervals, still potent as a tradition, but there is no escaping the fact that the entire civilized world is busily engaged in the effort to understand and cope with the vast submerged portion of the populace that used to be inarticulate but is now anything but. I mean, of course, the working classes.

To attempt to bottle up these protesting rebels with their grievances is bad politics. To make martyrs of them is, after all, to make martyrs of them. It is far better to invite them to "free speech," and it is highly practical to encourage them to affiche their ideals in public places so that they themselves, in the course of nature, may tire of them. Unrelieved vulgarity without the presence in the picture of a gentleman villain is, after all, monotonous.

The mere fact that I go on like this shows that the artist has hitched his muse to at least one of our band wagons. He may retort that it is too much to expect one muse to propel the entire circus. That may be granted. Even grasping at one phase of our many colored life is something, however, and suggests that the artist, if he chooses, can still have his say. That Mr. Benton's "say" will attract attention and acrimonious discussion is its best point. Other artists, envying this desirable publicity, may be encouraged to say something, too.

The New York Sun, December 10, 1932

MAURICE STERNE IN RETROSPECT

MAURICE STERNE was born at Libau on the Baltic in 1878. In 1889 he came to New York. In 1904 he went back to Europe

and vulgarity. He even paints into his panels the words of certain songs that are broadcast, such as: "Ain't gonna let no one woman make a fat mouth out of me" and "I'll shoot poor Selma just to see her jump and fall"; and adds by way of benediction: "And it's all good enough for me."

There you have the weak spot in Mr. Benton's philosophy. There is no denying the fact that vulgarity is a part of life and even has a necessary place in life, but it is by no means the whole of life. Quite evidently the artist thought, in all this, that he was being broadminded, like the Walt Whitman who accepted everything, who was the poet for "the foolish as much as the wise," who was "stuff'd with the stuff that is course and stuff'd with the stuff that is fine"; but, alas, in accepting only the vulgarity of life one is far from being broadminded. If Mr. Benton will take another look at the "Leaves of Grass" he must discover that Whitman balances every ugly thing with a beauty, every ignoble thing with something that is noble; that, in short, he keeps the balance.

The painting of these panels is quite as raw and uncouth as the subject matter. Any one who has been educated to what has heretofore been considered "style" in painting must shudder at Mr. Benton's cheap colors and the unnice manner in which they have been banged upon canvas. By style I mean the sensitiveness in the use of the pigment that is seen to perfection in the works of such masters as Frans Halls, Velásquez and El Greco, a sensitiveness that results in making each square inch of a picture pleasant in its own right and merely as texture. Mr. Benton disdains, or perhaps is incapable of, such graces. He is as remote, in painting, from Frans Hals as Theodore Dreiser is in his use of English from Walter Pater.

In spite of all this the choice of Thomas Benton to do the murals for the library is the wisest thing Mrs. Whitney has done since she has been running a public museum. Vulgar as are the subjects the artist has chosen to depict, and caricaturish as is his manner of depicting them, there will not be lacking those to whom both subject and manner will be acceptable in a way that a Frans Hals subject and manner never could be. The times, in other words, have changed.

The Sir Philip Sidney type, who was all grace, has definitely vanished. So why should we be surprised that grace has disappeared from modern painting? I hate to add that "the

ing the boudoirs of the fashionable. So when the day comes that Rivera speaks of, when all will love Kandinsky, it will mean that we are living in a better world.

The New York Sun, November 12, 1932

THOMAS BENTON'S MURALS
AT THE WHITNEY MUSEUM

WITHOUT BEING much carried away, personally, by the Thomas Benton decorations for the Whitney Museum's library, I can nevertheless discount my personal tastes sufficiently to see very definitely that these murals are the most important outcome, to date, of the Whitney Museum enterprises.

They are going to horrify the refined portion of the community, for they are pure "tabloid" — if a tabloid, from any viewpoint, may ever be thought "pure" — and they are going to rejoice the souls of those restless illiterates who "march on Washington," bomb judges and otherwise annoy the government — if restless illiterates, from any viewpoint, may ever be thought to have "souls." In short, these mural decorations of Thomas Benton are "red."

This atmosphere of rebellion is produced, not by any direct reference to the proceedings in the law courts, but by a caricaturish insistence upon everything that is hectic and rowdyish in the American system of living. There isn't a single reference to the rewards of virtue or the charm in ordered living. There is no order whatever in Mr. Benton's America. It is all discord, temporary excitement, roughness,

KANDINSKY'S FIRST ONE MAN

EXHIBIT IN AMERICA

ALTHOUGH KANDINSKY'S work became known in this country twenty years ago, making one of the outstanding successes with the connoisseurs at the time of the famous Armory Exhibition, it has never been exploited by the dealers and consequently has never achieved the publicity it deserves. The exhibition given him this week in the Valentine Gallery is the first one-man show he has had in America.

Yet during all these years Kandinsky has been a constantly increasing influence upon artists of the modern school, and all those who deal in abstract art yield him high praise. The remarks of Diego Rivera, quoted in the catalogue, are both touching and typical: "One day Kandinsky will be the most familiar and the best loved by men. I know of nothing more real than his painting — nothing more true and nothing more beautiful. The painting of Kandinsky gives the maximum of possibility for the dream and for the enjoyment of matter." The slight tinge of foreignness in Rivera's language makes the tribute all the more appropriate to an art that also has its foreignness.

For Kandinsky deals in the abstract. He is a genuine painter — any one can see that who is sensitive to what painting is — and he is a gorgeous colorist, but he is so imaginative that he long ago left the world of commonplace ideals behind him and now speaks in symbols that can be understood by the sympathetic but which sometimes baffle the lazy.

Kandinsky's work is serious, in fact, solemn. He seems to seek for a pure beauty that is part of light itself, and will be understood consequently wherever light penetrates. It is a language, he hopes, suitable for conversations between the stars; suitable even for prayers. That is why he is solemn. He apparently gives no thought to the ultimate use of his pictures, as the Parisian painters do who live in the gay world and see their works, even in the midst of creating them, already adorn-

somewhat get the idea. The extraordinary remoteness of this small power that has been translated into motion reminds me of a Stravinsky piece I once heard played by the Lange Quartet, a piece so pianissimo it could scarcely be heard, yet, for all that, with a recognizable purpose that finally breathed out its design. It suggested the quiet business of a fish in deep water, or the ardent but noiseless activity of a spider. With such things, these abstract sculptures, I am sure, have affiliations. Not that they imply fish or spiders, but they suggest a set of values borrowed from some other world than this.

"Slight," will be the hard-boiled, native art-appraiser's comment on this, "very slight"; and possibly in the final analysis young Calder's work may turn out to be so. For all that it is well to remember that one cannot have cake and eat it, too; and if one must be hard-boiled and estimate everything in dollars and cents then one must expect to lose a great deal that is playful. Paris still has the capacity to play with art and the things that fringe upon art, and it is that that makes her so comforting and comfortable for artists.

As for young Mr. Calder, we don't have to do anything in particular for him, since Paris has quite adopted him, much as she adopted Man Ray some time previously. There is no sense in lamenting these two artists as expatriates, since we cannot provide them with the sustenance necessary to their mental existences; and Paris can. Both have become as complete Parisians as Picasso, and it is to be noted that the loud acclaim for their inventions does not come from American friends but from the French themselves. This is quite as it should be; for there are always these two sides to expatriatism. If an American artist must live in Paris for his soul's good, that's his affair; but in doing so he automatically becomes French and must gain French support rather than live, parasitically, upon funds from home.

The New York Sun, May 21, 1932

MOTORIZED CALDER

WITHOUT IN the faintest degree intending it as a reproach to my country, I say that Alexander Calder's sculpture, now being shown at the Julien Levy Gallery, could scarcely have been brought to its present state of detachment from life here. In spite of the fact that this sculpture looks like machinery and moves like machinery, it is scarcely the sort of thing that we Americans would be likely to encourage.

It needed the dark, dull afternoons of a Paris winter for its inception, and needed them also, once the work has been finished, for its appreciation. We really have too much sunshine in New York during the season. There are so many more interesting facts presented to us than we can cope with, that we have no energy left for chimeras. Not even for chimeras that resemble instruments of precision in a laboratory built for Prof. Einstein. But I insist this is not a reproach to us. Every country has its specialties, and if the livid atmosphere of Hollywood gives our cinema a special cachet, then we won't moan because the murky air of Paris also has its uses. If we find that we need these moving sculptures of Mr. Calder for the betterment of our souls, then we'll import them. There'll be no harm in that.

But first we must be sure Mr. Calder is serious. It is too bad that Marcel Duchamp is not in this country. He would have been just the parson to preach Mr. Calder's kind of truth. When Marcel was here we almost got to the point of thinking that art consists of things rather than the painted reflection of them, but he went away and all of us but Walter Arensberg of Los Angeles and Katherine Dreier of Connecticut backslided. Now, it seems, we shall have to begin all over again.

At any rate, we can be fascinated at once by the cute little motors that run these disks and wires and small planets. They are no bigger than your fist. And the Saturns and Jupiters, if that is what they are, move so lazily on their orbits, that, too, is fun. You see, I too was in Paris once and

BEN SHAHN'S THE PASSION

OF SACCO AND VANZETTI

GOOD SHOWMANSHIP must be accredited the Downtown Galleries for putting on the "Passion of Sacco and Vanzetti," by Ben Shahn. Mr. Shahn himself must be allowed one of the genuine hits of the season. It is not often in these days that an artist has the sense of speaking directly to the people. Rivera did it in Mexico, and now Shahn does it in New York. It must be a great satisfaction to him.

The exhibition has been largely attended, and by unusual people. They behave before the drawings as though they were in church, and when, on the occasion of my visit, I indulged in a little light conversation with Mrs. Halpert over by the desk some of the visitors turned upon us reproachfully as though we were misbehaving in a sacred edifice. We promptly subsided into awed silence, for, after all, the seriousness of the students merited respect.

All this is certainly a triumph for Mr. Shahn. I am not a communist myself, and I thought the Sacco and Vanzetti trial was conducted fairly, but that does not prevent me from taking an unholy joy in Mr. Shahn's violent arguments to the contrary. It is rather amazing to see how he makes his effects. He has depended upon photographs, naturally, and he reflects the photographic feeling in a way that is practically burlesque and at the same time attains to extraordinary sincerity. As an artist he half laughs at his distortions, and yet the feeling back of the work is that of the zealot.

It is this feeling that gets over "to the people." The partisans are so persuaded that Mr. Shahn is on their side of the argument that their first impulse, being partisans, is to deny that there is any distortion or burlesque anywhere in these water colors, and no doubt they will say that the dreadful portrait of Judge Webster Thayer is entirely too good for him. Well, Boston is going to have a grand time with these novel works of art, for I hear they are to be shown there.

The New York Sun, April 16, 1932

291

mous number of pictures, not all of which are equally suscept-
ible to fame.

Consequently, these honest outsiders who may some day
be converts might as well be told at once that Mr. Eilshemius
is a simple man who evolved a delightful way of painting all
by himself, in the course of which he made one or two obvious
challenges to pictures that were being acclaimed at the time
when he was being rejected by officialdom. Curiously enough,
Ryder, the artist with whom Eilshemius is most akin, was the
object of his envy, and so there is no occasion to make much
of the discrepancies between the "Flying Dutchman" and the
picture in the Whitney Museum which Eilshemius painted
in emulation of it, and in the "Macbeth and the Witches,"
which derives from the same competition.

Instead the seeker should go at once to the long series
of mellowtoned pictures that record the artist's adventures
in the South Seas. These works please lastingly. They are not
intellectual, like the performances of Mr. La Farge in the same
region, nor erotic, like the canvases of the recent Mr. Gauguin,
but simple and youthful ecstasies that have an unmistakable
singing quality though expressed in paint. The pictures have
so little "side" to them that one suspects that these are just
the sort of pictures the Samoans might have painted of them-
selves had they been versed in this particular medium. But
with all their simplicities of painting, the color has a peculiar
and vital vibrancy, and the tone of the work impresses you
more each time you encounter it. The chances are, once you
have accepted these South Sea pictures, you will go on to ac-
quire a special affection for all the works of the artist, for there
is a rusticity to them that is especially attractive in these days
of our first rebound from "the culte de Europe."

The Eilshemius paintings are now being shown in the
Valentine Galleries and the present group will be replaced by
another set a little later on, as the Valentine Galleries are
eager to put the whole "oeuvre" before the public.

The New York Sun, February 27, 1932

have noticed, have recently reappeared and, the tone of them is as unabashed as ever.

But all this is mere prelude to as curious a story as you would care to read. There was no indication that the admirers of the letters took the claims that were made in them for Mr. Eilshemius's art seriously. I never heard that Mr. Kingsbury ever bought one of the pictures or walked half a block out of his way to see one. That, it now appears, is where Mr. Kingsbury made a mistake, for many people, at this late date, begin to say that the pictures are very good indeed and that the artist is quite justified in refusing to assume hypocritical airs of modesty in speaking of his work. The letters are just as quaint as ever and it is still all right to laugh at them, but unconsciously one laughs with them instead of against them when one learns that the artist really is a good artist and that the letters, all these years, have been a sort of an antic disposition assumed to pierce the skin of an indifferent public.

Why the pictures of Mr. Eilshemius were rejected for an entire generation is easily enough explained. The artist's ideas, feelings and manners were helplessly American, and they were brought forward in a period when it was fashionable not to be American, when the painters were all struggling to be European and when Henry James, Whistler and Sargent preferred having London residences rather than New York ones. There was not a touch anywhere in poor Mr. Eilshemius's paintings that was fashionable – there is not to this day – but there was much that was poetic. In fact, the despised Mr. Eilshemius is that rare thing – a genuine lyric painter.

In the dozen years or so since Marcel Duchamp and the Societe Anonyme discovered the true worth of Eilshemius in the exhibitions at the Independents, there has been a steadily increasing band of converts, and lately there is evidence that some of the young people are making a political cult out of the affair, all of which may help the cause of the artist and incidentally the young people engaged in it. However, young people dearly love "a cause" and, once persuaded themselves, like to make it as difficult as possible for the enemy – i.e., those not yet converted. These outsiders, hearing so much noise, are sure to inquire into the matter and, as like as not, will be confronted at first with the less-acceptable paintings, for Mr. Eilshemius, in a long life time, has painted an enor-

that Mr. Macbeth was obliged to borrow many of his speci-
mens from public collections implies that the museums are
already upon the trail. They can do more about it, however. A
roomful of pictures by John F. Kensett, Jasper F. Cropsey,
Jervis McEntee, William M. Hart and David Johnson would
not be a handicap to any American gallery.

The New York Sun, February 6, 1932

EILSHEMIUS AS A CULT

READERS OF The New York Sun are not unaware of the name
of Louis M. Eilshemius. In fact, readers of The New York
Sun know the name better than most people. But they associ-
ate it with literature. They think of Mr. Eilshemius as a letter
writer. He has been The Sun's most assiduous correspondent
for years. He wrote on all sorts of subjects, but chiefly on the
supremacy of Mr. Eilshemius as an artist.

These letters had such a curious tone and made such
astounding claims that I think they bewildered even The Sun's
editors at times. Just who had the courage to accept them first
for publication I have never learned, but I suspect it to have
been Mr. Kingsbury, who was on The Sun in the early days,
and who had a subtle feeling for humor and literature. At
any rate, The Sun was vastly entertained by its novel corre-
spondent for some years and then, possibly thinking that
enough of even a good thing was enough, decided to drop
him. Somehow this was not so easy. A newspaper's readers
are its emperors and their will is law; and The Sun's readers
had acquired the Eilshemius habit. The letters, as you must

social system and were still able to be annoyed many years later when young Rudyard Kipling again took exception to our way of doing things. It is only comparatively recently that we have learned to keep cool under criticism, and now when Bernard Shaw and Aldous Huxley make unkind remarks about us we simply say, "Oh, yeah?" and let it go at that. It was the last great war that taught us our true position in the world. Whatever else that war did to Americans it at least gave them a keener sense of the word "home" and a keener appreciation of everything that led up to our having a home.

Now that we are at last willing to stand upon our own feet, it is to be noted that the very expressions we once feared were provincial have become dear to us. This phase can be noted in literature as well and explains the prominence that is given to Sherwood Anderson's work, which is not only not chic but appears to studiously shun the chic.

In taking up again with our past, however, it does not follow that we take up all the past. Time is an editor. Freed from the contemporary prejudices of a former period we look at it in a detached way and accept only the livelier items. There is agreeable drama in the "Conway Valley" and "The Valley" by John F. Kensett in the present exhibition, as well as in the "Storm Clouds" and "Harvest Scene" by Jasper F. Cropsey and the "Foothills of the Catskills" by William M. Hart, but I think that most people who share the taste of today will remain cool to such things as Albert Bierstadt's "Rocky Mountain Scene." George H. Smillie's "Wood Interior" and Thomas Cole's "West Point."

The point is that no subsequent and amiable generation can put life into the work of a former period if it did not have it in the first place. A work that is stodgy in the beginning remains stodgy. A rigorous division can be made between perfunctory painting and painting that has drama in it, and as time goes on, the division becomes more and more rigorous. There is, to be sure, a second chance for certain inexpert artists when their subject matter becomes quaint, but even this implies an original and personal outlook. The one deadly sin is perfunctoriness.

The present exhibition seems to invite some critic with a constructive turn of mind to go into the Hudson River School more deeply. It is time the sheep that abounded in that pasture were separated completely from the goats. The fact

COMEBACK

FOR THE HUDSON RIVER SCHOOL

IT WAS inevitable, after Holger Cahill's fine work in convincing the public that there was genuine aesthetic interest in the productions of the early American primitives, that something should be done in the way of restudying the despised Hudson River School. The present exhibition in the Macbeth Galleries is a step in that direction. There must be more of it before scholars can come to definite conclusions, but already there are clews.

The term "aesthetic interest" which has been applied to the American primitives does not commit one too much and can be used with equal justice on the Hudson River men. There is no suspicion as yet that any of them can be ranked among the great landscapists of the world, but even without supreme merit of that kind it is apparent that some of them — not all — can claim "aesthetic interest," and besides that, help us to know ourselves. They are an essential link in the historic chain which it seems has never been completely without "aesthetic interest."

Just why we threw the entire Hudson River School out, bag and baggage, about forty years ago, is a matter for psychologists to bother about. It seems rather funny now. We suddenly grew ashamed of them. It was not that we realized that no one of them was a Ruysdael or a Claude Lorraine, but merely that we had discovered them to be insular. They lacked a fashionable touch, they lacked what the French call "chic." The first great excursions of artists to Paris had begun and when Chase and Weir and Whistler and Sargent began to show their modish wares we hastily swept the Hudson River landscapes into our closets and denied that we had ever been like that.

We were very susceptible to criticism in those days, which shows that we were not quite sure of ourselves. We foamed with fury when Charles Dickens found a few flaws in our

impressively on the walls of the Knoedler Galleries, who wins the competition, the sitter or the painter? I vow I am scarcely prepared as yet to settle this matter even to my own private satisfaction. I am not in possession of all the facts. One thing, at least, stands out quite clearly: Sir William was not a human being at all, but a machine. In a way, that exonerates the sitters, don't you think? You can't hypnotize a machine so you can't say that they put themselves over on Sir William.

Machines, on the other hand, are not choosers, and there was one slight element of choice in Sir William's work that was not quite biased enough to enable us to classify him among frail humans like the rest of us, and yet not pronounced enough to imply that he had a weakness as a machine. I refer to his apparent predilection for power in persons. He did seem to relish what are known as human dynamos. I mention this apologetically, as I wish to make out as good a case for Sir William as I can.

James Stephens, the Irish poet, used to say years ago that Sir William had the best eye in the world for seeing but what he saw wasn't worth seeing. If James Stephens were here now I think he would be the first to modify this statement, for at the time he made it Orpen had not seen all these wonderful Americans, and unquestionably they were worth seeing. Going about in the Knoedler Galleries from one effigy to another one cannot resist the thought that these are the very people who made this period what it is. If not all of it, they were at least a large part of it.

Hard, relentless, dominant perhaps. One needs such qualities in these days not only to get anywhere but even to guard what one has already got. Is it a reproach? Is it a reproach to be a success? Nonsense. You wouldn't consider it a reproach to be thought another Lorenzo the Magnificent, I am sure; and the busts of the early members of the Medici family show them to have been as like our great men of affairs as peas from the same pod.

The New York Sun, January 23, 1932

PORTRAITS BY ORPEN

DAT OLE debbil Vainglory has a lot to do with the art of portraiture, but on the other hand, if Ecclesiasticus is to be believed, Vainglory has a lot to do with everything. Sins in which we all share are venial. Vanity, after all, is not a penitentiary offense, and only he who has never sat for a portrait can afford to scoff at him who hath enjoyed seeing his flesh exactly rendered.

So whatever else it may be, the present occasion of an exhibition of portraits in the Knoedler Galleries by the late Sir William Orpen, is not one on which to pin a mockery of the rich and important Americans who succumbed to the insidious flattery of an immortalization on canvas by the most precise portraitist of this generation; though one cannot resist surmising what they thought of their experiences after Sir William had finished with them. One can only surmise; one will never know.

Portraiture, it has been said, is a competition in willpower between the painter and the sitter, the painter striving to glorify himself and the sitter insisting on being himself the protagonist. Others say, especially when the picture turns out to be a real success, that it is a matter of cooperation between the two parties to the affair. No doubt every cultured person, on mounting the model-stand, fully intends to cooperate, but those secret, inner forces, about which we all now know so much, tend to develop in the gentle sitter only too often what the artist must regard as — misbehavior. Was it not John Sargent, the most petted and indulged of all our recent artists, who defined a portrait as "a painting in which there is always something wrong with the mouth?"

In a Sir William Orpen portrait there is never anything wrong with the mouth. There is never anything wrong with anything. Of course, that is the trouble with them. The sitter is so tremendously pleased with the result that nobody else is pleased at all.

And yet, in all these instances spread out before us so

completely organized in these States that the experiences of one were common to all. They each had things of moment to tell. Today the individual has to go farther in the search for things to tell, but, even so, individuality is still a thing that may be achieved.

All the early pictures in the present display invite smiles and affection both. The portraits are always vital and assured, and if the painter was unembarrassed by not knowing precisely how to draw a foot, neither should we regard the predicament as fatal. Beauty depends upon larger matters, and all these painters had ideas of beauty.

Joseph Pickett, who, in his "Manchester Valley," shows the first railroad train entering New Hope, Pa., gives the railroad engine an intrepid look as though it were a gazelle leaping from rock to rock, yet nevertheless has such earnestness in his account that you unhesitatingly accept his version of the affair. Edward Hicks, author of "The Peaceable Kingdom," a picture in which the lion and the lamb and a lot of other animals lie down side by side, and William Penn and the Indians converse amiably in the distance, is another who has so much conviction that your own weak doubts are swept ruthlessly aside. These pictures, if they teach anything, certainly teach the importance of being earnest.

The Gallery of Folk Art in its researches is endeavoring to classify and place the early practitioners of the arts, and among the others has been doing some work on the subject of Raphaelle Peale. This disregarded member of a well-known family of artists signs an early still-life of a bath towel with bits of the bather showing here and there, which is thought to be one of the earliest still-lifes painted in this country. It is so well realized, or at least the towel part is, that all the "primitive minded" will look upon it with extreme interest. In fact, even those who are not as yet "primitive minded" ought to concede that it contains good work.

The New York Sun, November 19, 1931

AMERICAN PRIMITIVES

THEY TELL me that the younger artists are taking great comfort in the collection of early American paintings now being shown by the Folk-Art Gallery at 113 West Thirteenth street. They acknowledge the little-known painters to be their great-grandfathers and great-grandmothers and seem to relish the fact that at last they have an ancestry.

This feeling is comprehensible enough. Somehow it recalls a remark I once heard back in the period of the late Mrs. Jack Gardner, for I am a survivor from that epoch. Mrs. Gardner, however, was not the one who said it. She who did was a radiant beauty of the type that used to be known as a "society belle." On being asked, on a particular occasion, why she felt so gay, she replied: "I am happy to be a woman. It gives me great satisfaction to know that men like me just for that." At the time I thought that this was one of the most brazen remarks I had ever heard uttered, but as time goes on, and pure womanliness becomes scarcer than it used to be, the fleshly philosophy of the lady seems less reprehensible.

At any rate, her principle applies nicely to ancestors. We don't ask anything of them but that — to be ancestors. Their little sins and shortcomings are immaterial. They are our forebears and that is enough.

In all the extraordinary emancipation of the present era, with illusions dropping from us at every step, ancestors still persist. In fact they seem more necessary than ever they were. So, doubtless, our younger painters are quite right in thus hitching on to history. Conscious that they have a definite background they may make more confident gestures.

But they might go farther into the matter than that. They might see that these early and little-taught artists had ideas, convictions and above all, distinct points of view. The great error of modern art instruction is that it erects a barrier between the student and life. It teaches so many "musts" that the pupil is never afterward certain of the "cans." Our grandparents had no such embarrassments. Life was not then so

munity that produces geniuses. The freedom and lack of convention that has guided these purchases are the greatest possible auguries for the future liveliness of the museum. A contemporary museum that is stilted and pedantic is — well, it is not a museum but a morgue.

Some of the most advertised of our present celebrities are not represented by outstanding examples of their work. Eventually they will be — or it will be their own fault. There will be plenty of time later on in which to discover "holes" in the representation, if there be any, and to make suggestions for remedying them, but, in the meantime, and even in the crowded attendance of these opening sessions, it was possible to notice a few men who stood out exceptionally well from the walls.

Among these who already better their reputations by this event are Edward Hopper, Niles Spencer, Stuart Davis, Louis Eilshemius, Joseph Pollet, Henry McFee, Reginald Marsh, Charles Rosen, Vincent Canadé, Bernard Karfiol, Gaston Lachaise and Cecil Howard.

By way of background to the work of living men a group of paintings by artists whose careers have ended has been included. It is scarcely likely that much of this museum's energy will be spent on backgrounds, but the inclusion of two works by George Bellows and Arthur B. Davies will be generally thought appropriate. The Bellows is the well-known "Dempsey-Firpo Fight." It is a picture that is destined to interest posterity because of the event but not aesthetically. It can be accepted, with many reservations in regard to the color and the composition, because of the reflection it gives of the forceful personality who painted it — a personality that is still potent in our midst.

The New York Sun, November 21, 1931

Mrs. Whitney, with a generosity unsurpassed in history, has supplied "the works," but it is up to us to keep them going. If, on the day of judgment twenty-five years hence, this museum shall be found wanting, it will not be Mrs. Whitney who has failed but we, for it is generally agreed that a nation and a period get the kind of art they deserve. We shall even be responsible for the choice of artists, since the times have greatly changed since the days of Mrs. Whitney's great predecessor, Lorenzo. We are no longer docile and we dictate even the benefactions we receive.

"The works," if I may be permitted so affectionate a term for such an impressive machine, are exactly calculated to our present need. They are easy to enter. They are right on the street, without lofty porticos and chilling entrance halls. The installation is rich, but not too rich. There is a comfortable feeling of prosperity about the rooms that will no doubt aid many people to trust the pictures more completely than heretofore, and this is very fortunate since many of the pictures are of the sort that nice people have not as yet sufficiently trusted.

In fact, the first phase of the Whitney Museum of American Art's "gesture" seems to be in the direction of our lesser known man. The collection has been greatly augmented and strengthened during the year of preparation, but the bulk of these works of art were acquired by Mrs. Whitney during the years of the Whitney Studio Club's activities, and were acquired as much for the promise as for the performance that lay in them. In the strict sense of the term many of them are not museum pieces. But it is altogether excellent that they were purchased when they were purchased and it is altogether excellent that they are shown now. If one were to wait until an artist becomes an acknowledged master there would be no sense in making the purchase at all — at least for such a museum as this, whose business is to make reputations, not to embalm them.

So the comfortable and enticing conditions under which the work of a whole horde of promising young artists can now be seen are achievements already to be thankful for. The unthinking demand "old masters" at once, but the unthinking are not aware that masters are never isolated and unattached, but are the choicest specimens from a whole forest of endeavor. Much art is necessary, and all kinds of it, to the com-

distinct partiality for native art, and the great Otto Kahn looked in on the affair and saw that it was good.

There were about five thousand others in attendance who cheered to the echo every hint of patriotism. The entire five thousand came in automobiles. The crush of motors was beyond belief. West Eighth street was, in the words of Henry Schnakenberg, an old resident, "as it never was before." The merchants on the street gave up all thought of business and joined the throngs on the sidewalks to gaze at the unwonted spectacle. It was grand, all right.

The five thousand, naturally, didn't see the pictures very well, but they saw each other and expressed enthusiasm unanimously for "the idea." At present the idea is more important than the pictures. Mrs. Force, the director of the new institution, in a frank little speech at the preliminary banquet that was given to the art critics of the nation, spoke of the enterprise as a "gesture," and added that the true test of the gesure could be made about twenty-five years hence.

Neither this remark nor this banquet were propitiatory. Propitiations, in this case, were unnecessary. The art critics and the public at large were completely won at the first announcement of the museum that was to be. The announcement was like a battle cry to which the only answer could be another hurrah. The only alternative, to the unthinkable minority, was a trip to Leavenworth, but so far no traitors have been unearthed. We have been as solidly knit into one party by this occasion as the British were at their last election.

This party-spirit smoldered all summer long only to burst into flame at the beginning of this season. The number of dealers who intend to handle the native production increased over night astonishingly and the word "American" has become, über alles," the word to conjure with. Of course it wouldn't be a party-movement without some exaggerations. I heard one reputedly intelligent young man exclaim, heatedly, "I'd rather have a poor American picture than a good foreign one," but the cool weather which the experts are now promising us definitely will doubtless bring this young man and his friends to a truer sense of proportion. The fact is, we all desire a place in the sun but not the sun itself, which will be permitted to shine as heretofore on such territories as the League of Nations approves of. The main thing is we've got our place in the general scheme at last.

the delicate Clement the finer singer of the two, but the vast public was never able to hear him. They all heard Caruso, however. In Beckmann's case there is still a suspicion that he is more concerned in making a noise than in saying something. He does, however, unquestionably make a noise.

The impressiveness of the sculpture leads one to believe that this is an art that lies well within the German grasp. Kolbe, De Fiori, Barlach, Sintenis, Belling, Marcks; all are able. The thing to be noticed by our struggling younger sculptors is the way these Germans define their basic ideas before starting to work. There is no fumbling. It is all definite, and in the end, easily read. De Fiori's clever portrait of Marlene Dietrich arrives at an opportune moment to share in the applause that is everywhere given to this actress; and the same sculptor's portrait of Jack Dempsey recalls once more the strange apathy of our own sculptors toward the superb material the boxing ring presents to them unavailingly. They're already beginning to say that Jack's marvelous legs are no longer what they were, and soon this opportunity to rival the ancient Greeks will have completely passed. However, as far as sculptors are concerned, Young Stribling, Ernie Schaaf and Chester Matan are almost as good.

The New York Sun, March 14, 1931

OPENING OF THE WHITNEY MUSEUM

THE STARS in their courses conspired to favor the Whitney Museum of American Art. The sign was right. The fates, from the very beginning, were amiably disposed. The grand opening was grand even beyond expectation. President Hoover sent a hopeful letter, ex-Gov. Al Smith, in person, confessed to a

really is matter here for your consideration, and which you will be obliged to consider sooner or later, so why not begin the study now, open mindedly? You will, for one thing, almost instantly discover that this new effort of the Germans to secure a place in the sun is only our own problem all over again, for we, too, have been barred from world recognition in the congress of arts and any effort of another nation to seek a new path up Parnassus is bound to be interesting to us – is bound to suggest ideas to us.

I say "forbear" because I didn't do it myself, at first. Until quite recently I had a distaste for German art that was quite too much for me. There was a certain grossness and hardness that I instinctively sidestepped. It was not a sufficient recompense, I felt, for the vigor, which was undeniable. Then I began making exceptions. I fell in love with the work of Paul Klee, who seemed to me a Chopin in paint. Later I began to see things in Camperdonck that I had not seen at first. Now I think him an excellent artist and the "White Tree," which is lent to the present show by Miss Dreier, is certainly a prize.

Then I began acknowledging, perhaps a little reluctantly, the undoubted power of Max Beckmann, Karl Hofer and Oscar Kokoschka. On the present occasion, I am distinctly tempted by George Grosz, and to a lesser degree by Ernst Kirchner. Of course, all along, I have accepted Georg Kolbe as a conspicuously successful sculptor; and in fact have regarded the Germans generally as able in sculpture. And so, when an American who started out with a prejudice against Teutonic art accepts Paul Klee, Camperdonck, Max Beckmann and Georg Kolbe, it begins to be apparent that the Germans are in a position to engage in international talk. I wish that the Germans would as frankly accept four living American artists. I do not, however, hold this remark over them as a threat. If they don't see us it's their loss.

Max Beckmann's paintings are the most dominant in the present collection and there will be many new people to concede that the style is sharply distinct. His pictures rely more upon power than upon charm. In that they follow a recent trend in Paris. Picasso, the most dynamic personality in contemporary art, has been minimizing charm, too, but however powerfully he speaks he always says something. In the great world, a forceful proclamation always takes the lead. It's the old story of Caruso and Clement. Many connoisseurs thought

of these paintings are not greatly varied, the moods are; and so the exhibition gives you an excellent idea of Pascin's power as a painter. It is not likely that a better collection will be made, nor that they can be more sympathetically shown.

The charm of the pictures is the dream-like quality that seems to surround youth. Adolescence had a peculiar fascination for this painter, and he never tired of its poetry. The pale, delicate tones are far from being evasive, and they answer to all the tests that are put upon works of art, in a masterly fashion. For instance, though they seem sometimes to have been blown upon the canvas with a delicate breath, they photograph unerringly well, and in the shadows of dusk, the forms still hold true. The drawing is about the most sensitive drawing of modern times. It has the quality of great calligraphy. From the beginning of Pascin's career, this was so. His style truly seems to have been born in him. It was himself. And it will live.

The New York Sun, January 3, 1931

CONTEMPORARY GERMAN ART

THE GERMAN show at the Museum of Modern Art is a difficult task well done. No one who has not tried to send a typical collection of American art to Europe will quite realize what the modern museum and the Germans have now accomplished in reversing the process. What the living Germans take seriously in their current production is here intelligently put before us. It is up to us to take it or leave it.

My advice, founded upon an experience of only two or three years, to those who would "leave it," is — not to leave it too abruptly. If your first impulse is to reject it — forbear. There

in the world, but nevertheless he could not but feel flattered and comforted by the open-eyed admiration that met him everywhere. He was a hero, of course, in Paris, but he was a hero among ten others. Here he was elevated to the chief position, the only unmistakable hero we had — of international fame, that is.

We also paid him the dubious compliment of imitation. That is the one chapter in the history of our relationship with Pascin that we shall have to live down. Too many of our susceptible artists copied the Pascin style. It got them practically nowhere, so the individual sinners need not be mentioned. Besides, everybody knows them.

It is likely that Pascin dreamed of Havana and New Orleans before crossing the Atlantic, but it was the realization that the New York winter can be formidable that quickly drove him South. New Orleans, oddly enough, was something of a disappointment to our artist. Possibly because it was too completely artistic in itself; "ready made" as Matisse felt Tahiti was. The artist always wishes to get in his word, you know; but neither Pascin in New Orleans nor Matisse in Tahiti could get in a word edgewise.

In Key West and Miami Pascin "connected." He simply adored the free, animalistic movements of the colored natives. In Havana, where he was to go later, his rapture continued. He had the delight of a discoverer, and he recorded the doings of the halfbreeds in clear-cut and rhapsodic lines. It was after his second visit South, I think, that I called upon him to see his work, and was amazed to find that Pascin had a steamer trunk full of extraordinary drawings. There was matter for several large exhibitions, and I foresaw a sensational Parisian success if they could be shown in the City of Light.

I am not aware that this ever occurred. There were of course plenty of Pascin exhibitions in Paris later on, but I do not recall one exclusively of Cuban subjects. I still hope that this may be managed some day. In the meantime it is pleasant to see some of them again in the memorial show that is now open to the public in the Downtown Gallery.

This memorial has been surprisingly well managed. That is, it surprises to see so many important paintings by Pascin in this country. At the time of his stay in America he had accomplished but few of them, most of his energy having been spent upon the delectable drawings. Although the themes

able position for any artist to find himself in, but in order to get world fame a still greater effort is indicated.

The New York Sun, November 8, 1930

MEMORIAL EXHIBITION OF PASCIN

IT IS fitting that New York should give a memorial show to the late Jules Pascin, for of all the internationally known painters of this period, he was the one most tied by bonds of sentiment to the city's life. This was more than the mere accident of his American citizenship, which was one of the exigencies of the late war, and was undertaken, paradoxically enough, so that he could the more quickly get out of the country and return to France, the land of his adoption.

But in spite of the fact that he was only nominally an American, he had an undoubted affection for the New World, its pictorial aspects and its people. Some of his most ardent friendships were contracted here and he remained faithful to them, in his fashion, to the end. He had one or two ennuis, naturally, at the beginning of his stay, due to a suddenly restricted income, to an unfamiliarity with the language, and to some of the war fears that he brought with him. But after a while he made friends, chiefly among the artists — for as Mr. Crowinshield has pointed out, he was essentially an artist's artist — and then he was happy.

They surrounded him with the atmosphere of belief and interest that go so far to fortify an artist. It is this atmosphere of "belief" that is so readily obtainable by all artists in Paris and which is the real secret of that city's supremacy in the arts. Pascin was the most modest and unselfish individual

personal feeling about life that can only be expressed in a personal way. One gets it by living rather than by going to school. Just about the time that I was renouncing Mr. Kuhn permanently he exhibited a lot of paintings in which the quotations from Derain, Pascin and the others, were so minimized that they were no longer the whole thing. Mr. Kuhn was being himself.

That was last year, I think. The subject matter was excellent. It was matter well calculated to send any artist off on voyages of mental discovery. Mr. Kuhn had occupied himself with the humbler people of the stage — chorus girls from the East Side music halls, acrobats from traveling circuses, and the like. What impels a hearty, buxom girl who might have made an admirable wife for one of our better "working men" to take up the precarious career of a chorus girl is in itself a mystery. What leads to the final choice of the particular tawdriness she affects for a costume is another mystery.

The possibilities of her being "straight," or really caring for her profession, her deportment in the petty squabbles back-stage, her resemblances to the Balzacian creatures that are now known as "gold diggers"; all these suggestions flit across the brain whenever she is contemplated by a complete outsider, but Mr. Kuhn helps you to few conclusions in regard to the specimens he selects. He disrobes them more or less but by no means unvails them. Compared with the researches of Toulouse-Lautrec in a similar field, his work seems halting and wooden.

Nevertheless last year the artist had "a good press." Most of the critics, including this one, felt that he had gone ahead, and when an artist goes ahead it is an item of news. There was no question but that Mr. Kuhn knew those chorus girls and with just a little more frankness and freedom in the painting it was thought we would have something to match the European output. But this frankness has not come about in one year. The chorus girls are as they were, posing on the model stand and as reluctant with their secrets as though they were posing for Mr. Whalen in a Rothstein case investigation.

In spite of this, Mr. Kuhn achieved last year, and still maintains it, a definite place in American art. He must be included in any of the "twenty best Americans" that our new museums may decide to bring forward. A private collector who goes in for Americana cannot ignore him. This is a comfort-

lows more intricate paths in these two pictures than in most of his work, but he gives himself up to his fancy without reserve and records his findings with the precision of an early Dutch master. The vision and the execution is startling, even in a period that has grown used to Picasso's abstraction, but in the end both are equally authentic. The new Museum of Modern Art, therefore, should see that these works remain on this side.

The New York Sun, October 25, 1930

SUMMING UP WALT KUHN

THERE IS great embarrassment to the critic in the necessity that sometimes arises to blow hot and cold with one breath. A sharp repulsion from the work of an artist is unpleasant, but at least it is a distinct feeling that can be measured. A glowing enthusiasm is equally easy to put into words; but a "yes" and a "no" applied to the same thing are confusing to critic, reader and artist alike. The Walt Kuhn exhibition in the Marie Harriman Galleries puts me in this predicament. I shall wriggle out of it as best I may.

I have been for and against Mr. Kuhn during all his career, which now at last begins to be successful — from the selling point of view at least — so I suppose he scarcely numbers me among the most helpful of his friends — yet I would be one — to the very innermost limits of my conscience.

My earliest difficulty was a lack of patience with his long search for a style, which he thought to find in the paintings of others. I am always opposed to that. I hold that style should come about unconsciously and should result from a

rity that are now his, and sees no cause to interrupt them. He is not belligerent by nature anyhow. He goes out of his way to avoid the disputes of the argumentative.

One night, at dinner, during Matisse's recent visit to this country, I asked him what he thought of the new young crowd of artists in Paris? At once the barriers were up. He was loath to be drawn into such a debatable region as that. At the same time, he is far from being reticent, and in fact is a fluent and brilliant talker, and before long he was explaining that he was old and not a proper person to appraise the young people, and besides had lived so remote from the streams of modern influences that he was scarcely aware of the new tendencies, and as for this young Miró, and Matisse gave a shrug of his shoulders to indicate an unwillingness to be responsible in that direction. He went on charmingly excusing himself for some time before I interrupted him to say: "But you did mention the name Miró."

Matisse looked as though he had been caught in a trap. Then we both laughed and changed the subject.

Miró is represented permanently in the Gallery of Living Art by his "Dog Barking at the Moon," a picture that is a sure test of mental old age. Young people do not mind it at all, and some of them like it very much, but people who have settled upon fixed principles for their guidance during life are apt to shudder at the barking of this dog. It is a bit of mystic symbolism, however, that ought not to frighten anybody. It is weird, fantastic and likely to give you dreams, but that, after all, is one of the chief businesses of a picture.

The new pictures show that Miró has more dreams than one at his command. He is weird and uncanny practically always, but he speaks in beauty, as an artist should. His color is invariably rich and evocative. He has the faculty of making color do unexpected things and yet seem right. The big panel called "Portrait de la Fornarina" is strangely decorative in subdued colors, and has a far-off relationship to the grotesqueries of Aubrey Beardsley. If our collectors were persuaded that this work were by Beardsley it would not seem difficult at all. It is, it seems, after all, merely the new name "Miró" that is frightening.

Certain other pieces, such as the "Interieur Hollandais" and the "Pommes des Terres" are really more difficult, but on the other hand have more sting to them. Miró's fancy fol-

tion was secure — but in saying that I am merely guessing.

He is "both timid and bold," he says himself, when describing his inner life. "I had the nostalgic and naive sentiment of a little apprentice of the faubourg; I loved the ancient tunes and the Barbary organs of those times; I was not made to be so terrible as they all say." Almost the first line in his recently issued "Souvenirs Intimes" contains the assertion that the artist should not stiffen himself with worries, but should above all things, "live in inner peace, without trembling at realities." It is clear that Rouault always held to this, both in his painting and in his writings. The "Souvenirs Intimes," I should add, is a delightful book, not at all literary, but full of heroic sincerities that put faith into other artists as well.

The New York Sun, April 5, 1930

MIRÓ AND MATISSE

RETURNING VISITORS from Paris are always met with the question: "What is brewing now on the Left Bank?" and for ten years or so the answers have been confusing and evasive. Of late there has been a little clearing up of the mists. A few names get mentioned in addition to the everlasting Picasso, Braque and Matisse. A name that recurs oftener than most is that of Jean Miró, and now at last a lot of pictures signed with his name are shown in the Valentine Gallery; and we can attempt to see what it is all about.

Henri Matisse is one of those who mentioned the name, but apparently against his will. Matisse is now, of course, a definitely arrived personage. He has seen himself increasingly successful during many years. He enjoys the peace and secu-

this time who have undergone, the hardships and not the artist.

Before going on to say something about the man I must put in a word about the pictures, which are remarkable and quite capable of exciting the collectors into unseemly rivalries. There is something ferocious about them, and has been from the start. The very titles of the pictures indicate that the painter lives a terrific inner life that would naturally disable him in the contacts on the market place. Among them are these: "Qui dira j'ignore encore?" "Tu gagneras ton pain par le sueur de ton front," "Le Clown," "La Crucifixion" and "Le Déménagement au Château en Espagne."

The gloomy thoughts that so frequently overwhelmed Rouault were reflected in the palette and most of the pictures that we first saw were somber in the extreme. The feeling in them was genuine and profound, but tortured. To this day, even now that I am convinced of the man's essential genius, I am repelled as well as attracted by the early work. Fortunately something happened of a clarifying nature. Rouault loses nothing of his integrity — such a man couldn't — but he looks into the abysses of life as from a height. The light shines through his colors as though it came undiluted from the mountain tops. He has a blue, and a use of the blue, that is dazzling. It is so obviously comparable with stained glass that one longs to test it out, at Chartres, in the Sainte Chapelle, or at St. Denis. One imagines that it would hold its own, not only in color, but in massiveness of design.

When I said that Rouault was not to be pitied I did not mean to imply that he did not know what trouble was. Probably his early steps were sufficiently hazardous; or how else could he have so quickly seen that life was terrible as well as beautiful? But when I first heard of him, now many years since, he was already under the wing of Vollard. Vollard had launched the Cézanne cult and was guarding Rouault, it was said, and grooming him to be Cézanne's successor. Then it did not seem long until I heard that the artist had become conservator of the Gustave Moreau Museum in Paris. This job was one of those little sinecures that seem to fall so frequently, in Europe, into the right hands. Thus Rouault had sufficient income for his modest needs, and could paint when and as he pleased. It may be that the clear blue tones that are now so wonderful in the pictures, date from the moment his posi-

from the notion that the "Seated Odalisque" occupies an important place in his production; so we did not come into collision upon this point.

The New York Sun, March 8, 1930

ROUAULT

FOR MANY years Georges Rouault has been known to the few as a daring and original painter. By "the few," I mean collectors who lean in tendency toward the moderns. He was not, it was apparent at once, a painter who made concessions toward collectors, not even toward modern collectors. It could be suspected that, as a man, he was difficult. Nevertheless, he was given a sort of reluctant fame. Even so, he had to wait thirty-five years for his first one-man show, and that occurs now in New York in the Joseph Brummer Galleries.

In order to stave off at once the avalanche of sentimental correspondence that usually comes to me whenever I mention the case of a great painter who has had justice rendered to him only after death or too late in life to do him any fleshly good, I may say that this time there is no particular injustice, and that Georges Rouault is not to be pitied half so much as some of the rest of us. Georges Rouault is still in life, living quietly in the way he likes and in the manner best suited to his type of genius.

He could have had exhibitions forty times over had he wished, or had Vollard, his merchant, wished. Heavens, how difficult has it not been to see his work in the recent years and what ennuis have not the collectors undergone in order to obtain his paintings! Hardships? Believe me, it's the collectors

lips. He says he was quite unprepared for it, that photographs and the cinema had given him no idea of the wonders he was to see.

He arrived in the evening, in time to see the twinkling lights in the great downtown towers, and then went straightway to rooms that had been held for him on the thirty-first floor of one of our new great hotels. He said the next day that he had slept perfectly in the lifegiving, invigorating air of New York (the enthusiastic adjectives are all quoted from M. Matisse), but awoke at sunrise to "assist" in that magnificent spectacle. He would have been quite content, he said, to have spent the entire morning looking at the views from his windows, but friends arrived to take him sightseeing. To show how much he had reacted to the energy in the New York atmosphere M. Matisse added that before 8 o'clock he had breakfasted and written two letters.

The first visit was, naturally, to the Metropolitan Museum of Art, where the artist spent three hours. By special indulgence he was admitted to the preview of the great Havemeyer collection that had been arranged for the critics, and he was filled with admiration for what he saw. Later he was taken to see the typical show places, such as Wall Street, the Brooklyn Bridge, one of the great cinemas, Harlem and the theater crowds of Broadway at night. It was all "incredibly" interesting.

M. Matisse is in excellent health and spirits. It is ten years since my previous meeting with him and I could not see that he had changed in any particular. Naturally at this moment his chief interest lies in his present experiences and it is difficult to engage him upon the subject of his own work. I did try to sound him upon the always delicate theme as to which was his best painting to date, but we did not come to terms. In my opinion this picture is the "Seated Odalisque," which was shown here some years ago in the Valentine Gallery and which remains in the artist's possession.

He said he retained it, with several others, in order to remind himself of the path he had previously trod. He said he remembered the mood and the outward "face" of his pictures always, but that he occasionally liked to look again at the details of certain effects much as a novelist might reread some of his published books. He did not, however, positively dissent

readily seem "spooky." But it is tangible enough to those who would give it the same amount of attention that they would bestow upon any other form of expression. For my own part, I find the language so legible — I accept so easily its conventions — that when I first saw Miss Wilborg's *Seated Woman* I read realism into it, in addition to its marvelous design and color. There was a majestic spaciousness to the mysterious figure in the alcove that fed the mind exactly as fine music does; and could be as illy spared, once known, as the Fifth Symphony. However, I had had, as I have said, twenty years of preparation for this acquaintance.

Creative Art VI No 3 (March Supplement I) (1930)

MATISSE IN NEW YORK

THE MOST surprising event of this week has been the arrival of Henri Matisse, the great French modernist. This arrival was unheralded and unexpected. The artist, who had heard something of the prowess of New York reporters, had decided to travel incognito, but he was recognized on the Ile de France by some of his fellow passengers and the incognito was completely ruined. In consequence Mr. Matisse has been steadily entertained during the few days of his stay in New York. He is expected to leave today for Chicago, San Francisco, the South Seas and possibly a world tour.

M. Matisse has been enchanted by New York. He is one of the most enthusiastic visitors that the city has yet enchained. He finds words quite inadequate to express his astonishment, but "incredible" is the one most frequently on his

lieve that abstract art can be anything but trickery then you might as well go your way and give up the study. That is the rock on which we all split. The lady at the dinner party admitted that she could see nobility in handwriting irrespective of the words, that ancient Cufic script had undoubted handsomeness, that early Chinese painting had grandeur of style even when employed on subjects that meant nothing to her, but she refused to see handsomeness, power, or nobility in anything that Pablo Picasso did. There are other attirbutes to modern art but the ability to feel the abstract is the real test. An odd thing is that most objectors, in a vague way, feel that this form of art is impregnated with sin, and this, too, in spite of the fact that the most respectable critics who have ever flourished, including Walter Pater and Ruskin, have put themselves on record, and at considerable length, as yearning for a form of art that would have the purity and fluency of music. It is true, of course, that neither Pater nor Ruskin, could they have survived to this day, would have recognized his child of their dreams — or should we say grandchild? — for without the extraordinary educational forces of today, including that most persuasive one of all, The Movies, how could they have had the clue? Poor Ruskin stumbled even upon Whistler whose "art for art's sake" was in line with his own theories but whose application of it was "so unspeakably vulgar."

That it will go on forever is scarcely likely. No art movement ever does. But that it has been the ruling power in the art world for twenty years is enough in itself to give it historic significance. No artist who lives henceforth will be in ignorance of what can be done in abstract art nor will remain unaffected by it.

To bring this unavoidably repetitious essay to a close, I may add that modern art is a flower that came into full bloom in Paris where it seemed and still seems remarkably in accord with its habitat. It is exactly like all the other things that are going there, and by that, believe me, I do not mean "sin"; and fits in perfectly with the period. To middle-aged Americans not deeply interested in painting but suddenly confronted with such a defiant emanation as the recent "Painting In Paris" exhibition at the Modern Museum, the whole thing could

have 'faith'?" "Yes," said she, sweeping triumphantly on her way. (These new long gowns again permit the women to make effective exists.)

Still oppressed by this crushing defeat, I fear I can only half-heartedly attempt an answer to several inquiries that have come to me in regard to Miss Wilborg's *Seated Woman* by Picasso — the star picture in the recent show of French art at the Modern Museum. One of these writers, who enclosed a stamped envelope for reply mistaking me for a man of leisure, said that he was a young art-student and would like to know why it was that all the art-critics made such a fuss over the *Seated Woman* for he could see nothing in it at all. The surprising thing about this inquiry is that it came from a young person. As a rule young people do not have to be told about modern art. They understand it instinctively. A thousand things, including the very advertisements in the newspapers, have taught them its language. I took advantage of this fact rather slyly at the time of the Brancusi Trial. After the first session of the court, the then commissioner of customs asked Mr. Duchamp, Mr. Steichen and myself, all three of us being witnesses for the defense, into his private office for a confab. He was not the judge in the case, but for his own private satisfaction he wished to know why we thought the disputed *Bird In Flight* was a work of art. He quite evidently accepted Mr. Duchamp, Mr. Steichen and myself as honest men but failed to follow us in our admiration for Brancusi's carvings. In the little talk we had, he mentioned that his daughter was an art-student. That was the point I seized on. I told him I was willing to wager that his daughter would be sympathetic to Brancusi's work simply because she was young. This commissioner died before the verdict for Brancusi was reached and so I never saw him again to learn if he had an "art insurgent" in his own family though I still think it likely in spite of the apparition of this new young unbelieving correspondent of mine.

To him, I would say, that the whole thing depends upon your attitude toward abstract art. If you can conceive that a noble or a forceful or in fact any kind of a personality can be expressed in abstract art then you are in need of no explanations from anyone. If you violently and flatly refuse to be-

Not the type, you would think, since she was unquestionably American, that would go in heavily for art of any kind, but she said again, seeing my hesitation: "Do tell me about modern art. I so want to know."

There seemed no way out of it, so I told her. I did my best. I had at first no great enthusiasm for my task, for it seemed a bit hard at this late date to have to tell anyone about a movement that had already been so well advertised. Twenty years ago I used to begin each review of each new artist as he came along, with a description of what he was attempting to do – but that was twenty years ago. One hates to stick always at the same point and to remain always at the beginnings of things, and if new inquirers happen along one is tempted to abandon them to the new writers, and to confine oneself to the initiated, to presume upon a few readers who know their abc's. In social intercourse I more or less follow the same plan and avoid altercatious academicians and sidestep "explanatory" conversations. But in this case I was in for it. And my neighbor proved to be a disputant. Practically everything I said met with a counterstatement. Early in the dinner she said: "But modern art is so unspeakably vulgar," and shortly after that she queried: "But don't you then care at all for Beauty?" We were in the middle of the fish course. There was an enticing arrangement of shad but the bones were still in it and had to be attended to. Nevertheless I managed to insist that I did care for Beauty (we both said it with a big B) but I didn't go so far as to say that the vulgarity in modern art was entirely in the eye of the beholder. I wanted to say this but I didn't quite dare. Instead I trotted out all my favorite theories about the imperious necessity of each generation to discover its own formula of expression – about the wonders of present-day life, especially here in marvelous New York, and the total inadequacy of Grecian or early-Florentine systems to compass the tumultuous mental experiences we were now undergoing but all this was without avail. The more I talked the more "set" and adamantine did my neighbor's face become. Finally the hostess gave the signal for the ladies to depart, for an interval, to a smoking room of their own, and as my companion arose she said, acridly: "It all sounds to me like the arguments that spiritualists use who wish to convert you to their belief." "You mean, you must

sin and virtue and are not yet certain which way they are
going; and finally there is the great "Parsifal!" cross posed
blackly and ponderously against a sky of molten crimsons and
vermilions, and with purple velvet mountains in the distance.
The mind pauses in contemplation of this picture. In fact,
it is distinctly not for the mind but for the "subconscious."
A gallery is no place for it. It ought to be viewed in church.
I should like Mae West to see it. It can only be properly
understood, one feels, by someone who knows life thoroughly.
On second thought I should like Mae West not to see it. It
might disarrange her views of play-writing — which would be
a public calamity. But one yearns instinctively to see this
picture do its work, just as one turns occasionally at the opera
to see the thought of the proffered forgiveness for too much
knowledge stealing over the wrought-up Wagnerians.

The New York Sun, January 8, 1930

MODERN ART

SOME PEOPLE would rather argue than eat. As for me I am
precisely the contrary. Occasionally one is obliged to combine
the two activities. Quite recently an energetic hostess, seating
her guests at the dinner table, mentioned to the lady who was
to sit next to me that I was one who could "tell her all about
modern art," and the lady in question dutifully said: "Oh, yes,
do tell me." I stole a look at her. She appeared to be serious.
In fact, she was evidently a serious lady, with a clearly chis-
eled face and grim lines to the lips that indicated she had
definite and decided views upon life and all that concerned it.

These matters are to be observed in the new Stieglitz Galleries, which have lately been housing the Marin water colors. The piercingly white walls of the new rooms, which so became the Marins, are not so fortunate for the O'Keeffes. They do not interfere with the new pieties of the artist, though they frustrate appreciably a work that I saw a few weeks ago in another place and which I then thought a chef-d'oeuvre of mysticism. I can go into that later, perhaps, but new religions, of course, come under the head of "news" and take precedence over everything else. Hence, like Georgia O'Keeffe herself, we must take up the crosses.

"Any one who doesn't feel the crosses," said Miss O'Keeffe, whom I fortunately encountered at the private view, "simply doesn't get that country." This reminds one of Maurice Barrès, who began his "Du Sang, de la Volupté et la Mort" with the statement that anyone who had once glanced at the forbidding, sunsered banks of the Tagus at Toledo had no need for the philosophies of Pascal. So much is brought back to us of the frivolities of the tourist colony at Taos, so much is said of the added pulse-beats that are caused by the high-powered ozones of that locality, that it is intellectually thrilling to find Miss O'Keeffe adopting so quickly the Spanish idea that where life manifests itself in greatest ebullience there too is death most formidable.

Her "Crosses" are something less and something more than painting. It is the fashion of the moment in critical circles to say that Miss O'Keeffe doesn't paint, but this is the subtlest compliment imaginable, since it is incontestable that she has her way with her public. None of the devoted band would think for a moment of inquiring whether Derain also painted like that, or whether anything in Matisse justified Miss O'Keeffe's methods. It suffices for them that they get the vibrations. Some of them will be cured of their lumbagoes and arthritic knees at this show — or I miss my guess completely. Since that cemetery in Massachusetts was closed by the police this new exhibition will be the only place of pilgrimage remaining open for business.

The "Crosses" run through several sets of chromatics and emotions. There is the "St. Francis of Assisi" in pale blues and turquoise, for those who have given over the world completely and live or attempt to live on the spiritual heights. There are several crosses for those who have dabbled slightly both in

Metropolitan Museum. From a bulletin issued by the new society the following excerpt may be taken as a reply to the query:

"Experience has shown that the best way of giving to modern art a fair representation is to establish a gallery devoted frankly to the work of artists who most truly reflect the taste, feeling and tendencies of the day. The Louvre, the National Gallery of England and the Kaiser Friedrich Museum, to mention only three national museums, follow a policy similar to that of our Metropolitan. But they are comparatively free of criticism because there are in Paris, London and Berlin – in addition to and distinct from these great historical collections – museums devoted entirely to the exhibition of modern art. There can be no rivalry between these institutions because they supplement each other and are at times in close cooperation. The Museum of Modern Art will in no way conflict with the Metropolitan Museum of Art, but will seek rather to supplement the older institution."

The New York Sun, November, 9, 1929

O'KEEFFE IN TAOS

GEORGIA O'KEEFFE went to Taos, New Mexico, to visit Mabel Dodge and spent most of the summer down there. Naturally something would come from such a contact as that. But not what you would think. Religion came of it. Georgia O'Keeffe got religion. What Mabel Dodge got I have not yet heard. But Georgia O'Keeffe painted a series of canvases with enormous crosses booming across ascetic landscapes. Some of them black crosses!

Art and to the first of its exhibitions, now open in its temporary galleries in the Heckscher Building, at Fifty-seventh street and Fifth avenue. This enterprise, so long and so devoutly wished, is so large in its promises and so positive in its present attainments, that it seems to have come full-blown upon us over night. It truly makes us rub our eyes now that we have gone such a journey to see that we have arrived at the destination.

And the exhibition itself is so incontestably serious and so impressively alive that the astonishment will now be general that so many fences had been erected to keep this art from the public. What was the insidious danger of it twenty years ago, or even ten years ago? Nothing other than that, that it was alive. The Philistine dwells in formulas, and formulas apply to the past, and that is why, I suppose, the born Philistine is always at sea when brought face to face with the art of the present.

The new museum wisely chose to give its first exhibition to the works of the four pillars of the modern movement, Cézanne, Seurat, Van Gogh and Gauguin, and by each of these artists it does nobly. It is not an exaggeration to say that no such showing of modern art has hitherto been made in America. The paintings fortify each other. Some of the most important of them, such as the Cézanne self-portrait from the Phillips Memorial Gallery, the still life of the Chester Dales and the still life anonymously loaned, have previously been shown, but never to such advantage as on the present occasion, when practically every item on the walls emanates greatness.

Seurat and Van Gogh, however, are the two painters who get increased auras out of the event, for both have been ill-understood in America, and both are now beautifully represented. The landscapes of both men are particularly revealing. We have known how to take the rugged Van Gogh figure pieces such as the "Facteur Roulin" and "La Mousme," but it is a fresh astonishment to come upon such an essay in pure music as "The Ravine," lent by Keith McLeod of Boston. In the same way, we have already been prepared for the endiablée "Parade" by Seurat, which the Knoedlers lend, but gaze with all eyes upon the sure serenity of such landscapes as the "Lighthouse at Honfleur."

From the moment the Museum of Modern Art loomed upon the horizon the question has recurred at intervals as to the possibility of collision between the new institution and the

OPENING OF THE

MUSEUM OF MODERN ART

HISTORY AT times makes the effect of being swift and inexorable. A thought comes to a man of genius that seems to give a new color, a new aspect to life. Just because it requires the spectator to make a readjustment in his point of view, to listen searchingly with his ears to a new set of harmonies, to seek confirmation with his eyes for the new color combinations, the lazy and above all things comfortable Old World, denies at once the truth of the new thought and very often succeeds in destroying the discoverer physically.

Then all at once without anything apparently having happened a change comes over the scene. The bones of Edgar Allan Poe, Paul Cézanne, Charles Baudelaire or whoever it happens to be, are disinterred and put in consecrated ground. People actually whisper prayers for the repose of the souls they had been trying to damn but a short time before. Léon Daudet now says that the "Fleurs du Mal," which was reviled as heartily at the time of its first appearance as anything ever written, represents the summit of the French spirit, and Vollard, the champion of Cézanne, takes a pride in the insults that were hurled at his hero, and gives up perhaps too large a chapter in his biography to recounting them.

In reality, of course, these characteristic reversals of public opinion are not so quick — they only seem quick. All the time quiet forces had been busy sowing the seed of the new opinion, usually in the minds of the younger generation, and in reality it is the coming of age of these young people and their prompt usurpation of the world, that convicts their predecessors of sin and gives the effect of inexorable judgment upon them already mentioned. Even in these swiftly moving times it still requires two decades before the harvest of new poesy and art can be reaped.

These ideas, not so free from smugness as I could wish, apply equally to the institution of the new Museum of Modern

258

tempted to quote an exceedingly apt passage from a book that has recently come to hand. It is the tenth-century Pillow-Book of Sei Shonagon which Mr. Arthur Waley has newly translated as a pendant to Lady Murasaki's marvellous Tale of Genji, of the same period. Many readers have wondered why it was that of this great age in Japan there were but these two women authorities. Mr. Waley answers the question thus:

"As far as the production of literature went, women did not, in fact, enjoy so complete a monopoly as European accounts of the period would suggest. But convention obliged men to write in Chinese, and not merely to use the Chinese language, but to compose essays and poems the whole attitude and content of which were derived from China. It may be objected that a potentially great writer would not have submitted to these restrictions — that he would have broken out into the vernacular, like Dante or Paracelsus. But this is to demand that a literary genius should also possess the many qualities essential to a successful reformer. The use of the native kana (the only form of character in which the Japanese language could be written with reasonable facility) was considered unmanly, and to use it would have made a writer as self-conscious as a London clubman would feel if he were to walk down Bond Street in skirts."

This statement ought to be sufficient in itself, I think, to fetch all the truant artists home from foreign parts. Of course, the moment the facts in it are digested there will be a cry of exceptions, but to them I shall reply, as before, that the times have changed. The only exception I make myself is in favour of Miss Stein and that is partly because she dates from that different period of before the war. But even she, I understand, is coming home. Young Mr. Virgil Thomson who has made an opera from one of her poems, The Four Saints In Three Acts, and who has been enchanting us lately with extracts from it, hopes to get the whole work performed in New York, and if he succeeds, he has Miss Stein's word, he says, that she will come on for the première. In that case the entire prop of the European invasion will have been withdrawn; and obviously, the riff-raff had better scuttle home at once before that disaster occurs; for if Miss Stein once gets here, believe me, she'll stay. She's too great an artist to be able to resist us.

The Dial, April 1929

but, and mark this, the doles were less in quantity than ever before, and more begrudgingly given. It was not the critics' fault, I do assure you. They covered up the nakedness of the stricken exiles as long as they consistently could, but the public itself, enraptured almost to the point of ecstasy with its new sense of world-authority has grown intolerant of diluted patriotism. "American artists who live in France"; the very phrase is condemnation. A fiat seems to have gone forth. At any rate cold shoulders in solid phalanges were turned in succession this year on the works of William Yarrow, Marsden Hartley, Paul Burlin, Guy Pène du Bois, Leon Kroll, and a long list of other expatriates.

The times, as a matter of fact, have changed. There is no longer the necessity (if there ever was) to study art abroad. The African savages whose carvings M. Paul Guillaume now sells for such exalted prices did not form themselves in Montmartre. Nor did Hokusai and Korin of Japan. Art is not a cloak that an artist borrows from someone else but a fabric he improvises for himself. I wish to make no rules. I know that at times strange distillations go to the making of a style but the younger Americans in search of one are herewith gratuitously advised that the chances of acquiring one in cosmopolitanism are noticeably less than they were a generation ago. The reason for this, to put it in a nutshell, is that the centre of the world has shifted. Paris is no longer the capital of Cosmopolis. All the intelligence of the world is focused on New York; it has become the battleground of modern civilization; all the roads now lead in this direction, and all the world knows this save the misguided artists who are jeopardizing their careers for the dubious consommations of the Café de la Rotonde.

As this is above all others the place of destiny, it follows that those who absent themselves from it, do it merely for reasons of self-indulgence. Indeed all the sinners whom I met in person this winter confessed as much. "We had a charming, eigteenth-century villa in the south of France, with two servants, for fifty dollars a month." "I must have wine. I won't live in a country where you are obliged to bootleg for it." Variations on those two themes were encountered ad lib. One man actually said, "I married a wife and my wife loves Italy." Comment on such remarks, you will agree, is almost superfluous. What is to be gained by talking sense to people who have already compromised with it to that extent? Nevertheless, I am

AMERICAN EXPATRIATES IN PARIS

ARTHUR SYMONDS once defined vulgarity as the state of un-regenerateness that prevails in the social circle immediately below your own; and by the same token sin may also be defined, I should think, as that state of morality that is immediately below your own. At any rate, just because I have gone abroad myself at intervals, I shall not be deterred from shying a stone at those others who go abroad too often and stay too long when they do go. Whizzing around the corner of the Boul' Raspail into the Boul' Montparnasse one evening last summer on my way to a dinner engagement I was thoroughly scandalized at the size of the student mob that crowded the sidewalks, the roadway, and in fact all the intervening space between the two notorious cafés that face each other at that point. It was not a fête-day nor anything of that sort but just a plain Saturday night, yet five hundred or more young people – my countrymen, I could see, in spite of the speed of the taxi – hovered about the spot waiting to seize upon any chair that might be vacated upon the densely populated terrasse. The effect, to the aroused moralist in the taxi, was that of a swarm of weak-willed insects drawn to a trap craftily baited with poisoned sugar. "Fools," cried he to the night air, "don't they know that one taste of that stuff is death? Won't somebody tell 'em?" but at that moment the taxi drew up to Miss Stein's door, and the general good cheer, including the extraordinarily good food, that Gertrude always knows how to provide, dissipated, for the moment, the hastily formed intention of shooing all those insects back to America where they belonged, and where, whether they knew it or not, they would have been so much better off.

That frustrated intention has recurred to mind often enough since then. One by one the cigales recollected that there was not un seul petit morceau de mouche ou de vermisseau in the larder and came knocking at the door of America petitioning supplies. There has been a constant stream of them all winter long. Doles have been handed out, it is true – for no one had quite the cruelty to say "Eh bien! dansez" –

1929–1938

the younger French modernists of my acquaintance if he agreed that Miró were great and I got a dubious and unconvinced shrug of the shoulders by way of reply. After a moment of reflection, however, my friend twinkled his eyes and said, "Well, I must admit that there is something great about that Dog Barking at the Moon."

M. Pierre, when showing me a big Miró canvas which divided itself practically into two bold tones of red and was called A Landscape, said — seeing that I was impressed and would probably stand for it — "It has the feeling of Rousseau's Egyptienne." I did stand for it. I really thought so too. This landscape has the same mysterious spooky quality that made the Henri Rousseau evocation so thrilling. Later I was shown another large canvas that had been touched in with the same spectral brushes. There was something that looked like a dog, too, in this composition and that helped me to realize how effective the Dog Barking at the Moon must be. "Very like a whale," I suppose you'll be saying if you are sceptical of all this. M. Miró, in truth, does very little for the dog that appears so frequently to him in dreams. The new art, you understand, is simple. It is almost like a Caran d'Ache dog, or like one of those stylized toy animals that advanced parents now give to their children. But all the same, the symbol has the power of something genuinely imagined and is painted as though to the order of Don Quixote himself. Accepting definitely three such pictures as these mentioned is something, and so I now feel committed to M. Miró.

The Dial, December 1928

I did not meet the young man though. M. Miró had him-
self felt the inclination to travel and had hied himself to his
native Spain. I very seldom meet the artists. I prefer not to.
They sometimes are so personally fascinating that they preju-
dice you in favour of their works and that complicates things.
Two of M. Miró's works, on the other hand prejudiced me in
favour of *him*. No matter what he might be like — and I heard
he was odd — the two pictures had answered my question and
I knew that the artist was worthy of bother. They were at the
new gallery, Pierre's, on the rue de Seine. They were not for
sale. (Instantly I had decided that either or both pictures
would do admirably for the New York Luxembourg, a mythical
institution for which, in my mind's eye, I am always making
purchases.) But they were not for sale. They were to adorn
M. Pierre's private collection, or the artist's own private collec-
tion, I forget which. That is the latest thing in Paris! The deal-
ers have become collectors. All the desirable objects of art are
not for sale. It is certainly the case, and with a vengeance, at
M. Paul Guillaume's. M. Guillaume looks positively offended if
you ask a price. It almost seems to be superfluous, under the new
system, to have a gallery. I have a vague notion, for instance,
that there were pictures at M. Paul Guillaume's gallery on
the rise de la Boëtie but recollect perfectly all the masterpieces
of the private collection and can even tell you their positions
on the walls if you insist upon it. I remember *them* very pre-
cisely. One of the members of New York's advance-guard was
calling upon Guillaume while I was there, and agreed with me
in thinking the collection excellently representative of the push
and urge of current feeling and that it would be a handsome
act upon the part of somebody to acquire the whole thing for
New York. When one or other of us voiced this opinion to
M. Guillaume he smiled at us incredulously and unhumor-
ously. The pictures, it seemed, were not for sale. Nevertheless
some people do seem to know how to get things away from
French dealers, even under the new system. I myself have
great faith in the efficacy of prayer. I pray, for instance, for
the two big Mirós to come to the Gallery of Living Art, or at
least to some New York collection, and preferably a public one.
For the three big Mirós, I should say, for there is another one,
The Dog Barking at the Moon, which I have only seen in photo
but which I am now persuaded is also swell. Before going
down the crooked little rue de Seine to Pierre's I asked one of

is sure to be a desire for a memorial exhibition of the dead artist's work, and this must be consummated. So many of his best things have been sequestered for years in private collections that the mere bringing together publicly of all of his work will do much toward clarifying opinion in regard to it.

Another phase of the man that makes his untimely cutting off regrettable was his unmistakable gift for connoisseurship. His instinct for the talents of others was truly remarkable. It was he more than any other who was responsible for the amazing success of the famous Armory Show of modern art, and he lived to see many of his early and daring judgments confirmed by the best minds of the world. He was an inveterate collector himself, and aided many of his friends to collect. Altogether he was a great power in the modern world, and it is impossible to think of any moving factor behind the scenes – for it was characteristic of him that his most important moves were secret – who could be so illy spared.

The New York Sun, December 22, 1928

M I R Ó

THE CHIEF question on my mind when sailing for France last summer was that of Miró. Was he worth bothering about? No other name, during the winter, had come across the seas with such insistence, and nothing came across with the name – no pictures. If he really were worth bothering about it would be necessary, it seemed, to make another of those fatiguing trips to Paris in order to do it there. A traversée "was clearly indicated," as the fortune-tellers say, and so, being essentially dutiful, I went.

denly turned upon him point blank and said, "How do." Mr.
Davies gave an effect of being awakened from a dream, but a
pleased look crossed his face. He held out his hand and began
at once to talk. Finally his talk became so enthusiastic that it
practically resolved into a monologue upon his part. When we
reached the chapel he said, "Let's sit together, will you?" and
I said, "Of course." Going up the aisle he talked, and all the
while we sat there in the otherwise silent chapel, and even
after the priest began reading the service for the dead, he
talked. I believe I was finally reduced to saying "Ssh." It really
seemed as though some hidden spring in his personality had to
be touched before he could communicate with his fellow men,
and when once started another secret spring had to be touched
to shut him off.

Such mannerisms are easily explained in modern psy-
chology. Davies's brain teemed with ideas and he wished to
give himself up to realizing them. Society, on the other hand,
seems specially organized at present to come between the
artist and his work. Too much friendship can be just as fatal
to self-expression as anything else. The similarity of the Davies
"case" and the frantic search by Eugene O'Neill for repose in
Shanghai, China, must be noted. It begins to be apparent that
we must establish asylums for our great producing talents.

Davies certainly was a great producer. It was his fecun-
dity, in fact, that sometimes made me doubt him. No man, I
am persuaded, can produce several thousand masterpieces.
He was always pleasing, always had a definite thought and
never was perfunctory. But I used to find it difficult when
arguing for him to those who were as yet unconvinced of his
talent to fix upon a definite canvas that summed up his genius.
I always required half a dozen, or even a dozen, paintings
to evoke the Davies idea. So many of the early, pleasing can-
vases contained a flash of a poetic thought but not the com-
plete expression of it. The effect was that of a study of a paint-
ing rather than the painting itself.

When the series devoted to the glories of the California
scene arrived this reproach was hushed. They were certainly
complete, poetic and important. To this day I suspect them to
be of Davies's best. It is too soon, of course, to try to make up
posterity's mind in regard to Davies, and, anyway, posterity
has a trick of making up its mind for itself. But Davies cer-
tainly secured a definite place. Under the circumstances there

DEATH OF ARTHUR B. DAVIES

THE NEWS of the death of Arthur B. Davies last October in a remote mountain district of Italy shocked the entire art world inexpressibly. That so prominent an artist could die unnoticed and alone anywhere on earth seemed more than strange to those unacquainted with the man: but not so strange to those who knew him. The fact is that of late he had become excessively furtive. Expansive enough, probably, with a few chosen intimates, nevertheless he increasingly dreaded contacts with the public at large.

I began to notice the trait at least ten years ago. Having written reams of commendation of the artist's work in the early stages of his career, I had a moment's surprise on encountering Davies in an art gallery and noticing that he palpably avoided me. I supposed I had inadvertently given offense, but when I mentioned the episode to a mutual friend my explanation of it was discounted. "Oh, no," said my friend. "There are times when he simply doesn't care to meet any one."

Being somewhat furtive myself I was quite willing to humor the quality in others, so after that, when chancing upon Davies in the galleries about town, I pretended not to notice him. Almost invariably on such occasions, after realizing that I had no intention of attacking him with talk, he would relent and would edge up to me, and at first shyly and stiffly, and afterward very frankly, converse at length.

My most curious experience with him occurred only last winter. Intending to go uptown to attend the funeral of the late Frederick James Gregg, I boarded a crowded subway train. The only vacant seat, I saw at a glance, was next to Arthur Davies, who sat there most unseeingly. He gave no indication of recognizing me, but I noticed that the irises of his eyes had dwindled to pin-points, as they do often in neurotics who are undergoing strain. Without any ado I took the seat and we both sat there stiffly for a moment or two.

Knowing that it was up to me to break the silence I sud-

for instance, has ever read a tabloid, yet in public gatherings we cannot escape catching glimpses of the headlines, can we? Consequently, "Here y'are. Read about yer red hot popper caught in love queen's kiss nest," doesn't seem so much of an exaggeration as it should. And the movie actors! What does not Mr. Arno do to them? There is a study of an impassioned love scene – in a bed, of course – with the hardest boiled of directors shouting "Feel-thee pictures," to the scared hero and heroine whilst a bunch of repellent camera men hover within arm's length for the "close-up." So cruel an exposure of the new art's technic would finish it as a business, one would think, in any other age than this.

Consequently, since we seem to be convicted of sin, shall we droop our heads in shame? No, hardly that. Sin, it appears, is fashionable. That's this artist's great discovery. And since fashion in America has more of the wherewithal to expend upon its draperies than it has anywhere else on earth, it follows that the mise-en-scene that Mr. Arno so faithfully records is the envy of those former citadels of chic that line the banks of the Thames and the Seine. London and Paris at last are copying us and since there is an undoubted exhilaration in escaping from provincialism after all these years of thralldom to it, why should we worry, even though our moralities, for the moment, be slightly askew?

As for the drawings, as drawings; – make no mistake; they are masterly. Peter Arno is our Constantin Guys; a Guys with a dynamic touch, and a wider range of outlook. His collection makes a superb effect, so fresh and vigorous it is. If nothing else, of so memorable a nature occurs this year, at least we shall be grateful to a season that permitted us to make our salaams to Peter Arno.

The New York Sun, December 15, 1928

Valentine Gallery, to be precise. They'll probably now be finding out his real name, too; for it has been whispered about for some time that in reality he is a member of the genuine haute noblesse who disguised himself as "Peter Arno" in order to evade issues with the Soviets who are increasingly prevalent, it is also said, in our midst.

But be that as it may, there can be no doubt but that he is the darling child of this period. He made this a period, some think, and probably they are right. We didn't know ourselves until he came along and stamped the hall mark "New Yorker," upon all the new types we have created and which are to give the age a distinct claim upon posterity. Now we see "Peter Arno" every time we take a stroll on Park avenue, and certainly every time we go out to dinner.

Only last night in a house the most respectable of the respectables, the lady on my left was bemoaning the treachery of her bootlegger upon the occasion of the coming-out party for her niece. The champagne didn't arrive. At the last moment a charitable neighbor supplied them with the miserable half dozen cases that they happened to have – a pathetically inadequate amount, naturally.

What was to be done? As it was a young people's party the hostess decided to take a chance. She commanded a champagne punch, mixing the real thing with White Rock or other effervescing fluids, and though she said she heard no actual complaints, there was certainly a marked lack of the inebriety that distinguishes a really successful coming-out party in these days.

That, of course, was Peter Arno stuff, though he, being a genius, would have expressed in three bold words what I have to mumble in a long paragraph. Even the little children in the Peter Arno drawings utter bold words. "By gad, officer, you'll answer for this," cries the small tot being ordered off the grass in Central Park by a policeman. By the time you reach the misses' age the tone becomes still more emancipated. "I'm sorry the Mater's out, Mrs. Marshall," remarks a young person to an immense dowager who has penetrated into the reception room of a gaudy modern mansion, "Shall I tell her you barged in?"

When Mr. Arno turns his relentless eye upon us adults then incredible things happen. That is, they would be incredible if we could disprove them; which we can't. None of us,

still enchained in Paris. These contain the splashes, if you will, but also an undeniable mystic quality. One of them that attracted much attention was called "The Dog Barking at the Moon." The moon was not precisely the literal moon and the dog was far from being a literal dog, but the two together exerted a powerful effect comparable to that that would envelop scientists who had just received an authentic message from Mars.

Any work from such an innovator would, in consequence, be worthy of study, but "The Signature" by Miró, which is now being shown by the Gallery of Living Art, at the New York University Building on Washington Square, happens to be the most significant of his paintings, after the "Dog Barking at the Moon" and the "Spanish Landscape."

It is really difficult. It will be mentally accessible, I fear, only to those who lean readily toward the mystical. It is cabalistic. It looks, at first glance, like the writings upon a cobalt canvas of a particularly lazy Indian. But the laziest Indian never paints a picture without putting himself in communion with the unseen powers, and so it is with Miró. There is more to be discerned in his work upon acquaintance; and it is fortunate to be able to make this acquaintance in the first flush of the artist's contact with the world.

The New York Sun, December 8, 1928

PETER ARNO

THE INEVITABLE has happened. Peter Arno has been discovered by the high brows. There is an exhibition of his original drawings in a bona-fide, Fifty-seventh street gallery — the

MIRÓ

THERE ARE certain art lovers who suffer, rather than encourage, art to progress, and one of these who has at last, though somewhat painfully, adjusted himself to present-day manifestations, permitted himself to say the other day that now that he understood it modern art was not so bad, but he was glad just the same that the worst was over and that art connoisseurs had reached a period of comparative calm.

It depends upon what you mean by "worst." I took it that what my friend really meant by the word was "difficult." In that sense, we are by no means over the worst. There is never any rest for the dilletante. There are always new phases popping up, and the new phases are always difficult.

Take the art of Joan Miró, for instance. It is something to be considered just because so much consideration has already been given to it in France. He is probably the most outstanding of the present group of rebels in Paris. The young people praise him extravagantly, and the old people, who have already stood an awful lot from the young people, positively refuse to go to Pierre's, where the Mirós are to be seen, at all. There, of course, they are wrong. Everything should be given a chance.

Miró is a Surrealist. That is to say, he disdains realism. He has certainly written over the door of his studio the word "Whim"; which, you recollect, is the word that Emerson wished to write over the door of his library. He gives full sway to his pencil and carte blanche to his soul. He must sometimes, when he has recovered from the trances in which he paints, be vastly surprised himself at what he has achieved. The paint pots which Whistler emptied into the faces of his public are simply nothing to the splashing effects of which Miró is capable.

Sometimes there is the splash and not much besides. The terrific gesture alone contents Miró's young friends. The great world, however insists upon more than gesture. It demands the goods. These, it begins to be apparent, it has discovered in two or three enormous paintings by the young artist, which are

HENRY MCBRIDE BY HIS PEERS

SOME OF HENRY MCBRIDE'S FAVORITES

1 Marcel Duchamp: Nude Descending a Staircase, oil, 1912
 Courtesy: Philadelphia Museum of Art, Arensberg Collection

2 Florine Stettheimer: Cathedrals of Fifth Avenue, oil, ca. 1921
 Courtesy: Whitney Museum of American Art, New York

3 George Bellows: Gramercy Park, oil
 Courtesy: Mrs. Leonard Franklin McCollum

4 George Bellows: Stag at Sharkey's, oil, 1916
 Courtesy: Philadelphia Museum of Art, Gift of Mr. and Mrs.
 George Sharp Munson

5 Charles Demuth: Nana Seated Left, and Satin at Laura's
 Restaurant, watercolor, 1916
 Courtesy: Museum of Modern Art, New York

6 Charles Demuth: Modern Conveniences, watercolor
 Courtesy: Museum of Modern Art, New York

7 Gaston Lachaise: John Marin, plaster
 Existence and ownership in question

8 Gaston Lachaise: Nude, pencil drawing
 Courtesy: Whitney Museum of American Art, New York

9 Gaston Lachaise: Nude, pencil drawing
 Courtesy: The Lachaise Foundation, Boston

10 Louis Eilshemius: War, oil
 Present ownership unknown

11 Charles Burchfield: Ice Glare, watercolor, 1933
 Courtesy: Whitney Museum of American Art, New York

12 Albert Pinkham Ryder: Jonah, oil, ca. 1885
 Courtesy: National Collection of Fine Arts, Smithsonian
 Institution, Washington, D.C.

39

38

36

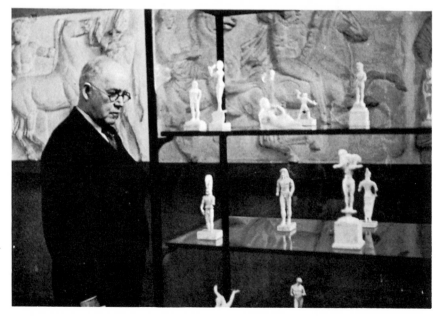

37

May 9 V.S.T. NYC

35

Henry McBride

33

34

31

32

28/29

30

26

27

24

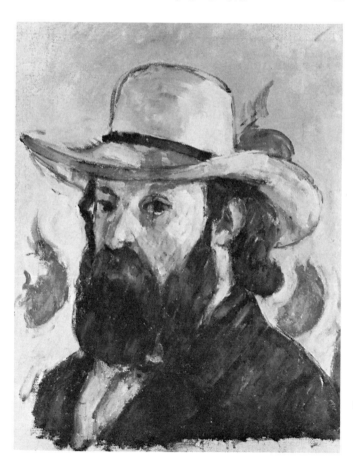

25

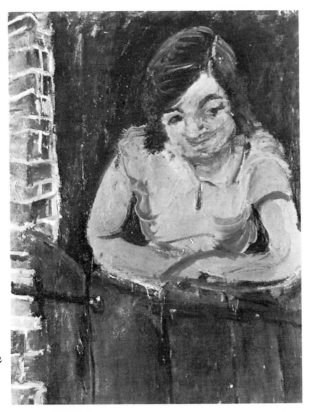

22

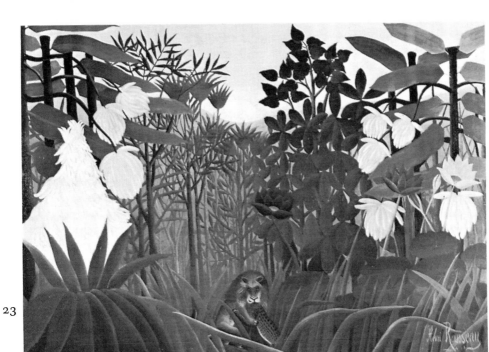

23

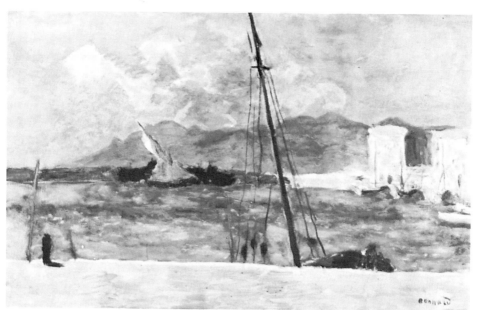

20

21

18

19

17

16

15

14

12

13

10

11

7

8

9

5

6

3

4

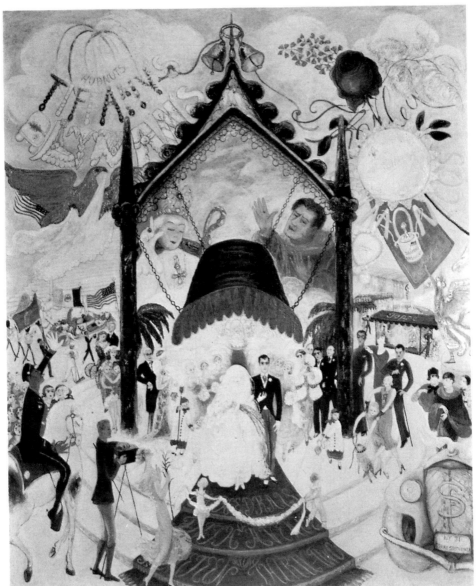

2

I

two or three sittings there was a definite character indicated. Oh, very heroic. But very heroic. Mussolini! Yes! Even more so. I had moments of compunction, feeling perhaps I was taking an unfair advantage of the sculptor. I thought of confessing that I was not, habitually, a Mussolini. Then I remembered Walt Whitman and decided to keep mum. Even so, I felt I ought to die at once before the truth came out. Besides, I argued, I *am* a hero — at times. I am one of those persons who when alone in their sanctums are unafraid of the truth. In public it may be a different matter. Face to face with one of those artists who have the bad taste to haunt their own one-man exhibitions, I have been known to reply to his enquiry with a "Yes, very interesting indeed," and then rush right home and scribble a review beginning with "These are positively the world's worst pictures."

But I did not die at once. Heroism for heroism I had not quite enough for that. The sittings went on. On certain days the green wax appeared to remain stationary. At other times the sculptor flung himself furiously at the work just as sculptors do in novels and in the autobiography of Benvenuto which is practically a novel. After one of these paroxysms, rather more prolonged than usual, Lachaise, in a small voice and almost apologetically, said, "Well, it is finished. I won't do any more," and I took a look. Mussolini had vanished almost completely! There was still a faint trace of him. But the subconscious part of Lachaise, the part that does the work, evidently thought I was but a modified form of hero. Well, I hastily decided, it was perhaps just as well. It would be fatiguing, at my time of life, to try to outshine Mussolini. Also, there were compensations. I was more refined than he. Refined and at the same time chastened. The refinement was due, no doubt, to suffering. I was glad to see that I had got something, after all, from what I had gone through. That person in the green wax might weep but he would march straight through to Calvary, nevertheless. Not totally unlike the famous Judd so recently and rightly electrocuted by the State authorities at Sing Sing. But refined! That was the main thing. On the whole I thought I came out of it very well. I was quite content with my experience as a poseur. I will recommend the idea, henceforth, with more courage to others.

The Dial, March 1928

McBRIDE'S PORTRAIT BY LACHAISE

THAT I AM not myself a person to flinch at the word "vain-glory" is proved sufficiently by the fact that I did pose for a portrait by Gaston Lachaise, the sculptor. When Lachaise first suggested the idea I said what I honestly thought, that it couldn't be done, that I was not a type for artists, that never in my life had a painter wished to do me, and that I was enough of an artist myself to see precisely why they didn't. I was wrong, Lachaise insisted, looking at me with that curiously appraising glance that is so disconcerting to some people, "there was something," he had felt it for some time, he knew definitely what he wished to do, et cetera, and in short – to boil the argument of half an hour into one sentence – I finally consented. This was last spring, at the close of the season, when all New Yorkers and especially the critics who had been compelled to study thirty to forty thousand pictures during the winter, were at the lowest ebb of vitality. If posterity were to peep at one, one might have preferred another moment. One might have been more there in the autumn, for instance. "But after all," I reflected, mounting waves of satisfaction completely engulfing me, "the affair is Lachaise's, not mine. Why should a mere sitter choose the moment, or choose the pose, or choose anything," and I remembered the famous nonchalance of Walt Whitman when getting photographed, and his explanation that he never "dressed up" for portraits and that their invariable success was due to his refusal to be fussed by a camera; and I resolved to keep calm.

So the posing began. It was very pleasant. There was something peculiarly soothing in the thought that Lachaise had it to do and not I. Lachaise "had been studying me for some time." He had "an idea of me." Gained from my writings, no doubt, for, after all, we had never had many talks! The green wax that sculptors use nowadays took form rapidly. Somewhat to my surprise it took on heroic proportions. So that was what Lachaise thought of me! Well, it's gratifying, say what you like, to have someone look on your bright side. By

expected way in which the artist has introduced a flower or an animal into the composition, which itself is usually concerned, and in the loftiest way, with man's relationship to nature.

Kuniyoshi disturbs conventional art lovers in two ways; first, by the liberties he takes with the proportions of the human figure, and second, by a reversal of the usual color values. Kuniyoshi is quite capable of indicating the color of a flower by a rich black, but in a way that is quite inimitable and which would make serious Chinese art patrons laugh with pleasure. He manages to make it stand out from the background and to have an unmistakable feeling of air in the picture. Stodgy people who are fixed in their notions take one look at a Kuniyoshi flower and fly the room, outraged to their souls; but if they could only outstay their first consternation they would soon see that Kuniyoshi is not taking away anything from art but adding to it, and that all his work is full of vivacity and life.

The matter of the proportions can be illustrated by the well-known "Boy Stealing Fruit," which has been lent to this show by Ferdinand Howald. Every one who looks at infants sympathetically must often have been struck, even in the case of the healthiest of them, with the preponderantly large heads and tiny hands. On first acquaintance with the naughty little boy who is stealing fruit in this picture, the largeness of his head does seem excessively insisted upon, but the furtiveness of the gesture is so natural and the design of the painting is of such masterly sureness that in the end what was at first questionable acquires the added charm of quaintness.

The recent paintings by Kuniyoshi can easily be picked out in this exhibition by those who have already studied his work. They all have an added richness of painting and profit by an extension to the artist's palette. A study of an interior with a window looking out upon the sea can be placed unhesitatingly among Kuniyoshi's best things. There is also in the second gallery a group of Kuniyoshi lithographs not previously shown, and these have all the decorative qualities and all the skill in handling blacks that will be expected.

The New York Sun, February 11, 1928

A KUNIYOSHI RETROSPECTIVE

THE DANIEL Gallery has opened a retrospective exhibition of Yasuo Kuniyoshi's work. This artist is one of the most outstanding of the younger group of Americans and the one who, because of a certain strangeness in the style, would be most likely to attract critical attention in Europe, but who – and just because of this strangeness – gets less backing from American collectors than he deserves. A sequence of paintings illustrating all parts of Kuniyoshi's comparatively short career is, therefore, something to be looked into.

It happens to Kuniyoshi, as it happens to many other modern artists, that the very traits that are acclaimed by his friends are the ones that set him back with timid connoisseurs. He is original, and probably unconsciously so. Originality is an excellent quality in an artist, in fact, a necessary one if he is to achieve great fame, but the great fame has to be paid for by a struggle. The public yields unwillingly and sometimes slowly to the painter who appears to defy the rules.

Kuniyoshi's originality is, in my opinion, unpremeditated and native to him. He was born as his name implies, in Japan, but was brought here at such an early age that all his education, including his artistic schooling, was obtained here. But all the Americanisms that have been imposed upon him fail to stop the flow in him, once he starts to paint a picture, of influences that can only be explained upon the score that they are pre-natal. His art is curiously atavistic. On the surface, it is taken straight from Kuniyoshi's experience as boy and man in America, but in the background of each picture, is something that is not only Japanese, but Japanese of the middle-ages.

Also his art is often light enough on the surface, but underneath it is always profound and serious. The Orient may have its triflers, but most of the great paintings we get from there awaken moods of solemnity in the beholder. The Chinese and Japanese connoisseurs frequently laugh when examining their own masterpieces, but it is at the ingenious and un-

It is an essential part of that wit that was his from the beginning that he should be pseudo-Greek. And there never was a pseudo-Greek that was quite so pseudo as his. The "Annunciation," for instance, which is expressed by a composition of two obviously antique carvings, might be thought impious were the times not so ribald. Voltaire had to fly from France and hide in foreign parts until the noise from utterances much less "free" than this had subsided. Now it will be merely considered a wonderfully fine bit of painting.

Shocked pietists who take their precepts literally may be consoled by the reflection that many other human aspirations are mocked by this De Chirico. Poets and scientists, especially scientists, come in for considerable bludgeoning at his hands.

There is a strange jumble in his work of past and present. All the prized emblems of our civilization, such as the cannon which thunder out our beliefs to the world and the railways that pander to our thirst for speed, are posed against relics from the ancients that suggest immemorial time. You may read them as you like. In "La Conquête du Philosophe," which contains railway trains, clocks, factory towers, cannon and two enormous artichokes in the foreground, it may be time that confounds the philosopher or it may be the pleasures of the table, as indicated by the artichokes. Most likely it is the latter.

In "Les Plaisirs du Poète" a tiny little poet is seen sauntering out into a formidably empty and repelling square before a railway station and at first you think, "What chance has a poet in a place like that, or, indeed, what chance has he anywhere in modern life?" but as you look longer you see that the clear sky is unfathomable and that the vast, lonely spaces of the picture are of the kind that do truly trouble poets, and in fact that the whole argument of the picture is that your genuine poet squeezes poetry from the most unlikely themes, and, furthermore, that poetry is unquenchable and must always persist as long as there are human beings to "yearn," as Bunthorne put it, for the unattainable.

The New York Sun, January 28, 1928

DE CHIRICO

AND NOW it is De Chirico that is brought forward by that temple of modernism, the Valentine Gallery. De Chirico is not an unknown name. Samples of the work have been seen here from time to time. It always commanded a certain interest. But when the phrase "brought forward" was used it was used intentionally. De Chirico is distinctly brought forward by the present exhibition in the Valentine Gallery. It is something to be seen.

It is something to be seen and something to be remembered. De Chirico's earliest examples were slightly dry. They had wit and a curiously self-conscious and wholly modern way of looking at the heritage of art from the past that still encumbers the shelves of the picture dealers. He might or might not become a leader among artists, so it was felt some years ago, but at any rate was certain to have a definite place in the affections of those who must be modern at all costs.

Well, he now emerges as a leader among the new people. He escapes from the clutches of the "advance guard" and becomes the property of collectors. This is because he has become a vastly improved painter. He preserves his wit, even adds to it, and achieves a largeness of style and a certainty in painting that are highly gratifying to behold. At this distance from Paris, where we take French pictures on their "absolute" qualities, and without study of the various causes that contribute to their invention, it is impossible to decide immediately upon the origin of certain tricks of expression, but these "origins" are always discovered, sooner or later, and credit duely given for them.

So it is not quite possible to decide at present whether De Chirico, in his pseudo-Greek passages, has been helping himself to a little of Picasso, or "vice versa," as Fluther Good says in that marvelous play, "The Plough and the Stars." Some say the one thing, others say the contrary. It doesn't seem to matter much, whichever way it is, since all that De Chirico now has seems so indubitably his own.

impure pigments supplied by the shops must often appal her and it would not surprise her annual critics too much to find, a few years hence, that she was carrying out her designs in colored glass rather than in paint.

There are two or three themes that haunt Miss O'Keeffe in the same way that Mlle. Pogany haunts Brancusi. One is the "Red Hill with the Sun." She got the theme in Texas, where she was born, or lived, or went once, I forget which. But the plain with the glaring sun impressed her psychologically, and until she gives out all that she got from it, she will go right on painting that terrific theme. This year's version does, however, seem complete to at least one outsider. The blazing sun on the red, red hills is as good as it can possibly be. It probably, in consequence, is the last of that series.

Another theme is the Shelton Hotel. Miss O'Keeffe lives there – by choice. It has long lines, long surfaces – it has everything. At night it looks as though it reached to the stars, and the searchlights that cut across the sky back of it do appear to carry messages to other worlds. Miss O'Keeffe has painted several versions of the Shelton and has been praised for them, but her increased plasticity, increased mysticity and increased certainty in intention have enabled her this time to achieve one of the best skyscraper pictures that I have seen anywhere. It combines fact and fancy admirably and ought to be easily accepted even by those who still stumbled over Miss O'Keeffe's petunia pictures.

Petunias are a third absorption of Miss O'Keeffe's. Or rather there is a group of flowers on which she dwells lingeringly. They can be taken just as decoration or as essays in pure color. There is the "Dark Iris, No. 1," which began as a simple study of an innocent flower, but which now presents abysses of blackness into which the timid scarcely dare peer. Or there is the "White Rose – Abstraction," in which there are rows upon rows of filmy transparencies, like one of Pavlova's best ballet skirts. These and similar paintings, content those who respond to the painter's touch and to her clarity of color – and mean just what the spectator is able to get from them and nothing more. To overload them with Freudian implications is not particularly necessary.

The New York Sun, January 14, 1928

He doesn't clutch at the stars like Blake. He never fails gloriously but succeeds methodically. Such extraordinary ease in execution is in fact rather tiresome. The immense collection of bronzes he displays gives a suggestion of rankness as though it had grown up over night in some most tropical forest. But the American public unquestionably likes free-flowering geniuses. Sert, for instance. They like him.

The Dial, January 1928

O'KEEFFE'S RECENT WORK

THE ANNUAL exhibition of the work of Georgia O'Keeffe is now open to the public in the Intimate Gallery. An annual exhibition is a severe test upon any artist's powers, and, as a rule, is not to be recommended, for it implies that something new in the artist's experience has been recorded, and it is not ever year that presents such new experiences.

Miss O'Keeffe, however, is better suited, temperamentally, to this open progress toward fame than certain others who might be mentioned. She seems to be unflustered by talk, to be unaware of much of the talk, and to pursue her way in calmness toward the ideal she clearly indicated for herself at the beginning of her career.

She comes nearer to it this year than ever before. She is an imaginative painter, not so much interested in facts as in the extraordinary relationships that may be established between facts. She is in love with long lines, with simple, smooth surfaces that change so slowly in tone that it sometimes appears as though a whole earth would be required to make them go all the way round; and she yearns so for purity of color that the

desk, in the approved lawyer manner. "I never heard of such a thing," said the sculptor, still smiling broadly. "Answer the question," said the judge, wearily. "No," replied Epstein meekly; and the opposing lawyer glared triumphantly around the room as though requesting the reporters to note especially that point.

But in the end, the bored judge, who looked as though he had never in his life had a job less to his taste than this task of deciding whether or no the Bird of Brancusi was a work of art or a dutiable object of utility, appeared to be impressed, in spite of himself, by Mr. Epstein's enthusiasm for it; and gave out the official pronouncement that the title of a work of art did not necessarily describe it and consequently that, though the object in dispute did not represent a bird literally it could very well embody certain impressions in the artist's mind that had been aroused by the flight of a bird. He immediately quelled, though, the mounting rapture on the back benches, by murmuring to himself, sotto voce, that personally he thought all this sort of thing nonsense, and had he to choose himself, between Michael Angelo and Brancusi, he would choose Michael Angelo every time. Those were not his exact words, of course, but approximately the burden of his refrain. In spite of this chilling lack of modernism, the little Brancusi coterie thought him a most excellent judge – far better than they had dared to hope for – and that in deciding the Bird not to be an object of utility, he had decided everything as far as the courts of law were concerned. . . . The amusing farce cannot end just yet, however. A legally necessary deposition from the author of the Bird – Brancusi is in Paris – delays the final verdict another six weeks. It cannot affect critical opinion whichever way it goes.

In the meantime the Epstein exhibition is attended by crowds of people who are vaguely but visibly impressed. No instances of outraged opinion have as yet been recorded. A foreign-looking Madonna astonishes nobody. In fact the idea long since became general that She was not American. So that is that. The other sculptors all admit him to be a sculptor. So do I – in spite of his lack of a diploma. He is not as deep as Michael Angelo, it is true, nor so suggestive as Brancusi, but he knows how to do what he sets out to do. There is a touch of sameness in the work that invites the suspicion that Mr. Epstein confines himself *to* the things he knows how to do.

Indian prince after all could only have been a disinterested art lover. Or do you suppose he could have foreseen Dr. Katherine Mayo and the havoc she was to make of American sympathy with the Far East, and was preparing against the day?

In truth, I have a wretched memory, and another thing I completely forget, though I should know it, for I must have been told, is how Jacob Epstein became so Indian. The psychologists say that this sort of forgetting is due to indifference, which is something I'm sorry for, if true; and anyway, if I should be proved guilty of indifference to the Indianization, as such, of Jacob Epstein, I certainly am not indifferent to the process of his becoming so. Processes are always interesting. Why, I wonder, did he take it on? When he might just as well, like Ralph Rackstraw in Pinafore, have remained an Eng-lish-mun!

Mr. Epstein made an awfully good witness for Brancusi. He has immense social skill, and with distinct leanings toward the histrionic. He will be a great success in America, just as he has been in England. Jacob Epstein couldn't fail anywhere. His charm of manner was just as certain in the spacious court-room as when produced for short-range effects across a dinner-table. He was grandly patronizing to the presiding judge and to the opposition lawyer, speaking to them from a height – as though to little children – and, with the greatest virtuosity, screening his amusement from them though getting it to us on the back seats perfectly. Just the same, and this will illustrate to him what he is up against in his return to America after twenty-five years of burial in England, neither this judge nor that lawyer ever seemed to have heard of Mr. Epstein before! It is always the legal game, I suppose, to discredit expert testimony, and all of Brancusi's well-wishers and witnesses were forced to reply to dull enquiries into their right to speak authoritatively upon questions of art. "Well, did you study anywhere?" asked the lawyer sceptically, when Jacob Epstein avowed himself to be a sculptor. "Yes, at the Art Students' League in New York, four years at Julien's, in Paris; and also at Carlorossi's, in Paris." "Well, have you anything to show for it?" "What do you mean?" "Any paper? Wouldn't they give you a diploma?" "Art schools are not like colleges . . ." began Mr. Epstein incredulously, as though scarcely trusting his ears. "Did you or did you not secure a diploma? Yes or No?" thundered the attorney hammering his

with the precision of expensive machinery, and the lips that fold them in, especially when seen in profile, are inexorably right in drawing.

The N. Y. Sun, December 24, 1927

THE BRANCUSI CASE

SEATED ON the benches in the court-room awaiting our turns to testify in the Brancusi case, I noticed an unusual ring upon Jacob Epstein's finger. The reporters in attendance appeared deeply impressed by Mr. Epstein's sartorial splendour and did full justice to it in their accounts in the daily press, but I don't think any of them noticed the ring. "What is it?" I enquired. "A ruby," he replied. "An Indian prince gave it me." It was, in effect, sufficiently Indian. The large ruby had been embedded heavily into the gold which had been carved into the semblance of a snake.

I had forgotten it temporarily but it came to mind when I had progressed but a little into the New York exhibition of Mr. Epstein's bronzes, at Ferargil's. The bronzes were so excessively Indian, so forcefully Indian! — so very different, indeed, from the sort of thing encountered in Dr. Katherine Mayo's new and sensational book, Mother India. The Indian Madonna and Child, in particular, were so aggressive that they might be supposed to have emanated in direct reply to Dr. Mayo's awful accusation. No wonder the Indian prince gave Jacob Epstein that ring. He should have given him a lac of rupees, as well, and a white elephant, and a half-dozen nautch-girls, and — but I am forgetting again; those bronzes were achieved long before Dr. Mayo thought of her book. The

He contented himself at first with the newspaper celebrities of the day, and one by one he "showed them up" in his drawings in a manner wonderful to behold and yet in a manner that left no trail of rancor. His "victims" were just as pleased and flattered as the victim's friends were amused. This, of course, is the genuine test for caricature, as Baudelaire long ago pointed out. It doesn't get very far unless founded upon sympathy. "If you say that, smile." The smile, according to the famous Western code, offsets everything, and implies a complimentary opposite.

By the time Covarrubias had reached Carl Van Vechten in his list of celebrities he had also, and naturally, made acquaintance with the elite of the colored population in the northern part of town. In Harlem he found a society perfectly suited to his pencil. He at once proceeded to make a marvelous series of drawings. He has missed nothing, apparently, in the well-known list of types. He gives you the "Jazz Baby," the negro "Preacher," the chocolate-hued "Sheik," the heavily jowled negro financier, the impassioned "Blues Singer." Even the now classic "Cakewalk" inspires him to a masterpiece.

All these extraordinary people and their equally extraordinary activities have been recorded very exactly in the art of Covarrubias, and the book of these drawings, recently issued by the house of Knopf, proves convincingly enough that in the young Mexican we have a caricaturist comparable in talent to the Frenchman Caran d'Ache. In the course of time he may go beyond Caran d'Ache, but to reach that degree of skill is in itself already astonishing. He is in the first, youthful, rapturous stage of recognizing lovely and too unbelievably amusing things in life. When he gets a little deeper into the puzzling maze of human existence and gets constructive impulses he may become a Daumier. He certainly has skill enough to be anything.

How he came to be such a phenomenon has not as yet been explained, and may never be. Mr. Crowinshield probably hits it off as well as it can be hit off when he asserts that the young man "mastered his metier solely by virtue of close observation and hard work." If it be true that he is self-taught, then the artist's instincts for form must be sound. In all the playfulness of exaggeration in the negraic heads there is always the suggestion of underlying knowledge of the true formation of the skull. The massive teeth close upon each other

owing merely to a little matter of sympathy in the arrange-
ment, the Intimate Gallery was able to dissipate this fear, and
to relate all the busts and ornamental pieces so perfectly that
all thought of sizes vanished. If miracles have been slow in
coming to Lachaise, this at least was one, for the Intimate
Gallery is as tiny as its title implies, and an acceptable instal-
lation of Lachaise's wilful carvings had not been anticipated.
It may augur that at length the season for miracles has been
ushered in.

The Dial, June 1927

COVARRUBIAS IN HARLEM

CARICATURE MUST depend upon an inner urge! It is rewarded
hugely and, generally, at once. In the long list of art's mar-
tyrs there are few caricaturists. Yet comparatively few, in
America at least, take it up for what there is in it. This is,
perhaps, lucky for us. We are spared the vast army of pre-
tenders that choke the vestibules of the galleries where the
more orthodox, more dignified forms of expression prevail.
The men of genius in caricature stand out clearly, and it is
usual that the idle public that merely loves to laugh unex-
pectedly finds itself in agreement with the severest critics.

Miguel Covarrubias is one of the gifted caricaturists who
pleases all the governors in a world that is now thought to be
even madder than it was in Shakespeare's time. He came up
from Mexico an untaught boy, so Frank Crowinshield says,
but the first drawings he showed to us convinced everybody
that he was a real genius. There was no fumbling around
either for the idea or for the method, but an adult assurance
that was as startling as it was pleasing.

because it was thought the public would fear "that" was the reason for the increase in the cost of telephone calls. A hideous charge against New Yorkers, if true. But of course it is not true — merely bad psychology — for even the dullest New Yorkers know that one statue in a vestibule would not appreciably affect telephone charges. But the failure of the telephone people to see the chance to do a really gracious act for their subscribers was only a minor tragedy compared with the packing away into store-houses of the two plaster Venuses and the halting of Lachaise in the production of things on the grand scale. That is the real accusation against the times we live in and against the state of art-patronage in America in particular. There is no rich person, apparently, with sufficient feeling for serious art to wish to do something handsome for the age in the way of monumental sculpture. There is no public place in New York that the people themselves yearn to see decorated. What is the use in attempting an ornament for a "place" or a public square that is always in process of change? Were there one spot in the Metropolis that positively called for sculpture, one of the usual "publicity campaigns" might be undertaken for Lachaise and "the people," always docile in the long run, might be induced to subscribe the necessary funds. But since there is no such spot the only alternative is to wait as patiently as possible for the miracle that is to produce it — city control of architecture must arrive sometime — and to keep Lachaise groomed against the day.

But I prolong the lugubrious note unduly. The grooming process has in itself produced a series of noble portraits, an imposing piece of garden sculpture, and a host of small bronzes, and when these things were recently shown in the Intimate Gallery, none marvelled at them more greatly than Lachaise's fellow sculptors. The voice of criticism was not raised at all. There was nothing but praise; and gratification for the way in which the sculptures explained each other. There had been some astonishment expressed at the first portraits, shown singly, for in them, as in everything else, Lachaise had shown a largeness of spirit that suggested he had been thinking inwardly of niches in the Escorial or some other such vast edifice, and that again patrons would have to do some tearing down and re-building — as for the two regretted Venuses — before the busts could be employed. But

does upon committees, would be difficult, but they little sus-
pected how difficult it was to be. Lachaise's art is not the
kind that pleases committees. There is nothing pretty about
it, nothing light nor reminiscent of the fashions of recent
years. On the contrary it makes an unusual demand upon the
spectator. Lachaise's sculpture, as much as the painting of
Braque, requires the party of the second part to have a sensi-
tive feeling for beauty in the abstract. At least I think it is
abstract beauty that makes the appeal when the student is
swayed by an ideal astonishingly different from his own.
Lachaise's own feeling in the matter is far from being ab-
stract, it's concrete enough. His ideal female of the species,
to come to the point at once, is fat. He is so innocent about it,
however, so intense and certain of his conviction, that I sup-
pose it must surprise him fully as much to see the models of
the day, dictated by the rue de la Paix, as it surprises commit-
tees to see what he puts forth himself. The actual creative
feeling back of his art can be explained interestingly enough,
I suppose, by Freud, but not Freud nor any other scientist can
explain away the right of an artist to express beauty upon his
own terms, nor minimize the positive achievements of La-
chaise in that line. The two big Venuses that I saw in 1918
and 1920, and which have never yet been put into stone or
bronze, seemed fat only in the first minute or two of inspec-
tion. After that they became, and have remained, immensely
satisfactory works of art, alive and beautiful. In fact I say
"fat" only because that is the word opposing critics have used.
I feel sure that if actual measurements were taken they would
not be found to be revoltingly larger than most of the Venuses
that have won the world's renown — including that one from
Milo. That one from Milo, I believe I have already said else-
where, would not herself stand much chance with the officials
of to-day, being more, I am persuaded, a product of the fields
than of the town, and committees are exclusively town. It is
not anyway so much a question of bulk, with Lachaise, as a
certain largeness in scale. There was something in those two
Venuses that started most of Lachaise's friends to imagining
the new Statues to Liberty that he would be doing, the statues
in scale to the new architecture. Here, at last, they all thought,
is the man for the New York job — but the nearest he ever
came to it was the design for the allegorical figure in the new
Telephone Building, a design afterward rejected, it was said,

Mr. Sterne an unfair advantage. And then there was the episode of Paul Manship. Mr. Manship, upon hearing that Jo Davidson was already on the spot in Oklahoma doing portraits busts of members of the Marland family, refused to have anything to do with the affair. "Call that a competition!" said he, with withering sarcasm. . . . But such things are trifles and every great art patron must realize sooner or later, and preferably sooner, that artists are after all human; and subject to all the wayward impulses the mind is heir to. The Great Michael Angelo himself had more than one sharp encounter with his pope and Benvenuto Cellini said things to his duke that he afterwards apologized for. The little fable about the puppies by Epictetus — "See how they love each other, but throw a bone among 'em" — is thought by some to be malicious but it is not; it is merely practical. Throw a commission for a five-hundred-thousand-dollar bronze statue among a group of sculptors and you may expect politics. That this should be so, will not I hope disillusion Mr. Marland. In fact the difficulties in doing good are part of the attractiveness of doing good.

The Dial, May 1927

LACHAISE

ALTHOUGH Gaston Lachaise has been widely recognized as a sculptor of importance these ten years past it is still the "might have been" aspect of his career that fastens the attention. Those who first made acquaintance with his talent in the Bourgeois Galleries in 1918 saw possibilities in the public use of it that are not yet realized. They already saw, those early connoisseurs, that the "public use," depending as it usually

one to whom the possession of millions would be but the start-
ing point. What I marvelled most at was the lack in his
features of any trace of strain or hardness. There was nothing
in him of Rockefeller asceticism or of Ford sternness. I had
always thought that the quick accession to riches could only
be managed at the expense of soul — an idea probably ac-
quired from a reading of the novels by Sinclair Lewis and
Booth Tarkington — but studying Mr. Marland and his associ-
ates, all of them young and uncrushed, I saw that I and the
novelists would have to readjust our conceptions of American
millionaires. Apparently a new type has arrived, a type we
artists can have something to do with.

And apparently there is in this first arrival the makings
of a most amenable art patron. It was reported, for instance,
that after his inspection of the twelve sketches by the twelve
sculptors, he expressed satisfaction in all of them and said
that he would be content with any one. That is decidedly the
proper spirit. A scheme of popular voting for the best of these
models has been inaugurated and it has already had lovely
results in publicity and will doubtless eclipse anything in that
line that we have experienced. Which is all to the good! The
public actually seems willing to think over the problem as to
which is the best of these twelve sketches. It is a little exercise
in connoisseurship that we ought to follow up quickly, if we
are to have educational profit, with another pleasing problem
of the same sort and only a shade more difficult. And by and
by we might have an art public. But that is looking far ahead.
Just at present, I believe, nobody in his senses, would agree to
letting the public have its way, even with this Marland Pioneer
Woman. The public would inevitably choose the least of the
twelve. Out of the million but very few, obviously, would
recognize the best bid for the permanently bearable. Mr. Mar-
land has wisely decided to cast the deciding vote himself.

Not but that he'll have his difficulties. There is no easy
way out in these matters. Already what is called "human
nature" has manifested itself in this competition. The twelve
little sculptors, it appears, are not just so many little lambs.
Already Arthur Lee, one of the little sculptors, has misbe-
haved himself in the actual presence of Mr. Marland. Some-
thing, I believe, about Maurice Sterne's innocent error in mak-
ing his sketch four feet high instead of the three feet to which
the others adhered. The cry arose that the larger model gave

enquired, thoroughly mystified. "Why, from Ponca City," she repeated, "the place where this statue is to be put up. I should think you would know where Ponca City is," and she eyed me doubtfully, as though suspecting a joke that through repetition had grown tiresome. Disavowing any intention of being funny and deploring my ignorance, I was able, after a while, to elicit the picture of Ponca City that still fascinates me.

It centres, it seems, about this Mr. Marland who made all the money for himself and the others so quickly, and who gives the statue. He it was, so my neighbour with the pearls informed me, who first of the new community became interested in art. "Indeed, he keeps us all stirred up," she continued. "He is interested in many things and likes us to share in his enthusiasms. For instance, he loves hunting, keeps a great stable, and on the day of the hunt any one at all decent in the town can go to his place and have a mount free. His home is a fine villa in the Spanish style. He entertains a great deal. We all came east in his private car — it is most comfortable. He took Mr. Davidson, who came to Ponca City to do portrait busts of Mr. Marland's family, out to the coast in this car upon a little excursion. Then there is the golf-course which is certainly handsome, and due, I believe, to his initiative. And, oh, so many things. He doesn't seem to think of himself but of the general life in Ponca City. You know this Pioneer Woman is but the beginning. He has other ideas for the advancement of the community. . . ." But she had said enough to make me think that pioneering must be, upon my word, vastly different now from what it was in the old days, and, take it all in all, a mighty attractive life for those who have the vocation. It was with the arrival of this thought that it occurred to me that there was, after all, no longer a necessity for me to go to Avilà, Spain, to spend my declining years, a plan that I had hitherto held to; Ponca City would do as well. Not that I altogether fancied dwelling in the shadow of a fifty-foot bronze Pioneer Woman by, possibly J. Bryant Baker, but I could have, I hoped, a little bungalow facing in another direction, with an outlook upon the inspiring activities of the place, and possible glimpses of all the sculptors going to and coming from the Spanish villa, and all that sort of thing. . . . Mr. Marland who just then arose to do a tiny after-dinner speech, looked the part that had just been given to him — an essentially modest man, markedly idealistic, and

THE PIONEER WOMAN

MRS. SHAMEFOOT "used always to say it would be at Versailles, or Vallombrosa, or Verona, or Venice. Somewhere with a V." I think if that highly modern but fragile lady were still extant she might now agree that it could begin with a P. At least Ponca City in Oklahoma has become the captivating though not quite realizable (perhaps it's for that very reason) city of my dreams. It used to be Samarkand, which was followed by a nostalgic interest in the eighteen-century cure at Lucca, and I even succumbed to a pre-Gauguin feeling for the Marquesas Islands (due to Melville's Typee) which dwindled, however, almost to the vanishing point before Gauguin arrived to give it the coup de grâce. As a rule it is wiser to restrict one's commerce with such places to the dream-world. To touch them is fatal. I made that mistake with New Orleans, the only city in the United States that had, in the generation just past, an appeal. I adored it a dozen or so years ago, worshipped at all the shrines, and came home to read in the newspapers of the destruction of the old Hotel St. Louis, the most romantic and satisfactory building on the continent, and the burning of the heavenly opera house. New Orleans immediately receded farther into the distance even than Tahiti. So, considering everything, I don't think I shall go to Ponca City, Oklahoma.

I had never heard of the place until the night of the Marland banquet in the Hotel Plaza to the competing sculptors. Mr. Marland had come on from the West with certain friends and business associates to view the submitted sketches for the monument that is to glorify the hitherto unhonoured Pioneer Woman of the Plains, and a little conviviality was considered necessary to put us and him in the mood. It was the lady who sat next to me at this dinner (pearls, white satin, and a calmly youthful face that in itself I thought distinguished — so rarely is calmness associated with youth nowadays in the eastern part of the country) who mentioned Ponca City. She came from there, she explained. "From where?" I

new and wonderful applications of the eternal truth which it contains. Hence epitomes have been called the moths of history; they eat out the poetry of it. A story of particular facts is as a mirror which obscures and distorts that which should be beautiful: poetry is a mirror which makes beautiful that which is distorted."

But in what Utopia will a custom-house official know anything of the eternal truths in which a Shelley and a Brancusi specialize?

Quite unconscious of the humiliating farce being enacted behind the scenes, the intellectual portion of the public flocked in greater numbers than ever before to the Brummer Galleries where the Brancusi carvings were exposed and where they had a real success. For my part, I felt that those who saw this sculpture only in the Brummer Galleries saw but the half of which these subtle and sensitive works of art were capable. They need the co-operation of the changing outdoor lights; or, indoors, some friendly shadows to which they may be tied. This is illustrated well enough in the truly excellent photographs with which the "Brancusi" number of The Little Review was illustrated. The exuberant Mr. Ezra Pound, who shares my aversion to definitions, said in that issue, that "it is impossible to give an exact sculptural idea in either words or photography," and while he is quite right, the photographs by which his text is surrounded go as far as photographs can to defeat the argument. They at least definitely show what the right surroundings can do for a Brancusi. Who wielded the camera is not stated, but the various versions of Mlle Pogany are entirely worthy of Mr. Man Ray. In the pitiless light of the Brummer Gallery the Portrait of Mlle Buonaparte swam for the first time into the ken of certain Philistines and got much whispered about. I met no artists but those who took it for what it is — a work of art — but the misunderstanding in regard to it doubtless was at the base of the confusion in regard to Brancusi in the Customs House.

The Dial, February 1927

ling in the New York bureau of the United States Customs who
insists that Brancusi shall pay several hundred dollars of extra
tariff upon his famous Bird in Flight on the plea that is is not
a work of art. The official definition of sculpture with which
this worthy fortifies his position, runs as follows:

"A work of art is not necessarily sculpture because ar-
tistic and beautiful and fashioned by a sculptor from solid
marble. Sculpture as an art is that branch of the free fine arts
which chisels or carves out of stone or other solid substance,
for subsequent reproduction by carving or casting, imitations
of natural objects, chiefly the human form, and represents
such objects in their true proportions of length, breadth, and
thickness, or of length and breadth only."

The wily concocters of this fiat doubtless thought they
had constructed a definition that was, as we say, "fool-proof";
but, it seems, they were mistaken. No law is or can be fool-
proof and the best safe-guard to justice is, as a celebrated
English jurist pointed out long ago, a sense of fair play in
the community. A frivolous editorial writer on The New York
World, citing the session of the United States Customs Court
that was held to consider "whether Christmas trees were toys,
timber or fresh vegetables," opines that there is an irrepress-
ible joker concealed somewhere in the Customs Bureau who
occasionally "must have his fun." Official incompetence is,
of course, highly amusing to unimplicated bystanders, but the
decision that attempts to fine heavily the superb Brancusi and
to rob him of his standing as an artist, is a joke that the visit-
ing Roumanian sculpor may not see.

The affair, however, is not grave, and the intended slight,
I am sure, will have been circumvented in some fashion be-
fore these lines appear in print, but in the mean time, one
must register one's distaste for the episode. As for definitions
they are, as I said before, futile. Definitions of life, art, poetry,
style, and justice are often diverting to those who already
know much about life, art, poetry, style, and justice, but they
cannot guide infallibly the inexperienced. I doubt, for in-
stance, if the ignoramus who fined Brancusi would be much
helped in judging poetry by Shelley's famous description of
it. "A poem is the very image of life expressed in its eternal
truth. . . . Time, which destroys the beauty and the use of the
story of particular facts, stripped of the poetry which should
invest them, augments that of poetry, and forever develops

will now be the most surprised people in the city to learn that Eilshemius really is a master painter.

Like Blake, this artist paints and writes, but whereas Blake's soul was always visibly burning "like a white flame" through any medium he employed. Eilshemius, or so it seems to this bourgeois, only really lights up when he has a paint brush in hand. It is that faculty that makes him. I cannot say that he plunges as deeply into the mysteries of heaven and hell as does the great English seer, but his paintings "sing," and Blake, were he here, would be the first to acknowledge it, though deploring, of course, the lack of prophecy and religious teaching. Eilshemius is not in the least pious, but is gay like a pagan.

The opinion that the Eilshemius muse is an undoubted muse, though light, is founded upon a study of only two small groups of his paintings, and further exploration may develop that she has more weight than at present. During the years of his unrecognition Eilshemius painted 3,000 pictures! That is formidable! I am always uneasy when I hear of artists who spread themselves out over innumerable canvases and know of no worse charge against Renoir than the interminable catalogue of his works.

The N. Y. Sun, November 27, 1926

BRANCUSI

EVERY ONCE in a while some half educated person in government employ mistakes himself for the whole government and commits an act of great foolishness. This time it is an under-

came to investigate and finally to appreciate the essential qual-
ity of William Blake during the lifetime of that unfortunate
artist. Perhaps like the Boswell who has recently been made
great in order to excuse the perpetual interest of his writings
he was not so unclever after all! In running after greatness, as
he avowedly did, he made too many "finds" to permit his
success to be explained away upon the score of luck. It is
doubtful if another human being since history began achieved
such a long list of famous friends as he did, and since lion
hunting as a sport is by no means obsolete it may serve a
practical end to point out that the chief secret of Crabb Robin-
son's "method" lay in the fact that, having no genius himself,
he "believed easily" in the genius of others. He was not so
much, in other words, a rejecter as an accepter.

He succeeded in the way that great business men suc-
ceed, by being continually on the try. To change the old
adage slightly, he put his eggs in many baskets and watched
all the baskets. It is something for collectors who would fore-
stall posterity to remember. To bank one's entire fortune upon
one bet is not the policy, I am told, of the best gamblers.

These curious remarks must be leading up to something,
you are thinking. You are right. They are leading up to the
announcement that there is a Louis Eilshemius exhibition
in the Valentine Dudensing Gallery at 43 East Fifty-seventh
street, and that all the Crabb Robinsons of the community
should look into the matter. It would be too annoying after
Louis Eilshemius's death to discover that we had had an ex-
cellent painter in our midst without knowing it.

The name of Louis Eilshemius cannot be unknown to
readers of THE SUN. It used to be signed quite often to letters
that appeared on the editorial page of this journal. No matter
what the topic of the day happened to be Mr. Eilshemius would
write a letter asserting that he knew all about the matter and
was, in fact, a past master at everything. Were he writing to-
day, for instance, I wouldn't put it past him to declare, like
Blake, "I have committed many murders." This sublime con-
fidence was thought by certain of our editors to be mad but
amusing, and it is true that many readers came to believe that
there must be something seriously wrong with the world when
the daily letter from Eilshemius failed to appear for some
reason. But I suppose that those editors and those readers

from a handsome sea shell. Just what it is that makes the Calla so esteemed in these days, other than the fact that it was considered vulgar a generation ago, I cannot say, but possibly that in itself is sufficient reason. The present seems determined to call the lie to everything in the past.

I have heard, though the rumor has not been affirmed, that this Bronzino-like portrait of a particularly robust Calla was intended by the artist as a tribute to the memory of a strange, erratic figure in the theatrical world who recently passed, as they say, to his reward. This is as it should be. I believe in "homages" and sometimes wonder that the artists, who are supposed to be so desperately searching for subjects, do not indulge in them oftener. Here, where the streets are not very often named after painters and sculptors, other pictures, at least, may be. Mr. Demuth, to do him justice, has painted several such tributes to contemporary artists — among them John Marin, Arthur Dove and Georgia O'Keeffe — and includes them in his present show.

The N. Y. Sun, April 10, 1926

EILSHEMIUS

"JUNE 13TH, 1826, called early on Blake. He was as wild as ever, with no great novelty. He talked, as usual, of the spirits, asserted that he had committed many murders, that reason is the only evil or sin, and that careless people are better than those who," &c. From the "Reminiscences of Henry Crabb Robinson."

It will always be a mystery to superior, intellectual people how the unclever, modest, well behaved Crabb Robinson

the challenge and wars it out with nature to tragic though triumphant conclusions.

Demuth, with the aid of science, doubtless wraps himself in some sort of a transparent cloak and shields himself from the contrary winds. He is like these deep sea experts who sink beneath the wave incased in glass, to come back when the supply of oxygen has been exhausted with reports of wonders. Not a ripple from the upper airs is allowed to disturb the intensity of his study. If a storm rages he will hear about it from Marin afterward. But this scientifically induced calm is by no means stagnation. There is life to be observed from the spot where he has taken up his station and, since science secures you from fogs, he gets it straight.

Physicists, consequently, will block the entrance to the Intimate Gallery, struggling to get at the color facts of the matter. Demuth is the one who hands them out. To me he is more reliable than Chevreul. But, then, Chevreul is dead and science always going marching along. Chevreul was not so much interested in those faint plum colored tones on the carrots or the carroty rust on the plums. He would have preferred those clearer tones that sometimes leap at you out of Demuth drawings like the healing rays recommended by our more expensive physicians.

I should think, indeed, these watercolors might have curative properties. You hear of stranger things. I can testify myself to having a slight relapse in health after being accidentally separated from one of my Demuths. Slight twinges of rheumatism developed, and that's a fact. One of my drawings, lent to a friend, got locked up in storage with all his things when he went to Europe, and it will be a year before he returns with the key and I can attempt to prove my theory and cure my pains with an application of pure color.

But can Demuth be modern, you ask, if Marin is? Why not? The oddest fallacy amid all those that persist is that there must be a formula for modern art. Both men connect with the times, though they connect differently. The submerged, inner life of Marin revolts at science and fights it. But the science that kills Marin keeps Demuth alive. Demuth chants the Hymn Intellectual, as Walt Whitman would say.

In addition to the watercolors that have made Demuth one of the half dozen best known artists in the land there are some oils. One of them is a vigorously drawn Calla sprouting

poetry. I am always quoting Emily Dickinson's definition of poetry but it has not yet staled in repetition: "If I read a book and it makes my whole body so cold no fire can ever warm me, I know that is poetry. If I feel physically as if the top of my head were taken off, I know that is poetry. These are the only ways I know it. Is there any other way?" . . . In this picture, as in most works that seem struck straight from the soul without any intermediary parleyings with the intellect, I am thrilled again by such details as the moon and stars which shimmer fatefully but positively as they never do in the night-scenes of the so-called realists. This Bohémienne, I understand, is part of the immense loot from the Quinn Collection that Mr. Rosenberg is taking back to Paris, but the circumstance to me is not sad. I am resigned, also, to the departure of Seurat's Cirque. In fact, I am more and more persuaded, as time goes on, that the correct lodging for a masterpiece is the country that produced it.

The Dial, March 1926

DEMUTH

NO GREATER contrast to the art of John Marin could be asked for than that that is supplied by Charles Demuth and which is exhibited now in the Intimate Gallery where Marin lately held forth. Marin grows more and more passionate, more tempestuous and nervous. The opposing currents of modern life seem to beat in upon his spirit relentlessly. He feels each jerky, jazzlike force that comes along and, to the death, must translate it into rhythms. He is another melancholy Dane who says "Oh cursed spite," but always in the end accepts

was debatable, and a public instead of a private appraisal of it would have been a great help.

It is the part of philosophy to accept what benefits accrue even from mishaps, so it is time to acknowledge that the portion of the Quinn Collection that was shown had all the old electrifying powers and drew a steady attendance of the "best people" who made valiant efforts "to understand." No doubt some of them succeeded. An immense amount of water has passed beneath the Brooklyn Bridge since the days of the Armory Show when aspiring amateurs shocked by such aspects of modern life as they caught from the mirrors being held aloft by the new painters could think of nothing better to shriek than the words "degenerate" and "imposture." The attitude now is certainly calmer, though here and there an unregenerate still thinks it necessary to insult an artist for being truthful. I have, for instance, just finished reading a rather dull satire by Mr. Hilaire Belloc who attempts to burlesque the modern frenzy for quick finance and tells of a lady who made a dubious *coup* on the Stock Exchange and was thereby enabled to repaper her Georgian house and hang her drawing-room with pictures painted apparently "by lunatics in hell." This is the only witty phrase, I hasten to say, in a book I have no desire to recommend. Mr. Belloc spends all his energy in contriving a picture of modern society that any visitor from Mars would consider hellish, but turns in a fury to rend the artists who are saying the same thing he does. The wonderful difference between the two points of view is simply that Mr. Belloc looks on life with scorn and our painters with sympathy.

My finest moment in Mr. Quinn's Inferno — for I don't care what Mr. Belloc calls it, modern life is the only life I have known and the only kind I enjoy — came with the discovery of his amazing Henri Rousseau, La Bohémienne Endormie. This certainly must be one of the great imaginative pictures of the era. How explain it, how measure its peculiarly psychic force? Luckily there are no vulgar chemicals to rob it of its secret, which will mystify, I hope, for many years to come. Like music it may be interpreted variously and all interpretations shall be correct. Is it a dream lion more terrible than a real one? Is it a dream gypsy sleeping in a desert that never was? You can take your choice but in either choice there is the same stab at your vitals or you are not susceptible to

THE QUINN Collection, at this writing, is still the topic du jour. In a case of general interest, such as this, the newspapers may be relied upon to publish the cold facts to the world and so it scarcely can be regarded now as news to state that the cold facts are that finally it was decided to place the selling in the hands of Joseph Brummer, one of our most able dealers, and to exhibit certain chosen pieces in the galleries of the Art Center by way of a memorial to the late owner.

These, I consider, are exceedingly cold facts, for the procedure resolves the Quinn Collection into money and nothing else. It leaves the modern art situation in America precisely where it was and Mr. Quinn might just as well have dabbled in stocks or drygoods as in art. A public auction, on the other hand, would have been a magnificent gesture, compelling professional attention, and awakening the public conscience as nothing else that can be thought of. It would have been as much of an eye-opener as the celebrated Mary J. Morgan sale of years ago which first taught the American public what a peachbloom vase was, only this time the lessons would have concerned themselves with Henri Rousseau, Picasso, and Derain. Since Europe has been so quick to buy examples of these men — the pick of the collection, it is said, having been made by a Parisian dealer — it is absurd to contend that Europe would not have competed in the auction; but had that even occurred, you may be sure those connoisseurs would have had competition from unexpected sources. It is a discouraging thought that I have harboured for a long time that it takes a dramatic occasion to fix the eye of our lethargic noblesse; and to realize that we have missed our great educational chance in the Quinn affair is doubly tragic for nowhere on the horizon is there another collection that could do so effectually the job. It is part of the immense advantage that Paris has, and which I continually resent, that there, periodically, the Hôtel Druot clears the air. The Quinn Collection contained many sure-fire hits but much also that

effective in preventing the sacrifice of the newer men. . . .
Then some of the newer American artists opposed the sale,
needlessly fearing the public test of an auction – but after all
what could they lose in figuring in such a famous event? . . .
And, finally, there were some ladies. Just who they were and
what were their claims upon the estate I have not heard but
I did hear that they assumed sentimental attitudes. They were
largely responsible for vetoing the auction last winter, holding
that the pictures should be kept together as a memorial to
Mr. Quinn; which was a fatuous notion, for, interesting as is
the collection, it was too unedited to warrant being kept intact.
Mr. Quinn himself was continually editing it and would have
thinned it still more had he lived. His action in regard to his
library is a fairly good clue to his plans for his pictures, and
so I think it a safe bet he would have auctioned them off, for
he was sufficiently shrewd to have known that if he brought it
off successfully, "the historical event" would provide a fine
enough memorial for any man.

To date, the sentimentalists have had their way, and a
"memorial," and temporary exhibition of the collection has
been arranged for to take place during January in the rooms
of the Art Center. This will of course draw many visitors but
when the fine fever of curiosity has abated, do you suppose it
can be re-kindled later on to provide the excitements upon
which auctions flourish? Mr. Quinn, himself, would have
known better than to deliberately invite, in this fashion, an
anti-climax.

The Dial, February 1926

print, nobody at present knows what is to become of the John Quinn collection of modern art. There are no rascals in the story. I don't mean that. But a horde of people with varying interests are pulling strings in all directions in an effort to sway the heirs and executors of the estate, and these latter, who appear to know nothing of art, are in as fine a state of confusion as you could wish to see. The chances are, therefore, that exactly those things will be done to the collection that its late owner would not have wished.

The perfectly obvious procedure would have been to have sold the pictures and carvings at public auction last winter in New York City. The times were ripe for it and the stage was set. Mr. Quinn's library had already been sold with immense success and the prestige of that event would have extended over to the sale of the objects of art. It is well known to students of auctions that the excitements of them are cumulative and the atmosphere of a big sale breeds a frenzy of buying that ensures success. The dealers, when consulted, invariably deny this. They say that to unload a vast quantity of pictures upon an innocent public is to invite disaster. As a matter of fact, what they dread is the effort that is necessary "to protect themselves" at the sale, for the modern dealer who has been selling certain artists for certain figures thinks it extremely compromising if the said artist fetches less at the auction than at the shop. This is an error both in fact and in judgment. What they ignore is that the details of a great sale linger in the public memory but for a few days and that chance bargains to connoisseurs do not interfere with the prices of staple goods. The records not only prove this but also that the dealers seldom do have to protect themselves in great sales. On the contrary the orgy of buying that ensues on such occasions brings a crowd of customers to the shops as well.

So of course there were dealers to advise the executors of the Quinn Estate against a sale last winter. There were other experts who thought certain works in the collection could only be sold in Paris. It is true that the late Mr. Quinn's taste was far in advance of the crowd and in particular that the cult for certain fine artists such as Derain and Brancusi, whom he affected, has not developed impressively as yet in New York; but the *réclame* of a famous auction reaches as far as Paris and the competition of European collectors would be

time not many among us apparently relish having the artists hold the mirror up to nature, and art, we appear to think, is something that relates to another period than this. And machines are so nice too; so neat, especially when new and hygienic.

Fernand Léger's first big exhibition in America is now taking place in the Anderson Galleries under the auspices of the Société Anonyme. The private view proved to be the first rally of the season for the advance guard, and they seemed more numerous than heretofore. The occasion was unlike some in the past for no one was heard to ask what the pictures meant. All seemed to know what the pictures meant. This indicates either that more people now understand cubism or that cubism itself has become clarified. Rumors have persisted of late that cubism is completely forgotten in Paris and that no one practices it anywhere any more. The Léger exhibition quashes that rumor.

Fernand Léger, so most of those in attendance at the first view said, genuinely feels his cubism. He means it. His pictures have the conviction of an artist with a message. He confesses himself that in exploring the modern world and trying to interpret it in current terms he feels just like a primitive. Certainly his immense decorations have the vigor and freshness of the earliest works.

The N. Y. Sun, November 21, 1925

THE QUINN COLLECTION

A DRAMA is now being enacted in New York that vividly recalls the closing chapters of Balzac's Cousin Pons and though the *dénouement* may be reached before these lines appear in

LÉGER

DIFFERENT AS is Fernand Léger's art from Bourdelle's, the two men have this in common, both might or should have been produced by New York had not New York been so furiously engaged in living art rather than in producing it. Léger is some sort of a cubist, Bourdelle is some sort of an academician. Bourdelle is energetic enough and scientific enough to fit a sculptural ornament to the façade of the Woolworth Building; Léger speaks through a use of symbols that ought to be legible indeed to Americans, since these symbols consist for the most part of machines, the things upon which American civilization rests.

That he, a Frenchman, living in a land where machinery is still in its infancy, should so insist upon the closeness of machines to life is curious. It merely means that if we have the machines France has the artists. Here, in a town where wire ropes and pulleys cross the vision at every turn, where steam dredgers and derricks pull down and erect with incredible speed, and where automobile sirens assault the ear incessantly, you could probably still find many to oppose the notion that machines affect the soul in any way; but on the other side of the water, being subtler in expression than we are, there are scores who seem willing to speak for us, to prophesy for us and to explain us. Why, the very best thing that has ever been written on the subject, the "Love Among the Machines," by Samuel Butler, was conceived in a flash by that sensitive thinker when machines first came among us, and now that they dominate the world there remains nothing to be said save that Butler was right.

Butler's discovery didn't depress him. There is nothing depressing in the idea of machines. America, the land of machines, is not a depressing country to live in, is it? Of course not. Youth who drive motors with great speed, heads of families who tune their radios with extreme nicety and housewives who sweep their rooms with electric sweepers, are not to be commiserated, are they? Not much. But at the same

The workmanship is mechanically exact. I think that is the quality that really appeals to the public. They have always felt, for instance, that in impressionism they were not getting their money's worth. To do Mr. Manship's carvings justice it must be allowed that they are never slighted. They seem to have been created by machines and finished by machines. This, too, fits in with our modern system of living, and when the terms are applied to Mr. Manship's art it implies both re- proach and commendation. Fifty years hence, if these sculp- tures still persist, people will say "they were hard people in those days and those carvings are as hard as they were." And others will say: "They were terrible people and those sculp- tures are terrible." But the truly discerning, of whom there are always a few in any age, will say: "Those things are imitations of other artists' work, and have no connection with any period."

The portraits in the collection are amazing — they are so stilted. They lack all sense of human connivance. There is no flow in them, no motion, no vitality. They seem like curious emanations from the studio of a spirit medium, a spirit medium working, be it understood, with first class machinery. That of Dean Keppell of Columbia has a slight approach to geniality, due possibly to the warm color of the stone from which it is carved, but the effigies of Miss Carey-Thomas and Lady Cholmondeley are simply ghastly. At the same time the carefully delineated threads of individual hairs upon the heads combined with the razor edged profiles are most distinctly to the public taste. Therefore, should Mr. Manship worry? I think not.

The Sun, February 7, 1925

forth, being apparently as lively now as on the day it was applied.

The Dial, February 1925

MANSHIP'S SCULPTURE

THE SCULPTURES by Paul Manship are having their usual success in the Scott & Fowles Galleries. People like them and go in numbers to see them. This is an encouraging or discouraging fact, according to your viewpoint. I occupy a middle ground which approaches indifference, but which permits me to look at the work from two angles.

In the first place, it is always interesting to know what people like. You may pooh-hooh best sellers as much as you please, but they always indicate something. We are said as a nation to be at the present time, hard, unimaginative and lacking in subtlety. All these are outstanding traits of Mr. Manship's art, too. The parallel looks as though Mr. Manship had been holding the mirror up to nature, but that is one thing, decidedly, he doesn't do.

He is frankly archaistic. He doesn't go to life for his subjects, but to the libraries. Contemporary life or contemporary feeling, apparently, doesn't interest him in the least. The small version of "Actaeon Pursued by his Dogs" is the sort of thing our grandmothers put under glass cases and kept on the parlor table. Mr. Manship, in fact, is a modern Josiah Wedgwood. He has, I think, carried his Wedgwoodism to a higher degree of finish than the original, but that is about all. The spirit is not more animated.

code by actually picking canvases off the wall of a public gallery? You see the difficulty.

Mr. Brummer smiled at himself sub-acidly, I fancied, as he recounted his lack of success with this show, but there are some failures that are more honourable than some successes. In the end I think he will have added to his prestige with the adventure.

I ought to add, to be honest, that my own pleasure in the work is quiet. With the best will in the world I see nothing over which to make a pertinent hullabaloo. And it is the first time, too, that I have encountered a thorough exposition of the Seurat *principe*, with its rise in the quiet but good student work to the quiet masterpieces of the later years. The pleasure is that which one takes in a sober, well-made book by a real person, the sort of book one goes back to continually for steady entertainment, but which never bowls one over. Even the satire of Seurat is quiet. It is satire, of course, though the Seurat enthusiasts of my acquaintance do not dwell upon it much. They are all for the workmanship – and in Mr. Pach's case, chiefly for the link in the chain of history. The distinctly plump young woman engaged in powdering herself is seen with humour, but with the correct satirical humour that Baudelaire insists upon, that is more than half sympathy. It is indeed amazing that so enduring and architectural an arrangement can have been evolved from such contorted furniture as the young woman owns and surrounds herself with; and that the effect is not arrived at impetuously is self-evident. Every touch is calm and unhurriedly exact. In the final, best work, the Circus, which now, by the will of Mr. Quinn, goes back to the Louvre, the wit struggles through the Seurat repression to a point that is almost bitter. The Mephisto touch re-appears like a Wagnerian motif all over the canvas, not only in the moustache of the ring-master, but in the chig-non of the *equestrienne* and the traits of those attending sprites, the people of the audience. One suspects the scene to be an outside attraction at a not-too-cruel modern inferno, but those of us who are hipped on the subject of good painting are not permitted to suspect too much. We are soon seduced by the perfect balance achieved between unlikely lines and the fresh-ness of a colour which is as much a testimony to Seurat's old-fashioned thoroughness of method as anything he puts

talked us into it. Seurat didn't murder anyone nor run off with somebody's wife. He is not a figure of romance. All he did was to paint studiously a few good pictures and die young. And good pictures in America do not make their own réclame.

I can see why two classes of society "failed" with Seurat. Even to the students who acclaim him he is not a subject of debate. He is not only twenty years dead, but twenty years known. He pops up casually in studio conversations, just as Blake, Redon, or Delacroix do, to illustrate a point, but like them, he is indubitably of the past. He is not in present-day politics. He may prove, for historians, the line of succession from Cézanne to Picasso and Braque, but what our talkers desire to know is who is to do the bridging out from Picasso and Braque into the future. They hustled up quickly enough last year to Wildenstein's to see the Greek Picassos, for it seemed likely, then, that they would all have to turn Greek, for they know quite definitely that when they do turn it will not be for a mere matter of twenty years backward. So much for our students.

The other reason is more delicate. Perhaps I shouldn't mention it. I have a disturbing fear it was given me by one of our great picture dealers in strictest confidence. But on my life I cannot recollect which art-dealer! So I'll chance it. Besides, sooner or later, you'd have to know it anyway. It seems that great classic art is no longer sold in public in America. Everything is done secretly. When the picture has been surreptitiously acquired then the great millionaires are let in singly to view it. If persuaded that no other millionaire has cast eyes upon the chef-d'oeuvre in question he buys it instantly. If not so persuaded, everything is off, the millionaire departs in a huff, and the Rembrandt, or whatever it is, is taboo. It is either deposited in the ash-can or presented, with the dealer's compliments, to some western museum. Why this should be so I cannot fathom. It is millionaire psychology, however, and it is only because I am not a millionaire that I do not understand it. But with such a state of affairs in this country you can see why nobody asked the price of the Seurats. Seurat is not a fresh discovery of the long-haired students, to be gobbled up instantly by the half-dozen who like to be in on the first of everything, and he must appeal, if he is to appeal at all, to the wealthy acquirers of classic art — and how could these formal connoisseurs violate their own

permanent material is the most disconcerting fact that his biographers have supplied.

The Dial, January 1925

SEURAT

THE BEST exhibition in town passes unnoticed. A percentage of the connoisseurs, those most closely allied with current affairs in Paris, have seen the Seurat paintings in the Joseph Brummer Galleries, but the public has been unaware. Four of the more important canvases are lent by the estate of the late John Quinn, but most of the works have been brought from France. They are for sale, but in the third week of the show Mr. Brummer reports that not a single individual has inquired a price. In a land were money speaks, so deep a silence is significant of much. Mr. Brummer is a shrewd man, shrewd in judging pictures and shrewd in judging men, yet he is frankly puzzled – as well he may be. Seurat, now, is an acknowledged European master and a rare one. The total number of paintings is not large and the first American exhibition of the work might reasonably have been imagined creating a flurry, yet the Hudson River was never for a moment in danger of conflagration. If anything, it froze.

Looking at the matter now with hind-sight, I find that our public, after all, ran true to form. The pictures are small, they are not new, they are quiet. How raise a sensation over things so essentially unsensational? Who is there here who buys a picture as a woman does a hat in a shop, because it has suddenly become a soul-necessity? No one. We buy because "the others" are buying or because some unevadable salesman has

their London success in 1915, but the getting to America of heavy sculptures, always a hazardous matter, was doubly so in war times, and no one was willing to undertake the affair. Now that they are come and duly installed in a museum gallery one must wonder that there was enterprise enough in a public institution to induce these works of art in this direction, for there are over one hundred pieces and many of them are very large. In a vague way one hopes that all monies expended in the cause of art will not be expended in vain even when expended in causes with which one is not wholly in sympathy, and one trusts that the Brooklyn Museum will be recompensed for the present severe strain upon its purse. But how? Only the Lord in Heaven knows. The public, I think, can be persuaded to visit the show in large numbers. I have done my best in the columns of the daily press to encourage an exodus from New York to Brooklyn and Brooklyn itself always turns out well for its own shows no matter what they are; so the public, I think, will see them. But will they buy? Ah, that's the rub. How can they? They really are so big, these sculptures! We have no church anywhere that could support Mr. Mestrovic's big figure of Christ in wood. An enthusiast said, "Well then, we should build a church that would hold it." I regret that I cannot share in that feeling. It is charming to have enthusiasms, but the populace doesn't have to justify itself for its furores and I do. I think, however, though we needn't build a cathedral for Mr. Mestrovic — we are having a slow enough time, as it is, Heaven knows, building St. John's — we might purchase a few of his things, and since private citizens cannot possibly get them into the sitting-rooms of the tiny apartments in which they are obliged to live, it seems to be up to the several museums to purchase a few. Also the various Jugoslav Societies in the various cities might help, as anything that happens in this line redounds to the glory of the new state. If I seem to take a light tone in this matter it is in perverse reaction, no doubt, to the too extravagant claims. Something had been said about Michael Angelo. Mr. Mestrovic is by no means a Michael Angelo, though he is Michael Angelesque. He is a good sculptor, one of the best of the exotic band to come here since the war, and he is serious. He is serious, but not profound. How could he be, working at that speed? Sculptures do not make themselves even in these days of mechanical aid and that a man of forty should already have carved 240 ideas into

intellectualism which was also in evidence. Instead there
is to be found the most delightful ease in painting to be en-
countered anywhere in the modern world. Young people say
he is our Rubens and I find nothing objectionable in the
phrase, particularly since I am one of those to whom the paint-
ing only in Rubens appeals. Rubens as a searcher of the soul,
or even as historian, leaves me cold. Matisse, in spite of his fa-
mous casualness as to subject, holds the mirror much more
firmly up to nature. I don't think he plunges to the depths,
however. He is not of the École Rembrandt. The soul is not
much more to him than it is to Rubens. But he at least gives
you its cadre. He is French, so very French. As French as
Chardin. A Chardin up-to-date. He dares to give you the bad
taste of the contemporary French scene. A positive smell of
chicory emanates from his canvases. The small-minded at first
thought this a treachery, but it is not. It is purest patriotism.
Only when faults are loved is the genuine affection reached.
These stuffy interiors of Matisse are killingly funny and at
the same time ineffably dear to those who know the bourgeoi-
sie upon which French civilization rests. And how superbly
are they rendered! Really, after all, the association of names
is a compliment to Rubens. Where in his work can you find
things so smashingly presented? And where anywhere is
such amazing energy attuned to such equally amazing deli-
cacy? I have no words with which to express my contentment
with the new kind of precision in values to be observed in
one of the interiors now shown. The room in nature must
have been a scream. A red and white striped table cover which
comes into terrific collision with a frightfully red rug and
turned, in this picture, into captivating wit by the adroit
brush of the artist! The stripes on the table-cloth alone vindi-
cate the doctrine elucidated from St. Matthew, 18:3. The
scholastic would carefully rule such lines and have them
exactly meet the down stripes at the edge of the table. But
not so Matisse. With an infant's wild abandon he lets the
meeting of the stripes occur as they will, and miraculously an
emphatic effect of nature comes to pass. The edge of that
table is masterly. Go see it, Philistines, and repent ye, ere it is
too late.

The exhibition of Mestrovic sculptures in the Brooklyn
Museum is stupendous in at least one thing — size. There was
a widespread desire to inspect these carvings at the time of

past. We glory in the excesses of our ancestors, even in their orgies of bad taste. Soon we shall be allowed to laugh at our present. Then, intellectually, we shall have arrived and satire will be possible. At present is is a penitentiary offense.

The Sun, October 25, 1924

MATISSE AND MESTROVIC

MATISSE ASCENDS the social scale in New York. That is to say he ascends the financial scale, the social and financial circles being so closely allied that the terms used in both are practically synonymous. The exhibition of his recent paintings in the Fearon Galleries indicates that his work now has marketable value. This quite apart from the actual prices that are asked and which are said not to be excessive – to be, in fact, French prices. For the Fearon Galleries aim for the Duveen, Knoedler, Scott and Fowles standards and eschew the experimental. In other words, Matisse approaches being considered "safe." Well, it is high time. In Europe he is no longer an argument. The irritation that existed in the early years against a recognized draughtsman who appeared to throw draughtsmanship overboard vanished as it gradually dawned upon the scandalized that, so far from throwing anything overboard he had actually added ballast to his equipment as an artist. To see freshly was the aim, and it must be allowed that there was disturbing consciousness in the early efforts to become as a little child. New York Philistines in considerable numbers, ten years behind their French brethren, are still shrieking "insincere," which is all nonsense. The consciousness, which was slight anyway, has long since disappeared, as well as the

But that would merely be impatience upon their part. There is lots of time yet for greatness, and in the meantime I think it pretty fine that Mr. Hopper should be interesting.

It is impossible, for instance, for the observer who views everything to ignore the fact that Mr. Hopper in his new drawings enrolls himself in a school that appears to be in process of developing and of which at present Mr. Charles Burchfield seems to be the head. It has been pointed out already that in the etchings this artist noted that however squalid the slums might be they still had the power to suggest beauty to an artist. He was not, however, stirred to passion or noble thinking by this discovery. In the present series of water colors the same feeling enables him to be forcefully eloquent upon the hitherto concealed beauty of some supposedly hideous buildings built during the Garfield administration. The dwellings, in fact, are hideous, and people of sensibility were quite justified in shuddering when they passed these relics of a dark era in American history upon the streets of Gloucester, although now that an artist has known how to extract beauty from them there will no doubt be a temptation to view them with affection.

Mr. Hopper is not as savage to Gloucester as Mr. Burchfield was to Salem, Ohio. He does not mock. He does not rant. He merely joins, and with more vehemence than most, in the cult that has restored the mid-Victorian forms to our hearts. The painted Windsor chairs, the New England hook rugs — the cruder the better — are part of the general movement. The first bitter drawings that Mr. Burchfield showed here had the appearance of having been torn from the bosom of a man suffering past endurance, lost to all sense of shame, indifferent to the opinions of bystanders. It is quite possible that Mr. Hopper has never seen Mr. Burchfield's drawings, for from the very beginning his attitude to life has been that he now discloses with increased freedom in his water colors; but on the other hand the shocks that have been received from Mr. Burchfield's ruder work and that compelled a frightened public to think have blazed a way for all sorts of freedoms — and in particular have presented our starving artists with a lot of new themes.

The chief matter for congratulation in all this is the broadening out that our collectors have been forced to take. We arrive at the point where we dare to make fun of our

HOPPER'S WATERCOLORS

THE STUDENT who not only weighs positive achievement but the possibilities for future achievement must have looked upon the etched work of Edward Hopper with respect from the beginning. It had its crudities but it was always honest. Mr. Hopper never succeeded in uniting himself as with hoops of steel to the life of the poor people upon whom he gazed from his studio windows — studios in Washington Square are admirably placed to induce broadmindedness upon the part of their occupants — but there was no question as to the sympathy he expended upon them. He was not a Millet agonizing over the injustices of the peasants, but he was sincerely sorry for their lot and incidentally noted that it had its picturesque moments.

The something that turns an honest recorder into an inspired one had not occurred to him. The assurance that can be felt in a first rate Seymour-Haden etching was not Mr. Hopper's, neither in the identification with the subject nor in an abandonment to the eloquence of the etched line. But this undeniable honesty of his, if not the whole of genius, is at least a long step toward it and predisposed most of the critics to be his friend.

All of these latter will now be gratified by a little exploit of Mr. Hopper's in another medium, water color, in which he appears to plunge forward. He doesn't plunge quite to absolute greatness, but he advances to a position where others than hopeful critics must consider him. In other words, he engages the attention of collectors and the public in general. In the F. K. M. Rehn Galleries the group of studies made by Mr. Hopper last summer in Gloucester, Mass., have not only aroused Mr. Rehn to a pitch beyond his usual enthusiasm, which is always considerable, but has so excited his clients that at this writing more than half the water colors have been sold.

These purchasers may think my own enthusiasm, which is also considerable, is, in spite of its quantity, coolish in quality, due to the fact that I insist on absolute greatness.

worth drawing properly, and the less said about the arms that hold the immense fan the better. A social register, however, is a not unuseful achievement. It has been remarked that the historians who accuse Horace Walpole of light-mindedness quote more steadily from him than from any other Englishman of his time. Without pretending that Mr. Sargent spoke for his 'nineties with the authority of a Walpole — for Horace occasionally looked below the surface and plumbed depths — nevertheless the record he accomplished makes a vivacious accompaniment to the histories of the two decades — the 'eighties and 'nineties — that are now being rounded out by the recent critics into an appreciable period.

It is not deep work. It is not finished work. In one technical feature, and in only one, it is first-rate. The "values" everywhere are unerring and superb. The colour used in the interiors is acceptable but undistinguished. The colour in the outdoor things is commonplace; in fact Mr. Sargent's whole point of view towards landscape is commonplace in the extreme. And finally, the drawing is uncertain. Everywhere in the New York exhibition we see arms that are awkwardly attached to torsos, and torsos that lack the support of legs. Even the Higginson ears lapse out of construction! In a loftier form of arm, errors of hand can easily be overlooked; but here where everything is passionless and superficial, the very great brush dexterity that is held out to us as a recompense is not enough. Not enough at least to enchain permanent interest.

I ought to add, I suppose, for those who like concrete statements, that I infinitely prefer Sargent to Sir Thomas Lawrence, but that I rate him well below Manet, Cézanne, Reynolds, and Gainsborough.

The Dial, May 1924

we have improved upon the model then extant in the way of
world leaders. We seldom betray impatience at the impor-
tunate princes and lesser nobles that now besiege our doors;
and as a rule we are uncritically willing to know and to feed
them. In the rush of accommodation to the new life, there is
little chance to indulge in our old vice of introspection; but
occasionally at odd moments we do recall the time when any
European had it in him to make us feel second-class. Be-
tween the Daisy Miller who had the "tournure of a princess"
and was so pitiably unable to cope with a hotel courier, and
the Newport ladies in The International Episode who so un-
accountably crumbled in the presence of a duchess, there is
not now, we recollect with astonishment, so very much to
choose. Indeed the average citizen of to-day is altogether
likely to agree with Mr. Howells in thinking Daisy Miller a
"supreme effect of the American attitude towards woman-
hood" and in considering the Newport ladies cheap. Their
failure certainly was a less bearable kind than Daisy Miller's.
Some of the stain left by this and all of Henry James' later
accusations against us is what the current exhibition dissi-
pates.

I don't suppose the gratification is a deep one — how could
it be in the intoxication that sweeps New York at present? —
but it nevertheless soothes in the midst of so many new dis-
tractions to discover that even a generation ago we were not
so bad. It is as though a *parvenu* were to be unexpectedly
blessed with a grandfather. In this case one should say grand-
mother, since it is the elderly women in the show who do us
proud. The men, with the single exception of Mr. Joseph
Pulitzer, all go to pieces as human beings, but several of the
old ladies are to be seen spiritually intact, and, as though
that were not enough, nicely costumed. The Victorian and
Second Empire dowagers really had nothing on Mr. Sargent's
examples whatsoever; and seeing this, it is all the more sur-
prising that the daughters, several of whom are prettily in-
dicated by the artist, should have undergone the European
abasements that Henry James said they did. It is as a sort of
social register that Mr. Sargent succeeds. His sensitiveness to
scale is amusingly illustrated in his portrait of dear Ada Re-
han, who it now appears, was not — how shall I say it? — not
quite a lady — and not being a lady therefore not interesting,
or at least, not to Mr. Sargent. He scarcely considered her

But that remark brings me with a jump to the present-day aspects of Mr. Sargent's art and — as the space at my command has a tendency to evaporate — I fear I must postpone a consideration of them for another occasion. The present exhibition undoubtedly invites appraisals, and as a hint of my feeling, which I may elaborate later, I must confess that Sargent, though not exactly a God, is secure enough of a place in the American heaven.

The Dial, April 1924

MORE ON THE SARGENT
RETROSPECTIVE

AS NEARLY as one may dissect the pleasure that a portion of the community takes in the Sargent exhibition, which is still charming dollars from pockets unaccustomed to paying dollars for art exhibitions, it lies in a pleased surprise at the good appearance we make. We are, or we were in the 'nineties, in better form than we suspected. At the present day form, as far as I can make out, is not much of a preoccupation with many people — the war seems to have dissolved form — yet even in the hilarity of our new prosperity it is apparent that the tradition of "quality" is not quite so dead but that surviving members of the former cult may réchauffer themselves at such embers of it as Mr. Sargent's art provides.

We have all, of course, with great readiness, accustomed ourselves to the *rôles* that fate has recently thrust upon us. We not only submit to, but enjoy, being grandees; and, recalling some of our experiences of a dozen years ago, rather think

body now damns rather than crowns. But in Sargent's day it was different. He had the supreme advantage of having parents who had undertaken the grand tour, and was actually born abroad upon one of their quests – and hence, came into the world upon the ground floor, so to speak, of cosmopolitanism. This gave him an advantage over the Henry James of thirty years ago that only the Henry Jameses could appreciate. When he had finished his studies with that archmountebank, Carolus Duran, Sargent was prepared to astonish the world, and did. Never, in my time, has an artist been so petted as he. You see, his public was being educated for him by the others, and from the apparition of that startling but dubious Mme X, down to the appearance of the tall, thin "Stokeses," there was never a question but that with him we had reached the apogee of the arts. I shall never forget the excitements of those early first appearances. For days before the public exhibitions rumours that had leaked out from the jury rooms whetted the appetites of amateurs and when the chefs-d' oeuvre were finally disclosed the public undissentingly rose to them. The little Beatrice Goelet was "far and away beyond the Velásquez Infanta in the Louvre," which it vaguely resembled; the Carmencita completely "put the kybosh" – I believe that was the term – "upon anything that Frans Hals ever did"; et cetera, et cetera. For the tall, thin Stokeses, doubts leavened the praise; for at that time the terrific tallnesses and thinnesses of El Greco had not so fully been recognized as great art as later they were, and the only thought that occurred to the innocents of the 'nineties was that perhaps Mr. Sargent didn't like the Stokeses and was exaggerating on purpose. However the public still clung to him. There was a great desire to be done. To be painted by Sargent distinctly helped socially and when this was realized the final débâcle could have been foretold had clever clairvoyants been consulted. There was a rumour one autumn that Sargent had dashed over from London to do sixteen portraits in sixteen weeks for five thousand dollars each. Whether hands were included for the five thousand I do not know, but I suppose not, for hands were a trial to this artist and he had frequent agonies over them. Even in the present exhibition hand trouble is everywhere in evidence – and that is one of the things that makes one smile in thinking of the old-time boast that at last we had excelled Frans Hals!

recently imported Maillol bronzes and Henri Rousseau paint-
ings, all in one afternoon and found it somewhat of a gulp,
consoling myself with the reflection that after all my pace in
New York could have been no swifter than the late King Ed-
ward's in Paris on the famous occasion of his doing both
salons on the same day with a state luncheon between. How-
ever, of course, King Edward was not obliged to deduce morals.
Well, I shall not deduce many.

Sargent has been out of the public eye for such a long
time that he seems like a new thing. The present collection,
chosen in the main, by the artist himself from his available
works, lacks certain noisily acclaimed portraits, such as the
Wertheimer series now in the National Gallery, the Car-
mencita, now in the Luxembourg, and the little Beatrice
Goelet, but on the whole makes the case as strong for Sargent
as it can be done upon this side of the water.

And will it have all of its old-time effect? Hardly. The
times and manners have changed once again. There is nothing
in the atmosphere of the age to back Sargent up. The fabric
he created for us still dazzles here and there, but in places
it has been worn thin. Perhaps some of the survivors among
the former enthusiasts of twenty years ago may catch again
at the thrill that comes from seeing a gentleman's gold watch-
chain made manifest by three dabs of a brush — but not all. In
the long run tricks tire and it is only the soul that counts, in
art as in life.

In the pre-Sargent era, throughout all our land there was
a craze for technique as such — born of the sudden realization
that our cherished Hudson River school of landscapists lacked
style — and it was supposed that certain masters in Europe,
and only those of Europe, could impart the secrets of true
painting. The crush of the 'eighties and 'nineties to acquire *ton*
now seems pathetic, for though the trans-Atlantic lines con-
tinue to flourish, the attitude of the travellers has undergone
a change. Then artists were humble, submissive, and dutiful;
and Bouguereau, Gérôme, and Bonnat were listened to, and as
far as possible, imitated. Now, students go to France for the
Quat z'Arts ball, for the Café du Dôme, and perhaps, though
not necessarily, for a glance at the Louvre. They have no
definite master in view and no longer hope to join the trade
union that used to sign in the catalogues with pride, "pupil
of Juliens," "pupil of Piloty," et cetera. To be a pupil of any-

really excellent, with a relentless, Roman tendency to squeeze every inch of the modeling into character. It is entirely worthy of the man who did the etchings and seems to insist that he had the inner, essential type of greatness that would have been fine in any form of expression. Much of the same kind of force radiates from the Lieut. Hulme head, but the effigy of Lord Fisher leaves one doubting, just as the splurgy, gaseous individual himself did. It is unquestionably, however, something to be preserved, if for nothing else then as an aid to historians in solving the riddle that this curious war lord posed. But who is to preserve the distorted, affected portraits of the duchesses? Not I.

The Sun, April 19, 1924

A SARGENT RETROSPECTIVE

TWO SHOWS have attracted crowds; the John Singer Sargent retrospective in the Grand Central Galleries and the J. M. Sert decorations at Wildenstein's. The Sargent crowds I take on hearsay, having been permitted an early private view of the paintings and so not having been obliged to be one of the ten thousand at the *vernissage;* but the Sert crowds I saw with my own eyes and I can certify that they were indeed immense, richly apparelled, and awaited without by motors, but in the end as completely flabbergasted by M. Sert's art as though they had not been awaited without by motors. I mean to go again, of course, to the Sargent rooms, just as soon as I get my breath, for next to seeing how I take pictures myself I dearly love to see how others take them. I had taken the Sargents, the new John Marin water-colours at Montross', the

of his name. There's something about it which is . . . I can only describe it as teleological, you know, culminant. Cézanne never would have happened without it. Then there's Gaudier-Brzeska, what? And Zadkine.' "

" 'What about Epstein, then?' somebody murmured interestedly.

" 'Exactly,' said Brawn. 'That's just what's wrong with Epstein. There's always an unappeased aspiration in Epstein. It's the ghost of the "z" haunting him. Haven't I always said that Epstein lacks — how can I put it? — teleology; culminance, if you like.' "

To the hard boiled American, Epstein lacks several things besides the unappeased aspirate, and among them is the faculty for being sincere. Sincerity may be out of date in London, but it still goes here — and reputations may be founded upon it alone. Without it the individual himself must put in an appearance and perform antics for us. The London gestures of Epstein have never quite taken on meaning at this great distance, nor, in consequence, have his works of art.

The present show of his carvings in the Scott & Fowles Galleries provokes the query as to the form this talent would have assumed had it developed in New York rather than in London. It is positively certain that it would have been un-recognizedly different. Epstein is undoubtedly clever. He knows form and how to manipulate clay, but his inner urge is merely to supply a demand. London likes to be astonished and is easily astonished, so in every exhibition in London, this sculptor puts forward a cheeky portrait of a duchess or an archaistic Christ, and immediately brings down the house. Catering to cheap applause has finally produced a style that is ruinously fatuous.

Whether Epstein could ever have been great is a matter that is ready for investigation. Doubtless the individual that would sell out to the wrong set in London would have sold out to the wrong set in New York. What in the mean time "makes the judicious grieve," as the phrase goes, is the fact that several pieces in his present display prove the talent that has already been admitted, and point the way to the greater success that might have been this sculptor's.

These are the bronze heads of Muirhead Bone and the late Lieut. T. E. Hulme, and to a lesser degree the heads of Augustus John and Lord Fisher. The Muirhead Bone head is

later on New York City, thus having a career? Or had his bolt been shot at Salem, Ohio? No one could say. Time alone could tell.

One glance at the new set of drawings now exposed in the Montross Galleries and we are reassured. The Burchfield talent is intact; nay, more undeniable than before. The ferocity and mockery are undiminished, and in addition there is a hint of a developing macabre along Poesque lines. In the way of treatment some of these water colors have been varnished. Isn't that terrible? No, it isn't. We had that out with Mr. Burchfield once before and Mr. Burchfield won. Henceforth, he can do as he likes. He can violate the old medium all he wants to as far as I am concerned. I intend to stay with him to the end.

But it is grand to think he hates Buffalo, N.Y., and is unfussed by fame. That was the great danger in capitulating to him that other time. Advice and adulation pour in upon a painter once he is publicly praised and often corrupt him. It appears this man is not that sort. Doubtless, like Turner, he doesn't read art criticisms; and at any rate hoping he doesn't, I have ventured this time to give way to my enthusiasm, for I don't wish to be the one to spoil him.

The Sun, March 22, 1924

JACOB EPSTEIN AND SINCERITY

IN THE very latest best selling type of satirical romance to reach these shores from London, called "Seacoasts of Bohemia," one of the heroes changes his name from Bloggs to Czkvmzl and immediately achieves the fierce light of publicity.

"'It's the "z," I think,' said Brawn, 'which is the keynote

until it hurts. He is less careful of our feelings than was the late J. N. Synge of those of the people of the Aran Islands. We might as well be the bones and shreds of the extinct Aztecs for all he cares. But how splendidly he lays out the remains! After all, it's art! Vive art! And vive America, for Mr. Burchfield is one of us. The phenomenon of a genius at work is to be observed in these States. "Take notice Europe," as Ralph Waldo approximately said years ago upon a similar occasion, "Unto Us a Man Is Born."

Mr. Burchfield is the artist who burst upon us some seasons ago with drawings that seemed to publish an extraordinary distaste for life as it is lived in Salem, Ohio. Mr. Burchfield seethed with rebellion or allowed himself to become the mouthpiece of those who did seethe with rebellion, at the miserable shanties and unlovely conditions in the small town where he lived. He mocked with a venom and a ferocity that Dean Swift himself might have envied, at the decay of the machine made dwellings, at the hideous corrugated iron shops, and above all at the terrible railway which drove relentlessly and implacably ahead and provided no escape from the hell that was Salem, Ohio.

These drawings were songs of hate. Furthermore they violated all the rules of polite water colorers. Water color is a medium that is supposed to have, like all other nice mediums, certain well defined limitations. Mr. Burchfield ignored these rules. He used gouache indecently. He drew in sizes that almost compared with the spring circus posters in the town he despised. But, que voulez vous? The man had genius. We squirmed in anguish for a while at the mirror thus held up to nature, and for a while we were tempted to shout, "Kill him! Crucify him!" but in the end, que voulez vous, art is stronger even than human nature, and we succumbed; and so strange is the psychology of admiration that instantly we began searching about for a pedestal for the artist, realizing that he is one of the great people of the land. Also a peculiar but secret relish for the horrors of Salem, Ohio, developed. The gigantic anything, even a gigantic horror, has its interest for Americans.

But, naturally, the place became too hot for Mr. Burchfield. He moved to Buffalo, N.Y. From the point of view of art, this seemed a tragic necessity. Mr. Burchfield's art was founded upon hate. Could he loathe increasingly Buffalo, and

BURCHFIELD

*"Then to the real artist in humanity what are
called bad manners are often the most
picturesque and significant of all."*
—WALT WHITMAN *in "Specimen Days & Collect."*

FROM THE trooping throng of attractions that the art galleries
have let loose this week upon an expectant city the water
color drawings of Charles Burchfield at Montross's seem most
potent in enchaining the eye, for Mr. Burchfield speaks
through the eye to the new patriotism that some of us feel
expanding in our midst.

Patriotism, I trust, is no new thing, and especially not
to readers, of THE SUN (to whom my salutations), but it can
scarcely be denied that an awakening has been brought about
among the young people by the great war and that their in-
stinctive detachment from the ideals of Europe has caused
them to look with a certain freshness of vision upon our own
assets that shall be realizable in art.

In this sudden closing in of horizons the coast lines, for
the first time in our history, lost themselves in mist, and a
fierce spotlight, directed by some one in Chicago, it is sus-
pected, called attention to the marvelous possibilities in the
soils of Illinois, Nebraska and the other middle States. The
writers, led by Mr. Sherwood Anderson, made frantic rush to
embalm the vegetations of those parts — some scoffers in the
East still call them weeds — in literature, but so feverish were
they that oftentimes the outlines in their studies became
blurred.

It is a pleasure to state that in the art of Mr. Burchfield —
the first artist to take an authoritative position in the mid-
Americas — the outlines are now blurred. Oh, look at these
drawings, Mr. Sherwood Anderson, Mr. Carl Sandburg and
Mr. Edgar Lee Masters, and take heart of courage. Here is
what you have been after. Are they not you all over? Whole
volumes in each one, complete, unflinching, wonderful, hor-
rible and very good art.

Mr. Burchfield is the sort of genius that communities
usually massacre and then afterward revere. He tells the truth

191

pute grew cold the picture was sold at a gratifying price to some one in the West, it was rumored, and after a tour to Chicago and other places retired to private life.

And now it comes again. And strangely enough, considering the uproar that once there was, it comes quietly and will be viewed quietly. This picture and the others by Picasso, Braque and De Zayas already have the air of classics. They are painted in reticent grays and browns and the whole atmosphere of the rooms has become thoughtful and serious.

So much for the processes of time! It is strange how dreadful a mere idea can be to those unaccustomed to ideas, and it is strange also how innocent the monster may become when robbed of unfamiliarity. The timid, or the perverse, may immediately jump to the thought that monsters, as such, are recommended. Not at all. The occasion merely serves once again to illustrate how fatal a bad prejudice is to the arts. It is not that the startling thing is necessarily good but that the startling thing is not necessarily bad.

The "crime" that the Messrs. Picasso, Braque and Duchamp committed was to speak to the imagination in the terms of the painter's language. No one ever supposed that the book and the bell and the candle, or the lemon, banana and peach, of the former generation's still lifes, had anything sacred in themselves — it was merely the style of the painter who happened to see something in them that counted. The new men merely put into practice the theory that Whistler preached and added a few new angles from their own experiences and the text books of the scientists — and scandalized the world.

The fact that this revulsion from the subject occurred at the time of the great war gives it a significance that it might not have had in times of peace, and we may be sure that the psychologists of the future will be most illuminating in their efforts to coordinate it with the other soul manifestations of the period.

In the meantime, as I said, it is most quiet and reposeful; and the average student of to-day who has already discounted the fierce attacks with which abstract art was greeted at first, will accept it easily enough for its decorative and other qualities.

The New York Herald, March 9, 1924

REAPPEARANCE OF DUCHAMP'S

"NUDE DESCENDING A STAIRCASE"

A PAINTING which perhaps more than any other has caused Americans to spill ink is again visible in our midst. This is the famous "Nude Descending the Staircase," by Marcel Duchamp, and it reappears in the Whitney Studio Club exhibition arranged by Mr. Charles Sheeler from the works of Marcel Duchamp, Pablo Picasso, Georges Braque and Marius de Zayas.

This picture was undoubtedly the star piece in the historic and sensational "Armory" exhibition of long ago. It was very well placed in the collection that set the entire United States once by the ears. Everywhere in the vast galleries were works of art that were calculated to start the placid and the sluggish to thinking, and the cumulative effects of so many cerebral shocks become unbearable at the far end of the Armory where Mr. Duchamp's painting hung.

A sort of locomotor ataxia developed and people could not or would not go further. They crowded about the picture shrieking for help. "What does it mean?" cried they, and the voices of those who tried to answer were drowned in loud choruses of "Noes." More "Noes" than anything else were heard. "No, I refuse to admit —" "This is too much," &c., &c.

To add to the confusion certain clergymen were found who declared that this picture, which purported to render the sensations of an individual descending a stairway conveyed a great moral lesson, and certain other clergymen were found who declared that the painting conveyed just the opposite effect. The wits reveled in this supposed challenge to their powers, and for two or three months there were endless bon mots on the subject. About the best, it was generally agreed, was somebody's definition that the picture represented "an explosion in a shingle factory."

This was repeated to one so often that finally it became unbearable and had as much to do as anything else with the shelving of this particular discussion. But long before the dis-

money on him, but I prefer to believe that it was merely be-
cause those cursed rules of Hambidge got in the way again of
the composition. Mr. Dempsey is over modeled. The shadows
on his body are not transparent enough. I did not see the
actual fight. I was hundreds of miles away in the wilds of
Pennsylvania listening to a befuddled radio man's frenzied ac-
cents, but I know enough of fights to know that Mr. Dempsey
must have seemed a dazzling mass of white suddenly flung
down on those black coats by the ringside. And if he weren't
at least he should have been in the picture, for pictures have
rules of their own, and Mr. Dempsey, though knocked through
the ropes, is still of the highest importance. Some of the prints
vary. In some Dempsey is quite in shadow, though even in the
clearest versions he does not count as he should in the com-
position.

Then the gesture of the referee is quite silly, I think.
Whether he is issuing commands or counting time, I do not
know, but it is inconceivable that he should be giving orders
already since it is still in the infinitesimal fraction of time in
which Dempsey is falling, as is indicated by the champion's
lifted leg. Although by all accounts "pandemonium reigned,"
I'm sure that referee had at least half a second of complete
petrifaction. At any rate, I don't like that gesture. And I don't
like the man who supports Dempsey. He seems to turn his
head away as though doing a simple gymnastic feat. He must
have been quite huddled against Dempsey to have rendered him
service. But there again the artist refused to allow his imagina-
tion to work in order to apply his rules for composing. As a
matter of fact, there are too many lines curving in the same
direction in just that part of the picture. And all the bystanders
seem to be saying, "Oh." Friends of mine who were there say
they said all sorts of things.

These few strictures upon an admittedly successful print
are to be understood as good natured. A print is not much good
that does not make people talk, and mine is just part of the
talk. The lithograph as a whole is a highly commendable un-
dertaking, and collectors who ignore it, in my opinion, will not
be wise.

The New York Herald, February 17, 1924

By "the most willing admirer," of course, I refer to myself. I am an easy admirer. I do not demand the impossible nor expect perfection, and often accept works of art only one-third of which may be said to be illuminated by the divine spark. But some touch of rapture, however slight, I must have.

So even in the new Bellows lithograph of the Firpo-Dempsey fight, which I mean to recommend to collectors, there are things which I have to brush aside and which I wish were not there. This print, which was issued a short time ago at $40, is already selling for $65 and is bound to go higher. Why shouldn't it? It is a stirring account of the most lively prize fight that ever occurred, and even were it by a less capable draftsman than it is it would still be a wonderful souvenir of a historic occasion. Money "values" are so distinct from artistic "values" that though Mr. Bellows has achieved more completely successful prize fights than this the "Firpo-Dempsey," for the association's sake, must take precedence of them.

Were sporting gentlemen aware of its existence they would doubtless exhaust the edition instantly, and it's a pity they cannot be first in on it, but the chances are that the investment seekers on the spot will get there before them. By way of solace I can at least print a reproduction on this page and will have a great curiosity myself to know what fight experts think of it. In particular, I hope the Messrs. McGeehan and Trumbull of the *New York Herald*'s staff will cast their eyes upon it and report.

Sportsmen in general, I suppose, will yearn for a little more precision in the likenesses, but Mr. Bellows's evasions in that line do not disturb me, for in the startling moment he chose to represent – that moment in which the fistic idol of Americans went crashing through the ropes – there was no time to observe eyelashes. There is no doubt, however, as to which is which. Firpo stands erect, conqueringly, with legs far apart upon a true Hambidgian triangle.

Firpo, artistically speaking, is eminently satisfactory, and so is Mr. Bellows's arrangement of the ringside ropes, and so is the point from which he chose to view the "disaster." But Dempsey, still from the point of view of art, could be ever so much better; and so could be the referee and the bystanders.

In fact Mr. Bellows was quite confused about the champion. Betting men will think, of course, that if the artist got flustered about Dempsey it must simply have been that he had

against these space enhancing glasses. It is quite in King Ludwig's best vein. Indeed that monarch never managed to lay his hands upon anything half so fairylike. The maquette that displays this tour de force in decoration is sure to impress our designers profoundly. But must it be imitated?

The New York Herald, February 3, 1924

LITHOGRAPHS BY BELLOWS

THIRD IN the sequence of recent exhibitions of the work of Mr. George Bellows, and by far the best, is the present collection of this artist's lithographs in the gallery of Mrs. Albert Sterner. In this medium Mr. Bellows's uncertain muse seems to feel more at home and to move about in it with greater ease and more frequent success than in any other that he employs. One is tempted to put this production at the head of the American black and white work of the period, and one would do so unhesitatingly and with a sense that it is a once for all rating were it not for the challenge that Mr. Boardman Robinson makes for this first position. But there is no denying that Mr. Bellows is the harder worker of the two and by far the more secure in popular favor.

Mr. Robinson is seldom in difficulties with the critics, however, while Mr. Bellows almost always is. The reason is that Mr. Robinson relegates technic to the second plan – or rather has mastered technic sufficiently to relegate it to the second plan – and the spectator is confronted instantly with the idea; whereas Mr. Bellows's technic sticks right out in front and the most willing admirer is obliged to wave aside certain awkwardnesses and confusions before arriving at the part that pleases.

in the Louvre looks faded and washed out beside these daz-
zling panels for the King of Spain and these others for his
Majesty's brilliant contemporary who lives at Palm Beach.

The advent of M. Sert to New York — Sheriff Bob Chan-
ler's home town — is wonderful but disturbing. One simply
cannot take these extraordinary panels and talk in the usual
way about chiaroscuro and all that rot. In spite of oneself
one thinks millionaire thoughts. How precarious it is to be
very rich! What extraordinary devoirs confront one! How
inevitably we approach the Louis Quatorze stuff.

And how necessary it is that we should be secret about it.
If the populace only had some sense, which of course it never
has, it would see that all these things in the end are for it.
The King and Queen do not keep a gilt rococo carriage with
silver haired lackeys on the back step for their own pleasure
by any manner of means, but just the moment that the price
of bread advances then all the barbarians begin shouting out
about the gilt carriage. But heavens, where am I? I think,
upon the whole, that it will be much safer to take up the
chiaroscuro aspect of M. Sert's art.

M. Sert's panels for the King of Spain were intended to
serve two purposes, to be designs for tapestries and to be
murals in themselves. The subjects glorify the market fairs of
Spain and nothing so opulent in the way of painting has come
out of Spain in recent years. The colors have a Ruben's clarity
that gives every indication of lasting intact, and our artists
will be sure to inspect them closely.

The maquettes of some of the most talked of of Mr.
Sert's European rooms, will also be closely inspected; and here
another fear unveils itself. We have an almost unconquerable
impulse in this country to do things in quantity. Now the ball-
room of Sir Philip Sassoon is quite safe in London, but not at
all safe here. We have such institutions as the movies. We
have the Follies and we have extravagant dance halls that can
get up startling imitations of things. How wrong it would be
were a dozen duplicate Sassoon ballrooms to confront us at
every turn. And what is to be done to prevent such a catastro-
phe? I ask you.

The ballroom of Sir Philip Sassoon must be M. Sert's
masterpiece. In it he destroys architecture by means of mir-
rors at the corners of the walls and ceilings and in various
places, and the romantic scene of his fancy erects itself

thought of composition, all thought of drawing and yielded himself unreservedly to the subject at hand he would be infinitely better off. As it is he cannot detach himself enough from the masters to be one himself. At the reception the ominous word "Goya" was continually rising above the choruses of praise, but to me there was far more Greco than Goya in the picture.

The New York Herald, January 6, 1924

DECORATIONS BY J. M. SERT

THE MOST millionairish works of art that ever I have seen are the decorative panels by J. M. Sert, now being shown in the Wildenstein Galleries. I should say they are distinctly multi. The main, big galleries at Wildenstein's, which always used to appear so sumptuous to us, now seem rather paltry and are indeed inadequate as backgrounds for the immense Cosden decorations. Tons of black marble and oceans of crimson velvet are needed to chime in with the gorgeous black and gold version of Sinbad the Sailor, and doubtless these will be provided in the latest of the Palm Beach palaces when M. Sert's decorations are finally installed in it.

M. Sert's art is staggering. Mere words cannot describe it, and so you are counselled to go and see for yourselves. The Queen of Sheba never dreamed of such things, even after her return from the court of Solomon. George Washington in his most optimistic flight never conceived a time would come when such grandeurs would descend upon a simple American citizen. For M. Sert is a modern Veronese. Veronese? Pouh! Veronese pales in comparison. The famous Marriage at Cana

would provide a startling sidelight upon the times we live in were not the clergy daily presenting us with still more startling food for thought. If the lady already quoted does not beat them to it I certainly would counsel some of these Modernistic leaders to acquire the new "Crucifixion" for one of their churches. There is no sin, not even a taint, in advertising, and this picture ought to do considerable in the way of advertising. The most careless, at least, would look at it.

Failing the lady and the churches, Mr. Bellows's picture is still sure of the most practical issue of success – it will pay for itself. It will, if allowed, travel around the country and sooner or later will win money prizes in the various exhibitions that offer them and finally can wind up in a museum for a good round purchase price. All that is success of a sort, and it is a success that other painters will envy and strive to emulate; so we may expect more and still more strenuous religious pictures in the near future.

But there is a reverse to the medal and there will always be those to look at both sides of the coin.

Is Mr. Bellows's picture truly great, either in feeling or in workmanship? Ah, there we get down to business. I cannot feel religious ecstasy anywhere in it, but on the contrary a continual reaching out for theatrical effects. All of the dramatic personae seem to be Broadway headliners instead of simple village folk overwhelmed with disaster. The Mary Magdalen of the hideous gesture could easily be Miss Olga Nethersole, and the "other Mary" kneels at the foot of the cross much as Mrs. Leslie Carter might. All the characters, in fact, are swayed by artifice rather than feeling.

In color, draughtsmanship and composition the painting is the reverse of commendable. Color always has been a trial to Mr. Bellows and he does not seem to improve. The blacks and whites out in the corridor show how much more the artist he is in lithography than when he wields the brush. Such feelings as I indicate would not be fatal to an artist who gave himself up unrestrainedly to his own muse. Am I not always lauding the work of Ryder, who knew nothing of technique but had poetry to express? And there is the case of the French Carrière, who had no color and achieved at least a style of his own.

Mr. Bellows has the prevailing American fault of self-consciousness, and if he dropped all thought of color, all

Now when all New York genuinely turns out, an art exhibition is "made." Something is generated in the atmosphere when our nervous, impressionable fashionables are crushed together into two or three small galleries and the sense that there is something important somewhere is born. Some such amiability is always necessary when viewing pictures, but it is remarkable and significant that true receptivity springs from crowds. Visiting foreigners always have commented upon the good nature of our mobs — but mobs for art have seldom been brought off, though when they are brought off they are, naturally, all to the good.

By this time the psychology of the maneuver is pretty well understood. Mr. Crowninshield, for instance, will be obliged to do what he did this year again next year. Foreigners are quite right in thinking the New York mob good natured, but they are not here long enough to also note that it is faithless. We lack the dutifulness and habitualness of London behavior that takes the polite mob year after year to Burlington House just because it was established by some strenuous, English Mr. Crowninshield of long ago, that it was the thing to do so.

Also it would be a great mistake to assume that just because the rooms at Anderson's were uncomfortably crowded for this show that the New Society ought instantly to seek larger and more ostentatious quarters. Psychology teaches that mobs love discomfort and go only where it can be had.

In such a hubbub, of course, criticism ran to extremes. I heard one lady say, for instance, that Mr. George Bellows's big "Crucifixion" was "the greatest picture ever produced by an American." If she really thought that she should have sold all that she had and straightway purchased it, for "the greatest picture ever painted by an American" is a very good buy and bound to go up. Mr. Bellows's picture was the rallying point all the afternoon for those who love to argue, and doubtless will be the most talked of painting in the collection.

As in all of Mr. Bellows's painting there is something to be said for it and something to be said against it. The points in its favor may be stated first. It is vigorous and ambitious. An artist who has his living to make doesn't undertake a religious picture in these days without considerable preliminary thought, and that Mr. Bellows finally decided to risk all the necessary time and energy is a high testimony to his courage. That religious pictures have, so to speak, "gone out"

does not have an "evening" soon in the Sheridan Square
Theatre I suppose I shall be to blame.

The Dial, December 1923

BELLOWS'S CRUCIFIXION

MR. FRANK CROWNINSHIELD was generally credited last year
with having saved the life of the New Society of Artists and
this year, with his strong right arm, he again admirably sus-
tains it. The institution had been in a precarious condition for
the first two or three years after its secession from the Acad-
emy. The reviews of the shows had been lukewarm, the at-
tendance ordinary and the sales less than ordinary. Something
had to be done, and quickly. Mr. Crowninshield, who was
obliged to assume the role of an eleventh hour, emergency
specialist, did it.

In the first place he assembled all the artists and told
them what he firmly believes — that they are the best artists
in America — they really are the best of the Academicians —
and conjured them to make good his belief by sending of their
very best to the show he intended "to put over." They all said
that they would. Then, through a corps of private secretaries,
he addressed his personal visiting list, the largest personal
visiting list that the world has ever known — M. André de
Fouquière's, in Paris, being nothing in comparison — and
commanded them all under threat of his displeasure to appear
in person at the first view of the New Society's incomparable
paintings. So potent was the appeal that none addressed dared
disobey. "All New York" saw and was seen at last year's vernis-
sage, and this year, with much less urging, "all New York"
again turned out, And besides there were a few outsiders.

and immediately the bravi shouted "Thank God" and otherwise
misbehaved themselves. By the time two or three well-known
people had died *sur le* champ d'honneur in Mr. de Massot's
poem the whole house was standing upon its feet and two
of the interrupters had actually mounted the stage to strike
Mr. de Massot, the one with a fist upon the cheek and the
other with a walking stick upon the shoulders. There was only
time to get in about two resounding whacks before the agents
de police bore the intruders, as I said, amid much flashing
of police clubs, over the heads of the audience to the exit.
Then the hale reader went on in absolute silence to tell us
who the others were who had died upon the field of honour,
and for half an hour or three-quarters, there was a boresome,
respectable silence for everything on the programme, even for
Man Ray's quite terribly-insulting-to-our-intelligence moving
picture. But by the time the dramatic offering to Mr. Tzara was
reached, the belligerent bravi had somehow crept back into
the purlieus of the théâtre Michel and were there to shout and
to mount upon the stage and to finally stop the performance.
They were undoubtedly the same bravi and the query is to
me, how did they fix it up with those gendarmes so to re-enter
the arena like that? What took place between them and the
police outside? Did the police say, "Now will you promise to
be good if we let you go in again?" and did they promise, or
what? At any rate it is possible to envy Paris her police system.
We have nothing like it here. I had to explain to Mr. Tzara
that we martyrize the first person who does anything in
America and that our martyrdoms are not amusing and do
not necessarily lead to much. I cited the Gorki incident for
him – of the hectoring Gorki received because of the lady
who came with him and who was not Madame Gorki. I ex-
plained that now half Greenwich Village lives with ladies who
hate the term Madame with a Queen Victorian hatred and that
at present Gorki could pass unmolested from Boston to Holly-
wood. Mr. Tzara seemed to think the amount of preparation
our public requires for an idea formidable. He was somewhat
sad and unsmiling as he talked of the evening at the Théâtre
Michel. He appeared to be conscious that there had been
something of a formula about it and that an effort in a new
country and under new conditions might help the cause. I
said as little about our police as I conscientiously could, but
nevertheless I fear I said enough to disturb him. If Mr. Tzara

TZARA AT THE THÉÂTRE MICHEL

I HAVE a suspicion now that gendarmes were dotted more thickly about the entrance of the little Théâtre Michel the night of the modern art "evening" than the apparently innocent programme of music and recitations warranted. Certainly they were called for and were of great use just as soon as the proceedings got under way, but I wonder how they came to be so conveniently there. Did young Mr. Tzara, who was the author of several of the poems and also the little dramatic sketch a portion of which we almost heard later on, tip them off, thinking it might add to the fun? And did the commissioner of police in detailing his men for the job instruct them to go easy? The psychology of those police gets me. There was such an uproar, you see, and seething-mob stuff, and flashing police clubs, and villains carried struggling over the heads of the audience and forcibly propelled through the door, and yet when all was over, no one went to jail, and no one had been hurt, not even a scratch. I puzzle over this the more since Mr. Tzara threatens to translate the scene of his activities to New York and actually contemplates an "evening" here. Could our highly sensitized policemen stand it, do you suppose? And go away nicely at the end merely shrugging their shoulders at "these artists"? As Mrs. Asquith said when the reporters became too tumultuous with their questions, "I wonder!"

The Théâtre Michel evening failed a trifle I thought from being over managed. There must be an uproar, of course, and scandalized upholders of virtue must protest shriekingly against the licence that comes to them from the stage, but in arranging for this Mr. Tzara secured more shriekers than things to be shrieked at. His bravi were so impetuous and unrestrained that at the very first line of the very first poem they shrieked themselves, the police aiding, out of the theatre. Young Mr. de Massot had a tiny poem each line of which said that somebody died upon the field of honour. He began, "Madame Sarah Bernhardt est morte sur le champ d'honneur,"

asked them for Monday or had forgotten having asked me
and they were promptly chased away. However they said bon
jour with the calmness of duchesses and will have had it made
up to them by Pascin later, doubtless. Then after Galanis left
I was allowed to look through piles of drawings, including all
the ones made in Tunis and which I like particularly, and
the series of mocking allegories in which "offrandes to Venus"
and hitherto suppressed details in the life of Scheherazade
are lightly sketched. From the débris on the table I turned up
two books, both of them inscribed. One was Paul Morand's
Fermé la Nuit which contained on the fly-leaf the author's
wish that Pascin might illustrate the work sometime. Morand
is about to have his wish, I understand, Pascin having under-
taken to do the drawings. The other book was by Cocteau
also with compliments upon the fly-leaf. Then too, Meier-
Graefe is to do a Pascin album; so here is one artist at least
who cannot complain of an indifferent press.

We lunched at the Café Manière. At the café we found
MacOrlan and Laborde, both of whom were charming as usual
and full of curiosity in regard to America. When I told Mac-
Orlan that I had dined at Brancusi's and that Brancusi himself
had acted as *chef* and had énormément de talent comme
cuisinier, he said that to cook was quite à la mode now.

The dinner was wonderful — but gracious heavens — I see
I have not left myself space enough in which to describe it.
Believe me it would require space!

The Dial, November 1923

feurs to race. Pascin and I had the young mulatress with us and she was enchanted that we won the race. We made a distinct sensation arriving at the Café du Dôme, and without in the least meaning to boast I think I may say that I shared the honours with the mulatress. People did look at us. If there is receptivity for art in Paris there seems even to be plenty of this commodity for art critics and there was a constant stream of persons coming up to claim acquaintance not only with Pascin, but with me. So much so that we scarcely had a moment actually to sit and Mahonri Young who had thought perhaps he might be of service to a newcomer retired abashed after one curious glance at the young coloured person. The café terrasse was crowded with the usual early Saturday evening crowd of students, oh, so much more gaunt and hollow-cheeked than they had been two years before; or so they did seem to me, comfortable in the knowledge that I certainly was to have a dinner. This festivity took place finally in a restaurant over near the Bal Bullier and the eats and the spiritual uplift were quite all right though the one-eyed gentleman took the host to task for allowing the men to be seated at one end of the table solidly and the ladies at the other; "If there is any possible way to bungle it trust Pascin," said he, with affectionate wrath. It was this gentleman who owned the large touring car that awaited without and into which about ten of us were whisked to the Café Suédois later on, standing up or clinging to side-steps as best we could, college boy style. Of the children who had gaily started out from Montmartre with us only the young mulatress was left and she was still maintaining a social status when I retreated from the Café Suédois at the discreet hour of minuit. At this party I met among others MacOrlan the writer and Laborde the artist, both of them keen and delightful, with worldly success apparently staring them in the face and André Salmon, the critic, equally delightful, but not so certain to get on in this life; and renewed acquaintance with Madame Pascin, one of the most remarkable women in Paris, which is saying much, and Mina Loy, the poetess.

At the banquet I asked Pascin when I could have a second look at his drawings and he suggested coming to lunch the Monday following. Galanis was there when I arrived and two young women who seemed not enthusiastic over my advent. Afterward I learned that Pascin had forgotten having

the original salle. Alice Toklas said it was not objectionable
to walk upon – though anyone who has ever attempted to
walk upon a tin roof would recoil from dancing upon tin. But
those Russians really are very expert and recoil from nothing.

That Juan Gris should be known to Diaghilev and that
Braque, Picasso, and he should do décors for him is merely
one hint that the pre-war receptivity is still on. Indeed the
receptivity is almost frantic, but beyond the admittance of
our own Man Ray to the ranks of the magicians there seems
to be no new name to be learned. The Parisians are just dying
to have an affair with some new artist, but the boldness of the
blandishments they offer seems to frighten rather than attract,
and young geniuses, if they exist, are incredibly coy. One
does not hear of them even at the Café du Dôme. Speaking
of blandishments, the Ballet Russe projects one of Molière's
pieces with musique by Gounod re-arranged by Erik Satie and
with a décor by Juan Gris. It is a project and not a certainty,
but merely to think of such a combination is going some in
the way of liberality; is it not?

Pascin gave me a miniature banquet – moi qui vous
parle. That is, there were at least twenty at table and that, I
think, entitles it to be called a banquet. I had supposed I was
dining seul, but when I reached the top of the almost endless
series of stairs on the Boulevard de Clichy I found ladies,
exuberant children, a solid bourgeois who had been rendered
more distingué by the loss of one eye at the front – and a
measurable family atmosphere that was a distinct surprise
chez Pascin. In a minute we all descended to the street made
more than usually noisy by the Fêtes de Montmartre then in
progress and I did my share in marshalling the exuberant
children among whom and the most so, was a young mulatress
of about ten. As it couldn't possibly be a French party without
somebody getting lost we promptly discovered that three or
four of us were missing. But we soon found them. The one-
eyed gentleman – whose name I never mastered – and several
of the children were discovered astride the shiny fat pigs of
the merry-go-round whirling in the air above our heads. Then
we were re-united only to be separated again into different
taxis for it seemed we were to go to the Café du Dôme for the
apéritifs. The ride across town was extremely gay, made so
by the children who were continually crying and waving to
each other from the various vehicles and inciting the chauf-

are the stains dripping from the wine press, the blues are dull turquoise; and onyx and lapis and alabaster and such terms spring to the mind in recalling them, in preference to the prosaic qualifications of the palette. The pictures may be said to reek with melancholy, but it is a melancholy more than made supportable by this colour. Even such a work as Meditation in which all the personae including the dog beneath the table seem steeped in woe, the general authority of the composition combined with the lovely colour make a noble, and, upon the whole, exhilarating appeal. It would be a fortifying possession for a Christian collector, and for a Jewish, wonderful. But I have a horrid scepticism as to all the collectors of the present, both Jew and Gentile, and fear the worst in regard to Weber's selling possibilities. . . . To be sure, there are the museums! !

The Dial, April 1923

THE BANQUET BY PASCIN

HAD I arrived two days sooner in Paris I should have seen the décor that Juan Gris made for the Ballet Russe charity performance in the Salle des Glaces at Versailles. Gertrude Stein had a card to see it privately in the afternoon and could have taken me. Gertrude liked it very much. From the description it certainly was new in idea — quantities of tin being used, covering the floor, I believe, and the steps to the platform, and gilt joining in — but startling only to those capable of being startled by ideas, for the passionately fashionable charitable folk who paid immense sums to attend seemed unaware that there was décor there at all, taking the setting casually as a part of

position and the extraordinary richness of his colour, I did not attempt to combat their prejudices.

It seems that this artist has been in retirement for some time, has shunned the public places and the disputes in the studios, and has been living alone in the country. The new pictures prove the wisdom of the course. Weber is not unsusceptible to influences and years ago when he first came back from Paris fresh from the contact with Rousseau le Douanier and Henri Matisse there was evidence of those encounters in his work and he was criticized for it. But not by me. In his first big exhibition he included his Woman and Tents, Chinese Restaurant, and another large panel, the title of which I forget, that portrayed a man wading in a stream; at St. Christopher or St. John the Baptist, perhaps. There were six or eight canvases so fine that I instantly forgot the forty that were of the École Rousseau and proclaimed Weber the best of the American moderns. Since then, and some years have elapsed, he has done nothing to justify the estimate, until the present exhibition, and now again he emerges strong, and more consecutively himself than before. However, in the meantime, John Marin, Charles Demuth, and Joseph Stella have also been emerging, and it is now more difficult to give precise ratings than it was; and unnecessary, since each individual of the quartette is significant, and, as they say of Vesuvius, "in active eruption."

In retirement, Weber's art has become Jewish. In another publication I already so qualified it hesitatingly, not because of any uncertainty of my feeling in regard to the work – that was clear and profound – but because of an apprehension that the term might be misunderstood. There was a danger that others might not regard it as the triumph that I insist it is, and there was the possibility (not important to my theory, however) that Weber himself might not be a Jew. The new quality is not based upon the lugubriousness of Weber's themes, nor the long beards of the Jews who wail upon the housetops after the manner of the prophets, but rather it comes to me in an abstract way and from the colour chiefly. It is the richest, most distinguished, most eloquent use of colour I have seen this winter. In a way I scarcely know how to define, it seems to have come straight from the Old Testament to Weber. It is sombre and with something in each tone that seems to crystallize a human experience. The faded reds

much. There is an enormous amount of aspiration, an enormous amount of intellectual energy in them and generalship in the execution — but also a lot that offends.

The thing has a ferocious amount of parallelism. The tall towers appearing behind each other are razor-edged. I get the effect that Stella's New York is all strung upon wires. My friend usually replies, "Yes, I feel all that too; but don't you think New York is like that?"

Perhaps it is. Certainly no city on earth seems so cruel to the individual who is not a part of it. Even the dyed-in-the-wool New Yorker returning from a month or two's touring in Europe is invariably seized by panic as he gazes at the relentless structures that loom over the waters at Battery Park. Once ensconced at his city desk the feeling promptly disappears; but even the most boastful New Yorker, if approached tactfully, will admit having been crushed at moments. However, there is nothing in all that that unfits the city for art. Nobody will blame Stella if he makes us terrible. In fact, we rather like being terrible. The fear is, at least my fear is, that he has made us ineffectual and thin. There is not the robustiousness that made his first Brooklyn Bridge so acceptable, nor the ingratiating suggestiveness of so many of his landscape abstractions. If he intended his New York to be so very wiry, then why not have done it in wires à la Marcel Duchamp? But I see I am venturing into criticism, which was not my intention, for, as I meant to have explained earlier, I feel that criticism should wait until these panels are shown elsewhere. The Société Anonyme's rooms are thoroughly charming, and generally helpful to all modern manifestations, but this time Mr. Stella is quite out of scale. His immense compositions quite swamp the Société Anonyme and are not only too close together, but too close to the spectator.

Undoubtedly, too, there has been considerable debate upon the merits of Max Weber's newer paintings, shown in the Montross Gallery, but unfortunately I have heard none of it. My lines, during the past few weeks, have been cast in exclusively with the Philistines and they, of course, detest Max Weber, but their detestations, at this late date, are not particularly amusing. As far as I can make out, they unite in thinking that Mr. Weber's nymphs' feet are too big — and perhaps they are in the right as to that — but since it was evident that they were blind to the authority of Weber's com-

of Marin admirers to seven, which would be wonderful if true.

The New York Herald, March 11, 1923

JOSEPH STELLA AND MAX WEBER

SO FAR, more people have asked me what I thought of Joseph Stella's new work at the Société Anonyme than have inquired into any other event of the season; and I have been more puzzled by the inquiries and have been more evasive in my replies than usual. I had set myself, upon first seeing the pictures, to the task of having a clear opinion of them, but without first-rate results; and it occurred to me that others had some uncertainties, too, and hence the questioning. There was no insinuation anywhere of opposition. Upon the contrary, Joseph Stella has already been adopted into the general affection, everyone wishes him well and everyone feels that something will come out of him that will credit all of us. The mere fact that he was standing up to New York, doing us, "the big city," predisposed the public — I mean, of course, the small public that follows the younger men — in his favour; but in spite of all this yearning, no loud shout of joy reached the heavens when the pictures were shown. They were impressive, they were interesting, they were undoubtedly sincere, but — were they what we were all waiting for?

Maybe they were. Perhaps we'll simply have to get used to them. But part of the yearning, when we heard that Stella was doing a big New York picture, was that it might be a crashing success; and this it cannot truthfully be said to have been. When asked, I have generally said, I liked them very

do for him or her, then nothing in this year's output will. It is a picture that is soaked with the moisture of the sea, lovely as to color, and a masterpiece of handling.

Then there is No. 20, "Camden Mountain Across the Bay," just two or three amazing splashes of color and a wafer sun against the white paper. This, too, is not for beginners, but for the initiated what fun! No. 21, a different version of the same theme, is glorious. There are a dozen works that ought to overwhelm those for whom color has meaning. They have the splendor of stained glass with an inflection of passion foreign to the older workmen.

There are also three pictures relating to downtown New York, part of the series begun with such distinction last year. The subjects have not aroused the artist to the extent that the Woolworth Building did, but this is possibly a matter in proportion, since the Woolworth Building is supreme of its kind. There are just two pictorial phases of the city that to the rest of the world seem unique — downtown skyscrapers and the crush in upper Broadway at night after the theaters. Foreigners, they say, have a sort of yearning interest in the activities of Wall Street and the things that go on inside of Mr. Morgan's banking establishment, but if these items linger on in history it will probably be the psycho-analyists who will put them there. Artists will get more from the two subjects preferred above.

Mr. Marin, by the way, might try what he might get from the night scene on Broadway. I don't think he has attempted much in the way of night things anywhere. He leaves the moon so severely alone that one suspects he shares Mr. Llewelyn Powys's hatred of the earth's hitherto admired satellite. Before quitting Mr. Marin for a while, I suppose I ought to mention that an unknown young lady who ventured by mistake into the press view of the Marin pictures and smoked one of the cigarettes that are only provided in the Montross establishment upon the occasion of press views announced that she loved the "Down Town View, No. 3," above all other water colors of this year. I preferred the sea view, No. 25, already mentioned, but I think an opposing opinion, such as this, should be considered. She was a remarkably prepossessing young woman, with clear, crisp speech, and rows of handsome, small teeth, like Herman Melville's young Tahitian friend, Fayaway, in "Typee." It may be that she swells the list

the young million now sprouted, who are to rule things twenty
years from now, will all agree with the six friends of Shelley or,
I mean, the six friends of Marin.

To them — these six — he is the most considerable artist
in these States at present. He has great natural gifts and seems
to exploit them unhampered. He is a water colorist, and con-
trary to the general experience has attained an extraordinary
breadth of vision and sweep in execution, all in developing
himself in this medium.

It is usually held that water color is a restricting medium
and that knowledge sufficient to give it a style must be ac-
quired by the artist in some more plastic method of expression,
but Marin has not found it so. He is more plastic than Wins-
low Homer ever was, and indeed more plastic, than any artist
I can think of, past or present. Without departing from the
confines of true water color he gets all that any painter can
ask for in oils. The way to this astonishing richness and power
in expression has been opened for him perhaps by the modern
revolt from literalness. There are so many things that a
Winslow Homer thought he had to do that are now no longer
required of any one, and indeed are not permitted of any
one — and the immense resultant release of energy allows
a human volcano like John Marin to simply explode with
feeling.

Last year it was remarked that a streak of something
somber, savage, sinister, ran through all the work. It was said
to be a "late Beethoven" feeling. It continues again this year.
It happened that I went from the Montross collection to an
exhibition in the Daniel Gallery, where there are some early
Marins that seemed so simple, innocent and youthful Mozar-
tian (one goes for one's comparisons to music, naturally) that
it amounted to a shock. Marin is a poet always, but once he
was a young one. Now he thunders — and people, as I said,
have to watch out.

There is a set of ocean pieces in this collection that seems
deliberately mournful. Marin sought the mystery, the aloof-
ness, the restlessness, of the sea and plays it almost in mono-
tones. These are difficult. They are profoundly moving to "the
six," but it is evident they are dedicated to the future. The pos-
sible candidate for entrance into the Marin Society is rec-
ommended, on the contrary, to go first of all to the picture
marked No. 25, "Study on Sand Island, 2," and if this won't

things but saw there was no use in telling him what he had already got.

The New York Herald, February 4, 1923

A PREDICTION ON MARIN

NOTHING BUT trouble at the Montross Galleries. The Max Weber paintings come down from the walls and the John Marin water colors go up. No respite for the weak at heart. The pace is terrific. People are obliged to watch each step they take. And this in America!

Considering feeling was aroused last year by the Marin exhibition in these same galleries, and some were so cross that they implied that they were going "to do something" if this sort of thing didn't quit. Well, it hasn't quit. John Marin is as bad as ever, if not more so. Ninety percent of the water colors in the exhibition are calculated to make Kenyon Cox turn over in his grave. And some people have the audacity to claim that these things are great. I myself am among the number.

How am I to prove it? I cannot, I fear, except to the small band who have spirit, who respond to spirit and who judge works of art by their spiritual content. This small band, however, forms the court in which the ultimate values are appealed — "the six friends for whom the poet Shelley wrote" — so after all there is nothing to worry about. The million opposed will pass away hugging the delusion that Marin is a bluff — just as the million of the previous generation passed away firm in the notion that Walt Whitman was a bluff; but

might say, and is the Sphinxian sniffer at the value of a secret. What these quests for truth are worth no one can precisely say, but the tendency would be to say, at least by one who has gone far to find them out, that they are not worthy of the earth or sky they are written on."

But they were worthy of the earth and sky they were written upon. This second exhibition makes it plain. If all those vapors had not been shattered by an electrical bolt from the blue, O'Keeffe would have undoubtedly suffocated from the fumes of self. There would have been no O'Keeffe. In definitely unbosoming her soul she not only finds her own release but advances the cause of art in her country. And the curious and instructive part of the history is that O'Keeffe after venturing with bare feet upon a bridge of naked sword blades into the land of abstract truth now finds herself a moralist. She is a sort of a modern Margaret Fuller sneered at by Nathaniel Hawthorne for a too great tolerance of sin and finally prayed to by all the super-respectable women of the country for receipts that would keep them from the madhouse. O'Keeffe's next great test, probably, will be in the same genre. She will be besieged by all her sisters for advice — which will be a supreme danger for her. She is, after all, an artist, and owes more to art than morality. My own advice to her — and I being more moralist than artist can afford advice — is, immediately after the show, to get herself to a nunnery.

And in the meantime, after the storm in the Bourgeois Gallery, we have peace in the present collection of pictures. There is a great deal of clear, precise, unworried painting in them. Alfred Stieglitz calls it color music, which is true enough. It sings almost as audibly as the birds in the "Cherry Orchard" do when the Russian actress opens that window to breathe in the morning air. That it will have the usual Stieglitz success goes without saying. Claggett Wilson told me that he rushed home from the show to put the emotions roused by it into literature and George Grey Barnard telephoned me in the midst of this writing to tell me of an extraordinary sunset picture of O'Keeffe's in which there were vast evolving forms as at an earth creation, interrupted by a darting line of yellow that had been the artist's color response to the massed cries of cattle heard in her youth upon the plains of Texas. His communication materially changed the tenor of this article. I had been upon the point of telling him some of the O'Keeffe

wish this exhibition, and adds that she guesses she was lying, for she consents to this exhibition of her own newly acquired free will.

For a lady to admit she lied represents the topmost quality of freedom. After that the fences may be said to be completely down. And as nothing that happened in San Francisco for two or three years after the earthquake seemed to matter much, so the final confession that she is not indifferent to what people say about her pictures nor even what they don't say about them is relatively unimportant. The outstanding fact is that she is unafraid. She is interested but not frightened at what you will say, dear reader, and in what I do not say. It represents a great stride, particularly for an American.

The result is a calmness. Younger critics than myself speak of the "punch," but I am not particularly interested in the punch unless there should be a knockout, when of course I must take notice. What I prefer is style, which occurs all along the line and makes the whole encounter interesting from start to finish. There was for me more of knockout in one of Miss O'Keeffe's former exhibitions – the one that occurred in, I think, the Bourgeois Galleries shortly after she had burst the shackles. That was the exhibition that made O'Keeffe (I think I must drop the "Miss" since everybody else does). I do not know if there were many sales, or any, nor if there was much attendance from the outside world. But certainly all the inside world went, and came away and whispered.

To be whispered about in America is practically to be famous. A whisper travels faster and further than a shout, and eventually registers upon every New York ear. The art crowd did not know that O'Keeffe had formerly had inhibitions, but saw that she was without them in the Bourgeois Galleries. Such a scuffing about for draperies there never was since the premiere of Monna Vanna. Even many advanced art lovers felt a distinct moral shiver. And, incidentally, it was one of the first great triumphs for abstract art, since everybody got it.

To this day those paintings are whispered about when they are referred to at all. Even Marsden Hartley, who is a fine writer with many colorful words in his possession, whispers. He says, "Georgia O'Keeffe has had her feet scorched in the laval effusiveness of terrible experience; she has walked on fire and listened to the hissing of vapors round her person."

And in another place he says: "She has seen hell, one

and Burchfield, firmly beside the fixed star, Winslow Homer, in a serious critical estimate is, to say the least, going some. It will not only be sure to affect the ideas of collectors but will put heart into the entire younger school.

The New York Herald, October 15, 1922

GEORGIA O'KEEFFE

GEORGIA O'KEEFFE is what they probably will be calling in a few years a B.F., since all of her inhibitions seem to have been removed before the Freudian recommendations were preached upon this side of the Atlantic. She became free without the aid of Freud. But she had aid. There was another who took the place of Freud. His success with her would give him fame at once had not his previous successes with John Marin and Marsden Hartley already placed him upon a pinnacle from which he could gaze down comfortably upon Coué and the other Great Emancipators. It is of course Alfred Stieglitz that is referred to. He is responsible for the O'Keeffe exhibition in the Anderson Galleries. Miss O'Keeffe says so herself, and it is reasonably sure that he is responsible for Miss O'Keeffe, the artist.

Her progress toward freedom may be gauged from a confession of hers printed in the catalogue. She says that seven years ago she found she couldn't live where she wanted to, couldn't go where she wanted to go, couldn't do nor say what she wanted to; and she decided that it was stupid not at least to say what she wanted to say. So now she says anything without fear. She says that she did say at first that she didn't

leads — and we are still Francophile enough to admit that — but it would require subtler mathematics than we possess to figure out by what percentage. It moves by previously acquired momentum rather than by actual force.

If momentum can do so much, think what it will do for us, with our great weight, once we start, and that we have started is now the general feeling. The real dramatic interest for us Americans begins to be here. There are some who will tell you that a death is just as captivating as a birth, but it is hard to convince young papas and mammas of that.

Communities all over the United States are, to use the old fashioned phrase, in an interesting condition. We have just fallen heir to the proud position of world supremacy that was Spain's at the time she produced Velásquez. We, too, can now afford to produce expensive geniuses, and we intend to do so — in fact have commenced. The general opinion is that they are to be as lusty as those that Walt Whitman prophesied for us. Is it any wonder, then, in these crisp October days, that we are undismayed as we peer into the immediate future? After all, the "cheerfulness of a convalescent" is too mild a metaphor.

Quite a few significant ripples upon the surface of the waters that sufficiently indicate the direction of the winds are the publications that celebrate the performances of the innovating artists.

The Picabia number of the *Little Review,* issued during the summer, was the most daringly modern review that has yet appeared in the States, and the fact that the issue was still nine-tenths French does not conflict with the assertions made above concerning our future, since the review concerned itself with actual attainments, with the period just over, but which still lights up the path we are now to tread.

The Dial, too, is all for modernity and seems so avid for American productions that it is now unlikely that our revolutionary thinkers will be kept waiting long at the gates.

A publication just announced that ought to help considerably is Albert E. Gallatin's new book about the American water colorists, for the work has been sumptuously printed under the eye of the famous Mr. Bruce Rogers and contains not only enthusiastic appreciations of the work of John Marin, Charles Demuth and Charles Burchfield, but careful reproductions in color of some of their things. To place Marin, Demuth

better world — that is, a world more at ease with itself — there cannot be better art.

But last winter was particularly ghastly from the point of view of accomplishment, and when it had finished every one connected with it breathed a sigh of relief, feeling that whatever more might happen the worst was over and that things must mend.

It is the cheerfulness perhaps of a convalescent, but that is not a bad kind of cheerfulness to have, and it is with that that we totter to the shutters, let in the light, rearrange our wares and prepare to keep peace between the artists and the public for another winter.

As a writer and an American, the straw that we clutched at when adrift in that sea of gloom last winter was the fact, patent to us at least, that native wares were looking up. They are not so profuse yet as the French or English, nor do we yet pretend to a worldwide authority that would appear to be in keeping with our brilliant financial position, but not only have we more living painters who are taking their inspiration directly from the soil than we had in 1914 but we have an immensely wider public that has learned to demand the native flavor in native goods. A group of clever but misguided artists of a generation ago had carefully drilled our public into the notion that to be good, art must be foreign, or at least foreign looking, and it has been no easy task to supplant this monstrous teaching with the theory — obviously true at the first glance — that is now gaining ground. Mr. Guy Pene du Bois, in a recent *International Studio,* made an accusation in rather vague terms that the present writer is Francophile. The accusation might have been less vague without giving offense in this quarter.

The fact is that this critic, up until about 1914, was a citizen of the world, perforce, in order to keep going as a critic. He was about nine-tenths French because nine-tenths of the art world were French. The Rodins, the Cézannes, the Rousseaus, the Matisses, with their live stuff, were compelling our eyes to Paris and obliging us to neglect the pathetic Blashfields. Coxes and Dewings, with their ineffectual echoes of the scholastic past. To be contemporary, then, we were obliged to go abroad.

But events have changed all that. The advantage that France had is now not so overwhelming as it was. It still

plates, aped painting. To me photography was one thing and painting another, and the foggy, blurred enlargements that to many of our experimenters seemed "artistic" were to me merely vulgar. I shrink from photographs that are too large anyway, just as I shrink from Brangwynnian etchings. There was a time when our "working classes" (Stieglitz will say that term is obsolete also) indulged themselves in a pathetic fancy for crayon enlargements of photos of their dead. They were rather horrible, but only a trifle more so than the gaudy silver framed affairs that now adorn the homes of our rich. I like straight photography and thought the profession had severed itself from art rather early in the game — that is to say, shortly after the daguerreotypes were relinquished. But Alfred Stieglitz reestablishes the link. He is a photographer, pure though not simple.

His prints include landscapes and city views, still life, portraits and studies from the nude, and in each of these divisions memorable work has been accomplished. Stieglitz's reputation is already so secure that it goes without saying that all who are interested in photography will see this exhibition. That it will have marked results upon the other members of the profession is certain.

The New York Herald, February 13, 1921

AMERICAN ART IS "LOOKING UP"

AT THIS season of the year it is impossible to resist a feeling of hopefulness in regard to the prospects for the art season, although to tell the honest truth no change in the world situation is visible to the anxious watchers in the tower, and without a

problem. For, unless I am able to vary — add — I am not in-
terested. There is no mechanicization, but always photography.

"My ideal is to achieve the ability to produce numberless
prints from each negative, prints all significantly alive, yet
indistinguishably alike, and to be able to circulate them at a
price not higher than that of a popular magazine, or even a
daily paper. To gain that ability there has been no choice but
to follow the road I have chosen.

"I was born in Hoboken. I am an American. Photography
is my passion. To search for truth my obsession."

By way of postscript he added:

"Please Note — In the above statement the following, fast
becoming 'obsolete' terms do not appear: Art, science, beauty,
religion, every ism, abstraction, form, plasticity, objectivity,
subjectivity, old masters, modern art, psychoanalysis, æs-
thetics, pictorial photography, democracy, Cézanne, '291' pro-
hibition.

"The term Truth did creep in, but may be kicked out by
any one."

Just why "prohibition" should be regarded as an obsolete
word is not quite clear. I find it an invaluable term myself
in describing certain present day effects, also I shall find it
difficult to say anything about the photographs without using
the word "art." The most astonishing of them, my favorite
I almost think, represents a typical, bourgeois American sitting
room. The room must have been thoroughly comfortable and
"homey," but there is scarcely one of the far too numerous
pieces of furniture but would require apologies from the mem-
ber of the family that pretended to æsthetic sensibilities. In
other words, it is a humdrum example of our civil war style
of decoration. Nevertheless, the photograph is beautiful. The
play of the late afternoon shadows among the furnishings is
delightful and takes hold of one's fancy. The picture would not
tire one quickly, I think, although the room from which it was
taken might have been a bore. Now the camera itself is a
mere machine and is incapable of seeing beauties in a stupid
thing. In using the machine, Alfred, I think, must have
searched. In other words, he expressed himself stylistically and
became an artist.

I admit that I myself drew away from photography about
the time the so-called "art photography" came in. I could not
stand photography that, through tricky manipulation of the

of its adherents that there was an injustice in allowing Stieglitz to sacrifice his career as a photographer to his service there in behalf of modern art, nevertheless the actual parting had been something of a wrench, a wrench that time had accented rather than healed, since it had become only too evident that no one had appeared to replace him. Where Stieglitz had been there was a distinct void.

So the meeting again with him was something of a fete. All the photographs were there that he had been doing, and about which there had been so much private conjecture, but greater than the photographs was Alfred, and greater than Alfred was his talk – as copious, continuous and revolutionary as ever – and no sooner was this recognized than the well re-membered look – a look compounded of comfort and exalta-tion – began to appear upon the faces of John Marin, George Of, Marius De Zayas, Marsden Hartley, Oscar Bluemmer, Walt Kuhn and Abram Walkowitz, for to them it seemed that "291" was operating as usual and that this long hiatus had been a dream. There was a slight change of background, considerable red plush instead of the inconsiderate gray paint, but the main thing, Alfred, was there and they were happy.

Alfred had fortified himself in advance for the meeting with a statement. It runs as follows:

"This exhibition is the sharp focussing of an idea. The 145 prints constituting it represent my photographic develop-ment covering nearly forty years. They are the quintessence of that development. One hundred and twenty-eight of the prints have never before been seen in public. Of these seventy-eight are the work since July, 1918. Some important prints of this period are not being shown as I feel that the general public is not quite ready to receive them. The fifty other prints never shown before were produced between the years 1908–1919. Of the earlier work I show but a few significant examples. With more the exhibition would become needlessly large.

"The exhibition is photographic throughout. My teachers have been life – work – continuous experiment. Incidentally a great deal of hard thinking. Any one can build on this ex-perience with means available to all.

"Many of my prints exist in one example only. Negatives of the early work have nearly all been lost or destroyed. There are but few of my early prints still in existence. Every print I make, even from one negative, is a new experience, a new

however, disdain them. It is one of those places which are cut through by the straight and terrible line of a railway and Mr. Burchfield has drawn this railway and the switchman's little hut with the sarcasm of a Swift. Mr. Burchfield is, of course, extremely young to be a Swift, so his case presents problems. There is almost nothing in his work but this hatred, and if he lived to be sixty he could not be a more vehement hater. What is to provide him with material if he progresses along this line? Salem cannot hold out all that time. He might come to New York. There is much in New York that is certainly worth hating, but somehow I feel it in my bones that Mr. Burchfield is not the man to hate it. Besides it's been done already. Nobody could hate New York so well as Lafcadio Hearn hated it, and that has gone on the records.

The Dial, August 1920

PHOTOGRAPHS BY STIEGLITZ

THERE IS SUCH a thing as loyalty in America, Alfred Stieglitz is now thinking, or ought to be thinking, for all of his old friends and disciples and many new ones turned out on Sunday and Monday afternoons to see his life work in photography, on view in the Anderson Galleries, and to shake the master photographer's hand and tell him how much they had missed him.

For Stieglitz had been in a state of eclipse ever since he closed the little gallery at "291" Fifth avenue — a gallery that occupied a share of the public regard wholly incommensurate with its size — and although even in the palmy days of that institution there had always been suspicions in the bosoms

tram-car manipulator expatiating upon the qualities of their offspring's cubism. (It doesn't have to be cubism – I merely use that term as it still happens to be anathema to most.) The wittiest study of the modern forms that has yet appeared was an essay by C. R. W. Nevinson's father in the Atlantic Monthly of some years ago in which he frankly confessed that he had found he had to take up the subject to keep pace with his son. And indeed, to drop into plain English, cubists are not so bad. Some of them are cubists for moral reasons. Was it Trelawney or one of the Gisbornes who met a young man at the house of a friend in Italy who seemed to be all goodness and purity but who bore the dreaded name of Percy Bysshe Shelley, and who left the house demanding inwardly, "Can this innocent creature really be the monster that is horrifying all Europe?"

The Dial, July 1920

CHARLES BURCHFIELD

ALSO LATE in the spring a collection of pictures by Mr. Charles Burchfield was shown in the Kevorkian Galleries, and this was the most interesting "first appearances" of the winter. Mr. Burchfield had the great good fortune to pass his young life – he is but twenty-six – in the loathsome town of Salem, Ohio, and his pictures grew out of his detestation for this place. No German hated England so hardly as Mr. Burchfield hated, and I hope hates, Salem! for what would become of Mr. Burchfield's art if Salem should reform or if he should move to some likable place? Salem is a place of shanties, so Mr. Burchfield says, dreadful, wobbly shanties that seem positively to leer with invitation at the passing cyclones, which,

"Do you suppose it's still air from Paris? Science tells us that air tightly sealed in that fashion quickly rots and changes its character," and before I could interpose an objection he wound me up with his contention of the day before.

The only drawback to *épaté*-ing the bourgeois is that half the time they don't know when they are *épaté*-ed. If my friend chances to read these lines he'll know. I'll squander a copy on him.

The Arensbergs are at home a great deal, and it may surprise the owners of J. Francis Murphys to know that they are seldom at home alone. People seem to like to come to see them. In particular the new poets and the newest artists flock to the studio. In addition to the pleasure that young people evince in merely being together there is always the further excitation that comes from a consciousness of being in the van of a movement.

But apropos of the Arensbergs I mustn't drag in a plea for modern art. I feel almost as though I were giving away a state secret in even hinting that they and their friends are having a mediaevally good time with it. But people have been so extraordinarily scary and silly on the subject here in New York that it seems only Christian to give this belated warning that there are social possibilities in the new things that the Horace Walpoles of this period ought to look into. The world is presumably to go on again with enough approximation to the old life to permit the arts to exist — at this moment this is indeed a presumption — and in this case people who have money to spend might just as well as not get the Arensbergs to explain to them how it is that one gets in contact with the creating talents in the world. If they can't or won't consent to mount Parnassus hand-in-hand with new geniuses, they will never get there. Looking at old genius already at the top through spy-glasses will not assist. One might just as well be — in fact, one is — a dealer in second-hand goods. Patrons must be as hardy intellectually as artists to register — as they say in the movies — as genuine patrons.

My own recommendation to those in doubt upon this point is — to know a "modern" artist. Mothers or fathers, for instance, whose sons or daughters happen to turn out to be cubists are usually as pleased as Punch after they get over the initial shock. Nothing ever delights me so much as to hear a prim old New England lady or a hard-headed Keokuk

parte by Brancusi that almost got rejected from this year's Salon des Indépendents in Paris upon the ground of immorality, is another item. Things by Gris, Braque, and Metzinger in vivid colours so pull the eye of him who enters the door that the big, and still uncompleted, chef-d'oeuvre in glass by Marcel Duchamp that is posed near the entrance is sobriety itself by contrast and assumes all the reticence of a piece of furniture or of a Rembrandt in the Metropolitan Museum of Art. Furthermore there is one of Picasso's "reasoned derangements" in paint, some particularly dynamic African fetish carvings, and plenty of the latest local outpourings in cubism. Some of the works individually verge towards violence, but they have been so carefully placed by the mad owners of the establishment that not only a perfect balance but a genuine if hitherto unheard of harmony has been attained.

However, my most educated friend saw only craziness and not harmony in the room. His education had been, perhaps it is necessary to explain, confined to the pictures of the past, and of life as it is lived at present he knew little. Doubtless, too, the Arensbergs played a little up to him. The temptation to *épater les bourgeois* is something nobody resists.

"Do you want to see Marcel's latest work of art?" Walter Arensberg asked me, upon the occasion of my first visit to the studio and after we had had a long and easy conversation without a word of reference to the Matisse, the Brancusi, and the other marvels, all of which I had seen perfectly without looking at them. From the grin upon his face I knew Marcel's latest was something larky. When Arensberg lifted a glass bulb with a curious tail to it from the protecting cottons of a wooden box I saw that my premonitions had not played me false..

"It's air from Paris," said my host, "hermetically sealed at a particular street corner in that city."

I'm not a bourgeois, so I didn't have a fit; I didn't even inquire the name of the street on which the air had been caught. Like Arensberg, I laughed. As a work of art "Marcel's latest" seemed pleasant and droll. Perhaps I instantly saw that the joke did not apply to me so much as to my educated friend. That's the advantage in not being a bourgeois yourself. And sure enough when I asked my friend if he had seen the Air from Paris by the famous Monsieur Duchamp, he replied drily:

tell realistically, and without seeming to borrow too much from the famous innovator, Picasso.

In the photographs Mr. Sheeler is more dominating. He has a relentless eye, it seems, when it comes to focussing; a personal feeling toward textures and values, and is even more Van Der Weydenish than ever in his compositions. All who look on photography as a means of expression should see these photographs of barns. They rank among the most interesting productions of the kind that have been seen here, and are all the more important as this artist never forgets for a moment that the camera is a machine, and he emphasizes the things a machine can do better than hands, instead of blurring them into so-called artistic effects, as so many photographers do.

The Sun and New York Herald, February 22, 1920

THE WALTER ARENSBERGS

"WALTER ARENSBERG is quite mad. Mrs. Arensberg is mad, too." The remark ended a conversation. There was a finality about it that would have ended any conversation.

My friend — one of the most reasonable and most educated of men — admitted that the Arensbergs were delightful, but raving lunacy was to him the only explanation for the possession of the works of art that adorned the Arensberg salon. The Arensbergs' big studio on West 67th Street is exclusively modern. The big panel by Matisse of a woman perched upon a stool and with most of the curved lines of the figure indefinitely extended to the confines of the canvas — it proved very trying to the public when shown in an exhibition in the Montross Galleries — is an item upon one of the vast white walls. The shiny brass "Portrait" of the Princesse Buona-

CHARLES SHEELER'S

BUCKS COUNTY BARNS

THE WORK of Charles Sheeler now on view in the De Zayas Gallery is an exhibition for the progressive element in the community. Mr. Sheeler is an out and out modernist, and there is very little in the past history of art that will assist the amateur to appreciate his. Only the sophisticated amateurs who love exploring will go along with Mr. Sheeler, who will be forced to rely for sympathy, probably, upon his fellow modernists.

Mr. Sheeler's subjects are Bucks county barns, flowers and still lifes, and these have been worked out both in photography and water color. It is of course possible that the artist may win some applause from totally uninstructed persons, who will see that Mr. Sheeler's barns are genuine Bucks county barns in spite of something in the work that the instructed will call "cubism," but these same uninstructed persons, while admitting that Mr. Sheeler's barns are barns, will doubtless sigh for a few more vulgar details, so that upon the whole their sympathy will not amount to much; and Mr. Sheeler's future as an artist will depend upon winning a few more converts among the instructed.

What will operate against a swift fame is a certain coolness in the work. Mr. Sheeler makes compositions that are as compact as Picasso's out of the various parts of a barn without destroying, as has been hinted, the barn resemblance; but his procedures are as taut and tight as Van Der Weyden's pictures of crucifixions and there is little plasticity in them to entice the nibbling picture-lover onward. In his art Mr. Sheeler is as ascetic as the early Dutch painters, but the Dutch painters flourished upon the fact that their asceticism was good form. They had the people and the patrons with them. Here in America asceticism is not good form. Not just at present, at least.

But all of Mr. Sheeler's fellow artists will see that he composes very well and that he contrives to make certain surfaces

1920–1928

Mr. Duchamp, author of the famous "Nude Descending a Stair-way." All the people at the party, Mr. Walkowitz says, are ex-tremely well known in the most advanced Greenwich Village circles. He mentioned them over to me, and I blushed at not having heard of them. Not to know the fair artist of the picture is to argue oneself unknown, I dare say, yet I cannot recall having heard of Mrs. Stettheimer before. I say "fair" advisedly, for the lady has painted herself into the party and she has some rather good things to say for herself. One of the gentle-men at the fete is lying face downward on the turf, and yet his toes point skyward. I believe it is Mr. Duchamp. At any rate he is very clever and could do it.

One of the trees is painted scarlet and one a bright blue. The shadows are such colors as pleased the artist, and that is the reason, I think, they now please others. Under the trees the refreshments were served. Mrs. Stettheimer appears to be a good provider. The more I think of it the more miffed I am that I wasn't asked to that party.

The Sun, April 28, 1918

sculpture. The most sacred things carry us beyond words, beyond definitions.

The first thing in a work of art is a feeling, and it cannot be defined if it be immense; and it is immense in the nude figure called "Elevation."

I like this figure immensely. It is as strange a piece of sculpture as any that has happened in America in recent years, but it is real and vibrant with the sculptor's emotion. Americans will I hope be properly impressed by the fact that this statue is a tribute by an ardent Frenchman to the women of this country. If the ribald laugh at it and call it a fat woman they may. What the idle think of a genuine work of art is unimportant. The main thing is that a sufficient number of intelligent art lovers signify their interest in the work emphatically enough to encourage the sculptor.

I believe, however, that this new artist has sufficient force to survive temporary non-comprehension. A worse thing for a young artist than neglect is a too vehement and fashionable appreciation.

The Sun, February 17, 1918

FLORINE STETTHEIMER

AT THE INDEPENDENTS

I AGREE with Mr. Walkowitz that one of the most joyous of the paintings is the "Birthday Party," by Mrs. [sic] Florine Stettheimer. Mr. Walkowitz assures me that the picture was done from the life and that there actually was such a birthday party, the birthday being in fact for no less a person than the great

GASTON LACHAISE

THE BOURGEOIS Galleries may be congratulated upon discovering a new young sculptor of talent. The bronzes and sculptures of Gaston Lachaise, now on view in these galleries, disclose a personality that is likely to greatly interest our public, and is sure to deeply impress the younger members of the population.

Mr. Lachaise is a young Frenchman who has been in America twelve years. The astonishing and encouraging feature of his work is its essential Frenchiness despite the twelve years of exile from the capital of Light. I do not mean of course that to be French is necessarily to be right in art, but I pin great faith upon an individual who keeps a firm clutch upon his native traits and upon his own ideals, when launched at a tender age upon a community like this, where every atom of the social fabric is aligned in an effort to standardize character.

Mr. Lachaise being French has been impressed by our recently enfranchised ladies. His attention so far has been almost exclusievly focussed upon our feminine voters. He feels, he says, and his work shows that he feels, something extraordinary and powerful in our women. They seem to be energy incarnate. There is a force in the air here that the sculptor felt when he first breathed it. There is energy stamped upon the faces of our men and upon their gigantic engineering achievements.

But these goddesses, the American women of 1914–1918, are the true equals of the men. (To look at the sculptures is to fear they excel men.) Aspiration and achievement are one with them, as Madame Nellie Melba recently said. They are full of the je ne sais quoi. The sculptor, who speaks excellent English, could not find words to define the emotion suggested by our superwomen. He dropped off into French, but in his native tongue also was continually saying "comment dirai-je?" This is as it should be.

There is nothing I like better to hear from a sculptor describing his aspiration than: "Comment dirai-je?" If he knew how to say it in words, doubtless he could not say it through

"What reprehensible proceedings are these?" demanded the astonished director of the museum. "Animals? In the museum? Who is responsible for this outrage?" eying with instant and instinctive suspicion the two fur coated museum directors from out of town. "Officers! Are there no officers here? Officers, do your duty. Arrest these people!"

"I had nothing to do with it," replied the fur coat named Bill. "I think it was her," pointing to Schmittie.

" 'She,' you mean," returned Schmittie sweetly. "Come kittie, nice kittie, come come to your muzzer," but the innocent cause of the disturbance had by this time mounted upon the altar rail before the Sargent portrait and was in no condition to be mollified by soft words. She let out alternate meows and hisses that resounded throughout the museum. The meows were prayers for safe deliverance from this scrape, the sincerest prayers doubtless that had been uttered upon that altar, and the hisses were for the attendants who were fast closing in upon her.

"Throw your coat over her, that's the only way to catch her," said the large lady named Amy, to the fur coat museum director named Bill. "Throw your own coat over her," returned that gentleman rudely. "Ain't been introduced to you yet," and he leaned so heavily against a pillar that the bronze "Frog Fountain" by Janet Scudder that surmounted the pillar fell to the floor with a reverberating crash.

"This is too much," murmured Dr. Robinson.

"This is too much," echoed the disdainful young man who had been assiduously copying the Regnault "Salome" in the next gallery. "What's the row?" said he from the doorway, appealing to Amy Lowell, for yes, 'twas she, the large lady mounted upon the divan. "What's up?" he insisted.

"The cat," returned Amy Lowell, pointing to Schmittie. "SHE LET THE CAT OUT OF THE BAG."

The Sun, January 20, 1918

"No, I can manage it, thank you."

"But your parcel is slipping. Why, what is in it? What have you in that bag? How it squirms! Is it alive?"

"It is. M. d'Hervilly, can I take you into my confidence? You have always been such a good friend of mine. . . . It's our cat. Yes, it's THE SUN's famous office cat. Ever since the recent cold snap it's been unwell. In spite of the forty-eight oilstoves that assisted the steampipes in the editorial rooms our cat took a severe chill upon that awful Saturday night when the thermometer went 13 below. Perhaps she imbibed some of the oil. She took a great fancy to those stoves. . . . So to-day when I found that I had to come up here I decided to give her a little airing in the park. She so seldom has the . . ."

"I tell you that picture is n. g.," the young person by the name of Schmittie was exclaiming, "and, what's more, Sargent is a flubdub. Why, Irving Wiles could beat it. It's only skin deep. It has no color. It has no interpretation, no style. Sargent was afraid when he painted that picture. He was afraid of the Schwartzkoeffer clothes and the Schwartzkoeffer chair and afraid of what the people would say. In a committee meeting room it would never be distinguished from the other portraits there. In a museum you would never know it to be a Sargent without the label. Bonaventura has given Sargent the go-by. He quit portraits once, he should have stayed quit."

Upon hearing these dreadful sentiments from the mouth of one so young (and so fair, for Schmittie has nice candid pale blue eyes like Bastien-Lepage's Joan of Arc), M. d'Hervilly and I in our agitation allowed the parcel to drop, and out sprang a frightened cat. It was such a strange place and such a curious situation in which a well bred cat should find herself that -- and is it any wonder? -- she immediately had a crise-des-nerfs.

Round and round the room she went. Never a glance gave she at "The Cremorne Gardens" of Whistler nor at Mr. Ranger's "High Bridge," though doubtless she well knew the difference between the two paintings. "What is it, a mouse?" gasped the psychic lady from Boston, pushing away her friend Amy in the effort to mount first upon the upholstered divan.

"It's a coyote from the zoo," said the fur coated man named Bill, making for the door.

"Oh, my, here's Dr. Robinson," exclaimed M. d'Hervilly, trying to escape.

"Nothing," I replied; "but the Red Cross Fund got $50,000 for it."

"Fifty thousand dollars! Gee whiz, say, that's going some, Bill!" said one fur coat to the other fur coat.

"Who are they?" I whispered to M. d'Hervilly.

"Out of town museum directors probably," said he.

"Great piece of work," said one of the museum directors to the other, "all except the coat. I don't like the way it fits him. Looks like the kind that Einstein, Schwartzkoeffer & Schnaz supply to college boys."

"Why, that's just the part I liked," returned the other museum director, "and besides I like Einstein, Schwartzkoeffer & Schnaz's things. It was from them I got this fur coat."

"They say he has psychic powers," said a large lady with a poetic cast of countenance and with the air of having just escaped from Boston.

"Everybody knows that, my dearest Amy," returned her companion. "His mediumisitic susceptibility is truly extraordinary. In Boston there are people who profess to know the very spirit that controls Sargent. It's 'Bonaventura,' if I remember rightly. And if the rapport is established, perfectly wonderful revelations appear upon the canvas, and if there is no rapport, why, nothing happens at all. It really isn't poor, dear Sargent's fault, you see, if the picture turns out badly."

"Do you mean to insinuate, madam, that this portrait turned out badly?"

"I — I —" gasped the lady addressed, "I beg your pardon, I don't believe I have the honor of your acquaintance."

"Schucks, Schmittie," impatiently exclaimed one of the young lady art students to the other young lady art student. "Aren't they the limit?"

"For two cents," returned Miss "Schmittie," "I'd tell 'em what I think of it."

"Amy, dear, I think we might be going," said one of the ladies from Boston.

"Psychic powers! Psychic fiddlesticks!" exclaimed Miss Schmittie loudly. "I'd like to see where you get soul revelations out of that awful picture."

"She said 'awful,' Amy. What a dreadful young woman she seems to be!"

"Permettez moi de vous aider, monsieur," said M. d'Hervilly to me, "it's slipping."

go to get the best view of the healthy Venuses of Hans Makart, which have now, alas! mysteriously disappeared.

"Yes, but I know where it is, thanks."

"But I'll show you the way. Let me carry your parcel for you. J'insiste!"

"Jamais. You are terribly kind. I am used to carrying parcels, or at least I am used to this parcel. No, no, monsieur, I'll carry it. And I mustn't trouble you. Really I know the way."

"But I wish to go with you," returned M. d'Hervilly, linking my free arm with his, and then whispering as we drew near the proud young man who was copying the Regnault "Salome," "I want to know what you think."

"Vous me flattez, monsieur."

"No, I honestly want to know what you think of it."

"Very well, then," returned I, and with that we rounded the corner into the Presence Chamber.

The mob of eight were extremely furtive in their attentions to the new Sargent. Although actually in front of it they kept looking about in worried fashion at the other things in the room and then returning in an attempt to meet the troubled gaze of the President, for the eyes of this Sargent do not follow you about as the eyes in some portraits do, but on the contrary appear to evade one. The portrait, in fact, seemed to catch some of the embarrassment that was thick in the room. I certainly had caught it, and the attendants had caught it. I had an alarmed sense that all the museum was perturbed. Why? Why, in Heaven's name?

And there was M. d'Hervilly still talking French to me, who had never talked French to me before!

"Dites. Qu'est-ce que vous penser, hein?"

"It's – it's a Sargent, you know," I faltered.

"I should think I ought to know that myself. Tell me, do you like it?"

"You know, Sargent hasn't been painting portraits much of late. He had retired from portrait painting. Circumstances compelled him to do this work."

"I know. But is it like him? Did you ever see him?"

"Wilson? I did not think him so pale, three months ago, as Sargent thinks him. But Sargent evidently tried hard to earn the money —"

"Money? How much money?" interrupted two gentlemen in fur coats. "What did he get for it?"

looked to see what had happened – nothing!" Dufy comes from Normandy, his ancestors being originally Irish, hence the name. There had also been a German intermarriage among his progenitors, nevertheless, with a smile and a military salute: "J'espère que je suis un bon français!"

The Sun, December 30, 1917

WOODROW WILSON BY SARGENT

TIME – Friday.
THE PLACE – The chilly, jaillike salon d'honneur of American art in the Metropolitan Museum. In the central position on the wall hangs the recently painted portrait of President Wilson by John Singer Sargent. It is hedged in by an altar rail at which the devout, if so inclined, may offer up their praise.

A MOB OF about eight people are assembled near the altar rail talking in barely audible whispers. In the next room, through the wide portal, can be seen a young man disdainfully copying Regnault's "Salome." Two young ladies in painter aprons, not so disdainful, consent to join the tourists in studying the Sargent. Uniformed attendants pass and repass with the nervously detached air of hotel detectives.

To these enter M. d'Hervilly of the department of painting and myself, talking French. That Mr. d'Hervilly, who himself is really French, should talk French with me, who am not really French, struck me at the time as something bodeful, ominous. He is as intense as the house attendants and doesn't know he is talking French.

"Vous allez voir le Sargent-Wilson, n'est-ce pas? C'est par ici," said he when we encountered each other by chance in the Silver Spoon section of the balcony, where we always used to

were about to sit down M. Dufy said: "Perhaps Monsieur
McBride would like white wine; we have some specially good
white wine," and without waiting to hear from me he im-
mediately arose and returned with a bottle of cobwebby white.
Now I have always noticed that when every work of an artist
contains something that is personally pleasant I am sure to
find the artist himself simpatico. Once again it proved true.
How did he know I liked white wine and always drank it in
preference. Simply by intuition lui et moi being simpatico.

In the atelier were stacks of canvases, some of them very
large. All that I liked best had been painted in the Midi, gar-
dens and balconies in the cavalier method of the moderns, but
recognizable as gardens and balconies just the same. Dufy's
color is always good, design good, and it can be felt that he
could be realistic if he wished. He is not a primitif because he
doesn't know how to paint, but for quite the contrary reason,
because he does know how to paint.

He asked me how I stood on the question of Picasso and
Matisse and was not horrified at my reply that I never found
their work completely successful, though always completely
interesting. (We were talking of the abstract performances by
these men. Afterward I found abstractions by them that to me
were completely successful.) M. Dufy said there were no new
names to place beside theirs. For him Matisse has awakened a
new interest in painting, which was a great thing. Apparently
everything had been said, but Matisse found new ways to say
it. Picasso was trying for problems that were perhaps insolv-
able, but his experiments had that interest.

He showed me a box of silks and damasks printed from
his designs, most of them from the "Bestiare," the book of
wood prints with text by Apollinaire. Apollinaire, full of
fantasy and an amusing fellow, both M. and Mme. Dufy
agreed. Dufy had designed stuffs for Poiret. Both Poiret and
he felt that the war would not sidetrack modern art. Never
could go back to the old, at least. For his part, if he did war
things they would be allegorical. Gave me a silk pochette of his
design, with all the Allies mounted upon white horses. He said
Braque had become a soldier, had found himself in the vie
militaire. M. and Mme. Dufy said that last year in the first
week in September there was an anxious moment. "Heard the
cannon, you know," most impressively. "We heard the cannon
of the Germans, and in the papers, next day, not a word! We

him. Just in front of the house under the trees an officer had
propped a rebellious motorcyclette upon a rack and it was
racing away like mad although standing still. The explosions
were terrific. M. Malye not being visible, I joined the little
crowd around the exploding bicycle.

Suddenly a young soldier who had been assisting the Lieu-
tenant of the bicycle stepped forward and said, "Is this Mr.
McBride?" and when I had replied "yes," explained that he was
Raoul Dufy. He had just learned that I was in Paris and had
come at once to thank me for the kind things I had written
about him in THE SUN the year before.

The people in my house and in the neighboring houses,
brought to the window by the noise, appeared to be vastly as-
tonished at my share in this military manœuvre, which was
increased by the arrival of my dinner guest, whom the simple
soldiers in the throng, including Dufy, had to salute. The
troublesome motorcyclette finally became adjusted and bore
its Lieutenant away. Dufy could not dine with me, as his wife
would be alarmed at his absence on the day of his "perme"
(all the soldiers, young and old, having immediately shortened
the word "permission" to "perme") so I agreed to lunch with
him and Mme. Dufy on July 14. Dufy's depot is not far from
Paris. He is in a bicycle corps, he explained, and that was how
he happened to assit the military cyclist in distress in front
of my house. He had an afternoon off once in two weeks.

His studio is in Montmartre, in the neighborhood of the
Place Pigalle, and it is full of works that America has not yet
seen, but would profit by seeing; but before looking at them we
ate an excellent luncheon. The plat was a work of art in itself,
a roast surrounded by four vegetables of harmonious colors.
The dish was decidedly worthy of being painted by M. Dufy.
It struck me afterward as strange that M. Dufy, who is fond
of still lifes, had never painted such a plat. Being devoted to
food myself, I imagined that in the presence of such a piece de
resistance the primitive artist's emotions — M. Dufy is a primi-
tive — are so aroused that there is no withstanding the im-
perative desire to "kill the thing one loves" and so every perfect
steak surrounded by vegetables gets immediately eaten instead
of painted. Certainly none of the modern primitives paints
them. They all paint lemons and bananas.

There was a bottle of red wine on the table, but as we

in the delicate thin drapery much after the manner of the
French artists of that day whose influence was powerful in
America. The idle and unobserving have called this statue
Leda and the Swan, and it is now generally so miscalled.

"The shop of William Rush was on Front street just below
Callowhill, and I found several old people who still remem-
bered it and described it. The scrolls and the drawings on the
wall are from sketches in an original sketch book of William
Rush preserved by an apprentice and left to another ship
carver.

"The figure of Washington seen in the background is in
Independence Hall. Rush was a personal friend of Washington
and served in the Revolution.

"Another figure of Rush's in the background now adorns
the wheel house at Fairmount. It also is allegorical. A female
figure seated on a piece of machinery turns with her hand a
water wheel, and a pipe behind her pours water into a Greek
vase."

The Sun, November 27, 1917

LUNCHEON IN PARIS WITH

RAOUL DUFY

MY MEETING with Raoul Dufy in Paris a year after the war
had begun had an amusing touch of surprise.

I had asked young Lieut. Malye, one of James Stephens'
friends, to dinner, and when I came home at 7 the domestique
said a soldier had just been calling for me who had said that
he would return for me in a few minutes. Thinking of course
that it had been Malye, I sauntered out on the avenue to seek

print with the matter of fact eyes of a director. I saw instantly what my committeeman could have seen as well as I, that it was one of the Stations of the Cross, and I told him so, and he was content. But the real beauty of the print I could not explain to him, for he was not of the kind that could understand beauty.

In regard to "The Rush Studio," one of the most beautiful of the Eakins pictures in the memorial exhibition at the Metropolitan Museum, a description of the picture by the artist has come to light. It is not only a charming description, but it contains certain points that will interest the students of early Philadelphia history. He wrote:

"William Rush was a celebrated sculptor and ship carver of Philadelphia. His works were finished in wood, and consisted of figureheads and scrolls for vessels, ornamental statues and tobacco signs, called Pompeys. When after the Revolution American ships began to go to London crowds visited the wharves there to see the works of this sculptor. When Philadelphia established its water works to supply Schuylkill water to its inhabitants, William Rush, then a member of the water committee of Councils, was asked to carve a suitable statue to commemorate the inauguration of the system. He made a female figure of wood to adorn Centre Square at Broad street and Market, the site of the water works, the Schuylkill water coming to that place through wooden logs. The figure was afterward removed to the forebay at Fairmount, where it still stands. Some years ago a bronze copy was made and placed in old Fairmount near the Callowhill street bridge. This copy enables the present generation to see the elegance and beauty of the statue, for the wooden original had been painted and sanded each year to preserve it. The bronze founders burned and removed the accumulation of paint before moulding. This done, and the bronze successfully poured, the original was again painted and restored to the forebay.

"Rush chose for his model the daughter of his friend and colleague in the water committee, Mr. James Vanuxem, an esteemed merchant.

"The statue is an allegorical representation of the Schuylkill River. The woman holds aloft a bittern, a bird loving and much frequenting the quiet, dark wooded river of those days. A withe of willow encircles her head, and willow binds her waist, and the wavelets of the wind sheltered stream are shown

CORRECTION

ON EAKINS'S "THE GROSS CLINIC"

AND EAKINS'S "THE RUSH STUDIO"

"The Philadelphia *Inquirer*,
"Editorial Rooms, Nov. 6.

"MY DEAR MR. MCBRIDE: I feel I should like to thank you personally for the page about Thomas Eakins in Sunday's SUN. . . .
"There is one thing, however, that I do not understand—the allusion to the figure covering its head in horror in the Gross portrait. This figure is the mother of the boy undergoing the operation. In those days such things were allowed, of course, or Eakins, with his regard for truth, would never have put her in. He took a course of anatomy and surgery under Gross in order to paint the picture and it is better than the Agnew because Gross never posed. Eakins made his study in the clinic. Mrs. Eakins retains the original head of the Gross, which is a great work.
"Yours very sincerely,

"HELEN W. HENDERSON."

You are right, of course. Mr. Burroughs of the Metropolitan Museum reminded me instantly that the shuddering figure in shadow in the Gross portrait was the mother and not a frightened student as I in my haste thought. It was not so much the figure that I felt as the shudder.

I fear I am rather weak upon the story part of pictures anyway and could tell you many amusing scrapes that I have got into in consequence. One will suffice.

Many years ago when I was directing a big State art school somewhere in the State of New Jersey a Dürer print hung upon the walls of my office. One day a member of the board of directors happened to be loafing in the room and idly fell to examining the pictures. Suddenly he called out "What is this?"

"A Dürer," I replied.

"But what is it? What's going on in the picture?" he persisted.

Would you believe it, dear Miss Henderson, although I had owned that Dürer for years and was very fond of it, I was compelled to rise from my seat at the desk and reexamine my

140

fronted by the pitilessly dissecting eyes of Thomas Eakins, painter? I am afraid you flatter yourself.

I fear I never shall convince Mrs. Talcott Williams, and I know I never shall convince Mgr. Falconio, that their portraits are fine human documents, worthy of the salons d'honneur in any of our museums. It will be easier to persuade artists of it, however.

In the "Mrs. Frishmuth" there is a large and awkward circle of musical instruments on the floor about the lady's feet. I never look at it without laughing to myself, yet I admire the work immensely and will be vexed if our museum allows some other museum to acquire it. The roughness of the decorative arrangement reminds me of a certain decoration of Goya's that I saw in Madrid and which has the same big lines and savage grace.

The "Miss Parker" betrays the same desperation of workmanship that marks the "Mrs. Talcott Williams," and will be found almost equally attractive to painters. Like several of the other feminine portraits, it bears a strange and haunting suggestion of the work of Bronzino.

How long Eakins worked on these pictures I, of course, do not know, but I imagine he spent vast energies upon them. I was reminded of Vollard's story of his countless poses to Cézanne, who always insisted that the portrait was but just begun. Like Cézanne, Eakins often got most when he thought he had least succeeded.

In great art the means are concealed in the end, so it is said. In "The Thinker" they certainly are. In it Eakins hides all his effort and withdraws from the scene utterly. In the "Mrs. Talcott Williams" there is almost a more vivid sense of life because the artist is still there. The creation is still proceeding. The spectacle assists. The lady trembles with the unwillingness to become bronze like "The Thinker." It is, and I scarcely dare to say this, lest you become angry, a "modern" picture.

The Sun, November 11, 1917

there would still be no quarrel here, for all of them are excellent.

But, and here comes the rub, I feel decidedly that were an individual to know the soul of Thomas Eakins solely by "The Thinker" he would miss much of extremest value from that painter's contribution. Furthermore, were the museum my private property and the collection controlled by my private taste — don't be alarmed, dear reader, this is only an argument — and in my typical museum poverty were I still restricted to but one example, my choice would not fall upon "The Thinker" nor upon any of the portraits named! For my private solitary King Ludwiggian delectation rather would I choose one of the so-called Eakins's "failures."

"Failure," of course, isn't the word, for in the strict sense there is no such thing as an Eakins failure, but I haven't a term ready at my hand for a second series of portraits, including those of "Mrs. Frishmuth," "Mrs. Talcott Williams," "Ruth," "Monsignor Falconio" and "Gen. E. Burd Grubb," which gave Eakins, the artist, a rude struggle. In them Eakins gained, and I am not sure he knew it himself, a rude triumph; and in them I take a rude joy.

He must have worked desperately upon these pictures, and most of them had the usual failure with the sitter. The "Mrs. Frishmuth" was loaned to the institution to which that lady had bequeathed her collection of musical instruments, and when the artist asked to have the canvas back to lend it to an exhibition he was told that he need not trouble to return the picture to the institution! Institutions are institutions, you know.

Mrs. Talcott Williams posed many times for her portrait and finally, growing discouraged, refused to pose any more. Probably the lady's relatives will agree that the likeness is not photographic, but, on the other hand, how much finer than a photograph it is. It is a great piece of painting, worthy to hang side by side on equal terms with the greatest things of Degas or Whistler. Mgr. Falconio also refused to continue the poses when he saw the sort of effigy that was growing between the painter's brushes. Who can blame Mgr. Falconio? Let him without vanity throw the first stone! Do you, reader, imagine that just because you take unholy pleasure in Mgr. Falconio's portrait you yourself would have had firmer courage when con-

for there are certain divergencies of style in the paintings in the Memorial Exhibition that fascinate me, but that, perhaps, will not fascinate those who followed me last week easily enough in praise of Eakins's concrete and monumental successes.

The fact is that Eakins made successes for the public and successes for artists. That the public will ever rise en masse to an appreciation of pure style in painting I doubt, but wherever and whenever a community becomes seriously interested and influenced by the arts there the abstract qualities of painting become more generally legible. It is for that reason that the "modern" movement makes such slow progress into the public consciousness. Its appeal must necessarily be to the few, to the few to whom the brush stroke is as pregnant with meaning as the poet's word. But these few we always have with us, and they will always remain the most staunch and inflexible defenders of that vestibule of style through which all pass who gain a secure refuge in the Hall of Fame.

In the series of Eakins's portraits the "Dr. Gross" and the "Dr. Agnew" take a preeminence that probably will pass undisputed. There remains a series that includes "The Thinker," "Prof. Rand," "Prof. Barker," "Dr. Horatio Wood" and "Prof. Rowland," works in which the characterization and finish have been carried to a degree unprecedented in the history of American art. In none of these has sincerity been sacrificed to finish. They are not in the least perfunctory or academic. They are lively and intense.

If public and artists alike were to join in a voting contest to choose one of these portraits for a public museum the choice, it is almost certain, would fall upon "The Thinker." This is the most restrained, most classic of all of the Eakins canvases. It is so restrained that it is almost more like sculpture than painting. Only the other day when talking of Eakins to a group of friends a sculptor who was present said he had seen an Eakins portrait years ago of a man lost in thought, with hands plunged deep into his pockets, and he matched his action to his words by assuming the identical pose of Eakins's "Thinker" for us.

It is indeed a memorable, unforgetable picture. Were it chosen by a museum, by our museum let us say for the sake of argument, there would be no quarrel about the choice with THE SUN. Were any of the other professors or doctors chosen

little gem. There is the most loving sort of brush work in every part of the canvas. Evidently the artist himself felt rather satisfied with it.

Another picture of the greatest importance is the "Katherine," a study of a young woman seated in a chair and teasing a cat.

But the clock strikes — the hour for going to press arrives. I find I have not allowed myself time to describe the feminine portraits, portraits of peculiar distinction and charm. There is much to be said about Eakins's method of painting, its merits and its defects — for it has its defects. It will also be found worth while to explain to the general public how the portrait of the female singer in trailing skirts of pink damask, is a fine portrait, even though her slippers do peep out from her skirts at the wrong places.

There is, indeed, much to be said of Thomas Eakins. This tale, therefore, is "to be continued."

The Sun, November 4, 1917

THOMAS EAKINS II

> *I depend greatly upon that which I do not yet know.*
>
> MAX WEBER.

> *You know our bargain; you are to write me uncorrected letters, just as the words come, so let me have them — I like coin from the mint — though it may be a little rough at the edges; clipping is penal according to our statute.*
>
> PERCY BYSSHE SHELLEY.

UPON THE whole, I am content that there should have been a stop of one full week between what I said last Sunday of the work of the late Thomas Eakins and what I have to say now,

arena benches in the background are confusedly placed and distracting.

In the "Dr. Gross," on the contrary, every actor in the drama is first rate in his part, and every detail of the picture has the highest distinction as painting.

There is a danger at this time with the question of surgery again so prominent in the public consciousness because of the war that there will be a difficulty in gaining public attention for the study of the style in these two important pictures, so absorbed and perhaps so shocked will the layman be by the spectacle.

It has been so many years, in fact, since any of our artists have thought it worth while to work over their pictures, or have had sufficient concentration to carry a complicated theme to a conclusion that the vast canvases, with their many figures, will be in themselves a surprise. Add to that the realism of the operation, the businesslike haste of the surgeons, the intensity of the assistants, the spattering blood, the total lack of modern hygienic appliances — and one must be pardoned if one thinks more at first of subject than of manner.

Although I intend to scold the public if I find it lays the wrong emphasis upon these two pictures, I confess that I had to overcome by force of will a confusion into which I fell myself at the first sight of the "Dr. Gross Clinic." My excuse is that I have not been in good health this autumn, and on the day of my visit to the gallery I was particularly unwell. In the Dr. Gross picture there is a figure at one side, of a new student who weakens at the sight of the operation and covers his face shudderingly that he may not see blood. I looked at him and at the thing he could not look at — and then suddenly I was compelled to leave the gallery.

I went back again, however. The "Dr. Gross" is one of the great pictures of modern times. It is the duty of every art lover to see it. But heaven grant that there be not too much silliness uttered upon the subject.

A safer theme for general discussion is the "William Rush Studio," a delightful picture that challenges in a vague way the work of the great German, Menzel. I saw this painting first a year or so ago at the retrospective exhibition of American art held in the Brooklyn Museum. I stated then that it was the finest work in the exhibition and urged that museum to acquire it for its permanent collection. The painting is indeed a regular

"He was in Spain seven or eight months previous to his return home in the summer of 1870. While in Spain he painted his first picture, that of the little gypsy, Carmencita Requina, dancing, also a portrait of her and some other studies."

The bent of Thomas Eakins's mind was strongly scientific, and science and scientists held great sway over him all of his life. The study of anatomy, so essentially part of an artist's training, led him to the clinics of the surgeons, that he might glean information at first hand, and to his studies in this direction, may be traced the two great pictures of Dr. Gross and Dr. Agnew.

The scientists in their turn were afterward impressed by the closeness of observation betrayed in Eakins in some of his pictures of animals in action, and a brochure by the artist on the subject, "The differential action of certain muscles passing more than one joint," was listened to with respect at the Academy of Natural Sciences in Philadelphia in 1894.

Eakins's enthusiasm, however, was not confined wholly to the surgeons, and the series of chemists and physicists that we owe to him are impressive to a degree. Each one may be said to have received so religious a celebration at his hands that the result in effect for each is an apotheosis.

The second interest of the painter was athletics, and his boxers, swimmers and oarsmen pictures are scarcely less important than the great portraits.

I have called the portrait of Dr. Gross Eakins's masterpiece. So little has been written of Eakins of an authoritative nature that it becomes necessary to rate a few of the most significant successes, so that our public, which likes to have serious painters made easy for digestion may not in its haste make mistakes of too glaring a nature.

I am aware that hitherto the "Dr. Agnew" in a private way has been called number one, but now that the paintings hang in the same gallery the extraordinary power of the "Dr. Gross" will probably pass unquestioned.

The "Dr. Agnew" is full of the impassioned painting that is characteristic of all of our artist's work, and the attitudes of the personages are as unconscious and the realism of the operation that is proceeding before us is as terrifying as that in the first named work, but the grouping is not so happily arranged and the picture does not rise to an overpowering climax in the central figure as in "Dr. Gross." Besides, the students on the

ing sympathy thought to be so necessary this artist relied upon the members of his family and a small group of his pupils and scientific friends. I asked Mrs. Eakins what she considered the most comforting experience of the artist's career, and she replied unhesitatingly: "The reception given to him in the city of Lancashire in 1912. It was arranged by two gentlemen of that place, one of whom had been once a student of Mr. Eakins, and the 'Portrait of Dr. Agnew' was shown in the exhibition. They were very kind to him and he always spoke afterward of the pleasure they had given him."

That was the only honor of the kind that fell to Thomas Eakins's lot. That little provincial reception becomes pathetic in retrospect when one now studies the achievement of the artist as displayed so tellingly in our museum. It is enough to make one weep when one contrasts it with the recognition so generously given out to the favorites of the hour.

However, I dare say it was a very nice party.

Thomas Eakins was born July 25, 1844. His father's father came from the north of Ireland and upon the mother's side his forebears were from England and Holland. His father was a caligrapher of prominence, writing diplomas and important governmental documents upon parchment.

After a little study at the Academy in Philadelphia Eakins went abroad and studied with Gérôme and Bonnat. Apparently he was not a facile student, and a remark of Gérôme's at that time was quoted about the student quarter and is still current. Gérôme said, "Eakins will never learn to paint, or he will become a very great painter."

Mrs. Eakins says of this period of her husband's history:

"I know from what my husband said and wrote of his early studies that he floundered about in his struggle to understand, unwilling to do clever or smart work or deceive himself by dash. Finally he wrote to his father, 'I know now I can paint, and if I can keep my health, I will push forward.' He writes of the great advantage of studying in the school from the naked model and with so great an artist as Gérôme to criticise, also perceives the advantage of making memory studies and studying by himself in his room between school hours. He was then 24 years old and had been in Gérôme's school two years, always independent, yet admiring and anxious to profit by the advice and example of the good painters.

ful, money making artists of the present era, I have sometimes
acknowledged to myself that ninety-nine-one-hundredths of
the character of these men is made up of the quality known
as "push." Thomas Eakins, on the contrary, was ninety-nine-
one-hundredths artist, so Fame held aloof from him until after
his death.

I don't wish to intimate that Eakins was totally without
artistic recognition for a few artists of prominence valued his
performance. M. Humphrey Moore and William Sartain, who
were fellow students of Eakins in Paris, were close friends.
William M. Chase was an admirer and formerly owned one of
the pictures in the present exhibition. But none of these men
were able to obtain honors for Eakins or even an adequate
hearing for such a serious painter. It is doubtful if they really
realized the full power of Eakins or they would have blazed
aloft their enthusiasm for him upon the rooftops and forced
attention.

The "Portrait of Dr. Gross," as I have said, was found
brutal by the artists of the day at the time that it was painted.
The same objection was held for the "Portrait of Dr. Agnew."
It was rejected by the jury of that year at the Philadelphia
Academy. It had been sent in the collection from this city, and
when the New Yorkers threatened to withdraw the whole New
York group unless it were hung it was reluctantly accepted.

Eakins's history is full of similar rejections. The important
portrait of Prof. Barker was offered to the university to which
he was attached and was not accepted. Eakins wished to ex-
hibit the portrait of Prof. Rowland in the Johns Hopkins Univer-
sity, but the generous offer was looked upon with suspicion
and he was discouraged in the attempt to show it in Baltimore.
Eakins was not even spared the ignominy of having portraits
that he wished to give to certain sitters refused. The Carnegie
Institute refused for its international exhibition the portrait of
Miss Coffin, which now finds an honored place in the memorial
exhibition along with the other formerly rejected pictures. Still
more recently the Panama-Pacific Exposition in San Francisco
refused to honor Eakins and itself; but that is so very recent
an affair that I shall be accused of talking scandal if I don't
watch out.

But nothing in the way of enthusiastic appreciation came
to Eakins from the public during his lifetime. For this sustain-

every point of view, impeccably composed, wonderfully drawn, vividly real and so intensely charged with Eakins's sense of the majesty of modern science as personified by Dr. Gross that the elevation of the artist's spirit is communicated to the beholder, and the ghastly blood stains — for Dr. Gross is shown in the clinic, pausing in the midst of an operation — are forgotten. It is not the blood that makes the painting great, any more than it is the blood that makes "Macbeth" great. However, the public will probably wish to dilate upon this blood, and it is welcome to the theme, providing it does not allow itself to be hoodwinked into vulgarizing the painting. I once knew a dear old lady who assured me that "Macbeth" was a poor play, basing her contention upon the undoubtedly correct plea that *Lady Macbeth* was "horrid."

But before taking up the study of the pictures something should be said about the painter and his career.

The long continued neglect under which the artist struggled — he died without tasting a real public success — is puzzling. He was a modest man, without guile, and quite ignorant of modern methods of self-exploitation, yet it is singular that such excellent works of art could remain hidden from public knowledge for such a length of years. With the exception of the great canvases, the portraits of Dr. Gross and Dr. Agnew, which are owned by the medical institutions in which these surgeons labored, the bulk of the paintings in the memorial exhibition are still owned by the widow of the artist. That is a startling fact and a sufficiently distrubing accusation against the taste of our collectors, both public and private.

I have often wished to make a study of the possibility of "art making its own reclame," of pictures succeeding upon their merit alone and because of their merit alone, and when I first visited the house of Thomas Eakins in Philadelphia after the death of the artist and saw the superb canvases lining the walls of the house from cellar to roof and piled against one another in corners of the rooms, pictures that had constantly been rejected at the academical exhibitions and were far finer than those that had been accepted for these exhibitions, I felt that should I attempt the essay I could find instances sufficient for my argument in the life story of Thomas Eakins.

For I confess that in moments of discouragement, when contemplating at too close range the activities of the success-

THE STRENGTH of the late Thomas Eakins as a painter, it is safe to promise, will come as a revelation to most of the students and connoisseurs who will visit the memorial exhibition of his work that will open to-morrow to invited guests and on Tuesday to the general public in the Metropolitan Museum of Art.

The name of Eakins is unfamiliar to the present art public, is practically unknown to our great collectors and is strangely absent from the lists of the so-called honors meted out by artist juries at the time of public exhibitions. Nevertheless Eakins is one of the three or four greatest artists this country has produced, and his masterpiece, the portrait of Dr. Gross, is not only one of the greatest pictures to have been produced in America but one of the greatest pictures of modern times anywhere.

Under the circumstances it can be seen that the Metropolitan Museum has undertaken an enterprise of importance — nothing more nor less than the crowning with honors of one of our most neglected geniuses. It will place the fame of Thomas Eakins. It will make more history, although it will not be more important, than the memorial exhibition to Albert P. Ryder, which is to take place later in the season at the museum, for in a way Ryder has long since found his audience and his place. Consequently in the most emphatic manner possible the public is urged to begin at once the study of the Eakins pictures and to study them long.

I say "study them long," for it is possible that the timid portion of the population unless held sternly in check will imitate the silliness of the timid people of years ago, who were stampeded from the "Portrait of Dr. Gross" by the cry, "It is brutal."

The picture is brutal, if you will, but it is brutal as nature sometimes is and science always is.

It is a stupendous painting nevertheless. It is great from

virtue. There is probably, as in most other things, both good and bad. Nor is it even necessary to establish my opinion that the good outweighs the bad.

"All that I wish to point out is, first, that the grouping system is to be found in practically every other exhibition, so that the good in it is not endangered, that the public has plenty of opportunities to follow the various evolutions and tendencies; second, that the system which ignores grouping is more consistent with the aims of this particular exhibition.

"There is, of course, a difference between the effect of such a system upon the artist or on the trained observer, that is the specialist from that on the average visitor, but I believe that is more a matter of degree than is usually supposed. But whether the bewilderment is almost nil or whether it is overwhelming, to me in either case it is healthy. I consider it of the greatest value that in at least one exhibition, and this seems to be the logical one, all works should be withdrawn from their accustomed environment and made to stand alone.

"It is so easy to confuse the environment which the grouping system has made inevitable with the work itself. A perhaps less important benefit lies in forcing the visitor to at least give himself the opportunity of looking at every work shown instead of concentrating upon those he has decided beforehand he is going to like.

"The general effect of the exhibition, as a whole, I consider, in this instance at least to be an even less important consideration, but even at that the independent exhibition just closed seemed to me most beautifully presented. However, that is a matter of personal taste rather than judgment. Very sincerely yours, MORTON L. SCHAMBERG."

The Sun, May 13, 1917

As for my own experiences, I found that I made fresh discoveries on each visit, and on the last Sunday night decided that if I could have a day or two longer of the show I could compile a respectable list of new people who deserve at least to be watched. I began there and then to make a little list, but about 9 P.M. the porters began rushing in to take the works of art down from the walls, and my scheme was only in part carried out.

I have been so handicapped myself by the alphabetical system of hanging these works of art and have met so many people who have spoken against the method that I was somewhat surprised on my last visit to the gallery to meet a group of exhibitors who were still keenly for the alphabetical system. Morton L. Schamberg of Philadelphia spoke so strongly in favor of it that I asked him to put his argument on paper for me. He does not convince me that the public is most benefited by the new way of hanging pictures, but all sides of the argument should be heard. He writes:

"Apropos of our conversation I am sending you my argument in favor of alphabetical hanging. I hope I have been able to make my points reasonably clear.

"Was the system of alphabetical hanging used in the first independent exhibition a success? There appears to be a difference of opinion. The abstract principle of justice — that is, the elimination of any possible inequality of opportunity due to favoritism or bad judgment on the part of a hanging committee — is pretty generally accepted. The difference of opinion is usually based upon other considerations.

"I find that most of the exhibitors favor the used system of hanging as regards their own works, and that the opposition mostly comes from those who are concerned with the effect only upon the public. Though an exhibitor myself, I am inclined to think that the later consideration is the more important one, and my reasons for favoring alphabetical hanging I base largely upon that very consideration; that is, the effect upon the public.

"The most frequent criticism of this system, which ignores the inevitable schools or groups into which most of the works fall, is that of the resulting bewilderment to the untrained observer. I entirely agree that the effect is bewilderment, but instead of finding in that bewilderment a fault I find in it the greatest virtue; not that I find it an undiluted

due to the alphabetical hanging of pictures, seemed to suggest the teeming mass of at present disunited ideals that go to make up the present stage of our civilization. Here and there, sticking out all over the exhibition, are little signals of aspirants who may later gain complete control of our melting pot to shape the national spirit into new forms.

Which way the forces will direct us no man knows, no more than he knows the exact form that our national life five years hence shall take; but it is something gained, at least, to put the principles at stake fairly before the public without the entanglements of politics, that the public itself may choose. In the end it is always the great public that chooses. By dispensing with the middlemen of the juries the public will economize, by saving whole generations of time. At least it has already done so in Europe.

But as an art critic I confess the exhibition was too much for me. In the limited time at my disposal it was impossible to get hold of the exhibition sufficiently for the purposes of an article. I saw it first the night of the private view and enjoyed the spectacle hugely, but the impression was made up of one-third pictures and two-thirds the picturesque mob.

A few days later I went again. There were very few in attendance, but among those few I found some friends. Each time, in fact, that I went I found friends, and although it is delightful to discuss amusing pictures with friends it is difficult to make classifications with them, and I estimated that a solid week's work would be necessary in which mentally to rehang and recatalogue the chaos of pictures before it would be possible to make a succinct report upon the proper modernity, that is to say the real spirit, of the exhibition. Although I am a reformed character and promise myself to do better next year, nevertheless I am already shuddering at my prospects if the ruling powers insist upon continuing the system of the alphabetical hanging, for of course all the trouble was due to that; to that and to the fact that there was no press view.

I went twice again, on the last Saturday and Sunday of the exhibition. The attendance had much increased, and I liked the look of the people I saw there. They seemed to be people with histories. A percentage of them clearly bore the look of having come from a distance; they seemed to have the aspect of the "new people" that the art world has been longing to annex, and they were unmistakably enjoying themselves.

the pictures, especially by new artists, that had points of interest to those of the public that wish to be kept abreast of the times we live in."

Reader, I knew that voice. It had been some time since I had heard it, but I knew it. It was Conscience that was speaking. Usually at this season of the year the inner spiritual existence of an art critic isn't worth two pence and the wrongs of Hecuba and the thirst for the adjustment of the eternal verities are swamped in the grand yearning for a complete silence, and really I knew no reason why I should not soundly sleep the day away as good art critics should. But such a tirade from a hitherto docile conscience indicates a situation that was grave, to say the least.

And the acrid accents continued. There was more of the same refrain. Sleep became impossible, and rising at the ungodly hour of 10 A.M. I resolved to square myself with the voice and my readers, if it be possible, and to add a post-scriptum to my history of the Independent exhibition that should include a few names of the newer artists who de-served a notice a month ago.

But first a short account of my experiences with the exhibition is in order. Not by way of excuse, you understand. No excuse is possible for conduct such as mine. An embarras-ment of duties confronted me and I apportioned my energies among them. I see now that was wrong.

In a constructive age such as this I should have neglected everything for the supreme duty of aiding the reconstruction-ists. But wait! There'll be another year with plenty of recon-struction in it, and mistakes are not mortal if they are recog-nized as mistakes. And my experiences may be significant to the committees who are to plan next year's attack, since they are, as I believe, experiences that others have shared.

First of all, I should like to say that I regard the show as an artistic success; a success far beyond what I had thought possible for the first year of such an organization. It interested me beyond any other public exhibition of the season. In fact, it has been the only public exhibition of the year that has much interested me, that has made me think and that has forced me to recall that there are artists living in America who are confronted with American problems.

The very conglomeration of the show as a whole, with its strange admixtures of cubism and the Hudson River school

to agree with Mr. Duchamp in spite of the price mark, but no one that I have heard of yet agrees with him in regard to "Supplication" except Mr. Eilshemius. I have a vague recollection of having received many missives in times past from Mr. Eilshemius in which he seemed to be not unaware of his own merits as an artist, but I confess that "Supplication" was one of the thousand or two paintings that I merely glanced at in passing. Mr. Eilshemius is to be congratulated upon having found so powerful a friend. I will look at "Supplication" again, on Mr. Duchamp's account.

The Sun, April 15, 1917

MORE ON THE INDEPENDENTS

LAST SUNDAY when I was about to retire for the night, or rather for the morning, for newspaper people never retire for the night, and I was asking myself the usual question, "In what have I failed to-day?" I was astonished to hear a voice in reply. I was astonished, for to tell the truth I had asked the question perfunctorily.

"You have failed miserably to-day," said the voice as clearly and distinctly as a voice from a phonograph, indeed distincter than that; "you have failed not only to-day but every day for a month past to give your readers a real account of the exhibition of the Independents. You have failed to state plainly whether you think the exhibition as an exhibition is a success or not, a thing upon which your readers have a right to your opinion. You have failed to give an account of the problems of management which the committee in charge of the exhibition have had to face. And you have failed to list

"No, I could not do that," she replied. "It would be plagiarism."

William J. Glackens, president of the new organization, was another of the unfortunate ones, and Robert Henri, George Bellows and John Sloan, who mind misfortunes that happen to Glackens a great deal more than they mind the misfortunes that happen to themselves, tried loyally to cheer him up, but the Glackens pictures were hidden away in the most remote corner of the whole two miles of pictures, and even when found could not really be viewed by the most zealous of friends.

But Glackens laughed again when he saw the "Claire Twins" by Miss Dorothy Rice. Everybody laughs when they see those twins. Even the Baron de Meyer laughed. Marius de Zayas of the Modern Gallery seemed positively glued to the floor in front of them.

"You'll be having that down in your gallery next," I bantered him.

"I should be only too proud," he returned. "I can't believe a woman did that. It's strong."

"She asks but $5,000 for it," said Mr. Montross, examining the little white card beside the picture.

"Mon Dieu, c'est pas cher," interrupted the Baron de Meyer, laughingly, and he fairly ran into the next alcove, where the Baroness de Meyer was critically examining her own portrait bust in red sandstone, to tell her of the $5,000 "Claire Twins."

The bust of the Baroness is by Renée Prahar, and is astonishingly like, although cubistic. Isn't it delightful that she has decided to openly patronize modern art? It is the stand that everybody has been hoping she would take for some time. There are distinct social possibilities in cubism, and it seems odd that the two or three people in town who dare to lead a fashion have been so slow in recognizing the opportunity.

Marcel Duchamp, author of the famous "Nude Descending a "Staircase," which was such a great hit in the armory show, says that Miss Rice's "Claire Twins" and a work called "Supplication" by Louis Eilshemius are the two great paintings which the exhibition has called forth. "Supplication" is valued at $6,000. Can it be that Mr. Duchamp has been with us so long that he has begun to estimate works of art by the price marks? In regard to the "Claire Twins" there will be many

four circuits of the building before I found the way out. Each
time I went round I met young Arthur Craven, the lecturer,
boxer and poet from Paris. The third time we met he said:

"I am glad I do not owe you money. What an awful place
this would be in which to escape from a creditor. When you
turn these corners you don't know what you're getting into."

The rooms, however, look very well. The massy pillars
have been somewhat reduced in volume by the partitions that
have been built against them, and the show as a whole has
the look of a real salon. It was especially effective at the pri-
vate view, when a truly Parisian mob of artistic notables as-
sembled as by magic. The scene was very like the foyer of the
Opera in Paris on a Ballet Russe night — except, of course,
that Miss Frances Stevens would never in the world have been
allowed to take her dog Sacha to a Ballet Russe. Miss Stevens
explained to a group of young men of noble countenances but
odd attire — leading members of the Washington Square
Players, it was whispered — that Sacha, being of a retiring
disposition, was at first reluctant to come, but on its being
explained that in times like these one should put thoughts of
self aside and live only for the public, had consented. Sacha,
however, did not appear to be entirely happy and emitted low
growls from time to time, especially when people approached
too closely the "Bride and Groom," carved and painted wooden
figures by Miss Stevens, that were evidently old friends of his.
The "Bride" bears a distinct resemblance to the fair sculptress
of the work, but this is quite by accident, the carvings being
purely imaginative, Miss Stevens says.

Miss Stevens's friend, Miss Mina Loy, was one of those
upon whom the whirligig of fate, I mean, of course, the al-
phabetical hanging system, had played a scurvy trick. Her
"Making Lampshades," which is clever with a European kind
of cleverness, had the misfortune to be placed next to Mr.
Lothrop's gem studded Venus, and there was a continual mob
struggling around that work, to the total eclipse of Miss Loy's
painting.

"How can you stand this?" said some one to her. "Why
do you not take those extraordinary and beautiful gold ear-
rings from your ears and pin them to your chef d'œuvre, since
that is what seems to go here?"

Miss Loy's sad eyes flashed with opaline brilliancy for an
instant and then as quickly dimmed.

cording to the alphabetical order of the contributors' names, there is no opportunity for the wily student to economize his time by skipping certain rooms, and one is forced to at least glance at all of the 2,400 works of art on display, not all of which, you understand, are gems of purest ray serene, lest one miss the real jewels that sparkle from Mr. Lothrop's extraordinary Venus or the neat manner in which Miss Marjorie Wood demonstrates by means of tactile values how certain brands of soap actually float on the waters.

These and the numerous other wonders of the great show – which perhaps should not be mentioned by name so early in a serious review such as this until the reader has been properly prepared for them by a few generalities – these wonders are sprinkled along the walls with an almost uncanny regularity, if one considers the entirely accidental nature of the hanging arrangements, and are actually enhanced by the sedate rows of nice, good, quiet, academical productions that seem to lead up, as it were, to these explosions of the underworld.

The proportion of inoffensive to offensive works is about ten to one, and offensive is meant in the complimentary sense of being challenging. The leaders of the "spring offensive," as they say, in modern warfare, are but one in ten, but even so they are a good many, and they seem to have the enemy at their mercy. Just when you have been flung into a drowsy state by eight or ten soporifically correct pictures of the sort that are usually rejected even by the academy, and you are wondering whether deep down in your heart you really care a pin for art, suddenly you stumble upon that stupendous production by Miss Dorothy Rice, the portrait of the "Claire Twins," and are waked up so effectually that you find yourself forgiving the neighboring half dozen commonplaces before you realize that you shouldn't forgive them. So it is all the time – you are led on and on, into the remotest corners of the building, and are led everywhere except out.

It requires, in fact, strategy to get out. The ground plan of the new salon is ingeniously contrived with a labyrinth of alcoves. The front gates of the Grand Central Palace seem to lead one into the show quite simply and naturally, but when one exits one must depart from somewhere near the middle of the exposition. On the night of the gorgeous and gay private view, after I had seen everything and everybody, I made about

with the critics, for Ryder was alone in the gallery. The clerk at Montross's told me who he was.

"I took my courage in my deux mains and spoke to him. I reminded him of our correspondence and of my wish to call upon him. He seemed to recall my name and made some explanations of his inability to be at home to me last year — explanations that were like the Gibran pictures, rather vague. We talked about his famous two paintings on the one wooden panel that were separated by some marvel of engineering, and, talking to me, he seemed to decide to himself that he might trust me. He said that I had his address, but he had another place where he would receive me, at 252 West Fourteenth street. It had been given to him, he explained. There was a man who had taken it, and finding it unsuited to his use, offered it to Ryder. Ryder asked Miller the painter if he would take the room if it were he, and Miller said, certainly he would, so, said Ryder, ending his tale, 'I took it.'

"How do you like these?" I asked, waving toward the Gibrans? "He seems to be after something mysterious. All of them are the same."

"He seems to mean it, at any rate," said R. "That's the main thing."

The Sun, April 1, 1917

OPENING OF THE INDEPENDENTS

UNLIKE THE Rowe's Wharf street car line in Boston, which Henry B. Fuller says "starts everywhere and goes nowhere," the chance visitor to the exhibition of the Independent Artists who starts anywhere will go everywhere.

Thanks to the new system of hanging the pictures ac-

of Mr. Fearon's, but wished a few days in which to arrange for it. Mr. Fearon explained that the artist lived in great disorder, and probably wished to fix up his room a bit."

"Two days later a messenger reported that Ryder was no longer at home. 'Probably ambling around the country roads in New Jersey,' explained Mr. Fearon, 'taking advantage of the springlike weather.'"

"Two days later than that the messenger reported finding Ryder at home, but the room appalling. Floor piled high with ashes and all kinds of debris. 'You know more than once,' said Mr. Fearon, 'the Board of Health has got after him. Once when Ryder was ill the Reillys, who live on the floor below, managed to get in and gave the place a thoroughly good housecleaning, but that is the only such event on record.'"

"Last Saturday Ryder called on Fearon and said that he would appoint a day soon for the interview."

"Mr. King said last night that he had called once on Ryder and Ryder had given him one of his rooms. 'You know his brother owns the Hotel Albert. He named the hotel after Ryder.'"

"Called at the Hotel Albert to-day. Mr. Ryder not at home. Clerk said Mr. Ryder was a traveling salesman. Didn't think he had ever owned that hotel. A Mr. Rosenbaum had owned the Hotel Albert for years."

I think it was Ernest Lawson who finally put me au courant, told me the sort Ryder was, the simplicity of his character and the style of life. As soon as I learned the facts I gave up the idea of an article, as I did not wish to assist in starting a pilgrimage of busybodies and idlers to the retreat of the aged and picturesque painter; besides, I knew that after such a terrific amount of preparation the interview would be so stiff and artificial that it would be useless for my purpose.

However, I did subsequently meet him. A year later a second entry in my diary records the event:

"At Montross's, where I had gone to get the photos of Bryson Burroughs for his forthcoming show, I met Albert P. Ryder for the first time. There was a show in the galleries by a Syrian artist, Gibran, who paints mystic pictures. I had written in THE SUN that they were confusedly felt and confusedly expressed, and every other New York critic made similar observations. Apparently the public for once agreed

will easily understand why our artist has been placed at the top of the list among the imaginative painters of America.

The admiration for Ryder is by no means local. All of the foreign experts who have seen the pictures share the American enthusiasm for them. Roger Fry, one time curator of paintings at the Metropolitan Museum of Art, is inclined to place Ryder at the very top of the American production and Dr. Willy Valentiner, our former curator of decorative arts, also rated him highly.

When Dr. Valentiner started the review *Art in America* he asked me to write a Ryder article for him. At that time I knew little of the circumstances of the poet-painter, and Dr. Valentiner only knew that he was great, that he was living in obscurity and that he was insufficiently appreciated by the public. I was quite eager to do something for Ryder if I could, and agreed with Dr. Valentiner that a personal contact with the artist would be the thing, so he introduced me to young Mr. Fearon, who could arrange a meeting for me with the artist.

Mr. Fearon was at that time the head of Cottier & Co. He had fallen heir to the firm's traditional affection for the painter and seemed to share in it sincerely. But I think that Mr. Fearon himelf will probably admit now that a less practical avenue of approach to the hermit artist could not have been hit upon. Mr. Ryder may have been a prophet, but Mr. Fearon was by no means a St. John the Baptist. Not exteriorly, at least. On the contrary, like a self-respecting Englishman, he turned himself out very well indeed. He was all amiability, explained that Ryder was difficult, but promised to bring off the meeting.

That, however, was more easily promised than performed. From what I now know of Ryder I can see that the prospect of entertaining a constellation of dazzling personages probably frightened him. Certainly the interview did not occur. All sorts of things seemed to interfere.

Upon consulting my diary for March 11, 1911, I find the following staccatic references to my ineffectual attempts to meet Ryder:

"He speaks of Ryder with great kindness, even affection, yet with something of amused patronage, such as a keeper of a trained bear might indulge in."

"Ryder was charmed at the idea of meeting a friend

of Ryder's most admired pieces escaped across the border and became famous in Montreal long before a public was found for the work here. I have been told, but not by Mr. McGuire, that the first painting by Ryder that was acquired by Sir William Van Horne was sent to him as a Christmas gift by Mr. Cottier. This perfectly innocent and legitimate dealer's trick apparently worked, for shortly after that we heard of the "Siegfried and the Rhine Maidens" and the "Tristan" as gracing Sir William's collection, and the "Temple of the Mind" going to R. B. Angus, and others to E. B. Greenshields, both of whom are also of Montreal. It is a tragedy for us New Yorkers that another group of Mr. Cottier's customers lived so far away as Portland, Ore., for in that remote region a second nest has been provided for Ryder masterpieces. It is to that veritable jumping off place that one must travel who would see the "Jonah," possibly the greatest of all Ryder pictures, in the collection of Col. C. S. Wood. Col. Wood also owns the "Tempest." Mrs. Helen Ladd Corbett of Portland owns the "Lorelei" and several are in the Ladd collection.

This wide division of the artist's work has had a retarding effect upon his reputation. Artists know of Ryder and speak of his great pictures with veneration, but trips to Portland and Montreal are out of the question, and it is not every one who has access to John Gettatly's collection in this city, where the great "Flying Dutchman" reposes, so little by little the enthusiasts lessen their tones in speaking of Ryders seen so long ago that the fine details can no longer be distinctly recalled.

Under the circumstances they will be a retrospective exhibition. It should be held preferably in the Metropolitan Museum, and it should be well done. That is, every effort should be made to induce our distant fellow citizens of Portland, and our cousins from Montreal, to be nice to us in this matter. We should do something nice in return, of course. We might offer Portland the entire present exhibition of the Spring Academy, for instance. For keeps, too. They could retain the pictures permanently. Do you suppose that would have any weight, that offer? But in that case, Col. Wood must lend us "Jonah" for three months at least. Everybody in New York should be given the chance to see "Jonah." Once the public has seen "Jonah," the "Flying Dutchman," the "Temple of the Mind" and half a dozen other of the famous Ryders it

picture frames, vast piles of old magazines and newspapers. Overhead long streamers of paper from the ceiling swayed in the air. All around the edge of the conglomeration sat dishes on the floor, tea cups with saucers over them, covered bowls, crocks, tin pails, oil cans, milk bottles, boxes of apples and packages of cereals.

"In one corner a pile of empty cereal packages mounted to the ceiling. In another a stately tall chair staggered under its accummulated load. A black wedding chest rich with carving was almost undiscoverable under the odds and ends that burdened it. A splendid Greek head, stands on top of the cupboard with a foot bath on one side and a box of hay on the other. Against an exquisite piece of portrait sculpture, the work of a master hand, a friendly package of rice. The confusion was unimaginable, incredible."

That was Ryder's room. Something to smile over, nothing to weep about. It suited Ryder and that was all there was to that. After his dangerous illness of two years ago that obliged him to go to St. Vincent's Hospital his old friends, Mr. and Mrs. Charles Fitzpatrick of Elmhurst, L. I., persuaded Ryder to come to their house for the advantage of the pure air and the country walks, and it was in their house that death came to him last Wednesday.

Mrs. Fitzpatrick herself had been an art student and had in that way come to know the artist, who took an interest in her studies and often gave her criticisms. It is a matter of deep congratulation for all those who have a sense of the fitness of things that Ryder was thus allowed to live his last years unmolested by the fashionable sentimentalists who might have descended upon him in worrying crowds had they suspected the combination of his innocent singularity and his true greatness; and also that when the end came he was cared for by friends of his own choosing.

It happened that the old firm of art dealers Cottier & Co. was to be the engine that was to bring Ryder's art to the attention of collectors. The late Daniel Cottier, according to William J. McGuire, who was once connected with the firm and knew Ryder for thirty-five years, was the first to take a serious interest in the artist.

It was through Mr. Cottier that certain Canadian clients of his became aware of the new artist, and in that way many

to obtain his painting. I told him it couldn't go out then unless 'twas done."

The processes of the artist were mysterious, and no man can explain Ryder's system of painting. Ryder could not explain them himself. He simply painted until he got a satisfactory result. He never learned how to draw, and it can't be said that he knew really how to paint, but he was a great artist just the same.

In his small, enamelled and fussed over panels he could put the weight and the power of the mighty ocean, and he recorded the most terrifying and dreamlike events with a biblical intensity. His color was good. It was as impossible to analyze it as it was to get the technical secret of his effects, but it had that supreme quality of good color of being inexhaustible.

The longer you peer into the moonlit oceans of a Ryder the more profound seem their depths. There is something supreme, too, in Ryder's sense of design. It is rarely faulty and is often masterly. He painted clouds and skies with an audacity and a strangeness that have not been matched this side of the early primitives by any one save Blake.

His career upon the whole was uneventful. He was clearly marked from the beginning to be a dreamer, and the fleshpots of Egypt had slight attraction for him. He lived with the simplicity of the prophets, and as he grew older drew further and further away from mundane things.

He had patrons, as has been said, who were his warm friends and who kept quiet eyes upon him to see that he had what was necessary for his comfort. All that is necessary for the comfort of a petted citizen of the world, however, is not necessary for a genuine John the Baptist, a William Blake or a Ryder, and so our artist's surroundings, it must be confessed, developed of late years into the decidedly bizarre and eccentric.

A writer in the *Press* of December 16, 1906, who penetrated into the small room that Ryder occupied at that time in a modest house in Greenwich Village gives this description of what he saw:

"Two-thirds of that room was full, packed solid, with things that had never been moved since they were set three years before, chairs, tables, chests, trunks, packing boxes,

THE DEATH OF RYDER

Heard melodies are sweet, but those unheard
Are sweeter; therefore ye soft pipes play on,
Not to the sensual ear, but, more endeared,
Pipe to the spirit, ditties of no tone.
—KEATS, *Ode on a Grecian Urn.*

ALBERT RYDER is dead. Ryder the artist. He lived a long life. He painted some great pictures. He lived quietly as he wished, apart from the throng. He died quietly, and, it may be presumed, as he would have wished, apart from the throng. So we need not weep for an Adonais, cut off in youth, whose name was writ in water, but may rejoice full heartedly in a life successfully spent for American art. For almost the first time I can comprehend the requiem dances of the antique Greeks. There is something special and triumphant about Ryder's death. If we had poets I would command them to celebrate it cheerfully.

Ryder was the painter for poets. He was their man as they were his. He knew them and strove to meet them on equal terms. The subjects he essayed are proof. "Constance," in the Sir William Van Horne collection, was inspired by the "Lawyer's Tale" of Chaucer; the "Temple of the Mind," belonging to R. B. Angus of Montreal, was suggested by Poe's "Haunted Palace"; a "Moonlight Journey" came from Sterne's "Sentimental Journey"; then there were "Siegfried and the Rhine Maidens," "The Flying Dutchman," the "Forest of Arden" and "Macbeth and the Witches," and the most wonderful of all poems gave Ryder his "Jonah."

Ryder spent laborious days, some say laborious years, in creating these pictures. In the period in which patrons began to appear he was almost as difficult for them, it is said, as was Whistler for his. Mrs. Richard Watson Gilder waited twenty years before the "Melancholy" that she had commanded was given to her. Tales of impatient clients are numerous and amusing. To them Ryder was adamant. The heavens might fall, but nothing could compel him to hurry with the peculiar alchemy that finished his pictures.

"One man," said Ryder once, "told me he had left instructions that his funeral procession was to stop here in passing

of solving the problem. Some painters can suggest a crowd while in reality employing but few figures. Mr. Bellows employs many, to his confusion — and ours.

Among the new paintings a portrait called "Lillian" and a picture of wharf buildings at "Mattinicus" are the most successful. To the great surprise of everybody this "Mattinicus" of Mr. Bellows's was hung in "The Morgue" when it was shown at the Academy, in spite of the fact that it was the best landscape in the exhibition by far. Probably the jury was misled by the touch of burlesque in the work, for even in landscape this artist yearns to satirize.

The buildings in "Mattinicus" actually look as though they were drunk. They seem about to gallop off into some sort of a monstrous mazourka. But it's no matter. They are all right for all that. If an artist is really in earnest everything goes, and Mr. Bellows was playing the game all through this odd landscape "Mattinicus."

Of some of the other landscapes in which our artist attempts to poetize the less said the better. There is a cattle picture in which the cows are a city person's idea of cows and the composition a country person's idea of composition. The colors in some of these unhappy landscapes are perfectly desperate combinations of purples, burnt siennas and the like. Even from a distance they refuse to melt into relationship and shriek through the gallery roof to heaven. Perhaps they typify the unrest of the times.

The Sun, March 18, 1917

is no reason why Mr. Bellows should discharge his muse. She has plenty of time even yet in which to make a Garrison finish.

But there is one picture in the exhibition that will startle and possibly disconcert many of those who are a little impatient to have Mr. Bellows and his muse come to terms, and that is his "Docks in Winter," an early work, and incomparably the best thing in the gallery. It was first shown a number of years ago and was much admired at the time and it is still admirable.

Two horses huddle together on a snow covered pier by the river and the sturdy horseman in attendance braces himself to withstand the gale that whistles through every portion of the picture. It is really strong. Apparently there was no thought in the mind of the painter at the time of the picture save that of the theme in hand, the fierceness of a storm in winter. He was not aware of spectators, and the regrettable self-consciousness that was to trouble him later had not put in its appearance.

The next best things are certain of the lithographs, and those that approach nearest to abstract art are the most successful. The "Preliminaries to the Big Bout" and the "Between Rounds" have interesting blacks nicely distributed, and the play of lights and shadow is well done. In other plates where one comes closer to details one doesn't like them. The burlesque is heavy, the humor forced.

Such things as "The Prayer Meeting" and the "Duties of Jurors" are not funny. The "Artists Judging Works of Art" sit around in barroom attitudes and might just as well be longshoremen in the midst of a carouse. Heaven knows the present writer holds no brief for art juries and would welcome gleefully any satiric shafts from any source that would aid in keeping them in order. But Mr. Bellows wields a lumbering stick where he should have employed the rapier. One's sympathies go, in consequence, where they shouldn't, to the art juries.

The "Sawdust Trail" has some rough laugh getting points, but it belongs to the series in which the artist overloads his composition with figures. Certain of the drawings and certain of the paintings are simply crawling with figures. The handling of crowds is as difficult for artists as it is for the police. So far Mr. Bellows has not approached within hailing distance

It can be argued that Christ himself spoke to the mob. But the mob understood only the miracles. "Immediately His fame spread abroad" when the man in the synagogue with the unclean spirit became cleansed. Once the multitude assembled came the sermon on the mount, but in spite of the extraordinary clearness of the words there is no hint that they alone made converts. The people were astonished at the tone, not at the words, "for He taught them as one having authority and not as the scribes." There is no indication even yet that the mob understands the sermon on the mount, but it is sufficient that a few get it. For the really supreme artist how can there be a large audience?

The Sun, March 4, 1917

UNEVENNESS OF BELLOWS

THE MOMENT the George Bellows lithographs were installed in the windows of the Milch Galleries the crowd began to form around them. The crowd will stop to see a Bellows in the window. There is something about almost everything this artist does that arrests the idle glance. It is not everything he does, however, that holds it long.

Inside the galleries the show is fairly comprehensive. It includes more of the lithographs and a number of paintings upon varied subjects that branch out in various directions. Success does not attend upon all of them. Mr. Bellow's muse rides a recalcitrant steed. Sometimes she is jolted terribly, sometimes actually flung to the ground and trampled in the dust. But muses, like able horsemen, love a spirited nag. There

pen of William Blake. Mr. Kent is far cleverer than William Blake when it comes to a representation of things, and each of his pictures has something that seems vividly realistic in spite of the artist's evident desire to shun representation. But in qualities of soul, or even in command of a mood there is no excuse to bring our artist's name into comparison with that of the great English mystic.

Mr. Kent, it seems, has been sojourning for months upon one of the bleak northern American shores, Labrador, Nova Scotia, or somewhere. He has communed with himself and apparently has been interrogating the stars. All that I like and commend him for. I am continually beseeching our artists who find themselves in a rut to get out of the rut. There are too many agencies, particularly in New York, that are calculated to make artists think alike and to think like the mob. Artists have no business to think like the mob. They must think for the mob. The regularity of our streets, the similarity of our buildings, with elevators and studios all of the same boxlike pattern, and the same reading matter for all; and is it a wonder that no one dares to be a Daniel, and that artists yearn to have motors and wear spats like the dealers?

But the gift of the spirit does not descend upon one the instant one quits Broadway. It takes time to shed old habits. However, the door will not open at all unless one knocks — and Mr. Kent may be said to have knocked.

Puzzling over the question as to why Mr. Kent's pictures only impress me upon the technical side, I have come to this conclusion in regard to them — that he is still too much in love with that popular and entirely worldly quality known as "the punch." Most of our hasty artists are enamored with the thing they call "the punch," and I think more of our bad pictures have resulted from this fad than from any other recent one. "The punch" is something that affects the unthinking, the torpid, the heavy souled. Blake in a whisper can breathe you into heaven or blast you to hell; but a cheaper artist with a "punch" merely causes you a temporary pain.

And I fear our artist has been levelling a blow that was meant to be dynamic for the mob. Did Blake or any other genuine seer secure the mob? The desire for applause upon the part of the artist is innocent enough. There are writers who say it is necessary for their sustenance. I only know that some of the greatest get along without it.

of undeniably good painting. Whether the unusual manner and the clever technique are secondary to a message of profound spiritual importance or not is something the present writer has not yet discovered. The cleverness and the strangeness, however, are acknowledged with gratitude.

The "House of Dread," which was reproduced upon this page last Sunday, is perched upon a desperately steep cliff by the sea. A brilliant light as from a calcium in a theatre beats upon the far corner of the domicile, where a man, nude, leans against the wall in a dejected attitude. From an upper window a woman bends, her tumbling hair obscuring her head. Only sufficient touches have been bestowed upon these figures to indicate that they are meant for human figures.

The sea is dark and forbidding. The horizon line wabbles, but the uncertainty of its edge does give an extra vastness to the ocean. Instead of focusing at a given point the eye wanders around the sea as it does when searching the actual sea; and greater space is felt than had the horizon line been done in the approved fashion with a ruler. The sense of space and loneliness upon the sea is all I got from the picture. The troubles of the man and woman and the calcium light upon the house scarcely awakened my interest.

In the "Voyager Beyond Life" a man, nude, sprawls along the bowsprit of a ship and there is a green sky, studded with stars in odd constellations, and a forbidding sea below. Odd constellations of the stars appear in most of the pictures. The stars are trickily conventionalized. They twinkle cleverly, however, from the funny circles in which they are embedded like jewels. In another canvas a small ship is about to sink with conventional circles of water about it, and shafts of light stretching down from a leaden sky. In still another, a young sailor appears to be crucified upon the top of a bare pole, which may possibly represent the mast of a ship. A landscape, and I think it's the picture I like best of the series, has corrugated ridges of rusty rock stretching across the picture in parallel lines, and above the sea horizon the leaden clouds that hover over Mr. Kent's dream country continually are also in corrugated ridges.

This is a hasty and hurried description, but it is perhaps sufficient to indicate that the pictures are odd. The reader has also read between the lines that I was not frightened to death by the pictures as I sometimes am by a tiny scratch from the

modern artists have prepared us for. At the second glance we become so enamored of the spirit of these beasts that we accept everything. The "Jeune Cerf" is particularly engaging. There's a mixture of a Greek vase and the Central Park zoo in it. But who cares? It's really like Debussy music.

But for the marbles, as I said, I hope Nadelman will stop right where he is. The pieces he submits are immensely interesting and some of them are very beautiful. The faces have a haunting grace, and a type that resembles Luini's Madonnas seems to lure Nadelman on and on, from marble to marble. In the last one I think the artist got her. In token of the intoxication that this Luini woman plunged Nadelman into, he lavished all sorts of affectionate extravagance upon her portraits, polishing them until they shone like water. Extravagance is becoming to a poet — but still there are bounds, as in everything else. Why should sculpture look watered? Positively I thought one of the heads had been dipped in glaze at first. Nadelman is sensitive in his appreciation of materials — notice the lovely patina on the bronzes — but I should like to check his extreme cleverness in stone cutting and polishing at a point somewhere before the porcelain effect is reached.

The Sun, February 4, 1917

ROCKWELL KENT

NINE PAINTINGS and a number of drawings by Rockwell Kent, all of which are upon the imaginative order, are being shown in the Daniel Gallery.

In each picture there is something to astonish or offend the lovers of the academic, and this is balanced by passages

and so superior to his technic. The things that he has done
seem to be authoritatively and exactly as the sculptor wished
them to be. The manner for the marbles especially seems to
have been pushed to the extreme. The spectator upon seeing
them feels inclined to cry to the sculptor, "Fine, but enough.
Go no further along that path." But before going further along
that line myself perhaps a word about Nadelman's general
style is necessary.

It is in a word refined. It is in the highest degree a before
the war art. It is cultured to the breaking point. It seems to
breathe out all the rare essences that were brought by the wise
men from all the corners of the earth to be fused by the
Parisians (yes, Paris was the crucible for that sort of thing)
into the residuum called "modern civilization," which now so
many million are dying for. It's for the boudoir. It seems to
call upon Louis Seize courtiers for applause and to Horace
Walpole for patronage. It's Greek, it's Italian and it's yesterday
in France. The past and the present are blended almost
cruelly. For that reason it recalls to me every time I see it the
last chapters of the "Ile des Penguins," that bitter before the
war book of Anatole France's, in which the early enamelled
and sculptured representations of the St. Orberose reappear
in the salons of the less than demi-mondaine. I find myself
growing frightened in the presence of this sculpture, just as
I was frightened by the two last books of Anatole France, for
I think and I thought, "Something awful is going to happen."
Then I recollect myself and grow more cheerful, for the
"something awful" has happened, is happening, and there is
nothing left for us appraisers and merchants of art but to
set values upon it, and high values; for art history, unlike the
other kind, repeats itself and before the war productions have
two chances on the market — as souvenirs and as works of art.

Nadelman's sculpture is nothing like Clodion's, but it has
this in common with it, it was built for a civilized audience,
people who lived in houses. Although this work looks very well
at Scott and Fowles the gallery in reality does it an injustice.
The pieces need placement in relation to something architect-
ural to speak properly. The bronzes will probably meet the
easiest acceptation, especially the bronzes of animals. The con-
ventions Nadelman imposes are rather steep, but although we
are not used to seeing stags and colts with such slender
shanks, still we see it to be a convention, and one that other

NADELMAN'S SCULPTURE

THE ELIE NADELMAN sculptures in the Scott and Fowles Gallery are important and should not be missed by any one. It is difficult enough for the public in general to follow all the activities in the art world, and most people take their galleries idly and their art education as it happens.

It is a nice, sunny afternoon, just the thing for a stroll upon Fifth avenue. The crush at Forty-second is worse than ever. Why join that dodging, dishevelled and rather absurd mob? It is too soon for tea, but there's — well's there's a picture gallery! Nice comfortable sofas. Let's sit down a moment and see what they have. So think our elite of New York, and they occasionally see in that way some excellent works of art and some that are not.

The few who have a deeper feeling for the significant in art have secret methods of intercommunication, just as true book lovers and musicians have, and they allow much less to chance. These, of course, already know Nadelman, for he has shown once before in New York, and will not think it a hardship to undertake a special journey to a particular gallery to see his new things. They will be repaid by being in a position to inform their more careless friends. There are in fact a half dozen or so exhibitions during the winter that are remembered afterward, and this is one of that sort.

Nadelman's art has certain points of perfection and certain difficulties, both so evident that even its admirers debate it more or less, while those who object to difficulties of any kind take the perfections as brazen impudences levelled at their academic minds.

This perfect part of the work is technical. There is no wish on my part even to hint that it is wholly technical. On the contrary, Nadelman the poet may be considered later, but when an artist possesses a quality that is superlative that is the quality that springs first to the lips. Nadelman is an able craftsman. I don't recall any of the modern men, with the single exception of Brancusi, who has seemed so freed from

had a press success," said Sterne, shrugging his shoulders, "but met no one who comprehended in the least what I was after. One young woman, I think she was a critic, actually asked me what first induced me to paint as I did, in a manner so different from the standard artists, pointing to some things by Redfield, Bellows and other chaps that were near by!"

At this, Mr. Sterne laughed heartily, and all the bitterness that had hitherto curved his lips left them.

"I tried to tell her that the 'standard art' of the great classics was just what had influenced me most, and that Redfield and the others were the ones who had forsaken the standards, but I fear she did not understand, for when she used the word 'standard' she thought of Redfield, who had been accepted by her world, whereas when I used it I was thinking of Lo Spagna, Donatello, Michelangelo, Signorelli and the others who had been accepted in my world.

"I found one pleasant oasis of art in the city. It was, I believe, some sort of ethnological museum, called the Marshall Field Museum, but it had some really superb works of ancient Chinese art. They exhilarated me immensely so that I felt quite repaid for my journey to Chicago.

"No one goes to see them, however. The gentleman in charge told me that the attendance upon the day of my visit was three. He appeared to tell me that with pride," and Sterne shrugged his shoulders again, this time triumphantly as though to imply that there were directors and directors.

The Sun, January 14, 1917

Art Institute consonant with the opening of the Maurice Sterne packing boxes. What it must have been to the poor Javanese who are pictured in the Maurice Sterne canvases heaven alone knows, for most of them wear loincloths only, but the director of the institution, who one would think should be immune to climatic changes by this time, and besides, like all other museum directors, probably owns a fur coat, took fright and never smiled again, or at least not to Maurice Sterne.

It amounted, so read the bulletins, to a suspension of diplomatic relations between this artist and this director. Mr. Sterne during the time of the exhibition of his pictures wandered about the city finding other museums that were more to his taste than the Art Institute and other individuals who were a degree more sympathetic than its director. When the time came for his departure, they do say that Mr. Sterne walked unseeingly by the chief custodian of art in Chicago and after taking formal and pointed leave of the fair typist in the office shook off the atmosphere of the Institute forever.

Maurice Sterne has now returned to New York. He is alive, but something in his interior has been damaged. He thinks it is his heart. He is so crushed that he has taken the old J. G. Brown studio for the winter. After his cruel experiences in the West he imagines that atmospheres can no longer affect him. Besides, atmosphere is not what J. G. Brown specialized upon. When seen recently, for a long time Mr. Sterne refused to speak but finally he said:

"Chicago is the most wholesale place that I have seen. Everything is thought out in figures. About the first remark that the director of the Institute made to me was, 'Do you know what our biggest attendance has been? It was twenty-four' – or perhaps more, for I'm not much on figures myself – 'thousands on such and such a date.' The vindication for anything in Chicago seems to be the figure that can be attached to it.

"My exhibition in the Institute was like a section of a department store; there were several other one man exhibitions going on at the same time in various rooms. I had no success whatever in the emporium. Nothing was sold. I have found out one thing anyway, the American people do not buy pictures – they have pictures sold to them.

"I found no art intelligence in Chicago to speak of. I

MAURICE STERNE IN CHICAGO

"The American people do not buy pictures
— they have pictures sold to them.
—MAURICE STERNE.

THERE IS THE most disturbing news from the middle West. Chicago and Maurice Sterne have had a quarrel. Chicago, to put the matter bluntly, was not up to Maurice Sterne. Chicago betrayed in this instance a revolting misconception of what is correct in present day standards of art.

Is it not really too bad! Just at the moment that all of us were hoping that at last Chicago was on the mend! But Chicago is no more able to appreciate Maurice Sterne than Lowell, Mass., was able to assimilate Whistler.

From a distance Chicago was as nice as she could be. She made the softest, blandest overtures, promising everything the heart of a sensitive artist could desire. Was not Sterne "modern," was he not a sensation in New York? What New York could digest she could digest. What New York could understand she could understand.

As for etiquette, Maurice Sterne need have no fear. Did not Chicago once entertain the Princess Eulalie of Spain without a mishap? In short, the burden of all the love letters exchanged between the Art Institute and Maurice Sterne was: "Come, only come, give yourself to us. You will find us worthy. Lend us your priceless art and your gracious presence for a little while. We thirst for what you can give us. Come, oh, come!"

Alas! many are called but few are chosen. In fact, no Maurice Sternes whatever were chosen in Chicago. Absolutely none. Not a single solitary sale was made.

To make matters worse Chicago openly avowed a preference for Redfield landscapes. Incomprehensible, dear reader, is it not? But the bulletins that have been received from Chicago leave no room for doubt. The benightedness of that hopeless land seems complete.

The icy temperatures that can develop along Michigan avenue would scarcely be credited by the New York newspaper reader, but a phenomenally chilly blast descended upon the

This phenomenon is frequently encountered among art-ists, and many who fail as artists fail for the reason that they never encounter a motif that carries them off, out of them-selves. I heard a successful painter comment upon this subject aptly once in the lobby of the Grand Union Hotel (now a hole in the ground), which was adorned with the prize burlesques by the Fakirs of the Art Students League. He pointed out a number of capital burlesques of pictures, burlesques that had wit as well as clever painting, and moralized upon the fact that some of the most brilliant caricatures were by students who had done nothing since that were of equal merit. The op-portunity to burlesque a Sargent, a Chase or a Saint Gaudens, so frequently offered in those days, had made the students lose the thing that artists are always lucky to lose, conscious-ness of themselves.

I should not, of course, forbid Mr. Sloan his search for "absolute" beauty. I think his best chance for a greater success lies in the direction of satire, but it is generally conceded to be wise for an artist to round himself out, and the part of the equipment that is weakest is the part that most needs to be fortified. A caricaturist needs to know beauty. A tragedian is in a dangerous state unless he has a sense of comedy, and the comedian for the same reason must practise tragedy. I once knew a musician who had a tendency toward the too heavily solemn and whose instructor forced him to play jingling, frivolous melodies for a time, in the effort to lighten up the opaque gloom of his style.

The Sun, January 30, 1916

course there must be one else it wouldn't be satire. The painting as painting has animation and there is excellent still life work in it here and there.

The "Haymarket" is more clear cut as satire. Two young women in extravagant white finery are entering the once notorious dance hall, and a laundress-mother and her child are passing. The little girl gazes backward as the dazzling creatures enter the brightly lit hall, and the mother drags her forward reproachfully. The idea here is unmistakable. It has not been carried out with the care and thoughtfulness that Hogarth would have lavished upon such a theme, but it is too much to expect an artist in rapid New York to rival in finish the artists of more leisurely epochs. Of course completion as to detail in such pictures is not of high importance. The important thing is to have such details as are used vitalized to the highest degree. Every shred of the thought should be made to count. The satire should be stamped upon the spectator's brain unforgettably.

In the "Carmine Theatre" a sister of charity passes with uncouth stride and gives a glance that may be interpreted in several ways to some children who pine to enter the abode of the movies. The intention here is satiric, no doubt, but again the shaft just misses. The "Savings Bank" shows a gloomy room, with crowds of depositors awaiting their turns in the shadow. As a picture it is not exhilarating. It has the look of a comment upon society, but ended in realism.

The fact is Mr. Sloan is most interesting when most satiric. It is curious to observe that when he sets out to record the fairer aspects of nature he is scarcely bearable. His landscapes have a certain vigor, but little beauty. The strangest part is that in them the color is quite obvious and unconvincing, while in the frankly caricatured pieces the color is all right. In the "Elevated Railway," which is caricaturistic in manner, the sky is excellent. In a neighboring landscape the sky is merely paint.

He needs the spur of the comic impulse it seems, to make him surmount consciousness of the paint brush. The little girls seating upon the rock are hopelessly inhuman and uninteresting, but the woman hanging out the wash upon the housetop and who put the clothespins in her mouth, being a funny object, is so much better that one might imagine it the work of another artist.

gives one the sense of age, of vast knowledge, of the accumulation of thousands of years of resignation to the difficult facts of life, and to thankfulness, just the same, for the good moments here and there.

Mr. Marin's art seems old, too, this year; much older than ever before. The fact is the whole world is feeling its age at present, and it is no surprise to find one of our most sensitive artists swayed by it.

The Sun, January 22, 1916

JOHN SLOAN

THE EXHIBITION of the American Hogarth, John Sloan, in the studio gallery of Mrs. H. P. Whitney on West Eighth street is fairly complete, and one may judge of his performance in many mediums — oils, etching, lithography, monotypes and drawings.

In such an exhibition the paintings naturally dominate, and as Mr. Sloan's chief gift is for satire, the satiric oils are those that attract first notice. The most prominent of them is called "Three A.M." and in the kitchen (or perhaps parlor, it is not easy to tell) of a tenement two unpleasant females are regaling themselves with food in the middle of the night. One, in a nightgown the reverse of chic, is frying a steak upon the stove and smoking a cigarette at the same time. The other is drinking coffee in an abandoned fashion from a cup that lacks the support of a saucer. The room is in disorder and the woman cooking the steak has unnecessarily thick and foolish ankles.

Just what the moral lesson is I am not sure, but of

What is the public's loss is, I am inclined to think, Mr. Marin's gain. As an artist he continually grows, and the present exhibition is one of the best he has ever given. Certainly the work is more subtle. This unmolested utterance of "melodic" color (the felicity of the work has a Mozartian strain) could hardly continue were Mr. Marin as great a popular favorite as, say, Harrison Fisher or Dana Gibson.

He would be owned too much by his admirers, and as the money value would be quickly and precisely fixed upon his efforts so would the immense weight of the public opinion (something that can be laughed at when you are safe from it, but which no giant can slay single handed in actual combat) be entirely borne upon the desire to make this money producer do the much advertised Mozartian strain over and over again ad infinitum, ad nauseam.

One of the most comforting things about Mr. Marin, the artist, is that though he belongs unmistakably to this year of Our Lord, he yet escapes from complete identification with any of the various cliques or schools. Like Albert P. Ryder, he would be gladly claimed by all the factions. There is frequently in his work a breaking up of outlines and a recomposition of them in the "modern art" fashion, yet I should hate to call Mr. Marin a cubist, a post-impressionist or any other term except "artist."

I am never very enthusiastic about labels or classifications, however, and in the present instance it contents me that Mr. Marin is a poet, and that in the development of his impression he even gives one vivid, if etherealized, realism. In almost every water color save those that look like Chinese hieroglyphics I get decided realism. It is realism to something rare, subtle, fleeting, dreamlike in the actual scene, and facts and measures have little to do with it. Even the Chinese hieroglyphics I "understand" sufficiently for myself. They are pleasing forms from nature juggled together in agreeable color and have the effect of the stamps one sees upon the back of a fine porcelain.

The Chinese feeling they suggest is continued in practically all the landscapes, although it appears simply in the increased mellowness and subtlety of the color. Many correspond in the harmonious use of grays to old Chinese temple paintings, but there is no sign that the artist himself was striving for such an effect. It is merely a coincidence. Chinese art

"His art is the most marvellous example of the reorganiza-
tion of the natural into a purely plastic domain. The reality
of his art is so marvelous, concrete and poetic that he succeeds
to a rare degree in making the static to vibrate. It is the very
spiritualization of matter form on earth. They are the first
writings of a powerfully creative, placid organizing, mind
controlling emotion and blazing intellect. In these water colors
can be seen and felt his power of synthesis in transforming
the chaotic into the purely architectural plastic.

"So intense, and often final, are these colored contours
that the blank areas stir the imagination, for they are imbued
with constructive color and form and are at once as satisfying
as if they had been carried as far as his most complete works.
So full of suggestion are these water colors that the spectator,
artist or layman, must for the time being become creative. To
me these water colors are complete works of art of great
distinction, wholly as important as the oil pictures."

The Sun, January 16, 1916

MARIN'S WATERCOLORS

THE IMPORTANT show of the week is the John Marin exhibition
of water colors in the Photo-Secession Gallery, at 291 Fifth
avenue. Mr. Marin's is one of the most undoubted talents in
America, and its slow progress into the consciousness of the
great public is a tragedy — for the public. It would seem that
such exquisite work would win instant applause, would be its
own recommendation; but the same old painful period of
purgatorial tests, it now begins to be apparent, will be ex-
acted of it, before it enters into the holy places of the mu-
seums and picture auctions.

The explanations that one hears offered by the young people are, however, too technical. Cézanne tried intensely to get the essence of the thing he felt to be beautiful, and although his water colors are told in but a few touches they give a sense of great completion. Every touch in them is meant. They are put in with so much certainty and power that even the spaces of white paper take on quality and meaning. Those who feel this and are enraptured by it lay too much stress upon what is after all a technical feat. To say that Cézanne is great because he makes these blank spaces vibrate, or because he interlaces forms, or notes the reaction of one color upon another, is quite as bad as Kenyon Cox's statement that Winslow Homer is great because he is a great designer. Cézanne is great because he is a great artist. This saying doesn't explain much, but, as has been said before, genius is unexplainable. It can be weighed and its effects measured, but it cannot be understood. The secret hope of the feeble is to unlock Cézanne's mystic power and to rework the vein again, for self-exploitation. It's quite useless, of course. No one can be Cézanne over again. The secret of being the intense vital artist who shall stand as chief representative of an epoch does not consist in imitating some preceding chief, not even Cézanne.

There is little hope that Max Weber's "foreword" to the Cézanne catalogue will explain much to the academicians. As art appreciation it will seem to them to be as wild as the pictures. It is, however, only fair to reprint it, as it shows the way the young now talk. The modern artists will like it, and nothing derisive or derogatory that the philistines may say will affect their appreciation. Who cares what Philistines say anyway? This is Max Weber's foreword:

"The rhythms, the interlaced and contrasted quantities and their energy of contour, are what he sought out in nature through these water colors.

"They are expressions of the first vital, fresh sensations he received from closest and intense observation, and they are his freshest expressions of what one might call colored geometry sought out by him in the landscape. They serve as a most satisfying and comprehensive introduction to his complete sculpturesquely painted pictures, the areas of which are constructed with color nuances and gradations — only Cézannesque — unknown to and unequalled by any other master or school in the history of painting.

This has always been the case with innovations and innovators. The history of the previous great art cause, impressionism, is not much taken up with distinguished conversions. The prominent, important, powerful people who opposed it went to their graves for the most part in perfect assurance that Manet and Monet were charlatans. We might console ourselves with the reflection that now that they have ascended to celestial glory they see things truly, that is to say, impressionistically; were we not too busy trying to make the prominent, important, powerful people of the present see truth from a totally different angle. The saints above, it is altogether likely, look with great leniency upon these ophthalmic sins of the flesh, so we must try to, too. The efforts of the prominent, important and powerful to stop the clock at exactly the point where they achieved their own material successes must look very amusing to them after they have quite done with earthly strife, and they look down upon each succeeding generation from the realms above and see each new set of successful old persons denying that what the new young crowd has discovered has any element of truth in it.

Life changes and so-called "truth" changes with it.

Lunching to-day with an academician I advised him to see the Montross show. "I will not," came so forcibly in reply that I saw indeed that it would be useless for him to see the pictures. He would not see in them the things he puts into his own work, and would be so outraged that he would be incapable of feeling the new thing that Cézanne does contribute. The new generation that does not share my academician's belief that art can be expressed only in an academical fashion, and seeks for something more subtle, palpitating, and nervously alive, finds it in Cézanne.

The young explain it, as I said, in hushed earnest tones. But to whom do they explain it? Only to each other.

It would be a miracle as astonishing as the conversion of St. Paul, were they to get a single feeling of theirs into the bosom of an academician. To me it is a thing impossible, therefore useless to attempt. The real thing is not to convert academicians but to proselyte among the immense number of human beings who won't go to academic shows, but who nevertheless live in the life of the present and can be interested in presentments of the emotions that they too have experienced.

spot is labelled with an artist's name, 'Cézanne, Redon, Matisse, Picasso, &c.' "

"And what are the wavy white lines on the big black splotches?"

"Those represent the people thinking!"

<div align="right">The Sun, December 19, 1915</div>

CÉZANNE

THE CÉZANNE exhibition in the Montross Galleries and the French art at Knoedler's continue to excite attention, and no doubt profound results will flow from both events. The Cézanne episode is almost being turned into a religious festival by the young artists of advanced tendencies, who openly acknowledge this artist to be the fountain head of modern art. The water colors in the Montross Galleries yield them especial instances for their arguments, and promulgations in hushed but earnest tones may be heard at any hour of the day. These young people are right to emphasize the water colors, for they illustrate perfectly certain things this artist contributes to modern art; whereas the oils, although fine as examples, are not so overpoweringly convincing (with the exception of the superb portrait of a man), as certain others that might have been shown.

Conversions to the faith, however, have not been so numerous nor so spectacular as those that are numbered and assorted by the publicity agents of the Rev. Billy Sunday. It doesn't seem possible that they ever will be. Adherents to the cause of Cézanne and the new school must come from the young. In other words, you must be born "modern" to be modern.

upside down, as many of my friends frequently did, it was still charming and satisfactory. The streaks from the painter's brush had been most carefully reproduced by the patient Japanese engraver. I once in a fit of arrogance endeavored to enlarge upon my appreciation of this print to a Japanese collector who chanced to visit me and I asked him if the Japanese cared also for the happy go lucky quality of the painter's soft touches regardless of what they might be supposed to mean. Of course he gave me a stare of mild pity and quickly placed me where I belonged, among the ranks of the barbarians!

I considered myself fortunate in meeting Mr. A. W. Bahr at the Weber exhibition. Mr. Bahr is well known in New York as an authority upon Chinese art, and as he was born in China and has lived there much, he has had the opportunity to study their viewpoint. We met in front of the "Chinese Restaurant" just as some one pronounced the name of the picture for us. "You can almost smell the Chinese food," exclaimed Mr. Bahr, laughing heartily, as he gazed with instant and complete appreciation of the new painting.

Immersed as Mr. Bahr is in the philosophies and ideas of the "unchanging East," it was almost a surprise to see how casually and easily he accepted and took pleasure in these "modern works" that certain upstarts of the day before yesterday declare to be a menace to tradition!

"What's that one?" he asked of a large canvas filled with well balanced swirling curves in soft grays and browns.

"An Interior with Music" I read from my list. "Lovely color" was his reply, and indeed the canvas had some of the mellow tones of Korean and Chinese tomb ware.

"You know this art might not be so difficult for the Orientals," he added. "You know they always hold the accusation against you Westerners, that the moment they begin to talk of things not actually seen you imagine them to be crazy!"

Young Mr. Weber was in the gallery too, and although I don't believe in asking artists about their pictures I couldn't resist the impulse, and just as though I were one of the hoi polloi asked him: "What are these big black things in the Comprehension of the International Exhibition at the Armory?"

"Those are the crowds around the paintings; see, each

The tints with mood must blended be,—
Their volume pulsed and breathed must be,—
And all in all the inner voice must be.—
My mind, magnet like,
Holds all——
All, that by it times,
To all new being it gives.

—BY MAX WEBER

As an artist Max Weber will be admitted by all to be
an excellent colorist and strong in design. With his abilities it
is altogether likely that he would have become prominent had
he lived even in the preceding generation, with its so different
viewpoint. He was born in his epoch, however, and his sensi-
tive makeup seems to respond to the influences that are now
in the air, with perfect reaction into art.

Picasso, the Spanish-Frenchman, whose latest work is
now on view a few doors below on the avenue in the Modern
Gallery, and who is the leading exponent of the school in
Paris, is a classicist in comparison. His latest painting is so
pure in spirit that the only thing it can be compared to for
purity is with Greek sculpture. But Max Weber, as befits an
American, is less ethereal and more tumultuous; he is as all
accepting as Walt Whitman, and at last we have an artist who
is not afraid of this great big city of New York.

For Max Weber has been listening "to the voices" in New
York, and the mere titles to the pictures ought to send all the
pupils in the art schools to the show. Here are a few: "A
Comprehension of the Grand Central Terminal," "Interior
With Music," "Interscholastic Runners," "Memory of a Chinese
Restaurant," "An Idea of a Modern Department Store" and a
"Comprehension of the International Exhibition at the
Armory."

Just how necessary the titles are to the success of the
pictures I leave to others. Whether I should have known what
the "Chinese Restaurant" was without the title I am not sure,
but this I do know, I should have taken great joy in its rhythms
and placements and startlingly agreeable and novel colors.

Abstract pleasures of that kind of course are not new
but customary, for artists have always been more or less ad-
dicted to the abstract. I remember possessing years ago a
charming Japanese print in which a few splashes of black
upon the paper might be interpreted, if you held the paper
just so, as a withered tree trunk; but no matter if you held it

among them. Our gradual appreciation of the Oriental standards is as illuminating as any. Numberless Japanese prints and Chinese porcelains found their way to these and European parts, and cultured "sensitive" people here and abroad owned these things, lived with them and exploited them for years as "curiosities," never suspecting that they were subtle art works put forth by most aesthetic races. We looked on beauty, but we saw it not.

When the De Gourmont brothers discovered Utamaro many Frenchmen saw beauty in Japanese art for the first time; Dante Gabriel Rossetti did as much in the way of illuminating the English, and Whistler's ravings over blue and white compelled some Americans to use their finer senses in the matter for the first time. It seems so obvious now that some of the hard headed types who are shutting their eyes to modern art will scarcely believe that Toyokuni and Haronobu once had to be fought for.

That it was inevitable that "modern art" should take the several forms it has adopted I do not insist. But now that it has laid an emphasis upon the abstract and upon plasticity I can see that it is apropos. The essence of modern art, which is the deep, heartfelt yearning for new forms of beauty that shall be in correspondence with present day experiences, might have been differently voiced. But the new art is expressing the aspiration, and it is not for us to quarrel with the form. Spirit is always wrecked upon too strict an allegiance to the letter. The outlines of all of our old faiths, customs, habits, had become blurred. The barriers between nations and religions had become broken — some call the new thing Triumphant Democracy, and perhaps that is its name — but at any rate the time was ripe for new ideals. They have appeared in all the arts and they are being denied. They came in an unexpected guise. The King of the Jews was not the sort of king that had been looked for. He was mocked and despised by the "best element" of his time, and it is a matter of comment that He disliked Philistines.

FORM

From origin and space unknown,
Rolling, thundering, deep blended matter tints meet;
And like current-tides contours make
And new form born must be.
The force of tide and time is the urge in me,—

MAX WEBER AT MONTROSS

THE MAX WEBER exhibition in the Montross Galleries is of the highest importance and one that no one who is interested in the art life of the day can afford to miss. Mr. Weber more than any of the native artists who have made themselves visible above the horizon of what is known now as "publicity" formerly known as "fame" faces the problems of the art expression of this time with courage equal to that that masters have ever employed.

There are still some people who ignore the fact that there is such a thing as "modern art," in spite of the constant succession of pictures and sculptures that are imbued with it, the new music in the concert halls and the new literature. It is of no great moment that so many philistines rebel at the new forms, for those rebel loudest who really care least for art of any kind. There are persons in this country still who would be revolted if confronted with a picture by Manet, for the millions still prefer J. G. Brown. Yet the cause of Manet is won in spite of the ignorance of the mobs, and it is now history.

Max Weber's cause, and the modern cause generally, is partly won, but not wholly. For that reason it is doubly interesting, because alive. Manet's cause, being won, is dead as a cause. There is nothing left to be recorded about it except its bibliography, which is immense. But one would imagine that the mental and soul courage of Max Weber and Picasso would be admired even by those who consider them mad men, yet I do not perceive that this is so. Art courage is as descried to-day as scientific fervor was in the Middle Ages. Yet without the spirit of the inventor what is art? Practically we put a premium upon the lowest forms of art, such as imitation and the mechanics, and endeavor to crucify those who listen to the voices of inspiration.

That individuals, who would pass as sensitive consider beauty a fixed state and the expression of it a fixed formula is sufficiently curious. There are such countless illustrations to the contrary in art history that it is embarrassing to choose

beautifully all that we have ever felt of Homer. There is no living American who could have written it better. He is a trifle more technical than the late John La Farge would have been upon the same subject, but his volume is likely to stand as an authority upon the most native artist this land has yet produced.

As a critic Mr. Cox is sound only upon work that is al-already a part of our traditions. Facing new forms of expression Mr. Cox is always hopelessly adrift and in consequence he did more damage to the generation he dominated than any individual in it. His influence upon students was not less fatal than his relentless attitude toward new talent in the public exhibitions, for which he seemed to be a perpetual juryman.

As a painter his successes have been few. In the early days there was the portrait of Miss Morgan, the harpist, that was not bad and there were occasional portraits of fellow artists that had merit. I have always felt that had Mr. Cox confined himself to portrait making and to illustrations in black and white he might have achieved a real reputation instead of this crumbling and shadowy one which a species of terrorism has imposed upon us. Color was impossible to him and design was not easy; but one can do portraits even without color.

I should be really grieved if this article should be misconstrued as an "attack" upon Mr. Cox. It is nothing of the sort. I have a sneaking respect for him which I cannot overcome, for I am a lover of traditions, and he has been with us so long and has always been such an Old Roman!

Besides, though unfortunate, he is incontestably honest. I consider that he should not have allowed himself to have been persuaded into the making of the long series of joyless mural paintings, but after all the real blame for this lies upon us, upon you who were smiling just now and upon me, because for years we have been permitting all the Western Senates in the land to acquire them without protest.

The Sun, October 17, 1915

MURALS BY KENYON COX

THIS IS the last afternoon in which Keyon Cox's decoration for the Senate chamber of the State Capitol at Madison, Wis., may be seen in the Vanderbilt gallery at 215 West Fifty-seventh street. It is entitled "The Marriage of the Atlantic and the Pacific": it is in three panels and is a characteristic work by this painter.

New Yorkers will relinquish these decorations without any great strain upon their philosophies, but those of us who have relatives in this far Western city feel somewhat disturbed.

Two figures representing the oceans (the Atlantic, being the older, is the gentleman) are being married by a third figure, in the central panel. The European nations coming to the ceremony occupy one side panel and the Oriental nations balance them in the third canvas. It would be easy to be facetious in describing these figures, for not a gleam of humor has restrained the artist in carrying out his motif.

In a picture painted for all time of course one is justified in ignoring the temporary differences of opinion that so inflame the Europe of the present, but even in an interval of peace there is something ludicrous in the way in which Mr. Cox has grouped his arriving nations in little boats. In any epoch so constrained, an embarcation would produce sea changes of dire consequence.

To be quite frank, and this is an occasion upon which French candor is called for, the composition is excessively amateurish and feeble. It is the sort of arrangement that art students who afterward give up art make, hard, awkward and without illusion. The expressions of the faces mean nothing, the figures themselves are monotonously out of proportion and the color, to put it mildly, is very unpleasant.

Mr. Cox has long been a conspicuous figure in our art life and in one or two ways has served this public well, but upon the whole his career has been unfortunate both for himself and us. He writes well. He has recently published his study of Winslow Homer, which is a credit to all of us, expressing

90

behaves himself with difficulty in a corner of the room. But Picasso himself had gone out.

He had been positively obliged to keep an appointment at 12 and had just gone out. The cat yowled so loudly we could scarcely hear ourselves. The wolflike dog was invited to assist the cat to depart. The acceptance of the invitation and exit of both animals were instantaneous. The cat's name was Zoise, madame informed me. She always called all her cats that. It was a good cat name, she considered. Down the passage way from a back room the animal noises were still arriving, though muffled.

I agreed to come again Tuesday morning, if possible at 10 o'clock; it would be better at 10, madame thought. But this time I was not serious in making the engagement, for experience had taught me that I was never fortunate in early morning adventures. Picasso would be désolé at not seeing me, madame said.

The next day prevented even an attempt to gain the studio, and the day after that Picasso and Mme. Picasso left for the south of France. I believe they took Zoise with them.

Shortly after their departure, I was twelve minutes late for a dinner at Miss Stein's. This was a triumph. In the late afternoon it had seemed written that I was to be an hour or even two hours late for this festivity, and there were questions of telegrams, petits-bleus and agonies. But miraculously I arrived but twelve minutes late.

Miss Stein said it would not have mattered in the least. No one in all the quarter was ever on time for anything. The only person she knew who was prompt was Picasso. He was never late, that is he was never late but once, and that wasn't his fault.

The Picassos were coming to the Stein's for luncheon, and the united households were then going to the vernissage of the Salon d'Automne. Mme. Picasso was to bloom in a new gown. But the dressmaker held off until the last moment. The Picassos were half an hour late for luncheon. Pablo was in a dreadful state. "Record of a lifetime smashed," added Miss Stein. "We led an awful life for three or four days because of it, and of course the vernissage was quite ruined for us."

The Sun, March 14, 1915

PICASSO AND GERTRUDE STEIN

IN PARIS

WHILE THERE may be no historic disputes over cubism in the Carroll Galleries during the present exhibition, the elect at least may have what young Mr. Demuth calls "moments." Mr. Demuth has a "moment" whenever he looks at a Picasso. There are in fact seven Picassos in the show.

Considering the gravity of the public exhibition of seven Picassos in New York it is a matter of deep personal regret that I am unable to contribute any first hand facts in regard to the master in honor of the event. It is true I had the pleasure of meeting him and madame one evening last summer at Miss Stein's, but because of my sins I was not permitted to see his studio nor his latest work.

He was leaving Paris the following Wednesday. Could I come to see him Monday morning at 11 o'clock? I said I could, and after wasting some minutes upon a taxi that didn't appear I set out in the Metro foreseeing that I should be one-quarter of an hour late. But the Metro is of no assistance when one searches for a new address in Paris. Neither are the gendarmes. They are not to be blamed. No intellect not Goethe's nor Voltaire's could master those little streets and impasses.

The gendarme on the Boulevard Raspail, somewhere near where I knew Picasso must live, blithely sent me on a mile out of the way. Eventually I retrace my steps and reach the atelier building precisely one hour later than the time appointed. I ring and there is no response. I hear a wild, melancholy cat yowl. There is no doubt it is the proper place. That is the famous cat about which we talked all that evening at Miss Stein's. Finally the loud thumps of the concierge upon the door bring a maid, and finally pretty Mme. Picasso.

The lean yellow and black spotted tiger cat stretches herself menacingly, feverishly along the floor. A wolflike dog

neighbors — from Java, Sumatra, Celebes? The Balinese alone of all the inhabitants of the archipelago have to this day retained the Hindu religion. Islam, with its art barrenness, has been imposed upon the neighboring islands.

"In abstract, austere Mohammedanism there is little room for art — it has sunk to mere decoration, tolerated as a prayer rug under the feet of the devotee — whereas to the impassioned Hindu it is a means of getting closer to God. With them art is religion's language, understood by God. Symmetry are its words, rhythm its phrases, perfect balance its sentences.

"Like the immense active volcano towering above the terraced rice fields and teeming tropical vegetation, religion, passionate and agitated, projects from their daily tasks. The same fire or unknown force which from the bowels of the earth exhales steam and molten lava from the mouth of the crater, gushes from the heart of the frenzied worshipper, leaving him prostrate and in a deathly stupor at the feet of his diety.

"The religious rites are for the most part hysteric trances or frenzies, and the elements are symbolically expressed in their sacred dances at the temple festivals. In the largest painting shown in the present exhibition I have tried to show one of these dances. Fire, water and air are represented by priests and priestesses carrying incense burners, bowls of water and fans. Rapid upward flickering action of flames, threatening sinuous flow of water, and irresistible air, are expressed in rhythmic movement and significant gesture."

The Sun, March 7, 1915

cern themselves with two sacred dances, one scene in a theatre and two in which Mr. Sterne's goddesses sell cocoanuts and rice in the bazaars. The other nine thousand works are sketches of female figures, some of whom happen to be doing something, and so the study, in the hasty, modern acceptation of the word, passes as a finished picture. There are no warriors brandishing spears, no weavers weaving, no boys and girls making love, and no lean missionaries being roasted alive. Some of these things are no longer done, it is said, but even so there is more to Bali than sacred dancing, although that would quite content Mr. Sterne's friend old Monsieur Rodin, who is quite fou, as everybody knows, over the gestures that these Eastern dancers make, particularly the flat posturing of their hands.

M. Rodin himself has drawn these gestures with the ineffable, indescribable effect of remoteness from us that these dancers make upon emotional Western natures. Mr. Sterne does the gesture well too, but without much mystery. He explains it to us, we understand it, we are not disturbed and we pass on to something else. Even John La Farge, who was quite as intellectual as Mr. Sterne or perhaps more so (we prefer to err, however, always upon the side of the living), got more of the haunting element into his pictures of Eastern dancers. Gauguin got more of the strangeness of the East into his color. It is true Gauguin's color was already Tahitian before he started for the Pacific, but we Gauguin admirers believe that his color was given to him in advance "as a sign."

To sum it up, Mr. Sterne explains where Gauguin suggested. Mr. Sterne gives facts where Gauguin, Melville and even La Farge made music. Mr. Sterne is an academician. We prophesy an instantaneous success for him in America.

There remains the apology that is due to Mr. Sterne for having so loosely grouped the various islands of the South Pacific in one class. He has so recently returned from Bali that he is probably still hot with a sense of all its differences from the thousand and one other islands. We are aware of some of these differences ourselves, but for the purpose of a review, written for an audience to whom all Malays look alike, they were considered de trop. It is but fair, however, in closing, to particularize upon the island, and for that Mr. Sterne may speak for himself:

"But wherein it will be asked does Bali differ from her

You like that one best, Mr. Marin! Why? That's like you to fix upon the most incomplete sketch in the exhibition! Don't you know that Sterne's forte is his line? Hush, he will hear you. Yes, they say no one gets so quick and powerful a line as he.

A good line is an intellectual attribute. Artists love those blocky, straightish lines. That is, the older artists like them. It is clear he was taught to block the figure in. The habit still clings to him, but he surmounts it. They can't kill a real artist, no matter what they teach him. They certainly cannot kill a man of intellect.

How finely he writes. Listen to this; it is from the fore-word:

"When Java at the end of the fifteenth century was invaded by the Mohammedans the Javanese fled to this thinly populated neighboring island with their customs and religion, leaving all worldly possessions behind them. This spirit was again shown eight years ago, when the price of cocoanuts having risen and Holland decided to annex Bali, about eight thousand of the highest caste of the population having arrayed themselves as for a temple festival, with precious golden bowls, silk brocades, lances and spears, they went to meet the conquering Dutch troops, with their guns and powder, and at a given signal the men, women and children drew their flame shaped krisses and killed themselves."

After that we trust you are sufficiently sobered to peer into these dusky, sombre canvases with the proper seriousness.

The sombreness must be meant. Artists who work out-doors without the protection of sun umbrellas sometimes get their work unintentionally black. But this lowness of tone fits in too closely with all that Melville and the other travelers have written of the beautiful Malaysian life that enacts itself in the mysterious and shadowy cocoanut and bread fruit forests not to have been intended. It fits in too with this artist's character, who unlike Melville saw little comedy in the South Seas, and to whom the women selling rice moved like stern goddesses. But there are no nuances. The shadows are not played upon. They are not used thrillingly. It is as though the artist said "Let the canvases be dark" and thought that enough upon such a point.

The commemorative pictures – perhaps that is not the word, the descriptive pictures, let us say – are few and con-

the mysteries of artistic succcess are laid bare, he who runs may read, and it will be no longer possible to protect John Marin if worldly success be really a temptation to him.

The John Marins (there are more than one of them) must go to Bali for fame. Bail is an island in the South Seas. A sojourn there will make one famous. It never fails. At least it never has yet. Herman Melville looked upon a South Sea island and became an artist. John La Farge and Stevenson looked and became greater as artists. Gauguin tried it and succeeded, and now Maurice Sterne tries it and returns with a cargo of marketable drawings.

Ten thousand of them he brings us, they say. Nevertheless, John Marin, the vein is not worked out. If you must be famous go likewise to Bali and when you return after a two years visit Sir William Van Horne and the Toledo Museum will buy your drawings almost before you get them unpacked. And, please don't you make more than about three thousand five hundred drawings. That's plenty for two years work. Leave at least a bone and a hank of hair for the next chap to do.

So much for fame and the sure method of entrapping her. In the meantime Maurice Sterne awaits without. A thousand pardons! It was not intended, we assure you. We know the respect that is due to talent. Louder with that fanfare, if you please. John Marin, take off your hat.

We are pleased to hear about the island in the South Seas whose religious customs are so different from our own. We are pleased to enter one more name upon our far too meagre list of geniuses. You are very welcome, Mr. Sterne. Ten thousand drawings! Thank heaven they are big ones, No, no, Mr. Sterne, drawings can never be too big. You are far too modest. We Americans like big drawings. We rejected one artist lately — what was his name? Oh, yes, Jules Pascin, just because he drew tiny pictures.

But yours are quite different. There will be no difficulty about yours, we assure you. Sir William was very clever to have secured that one. We should have chosen it had he not beaten us to it. Never mind. These are wonderful too. Pray give us an option on this half hundred for a few days until we may decide upon ten of them. Thanks so much. We have room but for ten. It is difficult to choose ten from ten thousand, is it not?

confusions to the museum directors. My advice to the museum directors would be to leave these experiments at one side for the present.

The experiments, you must not forget, have been made by an intelligent artist, and have that interest. Later experiments by Marin and future artists may go further along the same lines, and then these present "confusions" may appear sweet and reasonable.

The Sun, February 28, 1915

MAURICE STERNE'S BALI PAINTINGS

LAST WEEK, when talking of the charming and insufficiently appreciated water colors of John Marin, we permitted ourselves to moralize a bit upon the advantages and dangers of a quick success for artists, but in the course of the essay the dangers suddenly began to appear so formidable that we wound it up lamely and in confusion. As the article appeared to be addressed particularly to Mr. Marin we hesitated to recommend him to take a single step in the direction of the Hall of Fame. He knows and we know that those who knock most loudly at that door are the least likely to be admitted.

So we religiously closed our lips last week upon the several ways of gaining the public confidence with which we are conversant. Last week! How difficult it is to live up to one's principles! This week everything is quite changed and now we would just as lief tell all we know of fame's weak armament as not.

This moral debacle upon the part of THE SUN's chronicler is due to the advent of Maurice Sterne, who shows his Balinese paintings in the Berlin Photographic Company's gallery. Here

In a certain country that won't be named the phrase "making good" is frequently heard. The prevalent opinion of the people of that country is that a genius who does not "make good" is not a genius. It is, however, an opinion that THE SUN'S chronicler has not been able to adopt. Full many a gem the dark unfathomed caves of ocean bear, THE SUN believes, and if it were not so mean to keep pressing the point, it would mention one or two undoubted geniuses long since mouldered to dust that the unmentioned country gave birth to and has not yet honored.

A fine, spectacular death, however, is undoubtedly an aid. Chatterton's sudden and painful taking off put an extravagant valuation upon his verses that has not even yet entirely worn from them. It is not a method to be conscientiously recommended though to painters. There are in fact many serious thinkers who hold that complete and universal fame is no longer desirable for an artist during his lifetime. They say that the world has grown too large, that the modern machinery of publicity puts too strong a light upon his every action, and that the crowd, even though they be admirers, rob him of his creative moments and his still more precious hours of solitude. Rodin is the instance most often referred to.

Whistler's name has been mentioned in connection with Marin's chiefly because it would seem that museum directors must have been prepared by Whistler for Marin. Marin has not so wide a range as Whistler, but in many departments of the game he is more elusive and subtle. Marin may or may not approach the standard of Whistler's big figure pieces. It is too soon to say. But in the present Marin exhibition there are a dozen watercolors which, if they bore the butterfly signature, would be rated, even by museum directors, as ranking near the top of Whistler's achievement. Pray, don't imagine for a moment that Marin is a Whistler copyist, however. Had he been he would have been adopted by the Philistines instantly. No; he is a living, live original. That's the rub.

He paints invariably in rare colors. There is the stir of air upon the waters and among the trees of Marin's pictures and a sense of arrangement that is quite Japanese. The trouble is that he sometimes attempts the impossible. For that the students love him. All genuine art lovers love a sport. Marin has never been accused of not being a sport. His reachings out for impossibilities result in certain works that appear to be mere

noisseurs have already seen Marins and have failed to appreciate them. This is extraordinary. One feels quite helpless to combat so unreasonable a situation. Not to like Marin is as inconceivable as not to like Chopin.

Not long ago at a little dinner a lady was heard to announce in a most sprightly fashion that she did not like the Boston Symphony Orchestra. She had been bored past endurance, she said, and at last had resolved to fling off the mask she had worn and never to hear the orchestra again. A frightened silence fell about the table, for the lady plainly believed she was saying something clever. Finally a gentleman turned to her and said, "What a misfortune!" and then immediately all of the guests talked about something else.

In fact nothing could be done for the poor lady and nothing can be done for people who do not like Marins. Talking to them won't help them. Explaining won't help them. As for the museum directors, that's another matter. Much more serious than the lady's non-comprehension of the orchestra! You would not, for instance, take such a lady and make her director of the orchestra, would you? Then why put men in charge of our museums who cannot respond to Marins? It makes one feel quite ashamed to think there are no Marins in the museums.

By and by, of course, they will be in the museums, just as the Whistlers are now, but for a long, long time the museums would not touch Whistler. It is understood of course that we are referring to museums in general, to those of Germany, England and Ireland as well as our own. The museums, in fact, would not touch Whistlers until after they had become expensive. Isn't that really curious? France was the exception. France bought Whistler's portrait of his mother for much less than she would have to pay now. France always spends her public art money better than the other nations, but that was an especially effective purchase, for it made Whistler.

Whether a museum could now make Marin by purchasing him is a question. The matter of ultimate success is so delicate. The weight of a hair sometimes starts the scales that finally register justice. If Whistler had kept perfectly quiet in his lifetime, had never quarrelled and had never written stinging letters, he must have arrived, we all think, at his present fame, by this time, upon pure merit as a painter. But it is not sure.

evitability of war. Anything so perfectly typical therefore will be invaluable later on.

"One has occasionally to hand out such bitter pills to your friends the academicians that it would be nice to pick something comforting in the way of a moral out of this great smash for them, but really I don't see anything coming to them out of the war. Matisse himself will not be broken. He and Rodin will go on working out their characters formed long ago. It is the great crucible that moulds public opinion that is broken.

"They will not have successors in the same line. But the academicians will not get back their dear Bouguereau. Very likely the history of our civil war will be duplicated. For a decade or so there may not be any art at all. Heroes and persons capable of great energy will give all their force to State and business reconstruction."

The Sun, January 24, 1915

MARIN AND TASTE

THE RECENT number of *Camera Work* seems to have been well ·timed. The enthusiasm of the young artists and art lovers who wrote down their reasons for liking the Photo-Secession gallery is of a sort to incline sceptics who have occasionally been shocked by exhibitions in the little gallery to give it one more chance. Those that make the venture will now find a John Marin show there which ought permanently to convert them.

Marin, as an artist, has so long been a private force among aspiring students that it is amazing to realize that he is not yet a celebrity. Mr. Stieglitz, who is in charge of the Photo-Secession, states that no public museum owns Marins as yet. This seems strange. He says too that certain American con-

"Yes," said one of the rival picture dealers, "Brother Montross has stolen a march upon us. Undoubtedly he will be able to do good business with this Matisse show. I'm sorry now I allowed him to get it away from me. Of course I've been selling old brown Dutch pictures for years and my eyes are unaccustomed to such straight, frank methods of painting. Still, now, that I have opened my eyes I can see the facts.

"Matisse is the greatest name in art to-day. There is no one in France who is talked about with the same earnestness, no one who arouses deep interest but him. Vuillard, Bonnard and Roussell are immensely clever Parisians who will be admired in America some day for their 'chic' just as they are appreciated for that quality now in Paris, but they owe too much to Matisse not to acknowledge him themselves as their master. There is nobody in England much in the public eye, and since Davis became accepted by fashion in America he has no longer been a subject for debate.

"Now there is the little point that strikes a businessman. The detractors say modern art is dead — that the great war has killed modern art. They forget that Matisse was the great name current upon people's lips all the critical period before the outbreak; a period, you may be sure, that will be analyzed by future historians from every point of view. To have been the conspicuous painter of such a day bespeaks future atten-tion for him.

"No doubt so great a cataclysm will change the atmosphere. It always does. It is difficult to see how people for years to come in Europe will care for the refinements of Matisse. Watteau and Boucher went out, as you know, in a similar situation, but they came back. Matisse may go out too, but he will come back. The world always has its recurring aspirations for the softer side once its robust, impatient gesture for fresh air has shaken down all the housetops.

"Art never had been so refined before, for the alliances and intermarriages between nations, due to the modern world welding brought about by science, compelled art to distil all perfumes into one essence. Congo and Persia, yes and no, thunder and flute pipings, nothing could be too blended for an age that knew everything, desired everything and got everything. The state of modern art did not bring on the war, as some cruel people suggest, but it clearly foreshadowed the in-

get from me, that the work Matisse has done since he became rich is remarkably true to the ideals he promulgated when poor."

I regret to say that at this point my academical friend lost his temper. He was leaving anyhow, and in fact was getting into his greatcoat with the assistance of Dubois the waiter, when he began to shout incoherently at me. I thought at first it was my innocent reference to the Matisse riches, for nothing irritates an academician so much as the idea, that idiots actually buy these things, but my poor friend thumped the table with his feet so heavily that a coffee glass jumped into the air to fall in fragments upon the mosaic floor.

"Dishonest, is it? I knew it all along. I don't give that for an art that's founded on dishonesty," pounding the table again so that two liqueur glasses joined the coffee glass, and then angrily stamping out of the room, leaving me to pacify the emotional Dubois.

The discussion had, in fact, the usual Matisse ending. Why even old friends cannot talk Matisse talk without squabbling is one of the mysteries, and, shall we say? one of the blessings of the modern movement.

Businessmen and people in general take a more rational viewpoint than my academical friend. My friend wishes to know how Matisse's work conforms to the principles of Leonardo da Vinci, as though that were the only test for a work of art. The businessman merely desires to know if the public is interested. The principle involved in art dealings is the same whether one disposes of picture post cards or Sung porcelains – one meets the demand.

The public, the dear public, knowing almost nothing of Leonardo and caring less, simply sees in these strange new paintings something that corresponds to some of their own experiences. They jump at them, as children do for new toys. It's an extravagant age. These are extravagant pictures. That they are accepted by the people any one may see who goes to the show.

The spectators glue their eyes to the weird colors and shapes, they linger long. The attention given is the sort that would have flattered Leonardo himself in his day. They were accepted by the people some time ago. They have now been accepted by the dealers. But it will be years before our public museums accept them.

"The idea? My poor academical friend, that's what you'll never get from me. Did you ever hear a Cook's guide explaining the Puvis de Chavannes style to a party of Nebraskan schoolma'ams in the Pantheon? Did you ever read Ruskin's art made easy for dull intellects? Explanations that do not explain! When a picture can be explained it's already en route for the garret."

"Well, what pleasure do you get from him, then?"

"Part of the pleasure is in seeing you ruffled, my friend."

"Nice character you give yourself. Easily entertained, you are."

"Yes. If you want to know I'll tell you something. I don't know any more about Matisse than you do. It's just by accident I happen to be in the fashion by liking him. If I were out of fashion I shouldn't worry in the least. I don't believe in fussing about him. I like some Matisses and dislike others, just as I accept certain Grecos and discard others. You wouldn't argue yourself into liking an artist, would you? What is it to you if you don't like Matisse?"

"I don't like to feel I'm missing something."

"On the contrary, you're acquiring an opinion. Always feel like congratulating a fellow who distinctly doesn't like a public favorite. My own pet vanity is a loathing for Murillo. I should have disliked Rubens, I think, but that Thackeray disliked him first. Cox and Chase are simply stunning, you know, in the hearty, wholesome way they detest Matisse. All the 'moderns' love to have Cox and Chase detesting Matisse. Some of the younger fellows weren't even sure that Matisse amounted to anything until Cox came out with his denunciations. Great sport, isn't it?"

"Tell me one thing. Is he honest?"

"Who, Cox?"

"No, Matisse."

"How on earth should I know? Honesty isn't an essential to good art, as Jimmy Whistler and Oscar Wilde discovered simultaneously. It was Whistler who found out that the lovelier the blue and white ginger jar was the less could one count upon the moral character of the Canton opium eater who had painted it! All that I can say about Matisse is that he is now rich enough to be honest if he wishes. He can certainly afford it. I really think, and this is the only critical opinion you shall

hundred thousand to the "modern art" show to giggle and argue and come to blows over the objects on display, there is something in the situation that the progressive art dealer, whose science it should be to know his public, might well ponder over.

For over a year there have been rumblings of modernism at the Montross establishment, little indications that those who know how to take a hint understood, but this great eruption of Matisse and the actual, visible turnstiles that refuse to turn until cold cash has been deposited will come as a surprise to some. We believe there is a limited free list for well known artists. Mr. Cox and Mr. Chase are both upon the list, we rejoice to say. Students later on will be allowed certain days for their hilarious selves.

But here is the curious thing that has happened. Mr. Montross, who sent for these Matisse things simply because he believed the public wished to see them, simply, in other words, as a business proposition, already admits that he likes them. He goes even so far as to say the paintings are beautiful!

There is no occasion to enlarge upon this phenomenon. You, dear reader, are likely to fall into the same state of mind if you go to see the pictures. If all that you know about modern art is what Mr. Cox told you, and you are perfectly satisfied with his account, then it will be much wiser for you not to go to the Montross Galleries. Much wiser. Even if all your young friends go and talk by the hour for and against the great or infamous Henri Matisse, be adamant. Don't go. To go is to fall into what Mr. Cox and the late Mrs. Mary Baker G. Eddy call "error."

Just there we felt a tug at our sleeve. We are writing this in a French café. We do not as a rule write criticisms in cafés, but there are times when every little bit of atmosphere counts. This is one of those times.

The tug came from a friend, an academician.

"Say, tell us: What's he driving at, that fellow Matisse?"

"Merciful powers! Have you never seen his work?"

"Sure; but the more I see of them the more my head spins. I thought at first they were simply fakes; but all you fellows see something in them, and maybe you're crazy, or perhaps it's me" — Anglais tel qu'on parle! — "that's crazy, but if there's an idea in it I'd like to know what it is."

considering Claude, and he scarcely thought at all of and certainly took scant pleasure in eclipsing the feeble contemporaries who he knew would be speedily forgotten.

The Sun, November 22, 1914

MATISSE AT MONTROSS

IF YOU do not wish to succumb to modern art, keep away from it. Mr. Kenyon Cox and Mr. William M. Chase are already lost, although they may not know it. But they have looked upon it. To look is fatal. We wish to give all of our other faithful readers the friendly warning that drawings, etchings, lithographs, sculptures (oh, those sculptures!) and paintings by Henri Matisse are now on flagrant view in the Montross Galleries.

Poor Mr. Montross! Little did he dream two short years ago that he would have such a show as this in his beautiful galleries. But he was led into it by degrees. He went to the armory exhibition frankly as a scoffer and he scoffed some, at the beginning, but the constant click of the turnstiles admitting famous ex-Presidents of the United States and other great dignitaries who do not as a rule frequent our exhibitions sobered him and put him in the proper mood for reflection.

He vowed then and there, mark his words, that the day would come when he would have turnstiles clicking ex-Presidents into his galleries. Art he saw was for the people. You might fool some of the people some of the time; but when they get to yawning at the academies and to saying that art is probably very fine and they are sorry but they don't care for art, and then when these same reprobates rush off by the

which can still be seen by poets, and the sorry decline from the former standard that now hangs about the railway station. The failure is just as interesting to a Walt Whitman as a success. All that is required is an interpretation.

The sum of our feeling in regard to Mr. Henri's new work is that it will have immediate but not a lasting success with the public. These are all interesting people that he shows us, that silly and wicked Jim Lee, the little dolls of Chinese girls, the brown Mexican and the Indian in feathers. We would all pop our heads out of the windows in a jiffy to see them and would part with them reluctantly as the train moved on again, wishing that we might know positively whether that doll was a good little Chinese girl or a bad bittle Chinese girl, and all sorts of things like that. We get cross at ourselves afterward for not having descended from the train to find out, and we grow annoyed at clever Mr. Henri, who might have found out more about these people, but didn't.

Mr. Henri can and will no doubt win a harvest of prizes with his Indians this year. To win a prize in the public exhibitions nowadays one does not have to compete with Goya and Holbein. We don't mean that in any unkind spirit. We have an admiration for the earnestness of Mr. Henri which we have many times publicly avowed, but we cannot suppress the desire to extend our admiration.

It is easy to win a series of prizes in the string of exhibitions that dot across our country, because all our artists, good, bad and indifferent, if they live long enough and play the game properly, win them. The prizes mean nothing except the emolument and the trifling "ad" that go with them. They have nothing to do with one's permanent reputation. For that we must keep an eye on Goya and Holbein.

Mr. Henri himself will not object to such a statement so much as will "the boys." Nothing annoys our young people so much as this constant harking back to the great names. Yet there are instances enough in history to show that those who achieved greatness, for the most part, aimed at it. Turner may or may not have been an intensely disagreeable person in the flesh, but there was no doubt in his own mind as to what he was after. He did the "Liber Studiorum" avowedly to eclipse the sketch book of Claude Lorraine, and he commanded that his pictures should be hung side by side with Claude's in the National Gallery. There never was a minute that he was not

does so. The little Chinese girl has been persuaded, no doubt against her will, to put on her pale blue dress that is edged with wine color. Even the old reprobate of a Chinaman, Jim Lee, seeing coins flashing, smiles a smile "that is neither child-like nor bland" and also poses. They pose.

One succeeds the other quickly and the gaudy colors are slammed upon the canvas. There is nothing reported that the ordinary tourist doesn't see. The ordinary tourist who has seen these Mexicans and Indians skulking about the railway stations in the far West will be glad to see them again, with nothing in the way of vividness of coloring left out. The stay at homes will also wish to see Tam Gan, a fat woman terrify-ing in her Chinese sleekness; Yen Tsidi, the Indian brave, with feathers and a pure vermilion blanket, and Ramon the Mexi-can, who smiles and shows you his gold tooth. The passion in this painting mystifies us because the soul, the secret, the representative quality, call it what you will, has not been sought for. Why get in a passion over the husks, the shell?

There is nothing of the sort of thing here that Lafcadio Hearn dug and died for in Japan. Who could forget the ex-quisite little lady who called with smiling lips upon Lafcadio's family, smilingly saying good-by although she knew she was saying good-by for ever, her physician having warned her of the imminence of death? Who could read the little sketch with-out a pang of illumination into a whole nation's refinement? Or reading, forget?

Have you read Parkman's "Oregon Trail"? Something about Indians in it. Indians in action, Indians on the job. Splendid that it has been written, splendid that a monument to so natural and poetic a race has been secured for all time. Read it, do. Since that day the Indian sun has almost set. The beaten people know they are beaten and for the most part live pitifully upon our "bounty." It is a horrid story from some points of view, but like all true stories of great fights has an invigorating and useful thrill for the spectator. Here and there in the West a flash of the old time spirit gleams occasionally from the dusk with a real echo of the former nobility; just as in Tangier there are Moors who dance and sing nightly, for pay, alas! of their glorious and historic "victory" over the Spaniards, forgetting entirely the subsequent and complete successes of the hated rival.

It is all "material for the artist," the episode of grandeur

ROBERT HENRI'S CALIFORNIA

PAINTINGS

"AFTER ALL not to create only," but to rally around the flag, boys! I confess I took almost as much pleasure in thinking of the joy that the youthful adherents and followers of Mr. Henri will take in this artist's new Chinese, Mexican, Indian pictures as in the more obvious first fact that Mr. Henri's new canvases are the strongest that he has shown for some years. Mr. Henri is to be congratulated; Mr. Macbeth is to be congratulated and the boys are to be congratulated! Mr. Macbeth will say, "I told you so," Mr. Henri will say modestly, "I can do still better" and the boys will say, "Ain't they great?" There will be sufficient glory, as Admiral Schley remarked upon a similar occasion, to go all around; so you boys must not take more than your share.

Mr. Henri, who has been wooing the muse in Spain and Ireland recently with fitful success, has worked in southern California during the past season and now has the air of having discovered a new country in having discovered his own. It is impossible to acquire in one short season in Ireland the rich brogue of a J. M. Synge or a Frederick James Gregg, and in returning thence with his spoils Mr. Henri must have felt this. The pupils, who are loyal or nothing, enthused as usual over the Irish brush strokes, but the great wide world clamored for the brogue, and being denied passed along.

This time they will linger. Our artist may not have studied these types to which he calls our attention as deeply as Leonardo studied Mona Lisa, nor even with the sympathy and insight of a Bret Harte, to get nearer to our locality, but he has been violently stirred, it is clear, by their strangeness, and has expressed his emotion, incoherently perhaps, but with such great passion that the public will be surely impressed.

We say "incoherently perhaps" because we ourselves cannot see the reason for the passion. After all not one of this wild coterie tells you a secret. The young Indian has been commissioned to dress up in his feathers, that is all, and he

the curtain. Hamlet, that is to say, Mr. Stieglitz, can hardly wait until the big scene in the fifth act, where he jumps into the grave and defies Mr. K-ny-n C-x to outweep him in grief for the corpse. The anticipatory emotion is so strong and so contagious that you, even you, who have seen the rehearsals and know that it is only a play, are beginning to wonder whether you are going to disgrace yourself by blubbering outright, when suddenly a horrid doubt intrudes itself. Perhaps we had counted too naively upon Mr. K-ny-n C-x always playing opposite roles to us. Mr. K-ny-n C-x likes ancient art of any sort. These are ancient carvings that we are about to show you, ladies and gentlemen. Mr. K-ny-n C-x will like these wooden images. He will not clash swords. He is, in fact, upon our side. Is it not wonderful? And vexatious?

It spoils our big scene completely. It's no fun having art shows unless we may wake somebody up with 'em. Whom can we wake up with these carvings? No one. They are several hundred years old and, therefore, hors concours. Everybody will love them. It would have been awfully wicked, perhaps, but in the interest of art, justifiable, to have dissembled a bit with this show. Suppose Mr. Stieglitz had assumed a timid air which he can do very well and had announced that he wasn't at all sure that there was merit in these productions, the work of a little colored boy named Rastus Johnson, who lived at 137th street and Lenox avenue, but he was determined to give them a trial; what a fuss there would have been!

Then when Mr. K-ny-on C-x had had his fit, and all of us critics had tied ourselves up into irretrievable conclusions, we ourselves probably holding Rastus to be an impudent little upstart totally lacking in sense of decorum and religious instinct, then, we say, Mr. Stieglitz could have come forward with the truth about these carvings, and he would have had us.

The Sun, November 8, 1914

is the extreme simplicity of his catalogue. Six of the aquarelles are labelled with the same title, "Trees," five are called "Dunes" and five "The Bay." Two are called "Conestoga." We have a vague notion that "Conestoga" is somewhere in Pennsylvania and that therefore our artist is a Quaker. In that case he will be more than ever worth watching, for he must be revolutionary, his sense of color being already beyond what we expect from a Hicksite.

The Sun, November 1, 1914

AFRICAN ART AND STIEGLITZ

THE GRAY WALLS of the little gallery of the Photo-Secession now support carvings, strange wooden carvings, queerer carvings than you will see anywhere else in town. Mr. Stieglitz is on deck with sensational and sardonic theories that surmount the din of battles and shine above the dust clouds arising from crumbling empires. His first lieutenant, Mr. Walkowitz, is there also, less wan and pale than of yore, but more unutterably philosophic than ever. Mr. Zorach, who is a primitive, very fond of painting his personal recollections of ancient Egyptian history, now enters upon his sophomore year in this academy of arts and thrills. Several of the new recruits had the look of being permanent additions to this society, although one of them, a most clever young man, an Albanian refugee 'twas said, had rather too decided and forceful a manner for a recruit. Being clever, no doubt he will soon subdue himself.

All of the dramatis personae are on the scene, you understand. They are all word perfect in their parts and eager for

DEMUTH'S FIRST EXHIBITION

IT IS Charles Demuth who now makes his debut in the Daniel Gallery. He exhibits twenty-five aquarelles, which are washed in with great freedom and are in pretty color, but whose landscape subjects are sometimes so vaguely indicated as to be practically negligible. This drawback will not puzzle that portion of the public which has learned to admire the faint color evocations of John Marin, but then it must be confessed that this portion of the public is the scared minority not numerous enough as yet to dare to raise the voice of praise.

John Marin's "indicated" water colors are not more elusive than many of Whistler's most popular pastels, but then Whistler went further upon occasions into completed portraits that anybody could recognize to be likenesses, and these could be rushed to the defence by the Whistler enthusiast, when attacked. Marin laughs at likenesses and defies you to recognize the particular hill or particular bridge. For that matter it is seldom that he even admits it is "a bridge." In consequence his followers get into difficulties when proselyting for him, and are sometimes called "highbrows." Nevertheless, their number increases steadily.

For them the question will not be "Is Mr. Demuth too vague?" but "Is he sufficiently different from Marin?"

This the present exhibition does not answer with sufficient distinctness. It will be allowed that Mr. Demuth's drawings are worthy of exhibition and that they have merit enough to induce us to hope that this artist will do still better. He has at his present command a good but not extraordinary sense of color. His drawing is uncertain and in consequence the waters in some of his seascapes travel up and down over a too concave earth. This might be forgivable if the color had been sought for in passionate subtleties, but the color is only "good"; and if the lines as lines had relationships to an idea worth expressing, but they are not concerned with ideas, and so as drawing must be rated "weak."

An amusing and novel feature of Mr. Demuth's show

Digging in subterranean passages has its dangers and so have the searchings of an artist among the wreckages of the human stream. The topic is an inviting one and one that must be discussed and understood in America before we can hope to make New York the capital of the arts. We have poised morality and art in the scales before this and sometimes morality wins and sometimes art wins, but so far, at each decision, there is always a voice that insists that there has been juggling with the scales! So much depends in young countries, such as ours, for instance, upon who is umpire! Emily Dickinson, our almost forgotten poetess, claimed in a poem that all Boston agreed was perfectly all right, that truth and beauty were one, and as truth and morality are also one, it follows as the night the day that morality and beauty are one; and consequently if Pascin's drawings are beautiful they are moral.

We may all agree nicely to this deduction at once or we may make a fuss and try to stamp upon Pascin as we stamped upon Gorki, Walt Whitman and Poe, but sooner or later we must come around, for art always wins in the end, and Pascin has a talent that's prodigious.

It is altogether likely that before the season is over we shall have a public exhibition of his work and then all the moral and scientific phases of his art may be considered in detail. It would be nothing less than a crime if we fail to show this stuff to our students. Think of a Degas coming to town with a hundred or so water colors and no one seeing them but a handful of experts! At any rate this visit is sure to figure in art history. As far as modern art is concerned nothing of greater importance may happen throughout the winter.

The Sun, October 25, 1914

it was beautiful down there – lovely architecture, rare colors, "as swell as Venice," some one in the crowd ventured; soft climate, "beaux negres" eminently paintable, good opera and eating; all in fact that the soul of an artist could desire, but Pascin did not succumb to our enthusiasms. Something that somebody told him years ago fixed Florida in his mind as desirable, and besides he firmly insists that Florida is not so far away as New Orleans!

Not that it is our affair! The choice of habitat by an artist of imagination is often swayed by trifles light as air. The planting of Gauguin upon Tahiti and Stevenson upon Samoa could not have been arranged by others, and the only point that concerns us is that in these places they found soil upon which they could flourish. Unlike Gauguin and Stevenson, Pascin is not looking for an asylum. He is a passenger bird. Be sure he will abstract honey from Florida, although personally I am not at all sure that Florida herself will recognize Pascin's product as honey.

To us disinterested Northerners it will be great fun to see what Pascin brings back in his portfolios from down there. For that matter, since he is to be with us a fortnight, we had better watch out ourselves. Mr. Benson's "Dodo" said of the marriage state. "It is both a responsibility and an opportunity," and the same may be said of Mr. Pascin's visit to us. It is all very well for us to brush our hair pompadour fashion, and sit straight up and down in our chairs in respectable poses. We can't, of course, keep that sort of thing up forever. We cannot even keep it up two weeks, and the exactly wrong moment of the tango is the moment that Mr. Pascin will catch us, you may be sure.

As an artist he is not enamoured of masks and poses. He has not said so, but judging by his drawings, I should say he is not deeply concerned with recording the outward aspects of respectability. Respectability is a thing that is sure to get itself recorded, automatically if no other way, and for that reason probably Mr. Pascin lets it alone. There is no crying need to publish it, since it publishes itself. He has none of the animosity against virtue that seems to put bitterness into the pens of our modern English satirists. He is, to put the matter as simply as possible, more concerned with beauty than with satire, although satire is there. It is as though the beauty in his drawings is conscious, the satire unconscious.

At the same moment some men appear flashing a lantern. An enormous load of hay drawn by a donkey blocks the passage from wall to wall. Six men and three women shout and pull at the donkey. The load has attempted to upset and is propped.

"Voilà," said my guide. "There is your tobacco shop."

I enter the garden in front of the shop. The crowd continues to exhort the donkey. By a great effort the load moves one foot and I am sealed in the garden. Every one laughs, says "Quoi fare?" and disputes. Pitchforks arrive and they pitch the hay into the garden.

"Take care of my roses!" shrieks a jeune fille.

The sad mademoiselle from the hotel arrives upon her promenade.

"Qu-est-ce que c'est?" says she. "O the poor little donkey under that great load of hay! Has no one, then, had the courage to give him a morceau to eat?" And she presses a wisp from the load to the sober animal's mouth, who lets it fall unheeding to earth.

"Ma foi," remarks the owner of the beast, "the whole load is for him and he knows it."

The Sun, May 3, 1914

PASCIN IN NEW YORK

JULES PASCIN of Paris has arrived in New York. He says he is not an emigré. He came to this country simply because he wished to see America. He will stay a fortnight with us and then flit southward to Florida, Cuba, he doesn't know where.

A number of us were trying to persuade him, since he must quit New York, to go to New Orleans, assuring him that

little iron cot and the grand view, which I forgot to look at next morning in my rush for breakfast.

There were about twenty at the table d'hôte. The cuisine was all right but not pretentious. The conversation unpretending also. Just at the last there was a flash of something Gallic. Mademoiselle at the end of the table rose to leave first. "Bon soir, messieurs, bon soir mesdames!"

"Where are you going like that?" asked one of the married ladies, with an appearance of concern.

"Oh, for a little promenade," returned mademoiselle, who had a sad, tired face, heavy drooping lids and ringlets that had once been effective and were still capable of certain effects.

"Are you not afraid?"

"Not at all. I'll not go far. Besides I have a conscience tranquil. Nothing will happen to me."

"Voilà!" exclaimed the married lady's husband, "that's the supreme reason for courage!"

"I think there are dangers. Have you never fear alone? Which is your room?" continued the alarmist.

"This one just over us, with windows on the square."

"Just the same, they can enter there, these villainous characters!"

"Or by the chimney," laughed mademoiselle, "if they fail at the windows." And then everybody joined in the most complimentary suggestions of possible ways which the rufflans might use to seize upon and carry off the fair hostage.

The village street was very dark. The shop opposite gave streaming light and peasants inside were talking excitedly, probably about the shooting season which had just begun. I watched them while screwing up my courage to enter. Suddenly a woman's voice out of the darkness beside me asked me if I wanted something.

"Yes, tobacco," said I with great presence of mind. "Are there cigarettes here?"

"No, m'sieu, not here. Tenez, I will take you."

We turned the corner into a narrow lane. The blackness was Egyptian. We turn another corner, guided by the sound of our footsteps. Suddenly we bump into a haystack.

"Mon dieu!" shrieks my guide, "what is it?"

spoil from the auction and knew that I was right. As I finished my little story I found my host blushing like a schoolboy.

"Ce que vous me racontez la," said he. "What you tell me gives me great pleasure. I have always held that style should be as recognizable as people."

A little later he said, "I always work outdoors from nature. It is an exhausting way to work, because the effects change so. I have a number of canvases going at once. The effect of course never is quite repeated and one must have a clear idea in one's head of what one is after.

"I have worked in the atelier, but the more I succeeded in that method the less interested I became. Now I have given the atelier up. But here is a canvas I began over a year ago and never have had a chance to finish.

It was beginning to be dark and we had had recourse to candles. I saw that it was time to make my adieux.

"When do you return to Paris?" inquired monsieur and madame.

"By to-night's train," said I.

"Impossible! You must not. I'll tell you! Stay to-night at the little hotel in the village. Then come immediately after your breakfast. I shall take you for a walk along the Cidelle, where I paint, it is very beautiful. You must see my country. After that we shall have luncheon here. Luckily for you, there are perdreaux. The hunting season has just begun. Then Josef can take you in the diligence to the comfortable afternoon train."

And so it was arranged.

Flourishing air about the hotel. Madame herself was pouring burnt sugar over flat dishes of pudding as I peered in at the kitchen door to inquire about rooms. Pots and pans, eggs on table, interesting debris, very paintable. "La cuisine française," cried madame gayly as she saw me grinning at her procedure.

There was a choice of two rooms in the annex over the garage. One room had a small bed and a fine view and the other had a grand bed and view ordinary. With inward qualms I recollected I had come to Crozant in my capacity as art critic and had a character to live up to. I therefore chose the poor

himself quickly, presents me to madame, and explains that he has a sore throat and cannot talk in the evening air, so we will go to the house.

In the meantime servants have arrived from somewhere and the doors and windows are open.

"We are not well installed," said the painter, "but the village houses are not especially nice and here we have the view. It is simple — "

"I like it for that," I interrupted.

"Moi aussi," responded M. Guillamin with a sympathetic glance. "Come up these steps. I will show you some of my canvases."

On the floor above there was a little room with many pictures on the white-washed walls gleaming through the half light like colors from stained glass. M. Guillaumin put aside a curtain from a little window which looked upon as fair a prospect as one could imagine. The ground dropped sharply off into a steep and intimate little valley all green with turf, and a few cypresses pointed upward. Umbrian fashion, upon the hill en face. To the right was the amusing village, with its church spire, just near enough for its evening sounds to melt into poetic jumble. A horse teased by flies galloped about one enclosure kicking vigorously. An old man leaned over a wall to direct an earnest dog in the fetching in of some cows. But I turned my back upon the panorama.

The canvases that had just been brought in were un-hooked. They were Guillaumins! Both were of the same motif, the river and a denuded branch of tree straggling across the toile. The color was undeniably the color of the pictures I had seen in the Hayashi sale. In spite of my cerebellum I actually had a moment's surprise in finding what I had come to seek.

Mme. Guillaumin enters. There are wine, biscuits and conversation. I recount that my windows in New York give upon a busy thoroughfare that is noted for its traffic and noise. The day after the Hayashi sale I was busily occupied in writing when I interrupted my task to gaze from the window a moment. There, in all the tangle of motors and carriages, some flashing colors caught my eye, paintings that were piled upon the back seat of a victoria. "Surely those are Guillaumins," I thought, and a little later I caught a glimpse of my friends riding backward on the front seat carrying home the

were in fact two passengers. A lady mounted to the one seat of the high wheeled vehicle with the driver and me, so the drive across country was enlivened by conversation. It was indeed, thanks to the driver, a lively trip.

He was one of those fellows who are interested in every-thing and who waken others up. There was scarcely a dull moment and if there was the driver took advantage of it to crack his long whip, which he did dexterously. We narrowly missed running over some sheep, we scattered some ducks that ambled upon the roadway right and left, we spoke to every one as we passed, and as for the man shingling a roof, we commanded him to stop pounding for a minute and then informed him in a roar that "his cousin had not come." Finally, as we were nearing Crozant, we came up with a bridal party in two coaches, who hurled facetious remarks to us and to whom we, or at least our driver, replied in kind. It was a very enjoyable excursion.

Between four and five in the afternoon I was set down before Guillaumin's house. It was close to the road, a simple, massive stone house of the kind that artists like. Knocks upon the various doors awakened echoes but no responses. Passers by informed me that Mme. Guillaumin had gone with monsieur, who was painting down by the Creuze.

There were offers to inform the artist of the arrival of a visitor and offers to conduct the visitor to the scene of the painting, all of which were refused. Instead, a little tour of the village, which is near by and which appears to be quite worthy of the diligence driver, for all the inhabitants are hearty, en-thusiastic and well individualized. The same may be said of the animals that find their way into the village street, so the entertainment to be found there is constant and varied.

Later I sat upon the stone wall near the Guillaumin house and waited.

Finally a boy comes along bearing a wooden color box. Behind him there are a slight old gentleman with two canvases tacked together and a lady with a sun umbrella. It must be Guillaumin. I approach with the question. It is "yes." M. Guil-laumin appears somewhat astonished, as well he may, at my apparition, especially when I announce that I have come all the way from Paris merely to say "bonjour," but he recovers

facts that were not only piquant in themselves but explained why Guillaumin had remained so long unknown to us.

M. Guillaumin in the early days of his painting had some modest employment in the Orleans railway service and lived at Clanmart. His landscapes were painted in that suburb of Paris and met with slight appreciation outside of the little band of enthusiasts of whom Manet was chief. It was as unfashionable to like a Clanmart landscape in those days as it was to live there.

Before the battle of the impressionist was won for Manet, Renoir, Monet and Pissarro, a surprising thing happened to Guillaumin. He drew a prize in the Credit Foncier of 100,000 francs. This was a fortune, so he promptly withdrew from the Sturm und Drang, gave up the search for his dealer, who is as important to an artist as his architect is to a sculptor, and retired with his family to Agay, there to paint to suit himself, the world forgetting and by the world forgot.

"Write him' that you are coming," said M. Bolt last August to me. "Guillaumin will drive over for you to the station. Crozant, where he lives, is six miles from St. Sebastian."

The fact was I had decided to take the five hour run down to the Creuse country just to call upon the artist whose work I had admired and then five hours back again to Paris. It takes the truly timid for bold projects. But I decided against a warning letter. It must be excruciating enough to have strangers popping in upon one without the extra agony of knowing the day before that the visitation is imminent. Besides I did not wish to put my victim to the trouble of a carriage.

The god who attends to the venturesome apparently had nothing else to do the day of my journey and gave his services exclusively to me. I had begun to feel excessively foolish as I landed upon the lonely railroad station and realized that cabs, trams and things of that kind did not exist. It developed, however, that there was a diligence.

The diligence driver was he, so the porter informed me, who was at that moment busily engaged in pinching the young ladies who sold the station's newspapers, with attendant shrieks and retaliatory blows upon the part of these young persons. He interrupted this pleasant pastime willingly enough when he learned there was a passenger for the diligence. There

time. He now has a dealer, which is a good sign. There is a shop in Paris where you can always find Guillaumins. He has had one man exhibitions recently with a unanimously amiable press.

More important still, his works have appeared in auctions and at a recent sale in Paris the prices advanced. And even more important than that, the young people who are thrilled by the canvases of the Salon des Indépendants have become aware of him. They place his name on the list of those they admire along with Cézanne, Redon, Rousseau le douanier, Maillol, Renoir and the new lot. To be admired by the new people who are coming along is one of the most reassuring things that can happen to any artist.

At the same time the world in general scarcely knows his name.

Until the Hayashi sale last winter at the American Art Association I for one had never heard of him. Mr. Hayashi, it seemed, was a Japanese art dealer in Paris who had assembled a most interesting private collection of the works of the moderns years ago, many of which it was said he had acquired from the artists in exchange for Japanese prints. At the time of Mr. Hayashi's death these pictures found themselves in Japan and as they had to be sold the heirs thought it the part of wisdom to sell them in New York.

Among them were twelve Guillaumins, mostly landscapes. Fortunately most of them were hung in a group. They made a stunning impression. They were decorative; they were simple; they were brilliant in color, and just about as powerful for landscape as Winslow Homer is for marine.

Who is Guillaumin? we asked. Nobody knew. Of course one always makes such discoveries at the eleventh hour just before the auction takes place. So there was a wild scurry here and there to warn one's friends that bargains were to be had. Here were perfectly good pictures by someone we had never heard of and some one who was not affiliated with any of the great dealers. It was a chance too good to be missed!

After the auction — it was a most enjoyable auction — need we say that some of the Guillaumins went to the right people? — we proceeded to look him up. Duret in his book on impressionism gave a whole chapter to Guillaumin and a few

those who take the trouble to learn the system. Once you get it started the movement is almost automatic; a touch or two to the levers, occasionally, a little pétrole, and there you are, almost famous.

To disregard the machine, to take yourself off to the country, to imagine that the charming picture that you have just painted will fly of its own accord to Paris, there to alight upon some place of honor and be raved over by poets, fashionable actresses and the Government, is to indulge in a pleasant but unpractical dream. There are all sorts of things to be done first before that can happen. They need not be recounted here. Those of you who already know the ropes and are highly successful and prosperous would only be bored by my repetition of the principles involved, and you who have never discovered them probably have the sort of genius that comes to its fullest fruition in loneliness and neglect. At any rate I shall not be sidetracked here into telling all I know of the publicity game.

The charming picture that you have just painted will eventually arrive somewhere where it can be compared with other pictures and after that it will take a rating in the world's affections. If you ignore "publicity," however, that moment just as likely as not, will be delayed until after your death or until the good opinion of your contemporaries has become a matter of indifference to you, which is next door to death. Cézanne had practically arrived at this stage when notoriety, or perhaps in his case the appropriate word is fame, knocked at his door. It is quite safe to say he never guessed how much Destiny was occupying herself with him.

Émile Bernard recites in his "Souvenirs" that he had owned a Gézanne still life for fifteen years and when he showed it to Cézanne the latter said:

"It's poor. If that's what they are admiring in Paris nowadays the rest of the art up there must be mighty weak!"

In the case of Armand Guillaumin, who was Cézanne's chum at the period of the Impressionistic Sturm und Drang and who is one of the most important of the valiant group of 1880 and in fact one of the strongest of modern landscape painters, there is every indication that the Fates are bestirring themselves to render unto him a little justice during his life-

the light strikes it now in the little gallery it is very like jade. The whole piece of marble is delightful as stone, and the artisan has cut it with fine appreciation of its quality. The "touch," to apply still another musical term to Brancusi's chisel, is extraordinarily caressing. Few pieces of modern stone cutting come up to it in "preciousness," and none that we have seen eclipse it. Certainly Rodin's do not. Sculptors who have any love for their trade as such and know in theory what "respect for the marble" is will concede this success to Brancusi.

The new piece, the "Danaide," is far more subtle and refined than the "Mlle. Pogany." Why she smiles we do not know, this Danaide. Is she the one who didn't murder her husband upon her wedding night or one of those who did? It is a most elusive smile, difficult to translate, but charmingly high bred. A Japanese noblewoman would smile like that just before committing harakiri. From every point of view the lines as lines are good. The swollen neck does not explain itself to us, but in another light "it might," as the young person in "General O'Regan" says. The hair is suggested in a most interesting way and the tenderness of execution is even more marked than in "Mlle. Pogany." "Mlle. Pogany" has the advantage in marbles, though.

The Sun, March 22, 1914

A VISIT TO GUILLAUMIN

IT HAPPENS in France, as it happens here, that an artist may do excellent work through a long term of years and escape notoriety. The modern machinery for publicity, although an immense affair, is also very simple, and is easily controlled by

One naturally seeks for comparisons for most of our modern artists among the musicians, for the continual search for the abstractions of beauty that goes on among our new men is only to be matched by the "absolute" in music that fascinated even the apostles of the leitmotif among our composers. One would wish that modern art would not borrow so much from music. One would wish that painting and sculpture might develop more strictly within their mediumistic limitations, or progress by adding more and more restrictions to method.

But what have one's private opinions to do with an age whose rallying word is "liberty"? An age in which all barriers are down; an age in which the women wish to be men; every country wishes to be like its neighbor, and an expert is required to tell the difference between an aristocrat and a democrat? With everything "upon the level" what's the use of kicking because painting has become another form of music? Or because sculptors take on the license of poets?

Those who deny "progress and liberty" will deny Brancusi. Those who are interested in life as it is and are more interested in the actual, unsolved, confronting problems of the day than in the completely solved, tabulated, indexed problems of the long dead past will accept him.

Those who can bear to look at Brancusi's sculptures, however, will find it difficult to understand the shudders of the philistines. They are not after all so very abstract. There is a tangible subject to each work. "Mlle. Pogany" is, if you will, a delicious piece of satire as soulful and ecstatic as dear Lady Angela in "Patience." She leans her amusing head upon her hands and bends forward properly "yearning" at the, to us, inaudible Bunthornish strain. The eyes in such creatures dilate until they are all of the lady that the watchers at the comedy see. Brancusi has dilated them until we see nothing but eyes. But what of that? Pray let us be consistent for once. It is an abstraction, but since we understand it what's the harm? Our ultra-moderns complain that it is too easy, that they "understand" it, in fact. If that should prove to be its fault, it is a fault that will make its appeal to all Academicians."

"Mlle. Pogany's" ear is a droll ellipse and may worry beginners in modern art study, but the same individual who will be astonished at such an ear in modern art admires exactly the same sort of art convention in a Chinese jade. As

BRANCUSI

THOSE WHO didn't "see" it last year at the show of international art ought to this year. Now that it finds itself in the sympathetic guardianship of Mr. Stieglitz in the little gallery of the Photo-Secession, at 291 Fifth avenue, which seems to have no secret architectural differences from other galleries and yet has the faculty of showing off modern wares that seem dubious in other places to extreme advantage, like the tailor's mirror in which you never can locate the imperfections that you fancied in the glass at home, the Brancusi art seems to expand, unfold and to take on a startling lucidity.

But a few short months ago there were jeers for the "Mlle. Pogany" and the "Is it an egg?" witticism threw the philistines into such paroxysms of uncontrolled glee that a consideration of the "Sleeping Muse" had to be postponed. It is impossible to reason with people in the grip of a passion, whether for laughing or weeping. It is perhaps impossible ever to reason the adverse into an appreciation of a work of art. Art is felt, not understood. All the talk and loud shouts in the world won't cause you to like a picture that you are convinced you loathe. But the laughters are finally stilled through sheer weariness of their own laughter. The thought imprisoned in the bronze at last speaks, and soon, if the idea be a pretty one, there is an audience so large for it that the fatuous laugher becomes an object for mild pity. People laughed at Beethoven! It is difficult for us now to see upon what they pinned their joke.

Brancusi, Beethoven! They are not precisely mates. Beethoven never laughed, or at least if he did you were more frightened than at his thunder. Brancusi laughs. Beethoven is godlike, primeval, ungentlemanly. Brancusi is suave, witty, elegant and rococo. There is no reason whatever for linking them save that their loves spell their loves with a B and both were mocked. If one must find a musical affinity for Brancusi, Rameau is nearer. But must one? He is more literary than musical.

56

world will not concern itself overmuch. Soldiers in the ranks are necessary. If you submit to being one the more fool you, says the great world.

If your idea is to be great you may gain a pointer from the position of Arthur B. Davies in the exhibition. The people laugh at Mr. Stella's "Coney Island" and Mr. Schamberg's "Wrestlers" and even at Mr. Taylor's linoleum designs, but to "Potentia" and the "Peach Stream Valley" of Mr. Davies they say, "How beautiful." No matter how abstract this artist may be he holds his audience. He has the power of interesting people and whatever manner he assumes, the essential fact is that it is Mr. Davies who is assuming it.

The moral is: to hold fast to yourself.

In the pedigree supplied for cubism by the writers upon the subject the great Ingres occupies an exalted position. Ingres is a fine name and all the different art sets are glad to own him. In the show last year at the armory Albert P. Ryder, the American, was proudly included. As in the case of Ingres, it is a name that any society would willingly admit.

Even among the Montross cubists you will find works by Maurice Prendergast, who hangs lovely color mosaics upon slight shreds of subjects, and the clever Mr. Glackens, who paints so like Renoir that he will be regarded as a mere trouble maker for Renoir enthusiasts fifty years hence, Renoir himself, they say, having painted six thousand of them. Ernest Lawson isn't there solely because he is inconsiderately having a one man show of his own around in the Daniel gallery. So you see if you have the courage or the "energia" to be "different," even the coming revolutionists of ten years hence who will look upon these present cubists as Quakers will take you in. But they certainly won't if you are only a poor cubist.

The Sun, February 8, 1914

deliberately apes Matisse, and several here and there are doing the Odilon Redon business. Most of them, though, here as elsewhere, go in heavily on Cézanne.

Hastily summarized here are a few of the features of the three exhibitions: At Montross's the popular puzzle will be the Shamberg "Wrestlers" and the popular appreciation will be the Stella "Battle of the Lights, Coney Island," many people having been heard to acknowledge that Coney Island always did affect them that way.

At the Macdowell Club Rudolf Dirk's color explosions will be rated No. 1, with a startling and beautiful landscape to top his individual list.

The National Arts Club is the biggest of all the shows and covers the widest range. Here are the very wildest of the futurists, as well as the solid and enduring George Luks and Jerome Myers. Two works here are sure to rival the celebrated lady who went down stairs last spring as a topic for social debate. They are by Andrew Dasburg. One is entitled "To Mabel Dodge," wonderful convolutions in scarlet in the midst of which a little tulip blooms. The other is called "Absence of Mabel Dodge," and the lines of scarlet have gone plumb to smash, as though shrivelled by lightning.

Being "in the swim" is very exhilarating. It has its attraction for every human being. People will go to the most stupid parties, hobnob with insufferable bores, learn excruciating new dance steps, give up their present life, and sometimes the hope of a future one, all to be "in the swim." Being "in the swim" is fine, we've got to admit, but it isn't necessarily being great.

Greatness in the arts is obtained from two sources, from nature and from within one's self. "Art is nature plus human nature," a famous old art teacher used to say. Both remarks are equally platitudinous and true. It is not, however, worth the pains to say these tiresome truths over and over again to all the young people who will now rush into cubism.

Thousands of them have already adopted this new uniform, and they will die in the fight unheralded, just as they fell in the battles of other days. They will be heroes, it may be, though obscure ones, and a sister or an aunt off back in the hills will shed a tear from time to time, but the great

day – and still moving. It occupies the centre of every art stage in civilization and affects all the arts. Characteristically the barricades are most stoutly defended in the art that is most completely a common property, literature. Miss Gertrude Stein of Paris is not only the patron saint to the new artists, but is herself an artist in the new use of words. Her poems, plays and essays enjoy an extraordinary distinction that is somewhat akin to the immense private fame that Rossetti began with. She is one of the most talked about creatures in the intellectual world and the slightest scrap from her pen is read with delight even by those "who do not get it," as the phrase is. Yet no single magazine or publisher sees the immense advantage to be gained from a satisfaction of the public curiosity in regard to this work. It is a curious and strange impracticability upon their part. When eventually a Mr. Montross, theatre manager, does produce a Gertrude Stein play, involving as it will a complete departure from the technique at present in vogue, with different lights, different costumes, action and a very different tempo in speech, what fun it will be!

Music is already there. "Le Sacre du Printemps" set all Paris by the ears, but even the most drastic of the critics admitted it to be sincere.

When an art striving or impulse keeps the world talking for six or eight years and affects all the sister arts, when emporiums spring up for the sale of works in the new system and magazines are created for its discussion, the affair may safely be called a "movement." That authoritative books upon the style have not yet been written merely means that the movement is still in progress. One never writes with authority upon a style until the style has passed. The funeral sermon is preached in the presence of the corpse. Without meaning to be unnecessarily unkind, and simply in an effort to end this paragraph, we may mention that authoritative works upon the subject of impressionism have long since been at hand.

America has a fine dashing way of naming things to suit itself and over here when we say "cubism" we mean everything and anything that is unacademic. As a matter of fact very little in any of the three shows corresponds to what the French call "cubism," involving the four dimensions. The followers of Picasso are few. A lady exhibitor in the Macdowell Club show

ones? At $1 "per" there would be millions in it for some one.
You see we could easily afford the dollar. Last year we had to
pay that entire sum just for the one armory show. This year
the Montross, the Macdowell and the National Arts are free,
comprenez vous?

We are also great believers in having some slight refresh-
ment with pictures. Don't you recall how delightful the Verest-
chagin battle pictures were, served with Russian tea? If our
manager for the bus line — by the by, it would have to stop at
Alfred Stieglitz's also, for the Hartley Berlin experiences are
still there — should prove to be a good one with half the sense
of even the most senseless of our new cubists he could include
the refreshments within the dollar. But the refreshments, we
insist on't, must be good ones.

The first sensation of the week naturally was the capture
of Montross' by the cubists. Since the Fall of the Bastille noth-
ing has been so astonishing. But the sun rises and sets just
the same. Managers of rival galleries gnash their teeth as they
see the crowds turn Montrossward, but the sun really rises and
sets just the same. Nature apparently accepts cubism as she
accepted all the other things, with complacence, so why
shouldn't we?

There is nothing in it to be frightened at or to be be-
wildered by. Don't worry if you find you don't like it. Why
should you? Perhaps you'll have other consolations. One of the
most deplorable attributes of the modern mentality is its
breadth. Breadth is essentially inartistic. If you find you don't
like cubism, cheer up. You'll be rather distinguished, upon the
whole. We know, for instance, a highly cultivated and charm-
ing individual who has been everywhere and done everything
except that he has not heard Caruso. It adds immensely to his
popularity. People make him tell about it at dinner parties.

The whole thing with cubism, as it is with every other
art form, is simply whether you like it or you don't like it. If you
don't like it, don't try to persuade your neighbor who does of
the error of his ways, for you will simply get disliked for your
pains and convince him that you are the old fogy that you are.
The person who doesn't like the big general art movement of
the day is an old fogy.

It is nonsense to pretend it isn't the movement of the

sister of Matisse's patrons, who writes in a strange jargon quite as queer as the pictures.

" 'He is doing what he had been doing; he was certain then that he was a great one, for he was doing what he was doing and was a great one when he was doing what he was doing,' read Mr. Chase, and the audience roared. For five minutes Mr. Chase read. Then he folded the paper and with evident disgust asked whether art was served by such 'stuff.' Then he declared that true art could only thrive through work and high ideals."

The *Press* declares the Contemporary Club has seldom had a better time. "They went to be informed and instead were amused. The temperaments of artists are not often exposed to view." But they claim to be as much as ever in the dark as to what cubism really is.

The Sun, December 14, 1913

THE GROWTH OF CUBISM

THE MONTROSS show isn't the only one. It is a good one, but it isn't the only good one. The Macdowell Club is a good one. It knew that it was a good one, so it lent some good ones to the National Arts. The National Arts knew that the Montross was a good one. We are good ones and we stand for the whole thing. Vive the good ones, as Walt Whitman would say! Isn't it a shame all of us good ones cannot get together? Couldn't there be a bus line established for round trips, and guides with megaphones pointing out to the tourists the palaces now occupied by the artists who paint and dealers who sell the good

of Post-impressionists who suicided, starved and died in divers ways because they could not get recognition, but they did not know the gentle art of advertising, said Mr. Cox; they did not capitalize morbidity, eccentricity and indecency. Their successors, Mr. Cox went on, did not want the enduring flame, but merely the flaming notoriety.

" 'I know of nothing more favorable to rapid changes than putrefactions. They are not vital, as is good art, but decayed and corrupt.'

"The audience had not known Mr. Cox well, but simply by reputation. His really refined way of saying nasty things impressed them, but every one sat pretty quiet waiting further developments before showing where to give sympathy. When Frederick James Gregg had spoken a little while the doubt was lifted.

"Mr. Gregg represents the school of the Isms. He is not at all backward about saying so, and in his early speech one knew that this was to be a debate of personalities. He disclaimed any intention of committing suicide or allowing any of the things that happened to the Post-impressionists to happen to him. He said that Mr. Cox had been speaking this nonsense all over the country, that his facts were vulgar and horrid untrue, and that Mr. Cox should put that in his pipe and smoke it. This drew a gasp from the listeners.

"He likened the interest in the present new art to the curiosity which brought about the Renaissance, and said no one ever went to an Academy exhibition any more. (He referred to the New York Academy.) 'You can bet your last dollar on that,' he added. He accused the artists of Mr. Cox's school of considering only their bread and butter when they refused to indorse the art of the cubist school, and concluded with the comment that Mr. Cox has a really develish quality of being very angry and very meek.

"They don't hiss at the Contemporary Club meeting, but it is certain that Mr. Gregg's address was not received in good humor.

" 'How insulting,' 'What bad taste,' 'He ought to be ashamed of himself,' were some comments."

"The gem of the evening came," said the *Ledger*, "when William M. Chase, taking a clipping from his pocket, read seriously an appreciation of Matisse, written by Gertrude Stein,

place to explain to our friend Anthony Comstock what is and what is not allowable in art. Suffice it to say that the source of an artist's inspiration is of no concern to any one but himself. We are not contenancing murder when we praise "Macbeth" and we are not commending vice in recommending Pascin.

The Sun, December 14, 1913

THE SPECTRE OF CUBISM

IN PHILADELPHIA

THE COMFORTING assurance was preached last spring that that horrid spectre cubism had been laid low. It had been vanquished, quite scotched. It was but "an error," as Mrs. Eddy would have said. We were to forget it and be good. But Banquo's ghost has appeared again. Not only that, but three New Yorkers went all the way to Philadelphia last Monday to hurl ultimatums at the apparition, and the Quakers at the seance grew quite frightened at the spectacle and published columns about cubism the next day with scare head lines.

The *Press* headline read: "Artists Snap at Each Other Over New Art," and the *Ledger* had it: "Contemporary Club Laughs at Cubists."

"It fell to the lot of Kenyon Cox," said the *Press*, "to open the discussion."

Mr. Cox is a tall, bearded, but withal a mild mannered looking, person. He carries his honors and reputation gracefully, and one would never expect him to say mean things.

"He started all the trouble. He said the present group of cubists and so on are only the imitators of the early school

certain sights and scenes of the capital as being characteristic-
ally Gallic and publishes them as such to the rest of the world.
They say: "We do not support these institutions, they are not
for us, but for vous autres, you foreigners," and that may be
in effect true. Certainly the tourists, even the most straitlaced
of them, eye with a peculiar fascination the seamier examples
of frank depravity that parade the boulevards for their ex-
clusive entertainment. After a month or two of acclimatization
the healthy tourist usually forgets "le ruisseau" and secures
as best he may his place in the main stream of French culture.

There are exceptional visitors whose health is not their
most striking attribute. Pascin is one such. He never gets over
his fascination for the dusty street acrobats, the travelling
Kirmesses and the denizens of certain Montmartian resorts;
and he paints them not with the simple humanity through
which Degas peered at his ballet girls, but with all of the un-
canny suggestiveness of a Beardsley. Pascin is as great as
Beardsley, if not greater. His interest in horrors is more gen-
uine, and his power to suggest them greater. With Beardsley
vice was arrived at, more or less, intellectually. He and
Arthur Symons, the poet, at the beginning of their careers
deliberately weighed the modern situation in the balance, and
deciding that respectability was over-worked material went in
heavily for "vice," as something "that had not been done."
Consequently, even with the best intent, they saw it from the
outside. The extraordinary Pascin has obtained a nearer view.

His women "In the Park" give themselves, and also the
artist, away terribly. Among other things, since they have seen
everything, "they have looked upon the line of beauty, but have
departed from it." In other words in these unlikely habitations
a shred of conscience lingers still to make them even more
repellant. There is an uneasy tinge to their fat bodies, heavy
eyelids and yellowed hair. They are the sort of creature that
the daylight of any park exposes too pitifully.

The children in the Pascin drawings are little monsters.
The animals are even worse than monsters. In "Dressing" some
young women array themselves for the boulevard and one of
them already in costume waits for her companions. Over the
back of her chair a dog climbs. Such a dog! A skinny beast that
creeps stealthily, fearfully, like an animal born and bred in
some dank reptilian cave.

Nevertheless, it is very fine art. This is perhaps not the

JULES PASCIN

THE HUNGARIAN, Bohemian and Austrian show of graphic art crowds the little gallery of the Berlin Photographic Company with 368 examples signed by gentlemen whose names, we think, would be greatly benefited by a subjection to the Andrew Carnegie-Brander Matthews system of reformed spelling. What a tax upon strength it would be to have to learn to pronounce and to spell such names as Ferenc Medgyessy and Jan Zrzavy, for instance, and yet these are among the easy ones! Happily our fears in this respect were ungrounded. So slightly had Mr. Zrzavy's and Mr. Medgyessy's works affected us that even before we had completely toured the gallery we had forgotten the particular prints they had signed. They will have to show us – with the Missourian accent upon "us" – before we begin to learn those names.

All of the latest fashions are represented in this exhibition. There are "color etchings" that look like mezzotints, and "color etchings" that look like Japanese prints. There are lithographs that appear to be porcelain tiles and others that seem to be sections of wall paper – much of the ultra-modern art consists in trying to be what it isn't, you know – naturally there is a deal of cubism. When we had quite finished our painstaking inspection of the exhibition it developed that the one individual that rewarded study, the artist who outtopped all his neighbors by far, was, if you please, not a Hungarian, a Bohemian, nor even an Austrian, but a Croatian – the familiar reprobate, but admirable draughtsman, Jules Pascin.

He is in this show by courtesy and in fact is only a Croatian by courtesy – the accident of birth counting as little in his case as with the "Americans," Whistler and Sargent – finding in Paris the particular sort of human documents that he elects to rework into art. The documents are more than shady, but the Pascin results are undeniable art.

Paris pays a penalty for being the playground of the world. The solid members of French society are continually in a state of mind when the straggler within the gates seizes upon

"It was not an unveiling that took place months ago, at which time the Prefect of Police decided that the monument was not appropriate for a cemetery. It was not a question of its decency or indecency; it was a question of its taste as a funeral monument, and many of Wilde's friends have never liked it.

"At the time of its unveiling the Prefect of Police asked a modification, and that being refused ordered it to be taken away and covered it until one thing or the other should be done. About a forthnight ago Alesteir Croley announced that if it were not uncovered and 'Epstein's masterpiece,' as he called it, made visible he should cut the cover off. This he did, but the police covered it again and up to date that is the situation."

Ardently as we desire new blood in our sculptural circles and however much we may believe in the benefits that may accrue to us from a discussion that may arouse the public and cause it to take an interest in and to look at sculpture, yet we cannot conscientiously invite Mr. Epstein to visit us with his carvings. He has said just enough about the puritans to frighten us and just enough about the "subject matter" to convince us that his sculptures have subjects.

Here we have done with that sort of thing this long time past. There is scarcely a week in which we do not have an exhibition of "absolute" art. And our absolutists, Mr. Epstein, are puritans. In the little gallery of the Photo-Secession, where Mr. Stieglitz and his disciples hold forth for months together, there is never so much as a lead pencil sketch in the little exhibitions which may be properly said to have so much as a shred of a subject, and the word of all other words that may be constantly overheard in the discussions there is the word "pure." Mr. Walkowitz's little drawings last year were pure. This year they are still purer. There is nothing in the current show to bring blushes to modesty's cheeks or to cause virtue to turn away her head.

It seems to be quite in the line of our natural national development. We wish to be up to date in our own way. Mr. Epstein's is the ancient London way. There everybody from Bernard Shaw down to Mr. Epstein makes a living by attacking the established moral code. Here we get along by submitting to it.

The Sun, November 30, 1913

attempt made in Paris to get the monument unveiled and I enclose a clipping from the *Times* of the 6th and a letter of mine printed in the *Times* to-day.

"As you know, when the monument was placed, the Paris authorities made objections. An agitation in favor of the work was started and a petition headed by Paul Fort and signed by writers and artists and people with brains was presented to the Prefect, but this was of no avail. Among the signatures were those of Bernard Shaw and H. G. Wells.

"Shortly after this I was asked to modify or alter the monument, which I flatly refused to do. Later I was told that the monument had been added to to the extent of placing upon it a pair of bathing trousers or draperies in bronze. Still the work remains covered, and personally I would rather it remained hidden from sight. I favor an agitation for the removal of the additions to the tomb and no other. The sculpture must remain as I originally left it. What will now be done I do not know.

"I have been at work on new things and hope to have a show in London in December, mostly new carvings in stone and marble. I am sending you a photograph taken by the *Daily Mirror* of a group of birds intended for a garden which is now showing with the post-impressionists and futurists in the Gallery, in New Bond street. It is a large carving in Paros marble about twice the natural size of birds and it might interest you, I thought, to see a photograph of it.

"I recall old times in New York and have often thought of going across, but have always been prevented. Perhaps I shall come with some sculptures. That is what I should like to do. I have done many carvings, some of which are very large and some of which, though I should like to show in public places, yet would raise such a storm of protest from the puritans that it would scarcely pay me to do so. Subject seems to count for so much with people; much less to me than my critics think; for the final test of a work is whether it is well done or not, isn't it?"

As it happened, a letter from Paris received in the same mail touched upon the same subject, but speaks for the opposition. The writer, a lady who has just jubilantly celebrated her sixtieth birthday, has known more or less intimately all of the celebrities of both London and Paris for a generation past, and among them the unfortunate poet Wilde. She says:

past year have produced visible results. The work last year had a hushed quality. It was as though some one were communicating to us in a whisper the news of some dreadful calamity. The voice this year is distinctly louder. The colors are brighter, much bolder, but still mournful. The people lying upon the grass in Central Park are not holiday makers. There will never be a holiday for Mr. Walkowitz. Instead they have been flung down in an exhausted state upon the lawn, worsted but still breathing, after another of the unkind tussles with misfortune that Mr. Walkowitz's dream people are always undergoing.

To get mournfulness into such bright colors is strange. Only the Orient has hitherto done that. We shall have to ask Mr. Walkowitz about his progenitors. The Spaniards, the Moors, the Arabians, you know, are sad even when they smile.

The Sun, November 30, 1913

EPSTEIN'S MONUMENT

TO OSCAR WILDE

THE VICISSITUDES of the Oscar Wilde monument in Pere Lachaise, Paris, have a special interest to New Yorkers, as the sculptor, Jacob Epstein, began his art career here as a boy and still has many friends in New York. In a recent letter the sculptor refers to a frolicsome adventure of the twenty Latin Quarter students who hastened to the cemetery upon a dark night and forcibly removed the draperies, "for the freedom of art," which the Paris Prefect of the Seine had placed upon the much discussed monument "for the public good."

"Perhaps you have heard," writes Epstein, "of the latest

as the minion of the little elevator conveys them down to outer darkness.

Of course business is not as it was. The great eruption of last year, when the armory exhibition showed us fashions in art that none of us had dreamed of, and that were as repulsive to our eyes as the hobbled skirt was at first to ladies, cannot be duplicated even in miniature so soon. Nature requires time to store up sufficient steam, gas or whatever it is for loud noises. But on the other hand it would never do to close up the shop. Mr. Stieglitz therefore resumes business at the old stand.

How people can have the heart to quarrel with Mr. Stiegliz we cannot comprehend. Like Charles II, he never says an absolutely foolish thing. He is most guarded in his references to Rembrandt. Comparison between the work of Rembrandt and the particular young artist who is exhibiting at the time in the Photo-Secession are always quoted. It is a young Harvard student who hitherto had not been much interested in art who sees the marked rapprochement between the new and the older master. It is a young lady, daughter of a clergyman who owns a precious Rembrandt etching and who finds that a Whistler cannot be hung in the same room with it but that a Walkowitz can. There is no hint in this of Mr. Stieglitz's own opinion.

He says invariably that he has had no occult vision that the protégés of his are to be the great men of the future. He Merely feels that they are tender, sympathetic beings, who seem to him keyed to our present needs. He doesn't know that they are great, but he intends to give them a chance to be great. Anything to quarrel about in that? On the contrary, it's fine.

Mr. Walkowitz's new work cannot properly be called cubistic. It is rhythmic, synthetic, disintegrated, but it takes more than that to be cubic. In the unfairly cursory glimpse of the drawings that the fates permitted us we detected no hint of fourth dimensions. We spent an hour and a quarter in the gallery, ten minutes of which was devoted to the pictures and one hour and five minutes to delightful conversation. Hence we feel we have a legitimate excuse to go again — and we shall.

In the meantime we can only report vaguely of Mr. Walkowitz that the influences brought to bear upon him during the

that" said she; or rather, she said, "Je – Je ne comprends pas ça."

"Moi non plus," replied Matisse coolly, lighting a cigarette, as though nothing had happened.

The Sun, November 16, 1913

STIEGLITZ AND WALKOWITZ

IT IS sometimes a question in our minds whether it is Mr. Stieglitz or the pictures on the wall at the Photo-Secession that constitute the exhibition. The pictures change from time to time in the little room, different artists emerge from somewhere to puzzle us, and having succeeded go again into the mist, but Mr. Stieglitz is always in the centre of the stage, continually challenging us, continually worrying us, teasing us, frightening and inflaming us according to our various natures.

We suppose there have been more violent altercations upon the subject of art in that gallery in the last ten years than in all the rest of the city combined, including even the Lotos Club. The maimed, the blind and the halt among the academicians are held up relentlessly to the light, that we may see them as they are. The villains in that body—there are some, it seems – are mentioned fearlessly by name and consigned to the exact strata that they shall occupy in the new Stieglitz inferno. Had ever a detectaphone been installed in the establishment we shudder to think of the consequences. As it is, the defenders of the faith, the faith that was, that is, can be seen almost any day fleeing from the Walkowitz drawings with hands raised to heaven, or eyes moist with vexatious tears

AT MATISSE'S STUDIO

THAT REMINDS us. We may be, we hope we are, addressing some of the Davies audience. In that case we should like to give them a tiny but sincere word of caution. Don't understand this too precipitately. "Understanding" a work of art anyway has come quite, quite out of fashion. Didn't you know that? It is a fact, really.

Only this summer a crowd of us motored out to Meudon to see the latest things of Matisse. There were four canvases awaiting our inspection all about the same size. All of them would be considered odd if exposed to view in a Fifth Avenue shop, but one of them was very odd.

The three odd pictures had undeniably interesting color, and somewhere in each one was something that resembled a motif — something that we could grasp at, but the fourth picture, the very odd one, contained nothing that had hitherto been associated in the mind of any of us with anything upon earth, or in the heavens about or in the sea beneath. Looking back upon it now, in calmness, we suspect the subject might have been obtained from the sea beneath — but we didn't think of it at the time.

We were naturally expected to discuss these pictures, and although Miss Stein was present, it fell to Miss Mildred Aldrich's lot — Miss Aldrich is a well-known Parisian amateur — to be pushed into the foreground and to speak. You know all those awful moments when an artist brings forward into the light his newest canvas and you are called upon to say what you think!

Miss Aldrich began glibly enough. "I like that," she said, to the first one, "and I like that" and "I like that" to the third one. Then came the very odd fourth picture and Miss Aldrich became silent. The silence prolonged itself and became so terrifying that some of the weaker vessels in the party half turned as though to escape from the place.

At last Miss Aldrich blurted out, "I — I don't understand

others the circular saw test. The painter quite frankly permits you to see the sections into which the tree trunks were cut, to allow of their being carried back and forth from the jewel inlayer. This is, however, the days of realism. Miss Gertrude Stein says that the one quality above all others that most impresses her in the work of Picasso is its intense realism.

But it is absurd of us to attempt to describe this picture for you. It is a picture that cannot be described. Besides, you will all have to see it. It is the best thing Mr. Davies has publicly shown in several years, and in consequence it will become a necessary part of our educations. It is in charming color, color that for want of a better adjective might be called "musical"; and the two standing figures have the strange wistful aloofness that these best Davies people have.

This is perhaps what we should have told you at first. The Davies "audience" is a large and respected one, the last in America that we would willingly disturb. It "took" slowly to its favorite artist, it learned from him a difficult lesson, and for them to fear even for a moment that Mr. Davies could be harmed by a contact with the Cubists would be a tragedy — for them. Not for him. Mr. Davies takes his Cubism lightly. He quotes it, just as he and any other stylist quotes, knowing what he quotes, and enjoying the aptness of it. Nothing is such fun in art as a really pat quotation. The grass is so quoted, but no one will mind, we think. Even the most straitlaced of us can stand cubistic grass. And the dark mound upon which the figures sit is quoted from "Sumurun" and even the "Jewel Bearing Trees" are — are —

The Sun, November 16, 1913

ARTHUR B. DAVIES AND CUBISM

WELL, WELL, well. It seems that Arthur B. Davies has been and gone and done it. Is everybody going to do it? We knew all along that the Armory Show wasn't the last of it, still we never suspected that Mr. Davies was being inoculated during that month last spring. Had it broken out in Jerome Myers or Gregg or Walt Kuhn or some of those other fellows who simply lived at that exhibition it would have been, we would have all said, no more than a mere proof that their health was in a perfectly normal state, nicely reacting under an exposure to a contagion that might not after all prove fatal. But to have post-impression, cubism, dynamism and even disintergation suddenly appear all in one picture by Davies is surprising, to say the least.

Yet the new picture, now to be seen in the exhibition of American paintings at Macbeth's, exhibits all of these symptoms and even some new ones as yet undiagnosed. It is, as the doctors would say, a highly interesting case.

And the patient is doing well too. We hasten to reassure you. Be not alarmed. The picture is a good one.

The painting is about the usual size that Mr. Davies affects. There is a lady who turns her back to us, clad in a robe that is designed in squares of color, colors that vibrate and refract, but always in harmonies. Then there are two characteristic Davies nudes, one of them with a Monna Vanna cloak; then the two trees, the "Jewel Bearing Trees" that give the picture its title, and basking in their precious shade are three more figures, one with fiery persimmon red flesh, one who is lemon colored, and one in ordinary flesh color.

"Bearing" in the title of the painting is used not so much in the sense of producing as supporting. The jewels of all the madonnas in the composition have been inlaid in spirals upon the bark of these trees. The trees have "assumed" virtue like the Queen in "Hamlet." They have passed through many trials, those trees, and have risen again beside the waters; among

ballet. We went every night. There are some in Paris who have never missed a performance. They regard it as they would some miraculously happy bubble that is liable to be swept away in an instant. The recrudescence of Bagdad's glories in a world from which the outward visible trappings of beauty are so remorselessly falling day by day warmed us "to the innermost fibres of our being," as Jane Eyre used to say feelingly. Fancy our delight in discovering that even the water color drawings for this thousand and second entertainment were works of art.

I don't think in those days that any of us students ever likened them to Dante and Bach. Art students are essentially artistic in their pleasures and never go in strongly for estimates and comparisons. They like what they like because they like it and never make any serious mistakes in consequence. I believe it was the Princess who lugged in Æschylus and Donatello. The Princess, it seems, in spite of the silver embroidery upon the brown broadcloth, was not any too secure socially and sought to strengthen her position by patronizing the arts. At any rate, hearing all this talk, every theatrical producer in Paris began running Bakst-ward.

Human nature is human nature. Given a fixed set of circumstances and a definite individual end it is a poor romancer who cannot work out the result. Take any timid, sensitive, aspiring artist, tell him that the great Serge de Diaghilev deigns to permit him to decide upon a decor for the great ballet. It is the chance of a lifetime. He toils over the ancient manuscripts, dreams, worries, tears his soul to tatters, prays to the moon and hands in his completed designs. They are good. Serge de Diaghilev is great. The schemes are carried out to perfection. Then Paris. Then the Princess. Then the rival theatrical managers. Then the Pisanello drawings that clever Mr. Birnbaum hides in his back parlor.

The Sun, November 2, 1913

individual, and in the entr'actes, when the leaping has ceased, the audience has leisure to read upon the programmes that the decor is by one L. Bakst. Comprenez-vous?

But before you decide positively to get rich and famous within the year think over the case of Bakst. Ponder it well. Venture into Mr. Birnbaum's back room, where the latest work is hidden. Then go back to the main gallery. It is a hard thing to have to say, but the latter is less admirable than the early work. Would you rather rush into riches and fame and be a worse artist a year hence than you are now or would you prefer to stick to the novel and guard your artistic soul? It is a tough proposition, but I am afraid some such choice is before you. You are more fortunate than Bakst in having the matter placed before you in so point blank a fashion.

Bakst, poor fellow, probably never decided the matter consciously. He just slipped and slipped and Nijinsky leaped and leaped, and then they had the exhibition at Bernheim-Jeune's, and then along came D'Annunzio with his St. Sebastian and Pisanelló and all was over, except cleverness. Bakst will always be clever, I suppose, but the possibility of preciousness has departed.

Would you believe it that the Bakst of the Bernheim-Jeune show of 1910 was actually timid? It is a fact. It was the timidity that is finer than strength, the timidity of the Persian miniatures, of a shy poet to whom colors are as jewels or fine gold.

We students used to saunter into the gallery every day. There would be five or six in the little room. About the second day a silver star appeared upon the very finest Bakst, indicating that purchasers were hanging about. Then rapidly we saw more and more stars, and soon all the best Baksts were gone. In Paris there always seem to be some who know.

From this time on the gallery filled with spectators and upon the last day there was a crush. I remember a magnificent motor arriving from which a lady of great distinction descended. Upon the front seats were a chauffeur and a valet in tall beaver hats and brown broadcloth coats that fell to their ankles, magnificently embroidered about the neck in silver. We decided she was one of those Russian princesses that one reads so much about, and it was about this era, we estimate, that Bakst's timidity began to slip.

Of course in those days we were all mad over Diaghilev's

may study it and do likewise, and finally we must decide whether we ought to like him or not.

Certainly we ought to like him. Is he not the fashion? Why next to Charpentier, the boxer, and Nijinsky, the dancer, he is the most popular person in France. He eclipses Poincaré by far. Merely by talking about him we shall become fashionable ourselves. Gratitude alone should compel us to like him, for now that the weather shows signs of becoming settled we shall need topics that may be indefinitely extended for the tea hour.

Nobody realized how much of its fame the Armory Show owed to last year's tea drinkers. The half of the party that had been shocked talked so jubilantly of their experiences that the other half were compelled to inspect the exhibition the next day merely to get into the conversation of subsequent occasions. History may repeat itself. There is no serious obstacle, not even the election, for that has become too disturbing to be taken with meals.

Should M. Bakst develop into this sort of New York success it will be accompanied by considerable gush; in fact we cannot allow it to be a success without the gush. To those with a sense of humor gush is not unduly trying, and particularly not in this case, where, just as likely as not, it will tend to excite equally two such opposite poles as Alfred Stieglitz and Kenyon Cox. It would be great to see those two warring under one banner against Bakst, would it not? However, let us not hope for too much. Just to show you to what lengths some of the Parisian "gushers" spouted we recall that some of them likened the performances of the Ballet Russe to the perfections of the works of Æschylus, Dante, Donatello and Bach, and called down upon themselves in consequence the righteous wrath of good Gordon Craig. But we shouldn't have mentioned the Ballet Russe. That brings us to another chapter.

You have been feverishly waiting, no doubt, to learn the secret of success. You would like to know how to become a world famous and wealthy artist in one year or less. It is very simple. Secure a job as designer for the Ballet Russe. The Ballet Russe will do the rest. Every time that Nijinsky leaps into the air, and he is certainly a leaper, your fame ascends with his. It is a case in which there is too much glory for one

BAKST

BAKST HAS come to us at last. At the very moment that you
read these lines a hundred and more of his water color draw-
ings are hanging in the galleries of the Berlin Photographic
Company all ready to be shown to you to-morrow. Are you
"en rapport," as the spiritualists say? Do you feel in the calm
of the quiet Sunday morning a sense of something strange
hanging over you? Has your wife remarked as she gave you
your coffee at breakfast that she "doesn't know why it is, but
she feels sure something is going to happen"? If so it is these
Baksts. Please advise us. It would prove two things — first that
these drawings are dynamic, and second that your wife has a
truly sensitive nature.

By "dynamic" we do not mean that these drawings are in
any way like the horrid pictures that shocked you last year
at the Armory. Oh, no! Nothing like that. Anyone, even a
child, can understand these. But they are painted in what may
be called "bursting" colors. Something goes out from them.
People who see them make exclamations. If one-half or one-
tenth of what Miss Gertrude Stein's young friends say about
dynamism be true then not only your wife but even you, solid,
respectable businessman as you are, ought to feel uncommonly
restless this day.

We are not referring to the Sultana couchée either. The
rooms of the Berlin company are intimately small and the floral
ornaments in the centre of the room force the disciples of mod-
ernism into solid phalanx close to the pictures, which is for-
tunate, for the "Sultana" hangs low, and the businessmen
who will have given up the front places to the ladies will not
be distracted by the Sultana from the main issue, which is
dynamics. The Sultana is a "femme dangereuse." She cannot
help it. It was the result of environment. No European lady
likes to be considered harmless. She is exceedingly well
wrapped up about the neck and shoulders. But we mustn't go
into details. First we must recount the Bakst history, ferret
out the causes of his success so that you who are ambitious

ers hearing the loud voices in the marketplace join in the fray and cite this artist in defence of their own projects.

The established writers of the day who have been dignified and orderly enough in their estimates of Rembrandt and Andrea del Castagno, suddenly seem to go quite off their heads and hastily sign their names to nonsensical utterances that haven't even a bearable literary quality.

What a pity all this is, and how unnecessary! From an economic point of view, what a waste of force! Hasty criticisms are so apt to be wrong, and yet all of our best advisers have by some "cursed spite" been rushed to their tables and been compelled to deliver to us their half-thought thoughts. It is not fair to them, nor to us. The gentle Amiel, we may recall, brooding upon his terrace at Geneva, came to more just conclusions about Wagner than did the professional litigants battling nearer Bayreuth, with louder but since forgotten words.

So, since the times seem out of joint for a correct definition of this baffling talent, let us pray our busy recorders who live for the most part across the seas, to confine their efforts to the gathering of facts. We should like to have all the items à la Vasari, that it is possible to collect, all the personal recollections of people who saw Cézanne paint and a volume or two of Cézanne's letters. With these and the 800 paintings that are known to exist some astute person yet to be born will be enabled to tell us whether the painter of Aix was an impressionist, a classicist, or perhaps something else. In the meantime we may be consoled by the recollection that the essential point is not in dispute. Cézanne is a great painter. All the fuss is over the descriptive adjectives.

The Sun, May 18, 1913

CÉZANNE AT THE METROPOLITAN

"But how hard it is to be precise about Cézanne." — MAURICE DENIS.

THE EVENT of the week took place this time in the Metropolitan Museum of Art. There, on Monday, were unveiled and shown to the public two works of art of importance, a large and showy but hitherto almost unknown Tintoretto, and a landscape by the once rejected Paul Cézanne, whom now more than seven cities would willingly claim.

The Cézanne is "La Colline des Pauvres," which had already been seen this winter in the Armory Exhibition of International Art. Its theme is not extraordinary. It takes one of the softest and most ingratiating of outdoor topics, the stir of gentle winds upon the tree tops of a wooded valley, with a house roof or two in the middle of the greens. It is painted with great simplicity and an honesty that cannot be questioned. Its color might even have been called "sweet," were not the workmanship so robust that a manlier adjective becomes necessary.

There does not seem to be anything dangerous or revolutionary about it. It hangs now in the room at the museum with the Renoirs, the Monets and Manets and holds its own in such company firmly but quietly. To the students of art who rely exclusively upon the Metropolitan for their knowledge of contemporary French work, why the advent of so innocuous a landscape should be considered momentous must be puzzling.

Cézanne painted other landscapes than the "Colline des Pauvres." He has, it is estimated, seven or eight hundred works to answer for, not all of them so persuasive as the museum's new possession, and about them oceans of ink have been spilled, and spilled in such a fashion that the waters have become rather muddied. It seems awfully difficult, as Maurice Denis pathetically observes, for anybody to be precise about Cézanne.

People who never before were interested in art suddenly understood him and became collectors. It is called "new" art, "post-impressionism"; and strange words such as "synthesis" and "reciprocal" colors are hurled about recklessly in brochures that come to us damp from the printing presses. Young paint-

1913−1918

THE ART CRITICISMS

OF

HENRY McBRIDE

works he had especially admired. He knew that over the years he had seen with the eyes of an artist and had written literate prose, devoid of jargon. He had recorded his thoughts and impressions without a furious rancor. He had made it a point not to bully the public but to lead it gently, even sub-humorously. To the end he wrote to educate, not in the manner of the "professors" but to enlighten through persuasion.

Other critics came and went. McBride survived. Through the best of his words we participate in an exciting epoch of twentieth-century art. One is always grateful to those critics who lead us early to what later becomes accepted judgment. During his period Henry McBride contributed importantly to that acceptance. One wonders at times how much he reflected the world of art and how much it — in the end — reflected him.

Daniel Catton Rich

catalogue and still walked about Fifty-Seventh Street looking for rising talent. In 1952 he was writing sympathetically of Bradley Tomlin and Mark Rothko and he was quick to recognize in canvases by Jackson Pollock of that same year that "he almost alone among the American practitioners of the abstract uses a technique not entirely imported from Europe and – this is the thing the lone watchers of the skies have been waiting for so long – a semblance of a native touch."

By this time he had given up all desire to revisit Europe. As early as 1922 he had found that he simply couldn't stand Paris. There was nothing there, he decided that he couldn't get as readily at home. "Paris is still beautiful," he wrote to Georgia O'Keeffe,[7] but it is a far off beauty of another period that has little to do with this one." After 1937 he never went abroad again.

His last few years were spent philosophically and calmly, tidying up his affairs. Sitting in his favorite arm chair in a sunlit apartment in Peter Cooper Village, he would read from one of his well-loved authors, Henry Adams or Santayana, or pick up a new book by an unknown. By this time his walls were bare of the pictures which grateful young artists had given him. In 1955 they had been sold at auction and he missed the Miró and the Demuth. Looked after by his devoted friend of over twenty-five years, Max Miltzlaff, McBride had finally retired.

For over four decades he had written about art. At times there had been discouragement. Years before he had acknowledged to Gertrude Stein[8] "that the present is black. There seems to be nothing doing in art, and I have the devil's own time in pretending to write art stuff. In fact I don't even pretend. That's why I don't send any of my pages because I know myself they are empty." Again, to Georgia O'Keeffe[9] he wondered if he ought to have written about the theatre instead. It would have been easier and more constructive. "One can do something with the threatre still, simply because so many people follow it."

By now he was the Dean of American Art Critics. The press said so and I can imagine that McBride was amused by the term. He had been honored by an exhibition that showed

7. On July 19, 1922 8. January 5, 1920 9. July 11, 1932

he refused to admire native achievement above French. The record shows that he wrote far more on American art than foreign and was sympathic to many of those Americans we now consider as firmly established. From the beginning he appreciated Charles Burchfield and Stuart Davis. He took up the cause of somewhat neglected painters like Vincent Canadé and Oscar Bleumner. When Marcel Duchamp pointed out Eilshemius in the first Exhibition of the Independent Artists, he took "a second look" at the Mahatma and called him a genuine lyric poet. Walt Kuhn and Reginald Marsh he admired. For Gaston Lachaise he had — from the first discovery — nothing but praise.

From 1930 to 1932 Henry McBride was editor of *Creative Art*. Though he brought distinction to its pages and contributed a section, "The Palette Knife," he was forced to resign at the end of the second year from sheer exhaustion. At that time he was writing 6,000 words a week for the *Sun* and visiting thirty or forty exhibitions. From time to time I would run into him in the galleries, a tall, dignified figure, looking keenly at some picture. His expression seemed skeptical and his sidewards glance is perfectly caught in a caricature by Peggy Bacon.

Strongly opposed to prizes and juries for art, McBride applauded the founding of the Society of Independents in 1917. He looked upon it as a place to express new ideas and to find new artists. Some thirteen years after its first exhibition he found that it had indeed brought a number of unknown talents to public attention. The "new ideas" he remarked dryly "have not been so many or so serviceable." As for the National Academy, he treated it as though it were the skeleton of some prehistoric monster. He walked round it, eyeing it with mock seriousness, constantly ridiculing its pretensions. The comparison between his columns on the Academy and the Independents gives us considerable insight into the vast gap separating establishment art and art free from censorship or constraint.

In 1950, after thirty-six years at the *Sun*, McBride's career at that paper suddenly came to a stop. The *Sun* had been sold and he was not hired by the *World Telegram–Sun*. Almost immediately *The Art News* appointed him to write a monthly page and until 1955 he continued to contribute opinions and reminiscences. From time to time he wrote a preface to a

successful. He had a clear realization that this was not his métier. "My Matisse book is out," he wrote to Malcolm McAdam, a friend of many years, "and it is terrible. I haven't had the courage to glance at it and it's been in the house four days."[5] The year before he had finished a Matisse essay "in the greatest state of rebellion – for I am an impressionist and I had no new experience to write from. I can't sit at a desk and churn myself into a state of excitement."[6] McBride needed the inspiration of the work of art.

Though he was prophetic in seeing that American art during the decade of the 1930's would gain popularity (and for that he cheered), it took a direction that did not much please him. Determined to be a 100-percenter, he found the proletarian drift of the depression years distasteful. "The determined patriot," as he called himself, was not at home in this drab America. There are contradictions between McBride's taste in art and taste in his pattern of living. Though he resided with Quakerish austerity in one room at the Herald Square Hotel during the season, escaping to the country to a little house he owned in Pennsylvania during the summer, McBride was essentially a conservative in politics and an aristocrat in manner. He had his suits and shirts tailored in London; his shoes were handmade and he enjoyed the social life of New York where he was a welcome guest at the homes of those rich who amused him. In the 1930's he bore down heavily on propaganda in art which he felt was swamping the American scene. True, he could enjoy Grant Wood's "American Gothic" but chiefly as caricature. (Hadn't he written an early article on "The Technical Tendencies of Caricature," illustrated by his friend, Gus Verbeck, the caricaturist?) He tried – during this period – to be fair. Thomas Benton's murals at the Whitney Museum "set his teeth on edge" but he recognized their force. When Ben Shahn showed his series on Sacco and Vanzetti, he acknowledged their validity but disliked their message. His greatest scorn was reserved for Rivera and Orozco. He felt that most of what Rivera had done outside Mexico was "trash" and he dismissed Orozco without, presumably, having seen his murals at Dartmouth.

Frequently McBride was attacked as an "apostate" because

5. Dated February 8, 1930 6. To Gertrude Stein, November 4, 1929

Customs at first refused to allow Brancusi's "Bird in Flight" to enter as sculpture but tried to charge duty on it as raw material. One remains delighted at his reactions to the première of the Gertrude Stein–Virgil Thomson opera, "Four Saints in Three Acts" at Hartford.

Not that he did not have limitations. He was primarily a critic of painting and the graphic arts. With sculpture he was less secure. He failed to rise to Giacometti and he had a peculiar, gallant and somewhat misplaced tenderness toward lady sculptors. The names of Edith Woodman Burroughs and Janet Scudder often appear in the early days of the *Sun*, though he justly ignored Malvina Hoffman. When forced to review a huge exhibition by Miss Hoffman in Virginia, he cannily concentrated on what the ladies were wearing and gossiping about – scarcely mentioning her art.

He had a deep distaste for German Expressionism. Max Beckmann he passionately attacked, finding him an "unentertaining and uninstructive Schopenhauer." At first he considered Vuillard and Bonnard unfit for export. Parisians could appreciate their refinements, but not Americans. Later, during the large Bonnard Exhibition at the Museum of Modern Art, he revised his opinion of this artist upward, discovering more than chic in Bonnard's paintings.

It is evident in studying his writings that the period between 1913 and 1930 was McBride's best. One of his last pieces, a short foreword to an exhibition of *"The Dial and the Dial Collection"* at the Worcester Art Museum in 1959, he titled "Those Were the Days" and it is significant that after 1930, some of the élan and drive are missing in his criticism.

The form in which McBride succeeded best was the short essay or trenchant paragraph. He was first and last a journalist, what the French call a *feuilletoniste*. And he needed the work of art, painting, drawing, print or sculpture as a springboard. There is often a striking difference between the freshly observed pages in the *Sun* and the more formal treatment of the same artists in *The Dial*. The *Sun* pages have a spontaneous and vivacious touch which the more structured articles in *The Dial* lack. When McBride attempted a longer, conventional appraisal, as in his monograph on Florine Stettheimer for her retrospective exhibition at the Museum of Modern Art in 1946 or in his little book on Matisse, published in 1930, he was less

interested in the social stage on which contemporary art was played. Next to seeing how he took to pictures he dearly loved, as he remarked, to see how others took to them. In the *Dial* articles he aimed "to touch upon the highlights of the New York season and to give his readers an echo of the talk and opinions that generate when individuals who have access behind the scenes meet." At one time his page in the *Sun* was headed *What is Happening in the World of Art.*

Wryly he observed visitors at an exhibition of Sert: "The Sert crowds I saw with my own eyes and I can certify that they were indeed immense, richly apparelled and awaited without by motors but in the end as completely flabbergasted by M. Sert's art as though they had not been awaited by motors." By 1924 he found the old-time fury against Picasso abating. It was hard for Americans to vituperate anything for two years in succession and it was doubly difficult for them to see immorality in a good investment. It appeared to him that Picassos were going up. By 1926 he found the crowd at the Tri-National exhibition walking about in a reverend manner. This was too much revering for McBride. It was apparent that modern art had now reached the state when it must be protected from its friends rather than its enemies.

Two years later he found that it now took some courage to oppose the art of the great French modernists and that especially toward Matisse the public's attitude had changed. Therefore he was dismayed at the "discreet" audience being entertained in 1930 by Mr. and Mrs. Arthur Sachs in their apartment "hissing" at lantern slides of pictures by Matisse. McBride's reaction was typical: "It is clear that a little more Matisse work needs to be done this winter." In 1948 at a great Picasso exhibit he found an audience of a totally different kind. On the first day the crowds of visitors were mostly savage young artists who would have liked to be Picasso themselves. Many stood with their backs to the pictures, eyeing the visitors menacingly. McBride got the impression if anybody said anything, he would be rigorously pounced upon. But he couldn't decide if it was envy, defense of the movement or a failure to understand the pictures that made them so belligerent. He certainly found anger in the air.

What a valuable account of changing American taste comments like these provide and what lively bits of reporting are McBride's columns on the Brancusi case where the U.S.

somehow, the air of one of Duchamp's "ready-mades."[4] The
effect of this jumble of articles is not altogether happy. There
is considerable repetition and good things are lost in the
design of the publication, which, in reproducing McBride's
actual newspaper columns, makes reading difficult. As propa-
ganda for modern art it was undoubtedly astute.

Part of McBride's significance today lies in his early
recognition of talent. His writings should be read in relation
to the years when they were first published. For this reason,
I have arranged them chronologically in this volume. It was
not enough for him to expound the virtues of Matisse, Picasso
and Braque. He chose to defend Léger, for many a difficult
artist, and from the first he championed Stieglitz and his group,
particularly Marin, Demuth and Georgia O'Keeffe. He under-
stood Max Weber's gifts and deplored his unpopularity. In
1928 he saw his first Mirós and was immediately converted.
He spotted Gorky at his original New York showing. From
Hopper's first etching exhibit he understood that artist's quali-
ties ("composed with a sense of dramatic possibilities of
ordinary materials"). Mark Tobey, Eli Nadelman, Stuart Davis,
Joseph Stella – these and many others were quickly identified
as significant. Of course, McBride was not the only writer
on art in America to favor modernism. Charles H. Caffin,
Sadaikichi Hartmann, Frederick James Gregg and Forbes Wat-
son, among others, stoutly attacked American provincialism
and wrote warmly of modern artists abroad and at home. But
as one turns the yellowing pages of the *Sun*, one is struck by
the absolute rightness of many of McBride's judgments. In
1913, poking about the "morgue," that poorly lighted back
room at the National Academy, he came upon his first portrait
by Thomas Eakins. By 1917 he was proclaiming the painter
of "The Gross Clinic" as one of the four greatest artists America
had produced and in 1923 he put Eakins first in figure paint-
ing. Once it had been Sargent, with Whistler a close second,
but his pleasure in Whistler had evaporated. Beside Eakins,
Sargent now seemed "paltry."

There is another dimension to McBride's criticism beyond
that of spotting – and defending – new talent. He was deeply

4. *Some French Moderns Says McBride*, selected by Marcel Du-
champ, 200 numbered copies. The artists included are: Cézanne, Rodin,
Brancusi, Matisse, Dufy, Signac, Segonzac, Gleizes, Villon, Duchamp,
Gauguin, Picasso, Picabia, Van Gogh, Derain and Marie Laurencin.
(*Société Anonyme*)

which he took to his friend, Frank Crowninshield, the lively editor of *Vanity Fair*. Crowninshield decided to publish it and it appeared in the June issue.[3] It was said (McBride never denied it) to be a portrait of McBride, himself. It seems to have been the first serious publication in an American magazine of any of Stein's work.

An invitation to join the staff of *The Dial* in 1920 made by its two young editors, Scofield Thayer and James Sibley Watson, allowed McBride to write a monthly essay on modern art. Both Thayer and Watson were crusaders. They bought up the assets of the old *Dial* (which had started out in the 1840's as the organ of the Transcendentalists, edited by Margaret Fuller and Ralph Waldo Emerson, and more lately had turned into a political and social review). They transformed it into a magazine devoted exclusively to "the best in all the arts." This meant "the best in both the accepted and unconventional forms of expression without prejudice to either." The new and old in America were to be placed next to the new and old produced abroad. For nine years *The Dial*, in its handsome format designed by Bruce Rogers, combined some of the best of contemporary literature with reproductions and criticism of contemporary art. McBride was not the only writer on art. Roger Fry, wisest of the formalist critics, and Thomas Craven, heavy-handed and often opaque, were occasional contributors but only McBride was given a monthly spot in this publication.

Taste in America was broadening. After the end of the First World War, a new tolerance towards modernity in the arts was apparent. The old isolationism in culture was disappearing. There was curiosity and even satisfaction with the new and foreign. In painting this meant catching up with masters like Cézanne and Van Gogh and Seurat and reporting on what was going on in Paris at the moment. The *Société Anonyme*, captained by the resolute Katherine Drier and advised by that international superstar, Marcel Duchamp, not only collected fascinating samples of "the new tendencies" but was on the alert for any defense of modern art. In 1923 a group of McBride's articles in the Sun from 1915–1922 were gathered into a publication by Duchamp who designed, as well, its eccentric format, a type of loose-leaf notebook, which has,

3. Vol. 8, no. 4, p. 55. Thirty-five lines were omitted in this publication. Later the entire piece was reprinted in a little pamphlet with a cover from a design by Pascin, a portrait of McBride

taste, without the faculty of selection, without vision, culture —
one is tempted to add intellect . . ."[2]

Samuel Swift resigned and McBride was promoted — but
anonymously. At first his articles ran without a by-line. Then,
by a curious quirk of fate, a typesetter included his name
and from then on the page was signed. In the first article
published under his name he took up where Huneker had
left off. The Metropolitan Museum had purchased a mild
Cézanne, "La Colline des Pauvres" from the Armory Show and
McBride devoted a long understanding column to the artist.
As the furor over Cubism continued, he made gentle fun of
the senseless battle. Admitting that he had known little of the
movement before the recent exhibit, he solemnly reported the
hysterical outpourings of Kenyon Cox in Philadelphia and
followed Cox by printing a little piece by Gertrude Stein.

Without planning it — or recognizing it for some time —
the *Sun* had acquired a critic who would soon become known
as perhaps the leading journalist to write winningly, as well
as convincingly, on modern art. McBride handled a host of
other exhibitions: old masters, Persian miniatures, medieval
sculpture, nineteenth-century etchings, the menu is long and
varied but his emphasis on contemporary painting is consis-
tent. In some ways he was ideally fitted for the job. He had a
direct pipeline to Paris where modern art had been born and
was flourishing. Gertrude Stein put him in touch with Picasso,
Braque and Juan Gris. He was in Paris when the war broke
out and managed to get back to New York at the end of
August, 1914. He returned to Paris in 1915 for two months,
June and July, as a war correspondent for the *Sun* and met,
among others, Raoul Dufy. Luncheon with Dufy, on leave from
the front, is revealingly set down in one of his lengthier col-
umns. Besides painting, McBride was familiar with other
avant-garde experiments. He knew — and corresponded with —
Guillaume Apollinaire, the poet, an early enthusiast of Cubism,
and read widely in contemporary French letters. He attended
concerts of "new" music and "new" ballets and plays by young
playwrights. By 1915 when *Vanity Fair* published its honor role
of eight established American art critics, McBride was among
them, no small recognition for one who had entered the field
only two years before. In 1917, McBride received from Ger-
trude Stein a poem, "Have They Attacked Mary. He Giggled,"

2. London, 1910, p. 4

through England, Belgium, Holland, Germany, Spain and North Africa. In 1907 he met the Bernard Berensons in Florence. He dined with the brilliant critic of Italian painting and took a special liking to Mary Berenson, his wife. In 1910 he was taken by Roger Fry and Bryson Burroughs to visit Matisse in his studio. As a child he had no doubt that the greatest picture in the world was Raphael's "Transfiguration." Now coming across the painting in Rome – years later – he was astonished at his feeble interest in the original. It was probably at that psychological moment he felt that he became an art critic.

All these experiences of travel and contact with personalities in the art world prepared him for the role of a newspaper reviewer in New York in the fateful year of 1913. In February, soon after McBride was hired by the *Sun*, there opened at the 69th Regiment of Infantry building, the notorious Armory Show. Organized by the Association of American Painters and Sculptors, it started as a worthy attempt to acquaint the city with some of the new experiments in European art along with works by American artists of liberal tendencies. Arthur B. Davies, Walter Pach and Walt Kuhn were among its organizers and before they knew it, they had assembled a vast display of violent and exciting importations from the Continent. This European section became the Trojan horse of the Armory Show. Here by comparison, the Americans appeared timid and provincial. Modern art had come to America with a vengeance and the public was shocked and horrified. Marcel Duchamp's "Nude Descending a Staircase" was surrounded by laughing or furious visitors and even Theodore Roosevelt was heard to mutter something about "the lunatic fringe."

During this art scandal the *Sun* kept fairly cool. In the articles which McBride contributed (then unsigned) along with those of his friend and chief critic of the art page, Samuel Swift, the tone is moderate and informative. Until recently the paper had enjoyed a notable writer on art, James Huneker. Primarily a music critic, Huneker also concerned himself with literature and painting and in 1910 had published a volume, *Promenades of an Impressionist* in which his admiration for Degas and Monet and Renoir were cogently expressed. But Huneker had balked at Cézanne, "crude, ugly and bizarre canvases . . . the results of a hard-laboring painter without

ham and his crew of eclectic architects had spread before the astonished gaze of Mid-Westerners. Amid the acres of academic painting he undoubtedly noted the brisk canvases of Zorn (local critics dismissed them as "loose" — almost a moralistic judgment) and dazzling portraits by Sargent. Did he venture into the Women's Building with its strung-out mural by Mary Cassatt and did he pause before Louis Sullivan's golden Transportation Pavillion, the one piece of original architecture in the Fair? He did become entranced with Javanese art and he did save money, about three hundred dollars, put aside to visit Europe the next year.

His first trip to Paris at the age of twenty-seven was to be one of many. Out of them came an early article on Puvis de Chavannes. He was now teaching at the Artist and Artisans Institute but pay was small and he tried his hand at writing. Rejections and some slight success. McBride practiced literary skills through an art almost forgotten today — letter writing. Abroad he wrote to his kin in Pennsylvania and to a few devoted friends. His style was easy, his interests wide and from the first his word pictures of places and people showed a trenchant sense of humor.

In 1900 he joined the staff of The Educational Alliance, a lower East Side settlement house. There he taught among others, Walkowitz, Samuel Halpert, Jacob Epstein and an "unruly" boy of twelve who was to become the sculptor, Jo Davidson. His interest in the poor of New York may have reflected his Quaker's conscience. At least it furnished him copy, sometimes accompanied by his own sketches for a stray article in a magazine or newspaper. Now in 1901, the Director of the School of Industrial Art in Trenton, he wrote his first serious criticism of painting on two pictures by Manet in the Metropolitan Museum.[1] In it he frankly admitted that he could not explain why Manet's "Girl with a Parrot" should be admired but that he admired it all the same.

During these early years McBride was broadening his horizon. A strong admirer of Ralph Waldo Emerson he practiced his own brand of self-reliance. He taught himself to read and speak French. He devoured novels, philosophy, poetry, history, belles-lettres. He went constantly to the theatre and to opera. Making repeated trips abroad, he walked and sketched

1. "The Two Paintings by Manet at the Metropolitan Museum," *Alliance Review*, Vol. I (No. 1, April)

Introduction

THE ART CRITICISM OF

HENRY McBRIDE

IN 1913 when Henry McBride climbed the two flights of wooden stairs in the old building on Park Row to take a job on *The New York Sun*, he was forty-six years old. So far he had done little writing on art. Born in Westchester, Pennsylvania, he came from Scottish and native American stock. His family were Quakers and he was brought up frugally. His first employment, at the age of about eighteen, was in a local nursery. Significantly, this job displayed two of his talents. He could draw and he could use words and soon he was illustrating seed catalogues and writing copy and characteristically saving money to study art. In 1889 he came to New York with two hundred dollars and enrolled in the Artists and Artisans Institute. Its superintendent was a somewhat advanced figure for his day, Professor John Ward Stimson. Stimson stressed not only drawing and painting but design in the nineteenth-century meaning of the word — applied pattern, tying in with the traditions of Ruskin and William Morris. More important, he tried to instill a sense of independence and excitement into his students. His teaching on color was ahead of his time as was his unacademic insistence on the connection of art with life. McBride was an apt pupil and in 1892 received an enthusiastic testimonial letter from Professor Stimson.

Summers, McBride spent in Pennsylvania with his relatives, walking the Brandywine Valley, painting and sketching. He was always to have this need for nature, a desire to get out of the city from time to time and return to the landscape where he was born.

In 1893 the World's Columbian Exposition burst upon the country. McBride travelled to Chicago and saw the "City White," that plaster extravaganza on the Midway which Burn-

I'd like to be acknowledged and have my books on the bookshelves like other writers.' At a time when no one else in England thought much of William Blake, Charles Lamb said: 'But there is really something great in "Tiger, Tiger burning bright." ' The six people who believed in Shelley, the six who believed in Gertrude, the six who believed in Blake have all had followers. The first step in acquiring fame is to obtain the six believers. . . .

"What Plato thought you can think." Certainly: as soon as Plato thinks it, but in the time afterwards taken to think it, too, — lies the tragedy. The battle against the time-lag in appreciation of arts and letters has been one of the big actions of our anxious epoch. A tuck in time, we tell ourselves, might have made Shelley an old man, made Blake's hell easier, stopped Van Gogh from gunshot or Lachaise from fatal frustration, made Nadelman appreciated in his fullness, or Eakins at the end of his long life. Today, as never before, museums and dealers do their busy, useful work, almost as if they were making up in guilt, for lost time. But Time still remains unimpressed and allows its own disinterested time to be taken. Artists who are hopefully 'discovered' rarely make up for those who are forgotten or remain to be uncovered, or set in their true stature. Today it is still easier to have six hundred, or six hundred thousand people admire a peripheral personality than to have six poets or critics define the figure, estimate it, fix it, as did Heine and Baudelaire, for Time's ultimate acceptance. For forty years Henry McBride has been one of the half dozen serious writers in America who has humorously drawn time's attention to half a dozen serious artists.

* Courtesy of Collection of American Literature, Beinecke Rare Book and Manuscript Library, Yale University.

cane, Marin's lower Manhattan skyscrapers and the international tennis matches at Seabright, New Jersey, since McBride was passionately interested in the game and particularly admired the *trois mousquetaires,* Cochet, Borotra and Lacoste. As for Thomson, McBride had written Gertrude Stein (May 20, 1929), on hearing the first audition of *Four Saints in Three Acts,* which had taken place in the Stettheimer studio, adorned with Nottingham lace and silver lilies which would become incorporated into the magnificent scenic investiture of the opera five years later:

But young Virgil Thomson really is a wonder. I never saw such self-possession in an American before. He is absolutely unbeatable by circumstance. When singing some of the opera to me he was constantly interrupted but never to his dis-ease. He would stop, shout some directions to the servant, and then resume, absolutely on pitch and in time. We all pray that the opera will be given. . . .*

Mr. Thomson is famous for his musical renderings of his friend's psychological characteristics. When Mr. McBride went to pose, in the ample salon of Mrs. Kirk Askew's in the East Sixties (in the mid Thirties), Thomson placed him in a comfortable chair. McBride took a book, commenced to read, silently. "Perhaps Virgil would like to have been interrupted, but I didn't." At the end of the portrait there is a brilliant tennis game, perhaps a reference to the Seabright matches in the Stettheimer picture. When McBride was played the finale, which enchanted him, he said: "Evidently, I won the game." Replied the composer, "You certainly did."

Mr. McBride closed his tribute to Florine Stettheimer in the catalogue of her memorial show at the Museum of Modern Art in 1946, with these words:

Now what pleases the 'discerning few' can please the general if the general be given a chance at it. In art, as in religion, the public finally arrives at the true values. You remember in *The Brothers Karamazoff* the old priest's dying admonition to the younger men: 'Give them the Bible. Do not think they will not understand.' Nothing that is worth while is above the public comprehension. There are no closed doors to opinion and certainly there is no class distinction in thought. 'What Plato has thought you can think. Shelley told one of his friends that he 'wrote for only six people,' Gertrude Stein told me personally in 1914, 'but

produce polemic, at others caricature, but rarely fine painting. Diego Rivera, the weakest of the famous Mexicans of the Thirties, but at the time the first to be well-known here, painted some cursory frescoes of a portable and ephemeral nature at the time of his show at the Museum of Modern Art. One showed a flop-house over a bank-vault. Wrote Mr. Mc-Bride in February 1932:

I believe I am as horrified as any man at the thought of the discomforts of the poor, but I don't seem to be outraged with the city's attempt to give them a shelter for the night. I am not at any rate outraged by Rivera's documents. They seem unofficial and second-hand. They seem to be the fruit of too much reading in the communist newspapers in the railroad train on the way up — a preconceived notion of "seeing New York" rather than a matter of personal observation. And New York, like Mexico can only be properly shown up by some one who has it in his blood. . . .

I admit that it is not as thematic pictorially as it might be, yet just the same, our life has its moments. How electrified we might have been, had Rivera chosen instead to do a fresco of our handsome Mayor Walker hurling defiances at the Seabury Committee from a cactus garden in California . . . or Miss Belle Livingstone triumphantly receiving her friends after a month's stay in jail for the most popular infringement of the law that we have.

Robert Chanler had just died, and with him a whole chapter of frontiersman flamboyance in American Bohemia. McBride wrote a generous epitaph, defending Sheriff Bob's famous, or infamous all-night routs on East 19th Street.

It is not so much that artists are to be immune to the law, like the ancient aristocracy of England, but that they can only arrange their systems of values in a state that gives them complete liberty. Artists approach morality through beauty, and if they are good artists find both; but people who have no eyes for beauty are incapable of judging their processes until, as I have pointed out, history has enabled them to take a more generous attitude. My present argument is simply this: why should you postpone generosity to artists since you must yield it in the end?

Robert Chanler painted McBride's portrait (now lost) and others who had him pose, besides Pascin and Lachaise, were Florine Stettheimer and Virgil Thomson. Miss Stettheimer indicated for a background palms in a Winslow Homer hurri-

. . . Mr. McBride, beyond contradiction is a moralist. He might deny it, although he has cheerfully acknowledged himself a sentimentalist, which he is not. It is not only his sense of humor that imperils our understanding of his moral outlook. It is even more the fact that his own understanding of morality is more penetrating than most that find their way into the periodicals of the day, especially those that deal with art. . . .

Mr. McBride, in "The Palette Knife" editorial section of *Creative Art* made his attitude towards morality quite clear, although it always remained implicit. It would be illuminated in little bursts, as exemplary notices of passing events, but his system was as orderly as a philosopher's, and when his scattered writings are brought together they could easily be grouped under the headings of: The Critic, The Artist, the Public (or Society). In December 1931, he wrote:

It may be an unpleasant fact, but it is a fact nevertheless that fifty years hence but a scant half-dozen of our living artists will be remembered with interest. It is a museum's first task and a contemporary critic's first task to be as right as possible about these half-dozen representative artists. . . . The gift of prophecy is not an endowment of the expert. Expertism operates on the past, not on the future. Prophets and seers are apt to be fakey and I believe the police are quite right in chasing them from our midst.

And he was rarely afraid to formulate a careful, light but nevertheless, when read aright with the full knowledge of his habitual courtesy, crushing judgment on influential individuals, with the full realization that he was exposing, first and foremost, himself. In April, 1931, even in the respectful atmosphere of *nil nisi bonum*, he could say:

The thought of Ruskin's error (in the case vs. Whistler) is enough to stay any critic's hand, but *que voulez vous?* — the moral of that affair was this: that it is the people who decide; and so I am fortified to put another unpleasant question up to the people. It becomes my painful duty to confess that, in my opinion, the memorial show to the work of the late Robert Henri at the Metropolitan Museum is not a triumph.

Nor was he easily taken in by the perennial dilution of art by the pressure of extraneous events, which sometimes

and penetration that it made him proud that he belonged to his profession.

And naturally day in and day out, week in and week out, year in and year out, all art-events were not of the same high interest. He would patiently write in *The Dial*, January 1923:

> The passions were not excited by the art shows of December (1922). There seemed to be no occasion to send a telegram to Charlie Demuth, at Lancaster, Pa.: "Mustn't Miss It. Come At Once," except possibly in the case of his own show at Daniel's and that of course he had seen already.

Demuth was a particular friend and favorite. McBride wrote often of him, perhaps never so suitably as in *Creative Art*, September 1929:

> The fuzzy bloom of the peach, the glittering polish of the aubergine, the controlled richness of the opulent zinnias, all these and other such splendours from the vegetable world inform the new Demuth water-colours with a style that it rejoices one to see appreciated.

McBride eventually assumed the editorship of *Creative Art*, which at first had been little more than an American supplement for the London *Studio*. He followed Lee Simonson, and in taking over his new duties, wrote to an audience already familiar with his "Palette Knife" praising Simonson as "a reformer," but making a personal distinction. He himself was no reformer:

> I like the world far too well to wish it changed in any of its essentials. But if I work on one principle more distinctly than another it is aiming at frankness rather than infallibility. "Being right" is lovely but it is not a condition that even a critic arrives at unaided. His chief business when confronted by a new problem is to think it out as best he may and then entrust it fearlessly to the public that in the end is the true arbiter of values.

While disclaiming the ambitions of a reformer and always preferring an almost anonymous and rambling easy tone, underneath it all there is always a seriousness masked by a modest mockery. Elizabeth Luther Cary noted this best of anyone in her appreciation of Mr. McBride when he retired from *Creative Art*, due to ill-health in December 1932.

the word 'art,') but to recall photographs to the essential powers of the camera as he has done is a great deal.

Of John Marin, and the violent initial reaction to his early and greatest watercolours McBride wrote in March, 1922, part praise and part prophecy.

The antagonism to Marin is the more curious in that, strictly speaking, he is not an innovator. He seems to grow more and more abstract as he grows older, but he is not the first to be abstract nor is it the fact that he is abstract that makes him notable. First and foremost he is a poet who is stirred at times to emotional heights.

In April 1922, he described the show of Brancusi at Brummer's with lapidary grace.

A head in this collection and a hand, both evidently late 'releases,' have the air at first glance, of having been polished by the sands beneath the sea for ages, like certain antiques that have been rescued from ancient waters with surface details polished off, but all the essential virtues intact. There is something ineffably precious and tender about these pieces and the workmanship in them is beyond anything hitherto encountered.

In Paris once, Marcel Duchamp and Madame Picabia were taking McBride to dine *chez* Brancusi, whose reputation as a chef only equalled that of his stonecutting. But McBride felt sick, unto death, and begged off. Duchamp said: "You'd better come along; you can die any time." Cured by Brancusi's cuisine, McBride remarked that he, too, had his two or three specialités. "Oui," said Brancusi, "comme les artistes modernes."

Lachaise, McBride had first admired at the Bourgeois Galleries in 1918, particularly in the large figure of a man holding a woman in his arms, which the sculptor destroyed in plaster, in discouragement as the perennial difficulties he had, even maintaining a permanent studio. Later Lachaise did McBride's bust, in gratitude, and every year, in spite of Lachaise's extreme penury, he and his wife invited McBride to a ritual dinner at the Lafayette, afterwards repairing to Madame Lachaise's apartment for hours of talk, which the critic still recalls as so exalted, on such a lofty plane of abstraction

You may have premonitions but Mr. McBride has the data, is succinct and matter-of-fact, — be your investigations in what field they may —: houses, furniture, dress, printing, painting, dancing, music, verse, sculpture; the camera, movies, the drama. Wit that is mentality does not betray itself and Henry McBride is adamant to the friend of a friend desiring encomiums.

He is not susceptible to self-eulogy. Where feeling is deep it is not a topic. Reverence that is reverence is a manifestation, as has never been proved better than by Mr. McBride.

Running through the bound volumes of *The Dial* today, it is difficult to realize that thirty years have passed. McBride's articles for the first three years alone give vital indication of the bearing of his mind and eye (entirely apart from his weekly stint on The *Sun*). For August 1920 there is a striking appreciation of Elie Nadelman's sculpture; together with Martin Birnbaum of Scott & Fowles, he was the first American critic to estimate this great artist at his just value. For September there was a delicious disagreement (and agreement) with Plato; for October, a fair statement of Gauguin's rebirth; for November, a subtle critique of The American Shyness (or Henry James and American portraiture; how James was what Sargent was not). For December, he wrote in words which only this year acquire the full measure of their modest irony, on the occasion of the first Van Gogh show in America (at Montross):

It does not now appear likely that the Metropolitan Museum will ever own as representative a group of his paintings as it does, say, of Manet.

In March, 1921 there was a splendid description of Rousseau's "Sleeping Gypsy." He had already long been the friend and admirer of Hartley, Demuth and Marin. Stieglitz said later that it was McBride who put Marin "on the map." With admirable restraint McBride wrote of Stieglitz (April, 1921):

To say that Stieglitz portraits go beyond, or even come up to the wonderful daguerreotype portraits taken by Lewis Carroll (the Alice-in-Wonderland Carroll) in the early days of the art, would perhaps be to say too much, (I myself have not given up the use of

with wonderfully complete information, amiability, and good sense. As we found out later he was and is the most unegotistical of writers; if he sometimes lost patience with the *Dial* management, they never knew it.

I remember the interview when Schofield (Thayer) made Mr. McBride one of his elaborately persuasive editorial propositions. It needed to be elaborate, for as it turned out we were asking him to find time to write for us every month for nearly ten years. The editors never stopped congratulating one another on his having accepted.

Mr. McBride's first article (July), covered the Walter Arensberg collection of classic cubist masters, as classics, even though they were then only installed in an apartment on West 67th Street, where he went with Marcel Duchamp. He also added a charming story of Albert Ryder and Kahlil Gibran; he noted in William Gropper here at last was one American cartoonist who looked better in reproduction than in his originals; hence his success. McBride's informal, informative, yet carefully conceived *Dial* articles remain unmatched in this country for their charm, perception and urbanity. They should be collected (together with others from *The Sun, The Arts* and *Creative Art*) to instruct a generation which has not known the rewards of courage and cultivation. Miss Marianne Moore, *The Dial's* ultimate editor, has described the magazine's attachment to McBride with her unique, though perennial precision and gusto:

With regard to Mr. McBride and his Modern Art commentary in *The Dial*, mere fact in the way of editorial gratitude has the look of extravagance. It is hard to credit Mr. McBride's innate considerateness as synonymous with his unfailing afflatus, thought so substantial as coincident with gaiety, and so wide a range of authority as matched by ultra-accuracy.

Each month, usually in the morning, Mr. McBride would bring his three pages of Modern Art commentary to *The Dial*, visit without hurry, but briefly, and infect routine with a savor of hieratic competence. The word 'competent' may have connotations of mildness, but not in this connection. Mr. McBride and insight are synonymous. You may have gone to the fair and come away with a gross of green glasses but not Mr. McBride. As he said of Elie Nadelman: "Directly in proportion to the vitality of an artist's work is the reluctance of the public to accept it."

of the great popular patriotic successes of the day. The ladies considered the war in a fiercely proprietary fashion; although McBride was long past military age, and America was not yet in the war his presence in Paris, out of uniform rankled them, and this, too, emerges from the portrait. But McBride was philosophical, even about his friends, and wrote of war and patriotism in his note on Claggett Wilson's battle pictures, in 1928.

> . . . as an American critic of art I have objected strenuously to foreignness in our native artists. . . . Yet just the same I make exceptions. When it appears to be "plus fort que moi" I have nothing to say. I have never thought it worth while to point the finger of scorn, for instance, at Mary Cassatt or Walter Gay, both of whom gave themselves up into such an wholesale admiration of the French that the French ended in claiming them to belong to French schools. They took their "bien," like Molière, where they found it and with a vengeance.
> . . . At the same time he (Claggett Wilson) fought with the American forces; and the soldiers in his drawings are our soldiers and this is "our" record of it. If there is anomaly here, make the most of it. For my part, I prefer to side-step, for twenty years or so at least, all these questions pertaining to the exact ratio of innate patriotisms. According to the slang of the day, one is either one hundred per cent or one is not one hundred per cent. There are no gradations, so they say at present, yet "they" are often wrong and probably are in this matter. At all events, it is one of those things that the future decides, like the Germanism of the Heine who lived in Paris years ago, and which has now been arranged to the satisfaction of all concerned. Probably Claggett Wilson found himself in the war as Heine found himself in Paris — with mixed feelings. It was just this equal balance between the "for" and the "against" that is responsible for his tinge of Spanish. . . .

In 1920, McBride became the art critic on *The Dial*, which had been recently bought and entirely reorganized by Schofield Thayer and Dr. James Sibley Watson. For nine years *The Dial* would maintain a distinction of artistic and literary values unequalled in America, before or since. Dr. Watson recalls the association:

> In 1920 when we had the happy thought of asking Mr. McBride to be our chronicler of modern art, his critical writings in the New York *Sun* were much admired and had been for some time. They revealed a spontaneous gift for gentle kidding, together

The friendship with Gertrude Stein, dating from 1913, was the occasion of a full and charming correspondence, fortunately preserved in the Collection of American Literature in the Yale University Library.* In 1916, Miss Stein composed *Have They Attacked Mary. He Giggled.* (A Political Caricature). It was first printed by the late Frank Crowninshield, editor, in *Vanity Fair* (June, 1917). He had been introduced to Miss Stein's writing by McBride. For reasons of space, thirty-five lines were omitted. It was later reprinted, complete, as a pamphlet, with a woodblock frontispiece, a portrait of McBride, by his friend, the painter Jules Pascin. A note stated:

It has been referred to as a 'portrait' of Henry McBride, art critic. It is in fact a genre picture and Mr. McBride is but one of the personages.

In *Have They Attacked Mary*, each paragraph is given a page numbering, thus:

page xxv
What can you do.
I can answer any question.
Very well answer this.
Who is Mr. McBride.

page xxxi
I cannot destroy blandishments.
This is not the word you meant to use. I meant to say that being indeed cônvinced of the necessity of seeing them swim I believe in their following. Do you believe in their following.

page xxxii
Can you think in meaning to sell well. We can all think separately. Can you think in meaning to be chequered. I can answer for the news. Of course you can answer for the news.

page xlii
You say he is that sort of a person. He has been here again. And asked about pitchers.

This indeed was a genre picture, a portmanteau composition of picture-dealing, art manipulation, the salon world of Miss Stein's domesticated power-politics during the first World War. The other personages were Miss Stein and her friend Mildred Aldrich, author of *A Hilltop on the Marne,* one

fined a spiritual dandyism, and could surprise magic out of the ordinary in rehabilitating the commonplace, McBride became the friend of poets and painters. He met Gertrude Stein through Mrs. Bryson Burroughs, and as early as 1913 suggested that Miss Stein's peculiar plays (in prose ? in verse ? in what ?), be publicly performed. He tried to have the actress Minnie Ashley (Mrs. William Astor Chanler) perform them in New York. He told Miss Stein that they were rather static, and could be improved by a stage-direction imitating the poses in stained-glass windows. The poet agreed. McBride's idea was prophetic of the hieratic production of *Four Saints in Three Acts* many years later. The New York production did not come through; McBride then suggested they be done at the San Francisco World's Fair of 1915. He wrote her August 28, 1913:

> The San Franciscans would love to be up to date, or a little ahead of it. Like my friend Mr. Polk (the Fair's Commissioner), I should like to keep up, too. . . .*

He counted on Miss Stein in Paris to keep him informed of developments for New York, from where he wrote her on December 12, 1913:

> I hoped to keep your good opinion and I was afraid you might not, after all, know me well enough to allow me to be both gay and serious at the same time. In this country of rural pedagogues and long-faced parsons, to laugh at all is to be thought frivolous. I laugh a great deal (so do you). I laugh like an infant at what pleases me. Americans as a rule laugh bitterly, at what they hate, or at what they consider misplaced.

Gertrude Stein prevailed upon Ambroise Vollard to send McBride his big life of Cézanne. In her *Autobiography of Alice B. Toklas* she acknowledged the service:

> There were Cézanne's to be seen at Vollard's. Later on Gertrude Stein wrote a poem called Vollard and Cézanne, and Henry Mc-Bride printed it in the New York *Sun*. This was the first fugitive piece of Gertrude Stein to be so printed and it gave both her and Vollard a great deal of pleasure.
>
> McBride also devoted a large Sunday article to the Vollard biography, and much of our local general interest in and influence of the Master of Aix dates from this notice.

Swift and Mr. Reick, who was then *The Sun*'s owner, disagreed about something and suddenly, and in spite of Mr. Lord's warning, I was obliged, as Frank Sullivan would say, to shift my brow 'into high.' I was left in command of the department and made responsible for the activities of about a hundred art galleries. It was then that the calendar speeded up and the whole week melted into a succession of Thursdays.

However, for two years, McBride's notices remained unsigned. Then, for no apparent reason except that a copy-boy attached his already familiar name to some copy, or forgot to remove it before handing it to the press, upon returning from Europe to his winter's duties, he found that he had acquired a by-line, which has, in the subsequent thirty years become as familiar as many metropolitan landmarks.

Mr. McBride was involved in the progressive movements of his epoch long before they had been (in Auden's phrase), tidied into history. In 1913, for example, he pounced on a portrait by Thomas Eakins in the 'morgue' of the National Academy, a small room chiefly dedicated to failures. His enthusiastic discussions of this picture with Bryson Burroughs (an intimate friend), had much to do with encouraging him in undertaking the large Eakins retrospective show at the Metropolitan which, of course, was the starting point of Eakins' modern fame. McBride was perhaps the first critic to call Eakins "great," at first causing some dismay among his Philadelphia friends. He wrote at the time of the Metropolitan exhibition in *The Sun,* 1917:

> Eakins is one of the three or four great artists this country has produced, and his masterpiece, the portrait of Dr. Gross, is not only one of the greatest pictures to have been produced in America but one of the greatest pictures of modern times anywhere.

In February, 1922 in his regular *Dial* commentary, McBride compared Eakins with Melville, an astute judgment (made on the heels of the first complete Constable edition and Raymond Weaver's pioneer biography). His reference and correspondences ranged far, like those of his critical masters, Heinrich Heine and Charles Baudelaire, two great poets whose records of the annual Salons of the mid-nineteenth century (together with Ruskin), mark the peak of modern art-criticism. And like Heine and Baudelaire, both of whom de-

as painter, he inaugurated the Art Department of the Educational Alliance at East Broadway and Jefferson Street, which he directed, as well as teaching life-drawing, for five years. At the same time he was the Director of the School of Industrial Arts in Trenton, New Jersey, where he worked three days a week, during the same period.

I recall an incident connected with my work (at the Educational Alliance), which may interest you (Mr. McBride wrote in an autobiographical sketch for the *Sun* in 1931). This was my meeting with the late Andrew Carnegie. The iron-master had been inveigled into the building in the hope that he might become interested in the work and possibly contribute to its maintenance. In the course of his inspection he was brought to my 'life-class,' and asked me what the students hoped to be. I answered that all sought professional careers. Suddenly, and to my surprise, the great Andrew pointed to one of the men and said: "That one. What does he expect to be?" And I replied: "He is already an exhibiting artist in the galleries up town." He had pointed to Jo Davidson, thus again justifying the Carnegie reputation for picking talent!

Among others that McBride taught in these days were the painters Samuel Halpert and Abraham Walkowitz, but after five years he was driven to feel that, by and large, at this state of our historical development, although many Americans possessed talent, few had drive. He stopped teaching and passed much time abroad, mainly in England, France and Italy, where he began to consider writing as a profession. He actually came to be an art-critic in a roundabout way.

Sometimes it seems only yesterday (this in 1931) that I climbed the two flights of wooden stairs in the Old *Sun* building on Park Row to interview Chester Lord and seal the agreement between us. I account for the difference between real and apparent time by the swiftness with which Thursdays (press-days) reappear. Thursdays follow each other just like minutes in the lives of ordinary people. It was their extraordinary frequency that first gave me an inkling of what Prof. Einstein's relativity was all about. If you have any doubts about that theory, try art criticisms for a year or two and it will become clear to you.

Mr. Lord's instructions to me were comparatively simple. About all he said to me was: 'Don't be highbrow.' The late Samuel Swift and I had followed James Huneker in the art department, and it was Mr. Swift who was to be highbrow and I was merely the humble assistant. But during that first winter (1913), Mr.

A QUASI-PREFACE

HENRY McBRIDE

BY *Lincoln Kirstein*

ANY ATTEMPT to equate a man's taste, the quality of his imagination, the extent of his influence, in visual terms, must fail. Assuming that one could borrow all the pictures and sculpture he particularly liked, even pictures and sculpture of exceptional merit, the objects themselves remain disinterestedly beautiful and seem to have no special connection with one man's position except that (like many others), he loved them. But when one looks at the objects and thinks of the particular man in terms of time, a connection grows. Understood as objects chosen by their early, and in this country, often their initial, champion, something of his position emerges. Something, but something only. For the valuable position of Henry McBride as critic depends upon his persistence in time, and his insistence over extended time on certain elements of freshness, elegance and humanity which are exemplified in the works of art arranged here in his honor.

He was born in West Chester, Pennsylvania in 1867. After graduating from local public schools, he illustrated seed-catalogues for the George Achelis Nurseries. This was scarcely inspiring and he came to New York to study at the Artists and Artisans Institute under John Ward Stimson, an erratic teacher, but something of a provincial genius. Stimson was an early American admirer of William Blake, an enemy of John Sargent and both Academies, National and Royal. Later, McBride worked at the Art Students League. After his formal training

This essay is reprinted with the kind permission of Mr. Kirstein and the Knoedler Galleries. It was written as an Introduction to the catalog of an exhibition made by the Galleries in 1947 honoring Mr. McBride.

3

THE FLOW OF ART

his appeal, moreover, that he wrote about such matters in a style that was always engaging, often witty, and never petty or pompous. His prose tended, indeed, to be conversational and anecdotal, yet it always served a serious purpose: to illuminate the aesthetic qualities of an art about which educated opinion in America otherwise remained in a state of bewilderment.

McBride's relaxed, personal style in writing about difficult artistic issues is still another thing, of course, that distinguishes his criticism from late-twentieth-century critical practice. Arcane theories of art were never much of a temptation for McBride. He seems to have weathered the storms of Freudian, Marxian, and Existentialist influence with his common sense intact and his commonsensical style unburdened by obfuscating distractions. He took his cues from the studio talk and the café conversation of the artists he admired, and his criticism thus reflects a close personal acquaintance with a good many of the leading European and American artists of his time. He was as much at home in Gertrude Stein's Paris salon as he was at Florine Stettheimer's Manhattan soirées. He was in regular attendance at Serge Diaghilev's Ballets Russes and Alfred Stieglitz's "291," and he lived to have an informed opinion about the work of Jackson Pollock. He knew everyone and went everywhere. He never set himself up as a dictator of taste, a role that would have appalled both his sense of intellectual modesty and his robust sense of humor. What he accomplished was something more important, however, and his writings now form for us—his posterity—a personal and remarkably perspicacious chronicle of the artistic life of his time, a period when modernism in the arts was tracing its historic course from a coterie interest to that of a mainstream cultural force.

It was yet another of McBride's distinctions that in the performance of his critical duties he moved so easily between the world of daily newspaper journalism and that of the elite literary intelligentsia—between, in his case, the *New York Sun,* one of the outstanding newspapers of the day, and *The Dial,* the most distinguished American literary journal of the 1920s, where his editor was Marianne Moore and his fellow contributors often included Ezra Pound, T. S. Eliot, Thomas Mann, and Bertrand Russell. In every venue, moreover—including his last, in the pages of *Art News* in the early years of the emerging New York School—McBride always spoke with a voice of his own. To remain unacquainted with that voice today is to miss out on some of the most intelligent criticism that the era of early modernism has bequeathed to us—and to miss out on some of the intellectual fun of that era as well.

FOREWORD: A NOTE ON HENRY MCBRIDE

Hilton Kramer

The American art critic Henry McBride (1867–1962) is a figure so unlike any of his successors in the last decades of the twentieth century that it now requires a certain leap of the historical imagination to think our way back to his exemplary career in the first half of the century. Almost everything we now take for granted on the contemporary art scene did not yet exist when McBride embarked on his critical endeavors. The modernist movement in the arts was then still widely regarded with great suspicion and often denounced with derision and contempt. The abundant, well-appointed dealers' galleries that now regularly bring us a vast range of new talent; the many well-established museums that boast of first-rate collections of the modernist classics while at the same time competing for the privilege of being the first to embrace new artistic developments; the friendly reception that is now accorded to even the most far-out innovations in art by critics in the mainstream press, academic opinion in the universities, and collectors with the means of acquiring expensive examples of the new art—all of this came much later, and in large part as a result of the pioneering efforts of a very small circle of artists and intellectuals. In that circle, McBride was the premier critic of the modernist movement as it emerged in this country in the aftermath of the 1913 Armory Show in New York. What so many others at the time found shocking and even repulsive in modernist art, McBride had the wit—and the aesthetic intelligence—to see as the classics of the future, and he had the good fortune to live long enough to see his judgment vindicated.

McBride thus occupies an important place in the early history of modernist art in America. At a time when even a great painter like Cézanne was a subject of controversy and a movement like Cubism was regarded as little more than a joke or a hoax, McBride took them in his stride, writing about them with uncommon sympathy and an uncommon clarity, and without any sense of rancor about or superiority to the controversies they provoked. It was very much a part of

Illustrations between pages 242 and 243

1939 - 1952

1929 - 1938

1920 - 1928

CONTENTS

*The articles reproduced are of the McBride collection in the
Collection of American Literature, Beinecke Rare Book and
Manuscript Library, Yale University, New Haven, Connecticut.*

First published in 1975 by Atheneum Publishers.
Reissued with a new foreword in 1997 by Yale University Press.

Printed in the United States of America.

Library of Congress Cataloging in Publication Number 97-60059
ISBN 0-300-06996-0 (cloth), 0-300-06997-9 (pbk.)

A catalogue record for this book is available from the British Library.

The paper in this book meets the guidelines for permanence and durability
of the Committee on Production Guidelines for Book Longevity of the
Council on Library Resources.

10 9 8 7 6 5 4 3 2 1

Henry McBride

The Flow of Art

Essays and Criticisms

EDITED BY DANIEL CATTON RICH

PREFACE BY LINCOLN KIRSTEIN

WITH A NEW FOREWORD BY

HILTON KRAMER

Yale University Press

New Haven & London

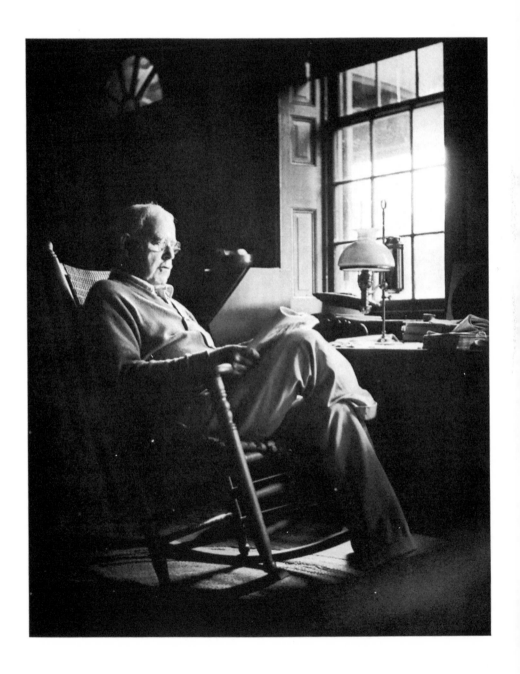

HENRY MCBRIDE SERIES IN MODERNISM AND MODERNITY